D1259530

St. Louis Community College
11333 Big Bend Blvd.
Kirkwood, MO 63122-5799
314-984-7797

Selling Shaker

Value, Art, Politics 1

Selling Shaker

The Commodification of Shaker Design in the Twentieth Century

STEPHEN BOWE AND
PETER RICHMOND

Liverpool University Press

St. Louis Community College
at Meramec
LIBRARY

First published in Great Britain in 2007 by
Liverpool University Press
4 Cambridge Street
Liverpool L69 7ZU

Copyright © 2007 Stephen Bowe and Peter Richmond

The right of Stephen Bowe and Peter Richmond to be identified as the authors of this work
has been asserted by them in accordance with the Copyright, Designs and Patents Act 1988.

1 3 5 7 9 10 8 6 4 2

All rights reserved. Apart from any use permitted under UK copyright law, this publication
may only be reproduced, stored, or transmitted, in any form, or by any means, with prior
permission in writing of the publishers or, in the case of reprographic production, in
accordance with the terms of licences issued by the Copyright Licensing Agency.

A CIP catalogue record for this book is available
from the British Library.

ISBN 1-84631-008-3 cased
 1-84631-009-1 limp
ISBN-13 978-1-84631-008-9 cased
 978-1-84631-009-6 limp

Designed in Quadraat by Geoff Green Book Design, Cambridge
Printed in Great Britain by MPG Books Ltd, Bodmin, Cornwall

www.liverpool-unipress.co.uk

This book is dedicated to our parents
Joseph Bowe and the late Mary Bowe
and the late George and Josephine Richmond

CONTENTS

FOREWORD

The appreciation of Shaker design has developed throughout the twentieth century and its influence has become global being found in America, Europe, Australia and Japan. Exhibitions have been instrumental in the promotion of the Shaker aesthetic and institutions such as the Whitney Museum of American Art have had an important role in the selling of the style and this has been evidenced in their 1986 exhibition.

Early developments at Fruitlands by Clara Endicott Sears and the creation of museum villages such as Hancock and Pleasant Hill are now well documented. Again these have increased the profile of the Shakers and have featured in numerous articles, books and moving images. In addition, other museums have created period rooms in which the furniture and interior design of the Shakers have been preserved. A number of these have been featured in this book and the following are acknowledged: Philadelphia Museum of Art, Metropolitan Museum of Art, Winterthur Museum, Chicago Art Institute, Boston Museum of Art and The American Museum in Britain. In addition, the collection of catalogues acquired for this book will be housed in the library of The American Museum in Britain which is located in Bath.

The idea for the title of this book is taken from a section in the Stephen Stein book, *The Shaker Experience in America*, entitled 'Selling of the Shakers', while the format and structure come holistically from *Religion in Wood: A Book of Shaker Furniture*, by Edward Deming Andrews and Faith Andrews. This project has been a long time in the making and basically started in 1990 when a programme entitled *I Don't Want to be Remembered as a Chair* was shown on BBC television in the United Kingdom. This in part documented the commercialisation which had become evident in the 1990s of a style which became associated with both Minimalism and Modernism.

The book is divided into four sections dealing with various themes and emphasises both exhibitions and the people involved in the promotion of the Shakers and their design. The first is 'Simple and Pure – The Early Promotion of Shaker Design in the United States of America' (1900 to 1945). The second is 'Forms and Forces – The Penetration of Shaker Design

into Museum and Popular Cultures' (1946 to 1975). The third is 'Spirit and Function – The Infiltration of Shaker Design into Museum and Popular Cultures' (1976 to 1994) and finally, 'West and East – The movement of Shaker Design into Museum and Popular Cultures from the West to the East and vice versa' (1995–).

There is increasing evidence of the selling of the style in deference to all other aspects of the Shakers' material culture and the iconic Shaker box has been used as a paradigm and many different forms have been illustrated. The photographs in this book show (a) single Shaker boxes (Plates 1–36), (b) Shaker boxes in a Shaker setting (Plates 37–40), (c) Shaker boxes in museum settings (Plates 41–45), (d) Shaker in period room settings (Plates 46–52), and (e) Shaker boxes in domestic settings (Plates 53–56).

There are many people to thank for a project – special thanks have to go to Dr Nita Pillai for her patience and understanding in giving unlimited amounts of time in the draft stages of this book. Other individuals requiring special mention include: Anne Armitage, Scott DeWolfe, Geoffrey Gale, Brother Arnold Hadd, Rich McKinstry, David Newell, Stephen Stein and the staff of Liverpool University Press. In addition, Winterthur Museum needs recognition for providing access to The Edward Deming Andrews Memorial Collection of Shaker material – without this unrivalled resource this book would have been impossible to complete. Finally, the institutions who have contributed material to this book need a group acknowledgement – thank you.

Note

The colours used on the cover are similar to those used in the new Shaker Kitchen range by Fired Earth (see Kenyon and McClafferty, 2006 and Manley, 2006). They also appear on the paint card produced by Kevin McCloud as Number 72 – Dragon's Blood and Number 106 – Ultramarine Ashes.

Selling Shaker

INTRODUCTION

It is ironic and somewhat paradoxical that as we enter a new millennium, a religious group – the Shakers – whose origins are founded in the eighteenth century, should continue to have such an influence upon contemporary society. It would seem that the twentieth and indeed now the twenty-first century, whilst celebrating the stylistic achievements of the movement, has turned its back on the underlying religious and spiritual ethos. Indeed this paradox forms one of the central axes of this book – that is the idea that participants in the twentieth century have used the Shaker aesthetic for their own commercial ends.

The husband-and-wife team of Edward Deming Andrews and Faith Andrews did much to promote the Shaker ideal in the middle part of the twentieth century, particularly via their previously mentioned book *Religion in Wood*. The book also served, in some part, as a paradigm for this present book. In the introduction it states:

> The Shakers acted out their American conviction within the framework of their own order, well aware that the 'world' was very much present around them, and that the serpent had come into Paradise. Already the irresponsible waste of mine and forest, of water and land, the destruction of bison and elk, were there to show that Paradise was not indefinitely self sustaining. Later the doors of the country closed to the immigrant and the refugee. American money became the greatest power in the world, and Paradise realized itself to be surrounded no longer with friendly hope but by impotent environs and frustrated hate.[1]

The history and background to the Shaker movement have been well documented in enough sources elsewhere for us to dispense with little more than a cursory glance at their origins. The Shakers[2] – a breakaway sect of the Quakers,[3] with a strict moral and spiritual code, whose communities in North America constitute its oldest communal society – have fascinated commentators almost since their inception in England in the 1750s.[4] For example, Nathaniel Hawthorne, an American Consul in Liverpool (1853–57)[5] visited the Shakers and wrote two stories about them:

The Canterbury Pilgrims and *The Shaker Bridal*, where the latter, in particular, displays more than a few of the negative responses of rigidity, fanaticism and emotional impoverishment,[6] characteristic of other contemporary writers on the group. The twentieth-century English avant-garde writer and poetess, Edith Sitwell, described the origins of the Shakers in her book *English Eccentrics*, as: '... heaven-inhabitants were the Shakers, and the foundress of this particular heaven was Ann Lee, who was born in Manchester in 1736. Eventually the Shakers settled in America, where their fervour, and particularly their tenets, caused a good deal of astonishment, and, in some cases resentment.'[7]

Throughout the course of the twentieth century, the Shakers and their seemingly inevitable decline have featured as fascinating subjects for numerous newspaper articles including *The Sun* from 11 April 1909. Here the future of the Shakers – following the controversial and widely reported dismissal of the disgraced Elder Ernest Pick – is reported upon in very salacious detail.[8]

At the other end of the century, whilst the regard in which the group is held has changed, the same salacious tone remains when the *Daily Express* of 14 September 1993 discussed the phenomenal rise in the prices of original Shaker furniture, as collected by the likes of the American television personality Oprah Winfrey. Here her expenditure is discussed in detail: 'She once put down £150,000 for a pine work-counter after falling in love with it at a furniture auction held by the Shaker religious sect in New Lebanon, New York.'[9]

Indeed it is the evolution of the interest shown by the media and general public in the Shaker story throughout the course of the twentieth century which forms the basis of this book. Whilst others have sought to examine the origins of the religious or aesthetic basis of the movement throughout the course of the eighteenth and nineteenth centuries, we have sought to deal with the Shaker phenomenon from a different angle. This book seeks to examine the means by which the Shakers have been 'promoted' during the course of the last century, by scholars and museum academics in order to establish a 'national' style, and then by commercial interests who have seen an international appeal that strikes a note with the commercial zeitgeist.

The book is divided into four sections which deal with this phenomenon

in terms of the cultural and commercial processes prevalent during the particular periods examined. In Section One we examine the evolution of twentieth-century Shakerism via an examination of early Modernity and the means by which it was a vehicle for the promotion of an American national style. In Section Two we see how that national style moves through an institutional conduit, i.e. the museum system, and how by that means it becomes a mainstream aesthetic that is promoted to a wider public both in the USA and ultimately a worldwide audience. In Section Three the Shaker style becomes increasingly more fractured – less of a specifically national American style – and more of a generic style that would ultimately infiltrate all of the 'advanced' commercial markets. This brings us to Section Four which sees the close of a circle – the move of the aesthetic from the eastern to the western seaboard in the United States, and then on to Europe, notably the United Kingdom, but also Italy and Germany. The long-standing Western fascination with Eastern minimalism completes the circle, and we examine the cross-cultural links between Japanese minimalism/Modernism and the Shaker style. In addition, Shakerism is taken up by an increasingly Post-modern commercial world looking to move into aligned markets such as alternative medicine; aromatherapy; environmentalism; music and the holistic lifestyle.

This process has caused certain stylistic 'anomalies', which have given rise to satirical accounts such as the piece from *The Irish Times* in which the contemporary preoccupation with superficial style and design is lampooned:

> Hundreds of oddly-dressed religious zealots appeared in Dublin last night, persuading homeowners to invite them into their kitchens and then refusing to leave. Locals said the invaders were 18th and 19th century Shakers, bent on reclaiming their reputation for beautiful furniture and devotion to God. The raids began early yesterday morning, when at least 50 Shakers arrived at a newly-built housing development near Leixlip, Co. Kildare. They used a similar pattern to gain entry to some 23 homes; first knocking on the door of the house, then presenting the owners with some freshly-baked apple pie, and finally asking if they might see the home's wonderful 'Shaker' kitchen. Once inside, homeowners say, the strangers asked them repeatedly if they were sure they really wanted a Shaker kitchen. If householders replied that they did indeed, the Shakers typically

installed themselves in the kitchen and refuse to leave. 'They said it wasn't a real Shaker kitchen at all, but they could put that right,' one homeowner said in a telephone interview. 'Then they started reefing out all the electrical equipment – the built-in fridge, the microwave, even the wood-panelled extractor fan.' She said her group of three middle-aged Shakers, two women and a man had taken particular offence when they tried to open what looked like a drawer. 'They are still in there but I'm afraid to go near them. My husband had to hand over his toolbox and I think they are making a hard chair,' she added. Apartment owners in the International Financial Services Centre said the 150 Shakers that arrived there yesterday afternoon seemed particularly zealous in their religious devotion. They chanted and sang in unison, rocking and shaking rhythmically back and forward, and have been trying to impose an entire lifestyle on local people. 'They said there was to be no more television, supermarkets, cigarettes or wine for us,' said a foreign exchange trader. 'Then they put me and my wife in separate bedrooms and warned us that the Shaker way included a life of celibacy.'

Last night the Shakers called off a press conference, due to be held in a hastily-built wooden meeting house, because reporters refused to switch off their mobile phones. But Shaker sources said they had come back to life because they were so appalled by the hijacking of their religion's name by Irish developers. 'These people seem to think that anything made of panelled wood is "Shaker". Well we say that whatever is fashioned, let it be plain and simple and for the good. If you want to be a Shaker, we can arrange that,' one source added ...[10]

It is this expeditious growth in what might be termed 'the Shaker heritage industry' in the form of magazines, books, films, music, art, reproductions of Shaker artefacts, Internet sites and museum exhibitions which forms one of the central themes of this book – acting as it does as such a stark contrast to the decline in the contemporary Shakers' fortunes.[11] It is here that the paradox is most striking and most poignant, with the few remaining members of the group being reduced to little more than living museum pieces in their preserved community.[12] In 1990 the *Timewatch* programme *I Don't Want to be Remembered as a Chair* examined the fate of the remaining members of the group and their relationship to the ever expanding market for Shaker artefacts when it stated:

Though life may be more comfortable than it was for the early Shakers, the community today faces pressures of a different kind. They know only too well that the very tables they eat off, the chairs they sit on and the photographs on their walls are considered highly collectible. As communities closed down their contents have been released onto the market. Today you are more likely to find Shaker furniture in the living rooms of wealthy Americans than at Sabbathday Lake.[13]

So what is it that continues to fascinate us about these people? Why has the Shaker style come to be such a potent force in the design panorama? As Stephen Stein noted in his book *The Shaker Experience in America* the dilemma the Shakers face today is that:

> ... the fascination and preoccupation with material culture have prevented a balanced recovery and interpretation of the past. The current popularity of the society's artefacts has overshadowed the fact that the Shakers chose to call themselves the United Society of Believers, not the United Society of Furniture Makers. This fixation on 'things' has begun to block from view the primary reason for the existence of the United Society ... In Mildred Barker's words, 'There's something special behind' those artefacts. 'There's the religion.'[14]

It is the intention of this book to attempt to disentangle some of the issues that have grown up around the interpretation and reinterpretation of the Shaker ethos by successive waves of historians, museum curators and more recently magazine editors and purveyors of lifestyle guides, and gain some insight into why and how the Shakers have become such a rich source of design inspiration to a wide variety of audiences. In short to both attempt to gain a balanced recovery and interpretation of the past and relate it to the growth in what might be termed 'Shakerbelia', a phenomenon that has developed with increasing momentum over the course of the last century and has moved into this century.[15]

Notes

1 Merton, T., 'Introduction', in Andrews, E.D. & Andrews, F., *Religion in Wood: A Book of Shaker Furniture*, 1966, pp. xii–xiii.

2 For a brief explanation of the Shakers see Foster, L., 'Shakers', in Eliade, M. (ed.), *The Encyclopaedia of Religion*, 1987, pp. 200–01 and Van Kolken, D., *Introducing the Shakers – an Explanation & Directory*, 1985.

3 There is some debate as to whether or not the Shakers' origins were truly Quaker or in fact Methodist: correspondence with authors and Geoffrey Gale, 16 January 2002.

4 See Francis, R., *Ann the Word*, 2000, a readable account of the early development of the Shakers in both the United Kingdom and the United States. Ann Lee founded the Shaker religion and had connections with Toad Lane in Manchester: see Apple, N., 'Ann Lee's Toad Lane Changed to Todd Street', *The Shaker Messenger*, 1981. Todd Street is located by both Manchester Cathedral and Cheethams library (both of which have material which would be of interest to Shaker historians and are worth visiting).

5 See Jones, R., *The American Connection* (including Liverpool's American Heritage Trail), 1992, pp. 24–25. Also for some background on Hawthorne and the Shakers see Gross, S.L., 'Hawthorne and the Shakers', *American Literature*, 1958.

6 Hawthorne, N., 'The Shaker Bridal', *The Works of Nathanial Hawthorne*, vol. 1, 1882, pp. 469–76 and 'The Canterbury Pilgrims', *The Works of Nathanial Hawthorne*, vol. 1, 1882, pp. 518–30. See also Coleman, W., *The Shakers*, 1997, p. 27.

7 See Sitwell, E., *English Eccentrics*, 1971, p. 19 (first published by Faber & Faber in 1933). Interestingly, the United Kingdom newspaper *The Guardian* reported on the Manchester Civic Society wanting a plaque on the wall of Manchester Cathedral to honour Ann Lee: see Ward, D., 'Call for Church to Honour Shaker Leader', *The Guardian*, 2000.

8 Unspecified, 'Disgraced Shaker Elder Ernest Pick', *The Sun*, 11 April 1909, p. 6. Taken from The Edward Deming Andrews Memorial Collection, Winterthur Library, Number SA 1717. The 1909 *The Sun* is an American newspaper and interestingly *The Sun* also exists as a UK tabloid newspaper, notorious for salacious stories.

9 Finn, P., 'Why Oprah is Worth her Weight in Gold – How the Winfrey Millions are Spent', *The Daily Express*, 14 September 1993, p. 19. See Bowe, S.J., *Watervliet Shakerism*, Master's Thesis, 1994, p. 129.

10 See MacCarthaigh, S., 'Gimme that old-time ... Kitchen', *The Irish Times* (Property Supplement), 1999. The text starts: ''Tis a gift to be simple, the Shakers said. So what would the 18th-century sect think of our mania for wall-to-wall Shaker-style furniture?' The Irish have embraced the Shakers and there is now a Shaker shop in Ballitore, Ireland. Ballitore is a partly restored Quaker village: see Sheridan, B., 'Quaker Village Provides Ideal Business Backdrop', *The Nationalist*, 1998 and O'Rourke, F., 'Ballitore Rich in Quaker History', *The Nationalist*, 1999.

11 For evidence of decline see Clifton, C.S., 'The Forgotten Shakers', *Gnosis Magazine*, 1995, and Unspecified, 'Endangered Species – The Last Seven Shakers in the World', *The Economist*, 13 February 1999. In addition, Brother Arnold Hadd has communicated in private correspondence that the numbers in 2001 have dwindled even further (letter dated 15 March 2001 from the Chosen Land).

12 See Wolkomir, J. & Wolkomir, R., 'Living a Tradition', *The Smithsonian*, 2001.

13 Taken from Post-Production Script (p. 10), for the television programme Treays, J. (producer), *Timewatch: I Don't Want to be Remembered as a Chair*, 1990. The text was accompanied by a visual image of Shaker boxes on a chest in Stephen Miller's living room.

14 See 'Preface' in Stein, S.J., *The Shaker Experience in America: A History of the United Society of Believers*, 1992, p. xiii. For reviews of this book see Delbanco, A., 'The Art of Piety (Extended Book Review of S. Stein's book *The Shaker Experience in America*)', *The New Republic*, 1992 and Westerkamp, M.J., 'Book Review – The Shaker Experience in America – Stephen J. Stein', *Winterthur Portfolio – A Journal of American Material Culture*, 1994. Also see Galway, L., 'Sister Mildred Dies at Sabbathday Lake', *The Shaker Messenger*, 1990.

15 The influence of the Shaker aesthetic continues with products featured in the Next 2001 catalogue, including circular storage boxes and waste paper bins, both with swallowtail joints. In addition, the October 2001 *House Beautiful* magazine features on its front cover 'Create a Shaker living room, a cosy bedroom & a garden with year-round appeal.' The photograph on the cover features the Shaker room.

1 SIMPLE AND PURE – The Early Promotion of Shaker Design in the United States of America

This section focuses on those developments that took place in the north-eastern seaboard of the United States, instigated by a number of key people who helped promote the cause of Shakerism and, by doing so, created a resource which was later used in the production of numerous exhibitions, publications and artefact reproductions. During the period from 1910 to 1945, North America was rapidly developing both economically and socially. In parallel with these changes in the world outside the Shaker communities, internal structural changes were also taking place in the now declining Shaker society. The majority of promotional activities centred on the Shakers and their material culture took the form of exhibitions,[1] together with their accompanying literature. The exhibitions during this period tended to focus specifically on the furniture and were generally small scale.[2] Exceptions to this included the 1935 exhibition at the Whitney Museum, New York, which was high profile in nature and helped to enhance the fashionable quality of the items on display as well as aligning their style with Modernity. Markets for original Shaker artefacts were strengthening and a cohort of collectors was established. The momentum for all things Shaker was gathering pace in the United States of America, but the society of Shakers and its material culture remained largely unknown outside this tight-knit group of academics/curators and collectors. This section features both the exhibitions of the period (which made specific reference to the Shakers) and also details some of the interpretations which appeared in popular culture venues such as shops and the press. This goes some way to explain later developments in which the Shaker aesthetic infiltrates many and varied cultural phenomena.

Influences taken from Museum Culture

In the early part of the twentieth century, the United States of America was still largely an agrarian society, with dramatic contrasts between the urban industrialised pockets, largely in the east and the north, and the rural communities. The development of the railroads in the previous century

was probably the most significant factor in the rapidly expanding economy of the United States, although as *The Times Atlas of World History* notes, other factors helped: '... abundant natural resources, a literate population, a managerial and organisational revolution, political stability, large-scale foreign capital investment and a pervasive entrepreneurial ethic.'[3] While major events undoubtedly had an effect on both the social and economic development, including the depression and the Second World War, the progression towards consumerism was all pervading and developed rapidly in the timeframe covered by this section.

Manufacturing and technology, production and consumption, transportation and communications all developed throughout the twentieth century and the evolution of a shopping culture reflected these developments and provides a useful paradigm. The product choice available meant that most Americans had the opportunity to become persistent consumers and this was the overarching way in which the United States developed and the context in which the Shakers were to be promoted to the world. The formation of the American consumerist society has been extensively discussed and debated – specifically in texts related to the United States[4] and generally in design history reviews.[5]

In terms of art and taste, the United States of America still looked for the most part to Europe for its inspiration[6] and used terminology and decorative styles which had their origins in Britain:

> In the meantime culture-conscious Americans, in their search for suitable decorative arts, as in their search for a suitable architecture, overlooked the products of the vernacular. Just as Washington Irving had filled his pseudo-Gothic 'Sunnyside' with furnishings many of which were pure Georgian, people everywhere tried to adapt assorted available styles to their everyday requirements.[7]

Clearly, the decorative arts were dependent upon a Eurocentric outlook, with the major American collectors of antiques largely overlooking indigenous arts and crafts. That having been said, home-produced furniture such as that featured in the Cadwalader study[8] was appreciated, albeit that it made direct reference to European styles. This however was to slowly change and would have an influence on how the work of the Shakers, and

Selling Shaker

particularly their furniture, was to be reassessed and ultimately highly valued.[9]

The increasing appreciation of American folk art can be linked to the staging of a number of key exhibitions in the first half of the century, together with the establishment of a variety of galleries devoted to the indigenous tradition. This was allied to a general trend in an awareness of American art[10] and national identity, which has been identified by Matthew Baigell. In 'American Art and National Identity: The 1920s' it notes:

> By 1916, the terms of the quest for an American art had changed. The vague search for an American spirit and an American identity in art, as well as the genial encouragement of artists to find these, were transformed: America was challenged for its past failure to define itself in art and was made to reconsider and reform itself for the supposed arrival for the truest American spirit in art.[11]

It started slowly with exhibitions at the Metropolitan Museum, New York (eventually leading to the development of the important American Wing, *circa* 1924, and later the institution also featured the Shakers in their Bulletin).[12] In 1909 the Metropolitan Museum staged an exhibition of early American art. The Walpole Society was also founded in 1909 creating a small group of influential collectors of American decorative arts. Other institutions such as the Whitney Studio Club (later the Whitney Museum) held exhibitions which started to enter the consciousness of the American public and had real mass appeal. Their exhibition of Early American Art, in 1924, helped start a trend, and similar exhibitions were staged at the Anderson and Dudensing Galleries, New York, plus the Newark Museum, New Jersey. In the book about The Index of American Design, produced in 1950, the growing move of museums taking up the folk art mantle was highlighted:

> In the early 1900s great impetus was given by such events as the Boston Museum's important exhibition of colonial silver in 1906; the Hudson-Fulton celebration in New York in 1909 when the Metropolitan Museum exhibited a collection of early American decorative art; the foundation in 1910 of the Society for the Preservation of New England Antiquities, whose editor, George Francis Dow, did pioneering studies of arts and crafts; the Werkbund exhibitions at the Newark Museum (1912 and 1922) that

brought to this country the message of an organisation which was one of the most important links in the progression from William Morris to modern design.[13]

A symbiotic relationship existed between the major art museums and a select number of wealthy and influential collectors, individuals such as Mrs John D. Rockefeller Jr, Mr and Mrs Nadelman, Mrs Isabel Charlton Wilde, Edith Gregor Halpert, Henry Ford and Henry Francis du Pont. They all became interested in extending their collections to include American folk art. In addition, Juliana Force,[14] Holger Cahill, Charles Sheeler, Dorothy Miller, William Lassiter and Eleanor Robinson, began to realise the potential of folk art and Americana as a means of authentic artistic expression, from a purely aesthetic standpoint, together with its enormous cultural power and potential in the establishment of the nascent national identity.[15] Juliana Force, for example, was to become instrumental in developing the 1935 Shaker Handicrafts exhibition at the Whitney Museum, and was also a collector of Shaker artefacts, mainly furniture. She was part of the clique which included the artist Charles Sheeler whom she recommended to various people.[16] Sheeler created fine art imagery,[17] photography[18] and designs[19] which had direct references to Shaker material culture[20] and were found in many avant-garde and influential art venues including the Downtown and De Zayas galleries.[21] He was important in the promotion of Shaker design via his connections with a number of influential, opinion forming figures in society and academic circles, including Algeria Cahill, Edith Halpert, Paul Strand, Ruth Reeves, Adolph Glassgold, Alfred H. Barr Jr,[22] Charles Beard, Frank Crowninshield,[23] and the Andrews partnership.[24]

He both collected[25] as well as included Shaker artefacts in his own work,[26] which was exhibited widely and, by doing so, he was instrumental in gaining a wider audience for Shaker design.[27] It is now acknowledged that Shaker design had a significant impact on the work he produced throughout his life.[28]

The influence of collectors such as Henry Francis du Pont[29] and Henry Ford[30] started to generate a mainstream interest in Americana which took expression in the founding of the American Wing of the Metropolitan Museum in 1924. Interest began to filter down from the institutional and

Selling Shaker

private 'taste makers', to the more historically conservative and 'Eurocentric' museums. From the late 1920s onwards, the momentum of interest in indigenous art gathered speed. In 1927 the Williamsburg restoration,[31] instigated by John D. Rockefeller Jr, developed interest in the establishment of 'living' museums – a move which was to have considerable significance for Shaker developments later in the century. Other important museums such as the Brooklyn, Boston Museum of Fine Arts, Philadelphia and the Museum of Modern Art, New York (MOMA), emphasised American artefacts in the 1930s by including them within exhibitions.[32]

Along with the emphasis on Shaker artefacts in the form of exhibitions, there was also some development in the performing arts, an early example being a piece created by Doris Humphrey – a pioneer in modern dance – who created *The Shakers*, which was premiered in 1938.[33] In addition, Aaron Copland produced a score for a ballet entitled *Appalachian Spring*, which was performed by Martha Graham and premiered in 1944 at The Library of Congress.[34]

In 1935 The Index of American Design was founded and Holger Cahill became the first Director of the Federal Art Project. Robert Hughes in his book *American Visions* gives a succinct account of the developments under President Roosevelt, which eventually lead to the creation of the Index:

> The new branch of the Works Progress Administration known as Federal Project Number One was set up in 1935 and lasted until 1943. It has four divisions, each with its own director: music under Nikolai Sokoloff; the Federal Theatre Project under Hallie Flanagan; the Federal Writers' Project led by a former journalist, Henry Alsberg; and the Federal Art Project (FAP) run by Holger Cahill.[35]

Because the Federal Art Project focused on regions in the United States, it was inevitable that the Shaker communities would eventually be featured. The Index of American Design was to have a great deal of influence upon the perception of Shaker arts and crafts, and the transmission of interest in Shakerism to a broader audience,[36] and as such it will be dealt with in greater detail later in this section. The importance of the Index in helping to break the 'Eurocentric' monopoly is perhaps best summed up by Gordon Mackintosh Smith, a supervisor in the Boston branch, when he noted that:

The search for a native American tradition in the arts and crafts is fraught with pitfalls. In the verge of labelling an object definitely American and of definitely American inspiration, we go deeper into its background and discover it to be merely an outgrowth of some earlier European form ... Consequently, when the Index of American Design was first established to make and preserve a record of our native arts and crafts, it was essential to choose among its first endeavours an art which we could call our own without reservations. The Shakers were chosen because they come closest to this ideal.[37]

Along with government interventions to promote design to the American population, individuals were undertaking research related specifically to the Shakers and their declining communities.[38] The most important was a collaboration between the husband-and-wife partnership of Edward Deming Andrews and Faith Andrews.[39] As a team they studied virtually every aspect of the Shakers, including their religion,[40] music and dance.[41] It is clear that throughout the twentieth century, and particularly from 1928, Edward Deming Andrews has been consistently associated with the promotion of Shakerism.[42] His role has been acknowledged by virtually all those who have documented the rise and fall of Shaker communities and their material and spiritual products.[43] Mark Van Doren in the foreword to the Andrewses' book, *Work and Worship: The Economic Order of the Shakers*, published in 1974, gives an account of the role of Edward Deming Andrews, which although might be regarded as somewhat hyperbolic, expresses both the knowledge and interest he had in the Shakers by noting:

The word authority, often loosely used to mean one who knows more than most people do about some subject, regains its dignity as soon as we consider Edward Deming Andrews. He knew more about the Shakers than anyone ever has, and I am quite certain that his knowledge of them will never be surpassed. He knew about them; he knew of them; he knew them. His interest in them was many sided, and indeed was inexhaustible. Not merely their furniture ... but their songs, their dances, their craftsmanship, their clothes, their manners, their customs, and finally – crown of all – their religion drew out of him a scholarship so dedicated that for purity, for precision, and for completeness it stands alone in our time.[44]

Andrews, together with his wife Faith, whom he had married in 1921,

formed a formidable partnership in Shaker scholarly circles. Andrews graduated from Amherst College in 1916 and later gained a doctorate in Educational Studies from Yale.[45] Throughout the late 1920s and 1930s, the Andrews team produced a substantial body of work on the Shaker movement, which included magazine articles, books and exhibitions (in collaboration with a variety of national and international institutions), and which started with their 1932 book, *The Community Industries of the Shakers*, published in collaboration with Charles C. Adams and the photographer William F. Winter.[46] Winter would prove to be a particularly important collaborator in that his photographs would form the paradigm by which Shaker design would be viewed. Constance Rourke,[47] widely regarded as one of the most perceptive observers of American culture, wrote a review for the *New York Herald Tribune* of Andrews' later book *Shaker Furniture: The Craftsmanship of an American Communal Sect*, which also featured Winter's photographs, giving them special praise.[48] Winter's work appeared in various publications and was widely appreciated.[49]

The late 1920s proved to be an important period in the development of a broader Shaker awareness. In August 1928, Andrews' article on the Shakers was published in *Antiques*[50] and, through this article, the Andrews team formed an important collaboration with Homer Eaton Keyes,[51] who was associated with *The Magazine Antiques*. Keyes offered advice on both the literature and exhibition work the Andrewses were then producing, helping with the staging of the 1935 exhibition at the Whitney Museum of Art.[52] Keyes also independently produced a number of articles for the magazine giving a positive view of the Shakers.[53] There also followed articles featuring the Shaker home of Mr and Mrs Andrews,[54] in which the Shaker philosophy is constantly aligned to the Modernist aesthetic[55] in order to play on its contemporary relevance:

> The word functionalism was probably quite outside the vocabulary of Shakerdom. But what was 'practical' and what was not, the Shakers understood better than most of their worldly neighbours. Untroubled by philosophies of style, they nevertheless held to a very clear philosophy of craftsmanship. Whatsoever they built must serve a useful purpose; it must be so far as possible perfectly constructed, and must be devoid of all decorative embellishment. In the upshot, this meant that Shaker dwellings and Shaker furniture represented a virtually unconscious response to current

styles and canons of proportion, which were in turn very consciously reduced to the ultimate of simplicity and subjected to further modification to meet the stern demands of utility. To Shaker furniture as it may be studied in individual examples ANTIQUES has in the past devoted considerable attention.[56]

This concern with functionalism can be seen in Andrews' book, *Shaker Furniture: The Craftsmanship of an American Communal Sect*. Here Andrews began to outline his ideas regarding not only the functionalist elements of the Shaker aesthetic, but also his concerns over the intimate connection between the spirituality of the Shakers and their material culture, which he was determined should not become divorced in any broader appreciation of the communities. He wished to study manufacturing methods, but also ensure that it was tied closely to the religion that underpinned that production. In the preface to the book, Homer Eaton Keyes speaks of the functional aspects of the designed object, but hints at the underlying philosophy which drives that functionalism – in the case of Shakerism this being their religion:

> Another phenomenon of our current life is the emphasis placed on what is called functionalism in all the apparatus of household equipment, whether utilitarian or assumed to serve decorative ends. These dictates of functionalism insist that the design of any article shall be determined first by a study of the purpose to be fulfilled, and secondly by a consideration of the mechanical processes by which the designer's conception is to be fabricated into reality. Functionalism eschews ornament as a superfluity and as a disingenuous attempt to conceal structure, in which, after all, resides the essence of what is often spoken of as the 'new beauty'.[57]

In the 1930s there was some Works Projects Administration (WPA) collaboration and the Andrewses were also involved in The Index of American Design. From this period on, it was a continuous process of publication, exhibitions and general promotion of the Shaker aesthetic on their part. This was documented in the Andrewses' book *Fruits of the Shaker Tree of Life: Memoirs of Fifty Years of Collecting and Research* which was in fact published after Edward Deming Andrews' death.[58] The publication of their book, *Shaker Furniture: The Craftsmanship of an American Communal Sect*, in 1937, helped increase awareness and interest – a fact they themselves were

only too keen to point out. Whilst the main impetus of the Andrewses' interest in Shakerism was on a scholarly level, they also used their role as early collectors of Shaker artefacts – by becoming important dealers[59] – in helping to raise the profile of Shaker design amongst the *cognoscenti*. In this way the role the Andrewses played was two-fold, being both academically and financially driven. Edward Deming Andrews seems to have been particularly good at forming fortuitous liaisons with people of influence, communicating as he did with Clara Endicott Sears[60] and Eleanor Roosevelt.[61]

By the 1940s the Andrewses had pushed the Shaker aesthetic almost to the top of the cultural agenda. In a broadcast on 24 November 1940, Eleanor Roosevelt detailed progress of the Federal Art Project and the promotion of American art and design which prompted Andrews to write to her requesting that some form of permanent record of the Shaker society be established. Mrs Roosevelt suggested that an association be formed with the Smithsonian Museum in Washington. However, its director Alexander Wetmore was unenthusiastic about the idea, believing that there was too little space at the Smithsonian for the establishment of a period room. As a result the Andrews team seemed to suspend the idea of a Shaker collection in a national institution and the core of the Andrewses' extensive Shaker collection would eventually find a home in the restored Hancock Shaker Village, while their manuscripts, photographs and other archival material were donated to the Winterthur library.[62] The Andrewses' views were throughout their lives largely unchallenged and it is really only since the death of Faith Andrews[63] that there has been a revisionist view of their contribution to Shaker scholarship. Whilst it cannot be argued that they had a fundamental role in promoting the Shakers, some have questioned their motives and ultimately the accuracy of their records. Stephen Stein in his book, *The Shaker Experience in America*, states:

> Edward and Faith Andrews became preoccupied with the pursuit of Shaker items. Friends and family initially scoffed at their new interest, but when the Andrewses sold two Shaker trestle tables 'at a considerable profit, they were impressed.' Soon the couple was scouring every standing building that had ever been inhabited by the Believers for objects … Edward and Faith Andrews inadvertently reveal the subtle ways in which they and others pressured the ageing Shakers to surrender their possessions.[64]

John Kirk, in *The Shaker World: Art, Life, Belief*, gives another revisionist account of the Andrewses – although it is tempered with some mild praise. Kirk questions the accuracy of the Andrews team's methodology, in particular the role of the various relationships they formed during the process of collecting Shaker artefacts. He notes that:

> It would be impossible not to honour the work of the Andrewses for it saved Shaker materials and made known Shaker theology, history and art. Furthermore, they became the premier scholars and dealers in Shaker materials, and helped form major collections. In the early 1960s, for example, they encouraged and helped Henry Francis du Pont to add Shaker rooms to Winterthur, and they were the major source of Shaker rooms and furnishings for the Metropolitan Museum of Art, and the American Museum in Bath, England. They did not, however discover the Shakers nor originate the collecting of Shaker things ...[65]

The Andrews partnership had a significant influence throughout much of the twentieth century, and as such they are central to the thesis of this book. Even after their deaths their combined reputations continue to have a profound influence upon Shaker scholarship.[66]

The Western Reserve Historical Society (WRHS) Collection and Fruitlands Museums – 1910 to 1920

The Shakers have always been something of a curiosity and received visitors from the outside world,[67] consequently a number of individual Shakers realised that they could use the interest of the 'world's people' to their advantage. John Kirk states that the first museum rooms were actually created by the Shakers themselves, who realised their own marketability and appeal. Interestingly, by doing so, they helped recreate the classic Shaker look within their less than perfect communities:

> As the Shakers were swept up in the colonial revival's interest in their past, they hoped that the ever increasing appreciation for their objects would lead people to understand Shaker values; it also brought them an even greater understanding of their own history. Sister Josephine Jilson may have created the first display of Shaker artefacts not contemplated as a period room. After she moved from the just sold Harvard Community to

the North Family at Mount Lebanon in 1918, she set up a display of Shaker material for the edification of visitors.[68]

Some of the pioneering collection of Shaker artefacts was with the external gathering of Shaker manuscripts at the turn of the century.[69] One of the most important and impressive was the formation of the Western Reserve Historical Society's (WRHS) Shaker collection in Cleveland, Ohio.[70] The Library of the WRHS has more than 1,800 volumes and 10,000 manuscripts. Amongst the people who were instrumental in developing the collection, arguably the most important was the director Wallace H. Cathcart.[71] He collaborated with the Shakers, particularly those at Mount Lebanon who were interested in the preservation of their material culture whilst the United Society was evidencing decline.[72] The years between 1910 and 1920 saw a rapid rise in materials introduced into the library so that, by 1920, the WRHS could claim to have a very comprehensive collection of Shaker books and manuscripts.[73] The following quotation provides an insight into Cathcart's dedication to the Shakers and the recording of their materials:

> There are several probable reasons why Cathcart started to collect Shaker books. First, he was a religious man and was very active in the Baptist Church. As is often the case, personal interests show up in collecting habits, and he began gathering books about various religious sects since late in 1890. Secondly, there had been a Shaker village (North Union Village, 1822–1889) near Cleveland in what is now Shaker Heights; therefore, Shaker material was part of the Western Reserve's history and came within the WRHS's collecting policy ...[74]

In an article by J.K. Pike, the Shakers themselves are portrayed as significant instigators in the collection of manuscripts by the WRHS with the availability of protective accommodation being a primary consideration, although monetary issues seemed to have also played a part, with the Shakers being paid in exchange for materials. Alonzo Giles Hollister – who was interested in early Shaker religious teachings – provided information and guidance, whilst the main motivation of Eldress Catherine Allen, who acted as a conduit, appears to have been concerned with keeping the memory of the Shakers alive for posterity:

Eldress Allen was too much of a realist to share Hollister's touching faith in the power of Shakeriana to win converts; while she appreciated the opportunity to publicise Shaker principles thereby, her main reason for favouring the transferral of Shaker records to institutions was to ensure that they would be available for future generations to study.[75]

The Western Reserve Historical Society continues to be an important resource for researchers and a venue for those interested in the Shakers, and was particularly featured in *The World of Shaker* in the 1970s.[76]

Another significant and early development was that of Fruitlands Museums, which had become almost exclusively connected with the communities at both Harvard[77] and Shirley – neither of which is now functional. Fruitlands Museums evolved and developed from 1914 to 1947[78] and was created by Clara Endicott Sears. Sears was a Bostonian philanthropist and she used her summer residence as a base for the amassed collections of various artefacts. Fruitlands also had connections with Bronson Alcott and religious experimentation[79] and Sears developed associations with the Harvard Shakers and was privileged to be given access to materials normally only viewed within communities.

The Harvard site was designated as a Historic District in 1974, with a listing in the National Register of Historic Places, with the majority of buildings now being private residences. There were originally four Shaker families – Church, East, North and South – located on the site, with the majority of extant buildings being within the Church family, located on Shaker Road.[80] It was a Church family building that was carefully moved to Fruitlands and authentically preserved to become a museum building with permanent Shaker exhibits.[81] Fruitlands Museums has recently featured in a television programme in the United Kingdom,[82] as well as acting as a focus for seminars[83] and, in 1991, the formation of the Harvard Shaker Community was celebrated there.[84] The complex includes a museum, library and special exhibitions space.[85] Fruitlands contains four distinct sections (with a reception centre and museum store): the first is housed in the Trustees' Office, with the other sections including Fruitlands Farmhouse,[86] the Picture Gallery and the American Indian Museum located on the site.

The museum has a strong collection of Shaker artefacts including good

quality furniture with textiles, labels, photographs and smalls, together with a considerable collection of research materials in the museum library. Special pieces pertain to the Harvard and Shirley communities – this being of particular importance, as artefacts from Shirley are scarce. However, it must be noted that the collection also includes material from other Shaker communities including Canterbury and Mount Lebanon.[87] The museum publishes a newsletter entitled *Under the Mulberry Tree*, providing news, curatorial information and calendars of events,[88] and continues to hold Shaker-themed exhibitions.[89]

When seeking to display her large collection of artefacts Clara Endicott Sears appears to have been reasonably sensitive to the privileges given to her by the Shaker community. In a photograph of the Shaker display at Fruitlands, from 1918–27, it is clear that artefacts are displayed within a room context – with the furniture placed around the walls and various pictures on the walls (including a gift drawing).[90] Interestingly, a lapse in her integrity concerning a gift drawing is highlighted in *The Shaker World: Art, Life, Belief* which states:

> In general, Miss Sears seems to have been faithful to the trust placed in her by the Harvard Shakers, even though she did hang a gift drawing in a public place after Eldress Catherine Allen, who had given it to her, asked her to keep it private.[91]

Sears also recorded and wrote about the Shakers and, in 1916, she published relevant materials in *Gleanings from Old Shaker Journals*, whilst in 1922 she wrote a novel entitled *The Romance of Fiddler's Green*, which contained some Shaker references. In addition, she also communicated with other interested parties. In a letter to Edward Deming Andrews, dated 5 December 1926, she writes:

> Of course Shaker Chairs were made in great quantities but I doubt very much if they did other pieces of furniture for the open market. They had many colonies to supply and at Harvard this industry was a lively one. I do not know whether you ever heard that when the Harvard village was sold I found then that no effort was to be made to preserve the houses. I moved the oldest house made by the Shakers to my place on Prospect Hill which includes the old historic house called 'Fruitlands' where Alcott and some English mystics tried to create a new Eden. I put the Shaker memorial

house near Fruitlands and both are open to the public in Summer. I mention this for in the house are examples of all their industries including many fine pieces of furniture. They made high linen chests reaching from floor to ceiling – lovely tip tables, desks, dining tables of the style of Refectory tables – in fact all the furniture at the Harvard Shakers was made by them. They used pine and maple and often curly maple – sometimes they painted the furniture a peculiar colour ...[92]

Sears was one of the first 'outsiders' to develop Shaker materials and as such played an important role in the promotion of the Shakers and their 'style' to a wider public. In *The Shaker Experience in America*, her role in this respect is examined and the connection between museums and the marketing of the Shaker aesthetic – which would have such a profound effect upon the public perception of the Shakers – is explored:

The establishment of museums and the restoration of the historic Shaker sites have contributed substantially to the growth of the Shaker market. The museum and tourist trade at both Sabbathday Lake and Canterbury set the pace. Both locations offered tours of their facilities long before the wave of interest in historic preservation. (In fairness, however, it must be noted that Clara Endicott Sears, a pioneer in the museum field, moved the trustees' Office from Harvard to Prospect Hill in 1920, where it became part of the Fruitlands Museums.)[93]

Clara Endicott Sears could claim to be one of the first to promote the Shakers as a group. Not only did she have connections with actual Shakers, but endeavoured to preserve their memory within early permanent museum contexts.

The New York Shakers and Their Industries at the New York State Museum in Albany – 1927 to 1938

The New York Shakers were featured in a series of significant temporary exhibitions shown at the New York State Museum in Albany.[94] The museum suggests that they started collecting Shaker artefacts in 1927[95] and the interest this generated was significant, coming as it did at a time when many communities were at risk and in decline. A series of groundbreaking exhibitions ran intermittently for over a decade and featured the

collection and work of the Andrewses.[96] They collaborated with William Lassiter, a fellow collector of Shaker furniture, who it seems worked in what appears to be a mainly coordinating role.[97]

The series of exhibitions was focused almost entirely on the Shakers centred on the Albany district and in the main were temporary in nature. The material displayed tended to focus on the communities found around Mount Lebanon (the Mother community and also known as New Lebanon). In addition to the core team of the Andrewses and Lassiter, others became involved to varying degrees, most notably the photographer, William Winter and the Shaker sister, Alice Smith. The first exhibition was held at the State Museum, Albany in June and July 1930,[98] and led to a smaller version prepared by William Lassiter[99] being staged at the New York State Museum, from September 1932 to July 1933. This in turn led to collaboration between the Albany Institute of History and Art and the New York State Museum, on a joint exhibition staged in 1938 – again prepared by Lassiter in which 40 of Winter's photographs were displayed. In addition, a loan exhibition of Shaker photographs by Vincente, Herlich and Vincentini was featured, the material having been sourced from the Works Projects Administration, Federal Art Project.[100]

A further association of the Andrewses was with Charles C. Adams, director of the New York State Museum. Much of the work that the museum completed is well documented in the *Bulletins* which were produced on a regular basis. The following, taken from a *Bulletin* of 1931, is part of a report by the director in which he places Shaker developments into a wider context:

> A small Shaker collection is on exhibition at the Museum of Natural History and Art, Pittsfield, Mass. There is also a collection at the Connecticut Valley Historical Society at Springfield, Mass. Clara Endicott Sears has a valuable exhibit housed in an old Shaker dwelling at Harvard, Mass. (Harriet E. O'Brien, Lost Utopias. Boston. 1929). There is also a small Shaker collection at the Schenectady County Historical Society, Schenectady, NY. These are the only collections which the State Museum has discovered. Of course there are many examples of Shaker furniture, and particularly Shaker chairs, in private homes. At present the Shaker collection in the New York State Museum is the largest and most important one in any Museum.[101]

Charles Adams' role was acknowledged in Andrews' *The Community Industries of the Shakers* as '... far-sighted recognition of the importance of the subject matter was the initial stimulus to this research ...'. Adams was responsible for 'The New York State Museum's Historical Survey' and also produced a collection of Shaker articles, becoming an early important promoter of the Shaker cause. In the Survey, emphasis is given to the collection's technical ingenuity:

> The Shakers invented a variety of mechanical contrivances, including the circular saw ... the original of which, according to the Shakers, is in the Historical Collection of the State Museum ... They excelled in basketry, making between 50 and 75 kinds. The chair business is still conducted. The tables, chairs, store and work counters, chests, cupboards and built-in drawers all showed great mechanical skill, simplicity and perfection of execution.[102]

Included in the Survey are a number of photographs which provide evidence of the early selections of artefacts made for exhibition. The exhibits appear cluttered and (in modern museological terms) poorly arranged but, importantly, the exhibition designers do not seem to have been tempted to place everything into room settings. One photograph shows Shaker household arts, as displayed in the State Museum temporary exhibit, and is labelled 'Shaker Industries from 1800–1825', which gives an indication of the time-scale in which the first organisers arranged exhibitions – mainly in what has now become known as the 'Golden Period'.[103] In general, the display made little or no attempt to contextualise, apart that is from some rudimentary labelling. Despite these shortcomings, the photographs provide clear evidence of the forward-thinking role the museum was playing in the preservation of Shaker artefacts from communities which were, even at this time, in sharp decline. The New York State Museum at Albany was one of the first to recognise this role, cataloguing a number of the Shakers' buildings at Watervliet (many of which are no longer extant). Charles Adams outlined this role when he later stated:

> As the New York State Museum is the central official state agency for historic objects, it became the responsibility of the State Museum to do all it could, with its limited facilities, funds and storage space, to preserve as much as possible of these Shaker materials.[104]

He goes on to state:

> My attention was first called to the Shakers more than 15 years ago by my then young friend, William F. Winter, of Schenectady, whose summer avocation was photographing the beautiful scenery in the Adirondacks. With keen aesthetic appreciation, he had recognised beauty in the buildings and handicrafts of the Shakers. When I came to the State Museum in 1926, he became my chief adviser on Shaker matters. It was, in fact, his suggestion of a loan of some of his Shaker photographs that led to the first exhibition of Shaker industries in the State Museum in the Spring of 1929.[105]

Charles Adams continued to write on the Shakers into the 1940s, reporting on the WPA's help, the acquisition of material from Canterbury[106] and the progressively declining communities.[107] Adams could make claim to be a pioneer in Shaker studies and he clearly acknowledges William Winter as being his mentor. Whilst Winter has generally been credited as playing a secondary role by most Shaker historians, his talents were however recognised by Keyes.[108] Charles Adams also mentions in the *Bulletin* in 1931 that Juliana Force gave a collection of photographs by William Winter to the museum. It states that they were '... the finest series of Shaker photographs and negatives ever made by William Winter – who was the outstanding photographer of the life of the Shakers.'[109] Whilst the Andrews partnership did not give Winter the credit he deserved, they did use him to manipulate the images in order to create the exact aesthetic that they wanted – one which was minimal and Modernist. However, a 1930 photograph by Winter, in *The Shakers and the Worlds People*, is interesting because it shows a room at Watervliet in a decidedly Victorian style.[110] John Kirk gives a different perspective on Winter's contribution. In his book, *The Shaker World: Art, Life, Belief*, he declares:

> The photographs of William F. Winter, Jr for Shaker furniture established for a generation how Shaker furniture should look and be arranged. The sensuous black and white images of sparsely arranged pieces, much of them stripped, look beautiful and proper. For example, the chest over two drawers in figure 248 looked handsome in modulated grey tones. Until fairly recently few stopped to wonder whether it had a yellow surface. It appears, in fact, much like the piece shown as figure 147. For the

photographs, unused rooms at Mount Lebanon and Hancock were cleaned up by Edward Andrews, and the Andrewses' collections arranged and rearranged to create a Modernist clarity of sparsely distributed forms (see figure 249). Those photographs still represent the way most people think of Shaker interiors. But actually, they speak of modernism, and they look like dealers' photographs.[111]

Adams gives some detail relating to the survey undertaken by the New York State Museum. It was apparent that the study focused on a number of different areas, including the collection of artefacts produced by the Shakers not normally appreciated – including machinery and raw materials – as well as finished products. He states:

> The Historic Collection of the State Museum contains the largest collection of Shaker materials possessed by any museum. The collection is particularly noted for its industrial materials, wood products, tin ware, wood and metal working tools, herb and broom material, the largest collection of photographs and architectural drawings, and mechanical equipment, particularly that used in the herb industry, and a valuable series of baskets. Textiles are represented by samples of linen and wool and textile equipment.[112]

As part of the continual recording of Shaker communities, photographic records were made of the buildings' exteriors and interiors. The museum also attempted to record construction techniques employed by the communities. In addition, old photographs were also collected and accurately recorded and labelled. To augment the photographs, architectural drawings of the buildings at Watervliet and Mount Lebanon were undertaken. Thus buildings at risk were recorded in a similar way to the Historic American Buildings Survey. Much of the work undertaken by the New York State Museum was ground-breaking, marking it out as one of the major institutions responsible for securing the knowledge base on the Shakers. Adams expands by recounting in the *Bulletin* information sources such as those found in the Western Reserve Historic Association. In addition, he also made reference to the sites of existing and former families at Watervliet, Mount Lebanon and Shakertown, Kentucky, amongst others.[113] In addition, the Canterbury,[114] Sabbathday Lake[115] and Hancock[116] sites were also given special mention.

Shaker Artefacts at the Berkshire Museum, Pittsfield – 1932

The Berkshire Museum is very different from that of the New York State Museum at Albany, being relatively small and somewhat provincial. Its involvement in Shaker promotion is chiefly due to its proximity to a number of communities, particularly Hancock. In 1932, the museum staged an exhibition of Shaker artefacts and produced a small catalogue with a contribution from Edward Deming Andrews, who also loaned a number of the artefacts on display.[117] In the book, *Fruits of the Shaker Tree of Life*, the importance of the exhibition is emphasised:

> The publication of the book on industries was followed by several exhibitions, a small one in Boston that attracted little attention, another at Albany State Museum which was more successful, and a third at the Berkshire Museum in Pittsfield, which was destined to have far reaching consequences. For it was here, through the instrumentality of its imaginative director, Miss Laura Bragg, that we became acquainted with Mrs Juliana Force, the director of the Whitney Museum in New York City.[118]

The exhibition was separated into two sections, the first highlighting the furniture, industrial materials and textiles of the Shakers in both New England and New York State. The second section included camera studies of the Shaker communities at Hancock and Mount Lebanon, taken by William Winter. Andrews' catalogue contribution was entitled, 'The Furnishings of Shaker Dwellings and Shops', and provides an analytical account of the means by which the Shakers designed both their homes and commercial premises, emphasising the utilitarian nature of the interiors. The exhibition was arranged as a series of period rooms:

> The exhibit presents an early Shaker sisters' 'retiring room', the name once given to those cloister-like but comfortable retreats where the Believers slept, and to which they could retire after the Sabbath or week-day duties were done. Brethren's and sisters' costumes are shown in the next space, which represents a clothes press and attic room. A sisters' sewing-shop, or work-room, presents examples of the weaves and handicrafts of the early Shaker sisterhood, with a number of the tools and devices employed in these household or small-shop industries.[119]

Further galleries showed representations of a community dining-hall with

its trestle table and slat back chairs, with most of the furniture, textiles and industrial objects having originated from the Hancock society, or the Mother community at Mount Lebanon. Whilst these recreations were accurate up to a point, they were nevertheless museum recreations and Edward Deming Andrews himself recognised that some of the arrangements of objects were artificial, when he stated that: 'The collection of objects and utensils in the brethren's shop is also an artificial rearrangement. The Shaker cobblers had rooms or shops to themselves; so also the coopers, carpenters, blacksmiths and mechanics.'[120] Andrews emphasised that the labour performed by the Shakers was part of their worship and that this had a fundamental relationship to the production of all their artefacts. The connection between work and worship was a recurrent theme in all of the Andrews partnership's writing on the Shakers and is central to an understanding of their approach to interpreting the communities.

The exhibition was featured in *The New York Times Magazine* under the headline, 'Native Art from Old Shaker Colonies – A Distinct Style of American Furniture which has Interest for our Times'. The article, by Walter Randall Storey, was essentially a review of the exhibition, in which he states:

> The collection of antiques may perform the service not only of preserving furnishings of superlative workmanship but also of rescuing from oblivion everyday furniture and domestic arts that possess great historical and other educational values. Museums now recognise the importance of these specialised collections; one instance of such recognition is the exhibition of Shaker furniture textiles and industrial material at the Berkshire Museum, Pittsfield, Mass ...[121]

Here we find the start of the recognition that everyday arts also had a part to play in the cultural richness of the United States of America, and that objects once considered 'lowly' now had a place in high art institutions. The placing of material into recreated rooms has a dual purpose, allowing a great deal of control to be placed in the hands of the curator/room creator, whilst also making the argument that artefacts are best seen in their 'natural' environment. This apparent paradox may well account for the popularity of the room reconstruction amongst Shaker academics. The emphasis Andrews placed on period room settings is one that will be

examined at various stages throughout this book, particularly with reference to how the Andrewses were able to control the Shaker aesthetic, via these recreations, in order to promote their own agendas – both overtly and covertly.

Design and Manufacture of the Shakers at the Lenox Library – 1934

This library exhibition was created by the Andrews partnership and produced under the auspices of the Lenox Library Association, Lenox, Massachusetts. In common with the 1932 Pittsfield exhibition, the majority of material came from Mount Lebanon and Hancock and was loaned by the Andrewses. The catalogue produced to accompany the exhibition has an illustration of a classic Shaker slat back chair on its front cover and contained a short essay by Edward Deming Andrews which expanded on themes he had covered in previous writings such as *The Community Industries of the Shakers* (1932), although he did recognise the shortcomings of a brief catalogue:

> In the applied arts and sciences of the Believers, a just appreciation of values is dependent, not alone on a technical analysis of design, material and function, but on a sympathetic understanding of the principles and spirit which motivated the labour of Shaker hands. This we can not hope to impart in a brief descriptive catalogue.[122]

Edward Deming Andrews introduces his recurrent concern with emphasising the link between the artefacts produced by the communities and their spiritual underpinning. The spiritual 'purity' of the community, gives, for Andrews, a physical perfection[123] to the manufactured artefacts: 'The Shaker ideal of purity, which found expression in a basic doctrine requiring confession of sin and the adoption of celibacy, excluded not only carnal or fleshly practises, but all "works" touched by error, blemish or imperfection.'[124] He defines this process further, by highlighting a trinity of attributes to be found in the craftsmanship:

> All craftsmanship in wood, nevertheless, possesses three general attributes: restraint in design, perfection in workmanship and a manifest usefulness. The first property, which applies in some degree to many schools of provincial furniture, was the inevitable consequence of the cult of simplicity, of

the Shaker belief that they must have the innocence and purity of children, and the direct, unquestioning acceptance of the Deity characteristic of primitive cultures. An entire section of their Millennial Laws was devoted to 'superfluities', those extravagant, useless, ornate things which 'shut out the sense of God'. The rejection of ornament has great significance in the craftsman's concept of design.

Andrews continues by noting:

> But to call this workmanship plain or severe is not to say it was unlovely. In renouncing the importance of embellishment (excess turning, carving, inlay, surface decoration, etc.) the Shakers paid compensatory attention to the values of symmetry and proportion, of straight lines and gentle curves. Delicacy and refinement played their purifying role. Crudeness and imperfection, with its religious and theological basis, swept the occupational scene free of dross, leaving works of chastened skill and serene charm. The third characteristic, utility, is intimately related to the qualities of restraint and perfection. 'Beauty', the Shakers say, 'rests upon utility'.[125]

Andrews goes on to analyse individual exhibits, taking the example of a simple trestle-table in order to highlight the concepts of 'simplicity' and 'purity' and their inextricable links with the communities' concerns with 'humility' and 'common purpose'. In addition to the main body of the exhibition, there was an associated exhibition of photographs prepared by William F. Winter, including photographs of Shaker homes and shops, still-life studies and Shaker furniture – owned by both the photographer and the Andrews partnership. The exhibition was featured in *Antiques*, along with details of how to visit Hancock.[126] This was important because it connected a constructed exhibition with a real Shaker experience at Hancock (it would be in the next three decades that Hancock would change from a Shaker community to a recreated museum village). Although the Lenox Library exhibition was relatively small scale (like previous exhibitions it was located in the State of Massachusetts near to actual Shaker sites), it was important because it prepared the way for the more prestigious exhibition at the Whitney Museum the following year.

Shaker Handicrafts at the Whitney Museum, New York – 1935

The exhibition staged at the Whitney Museum in 1935 was arguably, in Shaker terms, the most important to occur in the decade between 1930 and 1940. In common with many of the institutions involved in the mounting of early Shaker exhibitions, the Whitney revisited the topic in a large-scale exhibition in the 1980s. The exhibition received a good deal of publicity including articles in the *Brooklyn Daily Eagle*[127] and the *New York Herald Tribune* and was generally regarded as being a great success, with over 4,000 people attending.[128] A small formal catalogue entitled *Shaker Handicrafts* accompanied the exhibition, in which the partnership effort of the Andrewses is acknowledged: 'The Whitney Museum of American Art wishes to make grateful acknowledgment to Mr and Mrs Edward Deming Andrews, to whom it is indebted for the selection and arrangement of this exhibition.'[129]

In the introduction there are details of the history of Shakerism and the factors that helped shape Shaker production. Three principles are noted: first, separation from the outside world; secondly, the employment of the talents and skills of all the community members and, finally, the central tenet of simplicity and the removal of the superfluous. These three characteristics are constantly and consistently repeated with the effect that the statements become absolute – fact rather than interpretations:

> All were inspired by a movement in which the route to a social-economic utopia was identified with the way to personal salvation. Devoted to prescribed principles, and bound firmly together by persecution as well as common belief, these small groups of perfectionists were destined to evolve a character distinct from that of the world about them, and a spirit which could not but be expressed by the work of the hands. Architecture, industrial products, textiles and furniture demonstrate, each in its own way, the values and requisites of community life, the high regard for 'strict utility' and the belief that 'true gospel simplicity … naturally leads to plainness in all things.'[130]

It was clear that the Andrews partnership wanted to promote the cause of the Shakers to an audience of receptive gallery attendees. They may have had other motives and recent commentators have endeavoured to suggest other agenda. In *The Shaker Experience in America*, in the section entitled

'Selling of the Shakers', Stein provides a rather more cynical interpretation of the motives of the Andrewses when he states:

> The next step in the evolution of the Shaker antique market was the mounting of major shows such as the exhibition at the New York State Museum at Albany in 1930, an exhibit in 1932 at the Berkshire Museum in Pittsfield, Massachusetts, another in 1934 at the library in Lenox, Massachusetts, and the display of 'Shaker Handicrafts' at the Whitney Museum in 1935. By the 1960s exhibitions of this kind were commonplace. These and other widely publicised events fed the rising interest and sweetened the market prospects for collectors and dealers. Such exhibitions also created customers for books about Shaker furniture.[131]

The Andrewses may have been motivated by making money – they needed after all to make a living. However, it is indisputable that they were genuinely interested in the Shakers and their religion and wanted to extol their virtues to whomever would listen. Even during the 1930s the work Edward Deming Andrews produced on the Shakers was being used in articles such as those found in *The Peg Board*,[132] and much of what the Andrews team instigated in terms of interpretation is still used and made reference to. For example, the chapter by Paul Oliver entitled 'Perfect and Plain: Shaker Approaches to Design', refers to a number of Andrews publications.[133]

In the Whitney catalogue we begin to see the emergence of a number of common themes including the consistent use of the term 'perfectionism'. Perfection in design, particularly with regard to notions of utility and the stripping away of the superfluous, is an idea which Andrews reinforced in this exhibition. He aligned the Shakers with the Modernist code of 'form following function' when he stated: 'Custom and law forbade surface embellishment, carving, inlay or excessive turning; the merit of the finished piece must depend on form alone, on rightness of proportion and linear composition.'[134] Albeit with the caveat that: 'The Shakers were presumably unaware of the aesthetic implications of "functionalism". Now and then, in their literature, such axioms appear as: "the truly useful is always the truly beautiful"; "beauty rests with utility".'[135] One of the Andrewses' consistent interests was that of inspirational drawings and in the Whitney exhibition a number of these were featured, including 'Tree of Life'.[136] This image has now become inextricably associated with the Shakers and

their visual imagery.[137] Andrews goes on to suggest that in broad terms the inspirational drawings are not unrelated to other products produced by the Shakers.[138] He finally states: 'All labour was pursued in the spirit of a founder who, at the beginning, had adjured her followers "to put their hands to work and their hearts to God".'[139] By doing so he brings the inspirational drawings into the fold of functional Shaker artefacts.

The catalogue indicates that the majority of material in the exhibition was taken from Mount Lebanon and Hancock and dated from roughly 1810 to 1850.[140] These dates are significant, falling as they do in the main within the so called 'Golden Period', as defined by Andrews and other Shaker scholars. We can therefore see emerging the notion of a 'high-water mark' for Shaker production, which was to have profound effects upon subsequent interpretations. The exhibits featured a variety of different types of furniture, including children's furniture, dining trestle-tables, book shelves, rocking chairs, sewing stands, oval boxes and also clocks.[141] Importantly, this was one of the first exhibitions to find its way into a cosmopolitan centre for art and design and gave Edward Deming Andrews greater freedom to define and promote his choice of objects. Nearly every object featured came from the 'Golden Period' of Shaker production and would have probably been of the finest quality – reinforcing the notion that this period represents the apogee of Shakerism – with Andrews careful to omit items such as fancy ware poplar boxes which, by definition, did not fit his thesis. It was not until much later that these sorts of items would be prominently featured in exhibitions and books. Clearly, the entire production of the Shakers and particularly that which was produced in the Victorian period was something quite difficult to explain when Modernism was so obviously connected with the artefacts (Shaker fancy ware does not look Moderne but seems surprisingly twee).[142] There have also been some reinterpretations regarding the Victorian influence on Shaker production.[143]

Shaker Craftsmanship at the Jones Library, Amherst, Mass. – 1937

The exhibition of Shaker Craftsmanship at The Jones Library from 12 June to 12 September has not been very extensively recorded – probably because it was eclipsed by the Whitney Museum exhibition previously discussed.

It has been included here because it is another example of an exhibition in which the Andrews partnership was involved. The exhibition also featured some photographs produced by William F. Winter. It emphasised the products of Shaker craftsmanship and in the catalogue stated: 'By the presentation of selected examples of Shaker handicraft, the Jones Library hopes to widen the dawning appreciation of an unusual type of indigenous workmanship, and incidentally to recall a social experiment of great significance in the history of this country'.[144]

The short catalogue was typical of the Andrews partnership's approach and provided a brief history of the Shakers. Along with the history they again used the event to communicate the Shakers' design and style. Interestingly, in the catalogue they also recommended their own book on Shaker furniture. This quotation highlights some of the consistent themes:

> Scorning the 'superfluous' and excessive in both colour and design, that which the world called 'art', they were concerned only with doing all things well for the glory of God, and in consequence, like their Puritan forbears, had to wait a long while for the appreciation of such values in their workmanship as simplicity and purity of form, utility sheer to the point of beauty, perfection of technique, the authentic stamp of the craftsman's spirit ...
>
> Every product of the lathe, the forge, the loom, the press, was a part of the 'united inheritance' or 'joint interest', and as such had to be perfectly fashioned: a small tool or sieve or foot rule, no less than a trestle-foot dining table, testifies to the application of a uniformly scrupulous and pious skill. This skill, moreover, was expended under a code which taught that rectitude of work, as of conduct, was a matter of simplicity, of directness, of mastery of fundamentals, and that nothing was gained by ornamentation.[145]

In the final section of the text, Edward Deming Andrews makes note of the declining communities and the five remaining sites:

> Five Shaker communities, with perhaps not over a hundred members, remain today of a society which numbered over six thousand at the time of the Civil War. The few sisters and fewer brethren at New Lebanon, the central society, and Watervliet, N.Y., Hancock, Mass., Canterbury, N.H. and Sabbathday Lake, Maine still cling, however, to many of the tenets which

Selling Shaker

have made the United Society the most successful and important of all American socialisms.[146]

The catalogue of the exhibition featured a school cupboard, a double chest of drawers, a drop-leaf splay-leg table and meeting-room bench. In addition, some chairs, textiles, ironware, a stove, small articles in wood, baskets, herb labels, books and manuscripts were also included; some of the material was contained in cases and was generally small scale in terms of presentation.

'Force' Sale of Shaker Goods – 1937

The sale by Juliana Force[147] (Mrs Willard Burdette Force) of her Shaker collection occurred on 18–19 May 1937. It was one of the first important recorded sales relating to Shaker furniture. The Andrews partnership helped Juliana Force in the valuation of her collection and may possibly even have gathered interested buyers into her home at Shaker Hollow, South Salem.[148] She was in financial difficulties and decided to sell her Shaker goods.[149] It is unclear as to who the precise clients of the sale were but it seems likely that the Andrews partnership was interested in some of the items.[150] Edward Deming Andrews wrote in the introduction to the sale catalogue that:

> The furniture at Shaker Hollow, South Salem, NY, represents the finest craftsmanship of the historic, and now almost extinct American sect of Shakers. All pieces are typical early products of the communal joiners' shops, discriminatingly selected, and brought together some years ago to form one of the few noteworthy collections in this field. As even single pieces of Shaker furniture rarely come into the market, an unusual opportunity is offered by the private sale of this authentically integrated collection. Items, however, will be sold separately and are so priced.[151]

The catalogue listed the sale items into general classes and gave some nomenclature. In addition, it was indicated that the furniture was made in the first half of the nineteenth century of indigenous woods (maple, cherry with fruit and nut woods). The catalogue detailed provenance for each piece as required from a sale of antiques. The sale was organised into over 45 items including Shaker chairs, tables and counters, chests of drawers,

desks, stands and sewing tables. Miscellaneous items were also offered including a rare Shaker wall clock by Isaac Youngs of the Mount Lebanon community dated 1840. Later it was to transpire that the Andrews partnership and Juliana Force had an argument about the ownership of various items: it was likely that this dispute was never fully resolved, and this seems to be indicative of the general difficulty of many of the Andrewses' professional relationships throughout their working lives.[152]

Shaker Arts and Crafts at the Worcester Art Museum – 1939

The exhibition at Worcester Art Museum was important because it appears to have provided a potential model for the way in which the Andrews partnership would approach the creation of permanent exhibitions and period rooms (particularly that which was created at The American Museum in Britain at Bath). Furniture was categorised and defined by rooms, use and gender, whilst additional items (which would never have been placed within real Shaker rooms) were used to contextualise the material. Another aspect of this exhibition was that they used the term 'Arts' in the title: this may have been because it was located in an art gallery, but it is more likely that the Andrews partnership wanted to convey the sense of a more 'highbrow' aesthetic for the objects on display. It would be fair to say that the Shakers essentially practised design, so it is interesting that they should find their work defined in terms of art. This is particularly ironic given their views on art and superfluous display and ornamentation.

The exhibition was entitled 'Shaker Arts and Crafts' and held at the Worcester Art Museum from 7 December 1938 to 8 January 1939. A catalogue was produced in which Andrews contextualised the materials in a number of defined sections with the overall title, 'Shaker Craftsmanship and Art'. In Part One, Andrews gives a brief account of the religion and its history and featured the principle doctrines of the Shakers including celibacy, confession, separation from the world and common ownership of property. In Part Two, Andrews featured the productive activity of the Shakers. In it he states:

> Buildings, furniture, textiles, ironware, basketry, industrial products of all sorts, even their hand-written hymnals and 'illuminated' drawings,

bespeak a consecrated culture, a spirit dedicated to the doctrine that to labour was to worship and responsive to Mother Ann's injunction 'hands to work and hearts to God.' Though such workmanship may be described as a folk, provincial or utilitarian art, it is best understood in terms of 'primitive rectitude' or rightness, 'Christian perfection,' 'gospel simplicity' and the plain but basic Shaker concepts of order and use ... They have a recognisable Shaker look; yet the fact that variants probably outnumbered duplications is a tribute to the ingenuity of the mechanic, joiner and weaver, an indication of the complexity of the social and economic structure, and a revelation of the many forms in which pure simplicity may be expressed.[153]

In Part Three, Andrews covers the area of inspirational drawings and mentions the fact that the Shakers would not have had these, essentially art objects, on their walls. He notes: 'But neither these nor the primitive landscapes or plans were ever displayed on the white walls of Shaker rooms, whose spacious surfaces were broken only by the omnipresent pegboards – examples again of order and use.'[154]

The Central Gallery contained what was essentially a room recreation of a Shaker dining area with a trestle-table and three-slat chairs, sideboard, splay-leg table, plus a number of other furniture pieces. In addition, there was also tin ware, steel candle stands and other contextual material including an etching of a stove by Armin Landeck.[155] In the right-hand gallery there was a recreation of the furniture and small wooden pieces which would be found within a Shaker brethren's room including a rocker, stand and pipe-rack, sill cupboard, wall clock, herb cupboard and costumes. In display cases within the gallery there were views of Canterbury, Alfred and New Gloucester villages, with additional graphic material including a seed poster and herb labels. In the left-hand gallery a Shaker sisters' workroom was featured including rocking chairs and footstool, peg-leg and rim-top stands, counter for tailoress, sewing desk and swivel chair. Also featured in a retiring room collection were a drop-leaf table and table desk, rocking and side chairs, washstand, blanket chest and sisters' costumes. In the display cases were products of sisters' shops: poplar baskets, sisters' tools, tapes, gloves and handkerchiefs, etc. Various graphic material was featured on the walls including inspirational drawings and

also a watercolour: 'Interior of Meeting-house, Mount Lebanon' by Benson Lossing, 1856.[156]

Shaker Architecture and the Buildings in the American Survey

Shaker architecture has been central to many collectors' interpretations of their material culture[157] and in the twentieth century there are examples of entire buildings being transferred from their original sites, as Julie Nicoletta notes:

> By the twentieth century, as the remaining Shaker villages closed, people interested in the sect began acquiring the material legacy of the Shakers ... Many collectors of American antiques and folk art began scouring Shaker villages for furniture and crafts. Collectors even acquired buildings. Clara Endicott Sears moved the trustees' office from the Harvard Shaker village to her Fruitlands museum in the town of Harvard, Massachusetts, in 1922. Electra Havemeyer Webb purchased a Shaker horse shed and moved it to her museum in Sherburne, Vermont, in 1951.[158]

Shaker buildings and the plans of Shaker villages have been studied for a considerable time.[159] During the declining period in the twentieth century neglected buildings became at risk and were recorded in photographs from the late 1920s and 1930s onwards.[160] Institutions like the New York State Museum endeavoured to record buildings because, clearly, they could not collect them as readily as furniture and other artefacts. However, this has not stopped some museums from acquiring fixtures and fittings from buildings for the creation of period rooms.[161] The Shakers themselves also recorded their communities, and stereoscopic views and postcards were produced for tourists.[162] The recording of Shaker architecture continues with surveys by Kidder Smith, who has placed images on the Internet,[163] and the analysis of individual communities.[164] In *The Magazine Antiques* numerous articles have appeared since 1957 featuring photographs from the Historic American Buildings Survey.[165] A number of books and articles have also been produced which have exclusively dealt with buildings and urban planning.[166]

The Historic American Buildings Survey was established in 1934 by the American Government with the intention to create an architectural archive

of photographic and printed material[167] with written records and analysis. The record which continued through the depression years included both newly produced material as well as collected archive material that was deemed relevant.[168] Over the years a number of gifts supplemented this archive including material from the New York State Department of Education and from Dr Elmer Pearson.[169] It was administered by the Interior Department's National Park Service. John C. Poppeliers was the coordinator who acted as the architectural historian responsible for some of the recording and Jack E. Boucher was the supervisor for photographs and pictorial records. In addition, Poppeliers also wrote about Shaker architecture in articles such as 'Watervliet Shaker South Family'.[170] The National Park Service collaborated with a number of other institutions, most prominently the American Institute of Architects, who provided technical and aesthetic advice. The survey was a broad-ranging and impressive study of different building types.[171] This included many of the buildings from various Shaker communities and featured some which are no longer extant, for example, the Church Family Dwelling House at Watervliet, New York[172] and the early (1800) South Family Cottage, which was demolished in 1938.[173] The survey photographed both the exterior and interiors of the buildings, and provided important evidence of genuine Shaker rooms before they passed out of community hands.[174] This photographic evidence is useful since it gives a clear indication of the condition of many of the buildings at Hancock and Pleasant Hill before they were restored and turned into museum villages. In addition to a photographic record, the survey also included data sheets, line drawings and blueprints of the buildings. In Shaker terms the survey was not comprehensive and some communities were entirely omitted. Particular emphasis was placed on those at Mount Lebanon[175] and also the founding community at Watervliet. In total there are 132 citations referred to in *The Shaker Quarterly*, as reported by Peladeau.[176] The period after the Second World War saw a lull in the recording activity and the survey was only reinstated in the late 1950s. Some Shaker communities had been neglected such as Canterbury, New Hampshire, whilst others had further work completed on them, as indicated in *The Shakers and the World's People*, in which Morse states:

Shaker buildings are periodically measured, photographed and recorded by the Historical American Buildings Survey, which began the architectural record in the 1930s in Ohio. The former Enfield, New Hampshire, community was surveyed by HABS summer teams in 1978 in cooperation with the residing Missionaries of Our Lady of La Salette.[177]

Canterbury, a community neglected in the original HABS surveys, has had considerable recording work done in the late 1970s as detailed in 'All We Do Is Build':

The first professional survey of the village – its land, buildings, and social history – was initiated in the late 1970s by the New Hampshire State Historic Preservation Office in cooperation with the National Park Service and Boston University, and continued under the auspices of the University of New Hampshire and Rensselaer Polytechnic Institute.[178]

In addition, the village itself has provided reports which have looked at structure and restoration such as that produced for the Carpentry Shop.[179]

A further report on HABS produced in 1974 by John Poppeliers, entitled *Shaker Built*, gave a more detailed account than that produced for *The Shaker Quarterly* – it was also extensively illustrated using original photographs by N.E. Baldwin, J.E. Boucher, W.F. Winter, E.R. Pearson and others. The communities featured included Pleasant Hill, South Union, Sabbathday Lake, Hancock, Harvard, Canterbury, Enfield, Mount Lebanon, Watervliet, Union Village and Whitewater.[180] It appears that the collection was one of the largest relating to Shaker architecture with nearly 1,000 photographs, documenting 175 buildings, from 11 communities, in six states.

The catalogue was produced to accompany an exhibition which was inaugurated to celebrate the Shaker bicentennial in 1974. It was the accumulation of a team effort and, like the William Hayes Fogg Art Gallery exhibition featured later, was a public showing of extensively researched material.

The Works Projects Administration

The basic background to the Works Projects Administration (WPA) has been given previously and there have been a number of books which have relevant detailed information on the WPA, including *Hands That Built New*

Selling Shaker

Hampshire and *Art for the Millions*. In *Hands That Built New Hampshire*, the focus is very much, as the title suggests, on the communities within that state. It was compiled by the writers' programme of the Works Projects Administration[181] and had a contribution by Ella Shannon Bowles, who was the State Supervisor. The WPA studied a number of different works and artefacts[182] detailed in various chapters, with one devoted to the Shakers due to their importance as producers of 'folk art'. The community at Canterbury was used as a focus, presumably due to the fact that it was then still a working community:

> On a hill at the end of a winding road in Canterbury, the last of the New Hampshire Shakers cling to the community that was started a century and a half ago by the donation of a rich, five hundred acre farm of Benjamin Whitcher and his wife Mary Shepherd ... Formerly there were two Shaker societies in New Hampshire; both started in 1792 – one at Canterbury, and one in the narrow valley on the shore of Lake Mascoma in Enfield.[183]

The book, having been written in a period when you could still experience the Shaker way of life at first hand, also indicated that visitors were welcome at communities. The Shakers are identified as having the most successful communistic experiment within the United States and we get an early expression from a non-scholarly source of the notion of a 'Shaker look', an idea that would gain increasing currency throughout the twentieth century:

> The Shaker societies carried on the most successful communistic experiment ever practised in this country. Its motivating power was religion of an intensely eager and mystical kind. Yet it had only one well-defined theological doctrine – the bisexuality of God, a radical departure from the Trinity of the Calvinist religion, against which Shakerism rebelled. The Shakers, like the Essences of old, were bound to their social system by the intangible force of their faith. The 'Shaker way', like the 'Shaker look', was the outward evidence of a habitual self-denial and the passive way of meeting life.[184]

The book also gives some indication of the uniqueness of Shaker crafts and tries to establish why this should be the case. One significant feature of the communities is that they were isolationist and apart from the world:

The Shakers put into their lathe turning, their joining, and their finishing something decidedly peculiar to themselves. That they were apart from the world in spirit, is seen in the physical arrangement of their lives, in the way they laid out their communities, placed furnishings in their dwellings and put away the dead in their cemeteries. Certain characteristics marked everything they wrought; severity of line, honesty of construction, uniformity of style. No appreciation of the productions of their daily lives is possible without an understanding of the way of spiritual life that lay behind this workmanship.[185]

Another theme of the material was that of functionalism in the design of the artefacts and some discussion about design and art was undertaken:

The motive behind Shaker craftsmanship was functionalism; an object was beautiful to them when it served the purpose for which it was designed. Mastery of design became of more importance than artistry in adornment, and simplicity was the mark of victory over the fleshy life. Yet the crude and awkward stage of Shaker workmanship did not last long. Anything they produced may have been severe in line, but the proportions were exceptionally well balanced. A typical piece of Shaker furniture, for instance, was a combination cabinet containing both drawers and cupboards, with space under a hinged top for storing linen. The effect, from an artistic point of view, is neither top-heavy nor ill-proportioned. Its maker did not even pretend to be an artist; had he been one, he would not become a Shaker.[186]

The Works Project Administration provided an official record of Shaker material culture which, like the Index of American Design (featured in the next part), is still used as a useful resource for Shaker scholars.

The Index of American Design and the Index of American Design Exhibition at the Fogg Museum of Art at Harvard University – 1937

In the publication *Art for the Millions – Essays from the 1930s by Artists and Administrators of the WPA Federal Art Project*, Constance Rourke – an authority on American art production – wrote about the Shakers and their utilitarian outlook on design and the manufacture of goods. She stated that the little-known production of the Shakers was to: 'Represent a definite native

impulse in American design.'[187] She also noted that the Index of American Design:

> ... presents the decorative and utilitarian arts of this country broadly by the vivid means of pictorial rendering, in a large series of portfolios. As a result, if this work is carried to full completion, the questions 'What is American Design?' or 'Have we an American design?' may answer themselves, possibly with some surprises, certainly with a wealth of fresh materials. In any event, these many-sided and many-coloured evidences will represent basic traditions in design which, as a people, in the past, we have chosen our own.[188]

The Civil Works Administration, of which the WPA and the Index were a part, was set up in 1933 as a measure to combat the high levels of unemployment and to provide opportunities in the arts professions. A Government project for artists was organised in December 1933, directed by Edward Bruce under the Treasury Department, and funded by means of a grant from the Civil Works Administration. This allowed for the employment of a number of fine artists – painters, sculptors and printmakers. However, designers and craftsmen were also having problems finding employment and, in order to rectify this situation, the Civil Works Administration and various State Emergency Relief Administrations set up handicraft and recording projects of which The Index of American Design was the most notable. It was organised as a nationwide activity in meetings of the Federal Art Project national staff in December 1935. The Index had a defined agenda to record within the scope of the popular folk arts of the United States. The artefacts that came under study were mainly three dimensional, but excluded architecture, it having already being covered in other projects such as the Historic American Buildings Survey.

The Index was placed under the direction of the Washington staff of the Federal Art Project, with Constance Rourke appointed as national editor and Ruth Reeves as national coordinator, who was succeeded by C. Adolph Glassgold in 1936, and Benjamin Knotts in 1940. In choosing objects for recording, priority was given to material of historical significance not previously studied and which, for one reason or another, was in danger of being lost. Regional and local crafts were emphasised: for instance, the early colonial crafts in New England; the folk crafts in Pennsylvania and

the Southwest; pioneer furniture, tools, and utensils in the Middle West and in Texas; early Mormon textiles in Utah; and various community crafts in Ohio, Illinois, Iowa, and other states. In addition, the arts and crafts of the Shakers were also deemed important enough to be recorded. The recording was done in situ if at all possible: 'The technique recommended in the Index manual (WPA Technical Series, Art Circular no. 3) for most categories of objects was a transparent watercolour method. The object was first carefully studied and a light outline drawing made.'[189]

The Index of American Design provided a valuable reference resource for anyone interested in viewing design[190] from an American perspective and was a precursor of many of the concerns material culture studies now encompass, relating to social history, production, manufacture and consumption.[191] The Index was also seen as a useful means of promoting the notion of good indigenous design, with the aim of developing a consciousness amongst the general public of what constituted American design. The Shakers were specifically featured in the Index appearing in the chapter entitled 'Work and Faith', which repeated themes that had already been developed by the Andrews partnership:[192]

> A rich heritage of the arts and crafts has come to us from the religious communities established in America largely after the Revolution and in the decades before the Civil War. As we have seen, the Pennsylvania Germans at Ephrata established one of the early religious settlements. Toward the end of the eighteenth century a few English Shakers founded the first of their communities in America ... Of the various Shaker societies only a few members remain, but the contributions the Shakers made to American culture have endured. Their furniture, particularly, represents a native American style of distinction and originality.[193]

It is interesting to note that many references to Shaker sayings were included in the main text, and words associated with Shaker design – plainness, beauty, utility and simplicity – were used throughout. The following quotation is of interest:

> The Shakers cared nothing for art; ornamentation was considered superfluous. Their walls had no pictures, but their floors were immaculate and their rooms were kept in the best of order. Work and faith were linked in Mother Ann's saying, 'Put your hands to work and your hearts to God'.[194]

The text also examines the religious and communal ethos within the Shaker communities. This meant that the individual craftsmen became subservient to the needs of the whole community. There is an emphasis on the 'Modernity' of the Shaker design philosophy and the notion of them being the precursors of the Modernist philosophy 'form follows function'. This is an early association with Modernity and one which would gain increasing currency with both Shaker and non-Shaker scholars. Other modern aspects of their work included the emphasis on crafts and the well-made object, and the avoidance of waste in both labour and materials. We can see here the start of what might be termed the twentieth-century hijacking of the Shakers, and their reinvention as 'modern' designers. The Index also focused on the Shakers' technological ingenuity as a means of emphasising their pioneering 'Modernist' role: 'Among the many inventions credited to the Shakers are the circular saw, the screw propeller, a new type of wood stove, a washing machine, a windmill, and numerous other machines and devices used in home and shop.'[195] The Index comments on the context of the furniture and artefacts:

> Shaker rooms were sober and cheerful. Pegboards line the walls. They are for wearing apparel and for hanging chairs off the floor at cleaning time. Plain baseboards lack the usual mouldings. Stoves exhibit the Shaker genius for simplicity at its best in a design that is low and horizontal, so that heavy logs can be handled with the least effort ... The excellence of their handicrafts is in the Shaker craftsmanship, but they also selected the finest materials and used the best tools. Basket-making was one of the many smaller industries in which they excelled. Where there was so much produce, baskets of various types were always in need, and some were made into sieves ... To give access to high drawers, the Shakers used stools with two or three steps of light but sturdy construction. The steps are dovetailed, and the edges are reinforced and cross-braced for rigidity. An orange shellac brings out the natural colour of the wood.[196]

The Index was designed to be a useful resource for both academics and the general public and was used in a variety of different guises including exhibitions at the Museum of Modern Art,[197] the Harvard University gallery and the Metropolitan Museum in New York,[198] together with articles in populist magazines such as *House & Garden*[199] and *The New York Times Magazine*.[200] Its importance lay in its ability to introduce a broader audience to what had

been an arcane subject and the credibility it gave to the makers of previously unregarded artefacts. The Index also became a valuable source for the designer, the craftsman and perhaps most importantly the manufacturer. In addition, it provided a range of exhibition pieces and colour slides that the National Gallery of Art could use in its education programmes. The Gallery arranged insurance on the ordered materials and a package of materials on Shaker craftsmanship included 35 watercolour renderings and photographs, with illustrations of furniture, costume, textiles and tools made by members of the Shakers. The slides (50 in total) included furniture, costume and textiles – including chests, cabinets, cupboards, bonnets and dresses.[201] Much of this material is still available and provides a valuable resource for those interested in Shakerism and its many facets[202] and has been part of a number of exhibitions such as the one in the Fogg Museum of Art, Harvard. This exhibition was relatively short-lived and took place over a fortnight from 27 January to 10 February 1937. It included material from the Index and featured a number of Shaker illustrations,[203] with reproductions by Alfred Smith, Irving Smith, Larry Foster, Victor Muollo, Anne Ger, Elizabeth Moutal, Frances Cohan, Lucille Gilchrist, Joseph Goldberg, Ingred Selmer-Larsen, Betty Fuerst, Alice Stearns, Lucille Chabot and George Constantine. In addition, other crafts were featured including textiles, crewel work, dolls and woodcarving. Constance Rourke wrote a foreword to the accompanying catalogue emphasising the importance of the development of American rooms in museums (perhaps she is making reference to the Metropolitan Museum, New York):

> It has long been the custom in this country to deposit articles representing the useful and decorative arts of our earlier periods in the rooms of local historical societies, mainly for reasons of sentiment or association. Old powder horns, a fine sword, china or silver used on the occasion of a banquet given for some visiting dignitary, or furniture belonging to well-known personages: these have seemed worth treasuring because they embodied personal phases of our history ... It is only within recent years that an aesthetic interest in these materials has developed strongly, or that they have found a natural place in the museums devoted to art. The 'American Wing' or the sequence of 'American rooms' has both dramatised and fostered this interest.[204]

Selling Shaker

Rourke then continues and discusses the educational relevance of the materials and praises the success of the project:

> The educational importance of the work has been evidenced by a constant demand for the exhibition of Index plates in public schools, art schools, art galleries and libraries throughout the country. The plates have already been studied by theatre designers, costume designers and workers in textile design. Originally planned to serve only as a ground work for the history of design in this country, the Index of American design has thus exceeded its purpose.[205]

The text then goes on to place some emphasis on the Shakers and indicates that the artists responsible for rendering made a record of Shaker architecture, furniture, textiles, and costume using both watercolours and photographs. The text then makes much of the associations with Modernity in Shaker work and states:

> They strove to achieve utility, simplicity and perfection. The arrangement of the Shaker buildings was akin to modern town planning. Their furniture also, in its emphasis on essential forms and its exclusion of superfluous ornament, is decidedly modern. The unity of their conceptions, the excellence of their craftsmanship, the ingenuity of their inventions and the originality of their style entitle the Shakers to a distinguished place in the history of American art.[206]

The Index still has some relevance to those interested in Shaker production, and materials from the study can now be viewed on the National Gallery of Art, Washington website.

Shaker Art and Craftsmanship at the Berkshire Museum – 1940

This exhibition was entitled 'Shaker Art and Craftsmanship' and attempted to create a clear link between Shaker craft and establish it as 'art' – stating that the Shakers had moved beyond pure functionality to an art form. The exhibition was considered important and featured in the local press and various magazines.[207] The catalogue is significant because it contains a person on the cover (a Shakeress)[208] rather than a product (furniture or spirit drawing). Perhaps this was an indication from the Andrews team that the people behind the objects needed some acknowledgment? The

exhibition was held at the Berkshire Museum at Pittsfield, Massachusetts and opened on 13 July 1940, and continued the institution's association with the Shakers. This exhibition took place some five years after the one at the Whitney and continued with similar themes. The catalogue was probably the most impressive in terms of size and content that the Andrewses had been involved in, and copies can be found in The Edward Deming Andrews Memorial Collection at Winterthur Library.[209] The exhibition was organised into three sections located within galleries and focused on furniture, including both small and large items ranging from a case of drawers to oval boxes. In addition, views of villages and inspirational drawings were featured alongside room recreations. At the start of the catalogue there is a quotation taken from the Shaker covenant (Mount Lebanon) dated 1795: 'We believe we were debtors to God in relation to Each other, and all men, to improve our time and Talents in this Life, in that manner in which we might be most useful ...'[210]

In the text there is an emphasis on the doctrines which guided the Shakers' everyday life: celibacy, separation and community of goods. The fact that the sect was non-conformist and that 'believers' developed over a long period seems to have provided the authors with some explanation as to why the sect and its culture were distinctive and rich. The text then discusses the common Shaker themes of religion and work ethics which combined to create beautiful and utilitarian objects:

> This doctrine of 'religion in work' (laborare est orare), implemented by ordinances on the nature of utility, beauty, plainness and 'progression', had a direct effect on the workmanship of the sect. Architecture and furniture; textiles and costumes; tools and the products of tools; gardens, fields and orchards, all illustrated, in their several ways, the concept of 'correspondent works.'[211]

The catalogue continues with exhibition details and contextualising text. In the material Edward Deming Andrews uses the term 'religion in wood'[212] in order to emphasise the connection between the religion and the artefacts produced by the people involved in Shakerism:

> The furniture, basketry, utensils and accessories may likewise be viewed as examples of 'religion in wood', the design and purpose of which have specific doctrinal implications. So strict was the artisan's adherence to the

laws of utility, so scrupulous his avoidance of 'superfluity', that all pieces of craftsmanship present an inflexible unity in appearance. The quality which marks a given piece, whether it be a large case of drawers or a small poplar basket, is a combination of mastery of process and restraint, a reduction of design to its simplest terms, a rightness of proportion, a refinement of line – these, and the various associations of use and setting which give such objects their peculiar distinction.[213]

The following quotation is important because it highlights the concern of Edward Deming Andrews with regard to placing artefacts into his preferred context – notably in a minimalist room setting. This is essentially one which the Andrewses helped create and where they believed the furniture looked its best. However, it must be remembered that, in reality, much of the furniture on display had actually been found in rooms that had been Victorianised by successive generations of Shakers and, far from being modern and minimalist, were cluttered, patterned and decorative.[214] It is not surprising therefore, given the prevailing Modernist aesthetic amongst the intellectual elite, that the majority, if not all, of those responsible for room recreations decided to use the Andrews model:

Their Shaker quality may be fully appreciated only when they are seen in the spacious, white-walled rooms of a typical dwelling; removed from the places to which they were consigned, they lose something of their meaning, unworldliness and beauty.[215]

In the final part of the statement in the catalogue, Andrews tries to differentiate folk art from that produced by the Shakers, perhaps as a direct result of their experience of – and contributions to – the Index of American Design:[216]

The Shaker Collection represents, in fact, a lost period of American industry and craftsmanship. Unlike most objects of 'folk art', the materials which compose it are the product, not of isolated individuals about whom little is known, but of a culture group with a recorded history. The Shaker movement persisted long enough to develop a definite philosophy and have its principles tested in the crucible of experience. As a sustained experiment in sociology and religion, it played a part – how influential it is difficult to say – in the development of the country. The manifestations of that culture, the craft and art which reflect so directly its character, are

therefore of the utmost historical importance. They may be enjoyed and utilised apart from such considerations. But they should never be scattered nor their latent meaning forgotten.[217]

Interestingly, Andrews also makes some play of the fact that the 'shops' in Gallery B were 'not planned as restorations' but were designed to be representative of the Shakers' basic industries. The following gives an indication of what was featured in Gallery B – textiles and costumes; furniture of the sisters' shops; herb 'shop' and materials of other industries; early imprints and manuscripts including Stereographs; manuscript hymnals and music materials; prints of the Shaker dance; and some furniture. This exhibition was to be the last the Andrews partnership were to be involved in for some time and the lull in activity during the Second World War provides a watershed after which the promotion of the Shaker aesthetic would take a number of different routes.

Interpretations taken from Popular Culture

In the preface to the book *Art and Labour*, the difference between 'high' and 'popular' has been discussed in terms of art, although the conclusions reached are just as applicable to design and the material culture of the Shakers: 'As art separated itself into "fine" and "minor", it also subdivided into "high" and "popular", the latter reflecting not customary or folk traditions but a mass culture manufactured for urban consumers … Meanwhile, a growing professionalism more strictly differentiated the designer from the maker, the architect from the carpenter, the academic from the vernacular. Though many artists remained artisans, offering their own work for direct sale, art was becoming a commodity and the artist a commodity producer.'[218]

Along with all the exhibitions which continued at regular intervals from 1927 to 1945 there was some evidence that the design aesthetic of the Shakers was beginning to filter into popular material culture. In the period 1900 to 1926, the Shakers were little known for their furniture.[219] The route from being a minority religious group, to the position where reproductions of Shaker furniture were being produced for the American homemaker is a complex one to document. Early twentieth-century articles

on the Shakers were likely to focus on decline rather than design[220] while later articles inevitably talk about waning communities.[221]

The major route of infiltration into mass culture came via popular magazines. In *American Design in the Twentieth Century*, Votolato recognises the significance when he notes:

Popular magazines including *House Beautiful*, *Ladies Home Journal* and *Good Furniture, The Magazine of Good Taste*, also campaigned for refined taste and commented critically on what they considered to be its opposite ... They minutely detailed the characteristics of particular styles, chronicled their rise and fall from favour, paid homage to their creators and champions and suggested many ways of expressing individuality within the broad arena of conventional appearances.[222]

It was not until the 1920s that the popular press became a vehicle for the marketing and promotion of Shaker design. This included feature articles, advertisements and publicity in the form of exhibition reviews and travel recommendations. Activity increased in the late 1920s in magazines such as *Vanity Fair*,[223] *Antiques*,[224] *The New York Times Magazine*[225] and *House & Garden*.[226] These focused on specific groups such as antique collectors, as well as more general features on interiors and style.

By the late 1930s, folk art themes – and in particular Shaker art and design – had moved from being the preserve of a few high art institutions and wealthy collectors, and had entered the mass market. The essential qualities and principles of Shaker design would be used to sell a 'lifestyle', including furniture and fashions. Whilst the museums had used folk art to sell the idea of a national identity, now the likes of the John Wanamaker Store[227] used the Shaker way of life to market the latest line in ladies' fashions. In an advertisement from *The New York Times* of 19 January 1939, the advertising copywriters extol the virtues of 'Shaker Simplicity':

The Shakers were a sober celibate little sect that settled in New Lebanon, New York, over 150 years ago. Wanamaker's resurrects the 18th Century Sabbath Day dress of these highly-sensitive, highly-religious Americans – finds in it an untapped source of inspiration for 1939 fashions! The plain simple functionalism and austere spirit smash straight into the core of today's silhouette – the fitted bodice and full rhythmic skirt. Come see our dazzling collection of pious exciting clothes! Bonnets that cape down

the back. A Basque-line bodice that V's in a keen plumb line through the midriff, inching off the waist.[228]

The blatant appropriation of Shaker design philosophy, and the none too subtle reference to the then fashionable Modernist virtues of functionalism and simplicity, is almost comical in the hands of the copywriters, with their talk of 'pious exciting clothes' and '... simple functionalism ... smashing ... into the core of today's silhouette ...' being so at odds with the reality of the Shakers' original vision. The copy continues in the same 'breathless' vein:

> No fuss. No feathers. Not one whiff of quaintness. Shaker-fine workmanship. Tiny tucks and gussets (and a few 1939 zippers) that give an alluring body line. A few 'this is strictly business' buttons. Colours like those the Shakers crushed from vegetables and the neighbouring hardhack trees. Earth colours! Plum like fruit of Lebanon orchards.[229]

Not only does Wanamaker's extol the virtues of Shaker-styled women's clothes, but it also mentions the fact that it was the first to begin promoting Shaker furniture.[230]

In 1945 an article that appeared in *House & Garden*[231] entitled 'Shaker – Pattern of Practical Beauty – Modern Then and Now' used illustrations from the Index of American Design by Vincentini and Herlich, whilst the text gave an indication of how contemporary designers could use Shaker design and style in modern interiors. In so doing, it made a direct connection between the authentic and the pastiche, and this led the way for numerous guides on a style that was to become so ubiquitous in the late twentieth century. Because the article can very much be seen as a forerunner or prototype, it is important for a number of reasons. There are some concurrent themes that are evident, and clearly this article has been influenced variously by The Index of American Design, the Andrewses' aesthetic, and Moderne ideas:

> Shaker design, modelled by specific needs and created according to particular beliefs, is as aesthetically apt today as its pared-down functionalism was practical and right for the 'Believers'. Its workable beauty and contemporary simplicity make it present-day applicable and remove any mark of quaintness or antiquarian preciousness. Here is a practical précis of Shaker work, twelve pages of legacy of art the Shakers have left us – important

now as it was then because Shaker concepts of beauty are strikingly close to the concepts of modern design.[232]

The article goes on to examine contemporary applications of Shaker design philosophy, linking it with Modernist ideas in interior design and using the Shaker 'style' to promote the notion of a unique American Modernism:

> American Modern should be the indigenous outcome of an American past. Believing that Shaker design is a native tradition with a future, we asked Everett Brown, the design coordinator for The Grand Rapids Furniture Makers' Guild, to plot a Shaker-modern weekend house for us ... Here's the house. It makes felicitous use of the Shaker look and practices the Shaker virtues of order and practicality ... Louvered blinds, a Shaker idea, make functional fitting windows; Shaker doors good architectural detail. Hand woven wool, the Shaker weaves ... makes draperies, upholstery. Plain unpatterned hooked rugs make sense on the wide board floors, which are sturdy enough to scrub down for cleaning. The lamps are a handsome transformation of Bennington jugs, so much used by the Shakers. Clean-cut floor space, utility with good looks, purposeful yet graceful furniture, concisely mapped wall space, are hallmarks of the Shaker look and right for our times.[233]

In addition, examples of Shaker furniture from the Index were highlighted in the section, 'Shaker Made – Worthy Tradition of Fine Craftsmanship'. Again the emphasis is upon the Modernist ideals of functionalism and utility, honesty of materials and attention to detail:

> The Shakers' metier was wood. They understood wood and respected it. They selected grains with as much care as they gave to the fine polishing of their furniture. Each piece is symbolical of their ideal of beauty, carefully proportioned and frankly utilitarian. Nothing ever left their workshops that was not the product of their best ability. Disciplined as their forms were, they enjoyed colour and used it. They stained their native woods with a light stain or gave the pieces thin and clear Shaker red, blue or yellow washes. Although they eschewed vain mouldings or worldly bevelling, they fitted their drawers with extraordinary care, dovetailing them precisely. Their knobs are as carefully turned as a pineapple post. No space was ever allowed to remain lazy. Whole families of drawers, fitted in with a puzzle maker's skill, fill up counters. Every beautifully planed board had a purpose.[234]

The developments that became evident in this period were to be magnified and exaggerated throughout the twentieth century. The momentum in the mounting of exhibitions increased and the infiltration of the Shaker aesthetic into mainstream design consciousness continued apace. The simple and pure design of the Shakers was to become increasingly popular with temporary exhibitions becoming permanent.

Notes

1 Prior to the period under discussion here, The Centennial Exhibition of 1876 in Philadelphia brought the Shakers' farming, agricultural equipment and furniture to the attention of the wider American public.

2 An article detailing the background of Shaker furniture is featured in Harrison, B., 'The Background of Shaker Furniture', *New York History*, 1948.

3 See Parker, G. & Winkleman, B., *The Times Atlas of World History*, 1995, p. 218.

4 See Votolato, G., *American Design in the Twentieth Century*, 1998.

5 See Woodham, J., *Twentieth-Century Design*, 1997.

6 See Kirk, J.T., *American Furniture and the British Tradition to 1830*, 1982, and also interesting material in Wellman, R. & Cahill, H., 'American Design – From Heritage of Our Styles Designers are Drawing Inspiration to Mould National Taste', *House & Garden*, 1938, p. 16, which notes: 'Recent research into the work produced by Shakers in America has brought the modern designer admirable old forms which have a fresh message for today. Some of the research carried on by the Index of American Design into Shaker work is illustrated in this issue of *House & Garden*. This work is a distinctly American offshoot of the same pure source that produced some of the finest "plain" work in eighteenth-century England. Shaker meeting houses, community houses, workshops and round barns express the Shaker ideal of austerity and simplicity. Shaker crafts are in unity with their architecture. Built in cabinets, ironwork down to the last wooden peg and iron latch are all part of a whole, designed for service and suitability. Shakers did not preach and write about functionalism – they practised it.'

7 See Chapter Five, 'The Figure in the Carpet' in Kouwenhoven, J.A., *The Arts in Modern American Civilisation*, 1967, p. 94.

8 See the *Cadwalader Study* produced in both book and video form in 1995 by Anderson, M.J., Landrey, G.J. & Zimmerman, P.D. from Winterthur, which contains information on the styles which had definite European influence.

9 Numerous auction catalogues are available to show the rise of interest in Shaker furniture that took place within the United States culminating in, for example, the Bourgeaults' Shaker auctions at Canterbury in 2000 (the Stokes Collection) and 2003. As discussed in later sections the high regard in which Shaker furniture was held eventually surfaced in the United Kingdon and this was discussed by Lars Tharp (an expert on the *Antiques Roadshow*) in *The Shaker Chair – For What it's Worth* that was broadcast on radio in 2002.

10 Refer to Cahill, H. & Barr, A.H., *Art in America in Modern Times*, 1943; Kouwenhoven, J.A., *The Arts in Modern American Civilisation*, 1948; and Rourke, C., *The Roots of American Culture*, 1942.

11 See Baigell, M., 'American Art and National Identity: The 1920s', *Arts Magazine*, 1987, p. 48.

12 See Knots, B., 'Hands to Work and Hearts to God', *Metropolitan Museum Art Bulletin*, 1943.

13 Cahill, H., 'Introduction', in Christensen, E.O., *The Index of American Design*, 1950, pp. ix–xvii.

14 Material relating to Juliana Force can be found in The Edward Deming Andrews Memorial Collection, Winterthur Library, Boxes 24 and 26 (Juliana Force letters and private sale catalogue): see McKinstry, E.R. (comp.), *The Edward Deming Andrews Memorial Shaker Collection*, 1987, p. 310.

15 Much of the information was obtained from a 1966 memo for the Museum of Early American Folk

Arts in which Mary C. Black gives a succinct summary of the development of folk art appreciations. See Black, M.C., *At the Sign of Gabriel, The Flag or Indian Chief – The Museum of Early American Folk Arts*, New York, 1966 and also Black, M.C., Catalogue for *Religion in Wood – A Study in Shaker Design*, 1965.

16 Also a letter from Juliana Force dated 23 October 1934 (The Edward Deming Andrews Memorial Collection, Winterthur Library, Boxes 24 and 26) is of interest: 'I am sorry I could not answer before. Mr Sheeler is in very straightened circumstances and could not afford to do the work, but he is most interested and agrees with me that the photographs we have are nothing but maps. He will be delighted to meet you, and I am trying to plan a day in Salem which will only be a short distance from Mr Sheeler's studio where we can meet and go over the matter with him. I will send you a wire as soon as I can plan the day ...'

17 See Troyen, C. & Hirshler, E.E., *Charles Sheeler: Paintings and Drawings*, 1987; Troyen, C., 'The Open Window and Empty Chair', *The American Art Journal*, 1986; McCoy, G., 'Charles Sheeler – Some Early Documents and a Reminiscence', *Archives of American Art*, 1965; and Stewart, P.L., 'Charles Sheeler, William Carlos Williams, and Precisionism: a Redefinition', *Arts Magazine*, 1983. In addition, for some early notes on Sheeler, see Baur, J.I.H., 'A "Classical" Modern', *Brooklyn Museum Quarterly*, 1939 and Cohen, G.M., 'Charles Sheeler', *American Artist*, 1959.

18 During his lifetime Sheeler produced work which had an essentially Shaker feel, including a number of photographs such as *Interior with Stove* and *Side of White Barn*, both produced in 1917. In addition, some of Sheeler's architectural studies have featured in Davies, K., 'Charles Sheeler in Doylestown and the Image of Rural Architecture', *Arts Magazine*, 1985.

19 See Parker, R.A., 'The Classical Vision of Charles Sheeler', *Studio International*, 1926 which discusses his designs for salt and pepper shakers as having the elegant simplicity of Shaker designs. Also see Fillin-Yeh, S., Catalogue for *Charles Sheeler: American Interiors*, 1987 which discusses his designs for silver, glass, china and textiles.

20 Specific reference to Charles Sheeler and the Shakers is given in Andrews, E.D. & Andrews, F., 'Sheeler and the Shakers', *Art in America*, 1965.

21 See Lucic, K., *Charles Sheeler and The Cult of the Machine*, 1991. In addition, the news release for 'The Photography of Charles Sheeler' exhibition (held at The Metropolitan Museum of Art from 3 June to 17 August 2003) states: '... Sheeler's photographic series became more personal, as he focused on the various aspects of Americana that interested him. Included in the exhibition are photographs of antique and Shaker furnishings in his own home ...'.

22 As an example of the connections and collaborations that took place see Cahill, H. & Barr, A.H., *Art in America in Modern Times*, 1943.

23 Frank Crowninshield wrote about Sheeler in *American Vogue* in 1939 and favourably reviewed his one-man exhibition.

24 In a letter dated 29 April 1999 Brother Arnold from Sabbathday Lake commented about the Andrews partnership: 'Virtually every exhibition on the Shakers during the 30s and 40s had to deal with Dr Edward D. Andrews. He touted his private collection all over the east coast. Of course World War II put an end to his public shows. By the end of the war Dr Andrews was making a good living acting as a dealer of Shaker objects.'

25 Melcher, M.F., 'Shaker Furniture', *Philadelphia Museum of Art Bulletin*, 1962 shows some illustrations of Charles Sheeler's Shaker collection of furniture (including a table).

26 For example, in the oil on canvas work *Americana* (1931) a Shaker-like box appears on the table top (although the characteristic swallowtails are not showing). In *Home Sweet Home* (1931) the chair which takes up the main composition could be of Shaker origin and the bench shown briefly in the right-hand corner is probably a Shaker piece. In the tempera with pencil on paper work, *American Interior* (1935) a stove not unlike the one portrayed by Armin Landeck (Miller, S.M., 'The First Shaker Icon: A Stove', *The Shaker Messenger*, 1996) is featured centrally (this work is now in the collections of the Metropolitan Museum of Art).

27 See Rourke, C., *Charles Sheeler – Artist in the American Tradition*, 1938 and Kirk, J.T., *The Shaker World: Art, Life, Belief*, 1997, in which he indicates that Sheeler had an impact on Shaker promotion along with

Simple and Pure

Edward Deming Andrews and William F. Winter Jr. It would appear that Sheeler has influenced how we view the Shakers and their work.

28 See Jacob, M.J., *The Impact of Shaker Design on the Work of Charles Sheeler*, MA Thesis, 1976.

29 See Cantor, J.E., *Winterthur*, 1997 which features the collecting of Henry Francis du Pont.

30 See Kedzie Wood, R., 'Henry Ford's Great Gift', *The Mentor*, 1929 and also Cantor, J.E., *Winterthur*, 1997 in which the following quotation is taken from p. 103: 'The American Wing was part of a larger movement in the 1920s to create "shrines" of American democracy. In 1926, Henry Ford established The Edison Institute in the shadow of his automobile plant near Dearborn, Michigan. Ford planned his museum and country village as a testament to American enterprise and as a recollection of the humble roots from which he and other successful Americans had sprung.'

31 This has been featured in Humelsine, C.H., 'Fifty Years of Colonial Williamsburg', *The Magazine Antiques*, 1976, p. 1267. Also Williamsburg has continued to have exhibitions with various folk art themes including Shaker inspirational work: see Unspecified, Catalogue for *Shaker Inspirational Drawings*, 1962.

32 See Anderson, P., Catalogue for *American Folk Art from Western New York Collections*, 1986 in which details of a 1932 ground-breaking exhibition at MOMA was referenced with its emphasis on American decorative art.

33 Taken from Morse, F., *The Shakers and the World's People*, 1980, p. 274.

34 Morse, F., *The Shakers and the World's People*, 1980, p. 181 and see the television programme Thompson, D. (producer & director), *Aaron Copland: American Composer*, 2000. Also hear Copland, A., *Appalachian Spring*, Boston Symphony Orchestra, 1994. In addition to Copland other musicians have found inspiration in Shaker melodies, for example the radio programme Brubeck, D., *Brubeck's Cool Jazz, An 80th Birthday Celebration*, 2000 and the CD by Adams, J., 'Shaker Loops', Minimalist, 2000.

35 Taken from Hughes, R., *American Visions*, 1997, p. 451. Also see the television programme Hughes, R., *American Visions – 2: The Promised Land*, 1996.

36 Watercolour drawing featured in newspapers such as *Boston Globe*: see Lawton, A., 'Water Colour paintings of Shaker Furniture (Index of American Design)', *Boston Globe*, 1937.

37 Smith, G.M., 'The Shaker Arts and Crafts', in O'Connor, F.V. (ed.), *Art for the Millions*, 1973, p. 173.

38 For those wanting a general overview of the Shakers see Coleman, W., *The Shakers*, 1997 and texts specifically by the Shakers refer to Melcher, M.F., *The Shaker Adventure*, 1968; White, A. & Taylor, L.S., *Shakerism Its Meaning and Message*, 1971; Evans, F.W., *Autobiography of a Shaker*, 1972; and Barker, M.R., *Revelation: A Shaker Viewpoint*, 1989.

39 Their progress and the history of their endeavours are recorded in Andrews, E.D. & Andrews, F., *Fruits of the Shaker Tree of Life*, 1975. Also see Dorschner, C., 'Faith Andrews Shares Her Experiences', *The Shaker Messenger*, 1984 and Stell, L., 'Faith Andrews: A Celebration', *The Shaker Messenger*, 1987.

40 See Andrews, E.D. and Andrews, F., *Work and Worship Among the Shakers*, 1974.

41 See Andrews, E.D., *The Gift to be Simple: Songs, Dances and Rituals of the American Shakers*, 1940 (reprinted 1962 by Dover Publications, New York).

42 For examples of Edward Deming Andrews and Faith Andrews' early writing see 'Craftsmanship of an American Religious Sect', *Antiques*, 1928 and 'An Interpretation of Shaker Furniture', *The Magazine Antiques*, 1933. Also the ground-breaking *The New York Shakers and Their Industries* produced by E.D. Andrews in 1930.

43 E.D. Andrews' obituary in *The Berkshire Eagle* of 8 June 1964, notes: 'Dr Edward Deming Andrews, who died on Saturday after a career as a researcher, educator and writer that had made him probably the world's best known historian of the Shaker movement' (Unspecified, 'Obituaries – Edward D. Andrews Dies; Noted Expert on Shakers', *The Berkshire Eagle*, 1964). This and other material relating to the death of Edward Deming Andrews (including the funeral service) can be found in The Edward Deming Andrews Memorial Collection, Winterthur Library, Box 26.

44 See Andrews, E.D. and Andrews, F., *Shaker Furniture: The Craftsmanship of an American Communal Sect*; in the 1964 reprint the memorial can be found on the inside front cover. The text also features in

Andrews, E.D. & Andrews, F., *Work and Worship Among The Shakers*, 1974 which contains the words: 'This Edition is dedicated to the memory of Edward Deming Andrews 1894–1964'.

45 See Oxford University Press press release from 26 August 1953 for the book *The People Called Shakers*, which indicates that Andrews graduated from Yale with a PhD in 1930 (Boardman, F.W., 'A Loaf of Bread Plus Thirty Years Equals an Unusual Book About an Unusual Group of Americans' (press release), 1953). See The Edward Deming Andrews Memorial Collection, Winterthur Library, Number SA 1322.1, which also details information on the Millennial Laws which the release claimed was the first time of publication.

46 William Winter and his photographs have featured in a number of newspapers, including the *New York Herald Tribune* which shows images of Sadie Neale and the cobbler's shop at the Church Family, New Lebanon, and Loring Dun, R., 'Photographs of Shaker Interiors and Crafts by William Winter at Art Institute', *Times Union Newspaper*, 1938, which has a Winter photograph entitled 'Hands at Work'.

47 For examples of Rourke's written work see Rourke, C., *Charles Sheeler – Artist in the American Tradition*, 1938 and *The Roots of American Culture*, 1942.

48 Quoted in Stein, S.J., *The Shaker Experience in America*, 1992, p. 376.

49 See Winter, W.F., 'Shaker Portfolio', *US Camera*, 1939 and, for a review of William Winter's photographic work, see Scorsch, D., 1989.

50 Together with Walter A. Dyer's 1929 article 'The Furniture of the Shakers' in *House Beautiful*, the 1928 *Antiques* article by Andrews, 'Craftsmanship of an American Religious Sect', was credited by Irene Zieget as being a seminal early work on Shaker interpretation. *Antiques* later became *The Magazine Antiques*.

51 See The Edward Deming Andrews Memorial Collection, Winterthur Library, SA 1381 for letters from Keyes, H.E. to the Andrews partnership.

52 In a letter dated 15 October 1935, Keyes arranges a meeting with Juliana Force at his home in New York. He also commented on some text that the Andrews partnership had produced for the catalogue of the Shaker Handicrafts exhibition at the Whitney (Andrews, E.D., Catalogue for *Shaker Handicrafts*, 1935), which can be found in The Edward Deming Andrews Memorial Collection, Winterthur Library, Box 24.

53 See Keyes, H.E., 'Exhibitions and Sales' and 'A View of Shakerdom', *The Magazine Antiques*, 1934.

54 See Andrews, E.D., 'Antiques in Domestic Settings (Solutions and Suggestions). Summer Home of Dr and Mrs Edward Deming Andrews in Richmond, Massachusetts, USA' and 'Antiques in Domestic Settings (Solutions and Suggestions). Shaker Home of Dr and Mrs Edward Deming Andrews in Pittsfield, Massachusetts, USA', *The Magazine Antiques*, 1936. These included a 'colour portfolio' of Shaker furnished rooms in the homes of Edward Deming Andrews and his wife in their Whittier home and the Richmond farmhouse (which had also been featured in other magazines). Also see 'Shaker Farm' in Andrews, E.D. & Andrews, F., *Fruits of the Shaker Tree of Life*, 1975, p. 187.

55 For a review of the Modernist aesthetic in design see Greenhalgh, P., *Modernism in Design*, 1990.

56 Taken from Andrews, E.D., 'Shaker Home of Dr and Mrs Edward Deming Andrews in Pittsfield, Massachusetts, USA' in Rose, M.C. & Rose, E.M. (eds.), *A Shaker Reader*, 1977, p. 77. Functionalism also features in 'Functionalism in Shaker Crafts', *A Shaker Reader*, p. 104, in which Dodd, E.M., a curator at Shaker village, looks at crafts: 'The Shakers' functionalism, which was a direct outgrowth of their religious beliefs, was a carefully articulated principle. It was also astonishingly prophetic of twentieth-century aesthetics ...' This is very similar to the Andrewes' thesis which had already been extensively published between 1930 and 1970: see Andrews, E.D., 'Designed for Use – the Nature of Function in Shaker Craftsmanship', *New York History*, 1950.

57 See Keyes, H.E., 'Preface', in Andrews, E.D. and Andrews, F., *Shaker Furniture: The Craftsmanship of an American Communal Sect*, 1964, p. viii.

58 Faith Andrews completed the book and her death was recorded in 1990: see Van Kolken, D., 'Shaker Historian Faith E. Andrews Dies', *The Shaker Messenger*, 1990. For a good, simple introduction to the Shakers refer to Van Kolken, D., *Introducing the Shakers – an Explanation & Directory*, 1985. Also see Stell, L., 'Faith Andrews: A Celebration', *The Shaker Messenger*, 1987, pp. 7 and 26.

59 The Ziegets purchased a bed (originally from Hancock) from Edward Deming Andrews, as detailed in

Zieget, I., 'Our Shaker Adventure', a manuscript in the Philadelphia Museum of Art. Also see Zieget, I., 'Our Shaker Adventure', *The World of Shaker*, 1973.

60 There is evidence of communication in The Edward Deming Andrews Memorial Collection, Winterthur Library, SA 1295.1.

61 The background of Eleanor Roosevelt and the Shakers is reviewed by Thompson, D., 'Eleanor Roosevelt: The Shakers and the Meaning of Craftsmanship', *The Shaker Messenger*, 1991 and Thompson, D., 'Eleanor Roosevelt and The Shakers', *The Shaker Messenger*, 1992.

62 See McKinstry, E.R., 'The Shakers', in Martinez, K. (ed.), *American Cornucopia*, 1990, pp. 87–90 and McKinstry, R.E., 'Three Manuscripts Describe Shakers', *The Shaker Messenger*, 1993.

63 See Dorschner, C., 'Faith Andrews Shares Her Experiences', *The Shaker Messenger*, 1984 for some indication of the Andrews' experience and also Nelson, G., 'Sixty Years of Shaker Study by the Andrews', *The Shaker Messenger*, 1983.

64 Taken from Stein, S.J., *The Shaker Experience in America*, 1992, pp. 396–97.

65 See Kirk, J.T., *The Shaker World: Art, Life, Belief*, 1997, p. 239.

66 See Bibliography for a complete list of the Andrewses' writings including articles, books and unpublished material.

67 See Sprigg, J., 'Out of this World: The Shakers as a Nineteenth-Century Tourist Attraction', *American Heritage*, 1980.

68 See Kirk, J.T., *The Shaker World: Art, Life, Belief*, 1997, p. 232.

69 In 1905, John Patterson MacLean compiled *A Bibliography of Shaker Literature*, containing 523 items. Also for a review of early developments see Richmond, M.L., *Shaker Literature – A Bibliography, vol. 1 – By The Shakers*, 1977.

70 See Gleason, G., 'From Their Hearts and Hands: A Shaker Legacy', *Americana*, 1973, p. 6 which recommends a number of museum collections, most of which are featured within this book: 'Museums with Shaker collections of unusual interest include the Boston Museum of Fine Arts; Henry Francis du Pont Winterthur Museum near Wilmington, Delaware; Old Shaker House at Fruitlands Museum, Harvard University, Cambridge, Massachusetts; Shaker Museum, Shaker Heights, Ohio; Shaker Museum, Old Chatham, New York; Warren County Historical Society, Lebanon, Ohio; and the Western Reserve Historical Society and Museum in Cleveland, Ohio.'

71 James W. Gilreath, a former archival fellow at the Western Reserve Historical Society, was one of the first to give this subject serious treatment in a brief article that appeared in a 1973 issue of *The Journal of Library History*: 'Cathcart joined the Western Reserve Historical Society in 1893 and a year later became its secretary. In 1907 he became its first full-time president and in 1913, vice-president and director. He entered into his duties with vigour and soon resigned his position with the Burrows Brothers Company where he had worked since coming to Cleveland. Elbert Benton, a historian of the Society, wrote that Cathcart's appointment as WRHS's first director 'represented a new era, one of very rapid growth. His skill as a collector put new life into the society. The formation of the Shaker collection is only one, albeit the most spectacular, example of Cathcart's achievements during his tenure at the WRHS until his death in 1942' (Gilreath, J.W., 'The Formation of the Western Reserve Historical Society's Shaker Collection', *The Journal of Library History, Philosophy, and Comparative Librarianship*, 1973, p. 133).

72 In a further account of the development of the Western Reserve Historical Society at Cleveland, Ohio, Kermit J. Pike endeavours to contextualise the collections by giving an indication of Shaker decline and the severe risk that documents owned by the Shakers were under in the early part of the twentieth century. See Pike, K.J., 'Shaker Manuscripts and How They Came to be Preserved', *Manuscripts*, 1977.

73 See Morse, F., *The Shakers and the World's People*, 1980, p. 254.

74 See Gilreath, J.W., 'The Formation of the Western Reserve Historical Society's Shaker Collection', *The Journal of Library History, Philosophy and Comparative Librarianship*, 1973, p. 135.

75 See Pike, K.J., 'Shaker Manuscripts and How They Came to be Preserved', *Manuscripts*, 1977, p. 231.

76 See Large Jr, J., 'Shaker Room is a Part of the Western Reserve Historical Society', *The World of Shaker*, 1972; 'What You Will Find At The Western Reserve Historical Society', *The World of Shaker*, 1975; and

'New Shaker Exhibit Opened at Western Reserve Historical Society', *The World of Shaker*, 1975. Also detailed in Murray, S., *Shaker Heritage Guidebook*, 1994, p. 251 in which it states: 'Considered to be the most extensive collection of Shaker books and manuscripts in the world. More than 300,000 pages of manuscript and Shaker printed materials are micro published as the "Shaker Collection" 1723–1952.'

77 For contextual material on Harvard see Fowke, J.S. & Longo, J.M., *The Harvard Shakers' Book of Days*, 1995. Also Lowry, J., 'Harvard Buys Land Around Cemetery', *The Shaker Messenger*, 1984 and Larrabee, C.M., 'Harvard on National Register', *The Shaker Messenger*, 1990, for details on modern developments.

78 These are the dates given in annotation of the maps of the site, which states: 'Created in this idyllic setting between 1914 and 1947, Fruitlands Museums are an outstanding example of the post-industrial period's urge to connect with the American past. Credit for this extraordinary vision goes to one woman, Clara Endicott Sears (1863–1960). In an age that she felt had lost touch with nature, philosophy, religion and true beauty, her purpose for the museums was to revive some of the thought-provoking ideas of the past. Today, people come for many reasons, but rarely fail to be moved by the breathtaking scenery, tranquillity and fascinating history on the site.' This information is available as tour guide material from the museum.

79 In an article by Lowry in *The Shaker Messenger*, 1984, it states: 'For many a visit to Fruitlands has become an annual outing, while for others, making a first acquaintance with the museum complex has meant the discovery of a place of unusual beauty and appeal devoted to the preservation of 19th century American religious and philosophical movements, art and the American Indian ... By the 1840s there were many non-religious community hopefuls, as there had been in the 1820s with the inspiration and example of Robert Owen at New Harmony in Indiana. Among them were the New England transcendentalists' Brook Farm, where Nathaniel Hawthorne and an intellectual company milked cows and shared farm chores. Later he wrote satirically about that utopian community in *The Blithedale Romance*. Fruitlands was a short-lived dream of Louisa May Alcott's father, Bronson Alcott, who refused to let his vegetarian communal family even use animals for field work because he considered it slave labour.'

80 See Murray, S., *Shaker Heritage Guidebook*, 1994, pp. 74–85.

81 Flo Morse in the chapter 'Preserving the Shaker Heritage – The First Shaker Museum' states: 'In 1920 a former Trustees' Office was carefully moved from the vacated Shaker village in Harvard to Prospect Hill, a few miles away. From the new location the building looked out over the Nashua Valley all the way to and beyond the former Shaker "twin" community at Shirley, Massachusetts. This "Shaker House" became the first Shaker Museum.' See Morse, F., *The Shakers and the World's People*, 1980, p. 264. In 1957, Comstock stated that: 'Individual examples of Shaker work are to be seen in other museums but the only other major exhibit which is both public and permanent is at the Fruitlands Museum in Harvard, Massachusetts. Here a house of the Harvard Shakers, built in 1790, has been moved to the grounds and contains a collection of Shaker crafts' (Comstock, H., 'Shaker Crafts on View', in the later published Rose, M.C. & Rose, E.M. (eds.), *A Shaker Reader*, 1977, p. 103).

82 A special edition of the BBC television programme *The Great Antiques Hunt* was recorded in the USA, in which teams had to differentiate between Shaker and 'outside' world furniture. The programme featured both the exterior and interior of the Shaker Museum at Fruitlands and included Jilly Goulden and the 'expert' Leigh Keno. It was clearly televised at the height of Shaker interest in the United Kingdom because the teams seem familiar with Shaker, although they do not entirely know what its characteristics are, both teams making a mistake over the identification of an egg basket (coloured salmon pink) with the characteristic Shaker swallowtail joints.

83 The Berkshire Shaker Seminars held their twentieth anniversary seminar at Harvard/Shirley on 10–15 July: see Nelson, G.G., Moriarty, K.M. & Wisbey, H.A., *The Twentieth Anniversary Shaker Seminar – Harvard and Shirley*, 1994. Also see Stier, M. & Fuller, R.N., *Shaker Sites in Harvard – A Guide for the Harvard Shaker Bicentennial 1791–1991*, 1991.

84 The 200th year foundation celebrations (along with many others in different Shaker communities) were featured in Van Kolken, D., 'Fruitlands Museums Mark Harvard's 200 Years with Exhibitions and Symposium', *The Shaker Messenger*, 1991, where the following text is of interest: 'A symposium and

three new exhibits mark 1991 as the year of the Shakers at Fruitlands Museums, Harvard, Mass. The focus of this year is on the Museums' Shaker collection to commemorate the 200th anniversary of the founding of the Harvard Shaker community of 1791 ... It is designed to further the understanding of the Harvard community where Mother Ann lived from 1781 to 1783 ... The first [exhibit], "A Good Name is Better than Riches; The Harvard Shakers' Commerce with the World" presents new research on the development of the industries and products of the Harvard Shakers in the years between the community's founding in 1791 and its closing in 1918 ... The second exhibit, "The Art of Sister Karlyn Cauley: Paintings and Prints in the Shaker Tradition", is the first major one-woman show in the eastern United States by the contemporary artist.'

85 Taken from Van Kolken, D., 'Exhibition at Fruitlands Museums', *The Shaker Messenger*, 1983, p. 24: 'An exhibition of Shaker baskets is featured this summer at Fruitlands Museums, Harvard, Mass. The exhibit focuses on baskets made from black ash splint and shows the techniques from the selection of the tree to the completed basket. Approximately 40 baskets have been selected from the collections of the Fruitlands Museums, Shaker Village at Canterbury, NH, the Shaker Museum at Old Chatham, NY, and the New York State Museum in Albany ... In addition, Martha Wetherbee, authority on Shaker baskets, made the facilities of her shop in Sanbornton, NH, available for photographing the process of making the baskets and provided her expertise in authenticating the techniques of construction.' Other examples of exhibitions include that featured in Van Kolken, D., 'Shaker Museum Opens 37th Exhibition Year', *The Shaker Messenger*, 1986, which states: 'Fruitlands hosts the exhibit "Inner Light: The Shaker Legacy" by Linda Butler. The travelling exhibition from The University of Kentucky includes 60 photographs documenting a vanishing way of life in Shaker communities. The exhibit opened May 15 and continues through June 30.'

86 In the promotional leaflet provided by the museum it states of the Fruitlands Farmhouse: 'In 1843, Bronson Alcott moved with his family and fellow believers to this remote farmhouse to start a utopian community called Fruitlands. The experiment in idealistic living, by the fruits of the land, was short-lived though its influences are felt today. The farmhouse now serves as a museum of the Transcendentalist movement and contains letters and memorabilia of the leaders – Alcott, Emerson and Thoreau.'

87 Taken from Van Dusen, G. (photographer), 'The New Shaker Exhibit in the Reception Centre at Fruitlands Museums', *The Shaker Messenger*, 1982, including a photograph (p. 13) with annotation: 'The new Shaker exhibit in the Reception Centre at Fruitlands Museums, Harvard, Mass., features chairs, tables and case pieces representing known work of Shaker craftsmen in Harvard, Shirley, Canterbury and Mt Lebanon. On the back wall is the alphabet board that once hung in the schoolhouse in the Shaker Village. Below the alphabet are photo enlargements of (from left) South Family Dwelling at Harvard by Jack E. Boucher, Historic American Buildings Survey; Meeting House, Harvard by Boucher and South Family Dwelling, Harvard, print from a glass plate negative, Fruitlands Museums.' Also see Van Kolken, D., 'New Shaker Exhibition', *The Shaker Messenger*, 1982, p. 13.

88 See Volmar, M., *Under the Mulberry Tree* (Fruitlands Museums Newsletter), Spring/Summer, 1996.

89 See Van Dusen, G. (photographer), 'The New Shaker Exhibit in the Reception Centre at Fruitlands Museums', *The Shaker Messenger*, 1982, p. 13.

90 In addition, a chair presumed to be owned by Mother Ann Lee was displayed at Fruitlands. In the book *Mother Ann Lee* the following is of interest: 'It is easy to imagine her rocking and singing in her primitive chair, which is now displayed at Fruitlands Museums in Harvard, Massachusetts. A seven-rung Windsor chair with wide rockers fastened to the legs, it is a crude forerunner of the exquisitely simple chairs for which later Shakers became famous'; Campion, N.R., *Mother Ann Lee: Morning Star of the Shakers*, 1990, pp. 140–41.

91 See Kirk, J.T., *The Shaker World: Art, Life, Belief*, 1997, p. 232.

92 See The Edward Deming Andrews Memorial Collection, Winterthur Library, SA1295.1, no. 657, Box 4.

93 See 'Selling of the Shakers' in Stein, S.J., *The Shaker Experience in America*, 1992, p. 399.

94 A 1930 press release, with the compliments of Chas. C. Adams entitled 'Special Temporary Exhibit of Shaker Antiques at the New York State Museum', states: 'A special exhibit of Shaker antiques is announced by Dr Charles C. Adams, Director of the New York State Museum, at Albany, to be opened

to the public on Monday, June 16th, and to be on display until Labour day. This exhibit illustrates the household occupations of spinning and weaving, and the medicinal herb industry, the latter being one of the most active of the various businesses conducted by "this sect during the past century."' In the exhibition reproductions of rooms were produced along with photographs by William Winter. The press release is quite detailed, being nearly three pages long. More information about the exhibition and some photographs are given in Adams, C.C., 'Twenty-Fifth Report of the Director of the Division of Science and the State Museum', *New York State Museum Bulletin*, no. 293, 1932, with illustrations on pp. 49–52.

95 See the New York State Museum's website (Exhibits and Programs) for the year 2000 Shaker exhibition, under the title *Shaker Legacy – Virtual Exhibit View Two*.

96 See Andrews, E.D., *The New York Shakers and Their Industries*, Circular 2 – Oct., 1930.

97 Lassiter also wrote for a wider audience about the Shakers and this included the article 'The Shakers and their Furniture', *New York State Antiques*, 1946, and also the book *Shaker Architecture*, 1966.

98 Photographs from this exhibition are featured in Adams, C.C., 'Twenty-Fifth Report of the Director of the Division of Science and the State Museum', *New York State Museum Bulletin*, no. 293, 1932, pp. 49–52.

99 This is further mentioned in Adams, C.C., 'Twenty-Sixth Report of the Director of the Division of Science and the State Museum', *New York State Museum Bulletin*, no. 298, 1933, pp. 19 and 24.

100 This is detailed in Adams, C.C., 'The New York State Museum's Historical Survey and Collection of the New York Shakers', *New York State Museum Bulletin*, no. 323, 1941.

101 See Adams, C.C., 'Twenty-Fourth Report of the Director of the Division of Science and the State Museum', *New York State Museum Bulletin*, no. 288, 1931, p. 23. See Bibliography for further reports from Adams.

102 See Adams, C.C., 'The New York State Museum's Historical Survey and Collection of the New York Shakers', *New York State Museum Bulletin*, no. 323, 1941, p. 78.

103 It is difficult to know who initially recognised that the Shakers had a 'Golden Period' of production, but certainly Edward Deming Andrews recognised this as an important period. It was also the period in which Shaker numbers were increasing and communities were relatively prosperous. The period could be defined as that which started around 1800 and went on to around 1860.

104 See Adams, C.C., 'The New York State Museum's Historical Survey and Collection of the New York Shakers', *New York State Museum Bulletin*, no. 323, 1941, p. 93.

105 See Adams, C.C., 'The New York State Museum's Historical Survey and Collection of the New York Shakers', *New York State Museum Bulletin*, no. 323, 1941, p. 93.

106 See Adams, C.C., 'One Hundred Fourth Report of the Director of the Division of Science and the State Museum', *New York State Museum Bulletin*, no. 330, 1942, p. 33. Also Canterbury has been discussed by Walsh, D. in 'The Canterbury Story – Establishment of the Community', *The Shaker Messenger*, 1979; 'Canterbury: New Challenges', *The Shaker Messenger*, 1980; 'The Canterbury Story – The Years of Growth and Prosperity', *The Shaker Messenger*, 1980; and 'The Canterbury Story – The Start of the Decline', *The Shaker Messenger*, 1980.

107 Adams, C.C., 'One Hundred Fourth Report of the Director of the Division of Science and the State Museum', *New York State Museum Bulletin*, no. 330, 1942, p. 56.

108 A letter from Keyes at *The Magazine Antiques*, dated 27 September 1938, taken from The Edward Deming Andrews Memorial Collection, Winterthur Library, SA 1381:

> Dear people,
>
> Winter's photographs of the farmhouse have just come to hand. I think they are perfect. I'm astonished to see how they follow my rough indications. On the whole, I think they are the best things Winter has done. They are so superbly lighted and taken with such an appreciative sense that somehow the spirit of Shakerdom has entered into them and infused them with a character of peace and serenity that might easily move one to tears – continued and signed as above.

109 See Adams, C.C., 'Twenty-Fourth Report of the Director of the Division of Science and the State

Museum', *New York State Museum Bulletin*, no. 288, 1931, p. 26 and Figures 7–10 (pp. 29–32). Also Winter, W.F., Catalogue for *Exhibit of Applied Photography*, 1934.

110 See Morse, F., *The Shakers and the World's People*, 1980, p. 273.

111 Kirk, J.T., *The Shaker World: Art, Life, Belief*, 1997, continues to talk about the association between the Andrews partnership and Winter. He appears to suggest that the Andrewses created Winter as a photographer of Shaker artefacts. It also seems that the Andrewses stage managed their photographs in order to achieve a modernist aesthetic. Kirk compares and contrasts the work of Winter before he became associated with the Andrewses and those after. It is clear that there are differences which can be evidenced in actual photographs.

Also Stein, S.J., *The Shaker Experience in America*, 1992, p. 376 states: 'Winter's photography created an apposite Shaker image to accompany Andrews' interpretation. Contrary to the impression he created, however, Winter did not always find the scenes he photographed; he frequently arranged them. By his own account he occasionally removed "an object which obviously did not belong in the picture; or something which did belong was moved in the picture space" ... Winter's photographs reinforced Andrews' frozen view of the Believers.'

Also Swank, S.T., *Shaker Life, Art and Architecture*, 1999, p. 44 states: 'The Shakers of the late nineteenth century were restrained interior designers when compared to their middle-class urban counterparts, but they were influenced by Victorian tastes. As the pictures and surviving physical evidence reveal, Shaker interiors of the late nineteenth century were definitely Victorian in style, and looked nothing like the interiors of Shaker museums that follow the modern interpretations of austere Shaker design formulated by Edward Deming Andrews and William Winter in the 1930s.'

112 See Adams, C.C., 'The New York State Museum's Historical Survey and Collection of the New York Shakers', *New York State Museum Bulletin*, no. 323, 1941, p. 129.

113 For information on Watervliet see Apple, N., 'Remaining Watervliet, Ohio Structures to be Destroyed', *The World of Shaker*, 1974 and Shaver, E. & Pratt, N., *The Watervliet Shakers and Their 1848 Shaker Meeting House*, 1994. For Mount Lebanon see Emerich, A.D. et. al., *Self Guided Walking Tour – Mount Lebanon*, 1991 and for Shakertown see Mastin, B.L., *A Walking Tour of Shakertown*, 1969.

114 For more information on Canterbury see French Hewes, M.J., 'An Afternoon at Canterbury', *The Shaker Messenger*, 1980; Ledes, A.E., 'The Canterbury Shakers', *The Magazine Antiques*, 1993; Tarbell, B., 'Canterbury Shaker Village – A Legacy Lives On', *Art & Antiques*, 1993 and the Canterbury website.

115 For more information on Sabbathday Lake see Barker, M.R., *The Sabbathday Lake Shakers*, 1985; Carr, F.A., 'Home Notes From Sabbathday Lake', *The Shaker Quarterly*, 1987 and Van Kolken, D., '200 Years For Sabbathday Lake', *The Shaker Messenger*, 1994. This is the only 'real' Shaker community and the Shakers can be visited at Sabbathday Lake: see Murray, S., *Shaker Heritage Guidebook*, 1994.

116 For more information on Hancock see Van Kolken, D., 'Hancock Shaker Village 25 – Founded in 1790 – 25th Anniversary as a Museum', *The Shaker Messenger*, 1985; Burns, D.E., *Shaker Cities of Peace, Love and Union – a History of the Hancock Bishopric*, 1993 (this also features the communities of Tyringham, MA and Enfield, CT that were part of the Bishopric with Hancock); plus the film/video Vila, B. & Ferrone, M., *Bob Vila's Guide to Historic Homes*, 1996 and the comprehensive Hancock website.

117 The exhibition is detailed in an early edition of *Antiques* in which two dining-room arrangements are photographed from the display. The display appears well done and has a stripped minimal aesthetic so characteristic of Edward Deming Andrews' vision. It states: 'Believers in functionalism who may yet be seeking definite idols worthy of adoration are advised to turn their attention to the furniture of the old-time Shaker communities such as has recently been exhibited at the Berkshire Museum in Pittsfield.' See Keyes, H.E., 'Exhibitions and Sales', *The Magazine Antiques*, 1932.

118 See Andrews, E.D. & Andrews, F., *Fruits of the Shaker Tree of Life*, 1975, p. 146 in the section entitled 'Collecting, Writing and Friendships'.

119 See Andrews, E.D., Catalogue for *The Furnishings of Shaker Dwellings and Shops Exhibition*, at Berkshire Museum, 1932, first page after title page.

120 See Andrews, E.D., Catalogue for *The Furnishings of Shaker Dwellings and Shops Exhibition*, 1932, final page of text.

121 See Storey, W.R., 'Native Art From Old Shaker Colonies – A Distinct Style of American Furniture Which Has Interest for Our Times', *The New York Times Magazine*, 23 October 1932.

122 See Andrews, E.D., Catalogue for *Shaker Furniture*, 1934 (The Edward Deming Andrews Memorial Collection, Winterthur Library, Number 597).

123 Perfectionism has become a constant theme when analysing the Shakers: see Williams, R.E., *Perfectionism: The Shaker Way of Life*, 1977 and Taylor, M., 'Two Paths to Perfection', *The Shaker Messenger*, 1985.

124 See Andrews, E.D., Catalogue for *Shaker Furniture*, 1934, p. 1.

125 See Andrews, E.D., Catalogue for *Shaker Furniture*, 1934, p. 2.

126 Keyes, H.E., 'A View of Shakerdom', *The Magazine Antiques*, 1934, pp. 146–47: 'From August 23 to September 8 an exhibition of Shaker furniture, shop and household objects, lent by Mr and Mrs Edward Deming Andrews of Pittsfield, were held at Sedgwick Hall, Lenox, Massachusetts, under the auspices of the Lenox Library Association. Mr and Mrs Andrews who have attained a position of recognised authority in the domain of Shaker history and Shaker customs, are the fortunate owners of many specimens illustrating the handiwork of the extraordinary communal sect, which has endured in this country for well nigh a century and a half, and still maintains some foci of activity. I have long been fairly well acquainted with Shaker furniture, and have cherished an admiration for its refined simplicity of line and its excellence of workmanship. Full appreciation, however, has waited on the opportunity to see typical pieces in their appropriate environment. The chance came, one evening, not long since, at the Shaker settlement of Hancock, near Pittsfield. Here I was permitted to view one of the least ostentatious but yet most singularly appealing rooms that I have ever entered. White as moonlight I remember its walls, white the plain linen curtains at the window, and against the pure background a few pieces of warm-toned nut wood furniture, soberly demure, yet without a hint of severity. On the bed in the corner a blue homespun coverlet of wool was neatly spread; braided rugs patterned the floor with ovals of soft colour. Near the centre of the room a chair stood beside a small round table, on which a single candle shone like the eye of innocence. An inexpressible atmosphere of quietude and peace pervaded the place, relaxing taut nerves like some beneficent opiate, and for the moment obscuring all realisation of the tumultuous world outside. Spirits of just men made perfect – perhaps they were still abiding there in calm silence. To me, at least, they seemed to surround like tangible presences.' See also Winter, W.F., Catalogue for *Exhibit of Applied Photography*, 1934.

127 See Adams, H.D., 'Whitney Museum Shows Shaker Handicrafts', *The Brooklyn Daily Eagle*, 24 November 1935, p. C13.

128 See Unspecified, 'Shaker Craft on Exhibition Here', *The New York Herald Tribune*, 16 November 1935, p. 16. In addition, a letter from the Whitney Museum of American Art dated 6 December 1935 (The Edward Deming Andrews Memorial Collection, Winterthur Library, Box 24) highlighted problems with furniture being damaged in the exhibition, and went on to state: 'I am sorry the Shaker exhibition had to close sooner than we had planned, but I find that about 4500 people saw it during the time it was on view. It was a beautiful exhibition and I am glad we had the opportunity of holding it in the museum. Thank you and Mrs Andrews for the splendid cooperation you gave us, with best regards, very sincerely yours, Hermon More (Curator).'

129 See 'Foreword' in Andrews, E.D., Catalogue for *Shaker Handicrafts*, 1935.

130 See Andrews, E.D., Catalogue for *Shaker Handicrafts*, 1935, p. 6.

131 Taken from Stein, S.J., *The Shaker Experience in America*, 1992, p. 397.

132 Colvin, H.M., 'The Educational System of the Shakers', in Joline, J.F. (ed.), *The Peg Board*, 1936, p. 32, makes reference to Edward Deming Andrews' book *The Community Industries of the Shakers* in note 3. Illustrations were also provided by Andrews such as that found on p. 19. *The Peg Board* was produced by Darrow School (located in the buildings at Mount Lebanon) and provided pupils with a forum for articles they had written relating to Shaker interpretation and analysis.

133 Taken from Gidley, M., Bowles, K. & Fowles, J., *Locating the Shakers*, 1990, p. 70.

134 See Andrews, E.D., Catalogue for *Shaker Handicrafts*, 1935, p. 8.

135 See Andrews, E.D., Catalogue for *Shaker Handicrafts*, 1935, p. 8.

136 There have been numerous publications based around spirit drawings including Andrews, E.D. &

Andrews, F., *Visions of the Heavenly Sphere*, 1969; Patterson, D.W., *Gift Drawing and Gift Song*, 1983; and Promey, S.M., *Spiritual Spectacles*, 1993. The Tree of Life also seems to have been a favourite of the Andrews partnership and they used the image on the cover of a number of their books.

137 The Tree of Life symbol has been used by Pleasant Hill Shaker Village and Shaker Museum, Old Chatham. In addition, it featured in The Guild of Shaker Crafts, The Shaker Workshops and Shaker Shops West sales literature. It was also used for a UNICEF Christmas card in 1974 (Morse, F., *The Shakers and the World's People*, 1980, p. 181).

138 Andrews was later to write about inspirational drawings for *The Magazine Antiques*: see Andrews, E.D., 'Shaker Inspirational Drawings', 1945.

139 See Andrews, E.D., Catalogue for *Shaker Handicrafts*, 1935, p. 10.

140 The dates associated with the objects in the exhibition are as follows: 1830, 1820, 1860, 1870, 1830, 1800, 1815, 1810, 1860, 1810, 1860, 1810, 1800, 1815, 1810, 1810, 1810, 1840, 1810, 1820, 1810, 1820, 1840, 1815, 1810, 1815, 1800, 1800, 1800, 1830, 1870, 1800, 1870, 1810, 1810, 1820, 1800, 1790, 1815, 1820, 1810, 1820, 1810, 1820, 1820, 1830, 1810, 1815, 1830, 1810, 1810, 1810, 1840, 1840, 1790, 1820, 1800, 1830, 1790, 1800, 1820, 1830 and 1815.

141 For a review of Shaker clocks, Gibbs, J.V. & Gibbs, R.F., 'Shaker Clock Makers', *National Association of Watch and Clock Collectors*, 1972, gives an excellent introduction to this important Shaker furniture form.

142 It has been featured in some publications including Klamkin, M., *Hands to Work – Shaker Folk Art and Industries*, 1972, pp. 167–69 and 'Poplar cloth and Poplar items' in Gordon, B., *Shaker Textile Arts*, 1980, pp. 216–37. Also see Boswell, M.R., 'Women's Work: The Canterbury Shaker Fancywork Industry', *Historical New Hampshire*, 1993; Casey, F.C., *Catalogue of Fancy Goods – Made at Shaker Village, Alfred, York County, Maine*, 1971 (reprinted from 1908); McCool, E., 'Shaker Woven Poplarware', *The Shaker Quarterly*, 1962; and Van Kolken, D., 'Canterbury Revives Poplar Industry', *The Shaker Messenger*, 1986.

143 See Gordon, B., 'Victorian Fancy Goods: Another Reappraisal of Shaker Material Culture', *Winterthur Portfolio – A Journal of American Material Culture*, 1990.

144 Taken from Andrews, E.D., Catalogue for *Shaker Craftsmanship*, 1937 (The Edward Deming Andrews Memorial Collection, Winterthur Library, Number 583).

145 Taken from Andrews, E.D., Catalogue for *Shaker Craftsmanship*, 1937.

146 Taken from last section of Andrews, E.D., Catalogue for *Shaker Craftsmanship*, 1937.

147 For a comprehensive account of Juliana Force and her associations see Talmey, A., 'Whitney Museum of American Art and the One-Woman Power Behind It – Juliana Force', *Vogue*, 1940.

148 Letter dated 15 October 1936 from Juliana Force, Whitney Museum of American Art to EDA (Mrs) (The Edward Deming Andrews Memorial Collection, Winterthur Library, Box 24):

> Dear Mrs Andrews,
>
> Mrs Force has decided to sell her Shaker things and would like very much for you to advise her as to what prices to place on them. She therefore thought that perhaps you could find it convenient to come to New York some day next week and on your way stop in at south Salem and look the things over. This will be of great help to her and she will be glad to pay your expenses ...
>
> signed Anna Freeman (secretary to Juliana Force)

149 Many of the best pieces went to Mrs John D. Rockefeller, Jr, in a private agreement negotiated via Edith Halpert. Interestingly, it was Mrs Rockefeller who provided some of the funds for the establishment of the Sheeler collection within Hancock Shaker Village which will be featured later in this book.

150 In Talmey, A., 'Whitney Museum of American Art and the One-Woman Power Behind It – Juliana Force', *Vogue*, 1940, p. 133, it states: 'For Mrs Force has the collecting instinct of an ant. In her time, she has collected American provincial paintings, alabaster ornaments, wax flowers ... and Shaker furniture, which she later sold to John D. Rockefeller.'

151 See Andrews, E.D., Catalogue for *Private Sale of Shaker Furniture From the Collection of Mrs Willard Burdette Force at 'Shaker Hollow'*, 1937 (The Edward Deming Andrew Memorial Collection, Winterthur Library, Box 26). Also see McKinstry, E.R. (comp.), *The Edward Deming Andrews Memorial Shaker Collection*, 1987.

152 See Andrews, E.D. & Andrews, F., *Fruits of the Shaker Tree of Life*, 1975 and Nelson, G., 'Sixty Years of Shaker Study by the Andrews', *The Shaker Messenger*, 1983.

153 Taken from Andrews, E.D. & Andrews, F., Catalogue for *Exhibition of Shaker Arts and Crafts at Worcester Art Museum*, 1938: see Richmond, M.L., *Shaker Literature*, 1977, Number 2958. There is a copy in The Edward Deming Andrews Memorial Collection, Winterthur Library, Number 714. Also see McKinstry, E.R., (comp.), *The Edward Deming Andrews Memorial Shaker Collection*, 1987.

154 Taken from Andrews, E.D. & Andrews, F., Catalogue for *Exhibition of Shaker Arts and Crafts at Worcester Art Museum*, 1938.

155 See photographic credits in Andrews, E.D. & Andrews, F., *Work and Worship Among the Shakers*, 1974 for detail on Armin Landeck: 'Many of the fine photographs in this book were taken by Armin Landeck, a personal friend of the authors for many years. Mr Landeck's photographs have not only recorded historical aspects of the Shaker movement, but also reveal the spirit that animated the Believers for so many years.' Also for a specific reference to the stove illustration see Miller, S.M., 'The First Shaker Icon: A Stove', *The Shaker Messenger*, 1996.

156 See Lossing, B.J., 'The Shakers', *Harper's New Monthly Magazine*, 1857. The work of Benson Lossing has been reviewed in many books including Clifford, D. & Sprigg, J., *An Early View of the Shakers: Benson John Lossing and the Harper's article of July 1857*, 1989.

157 See Meader, R.F.W., 'Reflections on Shaker Architecture', *The Shaker Quarterly*, 1966 and also Wisbey, H.A., 'Shaker Scholar Lists Favourite Structures', *The Shaker Messenger*, 1984 for a scholar's choice of Shaker structures. Meader, R.F.W. also produced an *Illustrated Guide to Shaker Furniture* in 1972.

158 Taken from Nicoletta, J., and Morgan, B., *The Architecture of the Shakers*, 1995, p. 161.

159 Refer to Emlen, R.P., *Shaker Village Views*, 1987.

160 See Andrews E.D., 'Communal Architecture of the Shakers', *American Magazine of Art*, 1937; Schiffer, H., *Shaker Architecture*, 1979; and Rocheleau, P., Sprigg, J. & Larkin, D., *Shaker Built – The Form and Function of Shaker Architecture*, 1994.

161 See Section Two which details the development of period rooms – certainly those at Winterthur contain fixtures and fittings from real Shaker interiors.

162 See Pearson, E.R. & Neal, J., *The Shaker Image*, 1994, the photograph of Canterbury in Starbuck, D.R., 'Those Ingenious Shakers', *Archaeology Magazine*, 1990, p. 42 and Starbuck, D.R. & Swank, S.T., *A Shaker Family Album*, 1998.

163 Internet images can be viewed under the Kidder Smith Images Project, while Kidder Smith, G.E., *A Pictorial History of American Architecture*, 1976, has images of Shaker buildings.

164 For Enfield, New Hampshire, see Phillips, H.S., *Shaker Architecture – Warren County Ohio*, 1971; Emlen, R.P., 'Raised, Razed and Raised Again: The Shaker Meetinghouse at Enfield, New Hampshire, 1793–1902', *Historic New Hampshire*, 1975; Emlen, R.P., 'The Great Stone Dwelling of the Enfield, New Hampshire Shakers', *Old Time New England*, 1979; and those associated with Canterbury included Starbuck, D.R., 'Those Ingenious Shakers', *Archaeology Magazine*, 1990 and 'Canterbury Shaker Village – Archeology and Landscape', *The New Hampshire Archeologist*, 1990, and Swank, S.T. & Hack, S.N., 'All We Do Is Build: Community Building at Canterbury Shaker Village, 1792–1939', *Historical New Hampshire*, 1993.

165 See Hopping, D.M.C. & Watland, G.R., 'The Architecture of the Shakers', *The Magazine Antiques*, 1957.

166 Emlen, R.P., *Shaker Village Views*, 1987.

167 Much material featured on HABS was included in Schiffer, H., *Shaker Architecture*, 1979.

168 See photograph in Peladeau, M.B., 'The Shaker Meetinghouses of Moses Johnson', *The Magazine Antiques*, 1970, p. 596. In the annotation it states: 'This is the only known photograph of the interior of the original Hancock meetinghouse; it was taken about 1926. The building, built in 1786–1787, was razed in 1938.'

169 See Poppeliers, J.C. (ed.) & Stephens, D., 'Shaker Built – A Catalogue of Shaker Architectural Records from the Historic American Buildings Survey', *Historic American Buildings Survey*, 1974, p. 1.

170 Poppeliers, J.C., 'Shaker Architecture and the Watervliet Shaker South Family', *New York History*, 1966 gives an account (with illustrations and photographs from HABS) of the exterior and interior details of some Watervliet buildings. He states (p. 58) that: 'In the twentieth century the community steadily

declined, and in the 1920s the number of brothers had decreased to such an extent that a non-Shaker superintendent had to be employed to manage the farm. Architecturally, too, the Shakers could no longer make a stand against the encroachment of the "world" ... Already in 1875, when the Ministry's Residence at the Church Family at Mt Lebanon was built, it was evident that the rule no longer strictly followed. Its rather simple ornamentation indicates in many ways a closer relationship to the average "Victorian" house than it does to Shaker structures built in the decades immediately after 1805.'

171 See Peladeau, M.B., 'Shaker Material in the Historic American Buildings Survey', *The Shaker Quarterly*, 1969, p. 110.

172 Filley, D.M. & Richmond, M.L. (ed.), *Recapturing Wisdom's Valley*, 1975, mentions a number of the buildings which are no longer extant.

173 Poppeliers, J.C., 'Shaker Architecture and the Watervliet Shaker South Family', *New York History*, 1966, p. 50 shows a photograph of the South Family Cottage.

174 See photograph (Schiffer, H., *Shaker Architecture*, 1979, p. 75) showing South Family Dwelling House, located at Mount Lebanon and described as a Sisters' Room. Also see examples of Winter's photographs in Kirk, J.T., *The Shaker World: Art, Life, Belief*, 1997, p. 241, figures 248–50.

175 A photograph from HABS showing the Meetinghouse at Mount Lebanon is featured in Nicoletta, J. & Morgan, B., *The Architecture of the Shakers*, 1995, p. 41. The annotation states: 'The interior of the Mount Lebanon meeting house provided ample room for worship meetings as well as seating for visitors from the world. The photo was taken by N.E. Baldwin in June 1938 when the community was still a Shaker village. The Darrow School altered the interior in the 1960s to accommodate a library.'

176 See Peladeau, M.B., 'Shaker Material in the Historic American Buildings Survey', *The Shaker Quarterly*, 1969, pp. 113–32.

177 Taken from Morse, F., *The Shakers and the World's People*, 1980, p. 342.

178 See Swank, S.T. & Hack, S.N., 'All We Do Is Build: Community Building at Canterbury Shaker Village, 1792–1939', *Historical New Hampshire*, 1993, p. 128.

179 See Cliver, E.B., *The Carpentry Shop – An Historic Structure Report*, 1989.

180 In addition to Poppeliers, further references for information on Shaker architecture include Andrews, E.D., 'Communal Architecture of the Shakers', *American Magazine of Art*, 1937; Andrews, E.D., 'The Shaker Manner of Building', *Art in America*, 1960; Kratz, C., 'The New York Shakers and Their Dwelling Places', *The Clarion*, 1979; Meader, R.F.W., 'Reflections on Shaker Architecture', *The Shaker Quarterly*, 1966; and Phillips, H.S., *Shaker Architecture – Warren County Ohio*, 1971.

181 Writers' Program of New Hampshire, *Hands That Built New Hampshire*, 1940. This is taken directly from the frontispiece cover in which there is mention of Francis P. Murphy as governor of New Hampshire.

182 Including ceramics, samplers, quilting, stonecutting and basket amongst others. See 'Table of Contents' in Writers' Program of New Hampshire, *Hands That Built New Hampshire*, 1940.

183 Taken from 'Shaker Crafts' in Writers' Program of New Hampshire, *Hands That Built New Hampshire*, 1940, p. 220.

184 Taken from 'Shaker Crafts' in Writers' Program of New Hampshire, *Hands That Built New Hampshire*, 1940, p. 221.

185 Taken from 'Shaker Crafts' in Writers' Program of New Hampshire, *Hands That Built New Hampshire*, 1940, p. 222.

186 Taken from 'Shaker Crafts' in Writers' Program of New Hampshire, *Hands That Built New Hampshire*, 1940, pp. 224–25.

187 Taken from 'What is American Design' in O'Connor, F.V. (ed.), *Art For The Millions*, 1973, p. 165.

188 Taken from 'What is American Design' in O'Connor, F.V. (ed.), *Art For The Millions*, 1973, p. 166.

189 See Cahill, H., 'Introduction', in Christensen, E.O., *The Index of American Design*, 1950, p. xiv. Also see Glassgold, C.A., 'Recording American Design' in O'Connor, F.V. (ed.), *Art For The Millions*, 1973, pp. 167–69.

190 See The National Gallery of Art website, which gives people the opportunity to access Index materials online.

191 See Zimmerman, P.D., *Seeing Things Differently*, 1992 in which various approaches to Material Culture

analysis are discussed including 'Change over Place', 'Change over Time', 'Techniques and Technology', 'Maker and Marketplace', 'Ritual and Custom' and 'Messages and Symbols'. Also see Martin, A.S. & Garrison, J.R. (eds.), *American Material Culture – The Shape of the Field*, 1997; McClung, F.E., 'Artefact Study', *Winterthur Portfolio – A Journal of American Material Culture*, 1973; and Mayo, E., 'Focus on Material Culture', *Journal of American Culture*, 1980.

192 The Andrews partnership did in fact have connections with the Index and this is featured in *Fruits of the Shaker Tree of Life* published in 1975 some time after Edward Deming Andrews had died.

193 See 'Work and Faith' in Christensen, E.O., *The Index of American Design*, 1950, p. 15.

194 See 'Work and Faith' in Christensen, E.O., *The Index of American Design*, 1950, p. 16.

195 See 'Work and Faith' in Christensen, E.O., *The Index of American Design*, 1950, p. 16.

196 See 'Work and Faith' in Christensen, E.O., *The Index of American Design*, 1950, p. 18.

197 The following from Storey, W.R., 'American Antiques Recorded in Pictures', *The New York Times Magazine*, 1936 indicates MOMA's involvement with the Index: 'In the exhibition: New Horizons in American Art opens at the Museum of Modern Art through Oct. 12. The work of the Index forms an important section, along with contemporary paintings, sculpture and other art products. A part of the Index is made up of paintings and photographs of furniture and fabrics produced by the Shakers ... Those who missed the display of Shaker furniture at the Whitney Museum last season will find these watercolours and photographs especially informing, for they present a type of design which has few American counterparts.'

198 Unspecified, 'Austere Beauty', *The Magazine Antiques*, 1943: 'The simple, celibate, cooperative Shakers were honest craftsmen. In England as in America most of the leaders and followers were artisans and factory workers, plain folk who consecrated their "hands to work and hearts to God." Their furniture, tools, and other products have been justly appreciated and celebrated, in the pages of *Antiques* and elsewhere. If the millennium has not arrived on the Shaker time-table, and if the sect no longer flourishes as it did for a century after Ann Lee came to America in 1774 with eight followers, the Shakers nevertheless have made a contribution to the American heritage ... Those who favour a revival of creative craftsmanship can study Shaker things with profit. Perfection was sought in every detail, whether in planning a village, making a chair, a barn, a tool, or in the breeding of stock. Everything was carefully and lovingly planned for efficiency, for easy cooperative usefulness; in addition to their balance, integrity, and austere elegance, Shaker products are highly functional. The cooperative techniques devised by the Shakers workshops were an approach to today's efficient factory techniques. The Believers are credited with numerous inventions, and this aspect of Shaker life is emphasised in the current exhibition of Index of American Design drawings and photographs at the Metropolitan Museum.'

199 Wellman, R. & Cahill, H., 'American Design – From The Heritage of Our Styles Designers are Drawing Inspiration to Mould National Taste', *House & Garden*, 1938: 'The modern American designer has few of the handicaps of the early craftsman. He has the machine to do the hard labour for him, and he can call upon materials from all over the world ... The contemporary designer will not make this mistake. He has no choice but to work for today, not against but with the machine. If he turns now and then to the past, it will be to refresh himself of the vital rhythms and sound workmanlike spirit of the craftsmen who came before him.' Included in the article is a Furniture Index in which 'we begin the presentation of 177 historic examples of American craftsmanship from the Index of American Design'. This includes some Shaker furniture but also many other stylistic sources. In addition, some examples of contemporary designers work via inspiration including Herman Miller's adaptation of a Shaker wall cupboard in solid maple in a rubbed natural finish.

200 Storey, W.R., 'American Antiques Recorded in Pictures', *The New York Times Magazine*, 1936 includes the following interesting quotation: 'This Index will consist of drawings and watercolours ... The pictorial record will perhaps be made widely available through colour reproductions for those who do not have access to the original drawings.'

201 The catalogue for the Index material ordering system was obtained from The Edward Deming Andrews Memorial Collection, Winterthur Library, Box 578. The pamphlet is dated November 1957.

202 See Gordon, B., *Shaker Textile Arts*, 1980 in which the annotation to figure 51, a photograph by Noel

Vincentinn from The Index, states: 'This hand loom was made and used at Hancock. The rug that is on the loom has a textured effect that is achieved by puckering (pulling the weft strips up out of the warp) at irregular intervals.'

203 The list of Shaker arts and crafts materials in the Index includes: furniture, labelled from 1 to 30 including number 11, 'a candle stand Circa 1810–1830. Cherry with dark brown stain. Made in Mount Lebanon, New York.' Textiles recorded from 31 to 50 include: '40 – Detail for silk kerchief for Sister's wear Circa 1825–1850. Made in Kentucky. Reproduced by Elizabeth Moutal. Original in private collection.' Costumes recorded from 51 to 69 include: 'Bonnet – Nineteenth Century – Palm leaf straw and silk. Reproduced by Frances Cohen. Original in private collection.' Perhaps one of the most enduring and famous illustration is that of the Shakertown Bonnet – a watercolour from the Kentucky Project in 1938. This is now located in The National Gallery of Art – Washington DC.

204 Information taken from Rourke, C., Catalogue for *Index of American Design Exhibition*, 1937, p. 2, found in The Edward Deming Andrews Memorial Collection, Winterthur Library, Number 706.

205 Rourke, C., Catalogue for *Index of American Design Exhibition*, 1937, p. 3.

206 Rourke, C., Catalogue for *Index of American Design Exhibition*, 1937, p. 6.

207 This exhibition was featured in Beede, C.G., 'Art and Craftsmanship of an American Communal Sect. Pittsfield Shaker Exhibition and its Significance', *The Christian Science Monitor*, 1940: 'The exhibition of Shaker art and craftsmanship at the Berkshire Museum in Pittsfield, Mass., announced recently in this paper, is of such importance as to call for further and extended notice. Further instances to the point might be mentioned but these may be enough to justify the statement that nowhere have we found a type or source of furniture and other decorative art recognised as purely American in conception and production, until that of the Shakers came to be appreciated during the last two decades. It was for "quaintness" and good construction that it gained first attention, and this from commercially interested people. But there were those who saw that Shakers' handiwork with the vision of symphatic students of the sect itself, who sought to learn the ideals of those who made and used objects possessing such peculiar and attractive individuality ... Dr Edward Deming Andrews and Faith Andrews may have known something of the Shakers from childhood, for both of them are native of Pittsfield, and the once prosperous Community in Hancock was but only a few miles away ... This led not only to the intimate knowledge which they sought, but to acquisition of a great quantity of many varieties of handcraft. This material they secured, so that it might not be dissipated commercially, but preserved permanently for public benefit.' The text is illustrated with views into the rooms that the Andrewses had created for themselves furnished with Shaker artefacts.

208 In a verbal communication (G. Gale) it was ascertained that the identification of the Shakeress was in fact Sadie Neale and that William Winter was the photographer.

209 The catalogue for the Berkshire Museum 1940 exhibition (Andrews, E.D., Catalogue for *Shaker Art and Craftsmanship*, 1940) can be found in The Edward Deming Andrews Memorial Collection, Winterthur Library, Box 518. In addition, see McKinstry, E.R. (comp.), *The Edward Deming Andrews Memorial Shaker Collection*, 1987 which acts as a guide, and also McKinstry, E.R., 'The Shakers', in Martinez, K. (ed.), *American Cornucopia*, 1990.

210 Taken from Andrews, E.D., Catalogue for *Shaker Art and Craftsmanship*, 1940. See McKinstry, E.R. (comp.), *The Edward Deming Andrews Memorial Shaker Collection*, 1987, Numbers 518–19.

211 Taken from Andrews, E.D., Catalogue for *Shaker Art and Craftsmanship*, 1940. See McKinstry, E.R. (comp.), *The Edward Deming Andrews Memorial Shaker Collection*, 1987, Numbers 518–19.

212 Edward Deming Andrews and Faith Andrews were to revisit this concept in their book *Religion in Wood: A Book of Shaker Furniture*, 1966 which records the furniture of the Shakers in and out of context and features a number of period rooms, furniture in domestic settings and developments in museum villages. These are all illustrated using black and white photographs. Reviews of this book can be found in The Edward Deming Andrews Memorial Collection, Winterthur Library, Box 16.

213 Taken from Andrews, E.D., Catalogue for *Shaker Art and Craftsmanship*, 1940 – the catalogue is not page numbered and the quotation is from the fourth page (title page included).

214 This can be evidenced in many photographs of interiors, a number of which are found in Pearson,

E.R. & Neal, J., *The Shaker Image*, 1994, pp. 64 and 65. The annotation for photograph 25, p. 65, states: 'Mount Lebanon, New York. Young sisters in their sewing room at the Church Family. The room contains many decorations, even a birdcage (pets had been forbidden in the early years), and the sisters wear contemporary hair and clothing styles.'

215 Taken from Andrews, E.D., Catalogue for *Shaker Art and Craftsmanship*, 1940.

216 See 'The American Index of Design' in Andrews, E.D. and Andrews, F., *Fruits of the Shaker Tree of Life*, 1975, pp. 153–55.

217 Taken from Andrews, E.D., Catalogue for *Shaker Art and Craftsmanship*, 1940.

218 Taken from 'Preface' in Boris, E., *Art and Labor*, 1986, p. xii.

219 The Shakers were however known amongst the wider American public for their production of seeds and herbs which were distributed both in America and Britain and were advertised widely in the press.

220 See Stein, S.J., *The Shaker Experience in America*, 1992, p. 490, note 31 which mentions an article in *Ohio Magazine* entitled 'The Last of the Shakers' dated July 1907.

221 See Roueche, B., 'A Reporter at Large – A Small Family of Seven', *The New Yorker*, 1947.

222 Taken from Votolato, G., *American Design in the Twentieth Century*, 1998, p. 54. In the annotation for the illustration in the quotation (figure 28) he states: 'Magazines dedicated to informing public taste have flourished throughout the century identifying and promoting a succession of modern and traditional styles. *Good Furniture, The Magazine of Good Taste* declared in 1916, "the time in which we live is one of eclecticism". Accordingly, its editorials offered general principles of decoration applicable to any style of design. In its pages the word "modern" was synonymous with "American".'

223 See Unspecified, 'By Their Works Ye Shall Know Them', *Vanity Fair*, 1928.

224 See Andrews, E.D. & Andrews, F., 'The Furniture of an American Religious Sect', *Antiques*, 1929.

225 See Storey, W.R., 'American Antiques Recorded in Pictures', *The New York Times Magazine*, 1936 (The Edward Deming Andrews Memorial Collection, Winterthur Library, Box B15).

226 See Wellman, R. & Cahill, H., 'American Design – From the Heritage of Our Styles Designers are Drawing Inspiration to Mould National Taste', *House & Garden*, 1938.

227 In Boris, E., *Art and Labor*, 1986, Wanamaker's store is mentioned: 'The last third of the nineteenth century marked the rise of a consumer society as well. Distribution underwent major changes with the growth of the department store and mass marketing. By the mid-1880s Marshall Field in Chicago, John Wanamaker in Philadelphia, Macy's in New York, and Jordan Marsh in Boston had expanded from small retail firms to huge multiproduct stores.'

228 See Wanamaker, J., 'Shaker Simplicity' advertisement, *The New York Times*, 1939.

229 See Wanamaker, J., 'Shaker Simplicity' advertisement, *The New York Times*, 1939.

230 An example of Wanamaker's furniture advertising Shaker influence can be found in *The New York Herald Tribune*, 16 November 1937. The company developed a gallery of American Design, in which they showed their 'Shaker Wing' (including the Watervliet bedroom group). As the company stated: 'Wanamaker's has adapted their designs to modern needs, and in so doing has created a whole school of furniture. It will sweep you off your feet with its delicacy, gaiety and functional honesty.'

231 Taken from Lassiter, W., 'Shaker – Pattern of Practical Beauty – Modern Then and Now', *House & Garden*, 1945.

232 Taken from Lassiter, W., 'Shaker – Pattern of Practical Beauty – Modern Then and Now', *House & Garden*, 1945, p. 37.

233 Taken from Lassiter, W., 'Shaker – Pattern of Practical Beauty – Modern Then and Now', *House & Garden*, 1945, p. 39.

234 Taken from Lassiter, W., 'Shaker – Pattern of Practical Beauty – Modern Then and Now', *House & Garden*, 1945, p. 42. Also the collections of the New York State Museum, Albany are recommended in an article by its director (Guthe, C.E., 'The Shakers', in a special edition *House & Garden* offprint from 21 April 1945), which also contains photographs of original pieces.

2 FORMS AND FORCES – The Penetration of Shaker Design into Museum and Popular Cultures

This section features continued developments that took place in the north-eastern seaboard and also focuses on western communities such as those at Pleasant Hill. The text develops on themes which became evident in Section One and Edward Deming Andrews and Faith Andrews continued to exert their influence by Shaker promotion, publication and exhibition. During the postwar period Americans became both more culturally aware and multicultural. Counter cultures became fashionable and the Shakers were applauded for their 'alternative' lifestyle. Museums were starting to be formed from extant Shaker villages and the period room became the ideal by which Shaker artefacts were permanently displayed for public consumption. This section also begins to evidence the spread of Shaker design from the United States of America to Europe – and particularly the United Kingdom. The American Museum in Britain at Bath formed their period room and Shaker exhibit, while Manchester City Art Galleries became the focus of British attention when it held a Shaker exhibition in 1975.

The temporary exhibitions featured in American museums became more varied and thematic, specialising in specific furniture forms such as the chair or concentrating on a particular community. Important exhibitions of the period include that of 'Shaker Arts and Crafts' at Philadelphia Museum of Art (1962) and the 'Shaker' exhibition at the Renwick Gallery, Smithsonian Institution (1974). Markets for Shaker artefacts continued to expand and develop, with greater collector interest and higher prices for all object types from furniture to textiles. This section also highlights various sales and auctions; exhibitions; period rooms; museum villages and popular culture interpretations aimed at an international market and context.

Influences taken from Museum Culture

In the United States of America there has been an increasing trend for the establishment of museum villages that have developed around historic

sites and these have claimed to create an authentic and 'living experience'.[1] Examples include Plimoth Plantation, Plymouth, Massachusetts; Old Sturbridge Village, Sturbridge, Massachusetts; Mystic Seaport Museum, Mystic, Connecticut; Conner Prairie, Noblesville, Indiana; Pioneer Arizona Living History Museum, Black Canyon Stage, Arizona[2] and Colonial Williamsburg.[3] This trend has also been evidenced in the United Kingdom with the establishment of sites such as Saltaire,[4] Quarry Bank and Styal[5] and the Ironbridge Gorge Museum complex[6].

The development of American museums and 'living experiences' has been commented upon in articles such as 'Travelling through Time': 'At each of these living-history museums, Americans can briefly escape the complexities of 20th-century life and be immersed in a simpler time and place. Living-history museums, as the name implies, bring history to life. Rather than locking the past in exhibit cases, they recreate bygone days; visitors experience the sights, sounds, and smells of long ago.'[7] Along with these concerns there was also an increasing debate relating to material culture and the study of the artefact in a wider context.[8]

In terms of cultural, social and economic developments the period between 1946 and 1975 proved to be a rapidly changing one in the United States. In the book *Landmarks of Twentieth-Century Design*, it states: 'The United States emerged from World War II as the richest, most advanced and most powerful nation in the world, and American business took the credit – for its superior industrial performance during the war and for the extraordinary revival of the consumer market afterwards.'[9]

Pluralism became a key feature of the period, as did the development of alternative lifestyles. In *American Design in the Twentieth Century*, it is noted that:

> Since the Second World War a growing awareness of the multiculturalism of America has had great impact on design theory. Loss of faith in inter-nationalism brought about by the Cold War and the Viet Nam debacle, the devastating effects of industry and technology on the environment, disaffection with the 'melting-pot' society, and breakdown of faith in religion, law, medicine and the family all have contributed to a cynical view of Modernism and its central notion of progress. The formation of a 'counter culture', recognisable since the Beat movement of the 1940s, established a tradition of questioning authority in all fields.[10]

Along with the interest in counter cultures, of which the Shakers were a supreme example, there was also an increasing awareness of design: the 1950 exhibition at the Museum of Modern Art based around good design is an example of many which took place in the post-Second World War period.[11] In the United Kingdom, design was also becoming an important selling factor in the marketing of products, and designers such as Gordon Russell, who was instrumental in producing the Utility furniture range with aesthetics similar to the Shakers, were very influential:

> Throughout his life, Gordon Russell's great skill was making connections: between hand and machine, craft and design, theory and practise and land-scape and architecture ... His work as a designer encapsulated the twentieth century, spanning two world wars, the rise and demise of Modernism, consumer booms and depressions, and the growth of mass communications, transport and marketing ... As an unrivalled international ambassador for British design, he could study the Shakers in America or visit Aalto in Scandinavia ...[12]

In terms of the Shaker aesthetic, activity primarily centred on major institutions in the United States of America and the creation of permanent displays of Shaker artefacts. These developments provided a dichotomous and didactic[13] approach in which period rooms were established within museum contexts. The development of the period room probably started with the Essex Institute in Salem, Massachusetts, *circa* 1907[14] and continued to develop throughout the century, but became particularly popular in the period studied in this Section and was very evident in Shaker interpretations.

Alongside the obvious education and entertainment factors there was also the important issue of preservation,[15] and the creation of museum villages at Hancock and Pleasant Hill have been used as case studies.[16] Nearly all the extant Shaker sites were being preserved in some way and there was an increasing awareness of the importance of the Shakers and their material culture. It was always likely that the Shakers and their artefacts would end their life in museum contexts.

Various authors have debated the validity of museum reconstructions and period rooms in both the United States and the United Kingdom. In one such case it was noted that: 'Many museums now recognise the power

of active communication over passive communication, as well as realising the importance of entertaining their visitors whilst educating them ... When an artefact is fitted into a copy of its original surroundings, the public can more easily comprehend the use and importance of the object.'[17] The New Museology indicates some of the theoretical issues which the presentation of such objects constitutes:

> The idea that artefacts have a complex presence which is subject to multiple interpretations has important implications for the way museums think about and present themselves. Most museums are still structured according to late-nineteenth-century ideals of rigid taxonomies and classification, whereby it was believed that artefacts could be laid out in a consistent, unitary and linear way. Meanwhile, intellectual ideas have moved away from a belief in a single overriding theoretical system towards a much more conscious sense of the role of the reader or spectator in interpretation.[18]

As indicated in Section One and also in material presented in this Section, the museum has proved tremendously important in the promotion of the Shakers and their design to the outside world. Not only has this been evidenced in the United States, but we begin to see it move into a European context with the travelling exhibition that appeared in the United Kingdom at Manchester City Art Gallery[19] and also the creation of the Shaker period room in the American Museum in Britain at Bath.[20] In Learning in the Museum, a conference at Annapolis is detailed with a summary of what people learned from museums and how museums influence their audience.[21] Clearly, museums have proved to be important in promoting various artefacts and cultures. This is true of the Shaker aesthetic and can be seen in the development of linking Shaker artefacts into created and recreated room settings. This resulted in the promotion of the style of the Shakers above all the other aspects of their religion and life, and the use of the period room has resulted in a successful network of permanent Shaker displays throughout the north-east seaboard of the United States:[22] 'There used to be a great vogue for period rooms, not only in the Victoria and Albert Museum, London (V&A), but also elsewhere, as anyone who has visited the great museums of the east coast of America will know: in New

Selling Shaker

York, Boston and Philadelphia there are whole sequences of them, torn out of their original settings.'[23]

Generally, the intent of the museum in creating room settings is to control the artefacts that are contained within them in order to create a visual and stylistic whole. In *The New Museology*, Smith has recognised a number of factors which negate the use of such rooms, and that maybe there are more disadvantages than advantages in the use of rooms in gallery settings.[24] One disadvantage is that very often the quality of the artefacts placed within a period room would not merit inclusion in a display of individual objects and space is an obvious issue: 'The first is the argument of priority in the allocation of available space. It is thought that, when there are so many artefacts which are not on display, it is not sensible to use up a large amount of space with a single gigantic artefact, especially if it is judged to be, on its own, of no particular historical significance (which so far as the V&A is concerned, means that it is not associated with a known designer).'[25] Another negative factor is that the period room itself may not fit within the museum building and this can be critical in terms of appropriateness, which can concern historical period and the architectural style. A third factor concerning authenticity is identified and is probably the most critical when analysing the Shaker period room. Smith states:

> Since the Clifford's Inn Room was acquired by the museum without any of its original furnishings, to put in appropriate furniture, even if it were of the right historical period, is held to be unauthentic, a form of make believe which might be legitimate for a museum of social history but not for a museum of art and design, which regards the authenticity of artefacts as paramount.[26]

The museum village does not have as many concerns regarding authenticity because the architecture is generally in place – although this may not always be the case.[27] The debate concerning truth comes when the external architecture is used as a container for a totally recreated internal structure and artefact arrangement, thus mixing what can be regarded as the authentic with the unauthentic. The creation of living museums has very definitely been something that has been critical in the development of the Shaker experience; visitors were considered important and educational facilities were central to promotion.[28] Indeed Hancock and Pleasant Hill

are very photogenic[29] and have been used extensively in many texts to illustrate a typical Shaker aesthetic.[30] Generally, although there are exceptions such as Fruitlands Museums,[31] the museum village site can be considered real. Gable, in *Theorising Museums*, has discussed Colonial Williamsburg at length,[32] while Sorensen has discussed 'real' versus 'pastiche':

> Historic theme parks, or their younger cousins the heritage centres, are usually to be found in one or other of two distinct types of locations. The first type has evolved from a 'real' place, where sufficient historic buildings and natural or man-made features survive 'on site' to allow, with some not always judicious restoration and doctoring, for their original appearance and associations to be revived and interpreted to the visitor. In the United States, Williamsburg, the one time colonial capital of Virginia, is a notable example of such a place and such a process ... Huge sums of money were spent on acquiring properties, demolishing and stripping away later accretions and recreating the town as it was believed to have been.[33]

The Andrewses were also to become involved in the creation of Shaker settings in a wide variety of different contexts and they were still productive in the late 1950s and early 1960s. For example, they organised a small exhibition on the Shaker herb industry (1959) at the Berkshire Garden Centre, Massachusetts[34] where Edward Deming Andrews also gave a lecture, and they opened their house for public view.[35] Edward Deming Andrews was also busy writing a series of articles in various magazines,[36] including *Art in America*, which used photographs of Shaker interiors and furniture from the Index of American Design to validate their manifesto. A quotation from *The New York Times* was also used to add a contemporary relevance.[37] The Andrewses also promoted their collection at Yale Art Gallery[38] and wrote an article in the *Yale University Library Gazette* entitled, 'The People Called Shakers':

> Visitors to the recent Shaker exhibit in the University Library may have noticed that one of its purposes was to relate what these people wrote, in reference to their work and worship, to what they did in translating their beliefs into practice ... These exhibits represented, as we have noted, only one, the economic phase of Shaker communitarianism. Fundamental to an understanding of the culture are the aforementioned documents which explain its religio-social structure and illuminate its historical experience ...[39]

Selling Shaker

Interestingly, during the period there was an increasing emphasis on the use of the photograph as primary source material – for both exhibition and academic interpretations. This is commented upon in 'Creating the Cult of the Shakers' when it is observed:

> It is fortunate that the active period of Shakerism continued well into the age of photography, and, although Hancock is poorly recorded, there are many photographs of Mount Lebanon and other communities that are invaluable when it comes to envisage the life today. A museum is bound to make its own interpretation, and so it is fascinating to be able to compare, let us say, the Ironing Room at Hancock (Fig. 8), with the Ironing Room at Mount Lebanon 90 years ago (Fig. 9). Americans often have a particular talent for these sorts of displays, but they tend to correct them and move towards a slightly earlier effect; in this case the furniture is of the more highly regarded earlier type than that in use later on.[40]

The Andrews partnership had accumulated a significant amount of material on the Shakers, including artefacts and, perhaps just as importantly, a vast quantity of written, photographic and archival material. The exhibition at Yale was clearly designed as an introduction to the history of the Shaker culture drawing upon their unrivalled resource.[41] In mounting the exhibition, the Andrewses comprehensively documented the development and activity of the Shakers, giving, for example, details of spiritual journals, revelations and accounts of mountain meetings, as well as the Millennial Laws.[42] The exhibition also provided a prestigious institution, under whose care the archive could be stored, with a huge additional resource for teaching and research purposes. When Lamont Moore, the director at Yale, decided to exhibit the Andrews collection, arrangements were made by the Andrewses to donate their collection to the university. Edward Deming Andrews became a faculty member and also taught on the American Studies programme and acted as consultant on Shaker History and Culture.[43] However, because of disputes involving the collection and the Andrewses' belief that Yale wanted to marginalize their Shaker material, the whole arrangement was rescinded and yet another acrimonious split took place. Edward Deming Andrews continued to exert his influence throughout this period and his importance cannot be overstated: the impact he had in creating typical Shaker interiors will remain,

as it were, 'frozen in time'. This vision has been perpetuated throughout the twentieth century and will continue to stand as 'typical' of the Shaker aesthetic, be it a true or false picture.[44]

In addition to museum and popular culture developments, in 1961 the Shaker community at Sabbathday Lake also began a discussion forum in a publication entitled The Shaker Quarterly,[45] which followed on from the earlier The Manifesto which finished publication at the turn of the century and interestingly mirrored the decline within the various communities. The Shakers at Sabbathday Lake also became involved in auctions, one being featured in a small booklet dated 20 June 1972.[46]

Finally, there was also evidence of increased activity in the antique marketplace with the amounts of money that Shaker artefacts were selling for being featured with headlines such as 'Shaker Makes The Big Time'[47] and in 'The Shakers' New Converts' a Shaker box is featured with the following text: 'This circular box with silk lining and an embossed cover sold for $225 in a Massachusetts auction in 1971 and is now on exhibit at the Shaker Museum, Old Chatham, New York. The piece is valued at more than $500 today.'[48] Articles were also commenting on the decline of the Shakers, for example in The Smithsonian,[49] Life,[50] Christianity Today[51] and The Magazine Antiques.[52]

The Formation of Hancock as a Museum Village

It is believed that the Hancock community was established in 1783 and is considered to be one of the Shaker communities which had a direct link with Ann Lee.[53] Around the Civil War the community was at its most successful with more than 300 Shakers occupying around 6,000 acres of land. The community was finally closed in 1960 when there were only three surviving members.[54] The 'City of Peace', as the Shakers called it, was thus one of the longest-lived of the 18 settlements.

In 1959, work had started to develop Hancock as a museum village, with a target audience of historians, artists, architects, teachers, researchers and students, as well as tourists.[55] Proposals to save the Shaker Community at Hancock, Massachusetts were circulated in September 1960 and Shaker Community, Inc. was formed as a non-profit corporation which instigated plans to acquire the land and buildings.[56] The evolution of Hancock into

Selling Shaker

a museum probably started in November 1959 at a meeting in the home of Mr and Mrs Lawrence K. Miller, of Pittsfield, Massachusetts.[57] The participants of the meeting discussed the urgency of making Hancock into a museum, due to the fact that the community buildings and 220 acres of land had already appeared on the market for $20,000. It was apparent that the architecture required preservation and these programmes were to take priority over other projects.[58] During the meeting one of the committee members, a Mrs Gilchrist, indicated that the preparation of a statement of intent was required and that the restoration should be developed as an 'outdoor museum'. In addition, the team agreed that the museum should contain the Andrews partnership collection.[59] Membership of the Board of Trustees for Hancock was also discussed and it was decided that the museum should be developed as a national institution. To aid this ambition subsequent collaboration with institutions such as the Society for the Preservation of American Antiquities and National Trust for Historic Preservation were instigated.[60]

Edward Deming Andrews played an important role in the development of Hancock, suggesting that Eldress Emma King of Canterbury, New Hampshire should be contacted in order that she might be persuaded to make a special selling arrangement with the trustees.[61] The initial strategy the trustees developed of saving the buildings was allied to a concern that Hancock should not be exploited in an over-commercial way. Seventeen of the original buildings – barns, dwellings, shops – were relatively well preserved, requiring minimal intervention, and so were easily prepared for opening to the public. The major negative aspect of the site was the lack of a Meetinghouse and this was finally resolved with the relocation of an original Meetinghouse onto the site where Hancock's own had been demolished in 1939.[62] June Sprigg, who has played a leading role in later developments at Hancock, notes that:

> From its earliest years Hancock – like the other Shaker villages – attracted visitors from the outside world who were interested in experiments in social reform or who were merely curious. During the first half of the nineteenth century these included literary figures such as Herman Melville, Nathaniel Hawthorne, James Fenimore Cooper, and Harriet Martineau ... In 1960 the last three elderly sisters left when the Central Ministry, in New Hampshire, chose to sell the property to Shaker Community, Incorporated,

a non-profit organisation dedicated to preserving the Shaker heritage. The descriptions of Hancock and other Shaker communities quoted in these pages, together with Paul Rocheleau's photographs suggest that although Hancock's Shakers are gone, the special quality of their City of Peace endures.[63]

The Museum was opened in 1961 and in *The New York Times* it was noted that:

> Hancock, Mass. – The first village-style restoration devoted wholly to the arts and culture of the American Shakers is scheduled to open in this small Berkshire town on July 1. To be known as the Hancock Shaker Village, it will occupy the site of one of the last surviving Shaker settlements in this country … It will open with a top ranking collection of Shaker furniture and effects, two restored buildings and a master plan calling for the eventual restoration of a dozen authentic Shaker structures and the re-creation of a typical Shaker village of the mid-nineteenth century.[64]

Edward Deming Andrews was instrumental in promoting Hancock[65] and he was credited with being the first curator and as such created reports on his activity.[66] Initially everything appeared fine in its development and there seemed to have been very little conflict. However, this was not the case and became apparent in meeting notes taken at a Special Meeting of the Board of Trustees of Shaker Community, Inc., held on Friday, 2 August 1963.[67] The meeting was the accumulation of acrimonious feelings which had developed between Edward Deming Andrews and other Trustees which had been documented by both parties. Mr Charles Crimmin had made a number of seconded motions, the most significant being that Edward Deming Andrews should be relieved of the position of Curator at Hancock.[68]

It would appear that yet again Edward Deming and Faith Andrews were involved in a dispute and it may be that, because the Andrewses were so committed to the Shakers, they could not let others take control of their interest. It is apparent that Edward Deming Andrews was a perfectionist and he would not suffer fools gladly. The whole scenario at Hancock obviously had a lasting effect on the Andrews partnership and some time after Edward Deming Andrews' death Faith Andrews produced *The Hancock Story* (1983), which for dramatic effect she told in two parts: 'Part I: The Opening

Selling Shaker

of the Door', highlights the development of their interest in Shaker culture[69] and 'Part II: The Closing of the Door', tells of their plans for a museum at Hancock and their deep disappointment at the events which prevented those plans from being realised.[70] Interestingly, it would appear that the Andrewses were not the only people to have had a negative experience of Hancock. The collector Mary Earle Gould wrote to Faith Andrews in 1968 when she stated:

> You may know of my disappointment about my rare collection at the Shaker Village. I gave it with all good faith and with many statements about the future. It was to be kept intact – the only collection of its kind in the country. Pieces have been taken left and right and scattered around the Village, with no labels and with no reason or rights. I was broken hearted and truly crushed to find such treatment and although asking for labels, they were not given.[71]

It would seem that this story had some resonance for Faith Andrews as she replied in a letter dated 9 February 1968:

> As I read on through your letter everything you stated seemed so applicable to the experience we went through. The bill for transportation is the final insult to one's intelligence and tolerance. Ruthlessness knows no barrier … No one is more aware of what is happening to Shaker items than I am. I keep away from all antique shops and listen to so-called authorities with my ears closed. Hancock has helped this situation to exist and flourish. Whether it be a ladder back chair, candlestick holder, a box, if the price is high enough they become Shaker items. I would like very much to know of your Liverpool honour. Also when you speak of your Will being most generous to the one who will eventually have your collection – are you referring to the one at Hancock?[72]

Hancock continued to develop despite various disputes, and the momentum created by the interest in the initial restoration continued to be successful and well documented.[73] The museum also continued to influence the Shaker exhibition agenda by allowing loan exhibitions, for example, at the University of Oregon Museum of Art in 1996 and at the Craft Centre, Worcester, Massachusetts in 1967.[74] The popularity of the Hancock and other museum villages seems guaranteed and various sites have been recommended as tourist destinations in the United Kingdom[75]

and the United States.[76] As people appear to want an 'experience', rather than a visit, it would seem that the popularity of museum villages is guaranteed for the foreseeable future.

The Formation of Pleasant Hill as a Museum Village

It would be true to say that interest in the Shaker settlements of Kentucky at Pleasant Hill and South Union increased during the period 1946–1975. In the book *Religion in Wood*, a special section was set aside for an analysis of western Shaker furniture[77] and a number of articles appeared after this comparing and contrasting with the northern communities' furniture production.[78] This initial interest in furniture blossomed into a quite substantial focus on the architecture,[79] and the whole material legacy of the western Shakers became both collected and documented.[80]

The Shakers started to move into Kentucky around the 1800s,[81] and by 1806 they had settled on a plateau above the Kentucky river[82] and developed a site called Pleasant Hill by raising a number of buildings considered to be of great architectural merit.[83] Forty-four members of legal age signed the initial covenant and started the community's structures, both physical and spiritual. The society evolved and was prosperous up until the Civil War, reaching its zenith around 1823.[84] A number of families were established, including the Centre family, East family and West family. At its height the community had around 500 residents and owned over 4,000 acres of land.[85] By the start of the 1900s only a few Shakers remained in the village and the site was formally closed.[86] The last Pleasant Hill Shaker died in 1923. Between 1924 and 1960 the community buildings were neglected, altered or sold, and most gradually fell into considerable disrepair[87] or were destroyed by fire.[88] A number of buildings also possessed Victorianised attachments (such as porches).[89] Some of the buildings had a more complicated history than others,[90] for example, the Centre Family House was used for storage by Goodwill Industries, whilst the Trustees' Office was used as a restaurant.[91] Sporadic attempts to preserve Shakertown or Pleasant Hill failed and the majority of structures appeared to be in terminal decline, the site being mainly used for agriculture.

One of the guiding spirits of the redevelopment of Pleasant Hill was Earl D. Wallace of Lexington, Kentucky. Wallace was Chairman of the

Selling Shaker

organising committee and in 1961, he was elected Chairman of the board of trustees of the non-profit corporation that now operates, maintains and preserves Pleasant Hill.[92] In April 1968, Pleasant Hill opened to the public with Shaker exhibits, food and lodgings, a craft sales shop and a general outdoor history museum. Part of the aim of the project was to improve the quality of contemporary life and also accurately represent Shaker life and culture. In addition, the management wanted to institute a variety of cultural, educational and recreational activities such as conferences and festivals. It was decided that observing other operations would be useful in the planning of Pleasant Hill and a feasibility report was undertaken that involved consultations with Old Sturbridge Village in Massachusetts, Boone Tavern at Berea College and Colonial Williamsburg.[93] Many people were impressed by the depth and commitment of the restoration team and Edward Deming Andrews had connections with a number of the team members as well as the site itself.[94] Jim Cogar had overall responsibility for Pleasant Hill and introduced a master plan of restoration and adaptation of the original Shaker buildings. The plan for the restored village was that all buildings would be of original Shaker construction, and the appearance of the restored village would be as of about 1856. All the buildings would be furnished in a Shaker style, and modern structures would be removed from the village grounds (underground services would be put in place such as telephone lines), with no reconstruction or new buildings.[95]

Certain buildings were selected for initial attention such as the Trustees' House, East Family House, East Family Sisters' Shop, East Family Brethren's Shop, Carpenters' Shop (now main Craft Shop) and Ministry's Workshop (adjacent to Trustees' House) which were painstakingly adapted and restored. The West Family House was partially restored in what could be classified as Phase One of the restoration. Phase Two included the majority of remaining buildings, while Phase Three started in 1975 and continued up until 1978, with the North Lot House and the East Family Wash House interior. In addition, there was a clean-up of cellars in some buildings and a number of ground improvements. Not every year of the restoration went smoothly and financial problems were evident: together with The Friends of Pleasant Hill, a number of significant sponsors – including Eli Lilly – were targeted to address these financial concerns.[96]

In total over 30 buildings have been preserved on a site of 2,700 acres

of farmland located seven miles north-east of Harrodsburg.[97] The site has also become a National Historic Landmark designated by the US Department of the Interior.[98] In 'Travelling Through Time', Pleasant Hill is featured at some length:

> If you've ever used a flat broom, a wooden clothespin, or a circular saw, you've utilised an object invented by the Shakers, an extinct communal religious society. Today the Shakers – so named for their violent shaking during worship – are known for the simplicity and perfect craftsmanship of their furniture. Shaker Village preserves 30 original 19th-century buildings and approximately 2,500 pieces of fine Shaker furniture and tools ... The historic area is on a hilltop surrounded by a working farm, where Leicester sheep – the same breed raised by the Shakers for wool – graze on the slopes. On a self-guided tour, you can walk through the Centre Family House, where 'brothers' and 'sisters' lived; learn about the uses of herbs as medicinal cures in the Farm Deacons' Shop, and watch broom-makers, joiners, coopers, spinners, weavers and quilters. There are interpreters in period dress at each exhibit. Special events during the year include additional craft demonstrations and displays of Shaker music and dance; and riverboat rides up the Kentucky River are available seasonally.[99]

In addition to the museum nature of Pleasant Hill you can also pay for on-site hotel accommodation making this a 24-hour Shaker experience. You can order a Shaker-inspired dinner and spend the night in a room furnished with reproduction Shaker furniture, including the bed you sleep on.[100]

The museum as it exists today is complex and offers the visitor a multilayered experience;[101] the village and its contents are constantly photographed[102] and have appeared in numerous articles[103] and books.[104] The final chapter in the 'Epilogue' from *Pleasant Hill and its Shakers* is enlightening:

> Modern visitors to the Shaker Village of Pleasant Hill must remember that in restoring the village members of the board of trustees and advisors attempted to follow as faithfully as possible both the physical and spiritual conformation of the community. Here, once a gathering of dedicated people went about their daily tasks and religious worship without fanfare or commotion. Just as important as the authentic restoration of the

physical artefacts of the Shakers is the preservation of the serenity of their village and their way of life.[105]

The village as a museum site continues to expand and the Friends of Pleasant Hill will move the institution forward and in 1995 they were looking towards the future and planning new projects.[106]

A Single Room – The American Museum in England at Bath

The Andrewses' influence can be seen in the structure and aesthetic of all the room settings in the major American museums. In addition, they were also instrumental in creating a Shaker period room in the United Kingdom.[107] The American Museum at Claverton Manor, Bath is located within a country estate and claims to be one of the first museums specialising in Americana outside the United States.[108] The museum was established in 1961 with the cooperation of Dallas Pratt[109] and John Judkyn,[110] who had previously visited the United States and observed the Shelburne museum in Vermont.[111] The museum now proves to be a considerable tourist attraction in the Bath area.[112] A characteristic feature is that it has specialised in the recreation of period rooms which reflect the history of the United States of America and the styles which have become associated with various decorative art movements over the past 300 years.[113] The museum concentrates on the period 1690 to 1860[114] and its format has considerable similarity with the Henry Francis du Pont Winterthur Museum at Wilmington, United States.[115]

The Shaker gallery can be found in the main house in a small room on the ground floor. It has been created as a Shaker resting room, displaying many of the characteristics of a classic Shaker interior, including a peg board along the wall, window framing, a stove and numerous pieces of Shaker furniture,[116] a number of which were acquired from Edward Deming Andrews.[117] This exhibit is accompanied by a small display gallery with examples of Shaker industries[118] such as seeds, herbs, boxes and sieves, as well as books, photographs and textiles.[119]

There was collaboration between the American Museum in Britain and Faith and Edward Deming Andrews in both the design and construction of the Shaker room and the accompanying gallery. It is apparent from letters

and other evidence that the partnership was successful.[120] It seemed infinitely appropriate that the Shakers should feature in the Museum, particularly as the museum at Winterthur was planning to have period rooms with Shaker artefacts. It was also significant that the participants in the project were interested in creating a permanent collection in the country which originated the Shaker movement and Ann Lee in particular.[121]

The design of the space and the location of the furniture was dictated by Edward Deming Andrews and shows his unmistakable stamp. Nearly all of the artefacts within the room are from the early or classic period of the Shakers and all have a consistent aesthetic which might be called the 'Andrews vision'. The room is essentially a display of furniture, rather than a means of explaining a lifestyle – in other words, it concentrates on the design and aesthetics, rather than attempting to recreate any sense of verisimilitude. This approach remains unchanged from the Andrewses' earliest writings and exhibitions through to their final collaborations. This consistency of approach is interesting and it would appear that the Andrews partnership (and particularly Edward Deming Andrews) had a very fixed vision of how they wanted to communicate the Shakers to the outside world.[122]

With regard to the Shaker room at Bath it should be noted that the housed artefacts, while being authentic, did come from a number of different localities, including Hancock and New Lebanon (there is some degree of uniformity in that the majority of furniture comes from the same geographical locality). To be truly accurate and authentic perhaps the period room should have been composed of just Hancock furniture – after all the woodwork and pegboard is claimed to be from a Hancock meetinghouse. The majority of the interior woodwork, including the shutters and window frame, is painted a classic Shaker blue colour – sometimes described as 'heavenly blue' – whilst the floor boarding is coloured with ochre. The furniture is arranged in a way that clearly takes account of movement through the room, and is austere and restrained. As with most recreations the success is reliant on the details, and the two swallowtail oval boxes (New Lebanon 1800–30) on top of the counter act as a focal point. They are made of maple and pine, one dark green, the other yellow.[123]

One of the most important pieces – and probably the most outstanding of the collection – is the small cherry stand with round top, tripartite legs

Selling Shaker

on a single support, made in New Lebanon around 1820. The provenance of the stand and other pieces of furniture owned by the Andrewses has been extensively detailed by F. Morse.[124] The Shaker room at Bath is the standard by which viewers in Britain can judge the Shakers. Its composition remains part of a design which has a defined aesthetic image and style and this is likely to continue for some time. Even in the 1998 'Shaker – The Art of Craftsmanship' exhibition the museum staff made the decision to display the artefacts mainly within room settings.[125]

A Further Five Rooms – the Creation of Shaker Interior Contexts

In order to illustrate the development of the period room, five American examples have been selected to show Shaker interiors and accompanying style development. The rooms have been chosen because they have generally been created from concept, rather than connected with any original Shaker architecture. The rooms featured include: (1) The Winterthur Shaker Rooms; (2) The Metropolitan Museum, New York; (3) The Philadelphia Museum; (4) The Miniature Room at Chicago and (5) The Museum of Fine Arts, Boston. Three of these rooms have been established for some time and featured in the Andrewses' book *Religion in Wood*, though the Chicago miniature room and the Metropolitan Museum room were not included. These are not the only examples of Shaker period rooms within American institutions, and other examples exist in locations such as The Warren County Historical Society Museum (Shaker Retiring Room)[126] and the Western Reserve Historical Society.[127]

The Winterthur Shaker Rooms

Winterthur is an institution which can rightly claim to be the premier period room museum[128] and is famous worldwide for its room reconstructions which developed over the twentieth century. It contains one of the United States' finest collections of decorative arts dating approximately from 1640 to 1840. The museum collections include furniture, ceramics, glass, silver, pewter, paintings, prints, quilt work, textiles and wallpaper, totalling approximately 89,000 objects.[129] Along with numerous rooms devoted to various 'antique' styles, there is also a series of Shaker rooms[130]

and interpretative galleries which contain Shaker artefacts including a Shaker box which was a gift of Helen, Margaret, and Pauline Brown from Stamford, Connecticut in 1960.

The museum was the vision of Henry Francis du Pont who, although an obsessive collector, was, unusually for the time, also concerned that his collection should reflect developments in the United States of America: 'I didn't believe the early-American arts and crafts had been given the recognition they deserved so I assembled examples of architecture, furniture and widely divergent early-American materials of all sorts to show America as it had been.'[131]

The Shaker rooms at the museum were created with the cooperation of Edward Deming Andrews and Faith Andrews. The major displays include interior architecture, furniture and smaller artefacts.[132] They are located on the eighth-floor wing and are situated by the pottery room and on the same floor as the Pennsylvania German bedroom (taken from the 1970 floor plan). The museum guide dating from the opening of the Shaker rooms states:

> During the past month, construction on the eighth floor of the Museum was completed, and three rooms – two Shaker rooms and a pottery room – were opened to the public. In association with the opening, a loan exhibition of Shaker inspirational drawings has been held in the Long Gallery of the Rotunda; and on April 9, Edward Deming Andrews, leading authority on Shaker Community, Inc., at Hancock, Massachusetts, conducted a seminar entitled 'Shaker Arts and Culture: Forces Behind the Forms'. Dr and Mrs Andrews have served as advisers on the Shaker installations here.[133]

The rooms have an austere simplicity and the smaller of the two rooms is based on an Enfield storeroom. It is a relatively accurate representation, with the colour of the woodwork being the same as the original. However, the floor boarding was colour matched on site to a reddish yellow colour, whilst some of the woodwork found within the larger room is less authentic.[134] The storeroom contains various objects made by the Shakers including a number of furniture pieces such as a maple side chair (with tilter buttons) and a storage box with original red finish, both made at New Lebanon. In addition, wooden smalls including coat-hangers also

feature within the display area. The large room contains more furniture including a large table from Hancock, and a revolver chair and bed from the New Lebanon community. In addition, a number of chairs are featured including a small rocking chair from Watervliet, a rocking chair with high back and an armchair with a woven-tape seat made in New Lebanon for sale to the outside world.[135]

Winterthur has been responsible for some innovative educational materials and takes the interpretation of the objects seriously. In 'The Evolution of Collecting and Display at Winterthur', it notes:

> A visitor in a period room at Winterthur confronts several perspectives about the past: those of eighteenth-century people, of an early-twentieth-century collector, and his or her own. For a guide, these perspectives are all resources for interpretation. Guides at Winterthur have the flexibility and knowledge to draw on three-and-one-half centuries of America's past and present, and they can develop a dialogue with visitors to achieve Winterthur's interpretive goals: looking at objects; thinking about meanings; applying the skills of looking and thinking. With their layered meanings, ambiguities, and changes, period rooms require the dynamic interpretation that is Winterthur's strength.[136]

It is certainly true that Winterthur has an excellent education programme which offers visitors a comprehensive tour of various rooms, including those devoted to the Shakers.[137] Interpreters at Winterthur use a material culture approach to analyse the Shaker rooms by looking at specific Shaker design devices such as the pegs that are attached to mouldings.[138] In addition, object interpretation for the visitor uses various categories that develop the skills of looking and thinking, which include 'Maker and marketplace'; 'Change over space'; 'Message and symbol'; and 'Technique and technology'.[139] This is aided by galleries which have individually displayed objects with explanation boards detailing various concerns, for example, 'Speculation'. In Discover The Winterthur Period Rooms, the following is of interest:

> The period rooms at Winterthur today represent the many stages of the institution's life. There are rooms that remain much the same as when they were originally designed by Henry Francis du Pont. Some rooms retain his original design intent but with a changing display of objects. Many objects,

once displayed in the period rooms, are now on view in the Galleries, a large addition completed in 1992.[140]

In addition to the period rooms' formation at Winterthur, a further development took place with the establishment of The Edward Deming Andrews Memorial Collection in Winterthur Library, which opened in 1969. The opening ceremony was attended by Faith Andrews and her two offspring, David Volk Andrews and Mrs Ann Andrews Kane. This was reported in the *Wilmington Evening Journal* and a photograph is featured of the display area. The dedicatory symposium included a slide/talk presentation by Mrs Mary Black and A.D. Emerich.[141]

The Metropolitan Museum, New York

The Metropolitan Museum in New York has produced a period room book in which it both admits their popularity and also indicates problems related to authenticity and accuracy.[142] Their Shaker room forms part of the American section and differs from Winterthur because it was not directly associated with Edward Deming Andrews. The room opened in 1981 when it was hailed as the first permanent Shaker installation in New York City.[143] The room features all the usual examples of the Shaker aesthetic and the purchase was made by using the Emily C. Chadbourne fund in 1972. It is described in the museum literature as a Shaker retiring room from Mount Lebanon, New York, dated around 1830 to 1840.[144] The retiring room acted both as a bedroom and also as a withdrawing room for meditation or silent thought. Although largely authentic, De Montebello in the book, *Period Rooms at the Metropolitan Museum*, states:

> Several of our rooms were installed principally as galleries to display suites of furniture selected from the Museum's holdings and combined in the setting to express a particular style, rather than to reinvent the original room. Clearly, curators must be responsible for making these exhibits as historically accurate as possible, but it is not always easy. Our Shaker retiring room, for example, contains one bed rather than four, as the original would have had; the Metropolitan does not own four Shaker beds, and it was decided that it would be more beneficial to the Museum visitor if the room was filled with other types of authentic Shaker objects than reproduction furniture. Whatever may be said about the nature of the

regrouping, at the Metropolitan the visitor is never faced with reproductions and may always be certain that all pieces on view in these rooms are original. It is only their context, their arrangement that may be a curator's interpretative re-creation.[145]

It seems to have taken some 10 years for the room to be completed, from acquisition to conservation and installation. The majority of the fixtures and fittings within the room were obtained from the Darrow School who had taken over the buildings at Mount Lebanon.[146] These included pegboards, window frames and a built-in cupboard and drawers. The Museum obtained the material in 1972 from the North Family Dwelling building which, like so many of Shaker origin, had fallen into some disrepair. In an ideal world it perhaps could be argued that it would have been better to have tried to protect and preserve the building *in situ*. However, the building was demolished in 1973 and before its destruction many fittings were removed and catalogued. Whilst the Andrewses were not directly involved in the room organisation, some of the furniture can nonetheless be sourced back to them and was purchased by the friends of the museum.[147] The Shaker room annotation gives brief details and the gallery label lists the furniture in the room.[148] Most of the furniture can be considered to be classic Shaker and included a desk and swivel chair which were made by members of the New Lebanon community. The desk was used by Sister Amelia Calver of the Church family and dated between 1825 and 1850, whilst the chair has a later provenance of about 1860–70 and could be described as a precursor of a swivel chair, a design that has been given a special section in *The Shaker Chair*.[149]

Philadelphia Museum of Art

The room at Philadelphia is part of the American Decorative Arts department and comprises a complete Shaker Sisters' 'retiring room' from Mount Lebanon (more specifically the North Family Dwelling)[150] and was a gift of H. Richard Dietrich. It is detailed as follows:

> The Shaker woodwork and built-in drawer unit were purchased when the New Lebanon North Family Dwelling was demolished in 1973. The Sisters' Room, occupied by two or three women, was on the second-floor

north-east corner. Healthful ventilation was provided by perforations on inside wall baseboards, swivel transoms and plentiful windows. The door on the left opened into a large walk-in closet. The wall pegs were used for clothing, implements and, at cleaning time, chairs. The iron stovepipe vented into the chimney and a small iron door at baseboard level opened to allow cleaning of the chimney flue. The room is furnished with several pieces from the New Lebanon community, as well as other objects given by Mr and Mrs Julius Zieget.[151]

As indicated, elements of the room were purchased in 1973 although the plans for the sale took place earlier.[152] The final room was created around the materials from Darrow School at Mount Lebanon, and was mainly furnished using the Shaker collection of Mr and Mrs Julius Zieget, who generously gave to the Philadelphia Museum of Art.[153] Their history of collecting started in 1929 when Irene Zieget decided to furnish a room at her summer residence in New Hampshire on a Shaker theme. The market for Shaker artefacts was still in its infancy and she was able to obtain some very good pieces at relatively modest prices. Aware that the Shaker communities were declining and were willing to sell furniture, she visited Hancock, New Lebanon and Canterbury in search of suitable items. Her visits to communities continued over the next 30 years and she collected materials as wide-ranging as seed boxes, linen herb bags and a musical notation pen (claimed to be invented by Isaac N. Youngs). She was also fortunate to form a relationship with Marguerite Frost and Bertha Lindsay, who helped her in collecting important items.

The museum's Shaker collection features in their handbook of their collections and a Spool box is both photographed and annotated: the box was made in Canterbury (1825–40) and was a gift of the Ziegets in 1963.[154] The text which is centred on the box states: 'As they pursued their spiritual vision, they devoted their lives to work and developed a unique sense of design as they fashioned objects that blended simplicity, harmony and utility. The oval box, which is fitted with a removable rack with thirty-eight dowels for holding spools of thread, perfectly reflects the Shaker aesthetic: it is an unadorned, functional and well-made object used for the productive task of sewing.'[155]

The museum period room at Philadelphia is part of a larger Shaker display featured in the audio tour of the gallery.[156] In 1989 a day was set

aside for the dedication of the Shaker gallery in the American Wing. In the press release it states: '... the Museum is dedicating the Shaker gallery in the American Wing as The Ann Newman Gallery. The Museum's rich collection of Shaker craft objects is enduringly popular with visitors, studied by scholars and frequently in demand for exhibitions. Among the simple and elegant objects made by Shaker men and women for daily use are chairs, bentwood boxes, baskets and textiles.'[157]

The Chicago Room

The miniature rooms at the Art Institute at Chicago have proved enduringly popular. They were created by Narcissa Thorne and have been detailed in a number of books and articles.[158] In 'Creating the Thorne Rooms' the following is highlighted:

> The Thorne Miniature Rooms are one of the most beloved exhibits at The Art Institute of Chicago. Each year thousands of visitors travel slowly down the long, darkened Thorne galleries in ones and twos, peering into the 68 lighted boxes which transport their imaginations to far-off times and places. For many of them, the Thorne Rooms are the most unusual exhibit in the museum. Although the Thorne Rooms are now close to 50 years old, their appeal seems as fresh as ever. Why are they so popular? The answer probably has to do with the fact that they are miniatures.[159]

The rooms have had an interesting history and Chicago is not the only institution to own some of the Thorne collection. For example, the Phoenix Art Museum and the Dulin Gallery in Knoxville have miniature rooms on show which draw from the Thorne collection. However, it is Chicago that has the greatest and most varied collection in terms of historical emphasis and context, having both European and American rooms. The Chicago Shaker room[160] is in miniature and the models were built to a scale of one inch to one foot, making them one-twelfth of the size of the original. For the Shaker room, *Shaker Furniture* by Edward Deming Andrews and Faith Andrews was used as a guide for the model makers.[161] The American rooms were presented to Chicago in 1942 and became permanently displayed in 1954. The rooms are beautifully presented and can be viewed in a special gallery.[162] They represent American interiors from many different periods

and styles and show the development and evolution of interiors from the seventeenth century to contemporary settings, although some periods are omitted. It is probable that the furniture for the rooms was created before the settings were decided. In the handbook it states:

> It is indeed a fully developed American Wing in miniature which in its full scale equivalent would require a larger area for its display than is at present given for this purpose in any museum in the country ... Even though the exigencies of a 'three wall' representation have in general forced certain departures from literal correctness, every effort has been made to preserve and emphasise the spirit of the room and to render it in accurate scale.[163]

In addition, it is indicated that the rooms may not be based on single examples, but are rather composites drawn from more than one source, and the accuracy has been questioned.[164] The Thorne Shaker room consists of a Living Room taken from a Shaker Community House dated to about 1800.[165] In the handbook the miniature room is validated by suggesting that it is more successful than a 'real' period room because all of the environmental considerations can be controlled and the miniature room provides a complete picture. It states:

> Models such as these, in spite of their necessary limitations, some of which are by no means obvious, are in many ways superior to the so-called 'period room' for presenting a complete picture of a type or style in its entirety. They offer a flexibility of lighting, setting and furnishing which the actual period room with its demands of piece by piece authenticity, its spatial requirements and the exigencies of lighting and accessibility, can never approach. Supplemented by displays of original objects and furniture, they would seem to offer an ideal solution of the hitherto unsolved problem of an adequate three-dimensional demonstration of the arts of decoration in the public museum.[166]

It is apparent that the internal composition of the room is somewhat over-arranged. It is perhaps not truly reflective of an actual living room of the Shakers: the flowers would appear to be totally misplaced and some of the furniture pieces are perhaps overcluttered.[167] Chicago is not the only location where Shaker artefacts are represented in miniature form.[168] Shaker miniatures have become popular for collectors who cannot afford the full-scale article or for those who want a small representation of a

design classic,[169] rather like those produced by the Vitra museum which features small reproductions of classic chair designs.

The Museum of Fine Arts in Boston – 1963

This period room differs slightly from the other chosen examples, in that currently the room does not exist within a museum context.[170] The room is featured in *Religion in Wood* where it is indicated that some of the furnishings originated from Hancock and came from the collection of Dr J.J.G. McCue.[171] Certain of the architectural details – including the door frames and windows which contain evidence of the original ochre stain – came from the South Family Dwelling House at Harvard, Massachusetts, a gift of Mrs F.L. Avery on 17 October 1963.

In a report by the Shaker expert Robert P. Emlen[172] in August 1978, detail is given about the period rooms on the Court Floor of the museum. It appears that the gallery was instigated in 1963 and created, in part, to house the Gerald McCue collection of Shaker artefacts. The architectural woodwork was received from two buildings at Harvard and included two complete windows which came from the north gable end of the attic loft in the South Family Dwelling.[173] In the Emlen report some aesthetic decisions were clearly made about the composition of the room: 'Strictly speaking, the gallery does not attempt to replicate an existing Shaker interior, but it does lend to the display a sympathetic exhibition setting ... Because the furniture from the McCue collection dates from the first third of the nineteenth century, a decision was made to compose a room of an earlier style.'[174] A particular aspect that required some thought was the pegboard:

> Being built at a relatively late date for a Shaker building, however, the room was originally outfitted with more modern cast-iron hooks instead of the traditional but outmoded wooden pegs ... Accordingly, lengths of pegboard which had been found stored in the Church Family's Trustee Office were purchased from the building's owners for the installation at the Museum. Additional pegboard was fabricated to fill out the other half of the wall space, and baseboard for the entire room was created on the model of existing examples in the Shaker Village at Harvard.[175]

Dr McCue helped Richard Randall in the arrangement of furniture, and on 20 March 1964 an opening ceremony was held. The room has been dismantled for museum reconstructions and alterations, but it has been indicated that the Shaker room will be reinstated in the future.[176] There have been some queries relating to authenticity within the museum because some of the architectural woodwork is reproduction and interestingly: 'The outer casings have been "earlied up" by the removal of their cast iron latch buttons.'[177] Future developments at Boston concerning their Shaker collections are still in question and there is no evidence of any Shaker materials in the museum catalogue produced for the public.[178]

The recreation of the past using material culture in a period setting is contentious and is subject to much debate. The use of period rooms was discussed at a conference at the Victoria and Albert Museum prior to the refurbishment of their English Galleries and period rooms.[179] Some perceive the concept of the period room as a pastiche. Certainly at Winterthur, where they are heavily reliant upon the period room, they have taken measures to address the question of interpretation by using galleries which emphasise the object's importance in the matrix of material culture theories.[180]

The period rooms featured in this Section have been selected from a broad range of examples. What distinguishes them from museum village recreations is that they are found within established museums which feature many artefacts from different periods and perspectives. The period rooms which are found in Shaker museum villages are very different and have been detailed separately, mainly because the architectural 'shell' in which they are housed and the fact that they are in situ gives them a greater authenticity and external context.

All the museums that contain period rooms validate the existence of the rooms by explaining their inclusion in the wider museum context. Some institutions have even taken the trouble to validate their use of period rooms in books, including Winterthur and The Metropolitan Museum, New York.[181] The Metropolitan has also featured their rooms in the booklet *The Met and the New Millennium* giving a vote of confidence in their continued use when it states: 'The creation of period settings to display various kinds of art together has long been an important part of the Metropolitan, beginning with the American Wing in 1924. Starting in the 1960s,

French furniture, decorative arts and paintings were beautifully installed in a sequence of grand rooms donated by Charles and Jayne Wrightsman, the most recent of which was opened only a few years ago.'[182]

The Work of Shaker Hands at the Smith College Museum of Art – 1961

The exhibition 'The Work of Shaker Hands' was staged from 4 to 25 January 1961 by the Smith College Museum of Art, Northampton, Massachusetts. As with a number of previous exhibitions, consistent themes emerged which indicated the influence of Dr and Mrs Edward Deming Andrews. Indeed the Andrewses provided items from their collection and these were supplemented by other materials which became part of a Shaker studies week at the college, with a number of publications produced in association with the event.[183] In addition to three-dimensional materials, visitors were also given the opportunity to view a selection of Shaker inspirational drawings. In the small catalogue that accompanied the exhibition, Edward Deming Andrews wrote a short contextual essay entitled, 'The Work of Shaker Hands', in which he once again takes the opportunity to lay out the now familiar themes of Modernity and perfectionism with which he had consistently aligned the Shakers from the 1930s onwards: 'In all their labours – their manner of building, their craftsmanship in wood and other media, their industries in shop and home and field – the Shakers adhered to the monastic doctrine of religion in work ... The aim was no less than perfection, in work as in conduct – a heaven on earth.'[184] In addition, Andrews continued stressing the importance of order, neatness, utility and simplicity in Shaker communities: 'The furniture in the dwellings, as well as the furnishings and equipment of the shops, testifies likewise to the high value placed on utility, simplicity and pure form.'[185]

The exhibition also included prints illustrating the Shakers' mode of worship, costume, architecture and craftsmanship. The catalogue contains a reproduction of a wood engraving of Hancock Shaker Village which opened in 1961. Interestingly, this Shaker exhibition appears, for the first time, to have placed greater emphasis upon the context of the artefacts and less upon their pure aesthetic appeal. For example, the catalogue indicates the inclusion of a relatively small number of furniture pieces. The majority of pieces were from New Lebanon, with a few from Hancock and

Sabbathday Lake, Maine; examples of small handicrafts were included in the form of oval boxes. There was also a large number of what are described as documentary materials, including photographic evidence of portraits of Shaker Brothers and Sisters. Also included were materials from the Index of American Design, shown courtesy of the National Gallery of Art. The Andrewses also decided to include some artistic representations of the Shakers including 'On a Shaker Theme', a painting by Charles Sheeler,[186] and a watercolour of the interior of the Meetinghouse at New Lebanon, New York by Benson J. Lossing (1856).[187]

In addition, a further short catalogue exists for 'Shaker Inspirational Drawings' with the sub-title 'The Collection of Dr and Mrs Edward Deming Andrews'.[188] The exhibition comprised 14 examples of Inspirational drawings.[189] The catalogue contained a short essay by Edward Deming Andrews and concise bibliography. The exhibition travelled to Harvard, Williamstown, Andover, Middletown, Northampton, Waterville and Amherst. Also a supplementary booklet entitled *The American Shakers* was available from Smith College Museum of Art.[190] In the comprehensive booklet it states:

> Certain misconceptions regarding the Shakers should be cleared up at the outset. They are *not* Quakers. Though the movement grew out of a branch of the Quaker sect in 18th-century England, and though the people were sometimes called 'Shaking Quakers' in this country, the two sects diverged in their development. The Quakers merged with the 'world'; the Shakers separated from it.[191]

Clearly, the travelling nature of this exhibition would have increased the audience for the material on show. Other Shaker exhibitions have also travelled, such as 'Shaker – The Art of Craftsmanship', and it would appear that the interest in Shaker material culture has been sufficient enough to sustain audiences throughout much of the post-World War Two period.

Shaker Arts and Crafts Exhibition at the Philadelphia Museum of Art – 1962

The exhibition at Philadelphia Museum was staged in the Spring of 1962, and whilst designed as a temporary event it would have lasting consequences and be instrumental in setting up the permanent display which is featured in the period room section. The husband-and-wife partnership of Irene and Julius Zieget were acknowledged in the catalogue for '… their generosity, interest, enthusiasm and zeal toward the project'.[192] The Ziegets[193] donated a substantial number of artefacts to the exhibition including documents which were classified as both printed and manuscript (numbered 221 to 257). Other individuals and institutions involved included Mr Meredith B. Colket of Western Reserve Historical Society and the Andrews partnership. In addition, the Index of American Design of the National Gallery of Art was acknowledged for permitting the use of Shaker architecture photographs. Lenders to the exhibition included Mrs Edith Gregor Halpert, Mr and Mrs Robert H. Jones, Mr and Mrs John D. Rockefeller III, and Mr and Mrs Charles Sheeler.[194] The exhibition was comprehensive and included a large number of furniture types including chairs, drawers, cupboards and beds (numbered 12 to 101). Several of these were illustrated in the catalogue, for example a swivel chair (number 90) lent by Mr and Mrs John D. Rockefeller. Smaller objects (numbered 102 to 169) were classed as utilitarian and included oval boxes, pails, carriers and baskets, while costumes and textiles (numbered 170 to 220) included examples of linen, cotton, silk and wool materials. In addition, the catalogue featured articles by a range of experts in the field and unusually was not dominated by the writings of Edward Deming and Faith Andrews. One article entitled, 'The Prose and Poetry of Shakerism', by Sister Marguerite Frost, concentrated on the history of the Shakers from the Camisards[195] to the decline years. Coming from a member of the Shaker community it provides a rather more insightful and less academic approach than usual: 'Were the Shakers seeking to develop a Utopia? Not at all. Something far more important. Their aim, as I see it, was not to do something for social betterment only (though that came about), but what they sought was to bring about a climate in which souls could become fully developed spiritually. The word they heard within was: "Be ye therefore perfect."'[196]

In another section entitled, 'Shakers in the West', Hazel Spencer Phillips provides a rare account of the Shakers in an area that has been largely neglected by the various scholars,[197] whilst M.F. Melcher provided a study of Shaker furniture with an emphasis on the renewed interest in, and development of the market for, Shaker artefacts:

> With Shaker communities dwindling toward their end, interest in Shaker architecture and furniture has mounted. Today, due partly to the activities of dealers in antiques, Shaker furniture is increasingly hard to get and, consequently, much sought after. A second and more important reason for the present-day interest in Shaker products is its functionalism. The keynote of functionalism is simplicity of line, influencing not only the exterior shapes of buildings but interior furnishings as well: nothing for show, everything for purpose. Many people feel that Functionalism owes something to the Shakers ... But to produce something beautiful, as well as useful, requires more than need or determination, more than perseverance. And since the Shakers were seeking utility, and not beauty – they were even afraid of beauty – how and why did they achieve it?[198]

The text continues placing emphasis on both the raw materials (mainly wood) and also the skill of the craftsperson, the Shaker box being highlighted:

> An example of the results of skilful steaming and bending of wood is the oval box made of two kinds of wood: pine for the top and bottom, and (usually) maple for the curved bands that formed the sides. To achieve the required thinness of an eighth of an inch, the final sawing had to be done with the wood resting on several thicknesses of paper. One end of a strip was cut into fingers to give a neat finish to the box. These fingers were steamed and bent into the right curve; little copper nails fastened them to the other and inside end. These boxes were sold in nests of six or twelve. When made with a handle and no cover, they were called 'carriers'.[199]

The article by Melcher begins to revisit all the themes and descriptors which the Andrews partnership had been using for some 30 years, which clearly suggests their significant influence in the way Shaker enthusiasts and scholars would interpret artefacts produced by the Shakers. Such devices include using Shaker quotations/sayings such as 'Do all your work as though you had a thousand years to live, and as you would if you knew

Selling Shaker

you must die tomorrow' and 'Hands to work and hearts to God'; a graceful beauty with emphasis on lightness and a concern for perfection:

> ... it takes a passion for perfection. This was inherent in the Shaker religion. The quest for spiritual perfection demanded a corresponding quest for perfection in daily work. Anything less would have been treason to Mother Ann. In a word, the Shaker workmen were perfectionists ... Some Shakers did come near to the perfection they sought, both in their lives and in the work of their hands. After one hundred years of careful use, Shaker chairs are still beautiful and intact. Their backs, legs and rungs are even yet as intrinsic a part of them as the limbs of the tree from which they came.[200]

Finally, as was the fashion,[201] the Philadelphia Museum included some Shaker art (numbers 1–11), and these were discussed in an article by David Sellin who was interested in their 'iconographic peculiarities'.[202] The following highlights other points including the alignment of the Shakers' 'art' work with modern movement fine artists/painters as well as more indigenous traditions:

> There is also a new appeal in their design that suggests to the modern observer the work of Klee, Steinberg, Rube Goldberg, primitive art in general and Fraktur in particular, but these associations have nothing to do with the original intention. These inspirational drawings are primitive in the sense given the word today. They tend to be linear in execution and are resolved in flat pattern, simple colour combinations, and frequently incorporating supporting text in the design.[203]

This is interesting because it develops the alignment of Shaker work with Modernity. From the exhibition it would appear that all of the 'products' of the Shaker world would be viewed as contemporary and Moderne – their furniture, their inventions, their society structure and empowerment of women, their dances, their music and now their art. It would seem that even their decline would be viewed in parallel with the decline in Modernism and the rise of Post-modernism. The Philadelphia Museum exhibition was important because it came at a pivotal point in an emerging popularisation of Shaker production.

Religion in Wood – A Study in Shaker Design at the Museum of Early American Folk Arts, New York – 1965

This exhibition, like the Whitney display of 1935, was based in New York City. As a consequence it featured extensively in the popular press.[204] In an article entitled, 'No Dust in Heaven …', Home Furnishings Daily, 4 October 1965, the writer notes:

> Any designer might listen with profit to the Shaker definition of perfect, for to them:
>
> 'Anything may with strict propriety be called perfect which perfectly answers the purpose for which it was designed.'
>
> 'A circle may be called a perfect circle,' according to the Shakers, 'when it is perfectly round; an apple may be called perfect when it is perfectly sound, having no defect in it … and so of a thousand other things.'
>
> This is one of the many gems, spiritual or material, that can be picked up at the 'Religion in Wood' show …[205]

The exhibition took place at the Museum of Early American Folk Arts[206] from 28 September to 14 November 1965 and was accompanied by a small leaflet. The majority of pieces on loan appear to have come from the collection of Faith Andrews[207] and the recently deceased Edward Deming Andrews, this being one of the first exhibitions after his death in June 1964. Edward Deming Andrews' influence was still evident in both the theme and composition of the exhibition. In addition, various museums began to influence the objects on display by providing loan artefacts from their collections which included Hancock Shaker Village (Shaker Inspirational drawings), Shaker Museum at Old Chatham (Shaker smalls and textiles), Fruitlands Museums (stove and peg rail) and the Western Reserve Historical Society in Cleveland.[208] A number of illustrations produced via the Index of American Design were also included as part of the exhibition.

As well as Faith Andrews, other leading private collectors loaned Shaker materials. The exhibition displayed over a hundred artefacts, some placed into settings such as a Sisters' Sewing room,[209] including a watercolour 'The Roll That De Holy Mudder Send' courtesy of Edith Gregor Halpert, New York, and a Swivel seat and wood box provided by Mr and Mrs John D. Rockefeller III, New York City. Mr and Mrs James Bissland, Charlemont, Massachusetts provided furniture, tools and textiles. The 'Introduction' to

the catalogue provided some historical context for the general public who might be unfamiliar with the Shakers' origins:

> Her seven disciples, labourers and farmers fleeing from persecution in England, founded the first of eighteen Shaker communities in this country at Watervliet, near Albany. There, Mother Ann presided over a communistic society unique in its development as an American movement despite its British origins. Mother Ann's moral and spiritual teachings became the basis of the Shaker religion. She taught celibacy, confession of sin, repentance and withdrawal from the everyday world. Every Shaker might win salvation, but since she taught that there would be no universal Judgment Day, Mother Ann promised each Believer salvation as he accepted her tenets.[210]

Like many institutions the museum became involved in showing further Shaker exhibitions and a temporary exhibition took place between 14 September and 21 November 1969, which included a focus on the Shakers of New York State with an emphasis on the communities at Mount Lebanon, Watervliet and Groveland, New York, and an examination of the Shakers' contribution to American artistic and social history.[211] A number of satellite events were organised, including a seminar and religious services, which apparently were attended by still practising Shakers.[212] In addition, a booklet was produced and identified as coming from E.D. Andrews for a Christmas event entitled *The Shaker Order of Christmas*.[213] Now called the American Folk Art Museum, this New York institution has consistently produced material about the Shakers, including exhibitions based on their artefacts and art.[214] It also stocks Shaker inspired pieces in its gift shop and will continue to offer the public glimpses of the Shakers in association with other American folk art traditions.[215]

Hands to Work and Hearts to God – Bowdoin College Museum of Art – 1969

This exhibition concentrated on the Shakers in Maine and was accompanied by a catalogue with both an essay and notes by Brother Theodore E. Johnson[216] and photographs by John McKee. It was staged at the Bowdoin College Museum of Art, Walker Art Building from 3 April 1969.[217] The

exhibition proved significant in that it indicated a shift from what might be termed 'outside' vision, to one in which members of the Shaker community played a much more proactive and influential role in the shaping of museum interpretations.[218]

The plates in the catalogue show a number of exterior and interior photographs, together with pictures of selected items of furniture, taken during October and November 1968 at Sabbathday Lake, Maine. One of the most interesting photographs is Plate 43[219] in which there is evidence of patterned wallpaper and patterned floor covering. This would indicate that the Shakers did have decorative items around them in their daily lives and there is quite considerable evidence to suggest that many communities in decline had veered away from the stripped aesthetic towards something altogether more conventional.[220] The exhibition's general approach was revisionist, and analysed the Shakers from a rather different perspective from that of the Andrews partnership. In a foreword by the curator Richard V. West, the following is of interest:

> The Shaker tradition in Maine is an unbroken one, extending from the founding of the first Shaker settlements here in the 1790s. The collection of objects at Sabbathday Lake, New Gloucester, community – one of the two surviving active Shaker centres – reflects this tradition and constitutes a precious artistic heritage which deserves to be better known. Bowdoin College Museum of Art is therefore pleased to publish this catalogue on the occasion of an exhibition of Shaker art, furniture and objects, mostly of Maine manufacture, now at Sabbathday Lake.[221]

West continues by providing analysis which compared the Shaker vision with that of the Bauhaus:

> It is certainly no coincidence that today we find in the Shaker vision so much of ours. In an era devoted to form as an expression of function, the Shaker solution for a piece of furniture or a tool seems inevitable. The original communal experience provided the means by which a form could be worked over, refined and then widely disseminated. It may be that it required artistic communal experience in the twentieth century, such as the Bauhaus, to open our eyes to the beauty and integrity of Shaker objects, the incidental offshoots of a desire to imbue daily life with spiritual meaning.[222]

In the essay by Brother Johnson, 'Hands to Work and Hearts to God', he concentrates on both the historical and craft references in Shakerism. He continues the revisionist angle when he tries to bring the Victorianised artefacts into the fold of all Shaker products:

> Some of the productions of the Shaker workshops are not, to be sure, without certain distinction, for the extremes of Victorian taste were almost always tempered by the older Shaker ideals of simplicity. The two Maine communities remained relatively populous, and here too Victorian preferences in design seem somewhat less marked ... Despite the fact that these productions of the late nineteenth century are to most of us less pleasing than those of the classic era, they are still a valid part of the Shaker story. They are in their way as meaningful a reflection of the evolution of a processual community as are the earlier pieces which accord so much more with contemporary taste.[223]

The essay clearly takes a view opposed to the normal Andrews paradigm by giving weight to the notion that the artefacts produced after the presumed 'Golden Period' of Shaker production had many positive features. The Victorians clearly had a marked influence on the Shakers and as their world disintegrated so it seemed that their design became diluted by the application of more decoration and detail. Johnson indicates that excellence in hand production was achieved in Maine during the 1900s and this somewhat goes against the general consensus that no Shaker work of any value was produced at the time: 'At Sabbathday Lake in Maine, Elder Delmer Wilson was producing, as late as the 1950s, oval boxes and carriers superior in lightness and delicacy to anything made during even the golden age of Shaker craftsmanship. Yet with the passing of Elder Delmer in 1961 the craft tradition, too, seems to have passed, although the community itself remains actively loyal to the Shaker way.'[224]

Shaker Arts and Crafts at the Memorial Art Gallery at University of Rochester, New York – 1970

This exhibition was held at the Memorial Art Gallery of the University of Rochester and travelled to a number of other venues in New York state in 1970/71. The catalogue contained contextual information on the Shakers

and their philosophy: 'Whatever is fashioned, let it be plain and simple, and of the good and substantial quality which becomes your calling and profession, unembellished by any superfluities, which add nothing to its goodness or durability ... Labour until ye bring your spirits to feel satisfied and thankful for that degree of modest plainness in all that you possess.'[225]

The exhibition material was loaned from a variety of large institutions including Hancock, the Munson-Williams-Proctor Arts Institute, New York, the Shaker museum, Old Chatham and the Office of State History, Albany, New York. The exhibits were divided by type into: Furniture; Utilitarian Objects; Textiles; Prints; Drawings; and Photographs. Many items including a number of textiles, clothing and millinery were from Canterbury,[226] while the inspirational drawings were mainly from Hancock, with some photographs from New York State History Collection.

The catalogue 'Introduction' gives a summary of the general history whilst also discussing Shaker in terms of aesthetics, design and also decline. Barbara Franco, Curator of Decorative Arts from the Munson-Williams-Proctor Arts Institute writes:

> Other important Shaker craft-industries included Shaker cloaks, oval boxes and the manufacture of brooms and brushes ... Shaker craftsmen are often pointed out as forerunners of 20th-century functionalism, which is based on the idea that beauty consists of the harmonious relationship between function and form. Beauty and function were not part of the Shaker vocabulary. To them, beauty, in its 19th-century sense, meant ornament and decoration, 'superfluities' which they strongly rejected. Rather than function, they were more apt to use terms like simplicity, order and use. Their functionalism was an outgrowth of both their simple practicality and their religious philosophy. The perfection which the Shakers sought in their spiritual life was carried over into their craftsmanship as well.[227]

Of decline she writes:

> Despite their decline, interest in the Shakers has continued and grown, Shaker arts and crafts are valued today for their intrinsic beauty, as well as for the insight into the life and thought of this unconventional sect which they provide. Distinctive Shaker objects, resulting from the unique interpretation which Shaker craftsman applied to otherwise traditional

'worldly' forms, are still admired for the simplicity of their forms and the ingenuity and inventiveness which they display.[228]

The catalogue was simple in form and well designed with a silhouette of a Shaker chair on the front cover. The plates within the catalogue are black and white and show the usual Shaker pieces, including a number of Shaker boxes. The exhibition was predictable in its format and reiterated many of the Andrewses' concerns, although the combination of photographic material and artefacts made an attempt to make connections between the makers and the objects.

Shaker at the Renwick Gallery – Smithsonian Institution – 1973

The Renwick Gallery forms part of the Smithsonian Institution in Washington and is a small but prestigious exhibition space devoted to the decorative arts. The gallery was developed as a venue for the promotion of craft and design. It was therefore an appropriate venue for an exhibition on Shaker design 'Shaker' which ran from 2 November 1973 to 7 April 1974.[229] In the foreword to the accompanying catalogue, the ethos of simplicity as a keystone of American design history is emphasised:

> In the variety evidenced by the remnants of nineteenth-century culture, the simple, direct expression of the Shakers communicates what we would like to believe is essential in American design – an economy of material and ornamentation. Although the unadorned forms of Shaker furniture did not appeal to periods in which American taste demanded complexity, decoration and historical association, Shaker furniture has been highly prized in recent years because of our tendency to equate 'good design' with simplicity. I hope that even as this exhibition has appeal to our contemporary tastes, it will also speak to us eloquently of the past.[230]

The exhibition was organised by Faith Andrews,[231] and material was provided from their former collection which had been dispersed to numerous museums including the Metropolitan Museum of New York. Mark Van Doren's memorial to Edward Deming Andrews is included in the catalogue.[232] The catalogue also contained illustrations showing the early Shakers: one of Shaker dance worship, the second of the Enfield community[233] and finally the Trustees' Office at Watervliet, New York.[234] The

catalogue includes a number of key essays including one by the late Edward Deming Andrews entitled, 'The Shakers of New England'. Perhaps more significant is the essay by Janet Malcolm, entitled, 'The Modern Spirit in Shaker Design', which helps to address the question as to why the Shaker aesthetic is so successful in design terms such that it has become part of the twentieth-century design history canon:

> Shaker furniture, which was largely disregarded in its own time, has become one of the most venerated of American craft forms. In American design it occupies a place like the one occupied by Robert Frost in American poetry and Edward Hopper in American art and, accordingly, it has become subject to the romantic blurring that we like to apply to our great indigenous productions – lest, perhaps, we recognise ourselves too clearly in them. Shaker pieces are popularly conceived of as lovely relics of a serene and untroubled pre-industrial past, whose simple forms and exquisite craftsmanship reflect the wholesome, simple-minded affirma- tion of the never-never land known as Early America. In fact, however, Shaker furniture is animated by a modern rather than a retrograde spirit, and derives its distinctive forms from the radical and often dark realities of the Shaker experience.[235]

The author then addresses the connections with the European Modern- ists such as Adolf Loos[236] by comparing the philosophy expounded in his essay, 'Ornament and Crime', with that of the Shakers. Malcolm continues by examining the social context of Shaker design: 'The social idealism that animated the pioneering work of Gropius, Le Corbusier, Breuer, Mies and Aalto, almost forgotten now that the International Style has been pre- empted by big business, was present in Shaker thought and is reflected in their creations – which also, ironically enough, are all too often owned by rich people when not in museums.'[237]

Malcolm also debates the work of the Shakers in terms of collectors and other interested parties: 'The present-day enthusiasm for Shaker forms – faddish, misinformed and superficial though it sometimes appears – is posited on certain fundamental affinities between Shaker aspirations and our own ... Although Shaker furniture was handmade, it reflects full acceptance of the machine's moral imperatives and aesthetic forms.'[238] Again the Andrews partnership is featured in terms of context and the Shaker infiltration into modern markets is discussed:

Several firms and individuals are making Shaker reproductions today, with varying degrees of success and on varying levels of workmanship. In their *Shaker Furniture*, Faith and Edward Andrews express their conviction that Shaker Furniture 'can be produced again, never as the inevitable expression of time and circumstance, yet still as something to satisfy the mind which is surfeited with over-ornamentation and mere display.'... More and more, in America, there will be people with limited means but educated taste, who will want their homes free from the complexity of useless embellishment, who will seek a union of practical convenience and quiet charm. Simple essential needs, not the whims of commercial manufacturers or the economy of overproduction, will increasingly dictate the kind and quantity of furniture to be used. Such furniture, like that made in the early Shaker settlements, will be flawless but inexpensive.[239]

The material in the exhibition included furniture from New Lebanon, Hancock, Enfield and Sabbathday Lake, as well as many interesting and sophisticated pieces such as Number 19, a tiered towel rack with the description: 'Painted pale blue with red shoe feet – No nails were used in the construction – just 14 wedged mortise and tenon joints, from New Lebanon.' Another exhibit numbered 40 included oval boxes and carriers with the description: 'New England and New York communities. Maple and pine – made continuously from 1798 to 1960s.' To quote the annotation: 'The oval box, made from a variety of woods, is peculiarly satisfying in its form. Construction was perfect; whether clear varnish, or glowing or muted colour was used, the same perfection resulted. A template was used to cut, from thin maple strips, the "fingers" or "lappers" characteristic of Shaker boxes and carriers. These were steamed, wrapped around an oval form, and secured with rivets to the pine discs used for the top and base.'[240]

The catalogue also contains quite a significant amount of material on the Andrews partnership and features an interesting conversation with Faith Andrews concerning the Andrewses' history of collecting. Included in this is a photograph taken from the 1940 Berkshire Museum catalogue of Sister Sadie Neale with the annotation: 'Dr and Mrs Andrews' best friend among the Mount Lebanon Shakers, about 1935. Sister Sadie always dressed in old-style Shaker fashion, as shown in the photograph. She is

holding a typical Shaker oval carrier. Photograph by William F. Winter, perhaps the most distinguished photographer of Shaker subjects.'[241]

This was an interesting exhibition because the material in the catalogue was probably more significant than the artefacts on exhibition. In the main it would appear that the function of the exhibit was to act as a memorial to Edward Deming Andrews and it achieved this with distinction.

True Gospel Simplicity in New Hampshire at the New Hampshire Historical Society – 1974

This exhibition was staged at the New Hampshire Historical Society at Concord, New Hampshire, from 3 July to 30 September 1974 and was organised to celebrate the Shaker bicentenary. An extensive illustrated catalogue was produced with a cover illustration of a detail from Shaker spirit drawing, 'An Emblem of the Heavenly Sphere'. This exemplifies the rather unusual approach this exhibition had to furniture production as it was probably the first to take a serious look at the Victorian influence in Shaker. As if the illustrations of furniture were not enough to highlight the alternative approach, a section in the catalogue entitled 'Victorians at Home – Contemporary Views of Shaker Interiors', shows the photographs of W.G.C. Kimbell taken in the last quarter of the nineteenth century at Enfield. These reveal the most elaborate, complex and decorated interiors which were in fact Shaker![242]

The main intent of the exhibition appeared to be interpretative and it tried to analyse how the furniture that the Shakers produced had evolved over time, particularly in the Victorian period. The introduction by Mary Lyn Ray[243] provides some explanation of the approach. It is a vision which is completely diametrically opposed to that adopted by the Andrews partnership and refocuses the history of Shaker production to make it more real and truthful. One possible explanation for a worldly influence would be that throughout the Shakers' history many Shakers entered the community from the outside and brought with them various influences:

> The furniture of the pre-Civil War period has enjoyed the ascription of a unique simplicity, but this furniture does not represent a distinct style. It is a paring down of vernacular forms from which carved or inlaid ornament is

Selling Shaker

stripped. Often there is little to distinguish Shaker furniture of this period from simple country furniture ... The plain needs of a community required plain solutions. Although there can be an elegance in forthrightness and abstraction, there can also be unredeemed plainness.[244]

The text also highlights the intense activity which occurred around the 1840s. After this date the Shaker communities throughout the United Society appear to have progressed into decline becoming victims of trends in the outside world:

The stern enthusiasm was, however, the phenomenon of only a decade; injunctions levied during the revival expired with the revival. Less strictly governed in their correspondence with the world when the revival had passed, the Shakers were more and more exposed to fashion and change. Anxious to define themselves in modern terms, they adopted 'progressive' habits and, at Canterbury, discarded 'old-fashioned' relics of the earlier nineteenth century in a 'museum' room.[245]

This is an important point, as it is evidence of the Shakers' perception that their community structures were out of date. The Shakers' 'classic style' might therefore be seen as a victim of fashion, as the simple surfaces became receptacles for Victorian details and style: 'The vitality of the Victorian period was generated by an eagerness to acknowledge the contemporary world while maintaining an allegiance to "gospel simplicity" ... Just as they rephrased their beliefs of a hundred years in the mode of modern grammar, the Shakers also restyled their traditional furniture forms to meet new needs. Shaker Victorian as a minimal Victorian, governed by obdurate simplicity.'[246]

It is apparent from visual evidence in contemporaneous photographs that the Shakers became more influenced by the outside world's changing taste – in all their designed artefacts including architecture, furniture, interiors and basket ware.[247] The increasing reliance on the outside world also brought problems with identity and influence. It is also important to note that contrary to popular belief very little Shaker furniture has been produced in the twentieth century.[248] The following extract from the catalogue discusses the Victorian context further:

During the Victorian period, much furniture was purchased from the world as well. The furniture trade established among the Shakers in earlier

years had been set up not so much to turn out untainted furnishings for the dwellings of Zion but to equip the community's needs more economically than furniture could be purchased from the world. In the decades following the Civil War, as the number of males in the Society decreased sharply, many of the community industries were closed and the Shakers increasingly relied on the world to supply their needs. At Canterbury and Enfield there remained several carpenter-joiners with the competence to answer community requirements. After 1900, however, little furniture was made by Believers.[249]

The exhibition tried to analyse honestly by using the production of Shaker artefacts over time. It also reflected on the different stylistic references within the furniture. The catalogue was important because it offered a highly revisionist approach to furniture interpretation and one which was out of step with earlier interpretations, such as those of the Andrews partnership. Particular pieces had been selected and highlighted because of their elaborate detailing and applied surface decoration including beds and tables.[250] This even went as far as a Shaker chair originating at Canterbury, with the primary wood of oak with tilters fitted to the legs. This chair was produced in the late nineteenth century and the following text is interesting: 'By the 1890s, however, the Renaissance revival (which influenced the style of this chair) had been supplanted by other fashions; and it is possible that the Shakers were producing something more *au courant*.'[251]

This exhibition and the catalogue article by Mary Lyn Ray were important because they were evidence of revisionist thinking with regard to the Shakers. Interestingly, it was a vision that went against that displayed in the Renwick Gallery exhibition which was held at about the same time. The following extract highlights the revision:

> But not all of the furniture called Shaker is religion in wood. Nor were all of the people called Shakers believers. From the beginning some persons admitted into the society did not subscribe to the millennial scheme. Association with the Shakers meant only a roof over their heads. Before the Civil War when membership grew to approximately 6,000 persons in 1850, the greater percentage of members believed that in fact they lived in the millennium. Correspondingly, much of the furniture from this period is an abstraction of their conviction.[252]

This exhibition was significant because it introduced the notion that there was an increasing variation that could be detected in the style of Shaker furniture produced around the time of the Civil War. As the various Shaker communities declined so the artefacts they produced fundamentally changed and it would seem that they lost their aesthetic direction.

The Shakers: The Life and Production of a Religious Community in the Pioneering Days of America at the Manchester City Art Gallery – 1975

This exhibition travelled around Europe and a number of catalogues were produced in different languages for the various venues.[253] It exhibited in Munich,[254] Vienna and Gothenburg and had two stops in the United Kingdom, at Manchester City Art Gallery and the Victoria and Albert Museum, London.[255] In Manchester, the exhibition ran from 25 March to 20 April 1975, and in London from 8 May to 15 June. In Manchester, Sandra A. Martin[256] helped coordinate the exhibition and information taken from the publicity indicates that it was supported by the Arts Council and the Greater Manchester Council.[257] The organisers also had cooperation from the Shakers at Sabbathday Lake.[258]

The original exhibition was conceived over a considerable period of time and was arranged and organised by Karl Mang, the Viennese architect and Wend Fischer, the Director of Die Neue Sammlung, Munich. It evolved from a previous one called, 'The Hidden Sense – Functional Design in the 19th Century', in the catalogue of which an essay on Shaker design appeared entitled 'Products of the Shakers and the Thonet bentwood furniture'.[259]

The catalogue produced for the exhibition was comprehensive[260] and contained contextual material, illustrations, photographs and also a number of well-known Shaker quotations.[261] Dr Fischer writes in the catalogue about Shaker design:

> In designing their buildings, rooms, furniture and equipment, the Shakers proceeded with the same unswerving thoroughness and logic as marked their search for a new way of life. Everything, even the most insignificant object, had to satisfy the demand for perfection. The criteria on which this perfection was based were the same as governed the believers' lives: purity, simplicity, integrity.[262]

In Manchester a report shows the exhibition to have been a significant and successful event attended by over 11,000 people:

> The exhibition was conceived by Dr Mang and his wife Eva. The founder of the Shaker movement, Ann Lee, was born in Manchester and emigrated to North America in 1774 with a number of followers. The exhibition was devoted to furniture, implements, items of costume and illustrations of architecture, all very simply designed. Members of the staff gave a series of talks, which were well attended, and the exhibition as a whole was extremely popular. The Shaker exhibition was one of the most unusual, interesting and popular ever held in City Art Gallery, and was later shown at the Victoria and Albert Museum. The attendance was 11,469.[263]

The exhibition was aided by a number of institutions and people including Hancock, Old Chatham Museum, Pleasant Hill, Sabbathday Lake, Fruitlands Museums, New York State Museum, Philadelphia Museum of Art and the collaboration of Susan Jackson Keig[264] and Elmer Ray Pearson.[265] The catalogue states:

> Our exhibition is devoted to the production and life of a Christian sect in America which is almost unknown in Europe. We believe that the historical attempt of the Shakers to establish a society founded on social justice in an environment of their own creation is worthy of our attention. In the simplicity and purity of form that distinguished their buildings, rooms, furniture and equipment was manifest the striving for perfection which governed their lives. Our own world is of another kind and bears a different aspect. To contemplate the past world of the Shakers, to reflect upon it, while at the same time reflecting upon our own world, is the purpose of this exhibition.[266]

Karl Mang and Wend Fischer[267] provide the contextual essays; Mang's, entitled 'The Shakers – another America', featured material concerning Shaker crafts:

> At the peak of its prosperity the Shaker community achieved a precise formal expression in architecture, products and design, which essentially reflected the ideals of their religious attitude. They felt no compulsion to change their form to follow a fashion or increase their sales, despite the fact that the world surrounding them was becoming ever more clearly stamped by the commercial thinking of the industrial era and the rising

Selling Shaker

standard of living. They preferred the high ethical values of life in a religious community to the fight for power and money in an individualistic society.[268]

In addition, Fischer discusses the architect Mies van der Rohe's design philosophy and its similarity to that of the Shakers,[269] while the twentieth century's emphasis upon novelty and built-in obsolescence is contrasted with the Shakers' more integrated and balanced view of novelty, fashion, beauty and utility: 'When quality and durability are disdained in favour of the attraction of passing novelties, the rapidity with which the new article becomes out of date demands ever new novelties. The Shakers appear already to have recognised the relation between fashion, wear and waste: "All beauty that has not a foundation in use, soon grows distasteful, and needs continual replacement with something new."'[270] The final paragraph highlights many of the concerns of the design historian relating to both production and consumption:

> For the Shaker, functional design was as little a problem of form as their communism was to them a question of politics; both were fundamental elements of their faith and life. With this conclusion the tremendous distance that separates us from the Shakers becomes evident – our remoteness from a world free from profit and waste, without commercial advertising and planned obsolescence, with no fashionable prestige products and formalistic innovations, without ugliness, without destruction of the environment. Our world is centred on the consumption of things produced primarily for their market value; the Shakers' world was based on the use of things made because men needed them.
>
> It would be unrealistic for us to try to pattern our life directly on that of the Shakers, for the fundamental conditions of their existence – their faith, withdrawal from the world and celibacy cannot be realised in our world. Nevertheless, it might well prove profitable to ponder on their way of life and concept of design, as we observe our own way with increasing concern and scepticism, and wonder what 'quality' of life we hope to achieve by it.[271]

This was the first major museum exhibition to be staged in the United Kingdom and attracted quite considerable press interest including advance publicity.[272] Articles in the broadsheets – *Yorkshire Post*,[273] *The Guardian*[274] and *The Times*[275] – reviewed the exhibition and introduced the British public

to the artefacts and the religion of the Shakers. In addition, the exhibitions at both Manchester and London produced a good deal of general interest which filtered down into various features in the popular press.[276]

Interpretations taken from Popular Culture

In the early 1950s a number of articles appeared in a variety of magazines including the *Ladies Home Journal*, in which Edward Deming Andrews' home in Richmond, Massachusetts is featured with text extolling the virtues of utilitarian design and 'unadorned perfection': 'Within this house itself, a most remarkable assembly of these Shaker furnishings fills the chaste interior, the plainness of whose plastered walls and unaffected woodwork provides just the unpretentious setting these pieces require.'[277]

In *The Magazine Antiques* of 1953, in a section entitled 'Collectors' Notes', there is an indication that good Shaker pieces were still available to an audience of reasonable financial means, and once again functionalism was highlighted alongside utility as central themes. The intention behind such articles, particularly in terms of reproduction or styled pieces, was to make the Shaker aesthetic more accessible to the growing numbers of style-conscious middle-class Americans.[278] Department stores in the United States of America were increasingly promoting Shaker style and Shaker-inspired ranges such as Bloomingdale's 'Eldorado' range of furniture from 1951. The advertising copy to accompany this promotion provides a typical example of the way Shaker style was being sold to the American consumer during this period:

> Paul McCobb's newest furniture inspired by American Shaker pieces makes an important contribution to the contemporary scene. There's refreshing originality in the see-through design. (The better to make rooms grow.) The solid hard rock Maple with warm 'nutmeg' or deep 'chicory' finish is crafted to promise useful service for years to come. New York store only prices range from 46.00$ for an End table to 439.00$ for a breakfast cabinet. At Bloomingdale's – 5 Floor – modern furniture.[279]

In addition to advertisements, a number of articles in interior focused magazines promoted both large and small Shaker items.[280] Edward Deming Andrews' name appears regularly in a number of these articles

with the consistent message that Shaker style represented restraint in design, perfection in workmanship and a manifest usefulness, in fact the very epitome of contemporary design aspirations. Ornamentation – in line with the Modernist orthodoxy – was rejected and regarded as superfluous and 'dishonest'. In an article from *Interior Design* in May 1954, Andrews also makes such claims for the contemporary relevance of the Shaker aesthetic when he states:

> In conclusion, I can testify to the satisfactions that my wife and I have had in adapting this native American style to our own homes, whether they were modern apartments or an eighteenth-century farmhouse. That these pieces accommodate themselves to space conditions and the diverse uses of contemporary living goes without saying. Equally satisfying is the way they harmonise with their background, whether white-plastered, panelled or papered walls. In a room thus furnished, colour may be freely used as well as the accessories of modern living. They set the tone of a kitchen, a bedroom, a living-room, imbuing interiors with a spirit which reminds us always of the high standard – call it utilitarian or aesthetic as you will – of the labour that went into their making.[281]

Andrews discusses this theme in an article from *Look* magazine of 23 March 1954, in which he states: 'Traditionalists and moderns discover virtues of Shaker furniture – honesty, strength, usefulness and the "gift to be simple".' The article then goes on to state:

> Among today's complicated designs, the straightforward Shaker approach commands admiration. Beauty was not sought; it was the by-product of utility ... Authentically original Shaker pieces such as these in collector Andrews' apartment in Yonkers, NY, and his home in Richmond, Mass., are rare finds today – but 'Shaker-style' furniture is in nearly every furniture showroom.[282]

Andrews continues by venturing some 'Shaker opinions' with a few examples, stating that: 'A Shaker, less concerned with looks, would have bent this top wood piece naturally, not sawed it against the grain.' He passes comment upon an individual piece of furniture by suggesting that 'The Shakers would certainly have admired this careful cabinetwork and the clean-white ceramic knobs',[283] all very speculative but with a clear intention to position Shaker design at the centre of contemporary design

thought. *House & Garden* produced an extensive summary of the Shaker look and promoted it as a significant trend-setting interior design theme, when it stated:

> Once again, *House & Garden* launches a significant trend in modern decoration ... Shaker that curious blend of austerity and charm. In a 12-page portfolio of Shakerisms ... including furniture and a Shaker-modern house ... March *House & Garden* shows that Shaker is functional, decorative and admirably suited to present-day living ... Sponsored for its inspirational value, *House & Garden* believes that Shaker will make postwar merchandising history, paralleling the success of Southern Highlands, Pennsylvania Dutch and Colonial-Williamsburg. All three were *House & Garden* firsts. All three were widely promoted by top stores.[284]

Shaker design reached popular American taste via a number of routes, not only what might be termed the interior design press, but also, for example, in articles in more specialist publications such as *Hi-Fidelity Magazine*, where the writer stated that:

> I would like to digress for a moment or two and put myself on record with regard to 'contemporary' furniture designs. The good ones are superlatively good and for an excellent reason – they are almost carbon copies of proven designs of over a century ago and I here refer specifically to the Shaker influence. We would recommend to the 'form follows function' adherents a visit to Fenimore House, Cooperstown, NY where outstanding examples from the comprehensive private collection of Dr E.D. Andrews, world's foremost authority on the Shakers, may be seen and examined at leisure. Dr Andrews and his wife, Faith Andrews, are also authors of *Shaker Furniture* (Dover Publications, Inc., NY), a definitive work on the subject; copies may be obtained at most public libraries and better book shops.[285]

Furniture designed in the Shaker style, following on from Bloomingdale's, was starting to be introduced into the mass market. For example, Drexel Furniture Co.'s range called 'Declaration', designed by Kipp Stewart and Stuart MacDougal was introduced in 1957 and had retail sales of $46.5 million. In addition, Kammerand, a custom furniture firm in Spring Lake, Michigan, produced, in collaboration with Faith Andrews, a collection of Shaker designs sold under the name of 'Guild of Shaker Crafts, Inc.' which were widely advertised.[286] A Shaker design portfolio,

including pen and ink drawings, was developed into a catalogue similar to those the Shakers used in selling their furniture. In 'Shaker Crafts Revived' taken from *Interior Design* of 1967, the same themes are evident.[287] At around the same time *American Vogue* (1968) also provided their readers with a style guide in the section 'Fashions in Living' which includes 'A rakish straw hat by Adolpho', and 'Shaker design, expressing in light and defined line the Shaker belief in simplicity and directness ... Now reproductions can be found at Altman's, New York.'[288]

Further magazine articles during the late 1960s and early 1970s emphasised Shaker style to an increasingly receptive public.[289] Various collectors were highlighted including the Roberts[290] and Upton families who featured their homes and Shaker collections. In both cases it is clear that they were eclectic in their approach, prepared to mix various pieces and styles in the achievement of comfort. The Uptons started collecting seriously in the early 1950s, purchasing furniture directly from Shaker communities, notably at Canterbury. In 1957 they were present at the major dismantling of a Shaker shop at Hancock:

> A few finds in antiques shops sustained our hopes until 1957, when we were so fortunate as to be first on the scene at the demolition of the Sisters' shop in Hancock, Massachusetts. Here we obtained stairs, panelling, floor boards, doors, windows and pegboards. The closing of this community in 1960 offered additional opportunities. In that year we finally achieved our goal of furnishing our home in Shaker.[291]

In the photographs by W.H. Tague, descriptions of the furniture within their room settings are given and, although they started collecting late compared with collectors such as the Andrewses, it would seem that they had been successful in obtaining high quality pieces, including some that had been in Edward Deming Andrews' collection.[292] They also appeared to have had approval from the Shaker communities in their collecting, which no doubt helped:

> During the past few years several of the Shaker sisters, including Eldress Emma B. King of the Canterbury society, have come to see us, and have approved our efforts. The sisters were pleased to see the furniture that was once theirs used and cherished outside their own society. One confessed that she had never slept in a Shaker bed until she came here, because even

before her arrival at Canterbury half a century ago the beds had all been sold.[293]

In 1972, McCall's promoted Shaker furniture in an article entitled, 'Shaker furniture: perfect unto its purpose'. The article notes that 'Most original Shaker furniture is now owned by museums and collectors, but these amazingly faithful reproductions, and many more, are available in assemble-it-yourself kit form. And McCall's readers can order the utility shelves, pictured, at a special discount price.'[294] While in *Better Homes and Gardens* of 1972, in an article entitled, 'The American Country Look – Shaker', the enduring quality of the 'Shaker style' is discussed and the notion of a timeless quality is mentioned as a possible reason: 'Of all the early country styles, perhaps none is so enduring or appealing as the Shaker. The perfectly proportioned, ever functional furniture produced by this gentle, innovative sect has a timeless quality. The Shaker style grew out of the same classic modes as other early designs, but it developed with a definite difference.'[295] The article gives examples of authentic Shaker interior settings and then shows its readers how to create copies. Interestingly, it features a Pleasant Hill bedroom – which itself is a copy – and annotates a photograph stating 'Shaker styles in a restored setting'. In the subtext a title 'Capturing the real Shaker flavour', states:

> If the quiet beauty of the Shaker style intrigues you, here's how you can adapt it to your home in an authentic manner. The furnishings shown here are all careful reproductions of old pieces. We left the hardwood floor uncovered except for a characteristic rag rug, then installed a pegboard painted in an original Pleasant Hill colour.[296]

Later in the article the point is made that it is possible to mix reproductions and adaptations, noting that:

> Don't be afraid to mix authentic reproductions and adaptations. In the living room at left we also introduced some distinctly un-Shaker-like comforts – carpet and a small upholstered sofa. The draperies in a Jacobean print are a departure as well. There are enough original elements to give the room an authentic flavour, however. On the wall hangs a copy of a clock made by Isaac Youngs, a Shaker craftsman who marked his clocks with a bit of philosophic verse on the back of the dial. The magazine rack is patterned after shelves that once held ironing in Shaker laundries.[297]

The article then continues with some advice about Shaker in a contemporary setting by designing a living room with Shaker furniture as 'accents' to create a modern setting. This includes Shaker-styled adaptations including a curio cabinet and also reproductions such as a candle stand.

In the article 'The Shakers' New Converts', the following is taken from the introductory text:

> Only a handful of Shakers survive today, but the crafts of their ancestors are suddenly more popular than ever before – and an analysis of the Shaker market shows it's as erratic as a Shaker dance ... Shaker experts of one ilk or another have existed as long as the Shaker movement itself; but the fine craft of this country's foremost utopian society is today riding an unprecedented wave of popularity that germinated in the late 1960s, and is only now cresting.[298]

The article is interesting as it highlights the popularisation of Shaker crafts in the 1970s and in particular the focus on 'style' above all else. In the section entitled, 'Keys in with Today's Styles', the following quotation sums up the situation to date:

> The overdue attention has come not only through the efforts of collectors but also designers who, attuned to the swing to a new asceticism and influenced by the spare existentialism of communal living styles, noticed that bare wood floors and clean stretches of monastically white walls keyed in perfectly with the reduced lines and pure functionalism of Shaker design. Rejecting superfluity of materials as well as of adornment, and with a functional design philosophy summed up by one of their elders in the tenet 'That which has in itself the highest use possesses the greatest beauty', Shaker craftsmen practised what the Bauhaus would preach 100 years later.[299]

In the concluding paragraph the following sums up the whole article and provides a good conclusion for this focus on the period from 1946 to 1975:

> But the Shakers' legacy in America is a rich one (it is gratifying that the US Pavilion at the Japanese 'Expo 70' World's Fair featured a display of Shaker furniture and crafts). The prime collectible, of course, is furniture. Shaker chairs are surprisingly light – they were made so that women could lift them to hang on the wall while cleaning the floor. Actually, Shaker furniture was made right up to the 1930s, when Elder Robert Wagan's

chair business was terminated. Wagan and Company made many chairs and rockers for mail-order firms and department stores (and their furniture won a medal at the 1876 Philadelphia Centennial Exhibition for its 'strength, sprightliness and modest beauty'). The Smithsonian exhibit and recent auctions indicate that, as the Shakers themselves die out, a Shaker renaissance may be beginning. Will Shaker be taken up by collectors, as have Windsor, Colonial and Federal? Collectors with an eye to the future insist that the new elite has already come to appreciate the Shaker form and what is left is merely national recognition. The true worth of Shaker, they say, is still partly hidden in a cloud of obscurity that hovers over a Shaker-buying public – which future major exhibitions and a cooperative media may serve to dispel.[300]

An extract taken from 'Force and Form: The Shaker Intuition of Simplicity' continues the apparent interest that observers have in the perceived perfectionism that is associated with the Shakers: 'The Shakers' achievement of practical perfection was both directly simple and natively progressive. They took perfection where they could find it, and they modified the form of their life to fit the needs of the future.'[301]

Notes

1 For a discussion of both artistic and historical period rooms see Alexander, E.P., 'Artistic and Historical Period Rooms', *Curator*, 1964 and also Keig, S., 'The Shakers – a Lifestyle by Design', *Communication Arts*, 1971, p. 65 which states: 'Interest in the Shakers has never been greater, due in large measure to the fact that Pleasant Hill has become a living experience, not just a museum of the past. It constitutes the only total Shaker environment where the visitor can experience this lifestyle, staying overnight in the actual rooms ...'. In addition, Keig also produced 'The Shakers – A Lifestyle by Design' – an exhibition at the Ryder Gallery, Chicago, from 9 September to 15 October 1971 – which featured artefacts and photographs with an emphasis on Pleasant Hill.

2 See Kallan, C., 'Travelling through Time', *USAir* (Magazine), 1991.

3 See Kallan, C., 'Travelling through Time', *USAir* (Magazine), 1991, pp. 54–55, in which Colonial Williamsburg, Williamsburg, Virginia is featured: 'Among the largest and oldest living-history museums in the country, Colonial Williamsburg is perhaps the best known. It is toured by more than one million visitors annually; and at least seven recent American presidents have toured its streets. Colonial Williamsburg is set primarily in the 1770s, covers 173 acres, and includes 88 original 18th or early 19th-century houses, shops, taverns and public buildings. There are an additional 50 major buildings rebuilt on original sites, and some 90 acres of public greens and gardens.'

4 See Styles, J., *Titus Salt and Saltaire – Industry and Virtue*, 1994.

5 See the souvenir guide by Sekers, D. & Rose, M., *Styal – An Illustrated Souvenir*, 1993 and the booklet by Spencer, P., *Religion in Styal – The Religious Influences Upon the Greg Family and Their Effects on the Development of Styal*, 1983.

6 See the souvenir guide by Trinder, B., *Ironbridge – A Pictorial Souvenir*, 1993.

7 Taken from Kallan, C., 'Travelling Through Time', *USAir* (Magazine), 1991, pp. 48 and 50.

Selling Shaker

8 Examples of this debate can be seen in Chavis, J., 'The Artifact and the Study of History', *Curator*, 1964; Glassie, H., 'Structure and Function, Folklore and the Artifact', *Semiotica*, 1973; and McClung, F.E., 'Artefact Study', *Winterthur Portfolio – A Journal of American Material Culture*, 1973. Also see Skramstad, Jr, H.K., 'Interpreting Material Culture: A View from the Other Side of the Glass', in Quimby, I.M.G. (ed.), *Material Culture and the Study of American Life*, 1978, pp. 175–200. This features exhibitions which have had a large material culture content such as 'American Arts and the American Experience' at Yale University Art Gallery.

9 Taken from 'Good Design 1950–1960', in Hiesinger, K.B. & Marcus, G.H., *Landmarks of Twentieth-Century Design*, 1993, p. 175.

10 Taken from 'Theories and Movements' in Votolato, G., *American Design in the Twentieth Century*, 1998, p. 89.

11 See Hunter, S., *The Museum of Modern Art*, 1984.

12 See Myerson, J., *Gordon Russell – Designer of Furniture*, 1992, p. 125.

13 In Hein, G.E., *Learning in the Museum*, 1998, p. 27, it is noted that: 'Museums organised on didactic, expository lines will have: exhibitions that are sequential, with a clear beginning and end, and an intended order; didactic components (labels, panels) that describe what is to be learned from the exhibition; a hierarchical arrangement of subject from simple to complex; school programmes that follow a traditional curriculum, with a hierarchical arrangement of subject from simple to complex; educational programmes with specified learning objectives determined by the content to be learned. In addition to "telling a story" with a beginning and an end – a story with a specific theme – didactic exhibitions make some claim that the story they are reporting is "true"; it is the way things really are. Thus, they would not be likely to include panels that suggest that this is only one interpretation of the historic event and that there might be others, they are not likely to refer the visitor to an alternative explanation, or indicate explicitly or implicitly that this arrangement is arbitrary, to be replaced by a different intellectual scheme at a later date or in another gallery in the museum.'

14 See Boyer, B.H., Weingartner, F. & Rossen, S.F. (ed.), *Miniature Rooms – The Thorne Rooms at the Art Institute of Chicago*, 1983, p. 12.

15 There is evidence in this period of Shaker settlements being recognised as at risk from destruction, for example, Apple, N., 'Remaining Watervliet, Ohio Structures to be Destroyed', *The World of Shaker*, 1974, whilst other buildings were being remodelled, see Baker, J., 'Remodelled Shaker Hall', *Architecture Forum*, 1962.

16 In Gleason, G., 'From Their Hearts and Hands: A Shaker Legacy', *Americana*, 1973, p. 6, it states: 'For people interested in seeing the legacy of the Shakers, there are four Shaker restorations that are open to the public, but not affiliated with the two surviving Shaker societies. They are the Mount Lebanon Shaker Village, two miles east of New Lebanon, New York; Hancock Shaker Village, five miles west of Pittsfield, Massachusetts; Shakertown in Pleasant Hill, Kentucky; and Shakertown in South Union, Kentucky.'

17 See Shafernich, S.M., 'On-Site Museums, Open-Air Museums, Museum Villages and Living History Museums', *Museum Management and Curatorship*, 1993, p. 42.

18 Taken from Smith, C.S., 'Museum, Artefacts and Meanings' in Vergo, P. (ed.), *The New Museology*, 1989, p. 19.

19 This exhibition travelled throughout Europe with catalogues published in various languages. See Fischer, W & Mang, K., Catalogue for *The Shakers: Life and Production of a Community in the Pioneering Days of America*, 1975, also published as *Les Shakers – Vie communautaire et design avant Marx et le Bauhaus* and *Die Shaker – Leben und Produktion einer Commune in der Pionierzeit Amerika*.

20 See Elsdon, J., *Visitor Guide – The American Museum in Britain*, 1998.

21 In Hein, G.E., *Learning in the Museum*, 1998, p. 150, they include: (1) museums make content and ideas accessible, facilitating intellectual 'connections' and bringing together disparate facts, ideas and feelings; (2) museums affect values and attitudes, for example facilitating comfort with cultural differences or developing environmental ethics; (3) museums promote cultural, community and family identity; (4) museums foster visitor interest and curiosity, inspiring self-confidence and motivation to

pursue future learning and life choices; and (5) museums affect how visitors think and approach their worlds, in contrast to what they think.

22 In fact not all the Shaker rooms remained permanent and the one featured in the Andrewses' book *Religion in Wood* at Boston Museum of Art can no longer be visited. However, a written communication from the curator of American decorative art assures us that it will be reinstated at some future date.

23 See Smith, C.S., 'Museums, Artefacts and Meanings' in Vergo, P. (ed.), *The New Museology*, 1989, p. 15.

24 Refer to Harris, J., 'A Cautionary Tale of Two "Period" Rooms', *Apollo*, 1995, p. 56, in whch he states (with reference to the USA): 'Across the land, hundreds of historic rooms were being installed in art museums and private residences, furnished accordingly and presented as the real thing. The truth is very different. Few rooms have been installed as they were *in situ*.'

25 See Smith, C.S., 'Museums, Artefacts and Meanings' in Vergo, P. (ed.), *The New Museology*, 1989, p. 17, in which he discusses this further and states: 'The first issue is; how does one establish relative priorities in the display of artefacts? In the case of the display of period rooms, since a careful historical reconstruction of the original appearance of the interior from contemporary inventories would permit the creation of a complete *mise en scène* which would enable the visitor to visualise the way artefacts worked and were used in their original environment, then this is worth the sacrifice of several display cases. But there is a larger issue at stake, which is the question of authority and who makes such decisions and on what criteria. One of the things that are uncomfortable about the way a state-run museum operates is that it maintains a belief in anonymous authority. Instead of viewing the display of a gallery for what it is, a set of complex decisions about a number of alternative methods of representation, there is an idea that the procedure must be suppressed: labels, for example, tend to be straightforward information which pertains only to the artefact alone, not to its place in the gallery as an arbitrary construction; the type of design which is currently in favour, at least at the V&A, is of a highly aesthetic late Modernism, the architectural style which is most inclined to reduce the elements of ephemerality and theatricality in display; and the design of galleries is thought to be a problem independent of the way that artefacts are viewed and understood by visitors, whereas, of course, the environment conditions and codifies the visitor's expectations.'

26 See Smith, C.S., 'Museums, Artefacts and Meanings' in Vergo, P. (ed.), *The New Museology*, 1989, p. 18. In addition he also states: 'The fourth argument against period rooms is concerned with audience. It is assumed that, as there are over a million members of the National Trust and less than a million annual visitors to the V&A, visitors will have a reasonably good knowledge of the historical and architectural context for which artefacts on display were originally made ...'

27 A number of Shaker villages have changed their architecture since becoming museums, for example, the Meetinghouse at Hancock. The Shakers themselves also changed their buildings during their life: interestingly they converted to Victorianised versions of architecture as in the Marble Hall in Phillips, H.S., *Shaker Architecture – Warren County Ohio*, 1971, p. 7.

28 See Stern, R.A.M., Averitt, J. & Carlin, E., 'Shakertown Visitor Center', *Journal of Architecture and Urbanism*, 1981. Also *The Shaker Messenger* and *Shakers World* feature developments within Shaker museum villages. Also see Tecimer, D., 'Shaker Aesthetic', *The World of Shaker*, 1974, p. 5, which details the visit of a group of students to both Hancock and Shelburne.

29 Many materials have been available relating to the photographic presentation at Pleasant Hill: for example, John Stines has produced two series of postcards (in limited editions) entitled *Shaker Village of Pleasant Hill* (Averso Publishing). Also calendars entitled 'The Living Art of the Shakers', designed by Susan Keig for attachment to a peg rail (1975 and other years) contain many photographs of Pleasant Hill, while books have been produced which have relied heavily on photographs of Pleasant Hill, for example, Bial, R., *Shaker Home*, 1994. In addition, photographs of Hancock by Solomon M. Skolnick can be found in *Simple Gifts – the Shaker Song*, 1992 and illustrations of Hancock by Wendell Minor were produced in Turner, A. & Minor, W., *Shaker Hearts*, 1997. A number of television programmes have also featured the villages, as detailed in the Bibliography.

30 Books featuring illustrations include Clark, T. & Ham, G., *Pleasant Hill and its Shakers*, 1983; Mac-Hir Hutton, D. *Old Shakertown and the Shakers*, 1987; Harlow Ott, J., *Hancock Shaker Village*, 1976; and

Purcell, L.E., *The Shakers*, 1991, which features both Hancock and Pleasant Hill. In addition, for very atmospheric and beautiful photographs of Pleasant Hill see Archambeault, J. & Clark, T.D., *The Gift of Pleasant Hill – Shaker Community in Kentucky*, 1991.

31 See Murray, S., *Shaker Heritage Guidebook*, 1994 and also Section One.

32 Taken from Gable, E., 'Maintaining Boundaries' in Fyfe, G. & Macdonald, S. (eds.), *Theorising Museums*, 1996, p. 179: 'Colonial Williamsburg is, at once, America's largest outdoor museum and a middle-sized corporation and resort ... What is referred to as the "museum" or "education side" consists of a 175-acre complex of 100 gardens and some 500 restored or totally reconstructed structures meant to replicate Williamsburg ... There are also research facilities, offices and several museums within the museum (DeWitt-Wallace Decorative Arts Gallery, Abbey Aldrich Rockefeller Folk Art Centre, James House archaeology exhibit).'

33 Sorensen, C., 'Theme Parks and Time Machines', in Vergo, P. (ed.), *The New Museology*, 1989, p. 62.

34 Unspecified, 'Shaker Collection Given To Yale', *The Berkshire Eagle*, 1956: 'From 1931 to 1933 Mr Andrews served as temporary curator of history at the New York State Museum in Albany. In 1937 he was awarded a Guggenheim fellowship for research in the arts and history of the Shakers. From 1941 until his present appointment at Yale, he was dean of students and head of the history department at the Scarborough School, Scarborough-on-Hudson, NY. His books have covered many aspects of Shaker life. *The Community Industries of the Shakers* was published at the New York State Museum in 1932. It was followed by *Shaker Furniture: The Craftsmanship of an American Communal Sect* (1937), co-authored by Mrs Andrews ... The Andrews home in Richmond has also been open to the public on two occasions, to benefit the Berkshire Garden Centre and Richmond Church parsonage. Dr Andrews has lectured extensively on various phases of Shaker culture, most recently at Williamsburg, Val. Mrs Andrews who has shared her husband's interest and work in Shaker culture, was Faith Young of Pittsfield until their marriage in August 1921. They have two married children: Ann, now Mrs Thomas Kane and David.'

35 The Berkshire Garden Centre, Stockbridge, MA, states in its magazine ('Visit Our Shaker Herb Industry Exhibit – Open from June 26th through July 26th', *Cuttings*, 1959): 'Important exhibition from the well-known collection of Dr & Mrs Edward Deming Andrews. Dr Edward Deming Andrews will give a lecture with slides on the Shaker herb Industry, Friday evening, June 26th at 8.00 P.M. for Garden Centre Members. Dr and Mrs Edward Deming Andrews will open their Shaker Farmhouse in Richmond, Mass., to the public on Saturday July 11th from 1.00 P.M. – 5 P.M. Admission of 1.00$ will benefit the Berkshire Garden Centre.'

36 See Bibliography for the Andrewses' comprehensive literature of the period. Also numerous articles in The Edward Deming Andrews Memorial Collection at Winterthur, for example the pamphlet Andrews, E.D. & Andrews, F., *Some Shaker Symbols*, 1966.

37 Taken from Andrews, E.D., 'Shaker Design', *Art in America*, 1958. The article provides the familiar themes of simplicity, linear look, well ordered, perfectionism and functionality, with which the Andrewses' had been promoting the Shaker aesthetic. Specifically, on p. 47 he quotes from 'Current Trends in Furniture Design', *The New York Times*, 1957: 'The use of American woods ... the exposure of dowels and dovetailing and a feeling for Early American details can be expected.'

38 See Lubovitz, F.R. & Bridgwater, D.W., 'Exhibitions – The People Called Shakers, A Search For The Perfect Society', *Yale University Library Staff News*, 1957.

39 From *The Yale University Library Gazette*, April 1957, p. 154 (The Edward Deming Andrews Memorial Collection, Winterthur Library, Number 490).

40 Taken from Cornforth, J. 'Creating the Cult of the Shakers', *Country Life*, 1974, p. 634. It is interesting that Cornforth should recognise the fact that the Shakers were becoming a cult as a result of the creation of Hancock Shaker village with its particular aesthetic vision. The new cult emphasis was on their design rather than their religion.

41 The Andrews exhibition at Yale was also featured in Lubovitz, F.R. & Bridgwater, D.W., 'Exhibitions – The People Called Shakers, A Search For The Perfect Society', *Yale University Library Staff News*, 1957, which states: 'The flat cases are devoted almost entirely to books and manuscripts. The most important item in this part of the exhibition is a letter from Father James Whittaker, an English follower

Forms and Forces

of Ann Lee and her successor as head of the movement, to Josiah Talcott. The letter, written from Ashfield in 1782, is the earliest extant Shaker manuscript.'

42 The Millennial Laws were significant to the Andrewses and these have featured extensively in Andrews, E.D., *The People Called Shakers*, 1953, pp. 243–89 and also Andrews, E.D. and Andrews, F., *Work and Worship Among The Shakers*, 1974, p. 41. Others have also discussed the religious significance of the Laws: see Johnson, T.E., 'The "Millennial Laws" of 1821', *The Shaker Quarterly*, 1967. Shaker religion is discussed in Williams, J.S., *The Shaker Religious Concept*, 1959; Stein, S.J., *Inspiration, Revelation and Scripture: The Story of a Shaker Bible*, 1996; and Stein, S.J., 'A Candid Statement of Our Principles – Early Shaker Theology in the West', *Proceedings of the American Philosophical Society*, 1989.

43 The arrangement was reported in Unspecified, 'Yale To Receive Collection Of Shaker Artefacts – Authority on Communal Religious Sect Also Named Faculty Member', *New Haven Register*, 2 September 1956: 'The largest privately owned collection in the United States of Shaker furniture, literature and other artefacts is coming to Yale University this fall. Lamont Moore, the director of the Yale Art Gallery, announced Saturday that Mr and Mrs Edward Deming Andrews, of Scarborough-on-Hudson, NY, and Richmond, Mass., are giving a major portion of the extensive collection of the cultural aspects of this historic American religious cult to the University for the permanent art collections ... Moore also announced that Andrews, an outstanding authority on the Shakers, has been appointed for a two-year period to the Yale faculty as consultant on Shaker history and culture.' Moore is then quoted as saying: 'The collection extends the scope of the existing collections at Yale in that present Yale holdings in early American are deeply influenced by European styles whereas the Shaker crafts and arts are more indigenous.' Parts of the Andrews collection have been exhibited at the Whitney Museum in New York City, at the Worcester and Berkshire Museums in Massachusetts, Fenimore House in Cooperstown, New York, as well as libraries in Lenox and Amherst.

44 See Davenport, T., 'Righteousness', *The New Yorker*, 1974, p. 31 where he states: 'One of the things I've tried to do in the film is to break down the constant effort of museum people to freeze the Shakers at about 1850.'

45 *The Shaker Quarterly* has produced numerous articles on the Shaker faith and philosophy and one such example is Weis, V., 'With Hands to Work and Hearts to God', 1969.

46 In the frontispiece of Casazza, E. & McKinnon, W., Catalogue for *Shaker Society Auction – June 20, 1972*, it states: 'The United Society of Shakers, Sabbathday Lake, Maine, have authorised The Maine Auction Service to sell at public auction on June 20, 1972, a select group of Shaker articles. The proceeds of this sale are to be used to establish a fund for the repair and renovation of the Shaker Herb House at Sabbathday Lake. This building is the last remaining structure of its kind in the country and must be preserved.' This auction as also commented upon in Reif, R., 'Antiques: Furnishings of the Shakers', *The New York Times*, 1972 in which she states: 'The auction last June, of some Shaker Society possessions from the Sabbathday Lake, Me., community brought astounding prices. Two sewing desks were sold for $3,250 and $3,500.'

47 See Rubin, C.E., 'Shaker Makes the Big Time', *The World of Shaker*, 1973.

48 Taken from Consolati, D., 'The Shakers' New Converts', *American Collector*, 1974 – in fact the round box is actually oval.

49 See Williams, R.L., 'The Shakers, Now Only 12, Observe Their 200th Year', *The Smithsonian*, 1974.

50 See Martin, D., 'Serene Twilight of the Shakers', *Life*, 1967 and also Leen, N. (photographer), 'The Shakers – A Strict and Utopian Way of Life Has Almost Vanished', *Life*, 1949.

51 See Kuhn, H.B., 'Whither the Shakers', *Christianity Today*, 1972.

52 See Delaney, B.S., 'The Shakers Today', *The Magazine Antiques*, 1970.

53 Ann Lee has been extensively discussed as in Campion, N.R., *Mother Ann Lee: Morning Star of the Shakers*, 1990 and Dobson, R., *Ann Lee – The Manchester Messiah: The Story of the Birth of the Shakers*, 1987.

54 See Harlow Ott, J., *Hancock Shaker Village*, 1976.

55 Hancock – letter from Mrs Lawrence K. Miller, 14 October 1963 (The Edward Deming Andrews Memorial Collection, Winterthur Library, Box 31): 'Dear Faith and Ted, Many different publics have been served by Shaker Community, Inc., during the three years since its organisation in 1960. Through

its operation of Hancock Shaker Village as an outdoor museum, enjoyment and education have been provided to 16,806 visitors. Our publics include – Historians, Antiquarians, Artists, Architects, College people, Graduate students, School children, Campers (2,000 strong), Teachers, Researchers, Casual tourists and serious viewers. Hundreds of dedicated men and women have studied our collections and have been assisted in their work by our director and staff. This year, alone, more than 1,000 attended lectures given by staff members; the story of Hancock Shaker Village reached still broader groups via radio and television ... I do not hesitate to appeal to Berkshire pride for support of the only Western Massachusetts museum village. In order to grow, we have to live through these early years, building from local interest and strength to the point where national renown assures us ample financing of the kind given by the possessors of great fortunes to museum villages like Greenfield Village, Colonial Williamsburg, Shelburne and Old Sturbridge. With all this in mind, we are keeping our sights high and our horizons broad.'

56 The plans for Hancock to become a preserved village were formulated before 1960, as a letter from Amy Bess Miller indicates: 'I owe you a thousand apologies for not having written to you first of all about my lunch with Mrs Adolf Berle who gave me the material which you and your wife had prepared on the proposed Shaker Conservation Project in Hancock, Massachusetts.' The letter is dated 27 June 1958. Taken from The Edward Deming Andrews Memorial Collection, Winterthur Library, Box 24.

57 Mrs Lawrence K. Miller is also known as Amy Bess Miller who has written about herbs, for example, 'Celebrate the Garden – Shaker Herbs and Their Relevance Today', Fall Antiques Show – In Celebration – The Herb Garden, 1981.

58 Perhaps the most important building for careful preservation and restoration was the Round Stone Barn. For a three-dimensional model of this building see Gillon, E.V., A Cut & Assemble Shaker Village, 1986. This was built in 1826 and considerable rebuilding was required to stop deterioration; its restoration has meant that it is now viewed as the jewel in the crown of Hancock: see Deeley, J., 'Round Is Beautiful', Connoisseur, 1987 and Ries, S., 'The Shaker Round Barn', Interior Design, 1987. Architecture is also detailed in The Realities of Restoring The Shaker Community at Hancock, Massachusetts – The Importance of Its Preservation as part of the American Heritage (unpublished manuscript, The Edward Deming Andrews Memorial Collection, Winterthur Library, Box 31). In addition, pamphlets were produced to promote Hancock in August 1960.

59 The development of Hancock was also featured in Shanor, R., 'Berkshire Shaker Village to be Museum Town', The New York Times, 1961, which states: 'The curator will be Dr Edward Deming Andrews, whom many consider the country's outstanding Shaker scholar and writer. The Andrewses' library and collection of Shaker furniture, religious drawings, music and documents has been given permanently to the restoration.'

60 Letter to Mrs Rockefeller (dated 9 July 1958 from the Andrewses' residence, Shaker Farm): 'Mrs Andrews and I are deeply appreciative of your interest in and investigation of the proposed Shaker Conservation Project in Hancock, Massachusetts ... Regarding your suggestion of the National Trust for Historic Preservation – we were in touch with Mr Howland last fall regarding possible ways and means of preserving one of the two remaining Shaker communities (Hancock, Mass. and Pleasant Hill, Ky.). Mr Howland stated in his reply that it was the policy of the National Trust to work only in collaboration with state and local organisations. Since we had already investigated the latter sources and found them lacking in interest, we knew that we could not expect any support from Mr Howland's organisation.' The Edward Deming Andrews Memorial Collection, Winterthur Library, Box 24.

61 Information taken from Trustees' meeting minutes from Winterthur source boxes; for example those dated 1 November 1959 (The Edward Deming Andrews Memorial Collection, Winterthur Library, Box 30).

62 Unspecified and Librizzi, J. (photographer), 'Moving Day at Hancock', The Berkshire Eagle, 1962: 'Moving day came again to Shaker Village, Hancock, this morning, as another 16-by-20-foot section of the historic Shaker meetinghouse arrived from Shirley. Here one of the movers guides the huge trailer back toward the new site. Structure is being moved in nine sections. Because of the 16-foot width of the load, this section had to spend last night in North Adams, and travelled with police

escort.' Also Shaker architecture, with specific reference to places of worship, has been featured in Mazmanian, A.B., *The Structure of Praise*, 1970, p. 31, which states: 'The meetinghouse on the following pages was moved to Hancock in 1962 from its original site at Shirley in the central part of the state. It replaces an identical meetinghouse on the site that had been built in 1785. Both were constructed by Moses Johnson of Enfield, New Hampshire, a Shaker who is thought to have built at least seven similar houses in eastern Shaker communities.'

63 See Sprigg, J., 'Hancock Shaker Village: The City of Peace', *The Magazine Antiques*, 1981, pp. 885 and 889.

64 See Shanor, R., 'Berkshire Shaker Village to be Museum Town', *The New York Times*, 1961.

65 Unspecified and Librizzi, J. (photographer), 'Moving Day at Hancock', *The Berkshire Eagle*, 1962: 'Dr Edward Deming Andrews, writer and collector who is generally regarded as America's foremost Shaker authority, is supervising the restoration and is also curator. The Andrews collections of Shaker furniture, documents and drawings, have been donated to the project by Dr and Mrs Andrews. "We're trying to present a complete culture," says Dr Andrews, "showing the things the Shakers contributed to American life through their religion, their craftsmanship and their agriculture. At the same time, we're trying to keep the spirit of the place intact" ... At Hancock, Dr Andrews had drawn on his three decades of study to recreate the site as a complete nineteenth-century Shaker village, including the gardens and grounds. In keeping with Shaker simplicity, there is no ornamental planting, but there are roses along the fence for making rose water, herbs in the garden for medicinal use, and fruit trees among the buildings. The simplicity continues inside the buildings, in the flat white walls, the straight butternut-stained woodwork, pegboards for hanging, and functional furniture ... Today the non-profit project includes over 13,000 catalogued items – everything from buttons to a seven-ton trip hammer. There is a complete blacksmith shop, a broom shop, a textile building and a domestic crafts building. Open for the first time this year is a music corner. Other exhibits pay tribute to the Shaker garden seed industry – the first large-scale US grower and distributor of packaged seeds – and to the medicinal herb industry, which was the first in the New World.'

66 For example, a report by Edward Deming Andrews, 24 March 1962, pp. 2–4: 'At our last board meeting in New York on December 7, 1961, I gave an interim report which outlined activities at Hancock Shaker Village up to that time. Included was a so-called "master plan" on the eventual restoration and furnishing of certain buildings, proposals for the development of the grounds, and suggestions on projects which we might consider to give the village an authentic Shaker atmosphere. Because considerable ground was covered in my last report, the present one will be concerned chiefly with recent activities on the part of the curator, and with recent developments at the village.' In addition, Edward Deming Andrews also indicated that he as curator had visited Colonial Williamsburg and viewed the Shaker inspirational drawings were on display: 'Our visit was productive in several respects and gave us an opportunity to talk with many people – museum directors and others concerned with American art and history – regarding the project at Hancock. The importance of such work as they and we are doing was well expressed by Dr Edward P. Alexander, a vice-president of Colonial Williamsburg. We ourselves were aware, at the meetings of the Antiques Forum that since we last visited Williamsburg in 1956 there has been a noticeable increase in interest in our national heritage, and that the mood of the public is becoming ever more serious. What is happening there and at other historic restorations has relevance for us.' The Edward Deming Andrews Memorial Collection, Winterthur Library, Box 31.

67 The Edward Deming Andrews Memorial Collection, Winterthur Library, Box 31.

68 The Edward Deming Andrews Memorial Collection, Winterthur Library, Box 31: the first page of the minutes indicates that Dr and Mrs Edward Deming Andrews were unable to attend.

69 Taken from 'Part I: The Opening of the Door' in Andrews, F., *The Hancock Story*, 1982: 'Late on a fall afternoon in 1923 Ted and I were returning home from a day in the country. Our Model T Ford seemed to slow down as we approached the red brick dwelling of Hancock Shaker Village. Suddenly we were hungry and the fragrance of bread baking tempted us to turn in at the back door. A Shaker sister answered our knock and the door was opened ... This marked the beginning of our Shaker adventures and the turning point in our life work. Sister Alice sensed our excitement and eagerness to know more

of the Shaker life and invited us to come for tea and meet the family members. It was within this community that we learned the basic rules of the Society, had our first glimpse of the furniture, and came to know its members as friends ... As news of our work and studies reached the Shakers in the remaining communities, we planned regular visits with them. Our collection grew rapidly through these contacts as did our knowledge of the culture. Exhibits, lectures and Ted's writing became an important part of what the Shakers would have called our "Joint Interest". Sister Sadie's gift of the original New Lebanon Covenant (1795) confirmed our belief that the building of a Shaker library was of utmost importance. With the help of the Shakers themselves we embarked on this major undertaking. Our search for material included a trip to Manchester, England, birthplace of Mother Ann, to study newspaper accounts of her activities ... Our many exhibits and publications laid the groundwork for what we hoped would be our greatest project, the restoration of a Shaker community and the creation of a museum dedicated to preserving and promoting the cultural values of the Shakers.' Unpublished manuscript, The Edward Deming Andrews Memorial Collection, Winterthur Library, Box 31.

70 See 'Part II: The Closing of the Door' in Andrews, F., *The Hancock Story*, 1982: 'Appropriately, Ted was appointed the Curator of Collections and consultant for programme development for the museum. Ted and I both felt that merely installing our collection into these buildings was not sufficient. As he explains in the "Guidance Services" section of his plan for the museum, the artefacts lack meaning unless they are related to the culture through educational programmes ... Because of our close friendship of some 25 years, Amy Bess Miller had seemed the logical person to spearhead Shaker Community. She was, additionally, an active and influential member of Pittsfield society and the wife of Lawrence K. Miller, editor of the local paper. We could not foresee that, after she became President of the organisation, our ideas would diverge and eventually conflict ... We believed that our vision for the museum was the same as that of Mrs Miller and the Board of Directors. Our vision, as Ted often reminded the Board in the minutes, was: That the spiritual values inherent in the Shaker culture be transferred to our project. Any museum can preserve and catalogue artefacts in increasing numbers and varying quality. But to preserve the spirit, the force out of which these artefacts came, could be accomplished only if all of us understand and profoundly believe in Shaker principles ... While our interests and goals remained the same, it became obvious that those of the Executive Committee were diverging. Wilber H. Glover, former Director of the Buffalo and Erie Historical society, was appointed Director at Hancock, a move that Ted welcomed, feeling the need for assistance with the increasing workload of administration. He did not foresee that the director was intended to replace him ... Ted died on June 6, 1964. Shortly after Ted's death, I called Mrs Miller regarding the agreement and she came to my house with Mr Glover. She announced that she had no intention of publishing the catalogue which was two-thirds completed unless given a large donation specifically for that purpose. No catalogue was published and no credit has ever been given for the collection.' It was stated by Faith Andrews that the document was not to be released in her lifetime.

71 See letter dated 25 January 1968 in The Edward Deming Andrews Memorial Collection, Winterthur Library, Box 24.

72 See letter in The Edward Deming Andrews Memorial Collection, Winterthur Library, Box 24.

73 See Lee, V. & Baldwin, J., 'Divine Art', *Homes and Gardens*, 1990, which features Hancock, and also Van Kolken, D., 'Hancock Shaker Village 25 – Founded in 1790 – 25th Anniversary as a Museum', *The Shaker Messenger*, 1985 and Van Kolken, D., 'Hancock Observes 200th Anniversary', *The Shaker Messenger*, 1990.

74 Eugene Merrick Dodd (Curator of Hancock Shaker Village) produced an essay on Shaker Design and Art for both exhibitions. See Dodd, E.M., Catalogue for *Shaker Art*, 1966 and Dodd, E.M., Catalogue for *Shaker Design – The Art and Furnishings of An American Communal Sect*, 1967.

75 See Lambert, A., 'True Colours', *The Sunday Telegraph*, 2000 and also the television programme Robson, K. (producer) & Nightingale, M. (presenter), *Wish You Were Here*, 2001.

76 The Smithsonian Guides to Historic America feature a number of Shaker sites: see Muse, V., *The*

Smithsonian Guide to Historic America – Northern New England, 1989 and Wiencek, H., The Smithsonian Guide to Historic America – South New England, 1989.

77 Refer to 'Western Shaker Furniture' in Andrews, E.D. & Andrews, F., Religion in Wood: A Book of Shaker Furniture, 1966, pp. 93–101.

78 For further discussion see Andrews, E.D., 'Kentucky Shakers', The Magazine Antiques, 1947, Neal, J., 'Regional Characteristics of Western Shaker Furniture', The Magazine Antiques, 1970 and Neal, J., The Kentucky Shakers, 1982 (Neal was a recognised expert on the Shakers and wrote generally about their development: see Neal, J., 'The American Shakers', Communities, 1985). In addition, others have discussed the merits of western Shaker artefacts, for example, Bookout, T.J., 'Western Shaker Furniture: Ohio & Kentucky', The World of Shaker, 1975 and Hines, T., 'Shaker Furniture from South Union', The Magazine Antiques, 1997.

79 The Shaker Micajah Burnett has been of particular interest to architectural historians because of his building designs at Pleasant Hill: see Thomas, J.C., 'Micajah Burnett and the Buildings at Pleasant Hill', The Magazine Antiques, 1970.

80 See Williams, R.M., 'Shaker of the West – One Man's Collection', Americana, 1979. Also refer to Watkins, D., 'Julia Neal Showed Early Interest in Kentucky Shakers', The Shaker Messenger, 1989.

81 See Neal, J., The Kentucky Shakers, 1982.

82 Taken from Haagen, V., 'Shakertown II: Settlement in Kentucky', Travel, 1973.

83 Winchester, A., 'Shakertown at Pleasant Hill', Historic Preservation, 1977, p. 14: 'The earliest building is the stone Farm Deacon's Shop, built in 1809 as a dwelling and later converted to a tavern for the "accommodation of wayfarers". The Meeting House, spiritual centre of the community, was built in 1820 and today the spare, spacious meeting room looks as it did when the Shakers used if for worship and their "shaking" dances. The brick Trustees' Office, perhaps the most beautiful building at Pleasant Hill, dates from 1839; its twin spiral stairways rising through three stories are a triumph of graceful construction.' Also see Chemotti, M.R., 'Outside Sources for Shaker Buildings at Pleasant Hill', Kentucky Review, 1981.

84 Much of the history is detailed in Clark, T.D & Ham, F.G., Pleasant Hill and its Shakers, 1987. This is the guidebook which is provided at Pleasant Hill to augment the general information for visitors.

85 This information was taken from the free guide provided to visitors at Pleasant Hill (printed by Gateway Press Inc.).

86 Notes taken from Mac-Hir Hutton, D., Old Shakertown and the Shakers, 1987, p. 7. In a concluding section entitled 'The End Comes' the following quotation is of interest: 'The dissolution of the Society took place in Sept. 1910 and later with the passing of Dr Pennebaker and Mary Settles, a well-known Elderess and teacher in the society, the doings of the Shakers passed into the realm of forgotten things. Upon the dissolution of the society all of the eleven members signed the agreement.'

87 Some buildings were damaged and this was identified in the regional press, for example in Griffin, G., 'Shakertown – Many Buildings In The Town Are Damaged', The Courier-Journal Magazine, 1961 and the specialist press, for example The Guild of Shaker Crafts Inc. (publisher), 'Restoration of Old Stone Shop Nears Completion at Pleasant Hill', The World of Shaker, 1973.

88 This has been commented on by Thomas, S.W. & Thomas, J.C. in The Simple Spirit, 1973, which contains a number of interesting photographs. On p. 7 it states: 'Careful examination of old photographs will show that many structures have been destroyed by neglect or by the calamities of wind and fire. Some have been moved and reused. Some are outside the restoration boundaries and are not open for public inspection.'

89 A photograph in The Guild of Shaker Crafts Inc. (publisher), 'Restoration of Old Stone Shop Nears Completion at Pleasant Hill', The World of Shaker, 1973, illustrates the restoration of the Old Stone Shop at Pleasant Hill with the annotation: 'Before restoration Victorian additions to Pleasant Hill's Old Stone Shop had changed its appearance considerably from Shaker days.'

90 Pleasant Hill, taken from Griffin, G., 'Shakertown – Many Buildings In The Town Are Damaged', Courier-Journal Magazine, 1961, p. 26: 'It's high time some organisation took action to preserve the stately old Shaker buildings with their double entrances. For, after withstanding the ravages of time

and the elements, some of them are being destroyed by man. Only the stone foundation and a pile of bricks mark the site of one of the ancient homes. Another old stone house with graceful lines is being carried away, rock by rock. Only parts of the Kentucky River marble walls remain standing like a skeleton atop a gentle slope. The roof is gone and so are the broad-boarded floors, the giant beams, the window sills and everything else made of wood.' The article continues: 'Outside is Unchanged – One of the original stone buildings, much smaller than most of the others, at the junction of US 68 and KY 33, remains on the outside just about like it was when the Shakers built it, in 1809. But the inside is different. The two big fireplaces have been plastered over. In recent years the historic old house has served as a gasoline station and as a restaurant. Probably the finest house occupied by the Believers now remaining in use is a large brick structure once used by the sect as their Trustees' Office, or administration building. Now it is an inn where meals are served to the public.'

91 Information taken from *A Map and Guide to the Shaker Village of Pleasant Hill, Kentucky*.

92 Taken from 'Project Started To Restore, Preserve Historic Shakertown', *Harrodsburg Herald*, 1961: 'Group Plans To Acquire Village and restore it to represent 19th-century Shaker Life. A new organisation to restore and use Kentucky's famous Pleasant Hill village called Shakertown, this county, was announced Wednesday night by Robert B. Jewell, chairman of a special committee reporting to the Blue Grass Trust for Historic Preservation. The meeting was held at the John Hunt Morgan House, Lexington, with Hilary J. Boone Jr, president of the trust, presiding. The Trust's committee on the Shakertown Project submitted a report stating that a charter of incorporation will be filed with the Secretary of State of Kentucky creating a non-profit, tax-exempt corporation called "Shakertown at Pleasant Hill, Inc.".'

93 See Muse, V., *The Smithsonian Guide to Historic America – Northern New England*, 1989 for complete details.

94 Pleasant Hill – article taken from *The Berkshire Eagle*, 9 November 1961, states: 'Organising is under way in Kentucky for the acquisition and restoration of buildings at the Pleasant Hill Shaker colony and their use for museum and educational purposes as a $1.5 million project. A report on the Kentucky plans was brought back by Dr Edward Deming Andrews, curator of Hancock Shaker Village here, who spoke last weekend at a seminar at Pleasant Hill. Dr and Mrs Andrews attended several functions arranged by the group working on the project, and were weekend guests of one of the board members, Barry Bingham, editor-publisher of the Louisville *Courier-Journal*. At Pleasant Hill, which is to be operated for the public under the name of 'Shakertown', are some 30 buildings described by Dr Andrews as "about the most beautiful examples of Shaker architecture anywhere", showing a southern influence in their design. The Shakers gave up the settlement in 1910 after a century of operation, and many of the buildings are in very poor condition, Dr Andrews said. "The Shakertown organisers," he reports, "have secured options from five owners covering 18 of the buildings and 110 acres of land." The group is seeking $500,000 to purchase the property and estimates that another million dollars will be needed to restore buildings and launch public operations …'

95 Much of the development is featured in a 1971 supplement of *The Harrodsburg Herald* entitled 'Shakertown at Pleasant Hill'. Pleasant Hill continues to be developed: see Sparrow, M.L., 'Research Reveals Pleasant Hill Shaker Sacred Outdoor Meeting Site', *Shakers World*, 1997.

96 A manuscript entitled 'The Dedicated Stewardship of Betty Morris – Twenty-three Years of Corporate Affairs and Financial Problems of Shakertown at Pleasant Hill, Kentucky, Inc.', states on pp. 22–23: 'Coming out of a quandary, I soon decided to drive to Indianapolis and explain our predicament to Mr Eli Lilly, who had become highly interested in Pleasant Hill since 1964. He asked me how much it would take to see us through the winter of 1970 and I told him $100,000. His response was "I had better see you through two winters". He spent $50,000 every six months for two years which saw us through the first operating crisis … A capital donation was necessary to begin the third stage. On his visit to the village a month before, Mr Lilly had asked me about how much remained to be done. So later I drove to Indianapolis and outlined the above third and final stage of restoration to him and he agreed to finance it to the extent of $270,000.' The Edward Deming Andrews Memorial Collection, Winterthur Library, Box 19.

97 See map in Thomas, S.W. & Thomas, J.C., *The Simple Spirit – a Pictorial Study of the Shaker Community*

at *Pleasant Hill, Kentucky*, 1973 and also Colihan, J., 'Shaker Retreat', *American Heritage*, 1995. See also Breeding, M., Lindgreen, J. & Thomas, J., *The Architectural Heritage of the Shakers at Pleasant Hill* (video).

98 'The Dedicated Stewardship of Betty Morris – Twenty-three Years of Corporate Affairs and Financial Problems of Shakertown at Pleasant Hill, Kentucky, Inc.', p. 22: 'The Honourable Rogers C.B. Morton, secretary of the US Department of the Interior, came to Pleasant Hill in 1972 and presented in person a certificate, and later a bronze plaque, designating the village and our 2,100 surrounding acres, formerly a part of the Shaker community, a National Historic Landmark.' The Edward Deming Andrews Memorial Collection, Winterthur Library, Box 19.

99 Kallan, C., 'Travelling Through Time', *USAir* (Magazine), 1991, p. 59. Interestingly the article states that the Shakers are extinct, which was/is not the case.

100 Colihan, J., 'Shaker Retreat', *American Heritage*, 1995, p. 28 describes how a museum village near Harrodsburg, Kentucky, lets visitors experience Shaker style by spending the night: 'We checked into a room on the third floor of the East Family Dwelling. How authentic were our accommodations? It seemed to me that Pleasant Hill has found about the right blend of historical flavour and modern comfort. In Shaker days men would have slept on one side of the house, women on the other, but now couples can stay together. Our room had a bare floor with rag rugs and a simple wooden bed. Whatever light we had came from a few candles, and although they were powered by electricity (real ones would have endangered the building), they cast a soft, nineteenth-century glow. We had a brand-new bathroom, a telephone, a television set. But the Shakers had no quarrel with progress; they invented a host of laboursaving devices and were quick to embrace new technology. My husband idly turned on the television. Swept up in religious fervour, I turned it off.'

101 Winchester, A., 'Shakertown at Pleasant Hill', *Historic Preservation*, 1977, pp. 18 and 20: 'The strength of the Pleasant Hill operation lies in its innovative application of the principle of adaptive use, following a plan developed and implemented by James L. Cogar, formerly curator of Colonial Williamsburg, who served as executive director of Pleasant Hill until 1974. While eight of the original Shaker buildings have been completely restored for use as exhibition areas, others have been adapted for use as guest houses, providing comfortable overnight accommodation in actual Shaker rooms for 140 people. Dining facilities have been installed in the Trustees' Office and one cluster of buildings has been converted to a fully equipped conference centre for group meetings. This practical use of major original buildings is rare, if not unique, in such a restoration and it has immense advantages: it obviates introducing modern hotel structures and thus preserves the unity and original character of the village; it gives visitors an unusual and intimate contact with the Shaker environment; and is remunerative. The old buildings are used too by the working craftsmen and the retail shops, for offices and other staff purposes – indeed for everything. Except for a maintenance shop and small snack shop, there are no new structures at Pleasant Hill.' Also Haagen, V., 'Shakertown II: Settlement in Kentucky', *Travel*, 1973, pp. 43–44: 'Upon entering Shakertown, visitors literally step back into history: even the Commonwealth of Kentucky has cooperated by re-routing a main highway that once ran through the community, and telephone and power lines have been buried to avoid marring the authenticity of the scene. Throughout the village, care has been taken to restore or reproduce every detail to its original state: the slate-blue and brick red interior paint, hallmarks of Shaker austerity, have been compounded from original formulas … Delicious congealed salads, fragrant home-baked breads and biscuits, pungent country ham – and a justly famous Shaker Lemon pie, containing paper thin shredded fresh lemons – are among the many offerings to lure trencherman miles off their planned paths, and which delight tourists and native Kentuckians alike. To fully savour it all, a one or two-night stay provides an opportunity to sample a hearty Shaker breakfast, lunch and dinner by candlelight, with sufficient time to tour the entire village and its exhibits.'

102 See Nickels, E., 'The Shaker Furniture of Pleasant Hill, Kentucky', *The Magazine Antiques*, 1990.

103 Pleasant Hill is featured in Meek, R., 'Rich Shaker Legacy', *American Home*, 1969 and Unspecified, 'The American Country Look – Shaker', *Better Homes and Gardens*, 1972, with photographs. It has also featured in an exhibition of 'Two Shaker Villages: South Union & Pleasant Hill, Kentucky' when it states: 'As we in America celebrate our 200th anniversary the rest of the world also finds much to discover and study

about America and its Shakers. Simultaneous with the initial showing of this exhibit at the J.B. Speed Art Museum in Louisville, Kentucky, Europe will be viewing an exhibit entitled "The Shakers" at the Musée des Arts Décoratifs in Paris, France. This European exhibit, which also contains many items from Kentucky, originated in 1974 in Munich, Germany ...'

104 For example, Archambeault, J. & Clark, T.D., *The Gift of Pleasant Hill – Shaker Community in Kentucky*, 1991 and Parrish, T., *Restoring Shakertown*, 2005.

105 See Clark, T.D. & Ham, F.G., *Pleasant Hill and its Shakers*, 1987, p. 97.

106 Dones, J., 'Pleasant Hill Friends Hear of Challenges at Village', *The Shaker Messenger*, 1995.

107 Many writers have commented on this, and in Kirk's book, *The Shaker World*, 1997, p. 239, he notes: 'In the early 1960s for example, they encouraged and helped Henry Francis du Pont to add Shaker rooms at Winterthur, and they were the major source of Shaker rooms and furnishings for the Metropolitan Museum of Art, and the American Museum in Bath, England. They did not, however, discover the Shakers nor originate the collection of Shaker things. Others, for at least two decades before them, had collected the Society's artefacts, and the Shakers themselves knew much of their own history through an active oral tradition, their own considerable written works (which were read extensively by members), and their archives.'

108 This was referenced in Elsdon, J., *Visitor Guide – The American Museum in Britain*, 1998 and Garrett, W., 'The American Museum in Britain', in a special edition of *The Magazine Antiques*, 1993.

109 After his death Dallas Pratt received an obituary in *The Guardian* newspaper in which he was given credit for the formation of the American Museum in Britain: see Rule, V., 'New World Seen by Old Eyes (Obituary – Dallas Pratt)', *The Guardian*, 1994. Also see Armitage, A., 'Dallas Pratt', *America in Britain*, 1994.

110 John Judkyn was given considerable credit in Morse, F., 'Creating a Shaker Room', *America in Britain*, 1998, in which Morse details the formation of the Shaker room at the American Museum in Britain. Details were also obtained from a fax dated 15 June 1998 from Flo Morse to Anne Armitage, the Librarian at the American Museum in Britain at Bath.

111 Armitage, A., 'From Dallas Pratt to Electra Havemeyer Webb', *The American Museum in Britain – Newsletter Number 7*, 2000, indicates a communication with Electra Havemeyer Webb: 'A fascinating item for us at the American Museum was produced by one of the symposium contributors, Henry Joyce, curator of art at the Shelburne Museum in Vermont. In preparation for his talk on its founder Electra Havemeyer Webb, he discovered in the archives at the Shelburne a letter to her from our co-founder, Dallas Pratt. The letter spells out succinctly what we have always thought – that our co-founders had been greatly influenced in setting up the American Museum by their visit to the Shelburne in 1958.'

112 See Rubin, C.E., 'American Museum in Britain', *The World of Shaker*, 1973.

113 The museum's collections feature similar periods as those found in Naeve, M.M., *Identifying American Furniture*, 1998.

114 The museum produces a small pamphlet, *New World in The Old*, with illustrations by K. Fassett which gives an indication of the periods and styles featured in the many rooms.

115 The museums have exchange visits and both formal and informal associations. This is featured in a number of *The Shaker Messengers*.

116 The list of Shaker artefacts within the collections of the American Museum includes:
Chairs
i. Sidechair for dining – 1810–20 – One-slat type.
ii. Sidechair for use at a high counter – 1840–50 – New Lebanon.
iii. Rocking chair – 1820 – Hancock – Brothers, 4-slat in cherry.
iv. Rocking chair – 1840–50 – New Lebanon – for Sisters' sewing.
Stools
i. Three step – 1830 – New Lebanon – in pine.
ii. Two step – 1830 – Hancock – in pine.

Chests of Drawers
i. Tailoring counter – 1820–30 – ? Watervliet – with leaf – 2 long drawers – 4 shorter above. Top and drawer faces of curly maple, panels of pine, stiles and rails of ungrained maple.
ii. Sewing cabinet – 1820–30. Hancock – with leaf and 5 drawers – mixed woods which includes maple.

Tables
i. Drop-leaf – 1815 – Hancock – New Lebanon – in cherry.
ii. Candle stand – 1820 – New Lebanon.

Looking-Glasses
i. Looking-glass – 1825 – Hancock. Frame veneered with curly maple on front and sides. With rack and knobs for hanging smaller items.

In addition, there are some significant smaller wooden items including a wooden box for holding firewood and a pine sconce dated around 1820 (New Lebanon) with a tin candlestick (1820). Finally, there is a metal stove dated at around 1810, which has a shovel and matching tongs. A more comprehensive list can be found in pp. 100–05 of the guides and curatorial information which were obtained from the museum.

117 In Bone, H., 'Shaker Room at American Museum Result of Careful Study', *The Shaker Messenger*, 1982, p. 10, the following is of interest: 'Much careful study was embarked upon before any purchasing was done and in the case of the Shaker collection visits had already been made to Old Chatham and Fruitlands. From what Dr Pratt and Mr Judkyn had learned there it became obvious that they must approach Faith Andrews and her husband, Dr Edward Deming Andrews, whose collection was legendary, and a meeting was arranged.'

118 The glass cabinets also feature other exhibits including silk handkerchiefs, labels, photographs and some reproduction spirit drawings and books. Clearly this section was intended to add substance to the material in the room and indicate some context for the various artefacts. Interestingly, there does not appear to be much evidence of any fancywork due probably to the fact that it clearly went against the grain of the mainstream Shaker aesthetic.

119 The formation of an accompanying exhibition space also took considerable time and effort. See Bone, H., 'Shaker Room at American Museum Result of Careful Study', *The Shaker Messenger*, 1982, p. 11: 'A Gallery leading from the room is lined with showcases displaying examples of their many industries. In the first case there are delicate baskets of poplar wood: the craft, according to Eldress Bertha at Canterbury, having originally been learnt from travelling groups of Indians.'

120 See Morse, F., 'Creating a Shaker Room', *America in Britain*, 1998.

121 Ann Lee has featured in a number of British writers' work, including Sitwell, E., *English Eccentrics*, 1971, and the context of her development in Rack, H., 'Establishments, Evangelicals & Enthusiasm in 18th-Century Manchester, England, Part 2', *The Shaker Quarterly*, 1989 and Dobson, R., *Ann Lee – The Manchester Messiah: The Story of the Birth of the Shakers*, 1987. Also, Adamson, J. talks about Ann Lee in a book review: 'A Prophetess Shaken and Stirred', *The Sunday Telegraph*, 2000, p. 14.

122 See Morse, F., 'Creating a Shaker Room', *America in Britain*, 1998. In part of the closing statement in the article Morse states: 'Edward and Faith Andrews have come in for their share of scrutiny for their "frozen", romanticised view of Shakerism. A biographer claims they knew the Shaker villages long before creating the "myth" of buying a loaf of bread at Hancock in 1923 that whetted their appetite for treasures beyond the Shaker kitchen. And some of their dealings with the elderly Shakers in a period of distress over waning numbers and income were strained.'

123 These are clearly shown in Garrett, W., 'The American Museum in Britain', *The Magazine Antiques*, 1993, p. 441 (plate 9), where it states: 'The Shakers' ideal was a simple economy based on agriculture and raising stock, which was eventually modified by economic realities to include the sale of seeds and herbs they packaged and the boxes, baskets, brushes, sieves and clothes they made. However, in every endeavour the integrity of individual workmanship was maintained, for work was considered a God-given privilege, a form of worship expressed in the motto Hands to Work and Hearts to God. The

merging of work and belief caused the Shakers to develop furniture that embodied the principles of harmony, purity, restraint, order and utility – indeed, religion in wood.'

124 Morse, F., 'Creating a Shaker Room', *America in Britain*, 1998, p. 11. This includes a page of text (and an accompanying photograph entitled, 'The finest stand in America') which states: 'Before the museum opened they [the Andrewses] travelled to Bath to supervise the arrangement of the Shaker Room – and during the 40 years since that initial meeting their installation has been one of the most generally admired exhibitions at the American Museum. Even today visitors with some knowledge of the Shakers note the Andrews "stamp" on the room. No wonder. It has the characteristic forthright look of Shaker interiors that Edward Deming Andrews arranged in many American museums, galleries, exhibitions and in settings for the photographs in his books.'

125 A photograph of the room entitled 'A Shaker Sitting Room' is provided in Morse, F., 'Creating a Shaker Room', *America in Britain*, 1998, p. 2.

126 See Weir, G., ' Shaker Seminar – Lebanon, Ohio', *National Antiques Review*, 1973, p. 17 (including a photograph of the room).

127 See Large, Jr, J., 'New Shaker Exhibit Opened At Western Reserve Historical Society', *The World of Shaker*, 1975. This includes a photograph with the annotation 'A "room within a room" has been produced as a part of the new permanent Shaker Exhibit at the Western Reserve Historical Society, and contains furniture, rugs, a stove, lantern (not shown) and other household items. The customary pegboard and built-in drawers and cupboards emphasise the authentic surroundings.' See Bibliography for other articles by Large on the Western Reserve Historical Society.

128 Stein, S.J., *The Shaker Experience in America*, 1992, p. 402 comments on the creation of material outside village contexts: 'Several significant Shaker museums or permanent exhibitions of Believers' objects are not located at former village sites. The largest of these is the study collection of objects and documents at the Shaker Museum and Library in Old Chatham, New York. Other noteworthy exhibits scattered throughout the country and overseas include those at the Henry Francis du Pont Winterthur Museum in Delaware, which was the recipient in 1967 of the Edward Andrews Shaker library ...' Also the museum has been featured in numerous publications, for example, Olmert, M., 'Winterthur's Forgotten Treasures', *Historic Preservation*, 1989.

129 Winterthur has produced a large book based on the collections and period rooms: see Cantor, J.E., *Winterthur*, 1997. Also see Eversmann, P.K., *Winterthur – A Portrait*, 1991, for an illustration of the Shaker room and a photograph of some Shaker boxes. This special arrangement photograph was produced in 1984 for a calendar. It is interesting that in the majority of material produced by Winterthur they generally feature a Shaker image and this would indicate the enduring popularity of the Shaker aesthetic.

130 See Cantor, J.E., *Winterthur*, 1997, p. 202 for a photograph of the Shaker dwelling room.

131 This extract features in Eversmann, P.K., *Discover The Winterthur Period Rooms*, 1998, front page. This booklet is intended for visitors to Winterthur and is part of the 'Discover' series.

132 In the review by Peladeau, M.B. of the book *Illustrated Guide to Shaker Furniture* taken from *The Shaker Quarterly*, 1972, the following is of interest: 'It is always useful to see Shaker furniture in Shaker settings. The Shaker Museum, although it owns no actual Shaker buildings, has attempted to do this in its recreated gallery displays. All these are extremely well done. It is hard to understand, however, why the author did not use settings of Shaker furniture in actual not recreated Shaker interiors. Sabbathday Lake and Fruitlands Museums immediately come to mind where Shaker furniture is beautifully displayed in extant Shaker buildings. Winterthur also has installed a flawless room from Enfield, NH, and furnished it with fine pieces.'

133 Found in Ward, G.W.R. (ed.), *Handbook for Winterthur Interpreters, A Multidisciplinary Analysis of the Winterthur Collection*, 1987, pp. 190–91; this material was also presented in the *Winterthur Newsletter* of 23 April 1962 and details the Shaker Rooms with both a room analysis and description.

134 See Ward, G.W.R. (ed.), *Handbook for Winterthur Interpreters, A Multidisciplinary Analysis of the Winterthur Collection*, 1987, p. 190: 'The woodwork in the larger room, with the exception of the horizontal sheathing on the west wall, is also from the building at Enfield, but is used as trim in the existing

space at the Museum. Such unusual architectural devices as interior skylights and a closet in the corner of a chimney projection have been introduced to provide auxiliary lighting in the room, but are copied from elements in the Shaker buildings at Hancock, Massachusetts. The dominant architectural feature of the two rooms is the storage wall dividing them and containing cupboards and banks of drawers which open alternatively into each room. This feature is a forerunner of storage facilities in modern buildings.'

135 See Ward, G.W.R. (ed.), *Handbook for Winterthur Interpreters, A Multidisciplinary Analysis of the Winterthur Collection*, 1987, p. 191: 'This chair represents the Shakers' mass production of chairs, which were sold at the different communities and were distributed through metropolitan outlets such as Lewis and Conger. Near the door of the Storeroom is a straight-backed armchair made early in the twentieth century at New Lebanon and indicate the continuation of the Shaker style of furniture through the chair industry, which closed as recently as World War II.' All Winterthur Museum's collections, including Shaker artefacts, are comprehensively catalogued.

136 See 'The Evolution of Collecting and Display at Winterthur' in Ward, G.W.R. (ed.), *Handbook for Winterthur Interpreters, A Multidisciplinary Analysis of the Winterthur Collection*, 1987, p. 17.

137 Walking from through rooms of different periods (internalised external architectural features) and many styles is an experience that takes some getting used to. Certainly many people find it enlightening whilst others find it overwhelming and difficult to read visually. Winterthur has taken this in hand in the new galleries which tends to focus on isolated objects, looking specifically at their significance and meaning.

138 Interestingly, Edward Deming Andrews in an essay produced in 1966 also looks at Shaker symbols such as the pegboard. On p. 3 it states: 'Another example. The walls of every room in a Shaker meetinghouse or dwelling was lined with pegboards ... Their function was utilitarian, not decorative. On them were hung cloaks, bonnets, utensils, chairs, clocks, looking-glasses, candle sconces. Their purpose, however, transcended the cause of mere convenience. If floors were to be kept clean and the room in order, there should be "a place for everything, and everything in its place". The pegs could have been crude sticks, nails or hooks. Instead, they were delicately turned and stained, regularly spaced and strong. On visitors entering a Shaker room, the first impression was one of scrupulous neatness. The peg was a symbol.' The Edward Deming Andrews Memorial Collection, Winterthur Library, Misc. Boxes.

139 This model is used in Zimmerman, P.D., *Seeing Things Differently*, 1992. It was also provided as information in the galleries as part of the exhibits and as free leaflets. The galleries give the visitor the opportunity to view material at their leisure while the period rooms adopt a guided tour approach.

140 Eversmann, P.K., *Discover The Winterthur Period Rooms*, 1998, p. 40.

141 See Spraker, E.C., 'Simple Art of the Simple Life', *Evening Journal*, 1969.

142 De Montebello, P., 'Introduction' in Peck, A. & O'Neill, J.P. (ed.), *Period Rooms in the Metropolitan Museum of Art*, 1996, p. 9, states: 'One of the most popular attractions at the Metropolitan Museum – and ironically one that is not without controversy – is our collection of period rooms ... It is clear when one visits the Museum why these spaces are evocative and appealing. What may not be clear is why their existence is subject to debate. Some scholars and experts in the field of decorative arts do not agree on their appropriateness in an art-museum setting, their purpose, and their degree of authenticity. Some would prefer to have such rooms confined to historic houses, where they may be seen in their original architectural context. But others feel that the careful combination of architectural elements rescued from condemned buildings with contemporaneous works of decorative art and furniture serves a number of important functions, not the least of which is preservation.' The book then goes on to discuss the room within the American Wing: 'The tradition of period rooms in America is usually associated with institutions that thrived during the 1920s, when entire buildings were created and filled with rooms in such styles as "Early American", "Colonial" and "Federal". Winterthur, Colonial Williamsburg, the Brooklyn Museum and the Metropolitan with its American Wing (which opened in 1924) all participated with great enthusiasm. As scholarship became more sophisticated, questions of authenticity were posed about rooms that had been "enhanced" where the original was in less than

perfect condition. Also, the beginnings of the activist historic-preservation movement made people aware that it was preferable to save buildings intact rather than to remove rooms. At this point, the period-room movement went into a quiet phase, which lasted for nearly 30 years, from the 1950s to the 1980s, when curators and art historians began to re-evaluate the importance of period rooms and in many cases revised not only their thinking, but also the rooms themselves.'

143 Frelinghuysen, A.C., 'Metropolitan Opens Shaker Room', *The Shaker Messenger*, 1981, notes: 'The Metropolitan Museum of Art in New York is opening a Shaker room Nov. 11 ... a new permanent installation in the new American Wing. The Shaker Room is part of the continuing 19th-century installations in the American Wing. The installation is a Shaker "retiring" room from the North Family Dwelling House of the New Lebanon, NY, Shaker community, one of the oldest and most important of all Shaker communities. The majority of the fixtures and fittings within the room were obtained from the Darrow School who had taken over the buildings at Mount Lebanon.' Also see Frelinghuysen, A.C., 'Metropolitan Museum's Shaker Room Opens', *The Shaker Messenger*, 1982.

144 Taken from the Shaker room chapter in Peck, A. & O'Neill, J.P. (ed.), *Period Rooms in the Metropolitan Museum of Art*, 1996, pp. 231–37.

145 Peck, A. & O'Neill, J.P. (ed.), *Period Rooms in the Metropolitan Museum of Art*, 1996, p. 11.

146 Reif, R., 'Antiques: Furnishings of the Shakers', *The New York Times*, 1972, p. 26, features the sale at Darrow with the school taking bids on the 1818 house contents: 'And so, in March, the building erected in 1818 and enlarged in 1963 will be razed. But first the ingenious and often extremely refined architectural elements and built-in furnishings will be removed – stick by stick, pane by pane – following the sale now under way. The Darrow School has prepared a catalogue of the 182 lots offered and is accepting bids through Jan. 15. "The reaction to our public announcement has not all been favourable," disclosed Ronald Emery this week. Mr Emery, who heads this co-educational school's English department, is supervising the sale. He said the news sparked many letters of outrage from preservationists and museum officials expressing concern over the building's demise ... With the exception of a staircase and a relatively simple room purchased earlier by the Metropolitan Museum of Art, the cobwebbed interiors are virtually intact.' Also see below on Philadelphia Museum in which material from Darrow School is detailed.

147 Frelinghuysen, A.C., 'Metropolitan Opens Shaker Room', *The Shaker Messenger*, 1981, p. 9, indicates that their influence could be seen in the furniture selection: 'The retiring room, where Sister Mozella Gallup and her predecessors slept and meditated, will be furnished with choice examples of Shaker craftsmanship from the Museum's collection. Much of the furniture that will be used in the room was originally part of the major collection formed by Faith and Edward Deming Andrews, which was purchased with funds from the Friends of the American Wing ... The furnishings reflect as accurately as possible the functions of the room – sleep, small handiwork and meditation prior to evening worship. Documentation was gleaned from instructions written in the Millennial Laws, print sources, 19th-century photographs, as well as the furniture itself. It would seem that authenticity only went as far as the furniture and smalls since reproduction textiles were used, including white linen window curtains, linen towels, pillow cases, blankets and a woven rag rug.' Frelinghuysen, A.C., 'Metropolitan Museum's Shaker Room Opens', *The Shaker Messenger*, 1982, gives more information and also contains a photograph of the room.

148 The following list is taken directly from the Shaker room annotation and is a sample only:
 1. Blanket chest – United States – 1835–75. Pine.
 2. Boxes – United States – 19th-century. Maple and pine.
 3. Hangers – United States – 19th-century. White pine (lent by the Andrews Collection).
 4. Bonnet – Enfield – Connecticut – 19th-century. Straw.
 5. Candle stand – New Lebanon, New York. 18th-century. Cherry, birch and pine.
 6. Pair of side chairs. New Lebanon or Watervliet, New York, or Hancock, Massachusetts. 1830–50.

149 See a definitive account of Shaker chair production in Muller, C.R. & Rieman, T.D., *The Shaker Chair*, 1984, including a section on revolving chairs on pp. 152–57. For an earlier review of furniture and

different chair types including a 'revolver' or swivel chair, see Meader, R.F.W., *Illustrated Guide to Shaker Furniture*, 1972, p. 32.

150 A letter dated 31 July 1973 from Beatrice Garvan (Assistant Curator American Art) to Mr Ronald Emery (The Darrow School, New Lebanon, New York) states: 'You will recall that you told me that someone had taken detailed photographs of the interior of that building before it was demolished. I understand the Metropolitan Museum did photograph their room, which is a mirror of ours. However, it would be most useful, indeed essential, for us to have a photograph of our room before it was dismembered, as the large chest of drawers had been dismantled before I got there, and it was impossible for me to even attempt such a recording process ...' This is just one example of letters between the two recipients and was provided by Martha C. Halpern, Assistant Curator. Also see Reif, R., 'Antiques: Furnishings of the Shakers', *The New York Times*, 1972. Interestingly, this article also mentions the Metropolitan Museum's acquisitions. In addition, the catalogue of the auction at the Darrow School can be found in The Edward Deming Andrews Memorial Collection, Winterthur Library, Number 539. The auction took place on Saturday, 5 August 1961 and Andrews recorded the prices of the various artefacts, including all sorts of fixtures and fitments. Also see McKinstry, E.R. (comp.), *The Edward Deming Andrews Memorial Shaker Collection*, 1987 for a catalogue of the Andrews archive.

151 Taken from the gallery annotation in The Philadelphia Museum of Art.

152 Letter from Ronald Emery from the museum's archive, dated 27 November 1972, states: 'May I also refer you to the copies of the floor plans of the building done by the WPA in the 30s ... Floors are included in the sale as well as baseboard, doors (in and out of casements), stone and brick, chair rail, stone stair entrances and wrought iron railings ...' Clearly, the dwellings were being stripped of their Shaker-derived elements – nearly everything could be purchased; the morality of this is questionable.

153 In 'In Remembrance of Mrs Irene Zieget', *The World of Shaker*, 1977, Julie Neal wrote: 'Today at the Philadelphia Museum of Art there is a fine collection of Shaker furniture and artefacts, the gift of Mr and Mrs Julius Zieget and their daughter – Marcia Zieget Reige – formerly of Ardmore, Pennsylvania. The Zieget collection had its beginning during the summer of 1929 when Irene Zieget decided to refurnish a room at "Breezy Hill", the family's summer residence at Peterborough, New Hampshire. Having always lived in the Boston and Philadelphia areas, Mrs Zieget knew and appreciated finely crafted furniture. However, it was not until that particular summer that she was introduced through two magazine articles to the fine qualities of Shaker-made furniture. Realising that she was living in Shaker country and hearing that the remaining Shakers were willing to sell furniture to interested individuals, she set out on what she later termed "Our Shaker Adventure". Visits were made to Hancock, New Lebanon and Canterbury, resulting in a "love of a room" at Breezy Hill. But that summer's adventure was merely a beginning. With few exceptions, annual visits to the Shaker villages were made over the next 30 summers.'

154 The story of the Ziegets has been well documented in, for example, Zieget, I., 'Our Shaker Adventure', 1967 and Zieget, I., *Julius Zieget – A Sketch*, 1960. In addition a letter to the Andrewses dated 10 September 1956 from Julius Zieget states: 'I am sorry that at the time we spoke about a display here in Philadelphia there is no space available at our museum. It is our present intention that ultimately our collection will go to The Philadelphia Museum of Art.' See The Edward Deming Andrews Memorial Collection, Winterthur Library, Misc. Boxes.

155 'American Art' in Babbitt, S., *Philadelphia Museum of Art – Handbook to the Collections*, 1995, p. 278.

156 Taken from the audio tour *Masterpieces of the Collections*, 20 December 1996, which has the music 'Gift to be Simple' in the background. It states: '"Hands to work and hearts to God". Thus Mother Anne Lee, founder of the religious group known as Shakers, instructed her followers in the pursuit of labour and spiritual vision. All the objects in this L-shaped room were created by Shaker craftsmen in the late 18th and 19th centuries. Practising the tenets of their faith in every aspect of their lives, the Shakers made objects with simplicity of form, honesty to materials, an inventiveness and purposefulness of design, and a true fineness of craftsmanship. Every piece here, from the short-back dining-room chairs to the beautiful built-in cabinets, reveals the commitment of Shaker craftsmen to economy of space and materials, and to an orderly, clean way of life. The flat broom, hanging on the wall in this gallery, was

a Shaker invention. By flattening out the shape of the common round broom of the time, it improves the efficiency of time spent sweeping. The Shakers were some of the first Americans to value the healthfulness of fresh air. Baseboards with holes and transom windows above the doors were some of the Shaker inventions that allowed for the passage of air even when the doors were shut.'

157 Press release dated 26 April 1989 and sent from Willem Brans, Resident Director, Landmark Renewal Fund, taken from material relating to the Newman bequest in the archive at The Philadelphia Museum of Art. The gallery dedication was performed by Anne d'Harnoncourt.

158 For example, see Pulliam, D., 'Narcissa Thorne's Miniature Career', *Piecework*, 1998.

159 Quotation by Bruce Hatton Boyer from Boyer, B.H., Weingartner, F. & Rossen, S.F. (ed.), *Miniature Rooms – The Thorne Rooms at the Art Institute of Chicago*, 1983, p. 9.

160 Room Number 18 described as 'Living room – about 1800', is detailed in Rogers, M.R., *American Rooms in Miniature by Mrs James Ward Thorne*, 1941, p. 40 (with a photograph on p. 41). Also in McKinstry, E.R. (comp.), *The Edward Deming Andrews Memorial Shaker Collection*, 1987, Number 512. The material for the text of this handbook was furnished by Mrs Thorne and edited by Meyric R. Rogers, Department of Decorative Arts, Chicago. The room is also illustrated in Boyer, B.H., Weingartner, F. & Rossen, S.F. (ed.), *Miniature Rooms – The Thorne Rooms at the Art Institute of Chicago*, 1983, pp. 126–27.

161 Boyer, B.H., Weingartner, F. & Rossen, S.F. (ed.), *Miniature Rooms – The Thorne Rooms at the Art Institute of Chicago*, 1983, p. 127.

162 The curator of the miniature rooms kindly provided us with details relating to the rooms and their relationship within the Art Institute. Letter dated 5 August 1999 from Rebekah Levine.

163 Rogers, M.R., *American Rooms in Miniature by Mrs James Ward Thorne*, 1941, p. 3.

164 Boyer, B.H., Weingartner, F. & Rossen, S.F. (ed.), *Miniature Rooms – The Thorne Rooms at the Art Institute of Chicago*, 1983, p. 127: 'Mrs Thorne's Shaker interior includes a communal living room, a study through the door at the right, and a bedroom on the left. While the main room gives the sense of order and harmony typical of a Shaker environment, the Shakers actually furnished their rooms far more sparsely and included many more built-in elements.'

165 Annotation taken from Rogers, M.R., *American Rooms in Miniature by Mrs James Ward Thorne*, 1941, p. 40:

The United Society of Believers in Christ's Second Appearing, commonly known as the "Shakers" were an offshoot of the English Quakers. Under the leadership of Ann Lee, a branch of the Society was established in this country in 1774 with headquarters at New Lebanon, New York. The name came from the spasmodic movements with which the members of the sect expressed their religious fervour ... Their devoted adherence to their principle of life, "Hands to work and hearts to God", did, however, create a highly individualised culture which emphasised an economy, directness and honesty of craftsmanship which was not without effect upon surrounding communities.

The "Believers" lived a communal life in huge barn-like buildings, avoiding all display and working like the best mediaeval craftsman chiefly for the glory of God. The women attended to household duties while the men cultivated the land and worked in the shops; for the ideal of each community was to be absolutely self-supporting. Deprived of any ornamental outlet, the craft spirit of the Shakers expressed itself in attention to proportion and fitness to purpose. The later communities in Kentucky and Ohio relaxed sufficiently to permit the use of colour, using blue woodwork and painting the furniture in dull red, mustard yellow and green. In order to show the essential characteristics of Shaker production in a condensed form, the model follows an interior constructed after the Shaker plan by an eminent authority on the cult to provide a setting for a unique collection of its furniture and crafts.

On one side of the dining-room table are the seats of the brothers, on the other, those of the sisters. At the double desk are two identical chairs presumably for the business affairs of the two component parts of the community. The broad-brimmed hats on the rack indicate part of the uniform of the men and the bonnet in course of construction, that of the

women. The vases of flowers are a concession to "vanity" which Ann Lee would probably have found displeasing.

166 Rogers, M.R., *American Rooms in Miniature by Mrs James Ward Thorne*, 1941, p. 4.

167 It would appear that Mrs Thorne was pleased with the Shaker room: 'Mrs Thorne was very proud of the 134 miniature objects she assembled in this interior and its side rooms – more than in any other model' (Boyer, B.H., Weingartner, F. & Rossen, S.F. (ed.), *Miniature Rooms – The Thorne Rooms at the Art Institute of Chicago*, 1983, p. 127).

168 Klyver, R.D., *The Shaker Heritage – An Annotated Pictorial Guide to the Collection of the Shaker Historical Museum*, 1980, p. 32 shows some rooms with miniature furniture (scale 1:12) including a Shaker kitchen, Shaker bedroom (retiring room) and a Shaker living-dining room made by August Schwerdtfeger of Poland Springs, Maine. These were presented to the Shaker Historical Museum by Mrs Elizabeth Nord *circa* 1972. Also see Van Kolken, D. (ed.), 'In Memoriam – Gus Schwerdtfeger', *The Shaker Messenger*, 1981.

169 For example in Eversmann, P., 'Small Wonders: the World of Miniatures', *Winterthur Magazine*, 1999.

170 A letter dated 17 August 1999 from Gerald W.R. Ward (the Carolyn and Peter Lynch Associate Curator, American Decorative Arts and Sculpture, Arts of the Americas) confirmed that the room was not present because of structural alterations to the museum: 'We had to dismantle the room several months ago because of some structural alterations to the Museum. It is currently in storage, and our hope is to reinstall it in the new American Wing a few years down the road.'

171 *Religion in Wood* was republished as *Masterpieces of Shaker Furniture* in 1999. The Boston room is featured on pp. 72–73.

172 Emlen, R.P., has written a number of Shaker-related articles including 'Raised, Razed and Raised Again: The Shaker Meetinghouse at Enfield, New Hampshire, 1793–1902', *Historic New Hampshire*, 1975; 'The Early Drawings of Elder Joshua Bussell', *The Magazine Antiques*, 1978; 'The Great Stone Dwelling of the Enfield, New Hampshire Shakers', *Old Time New England*, 1979; and 'The Best Shaker Chairs Ever Made', *The Shaker Messenger*, 1981.

173 The architectural integrity of period rooms has been debated in Borchert, C.E. & Holst, N.A., *The Installation of Historic Architecture at Winterthur*, 1998, p. 71. In the conclusion the following is of interest: 'As these objects represent a primary source of information about the past, we have a responsibility to interpret architectural fragments for the benefit of all. We therefore adopt the following principles as guidelines for acquiring, documenting, managing, preserving, and using collections of architectural fragments: (1) In recognition of the preference for *in situ* preservation of historic structures, architectural fragments should not be removed if such removal will adversely impact the structure's integrity. (2) When architectural fragments are removed from structures, thorough documentation should accurately and permanently record the historic context of the fragments within the structure. (3) Architectural fragments and their associated documentation should be collected, organised, stored, maintained, and conserved in accordance with established professional collections management practises of the museum and historic preservation communities.'

174 This is detailed in Emlen, R.P., *A Report on the Court Floor Period Rooms*, 1978, p. 27, which was provided to us by the Museum of Fine Arts, Boston.

175 See Emlen, R.P., *A Report on the Court Floor Period Rooms*, 1978, p. 27.

176 See Emlen, R.P., *A Report on the Court Floor Period Rooms*, 1978, p. 27.

177 See Emlen, R.P., *A Report on the Court Floor Period Rooms*, 1978, p. 29. In addition to this there is also discussion about the acquisition of the Tibbetts collection.

178 Shallcross Wohlauer, G. & Rogers, M., *A Guide to the Collection of the Museum of Fine Arts, Boston*, 1999.

179 The conference on the period room took place in 1997 at The Victoria and Albert Museum, and discussed room contexts with reference to worldwide representations of the decorative arts in room recreations.

180 Some of these issues and interests have been featured in Fennimore, D.L., *Eye for Excellence – Masterworks from Winterthur*, 1994.

181 See Cantor, J.E., *Winterthur*, 1997 and Peck, A., *Period Rooms in the Metropolitan Museum of Art*, 1996.

182 Taken from De Montebello, P., *The Met and the New Millennium*, 1994.

183 These are detailed in Emerich, A.D., 'A Select List of Publications', in Emerich, A.D. & Benning, A.H. (eds.), Catalogue for *Shaker: Furniture and Objects from the Faith and Edward Deming Andrews Collections*, 1973, pp. 44–45. Numbers 38, 39 and 40 are associated with Smith College: the annotation for Number 39, Catalogue for *The Work of Shaker Hands* (Andrews, E.D. & Parks, R.O., 1961) states: 'No. 39 was prepared for a January exhibition of furniture and other artefacts at Smith only, prior to their permanent installation at Hancock …'. There is also material dealing with Smith College in The Edward Deming Andrews Memorial Collection, Winterthur Library, specifically in Box 22; a list was provided of all the box contents numbered 1 to 32.

184 In Andrews, E.D. & Parks, R.O., Catalogue for *The Work of Shaker Hands*, 1961.

185 See Andrews, E.D. & Parks, R.O., Catalogue for *The Work of Shaker Hands*, 1961, second page of written material in 'The Work of Shaker Hands'.

186 This piece was in the collection of Mr and Mrs Stephen Stone and other Shaker references in Sheeler's work are reviewed in Andrews, E.D. & Andrews, F., 'Sheeler and the Shakers', *Art in America*, 1965. The Mr and Mrs Stephen Stone Sheeler work 'On a Shaker Theme' is illustrated in Jacob, M.J., *The Impact of Shaker Design on the Work of Charles Sheeler*, MA Thesis, 1976, figure 29.

187 A print of this image also features on the last page of Andrews, E.D., Catalogue for *Shaker Inspirational Drawings – The Collection of Dr and Mrs Edward Deming Andrews*, 1960. Also see Lossing, B.J., 'The Shakers', *Harper's New Monthly Magazine*, 1857.

188 See Andrews, E.D., Catalogue for *Shaker Inspirational Drawings – The Collection of Dr and Mrs Edward Deming Andrews*, 1960.

189 See Andrews, E.D., Catalogue for *Shaker Inspirational Drawings – The Collection of Dr and Mrs Edward Deming Andrews*, 1960.

190 This features as no. 40 in Emerich, A.D., 'A Select List of Publications', in Emerich, A.D. & Benning, A.H. (eds.), Catalogue for *Shaker: Furniture and Objects from the Faith and Edward Deming Andrews Collections*, 1973, which states on p. 45: 'The American Shakers. Six illustrated, unsigned pamphlets bearing the following individual subtitles: I. Organisation of the first communities; II. Principles and practises; III. Early history. Persecutions; IV. Their mode of worship; V. Industries and craftsmanship; VI. Their religious art. The first five were originally published in *The Berkshire Eagle* (Pittsfield, Massachusetts) in 1960 and reprinted in 1961 by the Shaker Community, Inc. (the corporation operating the new Hancock Shaker Village museum). The sixth contains the same text as no. 38, reprinted with permission of Smith College. This pamphlet is strongly recommended as an introduction to the Shakers from Edward Deming Andrews' perspective.'

191 Emerich, A.D. & Benning, A.H. (eds.), Catalogue for *Shaker: Furniture and Objects from the Faith and Edward Deming Andrews Collections*, 1973, p. 1. Also see Brinton, H.H., *Quaker Education in Theory and Practise*, 1958 and Pointon, M., 'Quakerism and Visual Culture 1650–1800', *Art History*, 1997, for some background on the Quakers.

192 See McIlhenny, H.P. & Madiera, L.C., 'Acknowledgments', *Philadelphia Museum of Art Bulletin*, 1962.

193 The exhibition was large and featured over 250 artefacts including 11 inspirational drawings from various sources, amongst them some from Mr and Mrs Julius Zieget. The Ziegets also owned a number of furniture pieces which were photographed for the catalogue, including Number 28, 'desk with twelve drawers, sliding shelf, outer cupboard with mirrored door. Made at Enfield, NH', and also Number 50, 'a table with turned legs, rectangular top, one drawer.' This piece had belonged to Zilpha Whitcher (1774–1856) of Canterbury, NH and Eldress Emma King. Also Julius Zieget stated to Edward Deming Andrews in a PS to a letter dated 10 September 1956: 'I would appreciate it very much if sometime we could get some watercolour "Inspirationals" I bought a reproduction of one of yours which was shown at the Art Alliance a year or so ago. I wish I could get the original.' The Edward Deming Andrews Memorial Collection, Winterthur Library, Misc. Boxes.

194 These names appeared regularly as contributors to various exhibitions, and pieces by them are featured in the catalogue, for example a tall chest of drawers, lent by Mr and Mrs Charles Sheeler (Frost, M., 'The Prose and the Poetry of Shakerism', *Philadelphia Museum of Art Bulletin*, 1962, p. 71).

195 The Camisards are featured extensively in the film/video by Kurtenbach, H., *The Shakers*, 1992.

196 Frost, M., 'The Prose and the Poetry of Shakerism', *Philadelphia Museum of Art Bulletin*, 1962, p. 82.

197 Mrs Hazel Spencer Phillips was director of the Warren County Historical Society and wrote for the catalogue. See Phillips, H.S., 'Shakers in the West', *Philadelphia Museum of Art Bulletin*, 1962, pp. 83–88 and Phillips, H.S., *Shaker Architecture – Warren County Ohio*, 1971.

198 See Melcher, M.F., 'Shaker Furniture', *Philadelphia Museum of Art Bulletin*, 1962, p. 89. Marguerite F. Melcher had Shaker relatives and also wrote *The Shaker Adventure* in 1968.

199 Melcher, M.F., 'Shaker Furniture', *Philadelphia Museum of Art Bulletin*, 1962, p. 90.

200 Melcher, M.F., 'Shaker Furniture', *Philadelphia Museum of Art Bulletin*, 1962, p. 91.

201 Inspirational drawings were also being shown at Williamsburg: according to a cutting in *The Berkshire Eagle*, some drawings from Hancock were shown from 21 January to 4 March 1962 in the Abby Aldrich Rockefeller Folk Art Collection, and there was also a seminar by the Andrewses (The Edward Deming Andrews Memorial Collection, Winterthur Library, Box 315). Also see Frankfurter, A., 'Shaker Inspirational Drawings', *Art News*, 1962.

202 Sellin, D., 'Shaker Inspirational Drawings', *Philadelphia Museum of Art Bulletin*, 1962, p. 93.

203 Sellin, D., 'Shaker Inspirational Drawings', *Philadelphia Museum of Art Bulletin*, 1962, p. 93.

204 'It is time to take a new look at Shaker design and a comprehensive exhibition of Shaker furnishings – just opened in New York – provides the opportunity. "Religion in Wood: A Study in Shaker Design", is now on view at the Museum of Early American Folk Arts. It will continue there through Nov. 14. The exhibition brings into focus again the Shaker exaltation of handiwork and their cabinet makers' desire to free their workmanship from all semblance of ornament. These craftsmen were not content to reproduce existing designs. The highboy and lowboy of their period, the canopy bed, along with banister backs and cabriole legs were rejected. For one thing they were more difficult to make than the simpler types, but also, the Shakers desired no commerce with "pretence or worldliness". Elements of cabinet design that express Shaker ideas on utility and simplicity give a definitive style to their furniture. These design characteristics include:
 – Rod-shaped or subtly tapered turnings of stand and table legs with foot or terminal shaping entirely omitted.
 – Profiled patterns of stand legs and chairs and rockers.
 – Sharply angled bracketing of the feet on cases and cupboards and chests.'
(Gropp, L., 'Refocus on Shaker', *Home Furnishings Daily*, 1965, p. 6, found in The Edward Deming Andrews Collection, Winterthur Library, Box 15. Included in the text are a number of photographs from the exhibition showing artefacts displayed on wooden floors and some artefacts on plinths, plain walls etc.).

205 Gropp, L., 'Design Tempo – No Dust in Heaven', *Home Furnishings Daily*, 1965.

206 For a history of the museum see Wertkin, G.C., 'The Museum at Twenty', *Fall Antiques Show – In Celebration – The Herb Garden*, 1981. Wertkin has also written a number of articles with specific reference to Shaker inspirational art, for example, 'Given by Inspiration – Shaker Drawings and Manuscripts in the American Society for Psychical Research', *Folk Art*, 1995.

207 Continuing the dynasty, materials passed on to his son by Edward Deming Andrews were also featured: Mr and Mrs David V. Andrews, Hastings-on-Hudson, New York provided Number 57 in the exhibition, an infirmary cupboard for storing herbs, and Number 58, an ironing table.

208 Three watercolours from around 1845 – Numbers 105, 106 and 107 including 'In Memory of Father Joseph and Mother Lucy', Eliza Ann Taylor, 1845 – were provided on loan.

209 Illustrations in Black, M.C., 'At the Sign of Gabriel, Flag or Indian Chief', *Curator*, 1966, show Shaker settings, for example figure 8, 'a view of "Religion in Wood – a Study in Shaker Design", a loan exhibition from leading museums and collectors specialising in Shaker arts. The central figure is an enlargement of a mid-nineteenth-century print showing a ring dance at Niskeyuna, New York', and figure 9 '"Religion in Wood – a Study in Shaker Design", a corner of a setting for a Sister's Sewing Shop. Furnishings on loan from the Fruitlands Museum, Harvard, Massachusetts, and Mrs Edward Deming Andrews of Pittsfield, Massachusetts'.

210 Taken from the first page of Black, M.C., Catalogue for *Religion in Wood – A Study in Shaker Design*, 1965 (The Edward Deming Andrews Memorial Collection, Winterthur Library, Box 15).

211 Details taken from Van Kolken, D., 'Shaker exhibition, seminar scheduled in New York City', *The Shaker Messenger*, 1979, p. 10: it included Shaker arts and crafts from a number of institutions including Hancock Shaker Village, Old Chatham Museum, Metropolitan Museum, Philadelphia Museum and New York State Museum, together with pieces from Mr and Mrs James J. Stokes and other private collectors. Dr C. Eugene Kratz, President of the Shaker Heritage Society in Albany, acted as the curator, while Karl Mendel, a collector of Shaker artefacts, dealt with the design and craftsmanship in over 40 pieces of Shaker furniture. Cynthia Rubin, lecturer and scholar, focused on Shaker crafts, with the installation of the exhibition being designed by Frank Sierra whose presentations reflected the aesthetic of Shaker simplicity and functionality. Also see a photograph of the 1969 Shaker exhibition in 'The New York Shakers' in Wertkin, G.C., 'The Museum at Twenty', *Fall Antiques Show – In Celebration – The Herb Garden*, 1981, p. 20.

212 Van Kolken, D., 'Shaker exhibition, seminar scheduled in New York City', *The Shaker Messenger*, 1979: 'In addition to their attendance at the conference, visiting Shakers will participate in a special religious programme at Trinity Church …'

213 Andrews, E.D. & Andrews, F., *The Shaker Order of Christmas*, 1969 taken from their 1954 book of the same name. The booklet was produced for an exhibition dated 24 November 1969 to 4 January 1970, Museum of American Folk Art, curated by Mary Black.

214 See Hoffman, A.J., 'The History of the Museum of American Folk Art – An Illustrated Timeline', *The Clarion*, 1989, p. 61, the exhibition entitled 'The Shakers: Photographs by Ann Chwatsky/Objects from Sabbathday Lake'. This was exhibited with help from Gerard Wertkin. They also produced a millennium exhibition featuring Shaker spirit drawings: see Wertkin, G.C. & Balmer, R., Catalogue for *Millennial Dreams*, 2000.

215 Again see Hoffman, A.J., 'The History of the Museum of American Folk Art – An Illustrated Timeline', *The Clarion*, 1989: the article features various exhibitions and also includes details of Shaker reproductions such as on p. 54, an illustration of a Shaker chair with the text: 'Museum's Home Furnishings Programme introduces "Shaker Furniture" at Fall 1984 Furniture Market in High Point, NC. 16 pieces of furniture to be produced by The Lane Co., including the number 7 Shaker rocker'.

216 Johnson was a prolific writer and before his untimely death was a promoter of current Shakerism at Sabbathday Lake. His writings include *Life in the Christ Spirit: Observations on Shaker Theology*, 1969; *In the Eye of Eternity: Shaker Life and the Work of Shaker Hands*, 1983; and 'Shakerism for Today', *The Shaker Quarterly*, 1963.

217 The private view card indicated that the opening took place on Thursday evening, 3 April 1969 between 8–10 pm.

218 The exhibition basically focused on Sabbathday Lake, which at the time was one of two remaining active 'real' Shaker communities. As such there is a tendency to reject design in favour of a more comprehensive look at the religion.

219 See the photograph showing patterned wallpaper and floor covering in Johnson, T. & McKee, J., Catalogue for *Hands to Work and Hearts to God: The Shaker Tradition in Maine*, 1969.

220 Some of the images in the catalogue look decidedly un-Shaker, particularly those in the section 'The Sabbathday Lake Community Today', although the set-piece furniture shots and images within the museum do have the 'normal' stripped Shaker aesthetic. Some of McKee's photographs even have the feel of the earlier William Winter photographs.

221 See 'Foreword' in Johnson, T. & McKee, J., Catalogue for *Hands to Work and Hearts to God: The Shaker Tradition in Maine*, 1969.

222 See 'Foreword' in Johnson, T. & McKee, J., Catalogue for *Hands to Work and Hearts to God: The Shaker Tradition in Maine*, 1969.

223 See 'Hands to Work and Hearts to God' in Johnson, T. & McKee, J., Catalogue for *Hands to Work and Hearts to God: The Shaker Tradition in Maine*, 1969, last full page.

224 See 'Hands to Work and Hearts to God' in Johnson, T. & McKee, J., Catalogue for *Hands to Work and Hearts to God: The Shaker Tradition in Maine*, 1969, last full page and last page.

225 See 'Foreword' in Franco, B., Catalogue for *Shaker Arts and Crafts*, 1970. Barbara Franco was the Curator of Decorative Arts at the Munson-Williams-Proctor Arts Institute.

226 Canterbury, being one of the last Shaker communities, has been very well documented and the artefacts produced at Canterbury have been featured in Burks, J., *Documented Furniture. An Introduction to the Collections (Canterbury Shaker Village)*, 1989; Boswell, M.R., 'Women's Work: The Canterbury Shaker Fancywork Industry', *Historical New Hampshire*, 1993; and Ledes, A.E., 'The Canterbury Shakers', *The Magazine Antiques*, 1993.

227 'Shaker Arts and Crafts' in Franco, B., Catalogue for *Shaker Arts and Crafts*, 1970.

228 'Shaker Arts and Crafts' in Franco, B., Catalogue for *Shaker Arts and Crafts*, 1970.

229 Consolati, D., 'The Shakers' New Converts', *American Collector*, 1974, p. 4, states: 'Enter the Shaker exhibit at the Smithsonian's Renwick Gallery. Gratifyingly, the show is not only timely (Mother Ann Lee and eight faithful followers sailed from England to America in 1774 ... The persuasive display is an eye-opener. Indeed if the exhibit succeeds in convincing the public that the 12-drawer pine and ash tailor's bench that sold in New York for $1,500 is easily worth triple, the show's Shaker experts may feel it will have been worth it after all.' Also see Hughes, C., 'Shaker Work Seen at Renwick Gallery', *The World of Shaker*, 1974 and The Guild of Shaker Crafts Inc. (publisher), 'Edward Deming Andrews Collection', *The World of Shaker*, 1973.

230 See Herman, L.E., 'Foreword', in Emerich, A.D. & Benning, A.H. (eds.), Catalogue for *Shaker: Furniture and Objects from the Faith and Edward Deming Andrews Collections*, 1973, p. 7. Lloyd E. Herman was Administrator at the Renwick Gallery.

231 Emerich, A.D. & Benning, A.H. (eds.), Catalogue for *Shaker: Furniture and Objects from the Faith and Edward Deming Andrews Collections*, 1973, p. 47, has a note in provenance and dating (produced in consultation with Mrs Edward Deming Andrews): 'Furniture, like other Shaker possessions, was a portion of "the united inheritance" – property of the community rather than the person. Pieces might be designed for a sister or brother, for a certain use, sometimes taking into account personal or physical needs, as some of the following annotations indicate. Ultimately, however, all became part of "the joint interest". With the passage of time, the makers, the earlier owners were often forgotten. With the closing of buildings, of families, of entire communities, material possessions were transferred. Thus, Faith and Edward Deming Andrews and others who began collecting early in the twentieth century could be sure of their own taste, of the fact that objects were acquired directly from Shaker hands, and sometimes of little else. Dr and Mrs Andrews perhaps persevered more than others in tracing and documenting their purchases, but often even they could be sure of little more than the room where a piece was found. Thus, these annotations reflect what they could learn at the time of purchase or in later years. The exhibition represents Mrs Andrews' selection of an important cross-section of eastern Shaker designs now or formerly in the Andrewses' collections. It concentrates specifically on the prime period of New Lebanon Shaker craftsmanship (the model for other societies) in the first half of the nineteenth century.'

232 Joshua C. Taylor (Director, National Collection of Fine Arts), in his 'Introduction' in Emerich, A.D. & Benning, A.H. (eds.), Catalogue for *Shaker: Furniture and Objects from the Faith and Edward Deming Andrews Collections*, 1973, p. 9, states: 'After Dr Andrews' death in 1964, Dover Publications, Inc., which has reprinted three books by Edward and Faith Andrews, with Mrs Andrews' advice, invited their friend the late Mark Van Doren to write a memorial tribute that might be included in all further Dover reprinting. Van Doren's paragraph, which applies equally to the wife who worked with Dr Andrews in all his projects, was as follows: "The word authority, often loosely used to mean one who knows more than most people do about some subject, regains its dignity as soon as we consider Edward Deming Andrews. He knew more about the Shakers than anyone ever has, and I am quite certain that his knowledge of them will never be surpassed. He knew about them; he knew of them; he knew them. His interest in them was many-sided, and indeed was inexhaustible. Not merely their furniture, though that may have been his chief concern, but their songs, their dances, their craftsmanship, their

herbs, their drawings, their paintings, their clothes, their manners, their customs, and finally – crown of all – their religion drew out of him a scholarship so dedicated that for purity, for precision, and for completeness it stands alone in our time. He knew the Shakers in this wonderful way because he loved them: not sentimentally, not nostalgically, but with an abiding respect for the ideas their entire life expressed. And he knew how to write of what he so perfectly understood. To enter a room full of Shaker furniture is a unique experience; it takes the breath. But to read one of his books is, to the extent that such a thing now is possible, to inhabit that room."'

233 Enfield has been featured in, for example, Hollick, F., 'Visitor Centre Opens at Enfield, NH', *The Shaker Messenger*, 1979.

234 The architecture at Watervliet has also been featured in Shaver, E. & Pratt, N., *The Watervliet Shakers and Their 1848 Shaker Meeting House*, 1994 and Poppeliers, J.C., 'Shaker Architecture and the Watervliet Shaker South Family', *New York History*, 1966.

235 Malcolm, J., 'The Modern Spirit in Shaker Design', in Emerich, A.D. & Benning, A.H. (eds.), Catalogue for *Shaker: Furniture and Objects from the Faith and Edward Deming Andrews Collections*, 1973, p. 18. A different version of this article also appeared in *Early American Antiques*, 1974.

236 Malcolm, J., 'The Modern Spirit in Shaker Design', in Emerich, A.D. & Benning, A.H. (eds.), Catalogue for *Shaker: Furniture and Objects from the Faith and Edward Deming Andrews Collections*, 1973, p. 20 states: 'Though it is doubtful that Loos had even heard of the Shakers, to say nothing of studying their curious code. "Cultural evolution is equivalent to the removal of ornament from articles in daily use," Loos maintains, and goes on to say, "If I pay as much for a smooth box as for a decorated one, the difference in labour time belongs to the worker. And if there were no ornament at all – a circumstance that will perhaps come true in a few millennia – a man would have to work only four hours instead of eight, for half the work done at present is still for ornamentation."' Also see Pevsner, N., *Pioneers of Modern Design from William Morris to Walter Gropius*, 1984.

237 Malcolm, J., 'The Modern Spirit in Shaker Design', in Emerich, A.D. & Benning, A.H. (eds.), Catalogue for *Shaker: Furniture and Objects from the Faith and Edward Deming Andrews Collections*, 1973, p. 20.

238 Malcolm, J., 'The Modern Spirit in Shaker Design', in Emerich, A.D. & Benning, A.H. (eds.), Catalogue for *Shaker: Furniture and Objects from the Faith and Edward Deming Andrews Collections*, 1973, p. 21.

239 Malcolm, J., 'The Modern Spirit in Shaker Design', in Emerich, A.D. & Benning, A.H. (eds.), Catalogue for *Shaker: Furniture and Objects from the Faith and Edward Deming Andrews Collections*, 1973, p. 22. One example of a company in the United States specialising in high quality Shaker reproduction is Barrett's Bottoms furniture: see Barrett, D., *Barrett's Bottoms Chair Makers*, 1992.

240 See Emerich, A.D. & Benning, A.H. (eds.), Catalogue for *Shaker: Furniture and Objects from the Faith and Edward Deming Andrews Collections*, 1973, p. 85: the boxes were lent by Mrs Edward Deming Andrews and photographed by William H. Tague.

241 See Emerich, A.D, 'A Conversation with Faith Andrews', in Emerich, A.D. & Benning, A.H. (eds.), Catalogue for *Shaker: Furniture and Objects from the Faith and Edward Deming Andrews Collections*, 1973, p. 26.

242 See illustrations 34 and 35 in Ray, M.L. & Stimpson, M., Catalogue for *True Gospel Simplicity: Shaker Furniture in New Hampshire*, 1974.

243 She has also analysed Shaker furniture in Ray, M.L., 'A Reappraisal of Shaker Furniture and Society', *Winterthur Portfolio – A Journal of American Material Culture*, 1973.

244 'Introduction' in Ray, M.L. & Simpson, M., Catalogue for *True Gospel Simplicity: Shaker Furniture in New Hampshire*, 1974.

245 'Introduction' in Ray, M.L. & Simpson, M., Catalogue for *True Gospel Simplicity: Shaker Furniture in New Hampshire*, 1974.

246 'Introduction' in Ray, M.L. & Simpson, M., Catalogue for *True Gospel Simplicity: Shaker Furniture in New Hampshire*, 1974: this is very interesting because it could be claimed that there is no such thing as simple Victorian. The understanding of Victorian is that it is decorated, elaborate and highly formed – ornateness, use of mixed motif, and over emphasis of decoration are generally the characteristics associated with Victorian style.

247 Shaker basket ware is interesting in that it developed poplar ware, which is essentially Victorian in its composition and styling. For more information on this see McCool, E., 'Shaker Woven Poplarware', *The Shaker Quarterly*, 1962; Kennedy, G., Beale, G. & Johnson, J., *Shaker Baskets and Poplarware – A Field Guide, vol. 3*, 1992; and Ryan, J.F., 'The Story of Shaker Poplarware', *Shakers World*, 1996.

248 Shaker furniture has been reviewed in Grant, J.V. & Allen, D.R., *Shaker Furniture Makers*, 1989; Kassay, J., *The Book of Shaker Furniture*, 1980; Meader, R.F.W., *Illustrated Guide to Shaker Furniture*, 1972; Muller, C.R. & Rieman, T.D., *The Shaker Chair*, 1984; and Rieman, T. & Burks, J., *Complete Book of Shaker Furniture*, 1993.

249 'Introduction' in Ray, M.L. & Stimpson, M., Catalogue for *True Gospel Simplicity: Shaker Furniture in New Hampshire*, 1974.

250 Ray, M.L. & Stimpson, M., Catalogue for *True Gospel Simplicity: Shaker Furniture in New Hampshire*, 1974 contains three examples: Exhibit 3 with the description: 'Bed with original springs and mattress – attributed to Franklin Young in the fourth quarter of the nineteenth century. Maple panels held by walnut framing and "smartened" with applied lozenges and shields – belying its Victorian pretensions, the bed rests on traditional turned legs. A similar bed is shown in a stereograph view, dated 1883, of an Enfield retiring room.' Exhibit 10 with the description: 'Table from Canterbury in the second quarter of the nineteenth century. Primary wood is birch while the secondary wood is pine. Note – An otherwise stubby table is given a lift by the wide overhang of the top and the "tasty" feet turned to resemble in wood the brass mounts popular on Louis XVI forms. This foot occurs not infrequently in Shaker furniture, usually accompanied by a slightly bulging leg with ring turnings at the neck, also associated with the Louis XVI style. Not peculiar to the Shakers, legs of this fashion are ubiquitous in New England country furniture of the nineteenth century.' Exhibit 11, described as: 'a table from Canterbury from the second quarter of the nineteenth century. Primary wood is pine which has been painted blue. Traces of trailing-vine decoration in a deeper blue-green may be seen on the front of the drawer and the back skirt, in apparent disregard of the injunction of the Millennial Laws against "flowery painted" furniture.'

251 Ray, M.L. & Stimpson, M., Catalogue for *True Gospel Simplicity: Shaker Furniture in New Hampshire*, 1974: the chair is numbered 32 and is illustrated in the catalogue.

252 See Ray, M.L. 'A Reappraisal of Shaker Furniture and Society', *Winterthur Portfolio – A Journal of American Material Culture*, 1973, p. 108.

253 See Fischer, W. & Mang, K., Catalogue for *The Shakers: Life and Production of a Community in the Pioneering Days of America*, 1974 (also published as *Les Shakers – Vie communautaire et design avant Marx et le Bauhaus* and *Die Shaker – Leben und Produktion einer Commune in der Pionierzeit Amerika*).

254 Fischer, W. & Ramseger, G., 'Timeless Beauty of Everyday Things – The Astonishing Products of the Shaker Commune in Exhibition in Munich, Germany', *The World of Shaker*, 1974, p. 7: 'The following review of Shaker exhibit in Munich was sent to the World of Shaker by Wend Fischer. The Exhibit was reviewed by George Ramseger for the national press, Basel, and is one of the first news releases of this exhibition in this country.'

255 Press release issued by the Department of Public Relations at the V&A, entitled 'The Shakers – Life and Production in a Religious Community in the Early Days of America. Exhibition from 8 May to 15 June 1975': 'The Shakers, originally called "Shaking Quakers" because of their ritual dances, were founded by Ann Lee, a blacksmith's daughter born in Manchester, but chased out of this country on account of her eccentric religious beliefs. She and a small group of her followers set sail for America in 1774. In America the sect acquired new members and by 1825 there were 19 independent and self-supporting communities. By the middle of the century the Shakers numbered as many as 6,000. The theology of the Shakers is based on a belief in the dualism of God as male and female in one. They held Christ to be a dual spiritual being who became manifest a first time in Jesus, the man, and a second time in the woman Ann Lee. With this second coming of Christ the kingdom of God had started on earth for the faithful. The Shakers lived strictly celibate lives in their communes, apart from the profane world. All this might seem just odd, but many visitors from the outside world testified to the contented and full lives led by the Shakers. They saw how happy the Shakers were in their work and remarked with envy on a form of social organisation in which law enforcement was totally unnecessary. It is a fact that the

Shakers pioneered women's rights and equality of the races. From the start they admitted Negroes and slaves to their communities as equal and free men. The Shaker communities were entirely self-sufficient. They produced enough for their needs, each member working for everyone in the community. They put up their own buildings and made their own furniture and cloths. These artefacts, as visitors to the exhibition will see, have a simple functionalism combined with high standards of craftsmanship which appeal very much today. The exhibition, which reviews all the different types of articles made by the Shakers and relates them to the history of the sect, has been arranged by the Neue Sammlung in Munich for a European tour. There will be an extra showing in Manchester, Mother Ann's birthplace, at the City Art Gallery from 25 March to 20 April before the exhibition at the V&A.'

256 Sandra Martin wrote an interesting letter, dated 13 February 1975, to the editor of *Design* magazine. It starts: 'I noticed in your January issue of *Design* an article called "Fitness for what Purpose", which was an appraisal of the validity of the Design and Industries doctrine. As it happens the City Art Gallery is holding an exhibition called "The Shakers" in late March. The Shakers were a religious community whose production of furniture and other objects from the late 18th century onwards was based on just this ideal, primarily associated with our own times. Sir Misha Black in this article was able to look back as well as forward in time when discussing the morality of this principle and it occurred to me that your readers might be interested in the Shaker exhibition. The Shakers were, as Engels pointed out, the first people in the world who established a society based on the common ownership of property and the principles governing their lives – simplicity, integrity and purity – were exactly those which governed their output, as I think you will observe from the photograph enclosed. Their furniture and other objects have been loudly acclaimed as being prophetic of the twentieth century in the functionalism and crispness of their design and I feel that most people who have seen the Utility Furniture Exhibition at the Geffrye Museum, which has been extended until March, would find the Shakers equally impressive.' (Shaker Exhibition file, Manchester City Art Galleries archive.) See also Martin, S., *The Life and Production of a Religious Community in the Pioneering Days of America* (Keeper's Report), Manchester City Art Galleries, 1975.

257 Taken from the publicity material: 'The Shakers – Do your work as though you had a thousand years to live and as if you were to die tomorrow. The words of Ann Lee, a blacksmith's daughter from Manchester, who joined the Shaker sect, so called on account of their violent tremblings when the spirit entered them. Persecuted for their beliefs, "Mother Ann" and her followers emigrated to America in 1774 and established a community there. Engels called them "the first people … in the whole world who had effectively created a society based on the joint ownership of property". That their whole way of life and production was governed by a desire for purity, simplicity and integrity, and above all perfection, can be witnessed in this exhibition which is supported by the Arts Council and the Greater Manchester Council.' (Manchester City Art Galleries archive.)

258 In a letter to Manchester City Art Gallery dated 20 February 1975, Theodore E. Johnson writes:

What a pleasant surprise it was to receive your letter in yesterday's mail. We were most pleased some months ago when we first learned that "The Shakers" will be shown in Manchester. Surely there is a peculiar appropriateness that it will appear there. You may know these verses from an old hymn of Elder Richard McNemars which we still sing:

AT MANCHESTER IN ENGLAND,
THIS BLESSED FIRE BEGAN,
AND LIKE A FLAME IN STUBBLE
FROM HOUSE TO HOUSE IT RAN.

We here at Sabbathday Lake have often wondered what the reaction of Mother Ann and those first Manchester believers might be to their native city's commemorating the work they had begun over 200 years ago.

First of all please let me assure you of our desire to help you with the exhibition and to do all that we can to make it meaningful for a Manchester audience. Our anxiousness to help is motivated not so much by a desire to make better known the small part of our life which is "our museum operation" but rather to help in seeing that the tradition and

heritage of Believers is properly interpreted. I do not know whether you are aware of the fact that this is the only remaining active community of Believers in the world. It is only here at Sabbathday Lake that the life and ministry of Mother Ann and those of her first followers in Manchester is both reverenced and regularly commemorated ... Please do not hesitate to call upon us to help in any way with your efforts toward the success of the exhibition. The community would in fact be most pleased to serve as your liaison here in the United States. We have enjoyed working very much with both Dr Fischer, who spent several days with us in February of 1973, as well as with Herr Mang who was with us for a more extended period of time in October and November of 1974.

259 Mang, K. had previously written about modern furniture and Thonet in *History of Modern Furniture*, 1979.

260 Mackintosh, J., 'Top Marx and Ann Lee', *Co-operative News*, 11 April 1975: 'A very different sort of book tells the story of Ann; it's the bulky catalogue of "The Shakers" exhibition at Manchester City Art Gallery. The well-illustrated volume is priced at £3 but visitors to the exhibition can borrow a copy for 10p. Why so ambitious a publication when the organisers of some art shows are content to offer a typewritten list of exhibits at 6p? The reason I suppose is that the history and aims of the Shakers which are detailed in the catalogue.'

261 Fischer, W. & Mang, K., Catalogue for *The Shakers: Life and Production of a Community in the Pioneering Days of America*, 1974: see p. 51 in which Shaker Maxims and Rules are featured with the sayings: 'Regularity is beautiful', 'There is great beauty in harmony' and 'Beauty rests on utility'.

262 Fischer, W. & Mang, K., Catalogue for *The Shakers: Life and Production of a Community in the Pioneering Days of America*, 1974, p. 21.

263 Taken from the archive at Manchester City Art Galleries.

264 Keig had been responsible for a number of publications and exhibitions prior to and subsequent to the Manchester exhibition including the Catalogue for *The Shakers – A Lifestyle by Design*, 1971; 'The Shakers – a Lifestyle by Design', *Communication Arts*, 1971; 'Munich Museum to Feature Exhibit on Shakers', *The World of Shaker*, 1972; and the excellent educational resource on Shaker trade entitled *Trade with the World's People: A Shaker Album*, 1976.

265 Pearson worked with Keig on 'Shaker Graphics of the 19th Century', *Print*, 1972 and also with Kealy on an article for *The Magazine Antiques* entitled 'Unusual Forms in Shaker Furniture', 1970.

266 Fischer, W. & Mang, K., Catalogue for *The Shakers: Life and Production of a Community in the Pioneering Days of America*, 1974, p. 5.

267 Fischer, W. & Mang, K., Catalogue for *The Shakers: Life and Production of a Community in the Pioneering Days of America*, 1974, pp. 21–22. Wend Fischer in his essay examines the functionalist and perfectionist aspects of the Shakers: 'The aesthetically satisfying outward appearance of the Shakers' world was the visible manifestation of their way of life. People who establish for themselves the Kingdom of God on earth must demand perfection not merely from the community and each individual but also of all premises and objects existing in that kingdom. The perfectionism which supported and motivated the faith and life of the Shakers had necessarily also to encompass the objective world in which they lived by this faith; for a perfect kingdom in which anything imperfect was tolerated – be it only a detail – would be absurd ... An object is therefore perfect when it is perfectly adapted to its intended use. Not "form" but utility was the Shakers' aim; form was regarded as the result of a design that has achieved the aim of perfect utility in an object. Practical value, fitness for purpose, utility, instructions and sayings handed down to us by the Shakers. These are often expressed in a manner which, almost a hundred years before Sullivan's proposition: "form follows function", anticipated the principles of functionalism: "Anything may be called perfect, which perfectly answers to the purpose for which it was designed"; "beauty rests on utility"; "Order is the creation of beauty. It is heaven's first law, and the protection of souls"; "That which has in itself the highest use possesses the greatest beauty". And almost identical with Sullivan's "Form follows function" is the Shaker statement that "every force evolves a form".'

268 See Mang, K., 'The Shakers – another America' in Fischer, W. & Mang, K., Catalogue for *The Shakers: Life and Production of a Community in the Pioneering Days of America*, 1974, p. 15.

269 Recalling Mies van der Rohe's inaugural speech in 1938 as Director of the School of Architecture in the Illinois Institute of Technology, see Fischer, W., 'Harmony in work and life – The functionalism of the Shakers' in Fischer, W. & Mang, K., Catalogue for *The Shakers: Life and Production of a Community in the Pioneering Days of America.*, 1974, p. 22: 'One hundred and thirty-three years later, in Chicago, Mies van der Rohe, speaking of the "goal, to create order out of the disparate confusion of our time ... We must have order, allocating to each thing its proper place and giving to each thing its due according to its nature, and this is where we shall start." For the Shakers, the order inherent in things which have been designed perfectly for their intended use resulted in the integrity which they called "harmony", and in the harmony of their environment was revealed the harmony of their community.'

270 Fischer, W., 'Harmony in work and life – The functionalism of the Shakers' in Fischer, W. & Mang, K., Catalogue for *The Shakers: Life and Production of a Community in the Pioneering Days of America*, 1974, pp. 22–23.

271 Fischer, W., 'Harmony in work and life – The functionalism of the Shakers' in Fischer, W. & Mang, K., Catalogue for *The Shakers: Life and Production of a Community in the Pioneering Days of America*, 1974, p. 24.

272 'In the words of a report to Manchester's cultural committee: "Their furniture was of great simplicity and beauty. They brought to perfection many hand operated machines and were an integral part of the Industrial Revolution ... they bequeathed a distinctive style of life as well as a distinctive architecture to accommodate their corporate life. Many lesser achievements, such as the introduction of packeted garden seeds were also to their credit."... It is being taken to eight important European museums and the organisers' offer to include Manchester stems from the city's involvement in the strange history of the Shakers 200 years ago.' (Duffy, M., 'The Shakers are coming to Manchester', *The Manchester Evening News*, 1975.)

273 'During the late 18th century, when many European designers and furniture makers were producing tables and chairs rich with decorative inlay, a religious community in the Mid West became known for simple workmanship ... Their rules of 1823 emphasised attitudes to design principles, avoiding anything fanciful – "no brass knobs or handles of any size or kind, three-bladed knives, knife handles with writing or picturing on them, bone or horn spoons, superfluous whips." Many other articles came under similar strictures.' (Hudson, D., 'The Collectors – The Shakers' Art', *Yorkshire Post*, 1975.)

274 'So, walking through the cool, quiet and serenely proportioned rooms of the exhibition (especially constructed to correspond to the originals) we are looking at a cloak, a bed, even a label for apple sauce, that were not made to be sold, for profit, but to be used by the community. The supreme elegance of the products resulted from the perfect fusion of function with form ...' (Bates, M., 'The Shakers at Manchester City Art Gallery', *The Guardian*, 1975.)

275 'Although the Shakers are now part of history, the objects and buildings they made live on. Their simple furniture and utensils anticipated twentieth-century functionalism and influenced American minimal art. Yet these should not be separated from the people who made them with such conviction of rightness and truth, and their purity of form cannot be divorced from the beliefs that inspired them. The simple and well-presented exhibition now at the Manchester City Art Gallery relates the Shakers' furniture and artefacts to their way of life by means of photographs and quotations and descriptions which are amplified in the excellent but expensive catalogue.' (Overy, P., 'The Shakers: Form and Function', *The Times*, 1975.)

276 See Money, E., 'Shakers and Jade', *The Spectator*, 1975; Vaizey, M., 'Basic Beauty', *The Sunday Times*, 1975; Dunsford, J., 'The Shakers Return to Manchester', *The Daily Telegraph*, 1975 and, perhaps most interestingly, a recipe section by Jane Grigson in *The Observer Magazine* in 1975 entitled 'Like Mother Ann Made It' with recipes for Shaker fried chicken and Sister Lizzie's sugar pie. In the article Grigson makes direct reference to the exhibition at the V&A.

277 See Pratt, R., 'Shaker House', *Ladies Home Journal*, 1950, p. 68.

278 *The Magazine Antiques* featured many articles on the Shakers and also produced collectors notes, for example in Day, C.L., 'Late Shaker Chairs', 1953, p. 396, in which it states: 'Some degeneration in

craftsmanship occurred after the Civil War, but very little in design, to judge from two rockers and two side chairs which I recently inherited ... But they also have the "Strength, Sprightliness, and Modest Beauty" that won a diploma and a medal for Shaker chairs at the Philadelphia Centennial in 1876.'

279 Taken from The Edward Deming Andrews Memorial Collection, Winterthur Library, Box 17.

280 See Hughes, G.B., 'The Furniture of the Shakers', *Country Life*, 1961, p. 633, which states: 'Sir Ambrose Heal believed that William Morris was influenced by the Shaker tradition in furniture.' Interestingly, Heal's still sells Shaker-inspired furniture, including large and small pieces in cherry and other woods. Also see 'A Rich Shaker Legacy', *American Home*, 1969, with photographs by Meek, R. on p. 76 showing an interior from the house of Charles and Helen Upton, and which states on p. 77: 'One of the best private collections belongs to Dr and Mrs Charles Upton ... The Uptons began their collecting in 1950. Although some of their finds came from antique dealers and private owners, they acquired many of their finest pieces by buying directly from Shaker communities, especially those being demolished.'

281 Andrews, E.D., 'Shaker Furniture', *Interior Design*, 1954, p. 66 features some illustrated boxes with annotation as follows: 'The geometric grace and simplicity of these oval boxes are symbolic of the Shakers' desire for perfection in all things, for construction was painstaking even in so common an object. They are still manufactured at New Lebanon and Sabbathday Lake.'

282 See Andrews, E.D., 'Shaker Influence – Traditionalists and Moderns Discover Virtues of Shaker Furniture – Honesty, Strength, Usefulness and the "Gift to be Simple"', *Look Magazine*, 1954, p. 77.

283 See Andrews, E.D., 'Shaker Influence – Traditionalists and Moderns Discover Virtues of Shaker Furniture – Honesty, Strength, Usefulness and the "Gift to be Simple"', *Look Magazine*, 1954, p. 78.

284 Taken from The Edward Deming Andrews Memorial Collection, Winterthur Library, Box 17.

285 See Maged, E., 'An Old Look For Your New Sound', *Hi-Fidelity Magazine*, 1955, p. 47.

286 For example, *The World of Shaker*, Winter 1974, p. 6, where an advertisement for the newest Guild catalogue states: 'We at the Guild of Shaker Crafts invite you to share with us the refreshing beauty of Shaker design.' Also Unspecified, 'Shaker Crafts Revived', *Interior Design*, 1967, promotes the Guild and its products using illustrations by Beverly Hallock. See The Edward Deming Andrews Memorial Collection, Winterthur Library, Box 19.

287 Unspecified, 'Shaker Crafts Revived', *Interior Design*, 1967, p. 137 notes: 'To the Shakers, the art of furniture craftsmanship was heaven inspired. It has been said that their furniture provides a better expression of their faith than their written theology. Today the Shakers are all but extinct. Their principles in craftsmanship, however, are not: three new "Believers" have formed a Guild of Shaker Crafts, Inc. in Spring Lake, Michigan, where they are reproducing a selection of Shaker furniture, accessories and a few items of clothing. Everything in this initial collection, which is illustrated in a handsomely designed "Portfolio No. 1", is copied from originals in the collection of the late Edward Deming Andrews and Faith Andrews, foremost authorities on the Shakers ... Because of the timeless quality, the furniture being reproduced by the Guild of Shaker Crafts is compatible with either contemporary or traditional settings. Since each piece is made to order, sufficient time must be allowed for delivery. Inquiries should be addressed directly to the Guild.'

288 See Massey, D., 'Shaker Design – Americana News', *American Vogue*, 1968.

289 See Blatchford, I., 'The Shakers and Their Achievement', *Art & Antiques*, 1965; Butler, J.T., 'Shaker Arts and Crafts', *Connoisseur*, 1971; and Walker, J., 'Shaker Design – 150 Year Old Modern', *Home Furnishing Ideas*, 1972, in which it states on p. 86: 'Order, harmony and purity are hallmarks of Shaker design. Today, these same principles have inspired a modern collection of bedroom, dining-room and occasional furniture. The new "Benchcraft" collection by Drexel offers a simplicity and grace of styling that blends well in either contemporary or traditional settings'. A selection of Drexel furniture is illustrated by Joe Isom in the section 'New Furniture Captures Beauty of Shaker Past', pp. 86–87.

290 The home at Canaan of Mr and Mrs John Roberts is illustrated in Andrews, E.D., 'Living with Antiques – A Shaker House in Canaan, New York', *The Magazine Antiques*, 1962.

291 Refer to Upton, C.W. & Upton, H., 'Living with Antiques – Shaker Adventure', *The Magazine Antiques*, 1966, pp. 84–85. C.W. Upton also wrote other articles, for example, 'The Shaker Utopia', *The World of Shaker*, 1972, which was also included in Rose, M.C. and Rose, E.M. (eds.), *A Shaker Reader*, 1977.

292 See Upton, C.W. & Upton, H., 'Living with Antiques – Shaker Adventure', *The Magazine Antiques*, 1966: a photograph on p. 89 shows their son's bedroom and the annotation follows: 'The maple bed in our son's room has beautifully tapered legs and large wooden rollers; it was once part of the Edward D. Andrews collection. At its foot is a four drawer pine blanket chest from Hancock. The low table from Canterbury is unusually pleasing with its wide over-hang and slightly splayed round legs.'

293 See Upton, C.W. & Upton, H., 'Living with Antiques – Shaker Adventure', *The Magazine Antiques*, 1966, p. 85.

294 See Ratkai, G., 'Shaker Furniture: Perfect Unto its Purpose', *McCall's*, 1972.

295 See Unspecified, 'The American Country Look – Shaker', *Better Homes and Gardens*, 1972, p. 51. Also see the earlier Evan, F., 'American Classic, Furnishings in the Shaker Manner', *Family Circle*, 1964.

296 Unspecified, 'The American Country Look – Shaker', *Better Homes and Gardens*, 1972, p. 51.

297 Unspecified, 'The American Country Look – Shaker', *Better Homes and Gardens*, 1972, p. 53.

298 Refer to Consolati, D., 'The Shakers' New Converts', *American Collector*, 1974, p. 3.

299 Consolati, D., 'The Shakers' New Converts', *American Collector*, 1974, p. 3.

300 Consolati, D., 'The Shakers' New Converts', *American Collector*, 1974, p. 14.

301 Anderson, J.M., 'Force and Form: The Shaker Intuition of Simplicity', *Journal of Religion*, 1950, p. 257.

3 SPIRIT AND FUNCTION – The Infiltration of Shaker Design into Museum and Popular Cultures

This section looks at exhibitions from the mid-1970s to the mid-1990s, all of which were temporary and held within the United States. The influence of Edward Deming and Faith Andrews was beginning to wane as new interpretations were coming to the fore. Mainly these drew on the work of June Sprigg, the curator and writer. In addition, a considerable amount of theoretical work from numerous academic studies in material culture was beginning to exert an influence upon interpretations of Shaker material throughout this period.

The last quarter of the twentieth century saw an explosion in mass communication and worldwide travel on a scale previously undreamt of. This allowed not only greater movement of ideas across continents but also encouraged the increase in specialisation and a move towards what became known as interdisciplinary studies. We can see how, for example, an exhibition at the Whitney Museum on Shaker design would attract a far greater degree of European press coverage than would have been the case 20 years before. Exhibitions were being organised with highly specialised aspects of the Shaker aesthetic being examined, such as the chair.

We also detail in this section the onset of the commercialisation of Shaker reproductions both in the United States and the United Kingdom, with the opening of the Shaker Shop in London influencing the infiltration of the aesthetic into British homes. As with the previous section details on sales and auctions appear alongside popular culture interpretations of the Shaker aesthetic and these in turn are placed within a global context.

Influences taken from Museum Culture

The book *Design History and the History of Design* states: 'As we have seen in the case of the Shakers, a visual style can be integral to a way of life. In the past, divisions between ranks and classes tended to be much more sharply defined and cross-class mobility far more restricted than today.'[1] The period 1976–94 saw an unprecedented increase in social mobility linked with a general rise in prosperity in the West. This led to greater international

mobility with an increase in travel amongst social groups for whom it had previously been out of reach, and the spread of information via print and electronic media which opened up the world to large groups of people in Europe and the United States. Consequently an exhibition staged at the Whitney in 1986 could expect to receive far greater worldwide coverage than its predecessor from the 1930s.[2] This may well explain why, for example, we see an upsurge of interest in Shaker design in Britain, even though there had not been a major staging of a Shaker exhibition.[3] Much of the material produced from 1976–94 which promoted the style of Shaker furnishings emphasised lifestyle. As Walker states: 'In recent years the word "lifestyle" has become extremely popular in the discourses of advertising, journalism and design. While it has the virtue of stressing the link between a style and a way of life, it also implies that this link is no longer organic and unconscious but artificial and self-conscious.'[4] Lifestyle articles of the period stressed the very obvious link between the Shakers' religious life and their artefacts and by association indicated that Shaker style could be linked with a particular design-led 'lifestyle', which included a tendency towards the increasingly fashionable notion of minimalism. This link will be dealt with in greater detail in the next section where the links between minimalism and the staging of a number of Shaker exhibitions will be discussed. Along with these – what might be termed popular – interpretations there was also an increase in theories relating to material culture.[5] Schlereth identifies the Henry Francis du Pont Winterthur Museum as a significant indicator of this trend when he states: 'Begun in 1952 the Winterthur programme, an interinstitutional (i.e. jointly sponsored by the Winterthur Museum and the University of Delaware), interdepartmental (i.e. comprising the departments of Art, History and English) and interdisciplinary (i.e. art history, social-cultural history, intellectual history) programme, served as the prototype for many of the other museum-university-related programmes that followed.'[6]

Theories relating to material culture also influenced interpretations of the period, and in museological terms were paradigms for how the majority of Shaker products were analysed. In short they were analysed in a multi-disciplinary way, addressing topics such as theology and social, design and art history.[7] In 'Mind in Matter – An Introduction to Material Culture Theory and Method', Prown questions the definition of material culture:

Selling Shaker

Material culture is the study through artefacts of the belief – values, ideas, attitudes and assumptions – of a particular community or society at the given time. The term *material culture* is also frequently used to refer to artefacts themselves, to the body of material available for such study. I shall restrict the term to mean the study and refer to the evidence simply as *material* or *artefacts*.[8]

The Shakers, due to the multifactorial nature of their society, have proved a rich area for multidisciplinary study[9] and this can be seen in the interpretation of the Winterthur Shaker period room as detailed in Section Two.[10]

The 1986 Whitney Museum exhibition may be seen as a pivotal event in the development of the promotion of the Shakers[11] and their material culture.[12] It continued the focus on the Shakers as designers and used themes which the Andrews partnership had developed for the 1935 Whitney exhibition on Shaker handicrafts. In the 1986 Whitney exhibition – and indeed the entire period featured in this section – there was the emergence of new concerns offered by contemporary analysts.[13] One consistent theme in design terms became evident: a focus on colour and particularly of the application of colour to artefacts.[14] In addition, other themes have been documented in order to convey a more truthful view of what the Shakers produced and how they produced it.[15] This has included studies of demographics, furniture, feminist concerns, children and authenticity in architectural restoration.[16]

The alignment of the Shaker aesthetic with Modernity, which began in the 1930s, continued through the writing of Peter Dormer.[17] In his article 'Why do the Shakers look like Modernists?',[18] he starts by placing the Shakers within the museum context, examining the ground-breaking 1986 Whitney Shaker exhibition and recommending the American Museum in Bath for the quality of its Shaker collections. In addition, Dormer also pays homage to Edward Deming Andrews by using his work for source material, and as a result he discusses Modernism/Shakerism with reference to both utility and ornament:

> And just as Shakers sought their beauty through an idea of harmony, perfection and regularity in utility, so Modernism was shaped through the harmonies and regularity in utility ...
>
> Why was ornament banished in Modernism? Why was it banished in

Shakerism? Ornament is an evolutionary activity, it grows from decade to decade and each new style carries with it hints and reminiscences of the old. Ornament is a carrier of values which may be antithetical to the doctrines of a new aesthetic or ideological movement ... Ornament got banned by the Shakers and Modernists because it was too talkative. But ornament is always permissible if it evolves from the beliefs or principles governing your own movement or aesthetic. For example, if one looks at a Shaker box one sees that the joints or rivets are arranged 'decoratively' just as Mies van der Rohe's Seagram building ...[19]

This article is important because it makes a number of claims relating to the Shakers and argues from an academic stance that the Shakers were probably the first to work in a 'Modernist' aesthetic. Others during the period examined the Shakers in similar terms, drawing comparisons with contemporary America and design. For example, William Hosley states that:

Their glorification of work was is also peculiarly American. In Shaker hands, the work ethic was made perfect. But with the passing of time, Americans have felt less secure in their inheritance of hard-won independence and more aware of having failed their mission: to be a model nation of working citizens, where talent and devotion alone are rewarded.[20]

The 1980s also saw a rise in the number of analytical essays aimed at specific audiences. For example, in an article entitled 'Pure and Simple' from the UK-based *Crafts* magazine, Richard La Trobe Bateman – the British furniture designer – analysed the Shaker legacy both from a craft perspective, but also in terms of a 'high' art aesthetic when he states that: 'The work of the Shaker community shows how utilitarian objects can have an inner vitality as inspirational as much "high" art.'[21] The article is illustrated with a number of artefacts featured in the 1986 Whitney Museum exhibition. Bateman highlights concerns about elevating objects conceived from a craft perspective to that of 'high' art and, by doing so, viewing them out of context. He also states:

The work is within the North European vernacular tradition, but reinvigorated by its transition to the New World as many aspects of culture were. It seems to show a greater awareness, on the part of the makers, of the traditional formal language of the vernacular, and a more deliberate, controlled

choice of form. The preference for forms generated by two rather than three-dimensional determining systems has an obvious parallel with quite a bit of work made today. However, none of these characteristics is peculiar to the Shakers' work; they are to be found in much ordinary, not to say mediocre, work. So its special inspirational character must come from something else ... The source is simple to describe in the abstract, but quite impossible to point to in an object. What we sense in the work is a spiritual serenity ...[22]

Bateman uses the article as a comparative vehicle in order to discuss contemporary practitioners in the craft field, with particular reference to woodworkers and basket makers. He states:

It is clearly not possible to work today in the same way as the Shakers did, but there is a handful of makers whose position is in some respects similar. As an example, nobody who has met the basket maker David Drew in his everyday working and living situation can doubt that the 'wholeness' of his approach is absolutely central to the quality we feel in his work.[23]

Interestingly, Bateman also endeavours to place the Shaker aesthetic, together with current practice in craft/design, within a Post-modern context:

Working within an international, media-orientated culture, and surrounded by a contradictory, fragmented, not to say disintegrating world, what do we do? We pursue the thrill of the new. Far from refinement of tradition, we embrace the opposite – an explosion of possible inputs ...

The rejection of past ideas and often, ironically (but with no irony intended), the rejection of utility in hitherto utilitarian fields such as jugs and chairs. The work of Fred Baier is an obvious example of this, more usual, response to the world around us ... That inward tranquility of the Shakers' work is a quality we can all be grateful for as an example – not to emulate, but just to remember somewhere in the back of our minds.[24]

The period 1976–94 is of particular significance to our examination, seeing as it did the development of what might be termed the 'June Sprigg aesthetic', taking over the mantle from Edward Deming Andrews who had so dominated the previous decades. Sprigg graduated from the Winterthur Museum Programme, at the University of Delaware, where she specialised in Early American Culture and then moved into museum management,

taking up the post of curator of collections at Hancock.[25] The 'June Sprigg aesthetic' evolved, to a large extent, out of the 'Andrews aesthetic', in that it is also very 'romantic', focusing as it does largely on the 'Golden Period' when the artefacts may be viewed as displaying minimalist and modern elements. Sprigg's weakness may be said to lie in the fact that she failed to examine the Victorian period of Shaker production with the same degree of rigour, a period which was to increasingly feature in exhibitions and articles in the coming years.[26] The major differences in Sprigg's and the Andrews partnership's approach are twofold: first, she used current material culture theories and placed emphasis on known Shaker makers, while the Andrewses had perpetuated the myth that the Shakers did not sign or acknowledge their work as individuals. In her analysis, Sprigg contextualises the material in terms of production, as well as consumption, using both design history and museological theory. Secondly, she placed emphasis on the Shakers' use of colour whereas the Andrewses' vision was largely monochromatic, in keeping with their stricter Modernist interpretation.

Sprigg's book *By Shaker Hands* drew directly from her experiences as a guide at Canterbury Shaker village and indeed she dedicates it to one of the Shakers, in the manner of the Andrewses' 1940 Berkshire Museum catalogue.[27] The front cover states that the book examines 'The art and the world of the Shakers – the furniture and artefacts, and the spirit and precepts embodied in their simplicity, beauty and functional practicality.'[28] These were concerns which the Andrews partnership had already extensively covered. Through their dedications, both the Andrews partnership and Sprigg were obviously keen to emphasize that their work made connections with and drew upon the experience of living Shakers. This acts as both a strength and a weakness, as it might be argued that her approach lacked detachment and consequently she was unwilling to criticise where necessary.

By Shaker Hands is subdivided into sections relating to various aspects of material culture. Subheadings deal with topics such as 'Time', 'Order', 'Simplicity', 'Perfection', 'Utility', 'Honesty', 'Permanence' and 'Progress'. Sprigg's prose style can be seen in the epilogue in which she writes effusively on Shaker love:

The success of the Shakers in making their heavenly ideals a working part of their everyday life and work is evident in all things they made ... Even more important, though, is something else they succeeded in making – something we can't see in a museum anywhere. More than any other ideal, they made love a part of their daily lives. They loved each other and they loved God with all their hearts; and they worked together, for each other, not against each other, without competition or pride. The proof that men and women can work together in harmony and accomplish great things at the same time is the greatest gift the Shakers can give us today. For them, at least, God's kingdom did come, and His will was done, on earth as it is in heaven.[29]

Sprigg uses a mixture of emotive and analytical language in her examination which at times leads her to make idealised claims. For example, her assertion that the Shakers always produced work to very high standards: 'when factories began to make everything faster and cheaper – and shoddier – the Shakers continued to make things with the same standards of perfection.'[30] However, an examination of Shaker artefacts reveals that this simply is not the case, and there are numerous examples of Shaker-made goods that are less than perfect.[31] However, to admit this would be to explode the myth of perfectionism which is one of the central themes of Sprigg's viewpoint:[32]

More than anything else, what shaped the Shaker way of life was their desire to be perfect in all ways – in their union of brotherly love; in their thoughts and acts; and because they believed in practising what they preached, in the works of their hands, too. When a Shaker carpenter built a desk, he made sure that each drawer fit perfectly because he used properly seasoned wood and patiently dovetailed each one. Often you can find the number of the drawer marked on the bottom to indicate its place ...

The reasons for the Shakers' demand for perfection were both practical and spiritual. Certainly, drawers that don't stick are useful and cloaks that are perfectly sewn satisfy a customer. But most of all, desks or cloaks or anything else made perfectly by Shaker hands satisfied the Shakers because they satisfied the pattern of perfection that God had set before men in His son, Christ. Since the Shakers believed that the world they saw in their villages was a true reflection of the inner spirit, they equated perfection in their works and daily deeds with spiritual perfection ...

Precision in all things was necessary for perfection. One way the

Shakers achieved precision was by using patterns, in their work and in their faith. Patterns also help achieve uniformity, another Shaker ideal.[33]

In the Section devoted to 'Utility' – a recurring twentieth-century, Modernist concept – Sprigg comments on force and form and makes reference to other contemporaneous icons in twentieth-century design:

> Long before the Chicago architect Louis Sullivan said: 'Form ever follows function,' and so changed the way American architects and designers thought about the environment they created, a small and relatively obscure religious sect was quietly putting this standard into every practice of their daily lives. The Shakers worded their proverb slightly differently, but the ideal was the same: 'Every force evolves a form' ... It took the twentieth century to produce an architect proclaiming that a house should be a 'machine for living', as Le Corbusier was to show in his designs; and only now are we coming to appreciate the Shaker Dwelling houses for being just that, almost a century-and-a-half before their time.[34]

The 'Simplicity' section deals with the international appeal of the Shakers including the showing of Shaker furniture at the World's Fair and the introduction of Shaker artefacts to a European audience.[35] Interestingly, Sprigg also discusses how the evidence of Victorian elements had been erased from numerous Shaker interiors in the twentieth century in order that Shakerism could be aligned with the International Style:

> And 'familiar': in many ways we feel at home in Shaker rooms because our century has seen fit to rid itself of the fussy ornament that dripped from Victorian eaves or perched on turn-of-the-century whatnots. A description of the International Style in architecture and design, which played the most influential role in eliminating fuss and feathers from the characteristic design of the twentieth century, is relevant here: ... the design was based upon such non-aesthetic factors as social utility or simplicity and economy of construction ... additionally emphasised by two aesthetic decisions – the rejection of all extraneous ornament and a preference for the neutral surfaces of glass and of flat, smoothly finished stucco ... white or near-white surfaces were more usual.[36]

Sprigg – like the Andrews partnership – is a prolific author,[37] exhibition curator/organiser and documenter of Shaker design over a 25-year period, examining their aesthetic from a mix of contemporary standpoints such as

design and styling as well as from a more orthodox historical view, as in her article 'The Development of Shaker Design':[38]

> Above all, Shaker life freed believers from the whimsical, merciless prison called style. They did not care what the world considered fashionable. The first believers of course, knew about worldly style when they entered Shaker life ... It was no accident that the best, purest examples of Shaker design date from the second quarter of the nineteenth century, when the first generation of Shaker children reached their prime. Shakers such as Rowley and Haskins did not so much create a new design as endlessly refine an inherited one.[39]

She continues by discussing the ornate and the Victorian, by stating:

> As worldly taste grew increasingly ornate in the mid-nineteenth century, the difference between Shaker and worldly homes became more pronounced. Haskins and other Shaker furniture makers continued to produce simplified versions of the plain, federal-style country furniture prevalent around 1800 ... The Shakers did not spurn beauty; they simply reinvented it. It is wrong to suppose that Shaker design was bound by endless restrictions. The Shakers had just one: do not make what is not useful. They saw every reason to make necessary things beautiful, according to their own understanding of beauty. Of the elements universally available to designers the Shakers rejected only applied ornament as unnecessary. The rest – colour, pattern, line, shape and proportion – they freely and joyously used. Perhaps the elimination of superficial decoration gave believers a keener eye for the shape of a thing and the relationship of its parts.[40]

Throughout the 1980s and 1990s interest in the Shakers had developed and spread to such an extent that a magazine for collectors of Shaker material was established – *The Shaker Messenger*. Its publisher, Diana Van Kolken, also ran a shop stocking various (mainly reproduction) Shaker artefacts. *The Shaker Messenger* was published from 1980 to 1996 and was an important source of articles, marketplace information and advertisements charting the developing interest in all things Shaker.[41] In addition, due to the gradual demise of the Shakers at Canterbury and the celebration of the founding of various communities, decline became a common theme of many articles, and can be seen in *Historic Preservation*,[42] *Down East*[43] and *The Shaker Quarterly*.[44]

Along with the obvious developments in terms of museum culture there were also numerous peripheral developments in other fields of the arts. A number of texts relating to poetry were produced including work by M. Angelou,[45] J. Harrison[46] and C. De Matteo.[47] In addition, Mahoney produced a small book on Shaker poems, sayings and songs,[48] whilst the music and songs of the Shakers were becoming significant as a research field in themselves.[49]

Simple Gifts – Hands to Work and Hearts to God at the William Benton Museum – 1978

The exhibition 'Simple Gifts' was staged at The William Benton Museum of Art at The University of Connecticut, Storrs, 20 March to 2 May 1978. It was the first of a number of exhibitions featuring the input of June Sprigg who acted as guest curator (alongside T.P. Bruhn). The main lenders to the exhibition were Hancock Shaker Village[50] with specific thanks given to Mrs Lawrence K. Miller, John Ott,[51] William Root and Priscilla Brewer.[52] The exhibition catalogue stated:

> We are grateful to the other lenders to this exhibition, the ideas of which could not have been developed without their willingness to lend choice pieces from their collections. Thanks to The Duxbury Art Complex Museum at Duxbury, Massachusetts, The New York State Museum at Albany, Shaker Village Inc., of Canterbury, New Hampshire, and The Society for the Preservation of New England Antiquities in Boston ...[53]

In addition, the organisers thanked Armin Landeck who has become associated with Shaker representations in both photographic and print form.[54] 'The Director's Note' by P.F. Rovetti is of interest as it highlights the museum's venture into the new field – at least for this institution – of applied arts and emphasizes the developing theme of the artefact as being seen as an art rather than craft or design object. This was a theme that had been, and would continue to be, taken up by other Shaker exhibition organisers:

> The exhibition 'Simple Gifts' is an exhibition unlike any that The William Benton Museum of Art has held before. It is the Museum's first venture into the area of the 'applied arts'. As a first venture the Museum chose to

Selling Shaker

deal with Shaker pieces because we believe in their aesthetic value as works of art in themselves. This exhibition is not an exhibition of 'Shaker chairs'. Such exhibitions have been held many times in other places.[55]

It is apparent that, like so many previous exhibitions, the organisers wanted to make direct links between the objects and the makers: 'We are attempting by showing this work to our viewing public to set the stage for the understanding not only of the furniture but the people who created it ...'[56] The organisers also emphasized other issues including practicality, innovation and spiritualism.[57] The exhibition featured 150 Shaker-made objects from the nineteenth century – both large and small – ranging from coat hangers to a six-foot chest with four dozen drawers. The interpretations emphasized the fact that the exhibition was not meant to be a substitute for visiting a Shaker community, albeit a museum village.[58] Perhaps one of the most interesting aspects of the exhibition was the fact that the organisers provided comparisons with contemporaneous artefacts produced in the outside world. This clearly served to highlight difference, but it also made it clear just how progressive and innovative some of the Shakers' designs were. In the catalogue it states:

> The William Benton Museum also suggests in this exhibition that Shaker forms should be looked at in relation to other expressions of the period in America, rather than always in isolation ...
>
> Several Shaker objects are therefore seen here side-by-side with others made at about the same time – or earlier, in cases where Shakers said they were producing 'old-fashioned' styles. We feel that far from diminishing either Shaker or general American craftsmanship such direct comparison can enhance our understanding of and respect for both ...[59]

In addition to the general comparative exercise, it is interesting to note however that the original intent on the organisers' part was to include pieces from other utopian communities, including the Oneidans. This idea was current in a number of books published around this time.[60] The Shakers themselves had long commented on how often they were mistaken for the Amish Community.[61] However, the organisers stressed that the Shakers achieved a far higher level of design than other utopian groups whilst the Amish sought to 'freeze' time by rejecting technological advances. By contrast, the Shakers, as we have already noted, were often

in advance of the 'outside world'[62] in terms of their own technological ingenuity.[63]

The contradictions inherent in the notion of a design/craft object being reconsidered as art – since by doing so it loses some of its essential functionalism – is discussed in the catalogue. It states: 'Seeing a Shaker chair in an exhibition like this, its inherent qualities of purity and simplicity emphasized even more by its display as a piece of sculpture, one can easily forget that Shaker objects were made for people, not for heavenly spirits, and certainly not for show.'[64] The ambiguous relationship between 'art' and life exists not only within the contemporary gallery space, but was also a topic with which the Shakers dealt in their everyday lives. A display of Shaker-related photographic material was included in order to validate – some might say contextualise – the objects by including images of the people who made them, but also provides an example of the new art technology that was developed and welcomed wholeheartedly by the nineteenth-century Shaker communities. As the catalogue notes:

> The photographs are from the last part of the nineteenth century and the early part of this one. Some were stereopticon views or postcards, sold at times by Shaker stores; others were commissioned studio portraits; at least one was taken for the Index of American Design during the 1935–36 Federal Arts Project. Photography was one intrusion of the 'World' Shakers seemed not to mind, indeed seemed fascinated by.[65]

This small example of the technological 'Victorianisation' at Hancock is one of many examples from the period of the communities keeping up with the times. For example in 1895, they modernised the Trustees' Office and Store, fitting it out with gingerbread trim, floral wallpapers and Victorian furnishings as proof to the World of their modern outlook – with half an eye on drawing in new converts.[66] As Sprigg notes in her catalogue essay 'The Gift to be Simple':

> The plain white plaster walls and bare wood floors of Shaker buildings – likewise the rule in 18th-century American homes – began to look 'grim' only when 19th-century taste burst into fancy wallpaper and bravely flowered carpets in colours and patterns that make modern decorators gulp. While fashionable furnishings sprouted fancy carved curlicues, swelled into bulges of upholstery, and broke out in rashes of decorative

paint, the Shakers continued to produce simple ladder-back chairs, trestle-tables, and blanket chests in their accustomed plain style. Shaker design has been hailed in the 20th century as 'ahead of its time' for its spare simplicity. Dickens and his cronies would have snorted; it struck most worldly 19th-century visitors as peculiarly outmoded ...[67]

This indeed would remain the case well into the twentieth century, and as we have already discussed it would not be until the advent of Modernism that Shaker scholars, such as Edward Deming Andrews, would reassess the 'outmoded' style and read into it a presciently Modernist aesthetic. From then on, up until the period during which Sprigg began to briefly revisit the Victorian Shaker phase,[68] it would remain untouched by the Modernist interpreters, for whom it appeared an inconvenient anachronism. However, with the advent of Post-modernism and revisionist theories in the last quarter of the twentieth century, new interest in this particular phase of the Shaker aesthetic would start to grow which we shall be examining later in this section.

The Gift of Inspiration: Art of the Shakers at the Hirschl & Adler Galleries Inc., New York – 1979

This exhibition was devoted to displaying Shaker and general American folk art spanning the period 1830 to 1880 and was staged at the Hirschl & Adler Galleries Inc., New York (3 to 25 May 1979). The catalogue included contributions from a number of people including June Sprigg, Amy Bess Miller and John Harlow Ott from Hancock Shaker Village. Extensively illustrated, it contained classifications and explanations[69] of the various emblems used in Shaker spirit (or inspiration) drawings, which in the case of this show were mostly produced at Hancock village.[70] It followed a previous exhibition at Hancock of similar drawings in 1970.[71] The Shaker materials are featured alongside folk art from the outside world, including portraiture, landscapes and seascapes.[72] As the catalogue notes, this was:

> The first comprehensive show of Shaker drawings – from practical maps, village views and architectural renderings, to the colourful exuberance of the unique 'inspirational' drawings, or divinely inspired visions of the spirit world – in contrast with the 'Worldly' art of the Shakers' 19th-century

neighbours – in the first major exhibit to examine Shaker art in the context of American folk art.[73]

Nina Fletcher Little wrote the preface entitled 'The Gift of Inspiration: Art of the Shakers 1830–1880', in which she states:

> The early converts to Shakerism came largely from the rural, middle-income Puritan stock whose families, like many others, were facing the social and financial adjustments that existed in the post-Revolutionary period. Some of these men and women who had renounced the World must once have been acquainted with the itinerants who paused in their neighbourhood to paint the plain, realistic images that would lend dignity and substance to their parlour wall. This display of personal pride, however, was alien to the basic tenets of Shaker faith that held ornamentation for its own sake to be sinful and abhorrent to true believers.[74]

Norman Hirschl contributed a short essay entitled 'Two Separate Worlds' in which he discusses the Shakers and their legacy and gives an indication of the criteria by which the exhibition had been formulated:

> The origins of this exhibition date back to my first visit to Hancock Shaker Village shortly after it opened the outer world's eyes to the stark simplicity of the Shaker way of life, and ... more particularly, to the dedication which they gave to craftsmanship in furniture, the clean architectural lines of their buildings, and the primitive beauty of their inspirational drawings. I experienced an instant realisation that there have been two worlds existing side-by-side, one an inner world bound by deeply religious customs and conventions, and the other, the outer world open to complete freedom of artistic expression – two separate worlds of folk art.[75]

The catalogue's 'Introduction' by June Sprigg attempted to examine the Shakers' creation of art by explaining it in terms of external visits from the likes of Charles Dickens, and internal exuberant events and evangelical fervour:

> It seems hard to imagine an environment less likely to produce colourful watercolours than relentlessly plain mid-19th-century Shaker communities. 'We walked into a grim room, where several grim hats were hanging on grim pegs, and the time was grimly told by a grim clock,' reported Charles Dickens of his 1842 visit to New Lebanon, New York. Yet, within a year, Shakers there created the first of the exuberant drawings.[76]

The exhibition was part of a promotional vehicle to help make Hancock more financially solvent as a museum village.[77] After the exhibition many of the pieces were returned to Hancock to appear in a refurbished East Gallery of the Poultry House Library.[78] The integration of Shaker spiritual drawings into the general Shaker design aesthetic would continue and they would be included in various exhibitions – particularly when there was a tendency to view Shaker production as art rather than design – such as 'Shaker: The Art of Craftsmanship' exhibition which is featured in the next section. In addition, Hancock has continued to promote and show Shaker inspirational art and this includes an exhibition in 2000 entitled 'Seen and Received'.[79] Clearly, because Hancock has such a strong collection of spirit or inspirational work it has been left to the curators of the collections to utilise them. The interest generated in work that has both a folk art charm as well as a high level of sophistication is very difficult to explain in terms of other Shaker material culture. It is this paradox which makes the 'art' of the Shakers so interesting to exhibition organisers.

The Shaker Chair – Strength, Sprightliness and Modest Beauty at Old Chatham – 1982

The exhibition was held between June and October 1982 at the Shaker Museum, Old Chatham[80] and dedicated to John S. Williams.[81] It focused on the Shaker chair – which had become a significant area of study in its own right for Shaker scholars[82] – emphasizing not only the iconic nature of the chair, but also documenting the variations which exist within the form.[83] Faith Andrews gave advice to the organisers in the early stages. The illustrated catalogue provided a contextualised analysis, including a contribution from Patricia Drumm Laskovski, who suggested that the Shakers had become almost exclusively associated with furniture:

> Of all the varieties of furniture by the Shakers, the Shaker chair stands alone as the most studied, the most common, the most discussed and clearly, the most controversial. The majority of the Shaker case pieces and other furniture were made for the sect's own use. Chairs (and footstools) on the other hand, were produced in greater quantities and sold to the 'World's People' or general public. Their chairs spoke of the ingenuity, high quality and expert craftsmanship that was associated with everything Shaker.[84]

The Shaker chair, as well as being an essential item used by the community, was also 'exported' through trade with the outside world.[85] The catalogue examined the combination of spiritual and economic concerns which helped shape and develop Shaker chairs under the themes of form, function and perfectionism: 'The early Shakers believed that furniture design was inspired by angels and given form by the individual craftsman. Religion dictated perfection in workmanship and form based upon function. Thus, the Shaker craftsman was expected to give all the time and effort necessary to perform the task.'[86]

Many chairs which were featured date from what has come to be known as the 'Golden Period' of Shaker craftsmanship – i.e. from 1830 to 1840 – although other examples, such as a rocker from the twentieth century, were also included. In the majority of cases chairs were designed to take account of durability, portability, lightness and ease of cleaning and repair. In addition, their specificity was also highlighted: 'Chairs were often adapted to accommodate specific needs, particularly for the elderly. Sometimes styles were created for convenience in performing a particular task. The Shakers were among the first to popularise the rocking chair principally for the comfort of invalids and the aged.'[87] For example, one of the exhibits is in a wheelchair form, whilst others include a slat back converted to a rocker, a revolver chair circa 1860, a dining chair, a sewing chair and a tall counter chair.[88] The Shakers also made chairs to order and for specific ages, which can be seen in various children's pieces, including the child's settee and a child's small rocker from Canterbury.[89] According to Shaker accounts, the manufacturing of chairs as a business began in 1776 with early designs undergoing subtle changes, with the industry reaching its peak in the 1870s under the Eldership of Robert Wagan of Mount Lebanon.[90] In a number of cases furniture manufacturers in the 'World' began to copy Shaker designs and as a result Robert Wagan adopted a gold transfer trademark under which the chair industry continued until 1935.[91] The catalogue makes the point that Wagan became aware of the commercial possibilities of the Shaker style and that the 'art' of Shaker design became increasingly self-conscious – arguably even contrived – when it states: 'Under Robert Wagan, the chair industry took on a new importance due in part to his recognition of the sales appeal of an old-fashioned style. In his hands, the earlier unconscious art became a deliberate simplicity.'[92]

This manipulation of the form in order to appeal to an 'outside' market is interesting, given that it occurs at a time when antique dealers had started to recognise Shaker pieces as significant, but before the major reinterpretations of the total Shaker aesthetic really took off. Clearly, the Shakers were quite prepared to adapt and sell their simplicity to a receptive audience, before that audience itself began to change the Shaker aesthetic through their own reinterpretation. It can be argued that production of chairs for the outside world lowered their own high standards and that they broke many of the rules that had dictated early internal production:

> Yet, these products were simple mass cut parts assembled at the factory. Calliper marks, the uniform finish, and loss of subtlety in form admit to a lower standard of craftsmanship. The plush upholstery and imitation ebony finish disregarded millennial law. Subsequently, consecrated industry became a profit operation that exploited the name of the society and reflected its decline ...
>
> As other manufacturers began to imitate the distinctive Shaker style, Wagan adopted a gold transfer trademark. The chair business continued under various Shaker groups until 1935.[93]

Along with the Shaker box, their chairs have become design icons[94] and clearly identifiable examples of the virtues of Shaker design. For example, in 1970, Peladeau stated in the article 'Early Shaker Chairs': 'Chairs and rockers made by the Shakers reflect most perfectly the flawless grace and purity of line associated with all things Shaker. They are a distillation of that which the Shakers held most dear – the virtue of simplicity.'[95] In the conclusion it states:

> Shaker chairs and rockers are a self-contained art form. Even though the design had roots outside of and antecedent to the Shakers, the form into which the chairs evolved was purely Shaker, reflecting the sect's religious spirit, as did all its other physical manifestations. Free from all vestige of ornament, the result is a product in which the beauty of pure form was stated with frankness, in which elegance and dignity were raised to a spiritual level in a physical environment.[96]

Whilst Shaker chairs had featured in previous exhibitions, around the time of 'The Shaker Chair' exhibition we can detect a significant targeted interest in the form.[97] We may be able to explain this by virtue of the

growing 'iconic' status of Shaker objects in general and the chair in partic-
ular, which in itself acted as a catalyst for further study into the area, in turn
helping to reinforce the iconic status – and so on and so on.[98] Whatever the
forces that brought about this renewed interest, the exhibition can certainly
be viewed as a forerunner of a number of texts which focused specifically
on the Shaker chair.[99] The Shaker chair and its design continued to be of
interest to exhibition organisers and featured in displays such as that held
in the Art Complex Museum, Duxbury[100] which we will be examining next,
together with the Community Industries exhibition of 1983, held at the
New York State Museum at Albany.

The Shakers: Pure of Spirit, Pure of Mind at the Art Complex Museum, Duxbury, Massachusetts – 1983

This exhibition, at the Art Complex Museum, Duxbury, Massachusetts,[101]
ran from 20 May to 4 September 1983. The associated catalogue was mini-
malist in design and contained a substantial number of photographs of the
exhibits including a large number of Shaker chairs.[102] The foreword by the
director, Charles A. Weyerhaeuser, described the Weyerhaeuser collection's
history which started in the 1940s when his grandmother purchased a
sewing desk and chair. Her son Carl. A. Weyerhaeuser continued collecting
Shaker items, many of which formed the core of this exhibition.

The exhibits included tables, chairs, cupboards, built-ins and a few
smaller pieces. In addition, some rare and unusual pieces were included
such as a child's wagon seat from New Lebanon, for which the annotation
in the catalogue stated: 'It was most unusual for the Shakers to custom
make furniture for the world. However, this wagon seat was made espe-
cially for an artist, A. Francois of Albany, NY.'[103] The catalogue included
evidence of a number of stoves including an elegant piece with penny
feet.[104] Interestingly, the catalogue does not feature any swallowtail boxes
possibly due to the fact that the exhibition was selected from a private
collection whose owner's main interest appears to have been in furniture.
In total nearly 150 pieces were photographed for the catalogue, providing
a fairly comprehensive and honest view of Shaker furniture production.
Although the majority of pieces display what might be thought of as the
orthodox Shaker aesthetic, some also show worldly influences including

Selling Shaker

mouldings, 'fancy' detailing and other decoration, as seen, for example, in the sewing desk by Elder Henry Green.[105]

The catalogue included a short essay entitled 'The Shakers: Background and Philosophy' by L. Valentine, which detailed the history of the Shakers from their origins in Manchester, England to their establishment in America and attempted to explain why Shaker artefacts look the way they do:

> In striving for the perfection of man through the spirit, Mother Ann stressed industry, neatness and faith in the gospel. She was often quoted, 'Put your hands to work and your hearts to God.' From this straightforward philosophy evolved the aesthetic tenet that 'form follows function'. The Shakers thought that beauty was of the world, and they used their craftsmanship only to make life more efficient. Their furniture was designed to be functional and strong, yet light enough so that it could be moved easily. Any beauty that resulted was a by-product and was not planned.[106]

It continues with a discussion on the wood that was generally used in furniture and emphasised the Shakers' disapproval of veneers and 'fancy' woods:

> They generally used pine, maple, birch, cherry and butternut for furniture. Woods such as mahogany were thought to be frivolous and veneers were considered to be deceitful ... The integrity of their craftsmanship is evident always and the simplicity has influenced contemporary furniture design ... Although the spiritual ideals of their movement have faded, the Shakers continue to be admired through their material accomplishments ... [107]

Whilst this exhibition used 'Pure of Spirit, Pure of Mind' as its title, in reality not enough was made of the spirituality evident in Shaker artefacts and we can only assume therefore that the exhibition organisers intended that the objects should 'speak for themselves' by way of their spiritual inspiration. The Art Complex Museum at Duxbury continued to exert an influence on the way Shaker materials were presented by acting as a major contributor to various later events such as the Whitney Museum's exhibition on Shaker design held in 1986.

Community Industries of the Shakers – A New Look at the New York State Museum, Albany – 1983

This temporary exhibition was developed in late 1982 and staged at the New York State Museum at Albany,[108] from 2 July 1983 and extended over several years. It was a very comprehensive examination of the Shakers and their material culture[109] and consisted of artefacts drawn from the very impressive and wide-ranging collections of the museum.[110] A catalogue, published by Shaker Heritage Society at Watervliet and edited by A.D. Emerich and A.H. Benning, was produced and featured highlights from the exhibition. The catalogue contained a dedication to Charles C. Adams, Edward Deming Andrews and William F. Winter, Jr, all of whom had been associated with the original exhibition which is featured in Section One.[111] The 1983 exhibition re-established the New York State Museum at Albany as the premier institution in terms of its Shaker collections. Much of the history of the collection is documented in the catalogue of the exhibition:

> Fortuitously, Dr Adams and other State Museum officers and staff members recognised the urgent need to preserve a record of this important communal religious society, before objects were subject to further natural deterioration of their property that accompanied their closing years. Many more Shaker artefacts were acquired in the next two decades, through generous gifts from the Shakers and others as well as by purchase (although Dr Adams operated, according to his daughter, with 'the most meagre of purchase funds'), while the remaining New York communities at Watervliet and later at Mt Lebanon eventually closed in 1938 and 1947, respectively.[112]

The collections of the State Museum contain industrial materials, wood products, basket ware, tin ware, wood and metal working tools, herb and broom material, photographs and architectural drawings, and mechanical equipment related to the herb industry and other Shaker manufacturing industries. The following taken from the catalogue acts as an introduction to the new exhibition: 'Although the Museum has loaned Shaker materials extensively to other museums in the north-east and abroad, until now 1938 marked the last major exhibition by the State Museum. Its Shaker collection has expanded greatly since then, and it is now time for a new examination of those materials.'[113]

The 1983 exhibition also provided the museum with the opportunity to be more creative and contemporary in exhibiting the material in its collection. This was done by using modern display techniques including the use of plenty of space, colour coordination and quality materials. Emphasizing this shift was the inclusion of a photograph of the original 1930–32 exhibition. This 1930s milestone show was one of the earliest museum displays of Shaker artefacts.[114]

The 1983 exhibition placed a great deal of emphasis upon the interpretation of the displayed material, with the catalogue dividing the material into various processes with a strong contextual interpretation of the exhibits. This process is illustrated by the subdivision which was entitled 'Craftsmanship in Wood': whereas previous exhibitions had chosen to display, for example, a piece of furniture in isolation, here the tools used in its manufacture, such as a turning chisel and marking gauge, were displayed alongside the finished piece. In addition to this craft context, an historical perspective was detailed:

> In 1789, within two years of New Lebanon's gathering, furniture was being produced at that community. Many Shaker cabinetmakers brought highly developed skills from the World. Following traditional designs, originated in America in the 17th and 18th centuries, they added the principles and restrictions of their faith to this work. These rules were set forth by Father Joseph Meacham, the Church's first American-born leader, in the 1790s ...[115]

The catalogue also detailed issues of functionalism and design:

> Shaker craftsmen thus departed from their colleagues in the World by designing furniture without elaborate scrollwork or ornamental turnings. Such decoration was regarded as 'vain show'. Instead, they crafted plain, perfectly proportioned furniture. They adopted and preserved a functionalism that was the essence of early American furniture. Furniture was initially simply and economically produced to serve their own needs. Even after they began selling their furniture (primarily chairs) to the World, craftsmanship for their own needs remained austere. The compactness of their built-ins and other functional pieces suited the requirements of communal living and illustrate Shaker ingenuity and their keen sense of design.[116]

Shaker artefacts featured as photographs within the catalogue included various pieces made at New Lebanon including a candle stand and a lap desk (originally made at New Lebanon in 1830 and with an original yellow wash). Larger pieces included a chest of drawers in black walnut, by Brother Emory Brooks (1807–91). The annotation in the catalogue states:

> Groveland furniture of Western New York State was often crafted in Walnut, like that designed by Western Shaker communities and possessed a worldly Victorian quality overriding the restrained simplicity of the older eastern Shaker style. This piece came to Watervliet when Groveland closed in 1892, and was acquired from the Watervliet Shakers in 1930.[117]

Other pieces of furniture featured included a revolver or swivel chair (1840), a commode (1850), a washstand (1830) and a tall chest of drawers (1840). There was also a number of Shaker chairs, including some with tilter buttons.[118] The majority of the furniture and artefacts shown conforms to the design of the 'Golden Period', being rectilinear and restrained, with classic use of materials and finishes. However, it is interesting that some more decorative and less well-proportioned pieces were included, for example, a sewing cabinet *circa* 1850 with white knobs, crafted by Brother Freegift Wells.[119]

The exhibition was unusual in that it focused on areas of production not normally included within a museum/art gallery context, such as agricultural industries with the inclusion of various implements such as a barley fork, butter worker, apple sauce buckets and presses. The exhibition also included a representative sample of printed material such as seed packets, labels and boxes.[120]

Along with agriculture, the mechanical arts and industries were also featured, with a variety of leather goods, brooms, brushes, tin ware and basket ware. In the catalogue it states:

> The Shakers possessed a wide range of skills in the mechanical arts, allowing near independence from the World, except perhaps as a source of raw materials. Only when it came to complex machines or devices requiring too much of their time did they buy outside – water turbines, boilers, steam engines and wool- carding machines. The self-sufficiency and skill of the Shaker craftsmen were and still are recognised by the World, as evidenced

by the former popularity of their products for their utility, and today as reflected by the prices they command from collectors.[121]

An additional section in the catalogue also featured textiles and garments (which had previously been featured in The Index of American Design which was discussed in Section Two): 'As soon as the Shaker communities were established, they began producing textiles. Some of the illustrations include a Brother's hat and coat and a number of smaller items – including mitts and gloves and coat hangers.'[122]

Shaker – Masterworks of Utilitarian Design at the Katonah Gallery, New York – 1983

The full title of this exhibition was 'Shaker – Masterworks of Utilitarian Design created between 1800 and 1875 by the master craftsmen and craftswomen of America's foremost communal religious sect', and it ran from 20 November 1983 to 8 January 1984.[123] The extensive catalogue, designed by E. Clark, included maps, photographs of both artefacts and makers and biographical information on Shaker craftspeople. The identification of specific makers marks out this exhibition's approach from that of earlier interpreters, including the Andrews partnership, who suggested that the Shakers preferred anonymous production.[124]

The exhibition's organiser June Sprigg also acted as guest curator and included were a number of highly regarded pieces from a variety of top quality collections including Fruitlands Museums, Darrow School, the Metropolitan Museum and Philadelphia Museum of Art, plus the two remaining communities of Canterbury and Sabbathday Lake. The exhibition included 64 high quality objects of varying sizes and types,[125] with various contextual notes.[126] Five geographical regions of the United States were examined: New York, Western Massachusetts and Connecticut, Eastern Massachusetts, New Hampshire and Maine.[127] The catalogue stated:

> The work of Shaker hands continues to elicit admiration and respect. It is a privilege to present in this exhibition 64 exceptional examples of Shaker design selected from important collections in the East, including several acquired directly from the Shakers earlier in the twentieth century.[128]

The objects were viewed in terms of being both design and art: 'Arthur Clark's installation design beautifully displays the objects, allowing the viewer to see them as works of art, while at the same time gaining an insight into the Shaker aesthetic and learning of the craftsmen and craftswomen who made them.'[129] Whilst the Shakers were expert in a number of craft techniques – most notably woodworking – they chose not to engage in certain other areas, for example the making of glass or silversmithing. Whether this was on ideological, logistical or purely practical grounds is speculated upon by Sprigg in the catalogue's introduction:

> Like other Americans, the Shakers were principally farm men and women whose main business was raising food and providing clothing for the household. They also maintained a wide range of trades: carpentry, cabinet making, joinery, blacksmithing, tinsmithing, cooperage, shoemaking, cordwaining, bookbinding, printing, weaving, spinning, dyeing, tailoring, basket making and stone masonry. There were no potters or glassmakers (the Shakers bought those commodities) and no silversmiths (they had no use for that proud metal).[130]

Sprigg continues by revisiting her by now familiar theme regarding Shaker temporal and spiritual matters:

> Shaker craftsmen and craftswomen incorporated their principles into their work: durability, simplicity, utility, perfection, grace. Their religion fostered excellence in temporal as well as spiritual matters ...
>
> These objects – furniture, baskets, textiles, drawings and small house wares – represent the essence of Shaker life and work: utility dignified by simple grace. Most of the objects are signed or soundly attributed. All are of the highest quality in design and workmanship, and many have never been previously exhibited. They illustrate the work and experience of over 40 individual craftsmen and craftswomen from Shaker communities in New York and New England. Although most of the works date between 1800 and 1875, the lives of the makers span some 225 years ... The evolution of a recognisable Shaker style was due to the influence of the head community at New Lebanon, New York, whose Parent Ministry established regulations for simplicity and uniformity and whose workers set standards for perfection of workmanship.[131]

It is significant that this exhibition, particularly the catalogue, emphasised

the role of the maker by providing contextual and biographical information on the various craftspeople.[132] The New York communities are detailed as a group – Watervliet (1787–1938), New Lebanon (1787–1947) and Groveland (1826–92). Other communities including Sabbathday Lake[133] are featured and the makers are placed within the context of their communities. The exhibition focused on a number of fine craftspeople, including both Brothers and Sisters, such as Daniel Crosman,[134] Orren N. Haskins,[135] Hannah Cohoon,[136] Delmer C. Wilson[137] and Isaac Newton Youngs.[138] As with a number of June Sprigg's interpretations, the exhibition catalogue also detailed Shaker decline:

> The general decline of Shakerism that began in the late nineteenth century brought an end to New York's Shaker communities by the mid-twentieth century. Groveland was one of four Shaker communities in America to close before 1900. It was sold and converted into a development centre for epileptics, in which use it continues today. Watervliet families began closing in 1915; the entire community closed just before World War II. Many of the buildings were destroyed or extensively renovated as the properties became the site of a country home, county jail, country club, major airport and private residences. The New York State Museum, with admirable foresight, preserved much of Watervliet's material during the 1920s. Today, the Shaker Heritage Society is seeking to restore a small part of what survives. New Lebanon closed a few years after Watervliet. Its remaining properties now serve as facilities for the Darrow School, as private residences and as the communal home of the Sufi society.[139]

In an article in *The Shaker Messenger*, Sprigg produced a summary of the exhibition and states:

> Since the 1930s there have been fewer than half-dozen major exhibitions on Shaker work; all perpetuating the myth that Shaker furniture and crafts were the product of anonymous craftsmen and women. Seven years of recent research at Hancock Shaker Village and a staff of contributing authors have brought to light dozens of examples of signed or attributed pieces and the names of more than 200 cabinetmakers.[140]

Complementing the exhibition was a series of additional events including a talk by Sprigg entitled 'Shaker Furniture in Its Own Context', and a series of demonstrations on Saturday, 10 December 1983 including Martha

Wetherbee (basket maker), Jerry Grant[141] (box maker) and John Monroe (furniture maker). The film *The Shakers* by Tom Davenport[142] was also shown on various dates throughout the run.

The move to analyse and link individual makers with identified pieces of Shaker furniture has continued. The developing interest in this area illustrated in the 1983 exhibition had, the year before, been discussed in a study symposium held at the American Wing at the Metropolitan Museum of Art.[143] Even if a link can not always be made between a maker and a piece of furniture it is certainly true that furniture can be grouped into community types. By studying construction and manufacture techniques we are able to obtain deeper understanding of the complexity of Shaker craftwork and gain a greater insight into the dynamics of the communities which produced the artefacts.

Ingenious and Useful – Shaker Sisters' Communal Industries, 1860–1960 at Sabbathday Lake – The Maine Exhibitions – 1986

This exhibition travelled to various locations and featured utilitarian objects from a late production period including some materials directly related to production in Maine.[144] The exhibition's importance is in its essentially revisionist approach – it featured a significant proportion of poplar ware and fancy material which had previously been largely overlooked. Many of the objects which were featured did not fit into the 'classical' image of Shaker design, being more Victorian in appearance, that is, highly decorative, heavily worked and with very little truth to materials. The catalogue had significant input from the late Theodore E. Johnson – the spiritual leader of Sabbathday Lake – being prepared before his death in 1986.[145] In the 'Introduction' the exhibition is described as the 'Communal Industries of the Shaker Sisters'. Brother Arnold Hadd also helped in the completion of the catalogue.[146] The significance of the exhibition was discussed with two main points being highlighted:

> First it demonstrates the transformation which occurred in Shaker communities during the Industrial Age, when mechanisation and declining membership lessened the importance of traditional Brothers' industries, such as furniture making and farming. With the approach of the twentieth century, Sisters' industries, chiefly the production of fancy goods to sell in

community gift shops and on trade routes, became increasingly impor-
tant. Trade with the 'world's' people, many of whom stayed at the grand
hotels which once dotted the New England landscape, was not only finan-
cially important, but also brought a great deal of enjoyment to the Shakers
through the acquaintances and friendships it fostered.[147]

The second point was related to the Victorianisation of Shaker manu-
facture:

> The second significant aspect of the exhibition is the theme of Victorian
> culture. While the Shakers are best remembered for their simplicity, they
> should also be known for their progressiveness. They believed in keeping
> pace with the times and thus did not resist Victorian influences – the
> wedding of traditional simplicity and Victorian ostentation produced many
> items which are distinctly Shaker. This influence accounts for the preva-
> lence of bright colours and fashionable fabrics which were used to attract
> the shopper's eye. The Victorian period of Shaker craftsmanship is often
> neglected, an oversight which the Sabbathday Lake community, in part
> through this exhibition, would like to correct.[148]

The exhibition featured what are generally termed Shaker 'smalls' or 'fancy
ware', a category which includes a number of items produced for sale to the
outside world.[149] Among the items included were highly decorated sewing
boxes and jewellery cases, and woven material made of split poplar[150]
manufactured in a number of the Shaker communities throughout the
nineteenth and twentieth centuries. The text in the catalogue features the
Sabbathday Lake Shakers and their production of fancy boxes:

> Early in the 1860s Sisters in the Maine communities began to produce
> boxes made by pasting bright, 'fancy' papers over cardboard or wooden
> bases. Sometimes one or more sides would be formed by glass (nos. 1,
> 6 and 7). Occasionally box lids were padded with velvet or provided with
> traditional pin cushions. With the rise of the poplar ware industries at the
> Church Families both at Sabbathday Lake and Alfred from 1869 onwards,
> fewer and fewer paper boxes were produced. However, their production
> at the North Family at Poland Hill continued until that family's close in
> 1887 and at the Second Family at Alfred until the turn of the century. The
> exhibition showed seven such examples. The boxes included marbled and
> silvered papers, wood effect paper and were generally made of wood and
> cardboard – most of which came from the Alfred community.[151]

Other items featured in the exhibition included baskets, firkins, jars and dolls, together with a number of oval boxes, which demonstrated early collaboration between Brothers and Sisters. This collaboration is evident in the production of oval boxes, where large pin cushions produced by the Sisters are placed on the lids of the boxes made by the Brothers. Similar collaborations took place in the manufacture of handled carriers with emery-balls, wax-balls, pin cushions and needle-books. A characteristic of these items is that they are far more highly decorated than would be expected of Shaker products and, from a classic Shaker viewpoint, it might be argued that this leads to a loss of their functionality. The increased decoration may well be accounted for by the fact that the Shakers were increasingly producing items for a non-Shaker market and therefore taking account of mainstream taste and fashion. Shaker smalls and poplar ware have both become highly collectable.[152] These 'fancy' pieces are, after all, *de facto* Shaker objects. However they provide a marked contrast with 'classic' Shaker artefacts, such as the unadorned oval box. This contrast is often not explored, as it does not fit the Modernist agenda promoted by Andrews *et al.*, in which 'Less is more' and the vision of 'ahead of its time' design requires a selective approach in order to construct a consistent thesis.

In Time and Eternity – Maine Shakers in the Industrial Age 1872 to 1918 – The Maine Exhibitions – 1986

This exhibition was unusual in that it focused primarily on archival photographs relating to the Maine Shakers.[153] A small catalogue was produced under the auspices of The United Society of Shakers which contained a foreword by Stephen Marini[154] and an afterword by Diana Emery Hulick. The photographs were from the period 1890–1918 and included a large selection of varying age and type, with the majority dating from around 1905–15. The photographs were taken by both the Shakers themselves and non-Shakers. Many are of interest as they provide a record of the Shakers in context: for example, there is an image of the Dwelling House and the Sisters' Shop at Sabbathday Lake.[155]

Other photographs also featured the Shakers engaged in their work,

for example, one photograph features Elder Henry Green on a sale trip (*circa* 1896). The annotation states:

> In addition to selling fancy goods in gift shops, the Alfred and Sabbathday Lake communities made regular trips to resort hotels throughout the region. Especially lucrative routes proceeded to the White Mountains and along the coast from Bar Harbor, Maine, to Rye, New Hampshire. Chief salesman was Elder Henry Green (1844–1931) who for 55 years made two coastal and two mountain trips for which he became known as 'The Old Man of the Mountains'. Sale trips were made as far as Florida ...
>
> On this particular occasion, the wagon is being pulled by Old Dan, one of the trusty work horses which took Elder Henry thousands of miles. The trunk at the lower right was one used for maple sugar candy. To the left of the trunks are folding tables made by Eld. Henry for the display of goods and still in use today.[156]

The main purpose of the exhibition was to present a variety of 'daily life' images[157] of the Shaker communities at both Alfred and Sabbathday Lake and as such it provides an insightful record of the Shakers' domestic history. The existence of the photographs were a result of the Shakers' wholehearted acceptance of the camera as a means of recording their daily lives – typical of their acceptance of new technologies – and they appeared comfortable with the idea of making a permanent record of their daily lives, unlike other contemporaneous groups such as the Amish.[158]

As mentioned above the images are the product of both Shaker and non-Shaker photographers, and it is interesting to compare and contrast the two.[159] Generally, those taken by non-Shakers are more formal, while the photographs by the Shakers offer 'snapshots' of both the people and community structures. Importantly, the photographs also record the Shakers' move into the twentieth century and provide both documentary evidence of the way individuals looked and also illustrate how they appeared within their domestic context. It is stated in the catalogue:

> Between 1872 and 1918 Maine Shakerism maintained its vitality and affluence in spite of rapid and massive change that permanently altered the state's society and culture. In an age when Maine was experiencing the multiple problems of industrialisation, urbanisation and immigration, it is not too much to suggest that these early photographs capture what observers from Ralph Waldo Emerson to Friedrich Engels also saw, namely

a working prototype for emerging industrial society that would equitably fulfil humanity's material and spiritual needs.[160]

In a concluding catalogue essay entitled 'Shakers and Photography: Documentary Folk Art in the Industrial Age', Diana Emery Hulick discusses the obvious Victorianisation that the photographs reveal:

> As a variety of images reveal, the calendar on the wall, the Victorian desk and table, the very amount of furniture in the room, contrast with the simplicity of the built-in Shaker drawers and the room's spare design. This juxtaposition of Shaker and worldly objects becomes a visual metaphor for the inter-relation of worldly and religious spheres.[161]

Finally, she states:

> Like Shaker prose and verse, which is noted for its sparse, direct, construction, Shaker photographs are for the most part squarely seen with a centrally framed subject against a simple background. Objects in them are discreet, bared and focused, and the purpose of the photograph is often clear as well. As with their furniture and their tools, which have so often defined Shakers to the outside world, photographs of and by Shakers reveal a particular sense of order that is aided by technology but yet reflects the Community's clarity of vision.[162]

Photography played a considerable role in the promotion of the Shakers through the twentieth century starting with the Andrews partnership's collaboration with William Winter as a means by which they could assemble and give permanence to their vision of the aesthetic. Similarly, Sprigg collaborated with Linda Butler to produce a series of black and white photographs for her book *Inner Light: The Shaker Legacy*.[163] She also worked with Paul Rocheleau[164] to produce colour images which were used as illustrations in the 1986 Whitney exhibition catalogue. These photographs and others have helped to promote the notion of the perfection of the Shaker aesthetic – images which have become synonymous with Shaker design – if not always an accurate account.

Shaker Design at the Whitney Museum, New York – 1986

This was arguably the most important Shaker-related exhibition of the last 30 years which changed the perception of the Shakers on both sides of the Atlantic and helped create new audiences for the Shaker aesthetic.[165] The exhibition designer Art Clark carried through the aesthetic to every level, from the catalogue design to the means by which the exhibits were illustrated and interpreted.[166] The exhibition was staged at the Whitney Museum of Art, New York from 29 May to 31 August 1986[167] and then travelled to the Corcoran Gallery of Art, Washington, DC from 27 September 1986 to 4 January 1987. The exhibition received extensive publicity and reviews including pieces in *Industrial Design*[168] and *Domus*[169] magazines. In the foreword to the exhibition catalogue, Tom Armstrong discussed the Whitney's strong historical links with Shaker design stretching back to the 1935 exhibition:

> In 1935, Juliana Force, then Director of the Whitney Museum, organised the comprehensive exhibition 'Shaker Handicrafts' with the help of Faith and Edward Deming Andrews, the only scholars who then focused on the importance of this material and to whom all subsequent scholars of the subject are indebted. A half century later, it is again a privilege to present more than 100 examples of Shaker work. This exhibition is long overdue. The objects are drawn from 40 collections including those from both extant Shaker villages, in Canterbury, New Hampshire, and Sabbathday Lake, Maine, and represent the work of some 30 known individuals as well as many artists who remain anonymous. A few of the objects in the 1935 exhibition are also included here, among them a candle stand (Cat. 26), a wall clock (Cat. 44), and The Tree of Life (Cat. 110). More than half the objects in this exhibition have not previously been exhibited or published.[170]

This exhibition was possibly the most high profile that June Sprigg would be involved in.[171] The extensive list of lenders to the exhibition included all the major collectors/collections including Abby Aldrich Rockefeller Folk Art Centre, Williamsburg, Virginia; Art Complex, Duxbury, Massachusetts; Fruitlands Museums; Museum of Fine Arts, Boston; Philadelphia Museum of Art; The Western Reserve Historical Society; The Shaker Museum, Old Chatham; Shaker Museum at Shakertown at South Union; New York State Museum, Albany and material from Canterbury, Sabbathday Lake and

Hancock.[172] The catalogue very much focused on design and the exhibition endeavoured to answer certain questions. In the catalogue's 'Introduction' by Sprigg she states:

> How did the Shakers create the design that remains distinctively their own, born of American traditions, infinitely refined and simplified? The Shakers were not an aesthetic movement, but a religious sect. To understand Shaker design, we must look at the inner life that created it.[173]

Sprigg endeavours to answer her own questions by continuing with her familiar concerns:

> It is easy to see the harmony of proportion in Shaker design that transforms common objects into works of uncommon grace. The reasons for this quiet beauty are less apparent, particularly because the Shakers themselves were not self-conscious about it. Their journals, rich in detail on many topics, are almost mute on aesthetics and design ...[174]

And she further states:

> The Shakers did not spurn beauty; they simply reinvented it. It was wrong to suppose that Shaker design was bound by endless restrictions. The Shakers had just one: do not make what is not useful. They saw every reason to make necessary things beautiful, according to their own understanding of beauty. Of the elements universally available to designers, the Shakers rejected only applied ornament as unnecessary. The rest – colour, pattern, line, form, proportion – they freely and joyously used. Perhaps the elimination of superficial decoration gave Believers a keener eye for the shape of a thing and the relationship of its parts.[175]

The catalogue details a variety of Shaker artefacts although furniture is the main focus. Cat. Nos. 1–44 feature a number of different furniture types including built-in pieces with dates *circa* 1800–50. For example, Cat. No. 3: 'cupboard and case of drawers – *circa* 1825–50 – probably Watervliet, New York.' The description: 'Pine, red stain, cherry pulls, brass hinges, iron locks and copper escutcheons.' The furniture was sourced from numerous communities including Harvard, Pleasant Hill, Enfield and Canterbury. It also featured furniture from particular makers, for example, a work stand attributed to Orren N. Haskins (1815–82).[176] Other items included 'smalls' (called household objects): Nos. 45–66 featured boxes (of different sizes

and colours), carriers, dippers, pails and tubs, baskets, bowls and brushes. Tools and equipment were numbered 67–84 and included various wood-working and metalworking items with agriculture-related material, stoves and utensils. In addition, textiles and related artefacts were also included (Nos. 85–102) and featured a spinning wheel, hats (Sisters' and Brothers'), a cloak, rugs and a sampler (circa 1810–20) by Betsy Crosman (1804–92).[177] Finally, graphic products numbered 103–14 included plans and views of villages, spirit drawings, date numerals, grave markers, alphabet boards and a meetinghouse sign.

A short pamphlet produced for the exhibition described the context of the exhibition and, whilst the author is not credited, it has the characteristics of Sprigg's work:

> One cannot fully explain the genius of Shaker design. But the Shakers themselves had a simple answer. They called the creative spirit a gift. The Shakers were not conscious of themselves as 'designers' or 'artists', as those terms are understood today. But they clearly worked to create a visible world in harmony with their inner life. The most appealing feature of Shaker design is its optimism. Those who would lavish care on a chair, clothes hanger or a wheelbarrow clearly believe that life is worthwhile. And the use of every material – iron, wood, silk, tin, wool, stone – reveals the same grace, as if the artisans were linked in their collective endeavour in ways that transcend understanding. It is no exaggeration to call Shaker design *other* worldly. In freeing themselves from worldly taste, the Shakers created a purity of design that endures.[178]

The exhibition isolated the artefacts on display rather than placing them into context via room displays, as seen in other exhibitions. The intention behind this was as Sprigg states:

> To introduce newcomers to the pure, simple beauty of Shaker design, as well as to show long-time admirers some things they have not seen often, or at all. For example, small objects from public collections are often hidden away in storage, or 'lost' in a big roomful of other objects. Things in private collections are usually available only to a very few outsiders. Although the Whitney exhibit included a number of pieces once owned by Faith and Edward Deming Andrews, the emphasis was off the 'old familiars', in favour of new works that are classics in their own right.[179]

Sprigg was clearly seeking to differentiate herself from the Andrews partnership's approach. By adopting an art rather than design approach to the display and interpretation of the pieces, Sprigg would help to influence future Shaker exhibition design and philosophy (this will be discussed later). She also appeared to be arguing against period room reconstructions and dioramas by isolating objects out of their normal environments. There is also an obvious interest in colour and a very definite emphasis on bright surfaces – many of the photographs in the exhibition catalogue are placed against black backgrounds – which make the bright colours 'sing out' of the page. Colour, surface patina and the use of paints would be taken up by other Shaker scholars. The exhibition which we will next examine, for example, took colour as its central concern.

Shaker – Original Paints & Patinas at Muhlenburg College – 1987

Staged at Muhlenburg College, Allentown, Pennsylvania, the exhibition was held from 17 November 1987 to 10 January 1988.[180] Its main intention was to focus on original finishes and the patina of age[181] and it included over 50 artefacts, some of which were photographed in both black and white and colour for the accompanying catalogue. The contributors included individuals such as Pam Boynton, Ed Clerk, Jim Johnson and Martha Wetherbee, as well as museums such as Hancock Shaker Village.

June Sprigg was once again involved in the organisation of the exhibition, and she dedicated her work to the collectors who had made the exhibition possible by resisting the temptation to over-restore the items they had collected, as she notes:

> When other early-twentieth-century buyers of Shaker furniture were busy removing paint and revarnishing, these people were passionate in their convictions that the original surfaces could not be improved, and that to alter them was to cause irrevocable damage. Their efforts and foresight preserved many masterpieces of Shaker furniture and woodenware, and they have greatly enriched our developing understanding of what Shaker design really is. I dedicate this catalogue to them.[182]

The exhibition was one of the first to try to understand the use of colour in Shaker work by analysing the surface treatments the Shakers applied to

their objects, although it must be said it was by no means the first work on Shaker colour and paints.[183] The catalogue examined the means by which the Shakers made objects and their uniqueness compared with the artefacts produced by the outside world:

> Heeding the teachings of Mother Ann Lee, the Shakers created a visual environment noteworthy to nineteenth-century commentators for its cleanliness, order, simplicity and lack of fashion. By largely ignoring changes in worldly styles (especially after the period *circa* 1790–1815 when the Shakers established their own communities, separate from the outside world), by seeking perfection in workmanship and by shunning ornament as vain and 'superfluous', the Shakers gradually developed a style in buildings, clothing and furniture that by the mid-nineteenth century looked different enough from other American styles to appear distinctively their own.[184]

The uniqueness may be said to be found to a great extent in the surface treatments the Shakers used[185] which, due to the vagaries of fashion and taste, came under threat during the course of the twentieth century:

> Today, Shaker furniture is widely appreciated for the simplicity and grace of its lines and forms. The colours and textures (equally important design elements) chosen by the makers, however, have received only secondary attention. This is due in part to the fact that much Shaker furniture has been refinished, by the Shakers themselves and by people who bought furniture from the communities as they declined and closed. In changing the surface appearance of their 'antiques', the Shakers and other Americans alike showed their zeal for the 'colonial revival' style, sparked by the nation's Sesquicentennial in 1926 and popularised by people like Wallace Nutting. As John Kirk suggests, 'woodness' – no paint appealed. Wood reminded Americans of their frontier heritage. As important, or perhaps more important, newly refinished furniture looked clean, not discoloured or 'dirty'.[186]

The artefacts selected for the exhibition were deemed representative of the range of surface finishes of furniture the Shakers produced. They included: unfinished and clear varnished wood; lightly tinted varnish/shellac; transparent finishes and completely opaque treatments. In the text of the accompanying catalogue it notes: 'None of these finishes was unique to Shaker furniture makers. As the nineteenth century progressed, however, the Shakers' use of paint and colour began to differ noticeably from their

worldly neighbours' in three ways, i.e., the absence of decorative painting; the choice of certain colours; the preference for transparent stains.'[187]

The catalogue compared outside world finishes with those used by the Shakers who seemed to prefer the use of transparent stains. These were generally bright rather than muted and sometimes overlaid with varnish or shellac: 'The question of matte or glossy finish was evidently of some concern to Believers in the nineteenth century. To the more conservative members, glossy finishes may have looked unnecessarily showy and therefore unacceptably "worldly".'[188]

The exhibition was innovative since it focused on a specific aspect of Shaker design: their use of colour, an aspect that would be increasingly viewed as important throughout the twentieth century.[189] The exhibition included furniture and smalls, from various communities including Harvard, Enfield, Canterbury, Hancock and New Lebanon. Once again the majority of items are drawn from 1820–60 – the so-called 'Golden Period' – with only a few pieces being dated outside this time-span. (For example exhibit 30, catalogued as 'Oval boxes, about 1830, Bright yellow stain – maple and pine, ex. EDA collection – now Hancock'.)

The Shakers' use of colour can often come as a surprise because most people associate their production with unadorned 'natural' wood. In reality, they used many different surface treatments, which in some cases completely obscured the wood's characteristics. The surface finish of original Shaker artefacts has become an important feature for collectors with absolutely authentic coloured pieces having the highest value.[190] Some researchers, such as Susan Buck, are continuing to study this complex area and the surface finish of Shaker furniture and smalls is revisited in the catalogue for the exhibition 'Shaker: The Art of Craftsmanship'.[191]

Simply Shaker – Groveland and the New York Communities at Rochester Museum and Science Centre – 1991

This exhibition was staged from 11 January to 2 September 1991 at the Rochester Museum and Science Centre, Rochester, New York.[192] Like other Shaker exhibitions of this period it focused on a specific geographical region, the Shakers of Groveland and the New York communities.[193] Lenders to the exhibition included individuals together with Canterbury

Museum; Hancock Village; Western Reserve Historical Society and the Henry Francis du Pont Winterthur Museum. The impetus for the exhibition came from Fran Kramer and arose out of her interest in the Sodus/Groveland Shaker community.[194] The exhibition was designed by L. Shaffer and J. Silvestri and was arranged in a series of sections each with a particular theme, such as history, textiles, and revenue-producing industries (including chairs, poplar ware, bonnets, seeds, brooms and brushes). The catalogue includes specific information on the exhibition and its intended focus:

> This exhibit focuses on the western New York State Shaker community of Sodus/Groveland 1826–1892, and its associations with the other two New York communities near Albany – Watervliet and New Lebanon. A representation of furniture, clothing, tools and items made for sale such as oval boxes, chairs, bonnets and baskets illustrates the life and work of the Shakers. In addition, photographs of the Shakers and their communities show their dedication to creating a 'heaven on earth'.[195]

The museum developed a comprehensive range of workshops[196] including 'A day with the Shakers'; 'Planting your Shaker garden'; 'Shaker cooking' and various craft workshops including basket making, box making, braided rugs and broom making. This participation/interaction with exhibition visitors was one that continued in later exhibitions and featured at both the Barbican and The American Museum in Britain. Those participating in the educational programme included F. Kramer, K. Moriarty,[197] J. Sprigg, C. Muller, J. Scherer and M. Wetherbee. The catalogue was expensively produced and was well illustrated with photographs of various artefacts and furniture, including some walnut case pieces with decorative detailing which was typical of the Groveland Shakers.[198]

In the foreword Kramer describes how her interest in the Shakers began. Like so many American experts it started with a meeting with a living Shaker – in this instance Bertha Lindsay.[199] Kramer describes how the Rochester Area Shaker Study Group had been formed by those interested in the Groveland Shakers. Significantly some of the community buildings proved to be at risk[200] as: '… the remaining Shaker buildings at Sonyea in Groveland became part of the prison complex. The State of New York measured and photographed the Shaker buildings and their locations

before the engineers and the construction crews came, but measurements and pictures cannot tell the whole story.'[201]

Again as with many of the exhibitions featured in this section the curators wanted to ensure that the Shakers as people, rather than merely producers of artefacts, received due prominence. The exhibition catalogue's 'Introduction' by J.L. Scherer (Associate Curator at the New York State Museum at Albany) states: 'The Shakers were real people. Their thoughts, emotions and general behaviour were no different from their contemporaries'. Some may have had problems adjusting to the world, some were perhaps a little strange or eccentric ...'[202]

An interesting aspect of this exhibition was the presentation of a 'diorama' of a Shaker retiring room where the exhibits were located in their natural spatial context, thus giving the visitor a better appreciation of the environment in which they lived. The catalogue also sought to reconnect the artefacts with their religious inspiration, when it stated: 'Objects presented in this exhibition are necessarily detached from the Shaker way of life. It should be borne in mind, though, that these things were produced by people for whom work was an extension of worship, that an essential religious purpose infused every aspect of their lives.'[203]

This exhibition like so many others was trying to make connections between the life of the Shakers and the objects which they used from day to day. However, this proved almost impossible to achieve because, by placing objects into a museum context, much of the essential functionality of the exhibit is lost. In this case, the inclusion of workshops, in some small way, helped to physically reattach the user to the object.

Receiving the Faith: The Shakers of Canterbury, New Hampshire – Whitney Museum of American Art at Champion – 1993

This comprehensive exhibition was held from 10 February 1993 to 9 February 1994, and was a continuation of an exhibition which had taken place at The Museum of Our National Heritage, Lexington, Massachusetts[204] and Canterbury Shaker village.[205] The original exhibition was curated by Cara A. Sutherland who was also instrumental in the reinstallation of the exhibition at the Whitney's Champion branch. Like previous exhibitions, items were loaned by individuals such as Stephen Miller[206]

and institutions such as the American Antiquarian Society, Canterbury Shaker village, Fruitlands Museums, Hancock Shaker village, Philadelphia Museum of Art, Shaker Museum and Library and Winterthur Library. The design of the extensive catalogue was by Elizabeth Finger with photography by Paul Rocheleau.[207] The featured photographs show both the external and internal architecture of Canterbury. In the 'Introduction' to the exhibition the following is important: 'A chronicle of the Shaker movement is more than a simple record of culture; it is a complex account not only of religious history but, because of the Shakers' unique contribution to American aesthetics, of the history of design'[208] acknowledging as it does the place that the Shakers hold in the design history canon.[209]

The exhibition focused on Canterbury, New Hampshire, which was established in 1792 and closed in 1992 when the last Shaker Sister died.[210] After this date the architectural shell of the community was developed into a restored museum and village which was then opened to the public. The village has subsequently become a significant tourist attraction and featured in numerous books, articles and holiday promotions.[211]

In the section of the catalogue entitled 'An Expression of Faith' there is a discussion of Shaker design which used much of the same material as in the Andrews partnership's interpretations. Clearly therefore, even though the influence of the Andrews partnership had waned throughout the intervening years, their work was still being acknowledged, albeit indirectly.[212] In the catalogue there is further discussion relating to the worldly influences seen in Shaker design with particular reference to the oval box:

> Whether divine inspiration was a factor or not, the Shakers clearly based their design on more worldly traditions brought over from England or cultivated in the New World ... The Shakers modified and improved forms inherited from other traditions. They did not invent the oval box, but they perfected the distinctive 'swallowtail' joint in order to make their work more resistant to changes in weather. A carefully carved joint allowed the wood to swell and contract without warping. Copper tacks replaced steel ones, which were prone to rust.[213]

The oval box was clearly seen as an important artefact in terms of its iconic influence and it featured on the catalogue cover, on which yellow and orange oval boxes from New Lebanon were arranged alongside other

specimens from various communities. The representation of the boxes in the catalogue showing them photographed against a black background would seem to indicate the developing move towards an art rather than design view of the artefacts. The position of the Shaker box as an icon will be examined further in Section Four, however the move towards an art interpretation at the museum level provides a curious contrast with the development of Shaker design within popular culture, to which we will now turn our attention.

Interpretations taken from Popular Culture

The period 1976–94 saw a significant expansion in the interest in the Shakers[214] and the market for Shaker artefacts. Numerous sales of Shaker goods took place which reflected both the expansion of interest in the market for Shaker artefacts and also fuelled the collecting of Shaker material as aptly evidenced in the catalogues of Willis Henry Auctions, Inc.[215] A number of large sales of major Shaker and folk art collections[216] occurred, the first entitled *Important Shaker Furniture and Related Decorative Arts: The William L. Lassiter Collection*.[217] This auction took place at Sotheby's Parke Bernet, New York, in November 1981. The catalogue for the auction features a number of Shaker artefacts including smalls, textiles, graphics and larger furniture pieces, including quite rare items such as a Benjamin Youngs clock from the South Family, Watervliet, New York. In an introduction by Gerard C. Wertkin the history of the collection and William Lawrence Lassiter's role is summarised when it states:

> William Lawrence Lassiter (1896–1977) was an inveterate collector of Americana. He assembled many collections, but will be remembered best as a collector of Shaker furniture, manuscripts and books, small crafts and tools, baskets, boxes, ephemera – even recipes. Bill Lassiter was a pioneer in the field, and his work as a collector, curator and scholar helped establish widespread appreciation of the Shaker contribution to American life ... Bill Lassiter used to say that there was a 'story behind each Shaker' and behind each piece of Shaker furniture. He was a raconteur with a delightful sense of humour who never tired of speaking of the Shakers. Lassiter took great pleasure in living with his collection ... he understood that the importance of his Shaker collection lay not only in its superb craftsmanship,

classic design and functionalism, but also in the warm associations it evoked of an extraordinary people.[218]

The estimates for the 179 lots of the Lassiter collection ranged from around $100 to $30,000 (the whole sale finally achieved $318,000). The Willis Henry auctions previously mentioned also proved successful, for example, in the article 'A Hot Day in the Country for Shaker' it states: 'New Lebanon, NY – Record prices paid at auction were established for a piece of Shaker furniture and for a Shaker box this past Sunday, August 7, at Willis Henry Shaker Auction ... Attendance at the auction was heavy with national representation from all of the major dealers and collectors.'[219]

A second sale featured a collection of both Shaker and folk art from the collections of George and Roberta Sieber, and took place at the Litchfield Auction Gallery on 30 July 1988.[220] The Shaker items included a spool holder, six Enfield chairs, a number of oval boxes and some rare pieces including an Enfield cupboard with an estimate of $75,000 to $95,000. The third major sale was an auction by E.F. Casazza and W.F. McKinnon,[221] entitled *Shaker & Americana*. In addition, Robert Skinner[222] also auctioned Shaker artefacts and *The Shaker Messenger* reported on many developments in an expanding marketplace[223] and influences on contemporary architecture.[224] Harvey Antiques organised an exhibition in February 1992, in which objects from Chicago collections were displayed and an accompanying catalogue produced, containing a number of black and white photographs showing Shaker artefacts.[225]

Collecting original and reproduction Shaker artefacts became more widespread in the 1980s.[226] An article from 1994 entitled 'Living with Antiques: A Folk Art Collection in Pennsylvania' by Jean Burks featured a Pennsylvanian couple who: 'Over the last 15 years ... have been acquiring American artefacts that reflect the conscious simplicity of the Shakers and the unconscious *naïveté* of folk art paintings, quilts, cast iron toy banks, and fire-related equipment.'[227] When talking about furniture, their primary consideration as collectors appears to be the finish and colour, with an original finish being viewed as essential and pieces with a vibrant colour preferred. This is a theme which would continue to excite collectors and was an interest of Sprigg and the new mood in the analysis of colour which she had helped foster in the exhibitions that have been discussed

above. The article continues by noting that: 'The husband's favourite piece of furniture in this regard is a chrome yellow washstand of about 1840 from Enfield, New Hampshire which was covered in grey paint when it was purchased.'[228] However, collectors were still interested in proportion and, together with colour and finish (original finish greatly influenced the price of an object), this was the main preoccupation of the majority of collectors in the marketplace. Jean Burks notes:

> The couple generously donate their time and financial resources to research and restoration projects at Canterbury Shaker Village in New Hampshire. They are also on the American Arts Board at the Philadelphia Museum of Art, and are members of the American Folk Art Society. Perhaps their most fulfilling endeavours have been to organise a continuing series of exhibitions of their collections, accompanied by catalogues.[229]

The Pennsylvanian couple, judging by the accompanying photographs to the magazine article, are very wealthy collectors and their collection is beyond the reach of the 'average' collector. Ironically what had been made with religious humility for utilitarian use have now become highly priced collector's items which adorn the homes of the rich and famous who, for aesthetic and/or investment reasons, desire Shaker and folk art artefacts and are prepared to pay large sums for them.[230] The collectors themselves have become a source of fascination for those chronicling the Shaker phenomenon and several have featured in documentary films, such as the BBC *Timewatch* programme.[231] Programmes such as these have helped develop the interest in Shaker design amongst the mainstream media and generate the spin-off industry in reproductions and lifestyle make-overs.

Away from the rarefied world of the Shaker original, the expansion in Shaker reproductions and the infiltration of the Shaker aesthetic into the wider retail market has been fuelled by books and articles in both the United States[232] and United Kingdom.[233] Other examples include the educational, such as 'The Shakers' Brief Eternity' in the *National Geographic*,[234] to the more commercial, for example *Colonial Homes* in 1979, which is typical in featuring museum settings including Hancock[235] and Pleasant Hill[236] mixed with advice on contemporary outlets for those wishing to purchase reproductions of Shaker artefacts. For example in a section entitled 'Shaker Pieces to Buy' it states:

Until recently, collectors often relegated Shaker furniture to the realm of 'modern' design. The reason is simple. The functionalism and geometric simplicity of Shaker forms satisfy 20th-century aesthetics as well as they did the communal sect's religious doctrines. Thus it is not surprising that the proponents of modern design were among the first to appreciate the Shakers' accomplishments.[237]

In the article 'The Shaker Surge' in *Colonial Homes*, a range of aspects of the Shakers' 'world' are featured: The Lassiter Sale, The Metropolitan Museum Shaker Room and contemporary Shaker-styled artefacts.[238] An article in *Home* magazine entitled 'Pure and Simple' provides a typical example of the 'life styling' copy about Shaker design used to reach a broader audience: 'Animated by a singular spirit that is at once classic and modern, Shaker designs now enjoy unprecedented popularity. From the elegant, light-weight ladder-back chairs to the perfect ovals of their wooden boxes.'[239] The article contained sources of Shaker artefacts including The Guild of Shaker Crafts, Shaker Shops West,[240] Shaker Workshops[241] and Barrett's Bottoms furniture.[242] The article is well illustrated with photographs of The Shaker Museum, Old Chatham:

> Classic lines account for the new found popularity of the Shaker style. 'It's so versatile because of its cleanness of form. It fits in with contemporary and country looks, and some pieces even fit well into traditional rooms,' says Laurie Cech, who, with her husband, Joe, operates the Guild of Shaker Crafts in Spring Lake, Mich. So popular has Shaker styling become that adventurous homeowners are creating whole environments based on Shaker design. Recently, the Manhattan design firm of Lemeau & Llana installed Shaker-style built-in cupboards in a library to house an array of electronic equipment, including a computer. And Ian Ingersoll has designed cabinets for a kitchen.[243]

In the article 'Simply Shaker' in *Art & Antiques*, there is an emphasis on the work ethic of the Shakers and in turn the puritan nature of the Shakers and their broader influence on American culture: 'The Puritan ethic has given way to a national obsession with surfaces, style, modernity. Were the Shakers the last Puritans – or the first moderns? Perhaps they will not let go of our collective imagination because they were both.'[244] The article then suggests that the Shakers have consistently provided inspiration to art and

design practitioners including Gustav Stickley[245] and the artist Charles Sheeler.[246] It also suggests the very important role that Edward Deming Andrews played in, and the subsequent growth of, what might be termed the 'Shaker Industry':

> But the sect's renown owes the most to Edward Deming Andrew and Faith Andrews, the collector/dealers who 'discovered' Shaker design in the 1920s and spent the next 60 years moulding and elevating the Shakers' reputation as icons of the antique world. Today, 'Shaker' is an international industry, with celebrity collectors, preserved villages, track-lit installations at prestigious museums, and a growing library of commentary and connoisseurship. Echoing the irony of its progenitors' original status as 'progressive puritans', Shaker art today appeals to both traditionalists, who admire hand craftsmanship, and modernists, for whom Shaker design foreshadows the minimalism of the twentieth-century avant-garde – a kind of Old Sturbridge Village meets the Museum of Modern Art.[247]

In chronological terms this section starts in 1976 and documents the turning point at which Shaker design moved from being a minority 'high culture' taste to a mass appeal commercial commodity with the potential to appeal to a variety of audiences cutting across many socioeconomic groups. Nancy Reagan gave Shaker her seal of approval when she gave boxes as presents to Senator's wives,[248] while Shaker-influenced designs were winning awards[249] and Shaker seed boxes were being used for window dressing at Saks Fifth Avenue in downtown Cincinnati, Ohio.[250] The increasing emphasis upon the lifestyle aspects of the Shaker aesthetic – particularly in relation to interiors and decoration – as opposed to the academic investigation of the design philosophy, has seen the rise of Shaker orientated articles in magazines such as *Vogue*. For example, their article 'Know Your Shaker' provided readers with advice on collecting and using Shaker material:

> Aesthetic principles followed the Shakers' theology. Forms followed functions; they were minimal, comparatively uniform, never decorative, Puritanical, anti-sexual, anti-materialistic, the Shakers created spare elegant furniture from the late 1780s to the late nineteenth century. Ironically, plain Shaker furnishings are now worldly commodities. A large trestle-table can sell for over $20,000.[251]

Edward Deming Andrews is mentioned with some deference:

> In the 1930s the first major collections of Shaker furniture were formed by Edward Deming Andrews. Ten years ago a larger public discovered the simple cupboards, trestle-tables, candle stands and rockers. Shaker forms were as pared down, as up-to-date as the designs of Mies van der Rohe or Le Corbusier. As the audience increased, prices rose, but many items, particularly chairs, remain reasonable ... The major dealers are in rural New England and New York, clustered around the original colonies. Some of those dealers lament the growing interest. They say there's been an increase in misrepresentations and fakes.[252]

The move of Shaker-style products into department stores, which began as far back as the 1940s, really took off in the 1980s. In 1982 *The New York Times* ran an article entitled 'A Store Salutes American Design' which states: 'Bloomingdale's Shaker room has an elegant pine four-poster bed, ladder-back chairs and a stencilled floor cloth'.[253] The article went on:

> A focus of 'America the Beautiful' is a series of seven model rooms, which Fred Palatinus, who designed them, calls 'statements which relate designs and styles to regions of America, reflections of the evolution and ingenuity of American style'. The rooms are at once historical vignettes of traditional American interiors and fantasies of possible future designs.[254]

In the article on Bloomingdale's it also mentions a promotion in a street-level arcade of foods featuring indigenous gastronomic delights such as cheese and garlic.[255] Also various restaurants have been reviewed in articles in which Shaker connections have been made, for example, *The Golden Lamb* which has featured in magazines where the food and environment has been recommended.[256] There has also been a proliferation of guides to making Shaker furniture and home decorating, featuring material such as measured drawings[257] and craft and decorating project books,[258] mirroring the general interest in do-it-yourself.

The expansion in American magazine features on Shaker design was matched in British publications. The *Telegraph Weekend Magazine* ran an article on Shaker design in a 'Homes' feature, 'Simply Divine', subtitled 'American Shaker style is newly popular in design circles; uncluttered and beautifully made, it is a hymn to honest toil'[259] which states:

Imagine a room devoid of decoration. It is uncurtained, very light and very clean; every surface is plain and unadorned. The narrow little wooden bed is on wheels and the chairs hang on pegs on the walls so that you can sweep the floorboards more easily. There are no pictures, no ornaments. No, this is not the latest in chic minimalism, but the classic early-19th-century style of the Shakers and, if we are to believe the design pundits, the new look in interiors that will finally tempt our jaded tastes away from those ubiquitous English country house chintzes and the ever-rising tide of swags and bows.[260]

The article continues by indicating the increased obsession with lifestyle:

In an era obsessed by image and in which lifestyle manuals have become one of the most popular categories of book, we have a dreadful tendency to seize on a look, give it a name, such as 'Shaker style', and then, ignoring the rich traditions it has grown from, accord it a Warholian 15 minutes of acclaim and popularity. In the USA, however, the Shakers have been getting quite a bit of attention recently, not just because the architecture of their villages and the quality of their artefacts are so special, but also because the Shaker way of life, which evolved over a period of 200 years, has proved to be one of the longest lasting and most intriguing of Utopian experiments.[261]

This fascination with lifestyle was initiated by the 'glossy' magazines aimed at niche markets, for example, style and high fashion publications. But this interest would eventually spread to more general 'down-market' publications as the twentieth century progressed.

The up-market society magazine *Harpers and Queen* produced an article entitled 'Plain Tales', subtitled 'The simple, practical furniture of the early American settlers is inspiring new ranges of settles, cupboards and chairs – Caroline Clifton-Mogg tells an unadorned story of Movers and Shakers'. In the article the author acknowledges original sources and recommends both the Conran Shop and Liberty for reproduction Shaker furniture.[262] An *Elle Decoration* article 'Shaker Maker', subtitled 'The austerity of Shaker furniture conjures up sober prayer meetings, strict morality and honest labour under a New England sky', states: 'Now Tim Lamb, the man behind the look of Next Directory, is importing these American classics'.[263] The article is basically a promotion for the soon-to-be-opened Shaker Shop, London, illustrated with photographs of Tim Lamb's house, the man behind the Shaker

Shop concept.[264] The Shaker Shop, which opened in London in 1990 and in fact developed from a mail order catalogue,[265] has had a very marked and substantial effect on the way the British perceive Shaker design.

The early 1990s saw a proliferation of articles featuring the Shakers and their artefacts in the United Kingdom. Gradually, they started to appear in style sections of the popular Sunday supplement magazines with a wider audience base. One example is an article in *The Independent on Sunday* from 1992, entitled 'Interiors (5. New Puritans) – Born Again Shakers', subtitled 'The austere elegance of Shaker furniture has now become all the rage among Nineties simplicity-seekers as Dinah Hall discovers'.[266] The article's tone is critical – but fairly accurate – in its assessment of the Shaker phenomenon as the latest fashionable money-spinner:

> Today's 'followers' are going into religious ecstasies over the pure lines of Shaker furniture, which was not at all what the Brothers and Sisters had in mind when they first made their chairs fit for angels to sit on ... Everyone seems to get terribly po-faced when it comes to Shaker stuff. You're not really allowed to admire it, without first being made to understand that it wasn't supposed to be gratuitously beautiful, that everything had a practical purpose ... All this leaves sensitive aesthetes in a bit of a dilemma. Coveting these beautifully designed pieces leads to feelings of being worldly and avaricious. Shaker, the London shop which imports a whole range of furniture and accessories, has obviously found it difficult to accommodate God in the profit and loss columns. The introduction to its catalogue sounds a rather sanctimonious note: a mini-obituary of one of the last surviving Shakers, Sister Mildred Barker, finishes with the words, 'She did not want the Shakers to be remembered simply as [sic] pieces of furniture. We respect that view.' But turn the pages and what you find is: lots of lovely furniture. The revival of interest in Shaker furniture coincided with an interest in the simpler lines of eighteenth-century Swedish Gustavian furniture and a Green-influenced movement towards a more natural style. After the rich meal of the Eighties – the swags and bows – people were hungry for a leaner look.[267]

Other articles have appeared in virtually every sector of the printed and electronic media. The Shakers have featured on radio in the United Kingdom[268] and the *Radio Times* in 1994 produced an article associated

with the programme *Simple Gifts*. The headline was 'Against the Grain' which dealt primarily with the community at Sabbathday Lake:

> Presenter Bernard Jackson and producer Amanda Hancox flew to meet the Shakers, a community whose name is now synonymous with the traditional wood furniture their early counterparts designed, built and furnished their dwellings with. Much imitated – the last genuine Shaker chair was made in the 1940s – and selling, in both reproduction and original form, for seriously large sums of money, the understated Shaker style has found favour in the back-to-basics 90s ...[269]

An article in *Homes & Antiques* is typical of the interest. Entitled 'Style File: Beautifully Simple – Perfectly Plain', it states: 'The Shakers believed that "beauty rests on utility" and made furniture fit for angels to sit on'.[270] Fiona Malcolm analyses the style in terms of its 'cult' following, defining the mood as:

> Monastic calm meets the country look, with utilitarian, airy rooms. Colours: White walls were complemented by wood tones. Subtle, earthy colours could be added on woodwork and furniture. Floors: Either bare or painted floorboards, with two-colour rag rugs on top. Windows: Bare wood or painted frames, sometimes with plain, simple curtains. Furniture: Usually wood, sometimes painted, in clean, simple lines. Long dining-tables and benches, rocking chairs, ladder-back chairs, wooden settles and drop-leaf tables. Beds were simple cots on castors. Lighting: Candles or oil lamps, wrought-iron candelabra or simple wooden fittings. Accessories: There would probably be a wood-burning stove in the communal room, plus portraits of elders, Shaker boxes, wicker baskets, tin pails and jugs.[271]

Many of the articles published had a commercial tie-in and recommended certain featured items that could be purchased from high street and mail order stores.[272] Many companies were realising the retail and marketing potential of Shaker-styled products and the steady infiltration of Shaker items into the British high street could first be seen with Laura Ashley featuring IKEA 'Shaker' boxes in its 1992 mail order catalogue. This was followed by Habitat selling a colonial Shaker-inspired range of furniture; Boots the Chemist selling an aromatherapy gift box packaged in a Shaker-style oval box; Marks and Spencer selling a gift collection for men in a

Shaker-style oval box; Dulux using Shaker boxes as promotional material for its paints; and British Home Stores using a composite Shaker box as part of its New England collection.[273] Shaker style had entered the mass market in the United Kingdom in a bewildering variety of guises.

Why has the Shaker style become so popular? Why was it that people from diverse social, economic and ethnic groups found it so appealing? What was it about the style that has propelled it into the rank of an iconic design classic? We shall be examining these questions in greater detail in the next section. Perhaps a review of the exhibition, 'America in London: Selected Items from the American Museum in Britain',[274] held at Christie's, London in 1994, gets closer than most to the heart of the appeal of the Shaker style, when it stated:

> Folk art puts us in touch with the initial encounter of the American citizens with the New World. The objects and images make us feel the power of wonder, abundance and ingeniousness that transformed the society. The streamlined simplicity and harmonies of the Shaker boxes and furniture, for instance, make a spectacle of the spiritual rigour, discipline, and pragmatism that defined the society. In their modernity, Shaker furniture is a quintessential metaphor of the peculiar American mixture of cunning and belief. The Shakers, who also invented collapsible walls and 'borrowed light', exhibit in their crafts a sense of Heaven on earth which so characterises the American experiment.[275]

Notes

1 See Walker, J.A., *Design History and the History of Design*, 1989, p. 166.

2 See Romanelli, M., 'There is No Dirt in Heaven', *Domus*, 1986, and La Trobe Bateman, R., 'Pure and Simple', *Crafts*, 1986.

3 However there was a symposium held in the United Kingdom relating to the Shakers: see Gale, G., 'England's Exeter University holds Shaker Symposium', *The Shaker Messenger*, 1989. The symposium resulted in the publication Gidley, M., Bowles, K. & Fowles, J., *Locating the Shakers: Cultural Origins and Legacies of an American Religious Movement*, 1990.

4 Walker, J.A., *Design History and the History of Design*, 1989, p. 167.

5 See Schlereth, T.J., 'Material Culture Studies in America: Notes Toward a Historical Perspective', *Material History Bulletin*, 1979, for a review of these developments. Material culture theory was also used in teaching materials for school groups, for example, Durbin, G., Morris, S. & Wilkinson, S., *A Teacher's Guide to Learning From Objects*, 1990.

6 Schlereth, T.J., 'Material Culture Studies in America: Notes Towards a Historical Perspective', *Material History Bulletin*, 1979, p. 90.

7 See Mayo. E., 'Focus on Material Culture', *Journal of American Culture*, 1980, which gives a list of materials and general sources of information relating to material culture studies.

8 Prown, J.D., 'Mind in Matter – An Introduction to Material Culture Theory and Method', *Winterthur Portfolio – A Journal of American Material Culture*, 1982, p. 1.

9 This has included the scientific study of the group, for example Murray, J.E., 'Stature among Members of a Nineteenth-Century American Commune', *Annals of Human Biology*, 1993 and 'Determinants of Membership Levels and Duration in a Shaker Commune, 1780–1880', *Journal of the Scientific Study of Religion*, 1995.

10 See Mayo, E., 'Focus on Material Culture', *Journal of American Culture*, 1980, p. 597. Of Winterthur she writes: 'McClung Fleming of Winterthur Museum has written of the role of the decorative arts in illuminating seven areas pertinent to understanding a culture: (1) craftsmanship as seen by tools, skills and techniques; (2) trade patterns as seen through origins of raw materials and distribution of finished product; (3) technology of the period; (4) wealth of the users; (5) customs, social patterns and social usage; (6) images reflecting the popularity of the subject; (7) the feeling for form and mood.'

11 See Sprigg, J., 'June Sprigg Explains Beginnings of Exhibit', *The Shaker Messenger*, 1986 and Billings, D., 'Whitney Shaker Exhibit Impressive', *The Shaker Messenger*, 1986.

12 For an account of material culture and folk art see Quimby, I.M.G. & Swank, S.T., *Perspectives on American Folk Art*, 1980.

13 Some contemporary views of the Shakers include Morse, F., *The Shakers and the World's People*, 1980 and *The Story of the Shakers*, 1986. For a photographic representation using high quality black and white photographs see Butler, L. & Sprigg, J., *Inner Light: The Shaker Legacy*, 1985. Also an analysis by Horsham, M., entitled *The Art of the Shakers*, 1989 and Beale, G. & Boswell, M.R., *The Earth Shall Blossom*, 1991.

14 See Sprigg, J., 'Shaker Colour and Light', *Art & Antiques*, 1988.

15 See Sprigg, J., 'The Shaker Way', *The New York Times Magazine*, 1975 and Fertig, F., 'Made by Shakers ... What Does it Mean?', *The Shaker Messenger*, 1981.

16 Bainbridge, W.S., 'Shaker Demographics 1840–1900: An Example of the Use of US Census Enumeration Schedules', *Journal for the Scientific Study of Religion*, 1982; furniture is featured in Hults, B., 'Shaker Chairs', *American Art & Antiques*, 1978, whilst feminist concerns are dealt with in Procter-Smith, M., *Women in Shaker Community and Worship – A Feminist Analysis of the Uses of Religious Symbolism*, 1985; Humez, J.M., *Gifts of Power. The Writings of Rebecca Jackson – Black Visionary, Shaker Eldress*, 1981; and Humez, J.M., *Mother's First Born Daughters – Early Shaker Writing on Women and Religion*, 1993. For children see Graham, J.A., 'The New Lebanon Shaker Children's Order', *Winterthur Portfolio – A Journal of American Material Culture*, 1991 and Bunnell, J., *Children at Shaker Village – Rural Living in the Nineteenth Century*, 1990. Shaker restoration projects have featured in Gill, B., 'Shaker Spirit (Architect J.B. Baker Restores Former Forge in New Lebanon, New York', *Architectural Digest*, 1992; Richards, D., 'The 1816 Spin House: A Restoration Project', *The Shaker Quarterly*, 1988; and Rosenberg, W.S., 'Shaker Buildings Preserved', *The Clarion*, 1988.

17 Dormer is a British writer who has written extensively on art, design and particularly crafts, and his work has been connected with The Crafts Council.

18 See Dormer, P., 'Art Lobby – Why do the Shakers Look Like Modernists', *Art Monthly*, 1986.

19 See Dormer, P., 'Art Lobby – Why do the Shakers Look Like Modernists', *Art Monthly*, 1986, p. 32.

20 Hosley, W.N., 'Simply Shaker', *Art & Antiques*, 1993, p. 76.

21 La Trobe Bateman, R., 'Pure and Simple', *Crafts*, 1986, p. 34.

22 La Trobe Bateman, R., 'Pure and Simple', *Crafts*, 1986, p. 38.

23 La Trobe Bateman, R., 'Pure and Simple', *Crafts*, 1986, p. 38. In addition, Shaker baskets have been extensively discussed in various publications such as Larason, L., *The Basket Collector's Book*, 1978; McGuire, J., *Basketry: The Shaker Tradition*, 1988; Wetherbee, M. & Taylor, N., *Shaker Baskets*, 1988; and Freeman, C.D., 'An American Tradition: New England and Shaker Baskets', *Fiberarts*, 1988. In addition, David Drew has also featured in Harrod, T., *The Crafts in Britain in the Twentieth Century*, 1999, p. 460 in which Drew is photographed making a basket.

24 La Trobe Bateman, R., 'Pure and Simple', *Crafts*, 1986, p. 38. Earlier work had aligned Shaker furniture

exclusively with Modernism, for example Gossett, A.R., 'An American Inspiration: Danish Modern and Shaker Design', *The World of Shaker*, 1977.

25　June Sprigg has had a long and successful career in what could be termed the promotion of the Shaker aesthetic. She has been curator at Hancock on two separate occasions and has authored a number of significant publications on the Shakers and their material culture. For example see Sprigg, J., 'Hancock Shaker Village: The City of Peace', in *The Magazine Antiques*, 1981. After her marriage in 1994 she changed her name to June Sprigg Tooley. As with Gus Nelson (organiser of the Berkshire Shaker Seminars) she teaches at Berkshire Community College and appears to be continuing her life-long interest in the Shakers with more research and publications. Note – a useful guide to all the twentieth-century articles on the Shakers in *The Magazine Antiques* has been produced by Hatcher and Gilbert.

26　See Gordon, B., 'Victorian Fancy Goods: Another Reappraisal of Shaker Material Culture', *Winterthur Portfolio – A Journal of American Material Culture*, 1990 and the exhibition 'True Gospel Simplicity'.

27　See Sprigg, J., *By Shaker Hands*, 1990: 'This book is respectfully and lovingly dedicated to the memory of Sister Lillian Fillips (1876–1973) of Canterbury, New Hampshire, who made all aware that above all else the Shaker way meant love, on earth as it is in heaven.' Thus it appears that Sprigg wanted to have an indirect seal of approval and connection with real Shakers.

28　See Sprigg, J., *By Shaker Hands*, 1990.

29　See Sprigg, J., *By Shaker Hands*, 1990, p. 191.

30　See 'Introduction' in Sprigg, J., *By Shaker Hands*, 1990, p. 28.

31　There are numerous examples of material that was produced by the Shakers that could be deemed to be aesthetically unappealing, for example, some objects featured in the George and Roberta Sieber auction catalogue including Number 160, 'Shaker grain painted cupboard and case of drawers' (p. 49) and Number 227, 'Shaker sewing and spool box with three tiers' (Pico, C. (auctioneer), Auction Catalogue for *Important Shaker and Folk Art – The Collection of George and Roberta Sieber*, 1988, p. 70).

32　See the section on perfectionism in Sprigg, J., *By Shaker Hands*, pp. 87–98 and Sprigg, J., 'Shaker Perfection', *Art & Antiques*, 1985, for further writing on perfectionism in Shaker design.

33　See Sprigg, J., *By Shaker Hands*, 1990, p. 87.

34　See Sprigg, J., *By Shaker Hands*, 1990, p. 99.

35　See Sprigg, J., *By Shaker Hands*, 1990, p. 77: 'When a World's Fair was held several years ago in Japan, one of the most popular features was an exhibit of Shaker furniture. Chairs without carving, tables without knick-knacks, the simplicity of Shaker stoves and baskets, even the white wall and the bare wood floors – all these made sense to the Japanese, who recognised and appreciated the same simplicity based on spiritual principles that characterises traditional Japanese culture. An exhibit of Shaker design a few years later in Germany met with the same reaction from admirers of Bauhaus design, who found in Shakerism a similar embracing of simple functional solutions based on social and economic principles. Opposite sides of the world – spiritual reasons versus practical reasons – no matter. What people saw and appreciated was the total simplicity of the Shaker spirit.' Also see Sprigg, J., 'Shaker in France and Germany', *The Shaker Messenger*, 1994.

36　See Sprigg, J., *By Shaker Hands*, 1990, pp. 77–79.

37　Two of the books include Butler, L. & Sprigg, J., *Inner Light: The Shaker Legacy*, 1985 and Sprigg Tooley, J., *A Shaker Sister's Drawings*, 1997.

38　In a footnote to 'The Development of Shaker Design', *The Magazine Antiques*, 1986, p. 822, Sprigg gives an indication of the source of the objects in the photographs by stating: 'The objects illustrated on these pages are included in an exhibition of Shaker artefacts at the Whitney Museum of American Art in New York City, to be on view from May 29 to August 31.' Others have also documented the evolution of design in Shaker work such as Burks, J.M., 'The Evolution of Design in Shaker Furniture', *The Magazine Antiques*, 1994.

39　Sprigg, J., 'The Development of Shaker Design', *The Magazine Antiques*, 1986, pp. 820–21.

40　Sprigg, J., 'The Development of Shaker Design', *The Magazine Antiques*, 1986, pp. 821–22.

41　See Van Kolken material in the Bibliography for examples of the variety and type of article in *The Shaker*

Messenger. Likewise for marketplace information see Kramer, F. (multiple references over a wide time frame).

42 See Kay, J.H., 'The Last of the Shakers', *Historic Preservation*, 1982: 'Elders Gertrude Soule, aged 85, one of the world's nine surviving Shakers' (p. 14); 'Real Shaker products, and genuinely attentive reproductions, have precisely the dignity that's lost when Shaker tradition is exploited. The appeal of the real thing, the simple elegance of Shaker objects, is deeply popular, however' (p. 21).

43 Cynthia Bourgeault describes how, at Sabbathday Lake, members of America's last surviving Shaker community celebrate a new beginning: 'For years now the Shakers of Sabbathday Lake, the last surviving Shaker community in America, have heard themselves pronounced for all intents and purposes extinct: the last struggling remnants of a once-colourful movement. But, in the words of a recent proverb, "It ain't over till it's over," and at Sabbathday Lake these days, things are feeling less like an ending, and more and more like a new beginning … For most people, America's Shaker tradition is something like an iceberg – only the tip is visible. The tip, of course, is an artistic tradition of incredible wealth and diversity. Almost automatically, mention of the word Shaker conjures up images of straight-back chairs, wooden clothes pegs, and barns – of a decorative style characterised by an austere beauty and simplicity … To a widening circle of enthusiasts the Shaker community has become a recognised hub in the network of "new age" consciousness, a kind of "foxfire" monastery, with a spirit all its own. This transformation is, in part, a natural outgrowth of those great social stirrings of the 60s and 70s: the "back to the land" movement, a heightened ecological awareness, and feminism. Pulling these diverse strands together, however, has been the almost single handed achievement of one Shaker – Brother Theodore "Ted" Johnson.' (Bourgeault, C., 'Hands to Work, Hearts to God', *Down East*, 1984, p. 34.)

44 Refer to Paterwic, S., 'The Last of the Shakers', *The Shaker Quarterly*, 1992.

45 See a book review in Graham, J., 'M. Angelou – Shaker, Why Don't You Sing', *Journal of Reading*, 1991.

46 Harrison, J., 'Shaker Chair', *Journal of Poetry*, 1993.

47 De Matteo, C., *Shaker Poems*, 1990.

48 See Mahoney, K., *Simple Wisdom – Shaker Sayings, Poems and Songs*, 1993.

49 For reproductions of Shaker music see Coulter, W. & Phillips, B., *Tree of Life*, 1993; Folger, R., *Gentle Words*, 1993; Hall, H., Thompson, D. & Phelps, L., *Let Zion Move: Music of the Shakers*, 1999; and Barker, M.R. (with other Shakers from Sabbathday Lake), *Early Shaker Spirituals*, 1996 featuring sleeve notes by Daniel W. Patterson. Also see Collins, M., 'Topic for Thesis Opened World of Shaker Music', *The Shaker Messenger*, 1985.

50 Refer to Cummings, H., 'Foreword', in Bruhn, T.P. (ed.), Catalogue for *Simple Gifts – Hands to Work and Hearts to God*, 1978, p. 10: 'The objects from the exhibition are mostly from Hancock Shaker village and are in the eyes of that museum – as well as this one – among the finest pieces in that collection. Only a very few items of questionable aesthetic value have been included just to give a better sense of the Shaker culture. It was impossible to resist a century-old permanent press dress, for one. Coat hangers, on the other hand, are here because these are lovely to look at …'

51 John Ott was responsible for the guidebook at Hancock: refer to Harlow Ott, J., *Hancock Shaker Village – a Guidebook and History*, 1976.

52 Priscilla Brewer has written a number of pieces on the Shakers with specific reference to demographics, including the detailed book *Shaker Communities, Shaker Lives*, 1968 and 'The Demographic Features of Shaker Decline 1787–1900', *Journal of Interdisciplinary History*, 1984.

53 See Bruhn, T.P. (ed.), Catalogue for *Simple Gifts – Hands to Work and Hearts to God*, 1978, p. 7, where, in the acknowledgements, it mentions the fact that the exhibition offered contemporaneous examples of design by way of comparison: 'We are grateful as well – and again, for this is only their most recent kindness – to The Lyman Allyn Museum at New London and to Peter H. Tillou of Litchfield for lending pieces from the "mainstream" of American design for purposes of comparison.'

54 See Cummings, H., 'Foreword', in Bruhn, T.P. (ed.), Catalogue for *Simple Gifts – Hands to Work and Hearts to God*, 1978, p. 11: 'Photographs of Hancock Shaker Village made by the artist Armin Landeck – on display here through Mr Landeck's generous loan – would not, then have seemed strange to the

Believers. The photographs show Hancock as it still can be seen today, without Shakers, but with the spirit of Shakerism in every detail ...', and also Miller, S.M., 'The First Shaker Icon: A Stove', *The Shaker Messenger*, 1996.

55 See Rovetti, P.F., 'The Director's Note', in Bruhn, T.P. (ed.), Catalogue for *Simple Gifts – Hands to Work and Hearts to God*, 1978, p. 9.

56 See Rovetti, P.F., 'The Director's Note', in Bruhn, T.P. (ed.), Catalogue for *Simple Gifts – Hands to Work and Hearts to God*, 1978, p. 9.

57 See Rovetti, P.F., 'The Director's Note', in Bruhn, T.P. (ed.), Catalogue for *Simple Gifts – Hands to Work and Hearts to God*, 1978, p. 9, which states: 'Emphasis has always been placed upon the sect's other-worldliness. It is true that marriage, private property, competition in industry and war were held in disfavour. It is also true that the Shakers had little interest in political or economic issues. They were practical people and their practicality is evident in the production of the fine furnishings here in evidence. They were also innovative and a number of pieces in this exhibition show that innovation. Perhaps more important than anything else is the clarity and beauty of design and craftsmanship, as that is what makes these furnishings works of art. We hope, in presenting this exhibition and in presenting some of the activities that are going on at the same time, to pique the interest of the university community and our visitors generally. We hope that what we do will lead to a better understanding of this communal sect ... Perhaps part of the way to understand the Shakers and their beliefs is through viewing what they produced. There was a direct relationship between their way of life and their way of work. Their lives were finely constructed and satisfying to them; in the same way their furniture was well designed and finely constructed. Their values, their spiritualism and their attempts to combat the evils of worldliness led them to produce furnishings and objects of applied art that were devoid in most instances of decoration and uselessness.'

58 See Cummings, H., 'Foreword', in Bruhn, T.P. (ed.), Catalogue for *Simple Gifts – Hands to Work and Hearts to God*, 1978, p. 10: 'They are together in this exhibition "Simple Gifts" not because of any certainty that a miscellany of itself provides a better appreciation of Shaker craftsmanship than does Shaker furniture alone. Nor does this exhibition pretend to give a history of Shaker crafts or culture. Certainly it is not meant to substitute for the experience of visiting a Shaker community like that of Hancock Shaker Village in Hancock, Massachusetts.'

59 See Cummings, H., 'Foreword', in Bruhn, T.P. (ed.), Catalogue for *Simple Gifts – Hands to Work and Hearts to God*, 1978, pp. 10–11.

60 See Whitworth, J.M., *God's Blueprints: A Sociological Study of Three Utopian Sects*, 1975, in which the Shakers are studied alongside both the perfectionists of Oneida and The Society of Brothers (or Bruderhof). In Hayden, D., *Seven American Utopias: The Architecture of Communitarian Socialism, 1790–1975*, 1976, the substantial text is subdivided into 'Seeking Utopia', 'Building Utopia' and 'Learning from Utopia', and the Shakers are featured in the section 'Heavenly and Earthly space'. The book also contains a useful comparative chart of communities (p. 358). In addition, Nordhoff, C., *The Communistic Societies of the United States*, 1966 (first published in 1875) gives a detailed account of many utopian societies such as the Amana, Harmonists, Oneida and Wallingford Perfectionists. The Shakers are featured on pp. 117–256. This can be considered an important early account of the Shakers from a contemporaneous standpoint.

61 See the television programme Treays, J. (producer), *Timewatch: I Don't Want to be Remembered as a Chair*, 1990, in which Brother Arnold mentions the Amish and the fact that visitors to Sabbathday Lake sometimes get the Shakers mixed with the Amish (Post-Production Script, p. 14).

62 See Harlow Ott, J., 'Ye Shall Know Them By Their Fruits', in Bruhn, T.P. (ed.), Catalogue for *Simple Gifts – Hands to Work and Hearts to God*, 1978, p. 19: 'In striving for perfection, the Shakers felt it was important to use their time as efficiently as possible, so they invented or improved upon many labour-saving devices. The flat broom, the circular saw, a large-scale washing machine and many pieces of industrial equipment have all been credited to Shaker inventors ...'

63 See Cummings, H., 'Foreword', in Bruhn, T.P. (ed.), Catalogue for *Simple Gifts – Hands to Work and Hearts to God*, 1978, p. 11: 'Originally the Benton Museum planned to show Shaker pieces not only in

Spirit and Function

the context of general American work but with some from other utopian societies contemporary with the Shakers, but this proved unfeasible at this time. Groups with German origins generally perpetuated foreign styles; Oneidans opted for "rustic" furniture; other groups bought from local craftsmen – or from the Shakers. Most utopian groups of the period believed with the Shakers in a simple and pure life, as perfect as could be in an imperfect world. Though achievements of other kinds were notable in American utopian groups, only Shaker craftsmanship achieved real distinction. Do we really know all the reasons? The relationship between a way of life and a way of work, between a community's values and its artistic expression, are, of course, incredibly complex. We can probably see links more clearly in the tightly integrated Shaker society than in some others – including our own. Perhaps seeing them somewhere will help a little in seeing them everywhere.'

64 See Cummings, H., 'Foreword', in Bruhn, T.P. (ed.), Catalogue for Simple Gifts – Hands to Work and Hearts to God, 1978, p. 11. The reference to 'heavenly spirits' refers to Edward Deming Andrews' assertion that: 'The peculiar grace of a Shaker chair is due to the fact that it was made by someone capable of believing that an angel might come and sit on it.'

65 See Cummings, H., 'Foreword', in Bruhn, T.P. (ed.), Catalogue for Simple Gifts – Hands to Work and Hearts to God, 1978, p. 11.

66 See Harlow Ott, J., 'Ye Shall Know Them By Their Fruits', in Bruhn, T.P. (ed.), Catalogue for Simple Gifts – Hands to Work and Hearts to God, 1978, p. 22.

67 See Sprigg, J., 'The Gift To Be Simple', in Bruhn, T.P. (ed.), Catalogue for Simple Gifts – Hands to Work and Hearts to God, 1978, p. 24.

68 Refer to Sprigg, J., 'The Gift To Be Simple', in Bruhn, T.P. (ed.), Catalogue for Simple Gifts – Hands to Work and Hearts to God, 1978, p. 26: 'With more furniture left than people, Shaker Brothers had little reason to make anything, but some of them returned to their wood shops. A few added simple Victorian ornament to their work, like their predecessors adapting and simplifying the prevailing worldly trend. Shaker sisters helped support their villages by making and selling "fancy work" sewing goods and household items in a style that pleased their customers. Ironically, the World's taste now began to react against the excesses Shakers had always shunned, and plain but comfortable Shaker chairs sold widely in the last years of the 19th century ...'

69 The drawings/art on show in the exhibition were classified into various groupings including: (I) Simple geometric design with little colour and classified as early; (II) Drawings with a message in the shape of a card, heart, olive leaf, or fan; (III) Drawings with emblems; (IV) Drawings with complex emblems – real life and the realm of fancy; (V and VI) Drawings by individuals with characteristic styles; (VII) The Tree of Life and other drawings by Hannah Cohoon; (VIII and IX) – Drawings in the declining period; and (X) Maps and Illustrations. For an excellent comprehensive background with checklist of known Shaker drawings, see Patterson, D.W., 'Gift Drawing and Gift Song – a Study of Two Forms of Shaker Inspiration', New York Folklore, 1987. In addition, for an Antiques Roadshow-type story regarding some 'found' gift drawings, see Garrett, W.D., Catalogue for Sotheby's – Important American Furniture and Folk Art, 1997, Lots 1559–61.

70 See Miller, A.B., Fletcher Little, N. & Sprigg, J. (eds.), Catalogue for The Gift of Inspiration: Art of the Shakers 1830–1880, 1979, pp. 19–21.

71 A small exhibition catalogue entitled The Gift of Inspiration – Religious Art of the Shakers was produced for Hancock. The exhibition was held from 27 June to 15 October 1970. The explanatory text gives an indication of the background: 'This exhibition of over 70 Shaker "spirit" drawings dating from the period known as the "Era of Manifestations" (1837–1857) has been assembled to commemorate Hancock's tenth anniversary as a public museum. Other institutions and private collectors have kindly joined us in arranging this exhibit, the first comprehensive one of its kind, as a tribute to the Shakers' contribution to this country's achievements in the visual arts.' Included in the catalogue was a blue insert with an essay by the curator Eugene M. Dodd in which he writes about a late production spirit drawing ('Consider the Lilies', ink and watercolour dated 1882, plate 5 in the catalogue): 'But this drawing was perhaps the Shakers' last, and with its direct reflection of what yet another member of the sect described at the time as "the debased & worldly Taste among us", it unequivocally suggests that the

Selling Shaker

"Gift of Inspiration" had departed beyond recall.' (Dodd, E.M. & Miller, A.B., Catalogue for *The Gift of Inspiration – Religious Art of the Shakers*, 1970.)

72 See Miller, A.B., Fletcher Little, N. & Sprigg, J. (eds.), Catalogue for *The Gift of Inspiration: Art of the Shakers 1830–1880*, 1979. This sort of folk art and the variety of artefacts which make up collections is also featured in the auction catalogue for the Sieber collection: see Pico, C. (auctioneer), Auction Catalogue for *Important Shaker and Folk Art – The Collection of George and Roberta Sieber*, 1988.

73 See Miller, A.B., Fletcher Little, N. & Sprigg, J. (eds.), Catalogue for *The Gift of Inspiration: Art of the Shakers 1830–1880*, 1979, front page.

74 Fletcher Little, N., 'Preface', in Miller, A.B., Fletcher Little, N. & Sprigg, J. (eds.), Catalogue for *The Gift of Inspiration: Art of the Shakers 1830–1880*, 1979, p. 6.

75 Hirschl, N., 'Two Separate Worlds', in Miller, A.B., Fletcher Little, N. & Sprigg, J. (eds.), Catalogue for *The Gift of Inspiration: Art of the Shakers 1830–1880*, 1979, p. 50.

76 Sprigg, J., 'Introduction', in Miller, A.B., Fletcher Little, N. & Sprigg, J. (eds.), Catalogue for *The Gift of Inspiration: Art of the Shakers 1830–1880*, 1979, p. 8. June Sprigg continues: 'Thus, the drawings were not the paradox they might at first appear. Inspired by love, expressed in Biblical images and rendered with designs borrowed from the outside world, Shaker inspirational drawings represented the etherealisation of an American art tradition into a uniquely Shaker form, elevated from the worldly to the purer spirit of the otherworldly.'

77 Harlow Ott, J., 'Afterword', in Miller, A.B., Fletcher Little, N. & Sprigg, J. (eds.), Catalogue for *The Gift of Inspiration: Art of the Shakers 1830–1880*, 1979, p. 69, where Harlow Ott, the director of Hancock, gives an indication of this in his final statement: 'This exhibit is but one part of our efforts to make the accomplishment of our fund-raising goal a reality. We hope you will become an even bigger part of this effort by visiting us often and becoming a Friend of Hancock Shaker Village, the Shakers' "City of Peace".'

78 See Van Kolken, D., 'A Comprehensive Show...', *The Shaker Messenger*, vol. 1, no. 3, 1979, p. 16.

79 A lavish full colour catalogue was produced for the exhibition: see Koomler, S.D., Catalogue for *Seen and Received: The Shakers' Private Art*, 2000.

80 The museum at Old Chatham has probably the most comprehensive collection of Shaker furniture, which includes many fine examples of chairs.

81 Williams was the founder and chairman of the Board of Directors of the Shaker Museum Foundation. Laskovski, P.D., Catalogue for *The Shaker Chair: Strength, Sprightliness and Modest Beauty*, 1982 states: 'It was Mr Williams' foresight and love of the Shakers and their way of life that inspired him to preserve this tradition and share it for generations to come.' An obituary in *The Shaker Messenger*, entitled 'Shaker Museum Founder John Williams Sr Dies', gives biographical information: see Van Kolken, D., *The Shaker Messenger*, 1982.

82 For example, see Sutherland, C.S., 'Shaker Chair Demonstrates Idealism, Progress', *The Shaker Messenger*, 1986.

83 Many of the types featured in the exhibition are also found in what can be considered the most comprehensive book on the Shaker chair: Muller, C.R. & Rieman, T.D., *The Shaker Chair*, 1984, produced two years after the exhibition. This book contains a detailed account of the difference in chairs based on the site of production, featuring details of finials etc.

84 Foreword/introduction in Laskovski, P.D., Catalogue for *The Shaker Chair: Strength, Sprightliness and Modest Beauty*, 1982; Patricia Drumm Laskovski was director of The Shaker Museum. The introduction also states: 'As far as we know, "The Shaker Chair: Strength, Sprightliness and Modest Beauty" is the first exhibit devoted solely to the Shaker chair. Drawing almost entirely from the Shaker Museum's own extensive chair collection, the exhibition focuses on the use of chairs, both by the Shakers themselves and the "World's People". The exhibit includes earliest known examples; chairs adapted or constructed to meet individual needs or a special task.' In addition, the exhibition aimed to look at manufacturers in the outside world who copied Shaker chairs.

85 For a background to Shaker trade with the outside world see the pack of materials by Keig, S.J., entitled *Trade with the World's People: A Shaker Album*, 1976: in the booklet chairs are featured on pp. 4–6 with the Shaker chair trademark featured on p. 5.

Spirit and Function

86　Laskovski, P.D., Catalogue for *The Shaker Chair: Strength, Sprightliness and Modest Beauty*, 1982: featured in the illustrated text.

87　Laskovski, P.D., Catalogue for *The Shaker Chair: Strength, Sprightliness and Modest Beauty*, 1982: see middle pages.

88　Some very unusual forms were not featured: see Muller, C., 'Authors Find Unusual Chair They Missed For Their Book', *The Shaker Messenger*, 1990, which states as part of the annotation to the photograph: 'This unusual chair, probably used to carry an elderly member of the Shaker family at New Lebanon, NY, to the lake, is one author Charles Muller wishes he had been able to include in his book, *The Shaker Chair*.'

89　For some illustrations of Shaker children's chairs see Bliss, A.C., 'Children's Furniture', *Design Quarterly*, 1963, illustrations 46–48.

90　The exhibition featured a number of chair types (many of which were illustrated in the catalogue), including: no. 0 Child's Rocker – late manufacture piece 1920–30; no. 1 Armchair which is typical of the Wagan period; no. 2 Production Rocker produced *circa* 1870s; no. 3 Production Chair produced *circa* 1900; no. 4 Production Chair; no. 6 Armchair, 1875–1900, characteristic of early Wagan manufacture; and no. 7 Production Chair, 1875–1900. Details of the Mount Lebanon chair production (including a page from the *Illustrated Catalogue and Price-List of the Shakers' Chairs*, 1876) are featured in Rieman, T. & Burks, J., *Complete Book of Shaker Furniture*, 1993, pp. 142–47, including three revolving stool forms illustrated on p. 147. Also see Wagan, R.M., *An Illustrated Catalogue and Price-List of the Shakers' Chairs*, reprinted 1992.

91　See 'Appendix A – The Imitators' in Muller, C.R. & Rieman, T.D., *The Shaker Chair*, 1984 which includes a number of illustrations connected with the manufacturers L. & G. Stickley Company. Also see 'Decadent and Doubtful Pieces' in Meader, R.F.W., *Illustrated Guide to Shaker Furniture*, 1972, pp. 111–25.

92　Laskovski, P.D., Catalogue for *The Shaker Chair: Strength, Sprightliness and Modest Beauty*, 1982, last page.

93　Laskovski, P.D., Catalogue for *The Shaker Chair: Strength, Sprightliness and Modest Beauty*, 1982, last page.

94　For books on design featuring Shaker chairs see Hauffe, T., *Design – A Concise History*, 1998, pp. 23–25 in which a photograph of a chair is featured on p. 23. For books on furniture with Shaker chairs featured see Lucie-Smith, E., *Furniture – A Concise History*, 1993, p. 140, where a photograph of a maplewood Shaker chair is featured and it states that: 'The Shakers found a ready market for what they made because it was clearly superior to anything else of the same sort which happened to be available. It was they who seem to have popularised the rocking-chair in the United States.' Also see Yates, S., *An Encyclopaedia of Chairs*, 1988, p. 76, which features a photograph of a Shaker rocking chair *circa* 1840 and Sembach, K.J., Leuthauser, G. & Gossel, P., *Twentieth-Century Furniture Design*, 1991, p. 18, which features Shaker furniture (including what they call a mahogany rocking chair) and states: 'Shaker furniture was sold all over the USA and was widely used.' In addition, Shaker chairs are discussed in Sutherland, C.S., 'Shaker Chair Demonstrates Idealism, Progress', *The Shaker Messenger*, 1986.

95　See Peladeau, M.B., 'Early Shaker Chairs', *Historic Preservation*, 1970.

96　See Peladeau, M.B., 'Early Shaker Chairs', *Historic Preservation*, 1970.

97　See Hults, B., 'Shaker Chairs', *American Art & Antiques*, 1978; Emlen, R.P., 'The Best Shaker Chairs Ever Made', *The Shaker Messenger*, 1981; and Rhodus, J., 'Ohio Shaker Chairs', *The Shaker Messenger*, 1983.

98　See Kirk, J.T. & Grant, J.V., 'Forty Untouched Masterpieces of Shaker Design', *The Magazine Antiques*, 1989, in which a number of chairs are featured from the collections of the Shaker Museum, Old Chatham, including some context photographs and museum interior views.

99　See Muller, C.R. & Rieman, T.D., *The Shaker Chair*, 1984.

100　In fact, the Art Complex Museum continued to use the Shaker chair as a source of exhibition material. This exhibition and accompanying catalogue featured contemporary craft and chair interpretations based on Shaker design (see Koomler, S.D., *Shaker Style – Form, Function, and Furniture*, 2000 and Catalogue for *Shaker Chairs: Their Story*, 2001).

101　See Nelson, G., 'Duxbury Show Offers Look at Quality Pieces of Shaker' *The Shaker Messenger*, 1983, which states: 'A second treat for those attending the Henry Willis Shaker Auction was the Shaker exhibit in nearby Duxbury, Mass. The exhibit, 'The Shakers: Pure of Spirit, Pure of Mind', features the distinguished Weyerhaeuser Collection of Shaker furniture ... The exhibition is quite attractively

displayed – seldom does one find such a collection of quality pieces in one place outside the major Shaker museum collections. This exhibit which runs throughout the summer, is supplemented by a handsome catalogue.'

102 A number of chair forms are photographed including armchairs and rockers (exhibits 1–37) and details of date and in certain cases provenance are provided. Various communities' production is highlighted including Enfield, New Lebanon and Hancock.

103 See Valentine, L., Catalogue for *The Shakers: Pure of Spirit, Pure of Mind*, 1983, exhibit 148.

104 See Valentine, L., Catalogue for *The Shakers: Pure of Spirit, Pure of Mind*, 1983, exhibits 114–17.

105 For more information on Henry Green (1844–1931), Alfred, Maine, see Grant, J.V. & Allen, D.R., *Shaker Furniture Makers*, 1989, pp. 154–57 and Carpenter, M.G. & Carpenter, C., 'The Shaker Furniture of Elder Henry Green', *The Magazine Antiques*, 1974.

106 See Valentine, L., 'The Shakers: Background and Philosophy', in Valentine, L., Catalogue for *The Shakers: Pure of Spirit, Pure of Mind*, 1983.

107 See Valentine, L., 'The Shakers: Background and Philosophy', in Valentine, L., Catalogue for *The Shakers: Pure of Spirit, Pure of Mind*, 1983.

108 This exhibition, along with a conference featuring a number of Shaker experts including Robert Emlen, Dorothy Filley, Ken Burns and Donald Emerich, was detailed in Van Kolken, D., 'New York Museum Opens Second Major Shaker Exhibit', *The Shaker Messenger*, 1983.

109 The leaflet produced for the 1999/2000 exhibition states: 'In 1983 the Museum commemorated its first Shaker exhibit in 1930 with "Community Industries of the Shakers – A New Look". This exhibit featured 1,500 Shaker artefacts from the Museum's collections … In 1986–87, a condensed version of that exhibition containing 350 Shaker artefacts toured the United States with the Smithsonian Institution Travelling Exhibition Service.'

110 A press release for the 1999/2000 exhibition states: 'An exhibition bringing this story right up to date was held at Albany entitled "A Shaker Legacy: The Shaker Collection at the New York State Museum", Nov. 5 to Jan 2, 2000. The State Museum has perhaps the largest collection of Shaker objects owned by any museum. In fact, Shakers themselves helped curators from 1926 to 1943 acquire this vast selection that included more than 100,000 Shaker objects. The time was right. Shakers at Watervliet, Mt Lebanon and other Eastern communities were seeing their population dwindle, and sought to preserve their heritage and culture. "We started the Shaker craze back in 1926," said John Scherer, Associate Curator of Decorative Arts, who is organising the exhibit. "We were avant-garde collecting Shaker before it was in vogue. The important thing about this collection is that it wasn't second-hand. We collected it from the source so we have the stories about these artefacts first-hand." … Many of these items will be displayed for the first time since 1982, when the museum commemorated the 50th anniversary of its first Shaker exhibit with a major retrospective: "Community Industries of the Shakers: A New Look".'

111 See Emerich, A.D. & Benning, A.H. (eds.), Catalogue for *Community Industries of the Shakers – A New Look. A Catalogue of Highlights of an Exhibition at the New York State Museum 1983–84*, 1983, p. 3. Charles Adams, William Winter and Edward Deming Andrews had all been instrumental in combining forces to study what was then a declining religion in the United States and this has been documented in Section One.

112 See 'Preface' in Emerich, A.D. & Benning, A.H. (eds.), Catalogue for *Community Industries of the Shakers – A New Look*, 1983, p. 7.

113 See 'Preface' in Emerich, A.D. & Benning, A.H. (eds.), Catalogue for *Community Industries of the Shakers – A New Look*, 1983, p. 7.

114 See 'Preface' in Emerich, A.D. & Benning, A.H. (eds.), Catalogue for *Community Industries of the Shakers – A New Look*, 1983, p. 6.

115 See Emerich, A.D. & Benning, A.H. (eds.), Catalogue for *Community Industries of the Shakers – A New Look*, 1983, p. 15, quoting Joseph Meacham: 'All work done, or things made in the Church for their own use thought to be faithfully and well done, but plain and without superfluity. We are not called to … be like the World; but to excel them in order, union, and peace, and in good works – works that are truly virtuous and useful to man in this life.'

116 See Emerich, A.D. & Benning, A.H. (eds.), Catalogue for *Community Industries of the Shakers – A New Look*, 1983, pp. 15–16.

117 See Emerich, A.D. & Benning, A.H. (eds.), Catalogue for *Community Industries of the Shakers – A New Look*, 1983, p. 19.

118 See Emerich, A.D. & Benning, A.H. (eds.), Catalogue for *Community Industries of the Shakers – A New Look*, 1983, p. 23.

119 See Emerich, A.D. & Benning, A.H. (eds.), Catalogue for *Community Industries of the Shakers – A New Look*, 1983, p. 20.

120 See Emerich, A.D. & Benning, A.H. (eds.), Catalogue for *Community Industries of the Shakers – A New Look*, 1983, pp. 30–31.

121 See Emerich, A.D. & Benning, A.H. (eds.), Catalogue for *Community Industries of the Shakers – A New Look*, 1983, p. 38.

122 See Emerich, A.D. & Benning, A.H. (eds.), Catalogue for *Community Industries of the Shakers – A New Look*, 1983, p. 40. Also see Milbern, G., *Shaker Clothing*, 1965 which gives an account of both male and female Shaker clothing.

123 A small private view card indicated that there was a members' opening on Sunday, 20 November, from 2 to 5 pm.

124 For further material on this see Sprigg, J., 'Marked Shaker Furniture', *The Magazine Antiques*, 1979.

125 Selected pieces from Sprigg, J. (Guest Curator), Catalogue for *Shaker – Masterworks of Utilitarian Design Created Between 1800 and 1875 by the Craftsmen and Craftswomen of America's Foremost Communal Religious Sect*, 1983, include Number 5, side chair in maple/birch with a replaced rush seat, New Lebanon, 1853: 'The patent for the tilter foot was created in 1852 by George O. Donnell (The Henry Francis du Pont Winterthur Museum, The Edward Deming Andrew Memorial Shaker Collection No SA 1001)' (pp. 22–23); Number 22, rag carpet *circa* 1850–75: 'Rag carpets appealed to the Shakers because they were easy to remove and clean, and made good thrifty use of scraps. The carpet reveals the skill of its maker. Not only is it beautifully woven, but its pattern exhibits a fine sense of order and balance: the stripes repeat in precise sequence and the plied (twisted) strands subtly alternate direction' (p. 32); and Number 23, bonnet (straw and dark red silk) *circa* 1825–50: 'In contrast to gaily trimmed Worldly hats, Shaker bonnets were models of modest simplicity, although typically made of the finest materials. The cape at the back served to protect the neck from sun and wind. Such bonnets were made at New Lebanon and in other communities for the Sisters' use and for sale. To this day, the Shaker Sisters in Canterbury wear their bonnets whenever they go outdoors' (p. 32).

126 As was the trend in this period, the interpretation tends to focus more on the production rather than the consumption of the objects, in that it gives contextual details of sites of production at various communities and also some detailed notes on the makers. This means that the emphasis is taken away from the object to the maker, thus emphasising notions of material culture.

127 See Sprigg, J. (Guest Curator), Catalogue for *Shaker – Masterworks of Utilitarian Design*, 1983, p. 33: 'The communities of Western Massachusetts and Connecticut were the closest geographically to the central authority at New Lebanon. Hancock, near Pittsfield, developed just five miles east of New Lebanon. At its peak, Hancock, the Bishopric seat, had about 250 members. Enfield, about 60 miles to the south-east, was established between Springfield and Hartford and had about 300 members at its peak. A small Society of fewer than 100 members grew in Tyringham, about 20 miles south-east of Hancock.' Also from p. 41 about Harvard and Shirley: 'The two communities formed a very close association and they in fact developed less than 10 miles apart. Harvard was always the larger with at its peak around 200 while Shirley had about 150. Shirley closed in the first decade of the twentieth century and was purchased by the Commonwealth for use as a correctional facility. Harvard closed about 10 years later. Many of its furnishings and documents were acquired by Clara Endicott Sears for preservation at the nearby Fruitlands Museum. The surviving buildings at Harvard are today handsomely preserved as private residences.'

128 Sprigg, J. (Guest Curator), Catalogue for *Shaker – Masterworks of Utilitarian Design*, 1983, p. 11.

129 Sprigg, J. (Guest Curator), Catalogue for *Shaker – Masterworks of Utilitarian Design*, 1983, p. 11.

Selling Shaker

130 Sprigg, J. (Guest Curator), Catalogue for *Shaker – Masterworks of Utilitarian Design*, 1983, p. 11.

131 Sprigg, J. (Guest Curator), Catalogue for *Shaker – Masterworks of Utilitarian Design*, 1983, p. 11.

132 In addition, the catalogue starts with a photograph of the Meetinghouse at New Lebanon (from the collection of the New York State Museum, Albany).

133 Sprigg, J. (Guest Curator), Catalogue for *Shaker – Masterworks of Utilitarian Design*, 1983, p. 11. In order to emphasise the religion and the still working communities of Canterbury and Sabbathday Lake, the 'Introduction' starts: 'Who were the Shakers? Or more accurately, who are the Shakers?'

134 In Sprigg, J. (Guest Curator), Catalogue for *Shaker – Masterworks of Utilitarian Design*, 1983, p. 21, the item 'Maker – Daniel Crosman – Number 4 – Oval box – 1844–1870' carries the annotation: 'Oval boxes had been made at New Lebanon since at least 1798 for home use and for sale. These all-purpose containers were used to store food, hardware, sewing notions – anything other than liquids. Marks from a planing machine on the large box in this exhibition indicate that it was made after 1832, the year the planing machine that left these distinctive marks was introduced. During Daniel Crosman's box-making years, nests of 12 boxes were made for sale ... This box was the largest size available; it is six "fingers" high instead of the usual five.'

135 See Budis, E.M., Catalogue for *Making His Mark – The Work of Shaker Craftsman Orren Haskins*, 1997, for a detailed account of Haskins' work and output.

136 See Crosthwaite, J.F., 'The Spirit Drawings of Hannah Cohoon: Window on the Shakers and Their Folk Art', *Communal Studies*, 1987, for details of the work of Hannah Cohoon. Also Wolfe, R., 'Hannah Cohoon', in Lipman, J. & Armstrong, T. (eds.), *American Folk Painters of Three Centuries*, 1980.

137 For notes on Delmer C. Wilson (1873–1961) see Sprigg, J. (Guest Curator), Catalogue for *Shaker – Masterworks of Utilitarian Design*, 1983, p. 55: 'His father died when he was three; five years later, Delmer's mother placed her two sons with the Shakers at Sabbathday Lake. By the time he was 14, Delmer had charge of the community's cattle herd. Later in life this versatile man worked as an artist, photographer, orchardist, builder, barber, dentist, beekeeper and woodworker. In 1931 he became Elder. Delmer Wilson died December 5, 1961, aged 88. Delmer is best known today for the oval boxes he made in the first half of the twentieth century. From 1910 to 1920 alone, he made over 8,000 boxes and carriers; a photograph dated 1923 shows him with 1,083 boxes, one winter's production. Most of his boxes were made of traditional maple and pine; among his special boxes are this all-cherry box (no. 64) and an extraordinary delicate nest of boxes – the smallest is just big enough to hold a folded postage stamp.'

138 Sprigg, J. (Guest Curator), Catalogue for *Shaker – Masterworks of Utilitarian Design*, 1983, pp. 30–31 gives very specific details about some craftsmen, for example: 'Isaac Newton Youngs, the son of Seth Youngs Jr and Martha Farley, was born July 4, 1793, in Johnstown, New York. Isaac was the younger brother of Benjamin Seth Youngs and the nephew of Benjamin Youngs Sr. When Isaac's mother left her husband and children, the family went to live with the Shakers at Watervliet; Isaac was then six months old. At age 14 he was admitted to the community at New Lebanon, where he remained for the rest of his life ... Isaac was also an accomplished musician. As a young man he introduced dance movements and wrote songs. Later in life he taught a system for music and made a "mode-ometer" (a colour-coded pendulum now at the Shaker Museum, Old Chatham, New York) and several music pens with five points for drawing a staff ... Isaac Youngs is best known today as a clockmaker. His interest in clocks began early. "When I was a child," he recalled, "I lived with my uncle, who was a clockmaker – I used to be with him in his shop and watch his motions, learned the parts of a clock and could put one together perhaps when 6 or 7 years old, and knew the time of day before I could talk plain. I had a relish for clocks and liked to be among them and handle the tools, but as I left my uncle, the spring before I was 10 years old, I did not arrive to much understanding or judgment in the business." ... At New Lebanon, Isaac was set to tailoring work. When he was 21, however, he got permission to work with Amos Jewett (1753–1834), who made wooden clocks. Soon Isaac was making "tolerable good ones" ... At least four of Isaac Youngs' wall clocks are known today, all in the collection of Hancock Shaker Village.'

139 Taken from Sprigg, J. (Guest Curator), Catalogue for *Shaker – Masterworks of Utilitarian Design*, 1983, p. 17.

Spirit and Function

140　See Sprigg, J., 'By Shaker Hands – an Exhibit of Shaker Pieces', *The Shaker Messenger*, 1983.

141　Jerry Grant produced the *Shaker Register* series for Shaker scholars in 1995 and 1996 (see Bibliography for details).

142　Davenport Films, *The Shakers*, 1974.

143　The American Wing at the Metropolitan Museum, New York has been detailed in Section Two.

144　This was featured in Richards, D., 'Travelling Exhibitions Organised by Sabbathday Lake Shaker Museum', *The Shaker Messenger*, 1986, p. 9: 'The Sabbathday Lake Shaker Museum is also pleased to announce the second travelling exhibition "Ingenious and Useful: Shaker Sisters' Communal Industries, 1860–1960". First exhibited during the 1985 "Friends of the Shakers" weekend at Sabbathday Lake, the exhibition features 173 artefacts and 11 photographs of the Shaker fancy goods trade ... The exhibition opened at the Eli Whitney Museum in Hamden, Conn., Oct. 8 and will remain there until Jan. 5, 1987. The second host institution will be the York Institute in Saco, Maine from April 27 to August 28.'

145　Theodore Johnson wrote extensively about Shakerism and included work in *The Shaker Quarterly* such as 'Shakerism for Today', 1963. In addition, Theodore Johnson also produced, with McKee, J., a catalogue for *Hands to Work and Hearts to God: The Shaker Tradition in Maine*, 1969. An obituary for Theodore Johnson was given in *The Shaker Messenger* by Morse, F., 'Brother Theodore E. Johnson Dies', 1986.

146　Brother Arnold was to become involved in both of the British venues of 'Shaker: The Art of Craftsmanship' which features in Section Four.

147　'Introduction' in Johnson, T.E., Catalogue for *Ingenious & Useful – Shaker Sisters' Communal Industries, 1860–1960*, 1986.

148　'Introduction' in Johnson, T.E., Catalogue for *Ingenious & Useful – Shaker Sisters' Communal Industries, 1860–1960*, 1986.

149　Catalogues were produced for these products, for example, Noyes, L.M., *Catalogue of Fancy Goods*, 1992 (reprinted from 1910 version).

150　The catalogue describes the process of making woven poplarware from early developments at Sabbathday Lake, Maine. Elder Otis Sawyer (1815–84) was one of the first to use poplar shavings in weaving. Once the fabric was woven it was backed onto plain white paper, ironed and crafted into various shapes.

151　'Fancy Box' section in Johnson, T.E., Catalogue for *Ingenious & Useful – Shaker Sisters' Communal Industries, 1860–1960*, 1986.

152　See Kennedy, G., Beale, G. & Johnson, J., *Shaker Baskets and Poplarware – A Field Guide, vol. 3*, 1992.

153　It features in Richards, D., 'Travelling Exhibitions Organised by Sabbathday Lake Shaker Museum', *The Shaker Messenger*, 1986, p. 8: 'Supported by a major grant from the Maine Humanities Council, the exhibition portrays life in the two Maine Shaker communities at Sabbathday Lake and Alfred between 1872 and 1918. Making use of 50 historic photographs taken by Shakers, primarily by Elder Delmer C. Wilson, as well as by professional photographers, this often overlooked period of Shaker history has been brought to life ... Since opening at Sabbathday Lake, the exhibition has begun a tour of six sites throughout the state of Maine.' The first stops in 1986 were at Alfred Town Hall and then on to Portland Public Library and the University of Maine at Farmington. In 1987 it travelled to Kent Hills School, University of Maine at Orono and Nylander Museum at Caribou.

154　Stephen Marini was detailed as being Associate Professor of Religion at Wellesley College and has provided observations on the Shakers over a number of years, including an interview in the television programme Treays, J. (producer), *Timewatch: I Don't Want to be Remembered as a Chair*, 1990.

155　See Richards, D., Emery Hulick, D. & Marini, S., Catalogue for *In Time and Eternity: Maine Shakers in the Industrial Age 1872–1918*, 1986, p. 9.

156　See Richards, D., Emery Hulick, D. & Marini, S., Catalogue for *In Time and Eternity: Maine Shakers in the Industrial Age 1872–1918*, 1986, p. 19.

157　Marini, S., 'In Time and Eternity', in Richards, D., Emery Hulick, D. & Marini, S., Catalogue for *In Time and Eternity: Maine Shakers in the Industrial Age 1872–1918*, 1986, p. 4, states: '"In Time and Eternity" presents a rare glimpse into the daily life of Maine Shakers between the Civil War and the First World

War as recorded in historic photographs from the collection of the United Society of Shakers at Sabbathday Lake. Most people know about the Shakers from seeing their famous furniture and "spirit drawings" in museums or from visiting their restored villages. These popular images, however, conjure up only the distant Shaker past and do not convey any sense of the post-bellum decades when Maine Shakerism achieved its greatest importance and influence.'

158 This was very different in Amish communities in which photographs were not acceptable and shunned. However, like the Shakers the Amish have managed to become recognised and popular in the United States: see Cong, D., 'The Roots of Amish Popularity in Contemporary USA', *Journal of American Culture*, 1994.

159 Some books recommended for photographs representing the Shakers and their world include: Wertkin, G.C., *The Four Seasons of Shaker Life*, 1986, which includes a portrait of the Sabbathday Lake community, with photographs by Ann Chwatsky, and Pearson, E.R. & Neal, J., *The Shaker Image*, 1994, which contains a comprehensive selection of black and white photographs.

160 See Marini, S., 'In Time and Eternity', in Richards, D., Emery Hulick, D. & Marini, S., Catalogue for *In Time and Eternity: Maine Shakers in the Industrial Age 1872–1918*, 1986, p. 6.

161 See Emery Hulick, D., 'Shakers and Photography' in Richards, D., Emery Hulick, D. & Marini, S., Catalogue for *In Time and Eternity: Maine Shakers in the Industrial Age 1872–1918*, 1986, p. 31. Diana Emery Hulick was Assistant Professor of Art at The University of Maine at Orono.

162 See Emery Hulick, D., 'Shakers and Photography' in Richards, D., Emery Hulick, D. & Marini, S., Catalogue for *In Time and Eternity: Maine Shakers in the Industrial Age 1872–1918*, 1986, p. 33.

163 See Butler, L. & Sprigg, J., *Inner Light: The Shaker Legacy*, 1985.

164 Also see Rocheleau, P., Sprigg, J. & Larkin, D., *Shaker Built – The Form and Function of Shaker Architecture*, 1994. In addition to books, the photographs of Paul Rocheleau have featured in a number of materials including diaries and calendars.

165 After this exhibition there is evidence of an exponential increase in 'popular press' articles on the Shakers in the United Kingdom. It is interesting that it would not be until 12 years after this date that an exhibition featuring Shaker would travel to the UK. It would appear that the Whitney Museum exhibition had repercussions far beyond the United States: see Heck, S., 'Shaker Design', *Architect*, 1986.

166 See Sprigg, J., 'June Sprigg Explains Beginnings of Exhibit', *The Shaker Messenger*, 1986: 'Publicity in newspapers, magazines, radio and TV has been better than anyone expected. So far, coverage has been provided by NBC *Nightly News*, the Voice of America, Christian Science Monitor Radio, Charles Kuralt on the radio, *Morning Edition* on National Public Radio – as well as newspapers from *The New York Times* to the *Washington Post*. I've received clippings from newspapers as far away as Florida and California. Magazines have been enthusiastic, including *Antiques*, *American*, *House Beautiful*, *House and Garden* and *Vogue* ... (yes, *Vogue*)!' In addition, the catalogue was extensively produced with sumptuous photographs by Paul Rocheleau, many of the objects simply shown against a white background, isolated out of all context: clearly the intent was to create art out of design. Derek Birdsall, an English graphic designer, designed the catalogue and it was printed by Balding & Mansell.

167 See Billings, D., 'Whitney Shaker Exhibit Impressive', *The Shaker Messenger*, 1986: 'The simplest and most charming part of the exhibit are three wooden mitten forms. Mounted on plain brass rods in a row, they emphasise the pleasure of the simple beauty of Shaker form ... More than 100 items which are on display range from stoves, tools, rag rugs, samplers, cloaks, bonnets, spirit drawings, furniture and maps drawn by Shaker brethren.' Also see Sprigg, J., 'June Sprigg Explains Beginnings of Exhibit', *The Shaker Messenger*, 1986, which gives an indication of how the exhibition was formulated.

168 See Green, D., 'Shaker Serenity', *Industrial Design*, 1986, p. 67: 'The exhibition includes a diverse selection of objects designed by the Shakers, with over 100 examples of furniture, tools, graphics and textiles. Ingenious mechanical inventions like a pill-making device crafted in walnut and brass, a sheet metal crimper made of maple and iron and a finely proportioned wheelbarrow all serve as elegant testaments to the Shakers' approach to design. As June Sprigg, guest curator of the exhibition, notes in her impeccably produced catalogue: "The most appealing feature about Shaker design is its optimism. Those who would lavish care on a chair, a basket, a clothes hanger or a wheelbarrow

clearly believe that life is worthwhile." … But the Shakers' highly refined designs were not simply beautiful objects made for their own sake: their tools of living were natural reflections of their religious beliefs.'

169 See Romanelli, M., 'There is No Dirt in Heaven', *Domus*, 1986, p. 5 translated as follows: 'Brother John Vance said that the Shakers loved beauty above all else; the beauty of flowers in bud rather that that of fruit or ripe corn. The objects of the Shakers were the result of an "unhurried hand: Do your work as though you had a thousand years to live, and if you were to die tomorrow".' The article includes a number of illustrations and also features the portrayal of a Shaker room.

170 See Armstrong, T., 'Foreword', in Sprigg, J., Catalogue for *Shaker Design*, 1986, p. 6.

171 See Sprigg, J., 'June Sprigg Explains Beginnings of Exhibit', *The Shaker Messenger*, 1986: 'I wondered before I saw the show, how these simple, humble things would look on Madison Avenue, the centre of American glitz … I was overwhelmed with a sense of awe at the quiet power of the show. It brings an oasis of reverence and dignity to Madison Avenue. Others have felt the same power. It is as if the spirit of the maker is present, and the galleries feel like a sanctified place.'

172 See Sprigg, J., 'June Sprigg Explains Beginnings of Exhibit', *The Shaker Messenger*, 1986: 'Another thing that surprised and pleased me was the way these things, from many different communities, blend together – they are clearly part of a simple movement. When you see things from as far apart places as Kentucky, Ohio, New York and New England – and yet they all look like the work of one hand – you are deeply aware of the "union" that joined Shakers universally to common ideals.'

173 See Sprigg, J., Catalogue for *Shaker Design*, 1986, p. 12.

174 See Sprigg, J., Catalogue for *Shaker Design*, 1986, p. 19.

175 See Sprigg, J., Catalogue for *Shaker Design*, 1986, p. 21.

176 See Sprigg, J., Catalogue for *Shaker Design*, 1986, pp. 50–51.

177 See Sprigg, J., Catalogue for *Shaker Design*, 1986, pp. 188–91, which shows a sampler which is as beautiful on the reverse as it is at the front. It states in the annotation: 'Like other known Shaker samplers, Betsy Crosman's is small and simple in the extreme, having only uppercase and lowercase alphabets … This sampler, however, is distinguished by the exceptional care given to its back, which is finished as beautifully as the front – evidence of the Shakers' belief that perfection is important even where it is not seen.'

178 See free leaflet which accompanied the exhibition, acknowledging the United Technologies Corporation for its sponsorship.

179 See Sprigg, J., 'June Sprigg Explains Beginnings of Exhibit', *The Shaker Messenger*, 1986.

180 Van Kolken, D., 'Shaker Items at Muhlenberg', *The Shaker Messenger*, 1987.

181 Sprigg, J., Catalogue for *Shaker Original Paints & Patinas*, 1987, p. 8: 'The purpose of this exhibition is to show Shaker furniture and a selection of wooden household articles with their original finishes … For the first time, viewers can see an assemblage of Shaker works as the makers intended them to look.'

182 'Acknowledgements' in Sprigg, J., Catalogue for *Shaker Original Paints & Patinas*, 1987, p. 5.

183 See Candee, R.M., 'The Rediscovery of Milk Based House Paints and the Myth of "Brickdust and Buttermilk" Paints', *Old Time New England*, 1968 and Candee, R., 'Preparing and Mixing Colours in 1812', *The Magazine Antiques*, 1978.

184 Sprigg, J., Catalogue for *Shaker Original Paints & Patinas*, 1987, p. 7.

185 Sprigg, J., Catalogue for *Shaker Original Paints & Patinas*, 1987, pp. 9–11, states that a definite issue addressed in the exhibition was that bright colour and its application onto the surface of artefacts was common and deemed part of the design process: 'Shaker craftsmen were continuing the long Anglo-European tradition of using paint to protect wood, to add colour to brighten the home, and to unify the appearance of a piece of furniture made of different woods for traditional, structural or other pragmatic reasons. Furniture and household woodenware without any finish at all are rare. By the 1820s, the Shakers began to favour a wider range of brighter colours. Examples of vivid colours popular among the Shakers between 1825 and 1875 include several oval boxes (Cat. 32–34) … Two colours deserve special mention: bright yellow, for its prevalence in Shaker use, and black, conspicuous for its virtual absence.'

186 Sprigg, J., Catalogue for *Shaker Original Paints & Patinas*, 1987, p. 7.

187 Sprigg, J., Catalogue for *Shaker Original Paints & Patinas*, 1987, p. 8.

188 Sprigg, J., Catalogue for *Shaker Original Paints & Patinas*, 1987, p. 15.

189 Susan Buck has been at the forefront of scientific work done on Shaker paints: see Buck, S.L., 'Bedsteads Should Be Painted Green – Shaker Paints and Varnishes', *Old Time New England*, 1995. Also see Van Kolken, D., 'Research Shows Shakers Used Bright Colours', *The Shaker Messenger*, 1996.

190 However, the majority of contemporary 'quality' reproductions of Shaker furniture follow the 'classic' natural line with few painted examples and most use cherry, maple and pine.

191 See Buck, S.L., 'Interpreting Paint and Finish Evidence on the Mount Lebanon Shaker Collection', in Rieman, T.D., Catalogue for *Shaker: the Art of Craftsmanship*, 1995, pp. 46–58.

192 See Kramer, F., 'Shaker Exhibit Opens at Rochester', *The Shaker Messenger*, 1991.

193 See Kramer, F., Catalogue for *Simply Shaker – Groveland and the New York Communities*, 1991. This extensive catalogue contains many black and white photographs of the exhibits, together with detailed historical information on the Shakers of Sodus and Groveland, including diary information, demographics and a bibliography.

194 See Kramer, F., 'The Shakers of Groveland, New York', *The Magazine Antiques*, 1991.

195 See 'Author's Foreword' in Kramer, F., Catalogue for *Simply Shaker – Groveland and the New York Communities*, exhibition at Rochester Museum and Science Centre, 1991, p. 7.

196 Details of these were given in a free leaflet containing information about the educational events which spanned the duration of the exhibition.

197 In the leaflet describing educational activities Kathleen Moriarty – described as a Shaker curriculum expert – was to give a talk on 'Visiting Shaker Museums'. She has produced a booklet entitled 'Integrating Shaker Studies Into Your Curriculum' for *The World of Shaker*, 1992.

198 See illustrations of beds dated 1865–70, made of walnut by Brother Emory Brooks, in Kramer, F., Catalogue for *Simply Shaker – Groveland and the New York Communities*, 1991, pp. 84–85.

199 Bertha Lindsay was responsible for a number of publications and was probably best known as a cook. She produced a cookbook – Lindsay, B., *Seasoned With Grace*, 1987 – and was featured in various magazines, for example, Haller, J., 'Great New England Cooks', *Yankee Magazine*, 1988. In addition she also wrote articles in *The World of Shaker*, for example, 'The Shakers' View of the Bicentennial Celebration', 1974 and 'Shakers I Knew – My Favourite School-Teacher; Jessie Evans', 1977. Others have documented her life as in Miles, L., 'A Conversation With Eldress Bertha Lindsay', *The Shaker Messenger*, 1981 and finally an obituary by Van Kolken, D., 'Bertha Lindsay, Last of the Shaker Eldresses, Dies', *The Shaker Messenger*, 1991.

200 See Kramer, F., 'Battle Lost To Save Groveland Building', *The Shaker Messenger*, 1984 and 'Marker Dedicated at Groveland Shaker Site', *The Shaker Messenger*, 1985.

201 See 'Author's Foreword' in Kramer, F., Catalogue for *Simply Shaker – Groveland and the New York Communities*, 1991, p. 7. For another version of the context in which the Sodus Shaker community developed, refer to Wisbey, H.A., *The Sodus Shaker Community*, 1982.

202 See Scherer, J.L., 'Introduction' in Kramer, F., Catalogue for *Simply Shaker – Groveland and the New York Communities*, 1991, p. 9.

203 See curatorial information by Eugene B. Umberger (Curator of History, Rochester Museum & Science Centre) in Umberger, E.B., 'The Exhibition', in Kramer, F., Catalogue for *Simply Shaker – Groveland and the New York Communities*, 1991, p. 53.

204 The exhibition at the Museum of Our National Heritage and Canterbury Shaker Village, Inc. was held from 22 November 1992 to 16 May 1993. A catalogue of the exhibition, with text by Cara A. Sutherland, contained 24 pages and 22 duotone illustrations (Todd Buchanan) and was available for $10 from the Museum of Our National Heritage. The Canterbury Shakers exhibition was featured in Ledes, A.E., 'The Canterbury Shakers', *The Magazine Antiques*, 1993: 'An exhibition celebrating the foundation of the seventh Shaker community in America, in Canterbury, New Hampshire, has been jointly organised by Canterbury Shaker Village and the Museum of Our National Heritage in Lexington, Massachusetts, where it will be on view until May 16. "Receiving the Faith: The Shakers of Canterbury, New

Hampshire" contains more than 500 objects including furniture, maps, costumes, baskets, boxes, and other objects made or used on the site ... The final section of the exhibition surveys the Shakers in the twentieth century.'

205 Two different catalogues were produced: the first, *Receiving The Faith* (Sutherland, 1992), has a door latch on the front cover and a footnoted essay with information on various commentators of the Shakers such as the English writer William Hepworth Dixon (p. 24, note 44). The second, *Receiving The Faith* (Monaghan, 1993) for the Whitney, had a more subdued plain biscuit-coloured cover and high production values, including good quality black and white photographs.

206 Stephen Miller, a collector of Shaker featured in the television programme Treays, J. (producer), *Timewatch: I Don't Want to be Remembered as a Chair*, 1990. He has written about ephemera, for example, Miller, S.M., 'Hancock Mounts Exhibition of Ephemera', *The Shaker Messenger*, 1988 and Miller, S.M., *A Century of Shaker Ephemera – Marketing Community Industries 1830–1930*, 1988.

207 Paul Rocheleau has been responsible for many photographs of Shaker material, for example, Rocheleau, P., Sprigg, J. & Larkin, D., *Shaker Built – The Form and Function of Shaker Architecture*, 1994 and Larkin, D., *The Essential Book of Shaker – Discovering the Design, Function, and Form*, 1995.

208 See 'Introduction' in Monaghan, K. (ed.), Catalogue for *Receiving the Faith: The Shakers of Canterbury, New Hampshire*, 1993, p. 3.

209 The Shakers frequently feature in many design history books: see 'Style, Styling and Lifestyle' in Walker, J.A., *Design History and The History of Design*, 1989: 'A clear-cut historical example of the relation between design and a social group, design and ideology, was the Shaker furniture produced in New England, Ohio, Kentucky and Indiana between 1790 and 1860. The Shakers were a monastic, puritan Christian sect who valued simplicity, order, cleanliness and fitness for use' (p. 166). Also Pile, J.F., Davis, S., Heinemann, S., Reynolds, P. & Meyer, S.E., *Dictionary of 20th-Century Design*, 1990, p. 241.

210 Ethel Hudson was the last Shaker Sister at Canterbury.

211 See Swank, S.T., *Shaker Life, Art, and Architecture*, 1999, a book which relies heavily on Canterbury Shaker village imagery. Also for articles see Tarbell, B., 'Canterbury Shaker Village – A Legacy Lives On', *Art & Antiques*, 1993 and also Van Kolken, D., 'Canterbury on Exhibit in Lexington, Mass', *The Shaker Messenger*, 1992. The travel programme Robson, K. (producer) & Nightingale, M. (presenter), *Wish You Were Here*, 2001 had a report by R. Owen on New England and Canterbury.

212 See Murphy, A.K., 'An Expression of Faith', in Monaghan, K. (ed.), Catalogue for *Receiving the Faith: The Shakers of Canterbury, New Hampshire*, 1993, p. 4, which has a marked Edward Deming Andrews feel to it: 'Shaker design is characterised by a respect for cleanliness and order, simplicity and sincerity. Outsiders often enlisted adages like "form follows function" to describe the perceived severity of Shaker design. Yet the shape of a chair leg or the placement of drawers in a cupboard are often arbitrary matters; one form may be as useful as another. A Shaker cabinetmaker's choice of wood or use of colour frequently reflects a more complex set of aesthetic and spiritual values than any platitude can fully explain. For a Shaker, a well-made chair was an expression of faith ... The Shakers were eminently practical, and rarely sacrificed function for form. Believers avoided useless ornament, and yet their most utilitarian, unadorned objects are often striking. A Shaker basket is so beautifully crafted that the patterns created by interwoven ash splints suffice as decoration. For Believers, excessive ornament seemed not only unnecessary but deceptive: decoration could disguise poor craftsmanship or inferior materials. The Shakers also shunned any techniques considered dishonest, like painting exotic grains on ordinary wood.'

213 See Murphy, A.K., 'An Expression of Faith', in Monaghan, K. (ed.), Catalogue for *Receiving the Faith: The Shakers of Canterbury, New Hampshire*, 1993, p. 5.

214 Van Kolken, D., 'Attendance at Shaker Seminars Proof That Interest is Growing', *The Shaker Messenger*, 1991.

215 See Willis Henry auction catalogues dated throughout the 1980s including the sale of the collection of Karl Mendel in 1988. Also see Sprigg, J., 'The Karl Mendel Shaker Collection', *Maine Antique Digest*, 1988 and Beach, L., 'A Hot Day in the Country for Shaker', *Antiques and The Arts Weekly*, 1988. Also Willis Henry auctions are featured in the television programme Treays, J. (producer), *Timewatch: I Don't Want*

to be *Remembered as a Chair*, 1990. In the post-production script Willis Henry Shaker Auction is featured on pp. 31–36, where Brother Arnold Hadd from Sabbathday Lake comments: 'I think that the market is, for Shaker antiques, has gotten wholly out of control, and it seems obscene to me for people to pay so much money – tens of thousands of dollars – for a piece of furniture' (p. 32).

216 Interestingly, Shaker and folk art have often been associated together and have featured in a number of books of the period. It is obvious why folk art might be aligned with Shaker (being both craft based and traditionally focused) but it is not so obvious why collectors are interested in both, the Shaker aesthetic being very different from many folk art traditions such as the Pennsylvanian Germans. See Shaw, R., *America's Traditional Crafts*, 1993 and Struthers, J., *Wood*, 1991.

217 See Nelson, G., 'Lassiter Sale Puts Shaker On Its Way' in *The Shaker Messenger*, 1982.

218 See Wertkin, G.C., 'Introduction', in Unspecified, Auction Catalogue for *Important Shaker Furniture and Related Decorative Arts: The William L. Lassiter Collection – York Avenue Galleries – November 13, 1981*.

219 See Beach, L., 'A Hot Day in the Country for Shaker', *Antiques and The Arts Weekly*, 1988, p. 46. It would appear that the dealer David Schorsch was very active in the marketplace, for example, paying $11,000 for a box in chrome yellow.

220 See Pico, C. (auctioneer), Auction Catalogue for *Important Shaker and Folk Art – The Collection of George and Roberta Sieber*, 30 July 1988, on the front page of which the Siebers state: 'As we collected Shaker furniture and artefacts, we could see that there was something beyond "just man" in the Shakers' design and craftsmanship. God used that reflection to draw us to Him. Then we understood. It was their reliance on the creative power and ability of Him dwelling within them to create and construct. Hands to work; Hearts to God. May these Shaker and other items be a blessing to their new homes as they have been to ours.'

221 See Casazza, E.F. & McKinnon, W.F., Catalogue for *Shaker & Americana Auction – Aug. 20, 1982*, final page: 'The family from which this Shaker collection was consigned have been admirers of the Shaker way and "things Shaker" for many, many years, and we feel fortunate to have been chosen as the vehicle by which this collection will be dispersed. Many of the cloth and small wooden items were purchased by this family at the Shaker Gift Shop in the 1920 and 1930 era. This is indeed a rare opportunity to purchase and admire the handiwork, love and perfection that went into each piece.' The most expensive piece (achieving a price of $4,750) was an Enfield Table, whilst most smalls achieved prices below $500: for example, an eight-inch oval box with original green colour (Lot 102) realised $275.

222 See Skinner, R.W. (Skinner Auctioneers), Catalogue for *Americana Auction*, 14 March 1980.

223 For various market reports in *The Shaker Messenger* see the Bibliography, from Kramer, F., 'Shaker in the Marketplace', 1986 to Kramer, F., 'Shaker Antiques in the Marketplace', 1993.

224 See Wheeler, D.H., 'Shaker Influences Architectural Design', *The Shaker Messenger*, 1991 in which a photograph of a lodge at Camp Madron (p. 10) indicates a Shaker-influenced interior.

225 See Pranian, H. & Pranian, R., Catalogue for *Shaker: The Simple Form – Outstanding Works from Chicago Collections*, 1992. Under the title 'Shaker boxes' it states: 'Oval boxes were made in many Shaker communities, although the design did not originate with them. The Shakers refined the form, producing boxes with slender fingers, thin sides, and tight-fitting lids. The sides and rims were usually made of maple, and the bottoms and tops of quarter-sawn pine. Sides and rims were soaked in hot water or steamed and, when pliable, bent around forms. The fingers were fastened in place with wooden pegs and later, with copper nails. Boxes were finished with clear varnish or shellac, or painted in shades of red, yellow, blue and green. They were made in many sizes to hold a variety of objects and sold individually or in stacks. One of the boxes, from New Lebanon, is inscribed in pencil on the bottom, "A present from Elder Richard to Antoinette Doolittle, Feb. 1857." The oval box is one of the best known, most recognisable Shaker-made forms.'

226 See Raycraft, D. & Raycraft, C., *Shaker – a Collector's Source Book II*, 1985.

227 Burks, J.M., 'Living with Antiques: a Folk Art Collection in Pennsylvania', *The Magazine Antiques*, 1994, p. 508.

228 Burks, J.M., 'Living with Antiques: a Folk Art Collection in Pennsylvania', *The Magazine Antiques*, 1994, p. 509.

229 Burks, J.M., 'Living with Antiques: a Folk Art Collection in Pennsylvania', *The Magazine Antiques*, 1994, p. 515.

230 Hewett, D., 'Records Fall at Annual Willis Henry Shaker Auction' *Maine Antique Digest*, 1988, p. 2-E states when subdividing Shaker devotees into three groups: 'At the top of the heap are those who truly are connoisseurs. They have studied Shaker life and products; they know what constitutes quality and who made an object and where; they know the value of the objects that they seek. A connoisseur will chase a tall chest with original paint through the ceiling. A connoisseur knows which colour covered box is the rarest. A connoisseur can choose between two Sisters' cloaks, discard the lesser, and set a new record when buying the best. Second comes the informed dealer class. They may possess all the attributes of connoisseurs, but they also know the value and saleability of the average or lesser pieces. When the piece is offered, they usually know its exact retail value. If there's money left in a piece, they'll buy it. Informed dealers will buy the production rocker when it's cheap and gobble up the refinished boxes when they know their customers will give them a profit. Last, there are those who, for lack of another word, can be described as in the decorator class. They buy because they like the looks of a piece, or have heard that Shaker is "in", and if they crave an item, they will chase it to absurd levels, especially when competing against another decorator.' At a Willis Henry auction in 1988 the following were present: David and Marjorie Schorsch, Richard Rasso, Charles Flint, Ed Clerk, Richard Klank, John Keith Russell, Elliot Snyder, Frank Gaglio, Jim Johnson, Tom Queen and Clint Bigalow.

231 See the television programme Treays, J. (producer), *Timewatch: I Don't Want to be Remembered as a Chair*, 1990.

232 See Nalley, R.V., 'The Simple Shaker Style', *USAir* (Magazine), 1983, p. 52, in which the simple Shaker style is discussed: 'Shaker goods, whose makers reviled the very notion of fashion, are all the vogue. A rocking chair that the Shakers happily parted with for $8.50 back in the 19th century might now fetch $950 or more. "Matters of taste are cyclical, of course," says Edward Clerk, an antiques dealer and Shaker specialist in Bethlehem, Connecticut. "For years people collected French and European pieces; they were status symbols. Now we have seen a big swing back to simple, well-built American furniture ... the value of Shaker pieces has skyrocketed."' Also see Muller, C., 'It Looks Shaker', *Ohio Antiques Review*, 1982.

233 This was evidenced in the production of a number of books that were widely available in the United Kingdom, often produced in a lavish full colour format, for example Sprigg, J. & Larkin, D., *Shaker – Life, Work and Art*, 1987 and Horsham, M., *The Art of the Shakers*, 1989 (interestingly both these books have 'art' in the title and this will be discussed further in the next section). In addition, there were also film/book promotions such as the film Burns, K. & Stechler Burns, A., *The Shakers: Hands to Work, Hearts to God*, 1985, and the book Stechler Burns, A. & Burns, K., *The Shakers: Hands to Work, Hearts to God*, 1987. Also see Ward, H., 'They Make Shaker Furniture in Yorkshire Too', *Design*, 1982.

234 Newman, C. & Abell, S., 'The Shakers' Brief Eternity', *National Geographic*, 1989.

235 Hancock is also featured in Ratcliff, C., 'Amazing Grace – The Artful Simplicity of America's Shakers', *Travel & Leisure*, 1986, which contains a number of sumptuous photographs by M. Melford. It states on p. 136: '... you see the Shaker spirit clearly manifested in simple and restrained carpentry. You see why contemporary artists (especially the ones labelled Minimalist) are so willing to acknowledge an affinity with the Shaker style. And well before the appearance of Minimalism, collectors had learned to prize Shaker chairs and cabinets as works of art.'

236 Pleasant Hill has been featured in numerous articles including Hendrix, G., 'A Heritage of Horsemanship', *Midwest Living*, 1990, p. 56.

237 See product information in Unspecified, 'Shaker Pieces to Buy', *Colonial Homes*, 1979, p. 159.

238 See Unspecified, 'The Shaker Surge', *Colonial Homes*, 1982, p. 119: 'Shaker design is flourishing ... it has now become an important part of the American artistic lexicon. Two recent events in New York have underscored its growing popularity: the installation of a Shaker retiring room, opposite, at the Metropolitan Museum of Art and a record-breaking auction at Sotheby Parke Bernet of one of the first private Shaker collections.'

239 See Clark, S., 'Pure & Simple', *Home*, 1983, p. 78.

Selling Shaker

240 Shaker Shops West, *Catalogue*, 2000, p. 3, states: 'Since the inception of Shaker Shops West in 1975, we have felt challenged to meet the standards of quality in our reproductions that the name Shaker implies. An association with Shaker design arouses an awareness of the spiritual environment in which it was formed. Virtually all the products of Shaker craftsmanship seem to radiate a special vitality which comes from a blending of the material and spiritual. Perhaps this is why Shaker is considered classic.'

241 Shaker Workshops has consistently produced high quality Shaker reproductions which it sells world-wide. Catalogues are published frequently with new items and they have branched out into many and varied products. See their 1998 – Spring/Summer catalogue, pp. 18–19, for some very odd products, including pressed flower frames! This contrasts with some early catalogues which have a purer aesthetic.

242 See Barrett, D., *Barrett's Bottoms Chair Makers*, 1992.

243 See Clark, S., 'Pure & Simple', *Home*, 1983, p. 84.

244 Hosley, W.N., 'Simply Shaker', *Art & Antiques*, 1993, p. 76.

245 See Muller, C., 'Stickley, not Shaker', *The Shaker Messenger*, 1982.

246 Also see Jacob, M.J., *The Impact of Shaker Design on the Work of Charles Sheeler*, MA Thesis, 1976.

247 Hosley, W.N., 'Simply Shaker', *Art & Antiques*, 1993, pp. 76–77.

248 Refer to Van Kolken, D., 'Mrs Reagan Orders Oval Boxes for Senate Wives', *The Shaker Messenger*, 1981, p. 16: 'Mrs Reagan apparently saw the reproductions of Shaker oval boxes made by Dick Soule of Orleans Carpenter at a store in Washington and ordered 180 of them.'

249 Steadman, K.R., 'Shaker Style Addition Wins Award', *The Shaker Messenger*, 1993, p. 9, states: 'His Shaker-style addition received a Citation of Merit in the 1993 Design Excellence Awards of the Rochester Chapter, American Institute of Architects. The jury called the addition "quality design achieved with a high degree of modesty and restraint".'

250 See Reser, J., 'Display Windows at Saks Fifth Avenue', *The Shaker Messenger*, 1991, which shows two photographs by Jeffrey Reser.

251 See Goldman, J., 'Collecting – Know Your Shaker', *American Vogue*, 1978, p. 56.

252 See Goldman, J., 'Collecting – Know Your Shaker', *American Vogue*, 1978, p. 56.

253 See Ferretti, F., 'A Store Salutes American Design', *The New York Times*, 1982, p. C8.

254 See Ferretti, F., 'A Store Salutes American Design', *The New York Times*, 1982, p. C1.

255 Food is featured in Carr, F.A., *Shaker Your Plate – of Shaker Cooks and Cooking*, 1985; Haller, J., 'Great New England Cooks', *Yankee Magazine*, 1988; Miller, A.B. & Fuller, P., *The Best of Shaker Cooking*, 1993; and Paige, J.S., *The Shaker Kitchen*, 1994. The number of Shaker-inspired books has increased as people have become interested in real food and recipes using natural ingredients.

256 Such as *Americana* and *Colonial Homes*: for example Unspecified, 'The Golden Lamb', *Colonial Homes*, 1985.

257 See Handberg, E., *Shop Drawings of Shaker Furniture & Woodenware*, 1991, and *Shop Drawings of Shaker Iron & Tinware*, 1991 for shop drawings of various Shaker objects made of wood and metal. In addition, Shea, J.G., *Making Authentic Shaker Furniture With Measured Drawings Of Museum Classics*, 1992; Abram, N., *Mostly Shaker From The New Yankee Workshop*, 1992; and Becksvoort, C., 'Building a Tinware Cupboard', *Fine Woodworking*, 1990. In addition, Wilson, J., 'Shaker Oval Boxes – Reproductions Make Fine Gifts or Storage', *Fine Woodworking*, 1993.

258 See Sprigg, J., *Simple Gifts – 25 Authentic Shaker Craft Projects*, 1991 and McCloud, K., *Kevin McCloud's Decorating Book*, 1990, p. 106 in which he creates a 'Shaker Parlour': 'This interpretation of a Shaker room, with its plain walls, bare floorboards and beautifully crafted furniture has a refreshing simplicity that will suit any modest room.'

259 See Calloway, S. & Freeman, M., 'Simply Divine', *Telegraph Weekend Magazine*, 1988. Others have used the word divine as a way of getting the notion of religion into the piece, for example Lee, V. & Baldwin, J., 'Divine Art', *Homes and Gardens*, 1990, features Shaker material.

260 See Calloway, S. & Freeman, M., 'Simply Divine', *Telegraph Weekend Magazine*, 1988, p. 48.

261 See Calloway, S. & Freeman, M., 'Simply Divine', *Telegraph Weekend Magazine*, 1988, p. 48.

262 Clifton-Mogg, C., 'Plain Tales', *Harpers & Queen*, 1988, p. 287, states: 'The Conran Shop, for example,

has had, since the new shop opened last November, a small but perfectly formed collection of furniture drawn directly from Shaker designs and made in oiled American cherry ... The Shakers have also colonised Regent Street – in the meeting house of Liberty. There is no new furniture being made by the Shakers nowadays ... The furniture that Liberty has acquired is made by an Ohio craftsman, when he is not making new pieces based on Shaker ideas and principles, is restoring the original ...'

263 See Constable, K., 'Shaker Maker', Elle Decoration, 1989, p. 120.

264 The Shaker Shop in London started out in 1988 and their history is featured on p. 134 of their catalogue published in 1999 in which it states: 'As a direct response to the success of the Catalogue, SHAKER opens its first shop in Harcourt Street ...'

265 See Lamb, T., 'Shaker Store Opens in London', The Shaker Messenger, 1990. See also Berridge, V., 'The Source', Homes & Antiques, 2004, p. 25, in which the Shaker Shop catalogue is recommended as catalogue of the month.

266 See Hall, D., 'Born Again Shakers', The Independent on Sunday (Interiors), 1992.

267 See Hall, D., 'Born Again Shakers', The Independent on Sunday (Interiors), 1992. Also see Lee, V. & Baldwin, J., 'Divine Art', Homes and Gardens, 1990, p. 116: 'Antique Shaker furniture now fetches high prices; in 1989 a six-drawer chest was auctioned for $32,500 and a candle stand for $154,000. Such prices would probably have the departed Shakers turning in their graves. Shakers believed in recycling – anything beyond repair was taken apart and the materials used again. Old Shaker furniture is now in short supply, like the Shakers themselves.' Also Mildred Barker – an important Shakeress who is referred to in the article – was also responsible for a number of books: see Barker, M.R., Holy Land: A History of the Alfred Shakers, 1986 and Poems and Prayers, 1987.

268 A BBC radio programme The Gift to be Simple, was broadcast in February 1989, and was followed the next month by Jones, M., 'The Shaking Quakers', The Listener, 1989 (information supplied by Geoffrey Gale).

269 See James, B., 'Against the Grain', The Radio Times, 1994, p. 43, which continues: 'The early believers were deeply earnest in attempting to discard worldliness, and tried to create products that symbolised their beliefs: thus all objects had to fulfil their appointed function with mathematical exactitude ... Shaker furniture, which the sect first started to manufacture because they couldn't afford to buy any, is without ornament. The now familiar ladder-back chairs, painted dressers, wooden boxes and pegboards (made so that other furniture could be hung up on pegs to let the floor be swept clinically clean) is the only image most people have of the sect. This depresses them – "I don't want to be remembered as a chair," said one Shaker, memorably. It belies the fact that their willingness to encourage invention meant they were the first in their rural areas to install electricity and buy some of the earliest cars. Shaker communities are also credited with inventing the clothes peg, the flat broom, the apple corer, first circular saw and even a primitive washing machine. And they're dismayed at the prices paid for original Shaker pieces, which came to the market over the years as communities disbanded. The fact that Oprah Winfrey once paid $220,000 for a Shaker chest does not fill the Sabbathday Lake group with pride: "We are turned off by this," says Sister Frances. "We embrace a vow of poverty. That doesn't mean we are terribly poor, but that we do not want or expect to have things we don't need." My favourite piece is a wooden shovel, beautifully made from one piece. But it wasn't made to go in a museum – but made by a man who needed a shovel and worked as Mother Ann taught: hands to work, hearts to God.' Also see the radio programme Hancox, A. & Jackson, B., Simple Gifts, 1994.

270 Malloy, H. & Symons, L., 'Style File: Beautifully Simple – Perfectly Plain', Homes & Antiques, 1994, p. 56.

271 Malloy, H. & Symons, L., 'Style File: Beautifully Simple – Perfectly Plain', Homes & Antiques, 1994, p. 57.

272 Companies recommended for Shaker-style products include Appalachia, Habitat, Jerry's Home Store, Shaker and AB Woodworking.

273 Bowe, S.J., Watervliet Shakerism, Master's Thesis, 1994 contains illustrations of all these products.

274 See Elsdon, J., 'America in London', Christie's International Magazine, 1994.

275 See Lahr, J., 'Exhibition Diary – Americana', The World of Interiors, 1994, p. 108.

4 WEST AND EAST – The Movement of Shaker Design into Museum and Popular Cultures from the West to the East and Vice Versa

This section features the movement of Shaker exhibitions between the eastern seaboard of the United States and the west coast. The movement took place in both directions as seen in a show formulated at Paine Webber in New York which eventually ended at the Seattle Art Museum, while an exhibition entitled 'Kindred Spirits', organised at Mingei International Museum of World Folk Art at San Diego, California, moved to both Florida and Massachusetts. Significantly another exhibition entitled 'Shaker: The Art of Craftsmanship' dominated the Shaker exhibition calendar for a number of years because it travelled extensively throughout the United States and also appeared in two contrasting venues in the United Kingdom at Bath and London.

In 1995 the Berkshire Shaker seminar – a group interested in the Shakers – visited Manchester, England in order to study the origins of the movement.[1] The contemporary developments in England are very much a focus of this section, as the period which it covers has produced considerable coverage of Shaker in terms of both journals and books.[2] This provides a rich source of information for analysis. This was specifically addressing European audiences and much of the television material made assumptions that the audience would know who and what the Shakers were.[3]

The evolution of the Shaker aesthetic in the United Kingdom has seen the development of a distinctive style featured in many British interiors, with varying degrees of authenticity. The style is perhaps epitomised by the 'Shaker' kitchen which has become a common feature in many manufacturers' ranges at all price levels in the marketplace. The popularity of Shaker style increased throughout the 1990s within the home furnishings and decorative arts market with the appearance of Shaker pastiches. In addition to the concentration of the marketplace on Shaker design there were also some new museological representations based on fine art and conceptual interpretations, with the focus on the Shaker aesthetic alongside both contemporary artists' interpretations and minimal artworks.

Introduction – High Art Influences from Museum Cultures

The Far East and its culture have a long history of influencing the West.[4] Japan and the work of contemporary artisans[5] and architects[6] and the ancient traditions of the designer/maker encompassing calligraphy, furniture, ceramics, metalwork and basketry, have all been subject to analysis and reinterpretation by scholars and artists in the West. The influence of the simplicity of the Japanese aesthetic can be seen in the early development of Modernist theory in Europe and North America from the late nineteenth century onwards. It is therefore not surprising, given this common history, that the Japanese and Shaker aesthetic should have had comparisons drawn between them.[7] Both are based on strong religious convictions, have a minimalist aesthetic and have been increasingly popularised by media and museum interest.[8]

Along with orientalism, minimalism was a fashionable theme in the world of design from the mid-1990s onwards, although arguably it is now less so. As Edmund de Waal states: 'Now that everyone has a pair of white porcelain bottles on their mantelpiece, is it time to call last orders for minimalism? Now that you can buy Shaker computer tables, should we just give up?'[9] He goes on to say: 'Those who live by style, mediated through magazines, are doing so. Any cursory glance will see that apart from some redoubts defended by architects like John Pawson or Claudio Silvestrin, minimalism – minimalism written with a lowercase m – is being abandoned in favour of the new baroque, deco-lite, urbo-ruralism or any other combination of ripe nonsensical verbiage.'[10]

John Pawson, a British minimalist architect who received a good deal of media coverage throughout the period covered by this section,[11] was featured in a *Sunday Telegraph* article entitled 'Slaves to Mastering Chaos'.[12] The article goes on to discuss the obsessive tidiness typified by the advocates of minimalism:

> To the mess maker, tidiness is one of the Seven Deadly Virtues – along with thrift, honesty, fitness, cleanliness, punctuality and abstemiousness. All these goody-goody virtues are, in fact, enemies of jollity and creativity and real life as it is lived moment by moment. They are deadly dull, and not virtues at all ...[13]

Pawson's minimalist aesthetic and its stylistic links with that of the Shakers all feature in his book *Minimum*, in which the architect states:

> Beyond looking at the ingredients of simplicity, I have attempted in this book to capture the essence of everyday life that embodies these qualities in an active way: the way that life is lived in a Shaker community, or a traditional Japanese Inn ...[14]

He continues by declaring:

> ... the Shakers with their fanaticism and embrace of celibacy, communal land-holding and way of life free from the encumbrances of personal possessions, produced architecture and objects of remarkable intensity, beauty and perfection, even though their principles strictly prohibited the use of 'beadings, mouldings and cornices which were merely for fancy'. The irony of course is that now that Shakerism has all but died out, its surviving artefacts are much sought-after as aesthetic objects and trinkets by the worldliest of interior decorators.[15]

As Pawson indicates, minimalist interiors and their associated artefacts have become increasingly popular as evidenced by the worldwide rise of retailers such as IKEA.[16] The company has featured a number of Shaker-inspired products such as boxes and furniture (including storage furniture and chairs). An article in *The Guardian* states: 'It started as a young man's dream in rural Sweden. Now IKEA has 158 stores in 29 countries and is about to embark on a massive expansion plan in Britain.'[17] It continues:

> IKEA's first UK store opened in Warrington in 1987, but it wasn't until the mid-90s that the company really felt it was making progress. The high profile 'Chuck out your chintz' ad campaign infuriated audiences, but it also appears to have worked: the chintz was chucked in favour of IKEA's stark simplicities.[18]

IKEA has used its antipathy to the traditional British chintz interior to promote a hybrid Scandinavian/Modern style that accommodates the IKEA philosophy of affordable design which is available to all.[19] As part of this hybrid style, IKEA has used the Shaker aesthetic to promote and sell its products to an audience who would by and large have been unaware of the origins of the style.

An article, 'Branzi's Dilemma: Design in Contemporary Culture', gives

an indication of 'the tentative mapping of some of the most prominent individuals and schools of design in the twentieth century'.[20] The Shakers are highlighted as a good example of a movement which has both extremes of spiritual and cultural ideals. Whilst this is undoubtedly true, the Shakers as craftspeople have produced little in the twentieth century and it is the Shaker artefacts produced in the eighteenth and nineteenth centuries that stand as the evidence by which we now judge them as makers.[21]

In the article 'Wielding the Force of Presence' an annotation to one of Linda Butler's photographs of the spiral staircase at Pleasant Hill reads:

> That the Shakers were doctrinally Perfectionists is the final explanation of the perfection of Shaker workmanship; or, of its beauty. We say 'beauty', despite the fact that the Shakers scorned the word in its worldly and luxurious applications, for it is a matter of bare fact that they who ruled that 'beadings, mouldings, and cornices, which are merely for fancy, may not be made by Believers' were consistently better carpenters than are to be found in the world of unbelievers.[22]

As in previous decades, there were still a number of collectors who were interested in quality Shaker artefacts, some of which were shown in specific exhibitions[23] and also sold at auction.[24] The profile of the 'typical' Shaker collector had changed from that of the intellectual or aesthete, as typified by the Andrews partnership, to that of a wealthier higher profile celebrity such as Oprah Winfrey[25] and Bill Cosby in the USA, or British artist Damien Hurst[26] and the late actor John Thaw.[27] All the media and celebrity attention inevitably had an effect on the price of original Shaker artefacts and a sale by Skinner Auctioneers in 1996 gives an impression of the sort of prices Shaker artefacts were now commanding. For example, an oval box, from Canterbury or Enfield, New Hampshire, had an estimate price of $4,000–5,000 and eventually realised $10,925 at auction.[28]

Throughout the 1990s a shift was seen from a craft based examination of the Shaker aesthetic to a more fine art based view as exemplified by the 1995 exhibition 'Shaker: The Art of Craftsmanship'.[29] Throughout this period there was a proliferation of publications examining the question of Shaker style,[30] and whilst some added to the debate others, such as *Essential Shaker Style* by Tessa Evelegh, merely acted as regurgitation of material.[31] This book consists of a series of chapters relating to different

interiors with an additional chapter devoted to Shaker style and its six essential elements, including colour palette, fabrics, woodwork, furniture, storage and accessories. The text contains some unusual interpretations of the Shaker theme together with a number of 'projects', including the creation of a herbal wreath and a hand-in-heart lavender sachet. Interestingly, Evelegh states that Shaker is:

> ... a style, developed and perfected over 200 years at an unhurried pace, that transcends commercialism. Its aim was never to make money. Its aim was no less than perfection, initially from a purely practical point of view ... Even if their style is not to everyone's taste (and certainly, during the last century when embellishment seemed to be all-important, many found Shaker designs impossibly plain), nobody can question the quality of the design ... We do not have to emulate the Shaker lifestyle to inherit the legacy of their design and the benefits of peaceful, harmonious surroundings. But without understanding them and their ideals, it is very easy to become sidetracked. Realising the appeal of Shaker design, many manufacturers have jumped on the bandwagon for commercial gain, labelling goods as Shaker style which go quite against Shaker principles. Understanding those principles will give you an instinctive feel for what is right and infinitely more pleasing finished effect.[32]

Much of what Evelegh suggests in her book is derivative, superficial and often interpreted incorrectly. However, she is not alone in this respect and other publications have taken a similar approach.[33] With the increased popularity of Shaker design it has become an iconic American style.[34] In *American Country* by Herbert Ypma, this process is outlined:

> Today, in a world where pared-down has become synonymous with chic, Shaker is fashionably stylish. Although the authentic Shaker furniture makers are long gone, fine craftsmen still use their methods and designs. Numerous firms in America devote all their energies to the manufacture of faithful Shaker reproductions, several antique dealers concentrate almost exclusively on Shaker Americana, and auctions dedicated to Shaker items are widely advertised and heavily attended. There are specialised Shaker boutiques in some of the world's most cosmopolitan capitals, including London and New York, and a French women, Elizabeth Jaeger, living in the Lot region, has carefully studied their techniques and now creates Shaker copies for sale in France that are fully worthy of this great tradition.[35]

Ypma wrote an article entitled 'Shaker Shaped' for the prestigious magazine *The World of Interiors* in July 1998, featuring the architectural team of Peggy Deamer and Scott Phillips and their design for a house in Long Island, New York. Deamer and Phillips produced a house displaying many Shaker influences in terms of its symmetry, purity and practicality. The article states:

> Following Shaker tradition, the overall construction was carried out according to a policy that can be summarised as 'simple but solid'. There was certainly no skimping on materials. Window and door frames were fashioned from solid mahogany, and beautiful blond timbers like beech were used for all the built-in closets and cupboards ... The owners' request for storage space to house blankets and quilts inspired this homage to the Shakers. Designed to be out of the way and invisible, the recessed cupboards began life as a utilitarian detail but have actually turned out to be one of the most beguiling features of the house. 'Closets were part of the architecture,' says Phillips. The positioning of the built-ins has resulted in a pleasing, rhythmic design, which is 'a pattern as a result on the placement of functional elements, not pattern for pattern's sake', as the architects are quick to point out ... Contrary to popular belief, the Shakers, concerned with quality and craftsmanship in all their endeavours, were not cheap or conservative in their commitment to achieve the best results. The famous round barn at Hancock, Massachusetts, for example, was constructed with the help of 53 highly skilled masons, at the absolutely extraordinary cost of $15,000.[36]

In addition to this specialist and specifically designed building, other property was available for sale in the United States which had Shaker influence. For example, in an advertisement for Shaker Brook Farm it states: 'The third structure – the gallery – was built in the late 1970s. While displaying a traditional octagonal Shaker barn exterior that blends with the surroundings, its interior reveals a contemporary multipurpose gallery designed to display the Barenholtz collection of antique toys and American Folk Art.' The sellers produced a lavish brochure for prospective buyers.[37]

One of the most prominent contemporary Shaker commentators to have taken up the mantle from the likes of the Andrews partnership, Sprigg and Stein, is John Kirk, who has written a number of important pieces on Shaker design including his comprehensive 1997 book *The Shaker World: Art, Life, Belief*.[38] Much of the material in the latter part of his

book had previously been discussed in an article in *Design Quarterly*, which encapsulated the themes and issues centred around the Shaker aesthetic.[39] Kirk also discussed his intent in *The Shaker Messenger*.[40] The *Design Quarterly* article entitled 'An Awareness of Perfection', which analyses Shaker design and compares it with contemporary American art, states:

> One recurrent American attitude toward design is the reductive aesthetic that characterises two expressions which at first seem to lack cultural and historical linkage: Shaker design and the spare and minimal creations made by certain American artists since 1950. A consideration of the visual and aesthetic intentions of both reveals a reductive spirit that under girds American art ... Everything the Shakers did was now affected by a passion for square, rectilinear or circular shapes. This included the design of towns, objects, patterned dances that were the core of worship services, and even how Believers ate at meals. Thus it was natural for them to adopt the restrained and geometric design attitude of the late classical styling of the 1810s and 1820s. For the Shakers the neat, no-frills aesthetic of this international movement fit for their functional, theological, and social requirements: easy-to-produce multiple units of chairs, stands and other basic furniture forms; a religious requirement for simplicity; communal needs which gave each member or room a similarity of things that prevented inequity.[41]

The article discusses repetition amongst the works of the Shakers in both their religious celebrations and material culture. He uses the famous built-in furniture at the Church Family Dwelling, Canterbury,[42] for comparison with a modern art piece by Donald Judd. The quotation that follows highlights Kirk's concerns:

> The Shakers and many of these artists have in common the use of sources – known images from which they draw when making personal statements. The Shakers did this automatically, and to a degree unconsciously, as they naturally took the familiar vernacular forms around them as the basis for their objects, and for theological and philosophical reasons simplified them further to meet their religious and social needs ... The 'Shaker look' came from a determination to have their environment reflect a special way of life; for contemporary artists it is seldom a casual process.[43]

It seems odd that Kirk should use fine art/conceptual art to examine the Shakers' material culture when they themselves considered any non-applied

art to be 'frivolous'. His analysis is based on a purely visual response and seems to ignore the functional aspect which was such an intrinsic element of their philosophy. The whole point of a Shaker artefact is that it has stood the test of time precisely because it is useful and well made – as well as being aesthetically pleasing. Would it not have been better for Kirk to compare (and more appropriately contrast) abstract artists with those spirit drawings produced by the Shakers, which have both figurative and abstract motifs? Kirk in his final statement says: 'Sitting on a refined Shaker chair seems as interfering as touching a surface by Judd or Martin. While all objects convey the surety and authority of their makers, they are available to the committed; the delight is in their ever-renewing power.'[44]

The point of a Shaker chair is surely that it should be used and whilst of course very few people have the opportunity to sit on or use an original piece, that does not mean that reproductions cannot embody the same integrity – it should be and indeed is as much a pleasure to sit on a modern version as an original. Kirk is isolating the artefact/object in a museum context and is ignoring the original intention of the makers. In the case of contemporary art the artist cannot claim functionality and, equally, the Shakers did not claim that their artefacts were in any sense fine art, although ironically a large proportion of Shaker objects have now been stripped of their original functionality by being placed in a museum context. All that the museum visitor can now do is play the part of the passive observer: what, no doubt the Shakers would ask, is the point of a chest of drawers if it is not used for storage? In Kirk's article 'An Awareness of Perfection' we can see this trend in which Shaker artefacts are viewed more as art than design. The role of the artist/maker in producing the object (be it art or design) is given greater importance than the viewer/consumer. Production becomes more important than consumption, aesthetics given priority over functionality.

Kirk divides *The Shaker World: Art, Life, Belief*[45] into 10 chapters; focusing on history, design, beauty, classic style, colour and, importantly, revisionist theories. Arguably, in terms of his examination of the Shakers in the twentieth century, the most significant chapter is 'Another View' in which he affirms his associations with the Old Chatham museum and its collections and also mentions the period room. He states:

Selling Shaker

In 1988 I was asked to choose my favourite pieces from the collections of the Shaker Museum and Library at Old Chatham, New York, and to arrange them in their largest gallery. I undertook the project with Jerry Grant ... because the quality of the museum's collections was obscured by an arrangement that scattered the furniture among the machinery that it produced it. This is an informative display technique for some visitors, but for most it is hard to see, study and compare related pieces when they are set far apart. Our new arrangement, which grouped more than 40 objects together, might seem to fly in the face of the ever-growing movement to 'contextualise' materials, but no 'period' Shaker room has yet met a high standard of accuracy.[46]

Importantly, Kirk in his book analysed the look of Shaker rooms in terms of both the written record and the photographic evidence (he includes a number of black and white interior shots). Regardless of the comprehensive evidence for the Victorianisation of Shaker interiors, the lasting vision of Shaker is still that interior which was described by Edward Deming Andrews.[47] This vision is the one which has been actively promoted by many institutions and individuals. In a complex series of statements Kirk examines the Shakers' promotional activities and indicates that they were largely responsible for their own marketing and fully realised the potential of 'the world' market. This was something which had occurred in the early development the Shakers and continues to the present day. In the twentieth century the Shakers would appear to have done this in a variety of ways including using the Andrews partnership's 'creation' to sell the Shaker style. This as Kirk suggests was in order that the Shakers could provide the public with what they perceived they wanted. Clearly, the products of the Shakers have created a want in contemporary society, although it is probable that the current Shakers would prefer that their religion was the element which attracted attention from the outside world.

Kindred Spirits – The Eloquence of Function in American Shaker and Japanese Arts of Daily Life – 1995

This travelling exhibition was organised by Mingei International Museum of World Folk Art,[48] San Diego, California from 21 April to 8 October 1995, and travelled to The Morikami Museum and Japanese Gardens, Delray

Beach, Florida (14 November 1995 to 3 March 1996)[49] and The Art Complex Museum, Duxbury, Massachusetts (12 April to 8 September 1996).[50]

The exhibition was based on a major loan from Hancock Shaker Village, with other institutions also credited including The Art Complex Museum, Duxbury; The Brooklyn Museum; The Fruitlands Museums; and the Western Reserve Historical Society and Library. The exhibition included 200 items divided between those produced by the Shakers and Japanese artefacts, from 1800 to 1995. The exhibition is of interest for a number of reasons, first, because it included both Japanese and Shaker objects and secondly, because alongside original works by the Shakers the exhibition also included contemporary interpretations such as a serving table by Shaker Workshops (*circa* 1994), oval boxes by Paul Dixon (1994–95) stamped 'Orleans Carpenters' and a basket by G. Kennedy (1992).[51] The Shaker objects within the exhibition included furniture pieces (rocking chair, case of drawers, sewing desk and revolving chair in the production period around 1850). A bed made of white pine, hickory pins, maple wheels, rope and a green paint, took pride of place. Other items included a hanging bracket for a candle (mid-nineteenth century), an adjustable double lamp stand (1830–50), a stove and small wooden items including a bentwood dipper, large oval carrier, small oval carrier, baskets and some textiles. One object which represents a cross-fertilization between the two cultures is a table by George Nakashima (1905–90), who was born in Spokane, Washington of Japanese parents, and who described his style as 'Japanese Shaker'.[52] The exhibition allowed the objects space to speak for themselves and avoided room settings in favour of an approach which maximised the essential intent of the exhibition to draw comparisons between Shaker and Japanese production,[53] a theme that had previously been explored in the article 'Shaker and Japanese Craft Explored', published in *The Shaker Messenger* in 1991.[54]

Martha W. Longenecker was responsible for writing the foreword to the catalogue and also appeared in the accompanying video of the exhibition. The foreword discusses the Japanese arts of daily life:

> In a similar quest for purity, the Bauhaus in the 1920s postulated the design precept 'less is more' approximately one thousand years after Japan had developed a similar aesthetic ... Although the strict religious tenets of the

Shakers may not be relevant, their glorification of God through the effective utilisation of time and resources developed into a Western aesthetic based upon purity in some ways strikingly similar to that of the Japanese.[55]

Longenecker goes on to discuss honesty to materials and spatial awareness:

> A comparison of cabinetry reveals that, for both the Japanese craftsmen and the Shakers, form was primarily determined by function. Simplicity, balance, utility and durability are common characteristics. In their specific approaches to materials and techniques, both cultures relied upon local woods, avoided decorative joinery and shunned veneers in favour of the honesty of solid woods. In terms of utilisation, the Shaker tendency to build case pieces into the room structure, use structural 'dead space' for storage and leave floor space open is paralleled in the nineteenth century only in Japan.[56]

Sprigg also contributed a prologue to the catalogue entitled 'The Fifteenth Rock: On Shaker Design',[57] in which she writes eloquently about both the Shakers and her first experience of Japan where she organised a successful Shaker exhibition at the Sezon Museum of Art in the early 1990s. She continues by providing a context for her essay on the Shakers:

> The Shakers' attitude about material possessions may at first seem contradictory to Western minds. On one hand, the Shakers felt a desire to free themselves from what was not essential. In their understanding, this meant freedom from an excess of possessions and also the elimination of ornament, which they considered superfluous. On the other hand, the Shakers cared very much about the appearance of their things precisely because they were felt to reveal the spiritual values that mattered deeply. As a group, the Shakers loved usefulness, simplicity, cleanliness and order in everything given to them by God ...[58]

June Sprigg encapsulates this cultural crossover between West and East when she states: 'Now, almost 40 years later, I see more of the way along which I have been led: from California to the East, further east to Japan, and east yet further back to where I began in the West.'[59]

William Thrasher, the guest curator, believed that the objects within the exhibition were capable of speaking for themselves; to this end, his

initial idea had been to eliminate labels or annotations to the exhibits. He stated that:

> Distinct differences in the histories of the American Shaker and Japanese culture make comparisons difficult. Even at their height the Shakers have remained but one utopian society within the great diversity of American culture. Today they have declined to one small community at Sabbathday Lake, Maine, whose mission is to sustain the United Society of Believers as a part of the spiritual life of America. They are not a living museum of the Shaker past. They no longer need nor have time to spin and weave textiles for clothing and domestic use, weave baskets or make oval boxes or chairs. Only insofar as such hand work serves their mission do they continue any of these traditions today.[60]

Thrasher summarised the objects in the exhibition as representing: '... the language of objects – form, shape, colour, texture, purpose, also includes essence, that intrinsic, unchanging nature of a thing which, like light, can surround and resonate within us.'[61] Indeed, Shaker objects have always been recognised as having a spirit and presence beyond the physical world – a sense of timelessness – which is perhaps due to the fact that the objects were produced with deep religious conviction by people who believed that they would be used and useful for many years.

The Mount Lebanon Shaker Collection

At the start of the 1990s the Mount Lebanon Shaker Village collection of Shaker artefacts became the focus of much of the exhibition activity in the United States and was featured in a specially produced catalogue. There was also a large amount of interest relating to the Mount Lebanon site[62] and its association with the Darrow School which had established the site and buildings as part of an educational institution. The preservation of the properties and contents of the village became the focus for much of the press interest as the village was viewed as the Mother community and therefore the most important of the Shaker settlements.[63]

The history of the issues relating to preservation have been well documented and the editorial comment in The Shaker Messenger gives a succinct account of the problems and issues.[64] A fundamental concern was that

the village had been sold to a school which appeared to struggle financially with the responsibility of preserving both the exterior architecture and interior fittings and furniture.[65] In the article 'Mt. Lebanon's Future Becoming Uncertain' it notes that:

> Two years ago the Darrow School faced a financial crisis that ended with the school's selling two major pieces of its Shaker collection – a 96″ tall cupboard with drawers to entertainer Bill Cosby for $200,000 and a Benjamin Youngs tall clock to inventor Ken Hakuta, Washington, DC for $165,000. Two years later, in 1990, Darrow School again faced a major financial crisis. Again they offered up some Shaker. Two more pieces left the site – a double cupboard over drawers and a rare alphabet board exhibited at the Whitney – this time Hakuta got both pieces for about $195,000.[66]

In addition to the issue of furniture leaving its intended location there was a good deal of concern about the stripping of internal fixtures and fittings for sale. The worst-case scenario was that the site could be left without any authentic Shaker artefacts or interiors and, in order to prevent this happening, a foundation was established to protect both the buildings and the general collections.[67] As part of a convoluted deal, the collection became the property of Ken Hakuta at what can only be described as a bargain price.[68] *The Shaker Messenger* detailed the collection as consisting of '… more than 100 major pieces of furniture, more than 1,000 books and paper objects, 200 bottles from the Shakers' herbal industry and 1000 other objects.'[69] Whilst the collection of the Mother community at Mount Lebanon was extensive, it had remained relatively little known.[70] The background to the sale was both complex and controversial, as noted by *The New York Times*:

> The story of how Mr Hakuta acquired his collection is a complex tale of chance encounters, mystical experiences with the dead, the difficulties of reaching Bill Cosby on the phone and hardball business negotiations … When the Mount Lebanon community withered away, the Shakers sold their buildings, furniture and land in 1930 to a small co-ed boarding school, the Darrow School, which still operates on the site. Few people then attached much value to the furniture, so Darrow used the 2,500 pieces in its dormitories and offices … Darrow parted with some minor pieces as interest in Shaker design developed in the 1970s but it wasn't until 1988

when, faced with financial problems, it sold one of its prize possessions, a *circa* 1820 cupboard, to Bill Cosby for $200,000 ...[71]

It continues by stating:

> As the school's finances continued to weaken, Darrow called Mr Hakuta in the summer of 1990, offering to sell him everything. Sotheby's had told Darrow the lot might fetch $1.3 million at auction, but the school hoped to find a single buyer who would agree to leave it on site ... Through tough negotiations, Mr Hakuta bargained Darrow down to $600,000 for the entire lot. Under the agreement, the collection would remain in Mount Lebanon and a local foundation, now called the Mount Lebanon Shaker Village, would have the right to repurchase it for an undetermined price for display in a new museum.[72]

The sale of the collection paved the way for the organisation by Art Services International of a large and comprehensive travelling exhibition on Shaker craftsmanship.[73] The exhibition catalogue contained contributions from T.D. Rieman and S.L. Buck. The catalogue's acknowledgments state:

> With the decline of the Shakers, popular culture has often misconstrued their beliefs, practices and accomplishments even further. A close examination of the exceptional craftsmanship of the furniture they made themselves at Mount Lebanon, New York – a principal Shaker community and the seat of the Shakers' religious authority – illuminates the level of their artistic achievement and the variety of their efforts. It is with pleasure that Art Services International introduces the creativity of the Mount Lebanon Shakers to audiences throughout the United States.[74]

The exhibition travelled widely throughout the United States and United Kingdom and received extensive publicity and press coverage.[75] Interestingly the exhibition changed from institution to institution – the curators within each museum/gallery deciding to emphasise different aspects of the Mount Lebanon collection on the grounds of either ideological preferences or gallery constraints – and as a result each of the 'exhibitions' had a different 'feel'. The exhibition run prior to moving to the United Kingdom included The Chrysler Museum, Virginia (18 February to 16 April 1995);[76] High Museum of Art, Atlanta (16 June to 10 September 1995); Wadsworth Athenaeum, Connecticut (7 October to 3 December 1995);

Sheldon Memorial Art Gallery, Lincoln, Nebraska (21 January to 31 March 1996);[77] Columbus Museum of Art, Ohio (19 April to 30 June 1996); Parrish Art Museum, Southampton, NY (20 July to 15 September 1996); Delaware Art Museum, Wilmington, Delaware (11 October 1996 to 5 January 1997); Wichita Art Museum, Wichita, Kansas (1 February to 16 April 1997); and the Munsen-Williams-Proctor Institute Museum of Art in Utica, NY (17 May to 13 July 1997).[78]

To illustrate the evolution of the exhibition at the various venues, we have chosen four to use as case studies. These are the Delaware Art Museum's presentation, the Smithsonian's Renwick Gallery presentation in the USA and the Barbican, and The American Museum in Britain.

The Art of Craftsmanship Travels in the United States – Delaware Art Museum, 1996 to 1997

The Delaware Art Museum at Wilmington is located close to Winterthur. The exhibition ran from 11 October 1996 to 5 January 1997 and was described by *The Kennett Paper* in October 1996, as:

> Functional furniture has been put on a pedestal and elevated to the role of art form in a show this month at the Delaware Art Museum. 'Shaker: The Art of Craftsmanship' opens Oct. 11 with 86 pieces from the oldest Shaker community, Mount Lebanon, NY. The exhibit contains furniture, ceramics, clothes, items made for use in the Shaker home and items made to sell to the outside world. According to information in the show catalogue, Shaker craftsmanship has long been admired for its clean lines and simple beauty, and this exhibit aims to show the pieces as though they were works of sculptural art.[79]

The exhibition's free guide featured a photograph of a Benjamin Youngs clock on the front cover, and noted in the 'Introduction':

> In 1774, Mother Ann Lee led a handful of members of the United Society of Believers to America from Manchester, England. The small sect, later known as the Shakers, established a community at Mount Lebanon, New York, in 1785. By the 1830s the sect had grown to more than 5,000 men and women in 18 settlements from New England to Ohio and Kentucky. They believed in a rich spiritual life, diligent labour, communal property,

egalitarian values and celibacy. Their worship practises were spirited, their work habits sober, and their lifestyle simple and harmonious. By the 1900s, celibacy combined with an aging population and industrialisation had reduced Shaker membership drastically. What survives is the strength of the design of their products. Stripped of all ornamentation and super-fluity, they not only echo the Shaker lifestyle but also elevate craftsmanship to an art form.[80]

The exhibition was divided into three sections: 'The Shakers at Work', 'Shaker Places' and 'The Shaker Legacy'. This remained common within a number of the participating museums who decided to emphasise the Shakers' industries and labour. The section 'The Shakers at Work' stated:

> In a self-contained community trying to satisfy its needs, one industry necessitated another. Shakers raised their own livestock, planted crops, wove fabrics, tailored clothing, built houses and fashioned furniture. In workrooms segregated by gender and occupation, men and women kept busy living up to their motto: 'Put your hands to work and your hearts to God.' The shops contained the items needed for the manufacture of the goods as well as appropriate pieces of furniture for work activity and storage.[81]

A number of tools and artefacts associated with craft were featured. Like many of the exhibitions centred around the Mount Lebanon collection, the curators decided to change both the emphasis and in some cases the inter-pretation. The annotations in the small free catalogue did not match the catalogue produced by Art Services International, for example the annota-tion for exhibition piece Number 6:

> Cupboard with drawers and tool brackets cab. 1840
> Pine, basswood, freighted knobs, iron hinges, brass latch, zinc yellow and iron earth pigments, tempera paint.
> This piece was built as a tool cupboard because most of the tool holders were installed before the interior paint was applied. Access to the tools is complicated. It involves going through several doors and removing security pins from above and beside each drawer. From an aesthetic point of view, this cupboard represents a significant item of Shaker work furni-ture because of its asymmetrical layout, the arrangement of doors, the use of colour and its overall size which measures more than 94 inches in height but is a scant 10 inches deep.[82]

The Shakers' living and working environments were examined as being seamless, resulting in the general functional efficiency of the community:

> The Shakers believed in divine inspiration to achieve a harmonious living environment. Such an environment is created not only through functional efficiency but also through visual appeal. Rugs do more than quiet footsteps on a creaky floor. Green beds do not merely rest tired limbs, they refresh tired eyes. Buildings, furniture and material objects have importance beyond their utilitarian function. In striving toward their version of heaven on earth, the Shakers created an aesthetically satisfying combination of shapes, sizes and colours within their public and private spaces, in their workrooms, meetinghouses and living quarters.[83]

The exhibition, along with many which were staged throughout the 1980s and 1990s, made great play of the Shakers' legacy, the trade with the 'outside world' and the quality of the artefacts produced:

> The 'outside world' or non-Shaker community soon recognised the pleasing appearance and superb quality of Shaker products. The Shakers at first merely accommodated those who came to buy their surplus goods but soon started to actively market their wares in showrooms and through catalogues. Today Shaker furniture with its appeal to modern tastes, brings top dollars. In its basic construction Shaker furniture shares much with furniture items built throughout the United States during the late 18th century and early 19th century. However, since the Shakers emphasised function over aesthetics and strove towards a 'plain and simple' concept in their products, their craftsmen proceeded to create a neo-traditional or modern style that extracted traditional design elements from familiar forms but excluded superfluous ornament, thus reducing objects to basic forms and structure.[84]

As with the general exhibition catalogue, the Delaware Art Museum emphasised the Shakers' use of colour and the many different treatments to be found on Shaker furniture including stripped and repainted surfaces:

> While design was probably subject to some specific regulations, it varied somewhat from community to community. Individual craftsmen often created complex patterns with asymmetrical juxtaposition of the vertical door lines and horizontal drawer masses. There is no question that the Shakers liked colour. However, it is easy to overlook the colourful nature of

Shaker furniture because so much of the original colour has disappeared. Surfaces were either refinished by the original owners in an attempt to 'redecorate' or subsequently were stripped and repainted in an effort to improve the appearance of the furniture item in question. While early production concentrated on opaque finishes in such shades as red ochre, raw sienna and chrome yellow, beginning with the 1830s and up to the end of the 19th century, greater amounts of plants or shellac were added to colour pigment. Opacity was thus reduced to a wash-like substance which lent a different appearance to the item by allowing the wood grain to be visible.[85]

The exhibition also contained smaller objects including an oval box made from maple and pine with copper tacks, with a red wash and shellac finish, dating from 1850:

> The oval was considered by many Shakers to be the perfect, or utopian, shape. In order to make a wooden box in an oval shape, Shaker craftsmen steamed a thin piece of wood for the sides of the box for hours, until it curved around an oval form without cracking. The swallowtails or 'fingers' were cut by hand with a knife and secured in place with copper tacks. The bottom was made of thicker wood, squeezed into the form and fastened with wood or brass points. A wash of red ochre, mustard or yellow was sometimes applied to enliven the box's appearance. A shellac or varnish finish sealed the surface. These boxes bear witness to the simple elegance of Shaker design and the quality of their craftsmanship. They were originally made by hand, but later specialised machines were developed to speed up production.[86]

Clearly, the Delaware Art Museum provided a distinctive aspect to the original exhibition and, as will be seen later, the same artefacts were capable of providing different readings according to the shifts in emphasis placed upon them by the curators at the other institutions on the tour.

The Art of Craftsmanship travels to the United Kingdom – Barbican Art Gallery, London – 1998

In 1998 the Barbican Arts Centre in London decided to undertake a 10-month celebration of Americana in their 'Inventing America' series. The Shaker exhibition ran from 22 January to 26 April.[87] A bulletin entitled

'Shaker' detailed a series of talks and workshops relating to the exhibition in which it stated that:

> The Shaker values of hard work and excellence produced extraordinary objects and industries. Shakers are probably best known today for the objects they made, which are characterised by simplicity in design and originality in craftsmanship. The Shakers aspired for perfection in all they turned their hands to in order to observe their religious faith, based on the beliefs of 'beauty rests in utility' and 'every force evolves a form'. This is the first major touring exhibition of furniture and decorative arts from one of America's oldest and most influential Shaker communities, Mount Lebanon (est. 1787). The exhibition outlines the development of the Shaker movement from its origins in England to its dissemination in America from the late 18th century to the 19th century, and examines the religious beliefs and utopian philosophy which underlie the Shakers' approach to design and workmanship. The exhibition will show over 120 works, principally drawn from private collection of the works from the Mount Lebanon Shaker community, New York, including furniture, craftwork, textile and costume as well as graphic work and archive photographs.[88]

The exhibition 'Shaker: The Art of Craftsmanship' featured talks by a number of interested parties including Sharon Koomler (Curator, Hancock Shaker Village), Brother Arnold Hadd (from Sabbathday Lake) and Tim Lamb (Director of the Shaker Shop, London).[89] It also featured workshops open to the general public including Shaker box-making conducted by AB Woodworking, together with a class in making a cherry woven-top footstool. The exhibition's education programme proved to be particularly popular as the gallery's education spokesperson Christine Stewart noted: 'Both the Harley[-Davidson] and Shaker exhibitions generated a lot of press coverage and very positive audience response. Over 67,000 people saw the shows and the comments books will be treasured as a memento of the extent to which these exhibitions really had an impact on visitors. All the gallery talks, special events and workshops were well received.'[90]

Significantly the exhibition was sponsored by the London-based Shaker Shop, but in the main featured pieces from the travelling exhibition organised by Art Services International. The exhibition was extensively publicised in the popular British press including *The Daily Telegraph*,[91] together with more specialised publications such as the *Church Times*,[92] *Perspectives*

in *Architecture*,[93] *Art & Photography*,[94] *The Friend*,[95] *Chic*[96] and *The Lady*,[97] amongst others.[98]

Staged on the top floor of the Barbican Art Gallery and designed around large room settings, the exhibition was designed to flow from one room to another, with a unifying pegboard around the walls on which was hung the signage for the exhibition, together with a number of chairs and brooms. The communication/educational materials produced to accompany the exhibition were varied, ranging from gallery guides to annotations associated with each room/space. The rooms were numbered from One to Eight, with each section focussing on a different aspect of Shaker life and production. Room One related to the Shaker movement, Rooms Two and Three featured the communal life, Rooms Four and Five looked at the Shakers at work, while Rooms Six to Eight developed the theme of contacts with 'The World'. The text was produced via collaboration between Tomoko Sato[99] and Geoffrey Gale[100] with the emphasis on producing accessible material for the non-specialist, a sentiment which was echoed both in the text material and general exhibition layout:

> The Shakers were the best-known and largest American communal religious society in the nineteenth century. Dedicated to productive labour as well as to a life of perfection, Shaker communities flourished economically and contributed a distinctive style of furniture, architecture and handicraft to American culture. Featuring the Mount Lebanon Shaker Collection, this exhibition shows fine examples of furniture and decorative arts from the oldest and most influential Shaker community. With an emphasis on key aspects of the Shaker life – religion, communalism and labour – the display is arranged to show not only the beauty of the Shaker-made objects but also their meaning in the daily lives of the Shakers. From the mid-nineteenth century onwards, the Shakers found it increasingly difficult to avoid the influences from the outside world. Changing times forced them to evolve, yet the Shaker membership continued to decline in number. The aging of the community members, combined with financial difficulties that intensified through the World Wars and the Great Depression, eventually led to the closing of many Shaker communities in the early twentieth century ...[101]

In addition to the main exhibition pieces a number of other artefacts were included exclusively for the Barbican Art Gallery, and provided by

Selling Shaker

Hancock Shaker Village, Geoffrey Gale, The Shaker Museum, Old Chatham and the Guildhall Library, London. The exhibits were arranged to allow for them to be seen in context – in so far as a museum environment allows – being uncovered and without the usual barriers of glass or Perspex.

The exhibition was shown in conjunction with a Harley-Davidson display, providing a striking juxtaposition of American ideology and style which added a unique dimension to the London exhibition. The lower floor of the gallery was devoted to the motorbikes, while the upper space was given over to the Shaker material. The interconnected nature of the building allowed for noise infiltration from the Harley exhibition which featured a loud soundtrack somewhat at odds with the more contemplative exhibition on the upper floor.

The Shaker exhibition included the showing of two video documentary films, *The Shakers* by Hatto Kurtenbach (1992)[102] and *I Don't Want to be Remembered as a Chair* by Jane Treays (1990), the latter having been previously broadcast as part of the BBC's *Timewatch* series.[103]

Perhaps one of the most perceptive reviews of the exhibition was by Rosemary Hill in her article 'Perfect for Intelligent Purpose':

> The artefacts with which Shakerism is now most associated were developed, like everything else, from first principles. 'Perfect for purpose' was the motto. Like 'form follows function', it was an attempt to escape from style which failed, as streamline Modernism failed, creating instead a distinct aesthetic. The Shakers carefully removed all that they could see to be superfluous in design, such as cornices and ornamental beading on woodwork ... The Mount Lebanon Collection, which has never been seen in Britain before, shows aspects of Shaker craft that are usually missing from books which tend to concentrate on the best and most typical pieces. Here, we see how the spreading ripples of Arts and Crafts and Aesthetic taste reached the Shakers, leaving a layer of shellac and wood stain on their chairs. By the 1880s, their design was losing its sharply innocent eye. The words 'Shakers Mt. Lebanon' sit unhappily on a porcelain jug of 1886 ... They could not escape style, but they were truly forgetful of self. Art history, preferring the named designer, tends to dismiss the Shakers as religious eccentrics whose artefacts are usually pushed to the folk-art-and-decorating margins of critical discussion. Viewed, however, in the light of our approaching millennium and our uncertainty about what to put in the

Dome, these 'Products of Intelligence and Diligence' might seem to offer a useful, even humbling, hint.[104]

The exhibition was heavily featured in the lifestyle magazines including an article in *The Mail on Sunday*, which examined the exhibition in terms of six different categories and stated that:

> Authentic reproductions of the original cherry oval boxes cost three times as much as this little trio. Normally the oval boxes are in unpainted woods, but this cobalt blue was used on window frames. The long tapering fingers are primarily to prevent the bent wood from splitting, but the functional often ends up being decorative too. Mini Shaker-style trio, handmade from juniper wood and painted cobalt blue, £19.95 (plus £2.50 p&p), from Lakeland Limited shops.[105]

The Barbican's exhibition did not attempt to recreate roomscapes in the manner of the other British venue at The American Museum at Bath, but rather grouped objects by theme or type. This meant that the artefacts were given space to be viewed in isolation and were not placed in room settings of questionable authenticity. If we now turn to the other British venue for the exhibition, The American Museum, we can appreciate how a very different type of exhibition could be created using essentially the same artefacts.

The Art of Craftsmanship Travels to the United Kingdom – The American Museum in Britain at Bath, 1998

The American Museum at Bath is Britain's only permanent Shaker collection containing as it does a Shaker period room in the main house. The exhibition ran from 16 May to 18 October[106] and was supported by the Richard Lounsbury Foundation, Inc. and the Cranshaw Corporation. The addition of the touring exhibition from the United States enabled the Museum to highlight its Shaker collection and bring it to the attention of a wider non-metropolitan audience. Like the Barbican, the American Museum encompassed both talks and workshops including 'How to Make a Shaker Box' with a demonstration by Tony Butler and Valerie Knowles and several tours and talks by Brother Arnold Hadd, including the Dallas Pratt lecture.[107] However, the change of emphasis placed upon the touring

Selling Shaker

exhibition material meant that a rather different exhibition was created from that which appeared at the Barbican Art Gallery in London, including sections on geography, space, setting and Shaker philosophy.[108]

The *Newsletter* published by The American Museum in February 1998 gave some indication of the importance the Shaker exhibition held in that year's programme when it announced in the forthcoming events section: 'This major international touring exhibition will dominate the 1998 season at the American Museum ... Nearly 100 objects exemplifying the Shaker virtues of simplicity, utility, order and fine craftsmanship will be exhibited, some within room settings such as a parlour, a bedroom and a meeting-house/school-house.' It goes on to discuss the logistics of the exhibition:

> In terms of size this year's special New Gallery exhibition Shaker: the Art of Craftsmanship was the largest we have ever put on. We knew that there were going to be some extra-large exhibits coming our way and so scale drawings and plans had been very much in evidence since last year. Even the logistics of getting the crates in through various New Gallery entrances were quite daunting. However, things had been so well planned by curator Judith Elsdon that when the trucks arrived with the huge crates everything proceeded very smoothly.[109]

The most striking difference between the Barbican and The American Museum's approach can be seen in the latter's decision to use room settings as the format for the exhibition. The change of format was unsurprising since much of the Museum's permanent collection is presented in period room settings.[110] Additional material to the Mount Lebanon artefacts was included on loan from the John Judkyn Memorial collections, together with other pieces from the Museum's collection. However, where the shift in emphasis is most apparent is in the concentration upon Shaker life, as the gallery guide notes:

> This exhibition is drawn from the Mount Lebanon Shaker Collection and shows examples of furniture and other decorative arts from what was the oldest and most influential Shaker community. With an emphasis on key aspects of Shaker life – religion, communalism and labour – the display is arranged to show not only the beauty of Shaker-made objects but also their meaning in the daily lives of the Shakers. The original exhibition was organised by Art Services International, Alexandria, Virginia and has

West and East

travelled to 10 cities in the United States and the Barbican Art Gallery in London.[111]

The gallery plan was subdivided into areas including 'Work & Trade'; 'Communal Furniture'; 'Boxes and Baskets'; and 'Chair Industry', with room recreations including sitting room, retiring room, sisters' workroom and school room. In some museum literature the exhibition design was explained:

> He [George Carter the exhibition designer] has arranged the exhibits so that a large proportion of them are contained in 'rooms' reflecting some of the important aspects of Shaker life. In the centre there is a three-sided sitting room, reminiscent of our own Shaker Room; behind is a retiring room with a simple bedstead and, to the right, a sister's workroom containing sewing tables and a loom; school-room and meetinghouse furniture are combined along one wall, on which hangs an evocative alphabet board.[112]

The guide attempted to provide a contextual basis for the rooms, including notes on design. The decision was taken to install various artefacts from the Mount Lebanon collection in the 'sitting room', including a kindling box, dustpan, broom, tongs, stove, mirror stand, tripod stand, rocking chair, case of drawers and rug. Whilst this worked well as an educational tool, it was not a truthful recreation of a Shaker room-setting and as such was an arrangement that harked back more to the Andrewses' aesthetic, rather than fitting into a modern museological desire for authenticity. As the guide noted:

> The Shakers lived in dormitory-like buildings, called Dwelling Houses, accommodating, in the mid-nineteenth century, 50 to 100 members. The house was divided in half with separate entrances, stairs and bedrooms, in keeping with the celibate way of life. They spent most of their time in the workshops but in the evenings the Brothers and Sisters often held Union Meetings in a retiring room, in groups of 10 to 12 with equal numbers of each sex and of varied ages. They would discuss community issues and sing songs. Members would bring their own chairs to be set in lines facing each other, genders separated by about five feet. Later in the century, as membership declined, unused retiring rooms started to be used as sitting rooms.[113]

Like the main catalogue the guide provided information on the Shakers'

production and included material on spirituality: 'Shakers are probably best known today for the objects they made. Some of the wide recognition of Shaker design stems from active furniture workshops and salerooms that they operated in the late nineteenth and early twentieth centuries. Yet it is the humble objects made for personal use that most clearly embody the Shaker approach to spirituality and "plain and simple" living.'[114]

After Bath the Art Services International material had finished its residency in the United Kingdom and travelled back to the United States and the Renwick Gallery, Washington. Undoubtedly the transportation of this material to the United Kingdom had a major effect on the way the Shakers' material products were viewed by people who could not easily visit original sites. The exhibitions not only created an institutional focus, but were also responsible for numerous articles in the press and other media coverage. This increased visibility of the Shaker aesthetic made it easier for companies in the United Kingdom to promote and sell their Shaker-styled products.[115]

The Art of Craftsmanship Travels in the United States – Renwick Gallery, Smithsonian Institute, Washington, 1999

After leaving Bath, England, the exhibition returned to America to the Renwick Gallery (part of the Smithsonian Museum, Washington) where it was much altered. Re-titled 'Shaker Furnishings for a Simple Life' it ran from 19 March to 25 July 1999. In the advance publicity it stated: 'Furniture and other objects made by the Shakers reflected their religious belief in "plain and simple" living. These chairs, tables, desks, cupboards, dressers, clothing and tools from the Mount Lebanon village, New York, are from the collection of Ken Hakuta.'[116]

Unusually the gallery felt it unnecessary to provide any supplementary literature, although there were text boards on the walls which served as explanation for the exhibits.[117] The main gallery was subdivided into sections with the exhibits located along the walls and divided into various areas of interest including 'Fancy goods', 'Seeds etc.', 'Schooling', 'Meeting room', 'Workshops', 'Textiles' and 'Chairs'. The introductory text board stated that:

> The Shakers were perfectionists – since labour was viewed as a sacred duty, even the humblest object had to be made perfectly. It also had to be thoroughly utilitarian. Indeed from a Shaker standpoint the beauty of an object was revealed in its functional perfection – not its artistic appeal.[118]

An unusual aspect of this version of the exhibition was the creation of a period room in an ante-gallery, the room being blocked off from the public with viewing from one side only. The room was based on a 'typical' Shaker retiring room and included large pieces such as a stove, bed, case of drawers, tripod stand with drawer and a rocking chair, together with smaller items such as a dustpan, mirror stand, rug, motto, kindling box, broom, iron tools, bonnet and dress, with the dates of the artefacts ranging from 1830 to 1890.

The exhibition was a restrained and rather low-key affair compared with some of the other venues on the tour and, whilst merchandising was limited, the gallery shop offered the usual range of books etc. and boxes by Jefferson Woodwork.[119] The film by Ken Burns, *The Shakers: Hands to Work, Hearts to God*,[120] was shown alongside the main exhibition together with a gallery talk by Jeremy Adamson entitled 'Shaker and the Furnishings of a Simple Life'. The Renwick Gallery, like a number of others in America, has been responsible for promoting the work of the Shakers by placing their artefacts in important gallery settings. The exhibition in the 1990s was not quite as spectacular as that which was featured in the last section, but nevertheless gave gravitas to the Shaker aesthetic being shown in America's capital city and within the Smithsonian Institution.

Sabbathday Lake – The Last Community – a Few Remaining Shakers

Arguably one of the most influential articles written about the Shakers to appear in the general press in the last 20 years is a piece entitled 'The Shakers' Brief Eternity' by Cathy Newman and Sam Abell, published in the *National Geographic* in 1989.[121] The text was accompanied by colour photographs illustrating various community villages (some extant) including Sabbathday Lake. It stated:

> The final amen has yet to be murmured; those left remind us that they are not dead yet. But nostalgia intrudes. We see them as if looking through a

stereopticon from an attic trunk. The reality is granite tough. Shakerism is religion, demanding, uncompromising. As a tenet of faith, Shakers are celibate; their life, communal. Who would accept such sacrifice? Those who had heard the trumpets of salvation. 'I found perfect heaven,' wrote one convert. In a glorious, if impossible, quest the Shakers committed themselves to perfection. Like other utopians, they wanted to create heaven on earth. But the dream dangled just beyond reach, a reminder that, like all mankind, they were only human.[122]

The article goes on to discuss the community at Hancock, along with the contributions of Sprigg and Andrews to Shaker scholarship:

In the brick dwelling-house attic at the Hancock Shaker Village in Pittsfield, curator June Sprigg reached up and twisted a slim peg out of the board circumscribing the room. A Shaker emblem of order might well be such a pegboard; nearly every room had one. From it chairs and clocks hung out of the way. The peg's hand-turned threads, extra work for the craftsman, ensured it would bear the weight of a small cupboard without pulling out. Such hidden details marks Shaker craftsmanship. Its elegant, unstudied simplicity becomes a statement of belief. Shaker scholar Edward Deming Andrews called it *Religion in Wood* ... Impressed by the excellence of the Shakers' goods, the world became their customer. They sold, among other things, chairs, baskets, hats, hides, seeds, apples, pickles, candies, preserves, herbs and brooms. The passion for perfection extended to anything their hands touched. 'Even their soil was perfect,' Amy Bess Miller remembers. 'Not a rock or pebble in it.' Work was a consecration. 'Put your hands to work, and your hearts to God,' Mother Ann said. But the result was not meant to be an icon. A bench was to sit on. A table to eat on. Does heaven have chairs?[123]

The *National Geographic* discussed much the same themes as the BBC's *Timewatch*,[124] both featuring an auction of Shaker furniture by Willis Henry and drawing attention to the increasing commercialisation of the Shakers; the uncomfortable juxtaposition of such 'worldly' concerns, with the poignancy of the dwindling Shaker communities:

The $80,000 chair sets a record for Shaker furniture sold at auction. The buyer, 23-year-old David Schorsch, a New York City dealer, bought it, he said, because he'd always wanted one. (The record has fallen more than once since then: last March a candle stand sold for $140,000.) 'Think of all

the people that money would feed,' says Sister Frances Carr of Sabbathday Lake when told of the $80,000 Shaker chair.[125]

The Smithsonian magazine highlighted this concern and featured a few of the remaining Shakers including Brother Arnold Hadd,[126] Sister Francis Carr[127] and Brother Wayne Smith. The structure of their community is examined:

> Besides farming, the community supports itself as Shakers always have: with this and that. For instance, the Shakers turned unused buildings into a museum. Now 6,000 visitors each year tour this isolated Maine community located north of Portland and south of Lewiston and Auburn. 'I'm the printer, and we earn a little selling publications, and also our jams and jellies and pickles and yarns,' Brother Arnold says. They market herbs as well. But many Shaker industries have dwindled away.[128]

Sister Francis Carr has been consistent in her promotion of the community and like Brother Arnold Hadd acts with great dignity. She has been responsible for a number of prophetic statements in the Timewatch documentary:

> There was a Shaker auction last week I understand that it reached the million dollar mark which is a lot of money. It's always difficult for the Shakers to be aware of these auctions that are bringing such prices for things that were made by the Shakers and of course it goes against Shaker principles to have such things commercialised so much. I think that you all heard the expression 'God writes straight with crooked lines'. I think this was demonstrated at the auction when a helper at the auction made the comment that someone said 'It always rains when we have these auctions' and the man looked up at the sky and said 'It's the old Shakers crying'.[129]

In addition, an article entitled 'A Life in the Day of' in the Sunday Times Magazine featured Sister Frances Carr as an example of one of the last remaining Shakers. The article states:

> All seven of us in our community live in the dwelling house, where there are separate staircases for the brothers and sisters. At 7.30am the large bell rings and everyone knows they have 10 minutes to come to table. Shaker cooking is basically plain, wholesome food, and before eating we have silent grace. The brothers and sisters sit quite separately at their own tables, but if we have visitors we'll bring the tables closer together, so we can all join in the conversation ... There's great interest in Shakers today:

Selling Shaker

I'm quite accustomed to Shaker furniture being fashionable. We think it's beautiful and glad others do too, but we don't really care for the over-commercialisation.[130]

By virtue of the fact that it is the last surviving Shaker community, Sabbathday Lake has received a good deal of media attention and has featured in numerous television, radio and press articles. Many of these seek to trivialise the community, treating it as something like a cross between a zoo and a fashion-lifestyle spread, as in 'No Sex Please We're Shakers' from *The Guardian Weekend*:

> No sex please, we're Shakers – and it shows. Once an eighteenth-century, thriving cult from Manchester, based on worship and communal living, they have been reduced to eight people in America's north-east state of Maine. Their remaining reputation is worldly – unique and expensive furniture. Henrietta Butler recorded them on film. Dina Rabinovitch tells their story.[131]

The article continues by noting:

> The shockingly rich do DIY differently from you and I. For a start, they pay for it. A line of the crocodile-heeled queued all the way down Harcourt Street in Marylebone last month displaying the up-market version of mobbing IKEA. Just what do the wealthy young want that badly this summer? Their aim was a small shop outlined in distinctive blue-green paint the colour of the Atlantic on a good day. Overhead an American flag hung gravely in the still air. The Shaker Shop was having its once-yearly, invitation only, sale. Inside for a hefty sum, you could buy flat-pack furniture to take home and assemble yourself ... Even those in the queue who realise that the furniture is – yuck – reproduction, are not put off, so powerfully has design hype exalted the name Shaker. In fact, the last genuine Shaker chair was made in the 1940s, but if you think reconstructed Shaker is dear, you should know that only super-billionaires like Bill Cosby consider bidding for the real stuff...[132]

Many of the articles featuring Sabbathday Lake illustrate the dilemma the remaining Shakers face with regard to dealing with the press and general public. Whilst naturally eager to promote their religion and lifestyle in order to attract converts, by doing so they risk courting crass publicity of which these articles are by no means the worst examples. In almost every

request for an interview, the Shakers at Sabbathday Lake are asked questions about their furniture and design philosophy rather than their religious beliefs. To some extent the present-day Shakers have resigned themselves to this and have sought to take the initiative and gain back some control by participating in exhibition tours that aim to lend some balance between the material and religious aspects of their lives. For example, Brother Arnold gave an interview to Robert Hughes for *American Visions*[133] and participated in the education programmes at both the Barbican and American Museum in Britain during the 'Shaker: The Art of Craftsmanship' exhibition tour.[134] This pragmatic approach appears on the whole the best way forward. It seems inevitable that, in the minds of the general public, the Shakers will be largely remembered for their design heritage rather than for their religious beliefs, and whilst it could be argued that if the Shakers do not wish this to be the case then they should not become involved in events that concentrate on their material culture, to do so would be naive. It would appear that one of the main concerns for people who visit Sabbathday Lake is the furniture and its production, or rather the lack of any manufacturing base. Sadly it would seem that the contemporary fixtures and fittings within the community buildings are no longer made by the Shakers. They have simply become part of the world.

The Quiet in the Land Exhibition – Institute of Contemporary Art in Boston, 1998

This exhibition, entitled the 'The Quiet in the Land – Everyday Life, Contemporary Art and the Shakers', was originally staged at Sabbathday Lake, Maine from 29 May to 31 August 1996,[135] before moving to The Institute of Contemporary Art, Boston, where it was held from 10 June to 27 September 1998.[136] Both venues shared similar publicity material – designed by Sahmeister Inc. – with the exception of a change of some of the illustrations. The exhibition, conceived by France Morin, is unusual in that it featured art produced in collaboration with an extant Shaker community and consequently received a good deal of publicity.[137] The Shakers involved in the project included Sister Frances Carr, Sister Marie Burgess, Sister June Carpenter, Sister Minnie Greene, Brother Arnold Hadd, Brother Wayne Smith and Brother Alistair Bate, whilst the artists

were Janine Antoni, Domenico de Clario, Adam Fuss, Mona Hatoum, Sam Samore, Jana Sterbak, Kazuni Tanaka, Wolfgang Tillmans, Nari Ward and Chen Zhen.

The exhibition can be seen as part of a trend in museology in which contemporary artists work in unfamiliar contexts.[138] For example, Mona Hatoum, an artist who works primarily in Britain on performance, video and installations, applied these contemporary media to her short residency at Sabbathday Lake.[139] As the article by Kay Larson in *The New York Times* states:

> Last summer, the artist Mona Hatoum gave a tour of the dark Shaker attic in Sabbathday Lake, Me., that had been her studio for a month. In it were fragile, small things. Green and yellow noodles had been woven together into a swatch of edible homespun. Dots of shimmering jelly gathered web-like on a tiny window, the result of squeezing Vaseline through the holes in an old metal pie plate. A sifting of powdered sugar over the springs of a wooden baby's crib left delicate diamond shadows on the white filmed floorboards; vanished childhood limned in pixie dust Ms Hatoum's sweet, simple powder outlined an old ethos of nurture – a glimpse of disappearing farm life centred on living things. Vanishing like the Shakers themselves, one might say, although the remaining seven men and women who live here and still practise the faith pray otherwise. Ms Hatoum and nine other artists spent a month each at the Shaker farm between May and September of last year ...[140]

Speaking about the experience of her residency, Hatoum noted that:

> I am a performance, video and installation artist. I wanted to participate in a community that had set itself apart from the world. It appealed to me to retire from the world for awhile, to forget about art and especially the art world. I think France invited me because my work deals with everyday life. For example, I often use furniture as a reference to everyday objects ... We collaborated on very ordinary things like painting the fence or packing herbs. In my case, I spent most of my time packing herbs in the herb room. Or working on the oval boxes. And then once a week the artists would cook. That was a kind of collaboration. But not in terms of our work. I did not see my work as being a collaboration.[141]

The exhibition was extensively reviewed in the local, national and specialist

press. *The Boston Globe*, in an article entitled 'Maine's "Quiet in the Land" Plumbs Art of Shaker Life', noted that:

> But is art not a prayer? That's the question brought up by 'The Quiet in the Land', an exhibition of works inspired by the Shaker experience at the Institute of Contemporary Art at the Maine College of Art in Portland, curated by France Morin. For four months, artists of international renown such as Janine Antoni, Domenico de Clario, Wolfgang Tillmans and Chen Zhen lived and worked alongside the Shakers. They rose early and spent the morning at work with the Shakers. The afternoon was reserved for pursuing art. They attended prayer services, dinners and community meetings with the Shakers. Artists and Shakers alike, it seems, discovered that they had more in common than they anticipated.[142]

The Boston exhibition had a number of ancillary events including a lecture by Gerald C. Wertkin, together with guided tours and a symposium. Brother Arnold Hadd was closely involved in the project and was described in *The Village Voice* as: 'Brother Arnold, 41, has been a Shaker for some 20 years. His thin, bearded face and strong features seem almost Puritan, but his manner is modern and frank.' The Shaker community were, it seems, completely integrated into the project and the article goes on to state that 'At the symposium, he [Brother Arnold] spoke with wonder of the seamless expansion of his small community. "They slipped on our lives like a garment," he said of the artists. "There was only one moment of discomfort: when I realised they were gone." Brother Arnold's perspective on contemporary art has radically altered. "I love these works," he said. "I understand them."'[143] The review continued by discussing some of the issues the exhibition addressed with reference to the work of Adam Fuss:

> The Shakers are still industrious, but their real work, Adam Fuss explains to me, is the inner labour of spiritual transformation through living in community and loving others. We're standing in the Institute of Contemporary Art's new gallery, where three thin ladders that Fuss cut from white silk (and based on the form of actual Shaker ladders) are hanging on white walls. They're an image of manual labour transfigured and of spiritual ascension. The white on white is purposely ethereal. 'It's like one's experience with trying to love,' Fuss says. 'You see it or miss it from different angles.'[144]

The exhibition was also reviewed in the art press including *Art Journal* and also *World Art*, who noted that:

> In Maine, in America's north-east, the six members of the only active Shaker community, at Sabbathday Lake, dedicate themselves to craft, worship and self-sufficiency as they have since 'Mother' Ann Lee arrived from England in 1774. Their religiosity, with its celibate lifestyle, worship of a dual deity and history of divine glossolalia, has attracted attention as an anthropological curiosity. Their craftsmanship, with its almost Bauhaus purity, has also brought them wide public attention through its incorporation into mainstream interior design.[145]

The article examined the relationships that developed between the artists and the Shakers as well as investigating the artists' motivations via sound recordings, paintings, sculptural installations, video and photographs produced during their residencies. France Morin (with contributions/interpretations from Janet A. Kaplan) noted that:

> 'The Quiet in the Land' sought to probe conventional notions of gender, work and spirituality, to redefine the making and experiencing of art, and to challenge the widespread belief that art and life exist in separate realms ... Its point of departure and inspiration was the Shakers ... It was a unique encounter; each group, each individual, travelled a great distance in an effort to understand the other. The space that was created and shared between them through these attempts is as important a component of 'The Quiet in the Land' project as the art-work in the exhibition. The Japanese word *ma* connotes this space between, this interval of fullness and harmony; although it is a concept with endlessly subtle associations ...[146]

The 'space' shared by the artists and the Shakers explored in the exhibition produced as many points of departure as contact and whilst the two 'groups' became close during the period they spent together, just how much insight the artists gained into the Shaker ethos is questionable given that one of the main objectives in the collaborative experiment was to seek to understand the relationships which exist between gender, labour and spirituality. Interestingly, given that it is so often cited as the quintessential Shaker design quality, functionalism was not a prime motivation for any of the artists. Rather they were drawn to the more abstract and conceptual aspects of the Shaker religion. It could therefore be argued that the artists

were only seeing half the Shaker philosophy, given that the Shakers themselves view the integrated relationship between labour (i.e. functionalism), spirituality and conceptualism as central to their ethos. What is true is that the exhibition, or rather the series of exhibitions, produced as a result of the collaboration, formed part of an evolution in museology that has seen a move away from a design to a fine-art-based interpretation of the Shaker aesthetic. Further exhibitions have sought to use Shaker design to understand and interpret contemporary art production and this is seen in the beautifully produced catalogue for an exhibition at the Tang Teaching Museum and Art Gallery at Skidmore College, USA.[147]

Shaker Gifts, Shaker Genius – Paine Webber Gallery – New York City – 1999 and Seattle – 2000

Entitled 'Shaker Gifts, Shaker Genius' this exhibition was staged at the prestigious Paine Webber building in New York City from 22 January to 2 April 1999 and was widely reviewed in both the local and national press including *The New York Times* who announced under the headline 'Busy Shaker Hands Moved by the Spirit' that:

> Out of all proportion to their tiny numbers, the Shakers (aka the United Society of Believers in Christ's Second Appearing) left an amazing artistic legacy. For sheer simple elegance, nothing matched the chairs, cupboards, wardrobes, tables, boxes, baskets and other handicrafts they turned out, works whose grace and harmony of design is today admired worldwide ... With nearly 400 objects on view – rocking chairs, oval boxes, bonnets, cloaks, washstands, woodworking tools, religious paraphernalia, song sheets, documents, visionary drawings, maps, historical prints, photographs and even a Shaker fire engine, made in 1822 – 'Shaker Gifts, Shaker Genius' gives an unusually rounded picture of this beehive sect. Chosen and arranged by Erin M. Budis, curator of the Shaker Museum and Library in Old Chatham, NY, the exhibits all come from the museum's extensive collection ... But the Shaker accomplishments remain as a bright chapter in American folk history ... They liven up even the pompous, unaccommodating lobby space at Paine Webber that serves as their gallery.[148]

Meanwhile, the *New Jersey Courier News* stated that:

Among the most unusual items – a rarely displayed 650-pound fountain stone that was used in outdoor worship in the 1840s by the Shaker community in Canterbury, NH. These are just a fraction of the museum's holdings, some 38,000 items, which reflect Williams' anthropological approach and fascination with tools and ephemera of all kinds.[149]

Amongst the specialist press *The Magazine Antiques* published an article entitled 'Shaker in a Skyscraper' which claimed:

> One of the most encyclopaedic collections of Shaker artefacts is housed at the Shaker Museum and Library in Old Chatham, New York. It is largely the legacy of John S. Williams Sr, an early collector whose mission was to acquire objects that reflect the astonishing breadth of Shaker craftsmanship and culture. He was so assiduous that when he turned his collection into a museum and opened it to the public in 1950, one journalist described it as ranging from 'a needle to a four-ton trip hammer'. A portion of the museum's holdings – some 18,500 objects – has been moved from the bucolic rural setting in Old Chatham to a streamlined urban one at the Paine Webber Art Gallery in New York City.[150]

Staged within the Paine Webber skyscraper atrium, the exhibition included small-scale to very large objects such as a stone fountain, and was arranged under two major thematic strands. In total the exhibition consisted of nine sections – 'The Shakers'; 'History of the Shaker Museum and Library'; 'The Shaker Chair'; 'Shaker Commerce and Industry'; 'The Division of Labour: Shaker Brother and Sisters'; 'Biographical Portraits: Exploring Shaker Identity'; 'Shaker Religion and Worship'; 'Communal Living: The Organisation of Family Life'; and 'The Shakers in the Twentieth Century' – each dealing with a particular aspect of Shaker production. Whilst there wasn't an accompanying catalogue, a short leaflet was produced which helped visitors understand some of the context to the exhibition.[151] The exhibits were drawn from the collection held by the Shaker Museum and Library at Old Chatham, New York State.[152] As the exhibition literature noted:

> Selections from the extensive holdings of the Shaker Museum and Library are presented in 'Shaker Gifts, Shaker Genius'. The exhibition explores two themes of the Shaker experience – the 'gifts' they received through spiritual revelation, and the inspired genius that found expression in the furniture, dress, music and products they created. The collections of the Shaker

Museum and Library were described by the founder, John S. Williams Sr, as 'the product of Shaker genius'. His phrase captures the Shakers' ability to harness the creative talents of the individual for the greater good of the entire community. From the early years of their experiment, Shakers have been conversant with the spiritual world. The divine messages or gifts the Believers received reinforced the spiritual life as their primary focus. The exhibition illuminates both areas of Shaker activity, presenting religious objects and documents, historical prints and photographs, as well as objects associated with their everyday life and work, many of which are now popular icons of Shaker design.[153]

The exhibition was extremely comprehensive displaying artefacts – including clothing, spirit drawings and tools together with material such as fancy poplar ware and Victorianised artefacts which had previously been marginalised by exhibition organisers – drawn from a variety of Shaker communities and every period of production. The exhibition sought to provide a 'truthful' picture of the Shakers and Shakerism. However, in attempting to achieve this aim the exhibition could be criticised for attempting to bring too much material together, although it must be said it worked well within the space of the New York venue. In keeping with the growing interest in examining the history of the Shakers in the twentieth century by placing the remaining communities in a broader social and economic context, the exhibition literature stated that:

By the early 20th century after more than one hundred years in existence, Shakerism was in decline. The number of members, especially men, had dramatically decreased, leaving a predominantly female workforce. Along with these demographic changes, the economic structure of the community itself was transformed as the cottage industries that dominated the financial life of the Shakers during the first half of the 19th century had trouble competing with industrial manufacturers and an expanding market economy. American culture too underwent an ideological transition as religion had less control over people's lives and a more secular outlook pervaded society. As the economic base shifted from agriculture to industry, the Shakers purchased more of their goods from the outside world. To earn revenue, Shaker Sisters produced fancy goods, knitted items, cloaks, dolls and food stuffs sold through catalogues and Shaker stores, and directed at the growing tourist trade. Shaker Brothers peddled

these fancy articles first by wagon, and later by car, to seacoast towns and vacation resorts, foregoing the traditional general stores and agricultural warehouses. Although many of the products were useful, most were inexpensive souvenirs and mementos targeted at female tourists.[154]

This statement is particularly interesting in that it acknowledges the fact that the Shakers produced souvenirs and mementos for a growing tourist industry, items which were quite unlike anything they produced for their own consumption. The fact that the exhibition organisers had access to the comprehensive collections at The Shaker Museum and Library, formed by John S. Williams, Sr, allowed for what might arguably be seen as the most wide-ranging and 'truthful' account of Shaker life, gathered in exhibition form, to date.

The exhibition was reformatted and travelled to Seattle where it was retitled 'Creating Perfection: Shaker Objects and Their Affinities' and ran from 5 October 2000 to 28 April 2001. The exhibition literature advertised: 'More than 150 examples of Shaker furniture, textiles, tools, and craft machinery, and an opportunity to compare the Shakers with their American contemporaries as well as modern minimal art.'[155] The Program Guide describes the exhibition as exploring:

> ... Shaker creativity by juxtaposing it with two related American artistic traditions. The first features the type of non-Shaker art made around 1800 in the neoclassical style from which the Shakers drew inspiration. This section of the exhibition includes silver, furniture, paintings, costumes and textiles. The second establishes a link between the Shaker aesthetic and a subgroup of contemporary art made after 1950 ...[156]

John Kirk[157] both wrote the exhibition catalogue and delivered the opening lecture which formed part of the accompanying educational series (other speakers included Julie Nicoletta, Susan Buck and Trevor Fairbrother).[158] In an innovative move in terms of Shaker exhibitions, the Seattle Art Museum also provided a programme of Shaker music which ran alongside the main exhibition, a move which can be seen as part of the ongoing process of moving Shaker interpretation away from a traditional design to a fine art arena. This, as we have already seen, was part of a continuing process of which John Kirk was a prime mover. We can only speculate as to whether this was motivated by a desire to investigate

the Shakers from a new and fresh angle, or whether it had a narrower aim of justifying the Shaker aesthetic in terms of a 'purer', more intellectually acceptable, 'high art' viewpoint, in much the same manner as was seen in the early years of the twentieth century; perhaps a strictly design-led exhibition would never have been shown at Seattle Art Museum. Whilst it might be argued that it can only be a good thing to broaden the audience for the Shaker aesthetic, from a design historian's viewpoint it is a retrograde step to interpret the material in too strict a fine art manner, distorting as it does the 'authenticity' of the material, given that the Shakers' intention was always to produce objects whose beauty could be evaluated by their functionality.

A Shaker Legacy: The Shaker Collection at the New York State Museum, Albany – 2000

The exhibition at the New York State Museum at Albany was shown first from 5 November 1999 to 2 January 2000 and an encore – accessible via the Internet – was produced from 29 July to 22 October 2000.[159] The appearance on the Internet as a virtual tour is significant not only for its use of a new medium, but also because it celebrated the historic role the State Museum played in the early Shaker exhibitions from the 1930s and 1980s. The promotional material that accompanied the exhibition stated that: 'The New York State Museum has perhaps the largest collection of Shaker objects owned by any museum. In fact, Shakers themselves helped curators develop this collection during the early part of the twentieth century. This exhibit will display more than 200 artefacts from this important collection.'[160] The exhibition also included photographic illustrations, directional maps and explanatory text – in total 20 views were featured. The catalogue acknowledged the debt owed to the pioneers of Shaker scholarship in the preservation of the Shaker legacy:

> The current exhibition, 'A Shaker Legacy', examines and honours previous efforts in the preservation and interpretation of Shaker material culture. Although the Watervliet and Mt Lebanon Shakers are gone, the foresight of Dr Charles C. Adams, William Winter, Edward D. and Faith Andrews, and the Shakers themselves has enabled their legacy to live on at the New York State Museum.[161]

In addition, the text in the small free catalogue also pays tribute to a number of Shakers in this respect:

> Eldress Anna Case of Watervliet was instrumental in helping the Museum build its collection, as was Sister Jennie Wells, who had come to Watervliet from Groveland in 1892. Eldress Rosetta Stephens and Eldress Ella Winship of Mt Lebanon were also very helpful in this endeavour. Sister Winship had also come from the Groveland Community, and she and Sister Wells provided the documentation for the Groveland artefacts acquired from Watervliet during these years. Other helpful Shakers were Sister Alice Smith of Hancock, Sister Lillian Barlow of Mt Lebanon, Sister Aida Elam of Canterbury, New Hampshire, and (natural sisters) Eldress Emma and Sister Sadie Neale of Mt Lebanon.[162]

In the later section the story of the legacy is brought up to date with details of developments including the Groveland Shakers Fountain Stone from the Craig Development Centre, together with material such as grave markers and home movies.

The exhibition featured various aspects of the Shakers' output including herb and seed manufacture, textile production, furniture production and basketry. An annotation taken from Exhibit View Sixteen states: 'Everything the Shakers made was the end product of the creative process that converted raw materials into finished goods through the application of energy and ingenuity. To understand how industry transformed resources into merchandise, it is important to have the product, the tools and the raw materials.'[163]

The guide for the virtual exhibition on the Internet included photographs from the 1930s to the 1980s, enabling a comparison between exhibition design styles. The previous exhibitions were far more cluttered and crammed in style,[164] whilst the 1999/2000 exhibition took a more minimalist approach, with a selected number of objects being exhibited on both low and high plinths. The exhibition's styling was based on modern theories of exhibition design in which objects are given the opportunity to 'speak for themselves', and to this end the colour palette is restrained, with plain walls in subdued colours. The exhibition was placed within a large space, subdivided into smaller sections with partition walls. In addition, a number of visuals and annotation boards were included. In

some of the exhibits large-scale furniture pieces are included with chests, spinning wheels and a low walnut chest. One of the annotations to Exhibit View Fourteen notes that: 'This low walnut chest was made for use in the Groveland community, Livingstone County, and is similar to the furniture made by non-Shakers. It reminds us that we should not stereotype Shaker material culture based on what we see in some museum collections.'[165]

The 'Shaker Legacy' exhibition provided a suitable finale to the series of exhibitions in which the New York State Museum was involved, each of which in their way reflected the changing emphasis in interpretation and communication of the Shaker aesthetic and lifestyle as seen through their artefacts. Partly due to the body of exhibitions staged throughout the United States and elsewhere in the preceding years, the knowledge of Shakerism amongst the general public has increased enormously: the audience has moved from being that of a coterie of collectors and academics into the mainstream and now, with the addition of a presence on the Internet via the virtual tour, has become truly worldwide. Whilst this increased interest has brought many benefits, there have also been significant drawbacks,[166] not least in the bastardization of the Shaker aesthetic by numerous commercial copies, an area to which we will now turn our attention.

Infiltration of Shaker Design into Popular Culture

The late 1990s saw an increasing infiltration of Shaker-styled furniture onto the British high street with Shaker-inspired ranges appearing in the Argos[167] and Index catalogues,[168] Marks and Spencer,[169] Habitat[170] and IKEA,[171] together with the more exclusive Heal's and The Conran Shop.[172] There was also an increase in the number of companies who specialise in selling Shaker products, often via mail order or the Internet, for example AB Woodworking,[173] The Shaker Furniture Company[174] and The Shaker Kitchen and Furniture Workshop.[175] As evidenced by the number of magazine articles and television programmes featuring the Shaker style, by the end of the 1990s Shaker had become fashionable.[176]

Original Shaker artefacts had become increasingly rare by the 1990s, with the majority of the best pieces held in museum collections. Items that did appear at auction including visual material[177] and furniture[178] would often fetch enormous prices way beyond their reserve. For example, a rare

Selling Shaker

three-drawer blanket box auctioned in 1996 sold for $140,000, when its reserve price had been $30,000–50,000.[179] These prices have continued to be documented in the sale catalogues of Willis Henry, Skinner and Northeast Auctions (see Bourgeault).

The market and interest in original Shaker material was covered by the likes of the journal *The Shaker Messenger* – having changed its name to *Shakers World* in 1996[180] – together with the new medium of the Internet[181] where numerous sites provide all manner of information for both the specialist and non-specialist alike. The greatest growth area of Shaker interest was in the wider media and amongst a general public in both North America and Europe, whose tastes had come around to an appreciation of Shaker simplicity by the early 1990s via the availability of both high-quality reproductions together with cheaper mass-produced high street items.

An example of this media interest can be seen in a 1992 American advert, by the firm of DuPont for its Stainmaster Luxura carpets. It featured a typical Shaker interior and the copy read 'How to Show Proper Respect to Your Resident Shakers'. Similarly, in the early 1990s in the United Kingdom, Dulux and a number of other paint companies used Shaker styling in their promotional campaigns.[182] Less overt references to Shaker influences can also be detected in a range of clothes known as 'Santa Fe', designed by Design Studio for manufacture by Marks and Spencer plc, which took inspiration from Shaker spirit drawings and textiles.[183]

Numerous companies have incorporated Shaker styling into their products such as Jonathan Avery Design who have produced MDF Shaker-style furniture, whilst The Cotswold Company has a Shaker shelf and The Art Room has produced a Shaker-inspired range including ceramics, pictures and oval boxes. Major United Kingdom retail companies such as Boots the Chemist created a 'Monogram Shaker Box' and also a 'Home Warming Gift Set',[184] while the charity Oxfam sold Shaker-style boxes which did not bear any relationship to Shaker design, the boxes being octagonal, a form the Shakers rarely used. Lakeland Plastics produced a number of boxes in its storage ranges, including cobalt blue 'Mini Shaker Style Trio' and a natural round box stack. Such has been the growth in the production of 'Shaker boxes' by all sections of the retail market that it has become the iconic symbol of the Shaker boom in the mass market interest and as such it deserves closer attention.

The oval form of the Shaker box has become inextricably associated with Shaker style among the general public, if not with the Shakers themselves,[185] and has featured in many of the exhibitions discussed in the course of this book.[186] The iconic status of the oval Shaker box is due in part to the apparent simplicity of its construction.[187] Although the Shakers did not invent the use of bent wood in an oval form, they did refine the process and there is some dispute as to the precise origins of the Shaker box in terms of differentiating between those made within Shaker communities and those from outside.[188] The historical context of Shaker oval boxes was outlined in an exhibition catalogue *Shaker: the Simple Form – Outstanding Works from Chicago Collections* produced for the 1992 exhibition at Harvey Antiques. It stated:

> Oval boxes were made in many Shaker communities, although the design did not originate with them. The Shakers refined the form, producing boxes with slender fingers, thin sides, and tight-fitting lids. The sides and rims were usually made of maple, and the bottoms and tops of quarter-sawn pine. Sides and rims were soaked in hot water or steamed and when pliable, bent around forms. The fingers were fastened in place with wooden pegs and later, with copper nails ... The oval box is one of the best known, most recognisable Shaker-made forms.[189]

Oval boxes were sold individually as well as in graduated nests:

> Oval boxes usually were sold in nests of graduated sizes, the earliest consisting of 12 boxes, then nine, and the later ones of seven and five. It was not until 1833 that they were referred to as oval boxes; until then, they were called 'nests' of boxes. Boxes were made in any number of sizes to accommodate a variety of uses in the households and workshops. They were used to hold everything except water. By 1834, boxes were numbered according to size.[190]

Many examples of original Shaker boxes survive – with both plain wooden and painted finishes – in cherry, maple, pine and walnut. The colours used are varied[191] and in some cases boxes were decorated,[192] faux finished[193] and even carved.[194] In addition, the boxes also had functional inserts including a reel holder for sewing[195] and subdivisions for spices.[196] Boxes varied in size from the small to the very large, such as the one from the collection of the Shaker Museum, Old Chatham, which measures $7^1/_4$ inches

high, 23$^1/_8$ inches long and 12$^5/_8$ inches wide, and is made of maple with a pine lid and bottom.[197] The Andrews partnership also featured a section in *The Community Industries of the Shakers* on oval boxes which stated:

> No product of the Shaker wood-working shops possesses greater charm than the multi-sized oval boxes ... which were made throughout the last century, and are still made at the Second Family at Mount Lebanon and at Sabbathday Lake. All kinds of boxes for all kinds of uses were manufactured, but the oval box was a successful refinement of the more common form, and its novelty and usefulness had wide appeal.[198]

Original Shaker boxes are highly desirable and consequently there is a large market for reproductions.[199] John Wilson[200] notes:

> Oval boxes continue to be the most popular product the Shakers ever offered to the outside world. Originally produced for their practicality (nesting boxes inside each other required little storage space) and utility (almost anything and everything was stored in these durable containers), they have become collector's items for their simple beauty.[201]

A number of plates in this book have been specifically devoted to the Shaker box in all its forms.[202] There are both obvious and subtle differences in both manufacture and construction. Some have been made in unusual materials such as silver and leather, whilst others have strange overlap devices and distorted forms. Shaker box shapes have even been used in packaging, for example, Waitrose have used oval boxes to protect Easter eggs and British Home Stores (BHS) have used a cheap composite oval box as part of their 'New England Christmas' range.[203]

While the oval box has been reproduced by numerous companies as both an item for sale in itself or as a form for packaging, other companies have used Shaker inspiration in their ranges such as New Heights furniture ('Winona' range), Jane Churchill ('Small Trees' wallpaper JO46F) and Alice Gibbons Hand Made Tiles (with their fruit and trees ranges, part of The Natural History Museum Collection), all of whom manufacture products which can be used by the serious Shaker stylist. Other companies such as Ocean mail order have adapted the use of classic Shaker artefacts, in this case pegboards, to produce contemporary products such as a peg rack.

Individual makers have also entered the market in reproduction, for example, in the USA, Marty Travis makes reproductions of tin ware and

seed boxes, while in Britain makers such as David Bryant produce Shaker reproduction furniture as part of a wider range of reproduction furniture. The large high street retailers, whilst not featuring Shaker ranges to the extent they did in the mid to late 1990s, still produce some Shaker-inspired items, for example the Visdalen range by Carina Bengs featured in IKEA's 2000 catalogue, and a jelly cupboard from the English firm of Scotts of Stow, described in glowing terms as being 'traditionally used by the Shaker people to store their home-made produce and these exquisite replicas are outstanding for their superlative workmanship, being carefully crafted in the Catskill Mountains in American hardwood with a satin smooth oiled finish'.[204] Tesco Direct also featured a range of inexpensive furniture based on the Shaker aesthetic as part of their contemporary range.[205] However, it has been the Shaker Shop that has been most instrumental in the promotion of the style in the UK from their London outlet.[206] Whilst the Shaker Shop may have started the trend for Shaker-inspired artefacts in the UK, it has been the high street retailers who have been the real force in shaping the British taste for the Shaker style. In particular it was the kitchen retailers, who throughout the course of the 1990s incorporated the style into their ranges and sold large quantities of Shaker-inspired kitchens to a British public eager for a taste of the simple life, following the excesses of the 1980s.

The Shaker Kitchen and Interior Design

With the rise in home ownership in countries such as the USA and Britain in the latter years of the twentieth century, interest in interior design and do-it-yourself (DIY) increased enormously, as demonstrated by the growth in home styling magazines and DIY superstores.[207] The general public has become far more sophisticated in its awareness and knowledge of design and styling, which was once the preserve of the professional designer. As with all such design-led areas, fashion has dictated trends in the home and nowhere is this more evident than in the kitchen. The kitchen has moved from being a little regarded functional space for food preparation in the middle years of the century, to the most important room in the modern home. As the book *The Name of the Room* notes:

Whether sold down the phone at the cheapest end of the market or marketed from air-conditioned premises at a 'good' address with a pseudo-professional kitchen designer sitting on a high stool in front of a drawing board or VDU, the kitchen is one area for which women are the indisputable decision-makers and spenders. A highly lucrative market has been infinitely expanded by the subtle insinuation that your kitchen is a personal status symbol – by their kitchens shall we know them.[208]

As we have already noted, throughout the 1990s there was a significant increase in the profile of what might be termed the Shaker style in all branches of the media, ranging from the specialist press to the tabloids and cutting across all socio-economic groups.[209] This was evident not only in Britain, but also America,[210] Australia[211] and Ireland.[212] In Britain this was particularly the case during the build-up to and showing of the Barbican exhibition 'Shaker: The Art of Craftsmanship' in London.[213] For example, Katherine Bergen, in her article on the exhibition entitled 'Original Recipe for Shake and Bake', noted that:

> Since the Shakers first offered their hand-crafted goods for sale buyers have coveted them, but it is only in the last few years that prices for Shaker artefacts at auction have become astronomical. The Shaker values of simplicity, utility, order and fine craftsmanship have filtered through to the British home, especially the kitchen, the most important room in the Shaker household. Food, and the sharing of it, are central to the movement's ethic.[214]

Bergen goes on to discuss the importance of built-in storage cupboards, well-scrubbed wooden tables and shining surfaces as totems of the Shaker style:

> Several companies now provide Shaker-style furniture and kitchens. Shaker Ltd has the sole British distribution rights for the Shaker workshops in Massachusetts. Kate Spontana, a spokeswoman for the company, says its appeal has a lot to do with simplicity. 'The style is laid-back and doesn't fight with anything else. Some kitchen styles overshadow the rest of the house. The Shaker one is so simple and classic that it won't fall out of fashion.'[215]

The kitchen isn't the only room to be styled in the Shaker aesthetic – every room in the house has become a canvas for the Shaker stylist, including the

bathroom[216] and bedroom.[217] However, with the increased importance of the kitchen, retailers such as the British supermarket chain Tesco have been quick to see the potential in using the latest ideas in kitchen styling to tie in with their own product ranges. Tesco, in their *Club Card Magazine*, produced articles such as: 'Revamp your Kitchen using many Shaker devices, for example a peg rail' and recommended outlets such as the Shaker Shop and the fabric designer Ian Mankin as a source for accessories.[218] Mankin's designs, which draw inspiration from both Shaker and Scandinavian styling, are an interesting example of how many of the feature editors confuse the Shaker style with Scandinavian, such as Swedish/Danish modern[219] and IKEA.[220] Many of the articles from the 1990s used hybrid designs under the general banner of Shaker design in order to appeal to a mass audience looking to recreate the look found on their local high street.[221] For example *The Daily Mail*, in their 'Weekend Makeover Winner' article entitled 'Movers into Shakers', created a Shaker kitchen: 'Using a computer design service to get the best configuration of units, they chose a kitchen based on the classically simple furniture produced by the American Shaker sect, with contrasting birch worktops.'[222] The article featured the transformation and gave details of high street outlets for selected Shaker-styled items, including companies such as The Art Room, McCord and Magnet Kitchens (Shaker Green Kitchen).[223] Similarly, an article in *The Sunday Telegraph* stated:

> The design principles of an 18th-century sect are making a comeback in today's kitchen, says Nicole Swengley. Check fabrics, rush matting, white china tableware, baskets and beeswax candles – one of the most influential decorative looks in recent years has been the simple puritan style of the Shakers. And nowhere does it look better than in the kitchen, a fact that has not escaped manufacturers who at every level of the market have been quick to produce their own interpretations ... Not even the Shaker Shop in London, where 90 per cent of the designs are based on the sect's originals, produce a kitchen made according to Shaker design principles. Not, that is, until Liz Shirley the shop's co-owner, moved home and set her heart on one. 'I was determined to find a Shaker kitchen that truly followed the original design and construction methods,' she says. And so she commissioned a company called Plain English to make one for her. The result pleases her so much that it is now available to order through the shop.[224]

The article then quotes Tim Lamb, co-founder of the Shaker Shop and one of the most influential promoters of Shaker design in Britain: 'Shaker designs are not just about furniture but a philosophy of living, the sect's religious and social values are fundamental to the designs'.[225] Whilst the Shaker Shop did, by and large, follow the principles of Shaker design, other retailers were less 'purist' in their approach.

British television also saw a proliferation of what became known as 'transformation TV', a format largely based on home styling and DIY in which a professional designer produces a room makeover based on a design theme. Programmes such as the BBC's *Real Rooms*,[226] *Changing Rooms*[227] and *DIY SOS*[228] have all proved enormously popular with audiences, and Shaker styling has been used as a feature on all of these programmes. For example, the BBC's *Real Rooms* programme visited the 'Shaker: The Art of Craftsmanship' exhibition at the Barbican in order to gain inspiration for a kitchen makeover, in which the challenge was to make the room more spacious and simple, incorporating the Shaker style.[229] By their very nature such programmes provide only the scantest context for the ideas that underpin the Shaker style, and few examine genuine Shaker artefacts as was the case here. Whilst such publicity increased the awareness of Shaker amongst the general public, the contextual elements of the style's origins are usually ignored, or even worse, factually incorrect.

The reasons behind the phenomenal success of Shaker styling are, as we have already investigated, manifold. In terms of kitchen design, perhaps its greatest strength is its adaptability in terms of design, taste and budget.[230] Custom and handmade manufacturers such as Plain English cupboard-makers provide kitchens in association with the Shaker Shop, London, which can cost tens of thousands of pounds.[231] Middle-range kitchens are produced by companies such as Magnet, Crabtree Kitchens, Newcastle Furniture Company, Rhode Design, Woodstock Furniture Company and Jonelle for John Lewis Partnership,[232] while other manufacturers/retailers such as Hygena[233] and MFI[234] provide relatively inexpensive, self-assembly flat-pack kitchens for the mass market. In addition, B&Q promoted their Shaker kitchens in a national double-spread magazine campaign in July 2003. Interestingly, the style appears to transcend social and economic groupings, as an article from *The Guardian* notes:

Contrary to popular belief, the Shakers did not start out with a small furniture shop on the King's Road. Those who pay attention to the small print may be aware that Shakers were, in fact, members of a religious movement that started in America in 1780s, but even they probably don't know that the English founder was known as 'Mother of the New Creation' ... Much of the most interesting stuff about the Shakers has fallen off the Shaker fact sheets: such as their belief in celibacy and their habit of bringing the dead into the flock, thus counting George Washington and Napoleon Bonaparte among their membership. All right, all right, they were into furniture, believing that creating something teaches patience (don't worry, Shaker furniture doesn't come in kits), and taking as their motto: 'Do not make what is not useful.' Where that leaves Shaker flying geese is a little confusing. But whether or not you want to buy into all the Shaker fluff, their furniture is selling, and Magnet ... is now doing Shaker kitchens of its own. 'Plain and Simple' goes the catalogue tag, which also kindly makes serving suggestions such as garnishing with tongue-and-groove effect and panels, or turned oak knobs. No, I don't think the Shakers thought their millennium would end like this either.[235]

Whilst the mass producer of Shaker-styled kitchens – turning out thousands of units for the high street – tends not to place much, if any, importance on explaining the style's context to their customers, companies supplying Shaker kitchens at the upper end of the market are often at pains to explain the Shaker ethos to what they see – rightly or wrongly – as their more design-literate clientele.[236] For example, the catalogue produced by Andrew Macintosh states:

At the beginning of the 1990s, a 'back to basics' philosophy emerged in order to shake off the excesses of the 1980s. Nowhere was this more evident than in kitchen design, where 'traditional' designs had become far too fussy. Inspired by the simple lines and earthy colours of the Shaker furniture, he launched the original and now highly influential, Shaker range of fitted and free-standing kitchen and bedroom furniture. Because of its North American origins, Shaker furniture has had little influence on British furniture design until now. Its utilitarian nature and its adaptability to accept the many appliances that are so essential for modern-day living make it an attractive and practical basis for a kitchen of today. Multidrawer cabinets were a common feature in Shaker interiors, where there was an appointed place for everything. The pegboard, with its regularly

spaced pegs, can hold all sorts of things and is ideal for displaying pans and utensils.[237]

However, simply because a company produces kitchens at the top end of the price range, does not mean that they get their styling details right. For example, a company called Alno Kitchens[238] produced a fitted kitchen with solid maple doors and some free-standing pieces of furniture. While the fitted kitchen has some of the proportions and design features for which the Shakers are known, the free-standing dresser cannot be described as Shaker – it is simply a Welsh dresser with a very small amount of superficial Shaker detailing.

In the article 'Cooler Shaker' from *Observer Life*, we can gauge something of the ambivalent reaction of the Shakers to this phenomenal increase in attention to their 'lifestyle'. In the words of Brother Arnold, one of the few remaining members of the Shaker community:

> What do the Shakers themselves think about it all? They tactfully refuse to comment on the pictures of reproduction furniture that I show them. 'We are happy to share what we have created with others,' says Brother Arnold, smiling sadly, 'but we would like people to know that the Shakers weren't just furniture makers; that they were motivated by something higher.' His sadness is understandable: these days, religion doesn't seem to matter half as much as a nice fitted kitchen.[239]

While the rise of Shaker-styled items such as boxes and kitchens has gone on apace on the high street, there has also been an increasing commercialisation of what might be termed Shaker-themed holidays in America with the formation of hotel accommodation in what were once Shaker communities.[240] It is now possible to immerse oneself in the 'Shaker experience' at Enfield, with the understanding being of course that all the comforts of contemporary living are provided for the guests! As *The Philadelphia Inquirer* notes:

> Guests can hang their jackets and hats on Shaker peg rails that line the walls of every room, or tuck their clothing into the hundreds of trademark drawers built into the walls. In the Shaker dining hall, they can take their meals prepared with herbs grown outside in the garden.[241]

The same 'experience' is available at Pleasant Hill[242] and Canterbury, where

visitors can stay in a small inn attached to the museum village. The authenticity of these 'experiences' – as with all such themed holidays of which these are simply a more specialised branch – is questionable. They provide only a superficial insight into the real Shaker life, having been stripped of its spiritual dimension which is largely unpalatable to the modern tourist. Britain, unable to provide Shaker village accommodation, did instead for a time have a themed restaurant called 'Shaker Brown'. With Shaker-inspired decor and staff dressed in Shaker fashion, the food was nevertheless very much in the style of the late twentieth century.

While the majority of articles in the popular media were content to present the Shakers as a stylistic resource to be plundered for interior design ideas, some articles sought to dig deeper, contradicting former orthodoxies and exploring the history of the movement in the twentieth century. For example, 'Cooler Shaker' takes a critical look at the role of Edward Deming Andrews and his motivation in the promotion of the Shaker aesthetic:

> It could, perhaps, have been very different, if the man who spread the word about furniture had applied his considerable promotional talents to the religion itself. Amazingly, Shaker style as it is known today is largely the creation of a single individual. In the 1930s, Dr Edward Andrews, who had grown up near a New England community, began to befriend its members. His reasons were dubious. Equally dubious were the motives behind his first book, *The People Called Shakers*. Andrews was an antiques dealer, and recognised in the furniture a potential big seller at a time when tastes in interior design were turning towards a new simplicity and lightness of feel. He also knew that, since Shakerism was in dramatic decline and communities were breaking up, large amounts of furniture was becoming available. If Andrews' writing romanticised Shaker life (the scandals of the countless elopements of Brothers and Sisters who had become a little too familiar were noticeably absent), his photographs actively reinvented their environment.[243]

The 1990s saw a proliferation of books which sought to detail particular aspects of the Shaker style, some from a technical academic perspective, others which might be termed 'coffee table' literature.[244] Christian Becksvoort,[245] a furniture maker whose book *The Shaker Legacy – Perspectives on an*

Enduring Furniture Style contained substantial information on Shaker furniture, states:

> A visitor to one Shaker community reported that the members believed their furniture was designed in heaven and sent to earth by angels. For the Shakers, every aspect of life was sanctioned by the breadth of the divine … The evolution of Shaker furniture closely parallels the development and decline of communities themselves. The earliest pieces are direct descendants of the country furniture native to New England, where Shakerism put down its first roots. Later, working under common rules of simplicity and utility, the Shaker craftsmen began to lighten and refine basic forms, honing a style as unique as their religion. The classic pieces built between 1820 and 1860 reflect the Shakers' most prosperous and creative years. When membership began to decline after the Civil War, the Shakers relaxed their restrictions on ornamentation and worldliness and tried, unsuccessfully, to attract new converts. The resulting Victorian furniture is not to everyone's taste, but it represents an important chapter in the legacy of the Believers.[246]

Becksvoort follows the orthodox Andrews line in terms of the Shakers' development, seeking as he does to place the Shakers' output in an historical context and draw parallels with contemporaneous American furniture output. The book is clear in its intention of showing that Shaker furniture was very much influenced by furniture produced in 'the world'. Whilst this may be so, the difference between the 'world's' output and that of the Shaker communities – for it is clear that there was a difference given that we can identify a distinctive Shaker style – must therefore lie in what the Shakers left out. Here we run into the problem faced by early Shaker academics such as Edward Deming Andrews, in deciding 'when was Shaker'. The creation of a 'Golden Period' was Edward Deming Andrews' preferred solution and, revisionist historians excepted, this has been the line taken by most subsequent serious Shaker scholars and collectors. This is why the Victorian Shaker period has been largely neglected, both by collectors and period room creators, as it doesn't fit the model formulated by the likes of the Andrews partnership in the early twentieth century. One of the major criticisms of the Andrewses is that they were 'antiques dealers' and, as such, the assumption is made that their main motivation and interest in the Shakers was in order to make money. Whilst this may

have been partly true, it needs to be looked at in the context of the work they did in helping to preserve – however imperfectly – the Shaker legacy. Whether they also made money in the process is neither here nor there and certainly they are not alone in this respect. The selling of the Shakers has continued ever since,[247] and through every conceivable medium including music,[248] ephemera studies,[249] retelling of the history,[250] material related to children,[251] horticulture and gardening,[252] theatre,[253] media projects,[254] fictional accounts and stories.[255] A review of Stein's book *The Shaker Experience in America*, entitled 'The Art of Piety', provides a useful insight into the commercial relationship that currently exists between 'the world' and the remaining Shakers:

> Stein is understandably fatigued by all the attention that Shaker crafts-manship has lately attracted. He has had enough of coffee-table books and earnest documentaries, and he begins his book by quoting one of the last surviving Shakers ruefully predicting that she will be 'remembered as a chair or table'. In 1990, we learn, Oprah Winfrey spent $220,000 for a pine work counter. Excellently suited for the taste of the '90s, the Shaker style promises expiation for the conspicuous consumption of the '80s and reminds us of our culture's genius for appropriating dissident language and turning it into a cant: one can now assemble 'Shaker' chairs from kits, and purchase 'Shaker' baskets that are manufactured in the People's Republic of China. And yet it has been precisely this commercialisation, at which the purists shudder, that has saved the Shakers from the oblivion of the other short-lived sects that sprouted with them in the antebellum years. It is, in its way, homage from the outside world.[256]

The ambivalent relationship between the Shakers and the outside world has existed almost from the time of the foundation of the sect. To what extent they have been successful in curbing the crasser elements of commerciali-sation is arguable. Certainly the Shakers have lost the battle in so far as converting the 'world's' people to their religious ethos. It seems inevitable that many of those people who buy Shaker original artefacts as an aesthetic statement or investment – or sit on reproductions or have a Shaker-styled kitchen – will think of them as a chair or kitchen or box. Worse still, they may not even know, or care, that there was once a United Society of Believers, known as the Shakers, at all.

Conclusion

The progress of the 'Shaker Style' during the course of the twentieth century is a remarkable success story. An aesthetic created by a small religious sect as the material embodiment of their religious philosophy – which sought to praise God in its simple yet perfect craftsmanship – has become a truly world brand. In the United Kingdom it has even surfaced in property and a development in Surrey has created Shaker-style dwellings at locations such as Pleasant Hill Road and Prospect Drive.[257] At the start of the twentieth century the Shakers, whilst in decline, were still sufficient in number to sustain a series of viable communities. By the turn of this century, they had all but disappeared and their numbers had dwindled to single figures.[258] It is therefore all the more poignant that in the intervening years, whilst the Shakers' material output should have so captured the wider public's imagination, their communities should have all but faded away.

Whilst there are numerous books which deal with the religious history of the Shakers and still more that provide a catalogue of the artefacts – in the form of the furniture, textiles and general everyday ephemera – that their communities manufactured, none have concentrated solely on the process of what we have chosen to call the 'Selling of the Shakers'. This book has attempted to chronicle the development of the Shaker aesthetic during the course of the twentieth century, from high culture exhibition presentations to popular culture commercial expansion and, by doing so, to examine some of the motivations behind that progress. The early Shaker scholars such as Edward and Faith Andrews provided the Shakers with an ambivalent legacy. While they undoubtedly helped to preserve material that might well have been lost as the communities declined, they also sought to 'form' the Shaker aesthetic according to their own Modernist agenda, an agenda that sought to exclude entire periods of production that were incompatible with their thesis. By examining the course of Shaker exhibitions throughout the century, we have sought to uncover some of the motivations and consequences of these high-profile events. Their concerns have, naturally enough, mirrored contemporaneous theories in art and design, and consequently towards the end of the century we see the emergence of revisionist and Post-modern inspired exhibitions. Exhibitions such as 'Crafting Utopia: The Art of Shaker Women', staged at the

Georgia Museum of Art in the autumn of 2001, looked not only, as the title suggests, at the particular role of women in the communities, but also '... tells the story of the Shakers through utilitarian objects central to daily Shaker life'.[259] The desire to engage with all aspects of Shaker life, even the most humble, is a relatively recent phenomenon. Similarly an appreciation of the Shakers as business people, an aspect which was in part a prompt for this book, was examined in an exhibition entitled 'Selling the Shaker Brand', held at the Warren County Historical Society Museum, Lebanon, USA also during the autumn of 2001.[260] A major contributor to the exhibition, Bob Menker, noted that 'The Shaker name became so well known for quality and honesty that other companies started to use it. There was no copyright on that name. One example is "Shaker Salt", which had an image of a Shaker woman on the box but had no connection at all with the religious communities.' This has particular resonance in the light of the contemporary commercialisation of the Shaker style.[261]

The decoupling of the Shaker aesthetic – a philosophy that was integrated with their religious beliefs – has led to a secularisation of the Shaker style which, paradoxically, has made it both more accessible to a wider audience and yet helped cut off a broader understanding of the ethos that underpinned that style. Instead, we now have a duality: 'Shakerism' – that is to say the religious aspects of the Shakers – and the 'Shaker Style'. The latter has progressively become the dominant force and spread out into the commercial world in a variety of hybrid forms – many of which have only the most tenuous link with the original aesthetic – to become what we term 'Shakerbelia'.

However, whilst the 'Shaker Style' might be a secular manifestation, we can still detect something of the Shakers' fervour in the almost religious zeal with which dedicated collectors acquire both original and reproduction Shaker artefacts. In a programme entitled *Meet Thy Shaker* made for the British television company Channel 5,[262] a modern day 'convert' to the Shaker style describes her passion. The narrator states, 'From the first day Jane Will set eyes on Shaker furniture, she was addicted, she can't get enough ...' When asked when she will stop collecting, she replies, 'When I've got one of everything.' Will's love of all things Shaker leads her on a 'pilgrimage' to the Shaker villages in America. The narrator tells us that, after this visit, there was only one thing left for her to do: '... join the

Selling Shaker

company ...' – that is to say, apply for a job as a sales assistant at the Shaker Shop in London which sells reproduction artefacts, not become a member of the Shaker community!

This is a common reaction of those who become passionate advocates of the Shaker Style. While *Meet Thy Shaker* attempted to view the objects in the broader context of the original Shaker communities, it can be argued that, for a significant number of people the appeal of Shaker objects lies less in what the design writer Jonathan Glancey notes as their 'spiritual' quality, but on a rather more commercial level. It is difficult to precisely analyse the qualities in these objects that speak to so many varied people, and perhaps we can only put it down to an inherent spiritual quality imbued by the Shakers' deeply held faith. If the mainstream attention is drawn more to the form of the artefacts and less to the philosophy that underpinned them, this may not be so unreasonable a reaction since the Shakers' religious ethos does not sit easily with contemporary life. Some might argue that at least the Shaker Shop, and commercial concerns like it, treat the aesthetic with integrity and respect. Other manifestations are less reverential. In an episode of the BBC's transformation TV series *Changing Rooms* the designer's brief was to produce a 'Shakery' room that brings the style into the twenty-first century, with touches of silver-chrome and glass. The resultant bedroom design was named 'Shakey-Wakey'.[263] It would be churlish to criticise what was, after all, intended to be a light entertainment programme, with no pretensions to 'authentic' Shaker inspired design, for failing to be true to the spirit. However, it does serve to illustrate the way in which Shaker style has, and is, evolving and transmuting, to an extent where it is becoming almost unrecognisable. This ambivalent and often uneasy relationship looks set to continue – that is, at least for as long as the Shaker 'brand' remains a favourite amongst designers and the general public alike.

The Shakers themselves have, almost from their very inception, understood and valued the importance of commerce and interaction with the 'world's people' as being central to their survival. This book has not sought to criticise that process but rather to investigate the means by which it has developed and, by doing so, gain an insight into the relationship between the Shaker style and the outside world. It is when that relationship becomes unbalanced by commercial greed and disregards the integrity

and authenticity of the source, that we lose something very important and cynicism takes over. For, as Oscar Wilde noted, a cynic is a person who knows the price of everything and the value of nothing.

Notes

1 See Nelson, G.G. et al., *Berkshire Shaker Seminar. From Manchester, England to Watervliet, New York*, 1995.

2 In addition, in 1995 Jerry Grant started to produce the *Shaker Register* in America which detailed various sources of information relating to the Shakers – a valuable source for Shaker scholars.

3 See Goodwin, D. (ed.), Shaw, S. & Shaw, T., *Home Front*, 1996 which features a section on Shaker style and how to achieve it (with T. Evelegh). Also the Shaker Shop, London is featured in Misrahi, K. (producer & director), *Making It*, 2000. Shaker design and style have also featured in the following television programmes: Bristow, M. (series producer) & Fisher, P. (ed.), *DIY SOS*, 2000 (featuring a Shaker kitchen) and Anderson, A. (director), Silver, E. (series producer) & McCloud, K. (presenter), *Grand Designs*, 2001, which features a Shaker-inspired summerhouse for Damien Hurst.

4 See Pevsner, N., *Pioneers of Modern Design from William Morris to Walter Gropius*, 1984, p. 150 (and p. 235, note 4).

5 See Faulkner, R. *Japanese Studio Crafts – Tradition and the Avant-Garde*, 1995 in which contemporary Japanese studio crafts are discussed in the context of the twentieth century; the book also provides chronologies of the history of Japan, China and Korea, and an extensive bibliography.

6 See Nitschke, G., *From Shinto to Ando*, 1993 in which Japanese religion, philosophies and aesthetics are discussed in terms of architecture and the work of Tadao Ando.

7 Shaker exhibitions have been popular in Japan: see Kramer, F., 'Hancock Prepares for Exhibit in Japan', *The Shaker Messenger*, 1992. Also see Kirk, J.T., *The Shaker World: Art, Life, Belief*, 1997, p. 82 which states: 'The pieces discussed here exemplify the type of Shaker designs some historians link to those of the Bauhaus, seeing in both groups of objects a conscious exploitation of the nature of the materials and an achievement of a new level of stripped-down functionalism. This is the Shaker work commonly placed alongside Japanese and 1950s Danish modern objects during discussions of the Shakers' use of traditional materials and their evocation of quiet beauty.'

8 See Sprigg, J. (ed.), Catalogue for *Kindred Spirits – The Eloquence of Function in American Shaker and Japanese Arts of Daily Life*, 1995.

9 See De Waal, E., 'To Say the Least', *Crafts*, 2001, p. 44. Edmund de Waal has been associated with orientalism and minimalism in ceramics using celadon glazes and porcelain. He has written extensively including a book on Bernard Leach – see De Waal, E., *Bernard Leach (St Ives Artists)*, 1997.

10 See De Waal, E., 'To Say The Least', *Crafts*, 2001, p. 44.

11 See Chatwin, B. & Sudjic, D., *John Pawson*, 1998. Interestingly, the Shakers are also mentioned on p. 12 where it states (in an introduction by Deyan Sudjic): 'When nothing is fudged, when every issue, even the smallest, is faced up to head on, you have the aesthetic calm of a Shaker interior, of a Japanese tea ceremony or the stripped classicism of Adolf Loos.'

12 Maxtone, G.Y., 'Slaves to Mastering Chaos', *The Sunday Telegraph*, 1995.

13 Maxtone, G.Y., 'Slaves to Mastering Chaos', *The Sunday Telegraph*, 1995.

14 See Pawson, J., *Minimum*, 1996, p. 10.

15 See Pawson, J., *Minimum*, 1996, p. 12. In addition, a number of illustrations have been used such as the staircase at Pleasant Hill on p. 190 and the Centre Family Dwelling attic area on p. 213.

16 See the television programme Thomson, G. (producer) & Walton, S. (executive producer), *IKEA Mania*, 2000.

17 Refer to Moss, S., 'The Gospel According to IKEA', *The Guardian (G2)*, 2000, p. 2.

18 Refer to Moss, S., 'The Gospel According to IKEA', *The Guardian (G2)*, 2000, p. 2.

19 See Thomson, G. (producer) & Walton, S. (executive producer), *IKEA Mania*, 2000.

20 See Buchanan, R., 'Branzi's Dilemma: Design In Contemporary Culture', *Design Issues*, 1998, p. 9, Figure 2.

21 See Gluck, N., 'Shaker Items Embody Shaker Beliefs ...', *Antique Week – Eastern Edition – Weekly Antique, Auction & Collectors' Newspaper*, 1996.

22 See Coomaraswamy, A.K. & Butler, L., 'Wielding the Force of Presence', *Parabola*, 1996, p. 47.

23 See Garrett, W.D., Catalogue for *Sotheby's – Important American Furniture and Folk Art*, 1997, as an example of Shaker material at auction. Also see Parkinson, A. & Parkinson, K.C., 'Rare Shaker Drawings Discovered', *Shakers World*, 1996. In addition, certain collections were featured in exhibitions, for example, Koomler, S.D., Catalogue for *Expanding the Vision – Gift Drawings in the Eric J. Maffei Collection*, 2001.

24 See Parkinson, A. & Parkinson, K.C., 'Auction News – Enfield Shaker Village' and 'The Milton Sherman Collection: Exhibit and Sale', *Shakers World*, 1997.

25 See the article Finn, P., 'Why Oprah is Worth her Weight in Gold – How the Winfrey Millions are Spent', *The Daily Express*, 1993 which is detailed in Bowe, S.J., *Watervliet Shakerism*, Master's Thesis, 1994, p. 129.

26 See the television programme Anderson, A. (director), Silver, E. (series producer) & McCloud, K. (presenter), *Grand Designs*, 2001, which featured Damien Hurst (probably the most famous and notorious of the Britpack artists) having a Shaker-style summer house designed in his main residence, featuring reproduction and original pieces of furniture. A booklet was also produced by Channel 4 television: see Jones, L. & Highton, D., *Grand Designs Indoors – A Practical and Historical Guide to Interior Design*, 2001. Hurst's Shaker-style retreat was also featured in Warren, J., 'All Shook Up', *The Daily Express*, 2001.

27 See the television programme Amirani, A. *et al*, *Meet Thy Shaker*, 2000. Interestingly, the programme features the Shaker Furniture Company (which no longer exists) and a number of collectors are mentioned including the late John Thaw.

28 A complementary lecture was given entitled 'Shaker Furniture: Why it was painted? How it was painted? Why so much was stripped?' by John T. Kirk, Emeritus Professor of Art History, Boston University. Also see Kirk, J.T., 'Art Historian John Kirk Explains Intent', *The Shaker Messenger*, 1988.

29 See Rieman, T.D., Catalogue for *Shaker: The Art of Craftsmanship*, 1995.

30 See Lacroix, C., 'Shaker Style', *The Sunday Telegraph Magazine*, 1996; Sonday, R., *Shaker Style Wood Projects*, 1997; Chamier, S., 'Ask the Expert – Shaker Style', *The Mail on Sunday*, 1998; Becksvoort, C., 'Elements of Shaker Style', *Fine Woodworking*, 1998; Wood, D., *Shaker: Creating The Style*, 1999; and even Shaker style in the garden (!) in Donaldson, S., *The Shaker Garden*, 2000.

31 See Evelegh, T., *Essential Shaker Style*, 1995. This is not the only superficial book on Shaker design/style, for example, the same book was produced for both the UK market – Wood, D., *Shaker: Creating The Style*, 1999 – and US market – Wood, D., *Handmade Style: Shaker*, 1999.

32 See Evelegh, T., *Essential Shaker Style*, 1995, pp. 6–7.

33 An example of which is Sprigg, J., *Simple Gifts – 25 Authentic Shaker Craft Projects*, 1991. There are also many books relating to wooden projects, for example, Ingersoll, I. & Miller-Mead, G., *The Art of Woodworking – Shaker Furniture*, 1995.

34 See Turner, A. & Minor, W., *Shaker Hearts*, 1997, in which illustrations portraying the American rural ideal are shown with accompanying text, both relating to the Shakers.

35 Ypma, H., *American Country*, 1997, p. 120.

36 See Ypma, H., 'Shaker Shaped', *The World of Interiors*, 1998, pp. 59–62. This had previously been reported in Ypma, H., *American Country*, 1997.

37 Found in a miscellaneous box at Henry Francis du Pont Winterthur Museum. The brochure was designed by Andrew M. Newman Graphic Design Inc. and included many illustrations.

38 See Kirk, J.T., *The Shaker World: Art, Life, Belief*, 1997.

39 This continues to be the case and also see 'Contextualizing the Gift Drawing', in Morin, F., Catalogue for *Heavenly Visions: Shaker Gift Drawings and Gift Songs*, 2001 in which Kirk writes about Shaker design in relation to Shaker art.

40 See Kirk, J.T., 'Art Historian John Kirk Explains Intent', *The Shaker Messenger*, 1988, p. 13: 'What was original in the designs of the Shakers results from their manner of using the aesthetic climates outside their communities. They did not set out to make new forms, rather their beliefs caused them to select the essentially functional and beautiful aspects of simple, worldly items and force them to greater practicality. Throughout the 20th century Shaker designs of the second quarter of the 19th century have been recognised as important aesthetic statements.' Kirk also states later in the article: 'From 1825 to 1850, when they were most retired and private, the Shakers produced their most stringently pure designs. The contemporary 1820s style from which they drew inspiration was the last and most simplified phase of the classical revival which employed lean rectilinear shapes that stressed plain, taut surfaces with a minimum of added decoration.'

41 Kirk, J.T., 'An Awareness of Perfection', *Design Quarterly*, 1992, p. 14.

42 Kirk, J.T., 'An Awareness of Perfection', *Design Quarterly*, 1992, p. 15.

43 Kirk, J.T., 'An Awareness of Perfection', *Design Quarterly*, 1992, p. 17.

44 Kirk, J.T., 'An Awareness of Perfection', *Design Quarterly*, 1992, p. 19.

45 See Kirk, J.T., *The Shaker World: Art, Life, Belief*, 1997, p. 230: 'The greatest thrusts to mythologize the Shakers' past occurred when America was seeking to adjust its relationship to Europe. Without realising that early Shaker designs were part of rural neoclassical styling, historians since the 1910s have used the Shakers' artistic expressions as evidence that the Shakers, and by extension other Americans, anticipated the tight, functional, stripped forms of the German Bauhaus. In a related way the artist Charles Sheeler used Shaker objects in his modernistic paintings and photographs of the late 1920s and the 1930s, to help his drive to make a modern American art that seemed independent of European precedents. By the 1940s Shaker art, particularly the furniture, was one of the American factors evoked to confront the foreign fascist threat, as it was admired for having no basis in a European artistic tradition.'

46 Kirk, J.T., *The Shaker World: Art, Life, Belief*, 1997, p. 246.

47 The interiors as featured in Andrews, E.D. & Andrews, F., *Religion in Wood: A Book of Shaker Furniture*, 1966.

48 A film/video was produced to accompany the exhibition which showed much of the objects within their exhibition context: see Marshall, P., Kaye, P. & Longenecker, M.W., *Kindred Spirits – The Eloquence of Function in American Shaker and Japanese Arts of Daily Life*, 1996.

49 See Baker, E.S., 'Kindred Spirits Exhibit in Florida Reviewed', *The Shaker Messenger*, 1996.

50 The exhibition also featured in Parkinson, A. & Parkinson, K.C., 'Utilitarian Objects, Crafted with Excellence and Artistry, Contrast Shaker and Japanese Cultures', *Shakers World*, 1996.

51 Kennedy has also written material relating to basketry and the Shakers: see Kennedy, G., Beale, G. & Johnson, J., *Shaker Baskets and Poplarware – A Field Guide, vol. 3*, 1992.

52 See Votolato, G., *American Design in the Twentieth Century*, 1998, pp. 173–74 and 228–30. On p. 230 it states: 'Nakashima's integration of functional simplicity and careful craftsmanship suggested the ideals of Shaker furniture makers as well as the traditions of the Japanese.' Nakashima is also featured in Becksvoort, C., *The Shaker Legacy*, 1998, pp. 18–19 which shows two colour illustrations of his work. In addition, see Kaufman, D., 'Wood Works', *Wallpaper*, 2002.

53 Interestingly, the Amish have also been analysed with regard to Japanese society: see Kidder, R.L. & Hostetler, J.A., 'Managing Ideologies – the Amish and Japanese Society', *Law and Society Review*, 1990.

54 See Haworth, D.K., 'Shaker and Japanese Craft Explored', *The Shaker Messenger*, 1991, which discusses an exhibition mounted at Carleton College, Northfield, Minn., entitled 'The Eloquence of the Simple – Shaker and Japanese Craft': '... like the Japanese and their tea bowls, so, too, the Shakers and their oval boxes: these paradigms of Shaker craft were not original designs but were refined from adopted designs' (p. 25).

55 Longenecker, M.W., 'Foreword', in Sprigg, J. (ed.), Catalogue for *Kindred Spirits – The Eloquence of Function in American Shaker and Japanese Arts of Daily Life*, 1995, p. 15.

56 Longenecker, M.W., 'Foreword', in Sprigg, J. (ed.), Catalogue for *Kindred Spirits – The Eloquence of Function in American Shaker and Japanese Arts of Daily Life*, 1995, pp. 15–16.

57 Sprigg, J., 'The Fifteenth Rock: On Shaker Design' (Prologue), in Sprigg, J. (ed.), Catalogue for *Kindred Spirits – The Eloquence of Function in American Shaker and Japanese Arts of Daily Life*, 1995, p. 13, discusses Shaker in terms of the Zen Garden of Ryooan-ji in Kyoto and the 15 rocks in the essentially dry garden.

58 Sprigg, J., 'The Fifteenth Rock: On Shaker Design' (Prologue), in Sprigg, J. (ed.), Catalogue for *Kindred Spirits – The Eloquence of Function in American Shaker and Japanese Arts of Daily Life*, 1995, p. 10–11. Sprigg also discusses Shaker design: 'What I am able to explain about Shaker design includes the qualities of restraint, simplicity, utility, order and excellence, all of which you can see for yourself in the objects in this exhibition. The why of Shaker design, however, remains beyond my power to explain. The work of Shaker hands bespeaks to me a serene mindfulness of the right place of things in the universe and a blend of dream and discipline that allowed the makers to create in earthly materials – perhaps re-create is a better word – something of an imagined ideal' (p. 12).

59 Sprigg, J., 'The Fifteenth Rock: On Shaker Design' (Prologue), in Sprigg, J. (ed.), Catalogue for *Kindred Spirits – The Eloquence of Function in American Shaker and Japanese Arts of Daily Life*, 1995, p. 13.

60 Thrasher, W., 'Commentary', in Sprigg, J. (ed.), Catalogue for *Kindred Spirits – The Eloquence of Function in American Shaker and Japanese Arts of Daily Life*, 1995, pp. 22–23. Thrasher concludes: 'Words too often pay more homage than objects require. In language describing things made by the Shakers and the Japanese, a word frequently used is harmony – harmony of all parts of an individual piece, and harmony with its environment' (p. 24).

61 Thrasher, W., 'Commentary', in Sprigg, J. (ed.), Catalogue for *Kindred Spirits – The Eloquence of Function in American Shaker and Japanese Arts of Daily Life*, 1995, p. 24.

62 See Van Kolken, D., 'Mt Lebanon Collection in New Book', *The Shaker Messenger*, 1987 and also Van Kolken, D., 'Mt Lebanon Collection on Exhibit', *The Shaker Messenger*, 1995.

63 Numerous articles in *The Shaker Messenger* in the 'Villages News' pages gives a flavour of the concerns at Mount Lebanon. In addition, Mount Lebanon was not the only Shaker site to be under threat as the Enfield Great Stone Dwelling was also raising concerns: see Muller, C., 'Editorial – "It's a Damn Shame"', *The Shaker Messenger*, 1991.

64 See Kramer, F., 'Mt Lebanon's Future Becoming Uncertain (Editorial)', *The Shaker Messenger*, 1990 and Kramer, F., 'Darrow Collection Preserved For Now', *The Shaker Messenger*, 1990.

65 Also see Baker, J., 'Remodelled Shaker Hall', *Architecture Forum*, 1962.

66 See Kramer, F., 'Mt Lebanon's Future Becoming Uncertain (Editorial)', *The Shaker Messenger*, 1990.

67 Van Kolken, D., 'Mt Lebanon Looks at Future Roles', *The Shaker Messenger*, 1994.

68 Perhaps one of the most significant events in the 1990s was the sale of the Mount Lebanon collection to Ken Hakuta (see Tamulevich, S., 'Dr Fad's Dilemma', *Art & Antiques*, 1992). The sale of the items was very controversial and created a lot of press interest. Peder Zane, J., 'Dr Fad's Advice on Buying Art: Keep it Simple. He's the Complete Shaker Connoisseur', *The New York Times*, 1996, places many of the issues concerning the collection in context. Ken Hakuta is a very wealthy America-based businessman: 'For about $1 million, he bought over several years one of the world's best assemblages of Shaker furniture, the Mount Lebanon Collection, dedicating much of his energy to preserving the cultural legacy of the millennialist Christian sect, whose heyday was before the Civil War and which largely died off by the 1940s.'

69 See Van Kolken, D., 'Mt Lebanon Collection on Exhibit', *The Shaker Messenger*, 1995.

70 The collections at Darrow School were documented and detailed in the 1987 booklet *Mount Lebanon Shaker Collection* with text by Charles L. Flint and photographs by Paul Rocheleau. In the foreword by Andrew J. Vadnais it states: 'The images in this catalogue represent a relatively little-known Shaker collection. For the past 57 years most objects in this collection have been inaccessible to the public. Therefore, this catalogue should be of interest to those concerned with American decorative arts in general and Shaker history in particular' (p. ix).

71 Peder Zane, J., 'Dr Fad's Advice on Buying Art: Keep it Simple. He's the Complete Shaker Connoisseur', *The New York Times*, 1996.

72 Peder Zane, J., 'Dr Fad's Advice on Buying Art: Keep it Simple. He's the Complete Shaker Connois-seur', *The New York Times*, 1996. Also in the same article it states: 'Now Mr Hakuta wants to "show the world the Shakers' wonderful legacy". After a recent exhibit in Hartford, the collection has travelled to Lincoln, Neb., as a part of a United States tour that will end up at the Smithsonian Institute in 1999. He would like to find a permanent home for the collection, but, he said, a museum will only accept the furniture as a gift if he includes perhaps $10 million to cover the costs of storage and display.'

73 The exhibition was featured in *The Magazine Antiques*: 'In 1990 the school sold their remaining Shaker artefacts to Mr and Mrs Ken Hakuta, who have loaned eighty-six objects from their collection for a travelling exhibition entitled *Shaker: The Art of Craftsmanship*. The show, which opens on February 18 at the Chrysler Museum in Norfolk, Virginia, and runs through April 16, includes furniture, household utensils, tools, costumes, printed ephemera, textiles, boxes, baskets, books, and documents. The exhibition was organised and is being circulated by Art Services International and future site will be listed in Calendar ... Shaker enterprise as never ending. They marketed their distinctive oval boxes in eleven sizes, and so many were sold that they used machines to make them. The seeds and medicines they produced in quantity at Mount Lebanon were labelled in bold type and rich colours to attract the consumer's eye, for the Shakers were very shrewd marketers' (Ledes, A.E., 'The First American Shaker Community', *The Magazine Antiques*, 1995, p. 252). It was also comprehensively reviewed in the United Kingdom: see Coatts, M., 'Exhibition Review – Shaker: the Art of Craftsmanship', *Crafts*, 1998.

74 See 'Acknowledgements' in Rieman, T.D., Catalogue for *Shaker: The Art of Craftsmanship*, 1995, p. 10.

75 Nancy Gluck writes about the Shakers – their history and artefacts, including price guides for collectors – in 'Shaker Items Embody Shaker Beliefs', *Antique Week*, 1996. In a section entitled 'For your informa-tion' the author recommends a number of villages including Hancock and Pleasant Hill, and museums including Winterthur, The Metropolitan Museum in New York and the Shelburne Museum in Vermont. The article then goes on to recommend the 1995 catalogue for *Shaker: The Art of Craftsmanship* by Timothy D. Rieman: 'The latter book is the catalogue for a travelling exhibit of Shaker furniture and other items from the Mt. Lebanon community. This exhibit, which opened in Hartford, Conn., in 1994, can be seen in Lincoln, Neb., and Columbus, Ohio, in 1996; and in Wichita, Kan., and Utica, NY, in 1997.'

76 See Van Kolken, D., 'Mt Lebanon Collection on Exhibit', *The Shaker Messenger*, 1995: 'Eighty-six objects taken from the Mount Lebanon Shaker collection for an exhibition of furniture and decorative arts opens Feb. 18 at the Chrysler Museum in Norfolk, Va. The selection was made by Tim Rieman, furni-ture maker, author and guest curator for the exhibition which will travel to eight American cities ...' In the end more than eight cities received the exhibition and the whole run could be regarded as highly successful.

77 Van Kolken, D., 'Shaker Exhibition Closes in Nebraska; Opens in Columbus', *The Shaker Messenger*, 1996.

78 See Van Kolken, D., 'Mt Lebanon Collection on Exhibit', *The Shaker Messenger*, 1995 and Van Kolken, D., 'Shaker Exhibition Closes in Nebraska; Opens in Columbus', *The Shaker Messenger*, 1996, p. 19.

79 Heald, G., 'Shaker Legacy: The Beauty of Craftsmanship', *The Kennett Paper*, 1996, p. B6.

80 Greenbaum, F., Catalogue for *Shaker: The Art of Craftsmanship*, 1996, p. 1.

81 Greenbaum, F., Catalogue for *Shaker: The Art of Craftsmanship*, 1996, p. 1.

82 Greenbaum, F., Catalogue for *Shaker: The Art of Craftsmanship*, 1996, p. 2, compared with Rieman, T.D., Catalogue for *Shaker: The Art of Craftsmanship*, 1995 produced by Art Services International.

83 Greenbaum, F., Catalogue for *Shaker: The Art of Craftsmanship*, 1996, p. 4.

84 Greenbaum, F., Catalogue for *Shaker: The Art of Craftsmanship*, 1996, p. 8.

85 Greenbaum, F., Catalogue for *Shaker: The Art of Craftsmanship*, 1996, p. 8.

86 Greenbaum, F., Catalogue for *Shaker: The Art of Craftsmanship*, 1996, p. 11.

87 One of the first review articles was Kinmonth, C., 'Exhibition Diary – Shaker: The Art of Craftsman-ship', *The World of Interiors*, 1998: 'Apart from a small collection at The American Museum in Bath, we are only passingly familiar with Shaker products through commercial imitation of photography. The opportunity to view a broad range of Shaker artefacts at first hand, is a rare one, which should not be missed.'

88 See the fold-out bulletin leaflet produced by the Barbican entitled *Shaker*: on one side information on the Shaker exhibition was given, while the other side was devoted to the Harley-Davidson exhibition running concurrently.

89 The commercial arm of the exhibition was clearly important and the sponsor Tim Lamb also took the opportunity to relocate a mini Shaker Shop into the ground floor of the Gallery to sell Shaker reproduction to those who felt that they needed to take something material away from the exhibition in the form of a souvenir. In addition, the bookshop also sold graphic-related materials including posters, postcards and books (including the Art Services International catalogue).

90 Letter dated 1 May 1998 from Christine Stewart in the Education Department at the Barbican Art Gallery.

91 In a review of the Barbican exhibition the following is interesting: 'Every few years a frisson of enthusiasm for Shaker furniture ripples through the fashion glossies. A culture palace in a great Western city holds an exhibition and urbanites are delighted by some chairs, chests of drawers and coat pegs made with utmost simplicity and absence of ornament. There are Shaker shops and books on "Shaker style", so you can re-create the aura of the furniture with wood stain, medium density fibreboard and an IKEA catalogue – all of which represents a magnificent contradiction. For the Shakers were puritans who abhorred striving after effect and even beauty, which one Shaker called "absurd and abnormal". They lived celibate, frugal lives, frowned on unnecessary curves and even replaced brass knobs on their furniture with less showy wooden ones ... The pathological plainness makes the tiniest details – a dovetail joint here, a variation in wood grain there – acquire almost fetishistic significance. When you discover peach-coloured silk lining inside a wooden sewing box, it verges on the orgiastic. At the same time the Shakers' indifference to the world led them to unusual arrangements of drawers or curious proportions ... Mass-produced furniture all but killed off the Shaker crafts. They reasoned that it was a waste of labour to make by hand what machines could do more efficiently and they started buying the products of industrial America, leaving behind the legacy of their furniture, which is all the more moving for representing the end of the handicrafts tradition.' (Moore, R., 'Putting Their Faith in Their Furniture', *The Daily Telegraph*, 1998.)

92 Refer to Laing, M., 'Fancy Articles Are Not Suitable For Believers', *Church Times*, 1998.

93 See Watt, J., 'Exhibition Review – The Art of Craftsmanship', *Perspectives in Architecture*, 1998.

94 See Higgins, R., 'Shaker – The Art of Craftsmanship Review', *Art & Photography*, 1998.

95 See Boulton, D., 'Shakers and Movers', *The Friend*, 1998.

96 Refer to Stead, T., 'A Great Exhibition – Now Buy The Goods', *Chic*, 1998.

97 See Bromidge, E., 'Simply Shaker', *The Lady*, 1998.

98 The Barbican press office has a very extensive cuttings file which has dozens of pieces on the exhibition which appeared in the regional, national and international press.

99 The organiser of the exhibition at the Barbican, Tomoko Sato, featured in an article in *The Guardian Weekend*: 'Sato's favourite object is the Shaker Tape Back chair, a fitting choice for the curator of the Barbican Art Gallery's new exhibition *Shaker: The Art of Craftsmanship*. It's a choice the Shakers themselves would have approved (and not just because of the good publicity) since it is based on two facts: one, it's a very nice chair to sit on; and two, it is "aesthetically stunning" – or, in Shaker speak, its "beauty rests on utility". Sato first encountered the chair while researching for the exhibition at the Hancock Shaker Museum library, which is furnished entirely with Tape Back chairs. The visual impact of the Tape Back *en masse* was stunning, but it wasn't until she sat down that Sato realised their true beauty. "The chair was amazingly light and comfortable," she says. "After hours of study, I didn't feel that I had been sitting." (Unspecified, 'Style Insider', *The Guardian Weekend*, 1998.)

100 Much material relating to the preliminary text for the exhibition was provided to us by Geoffrey Gale. The final sheets were beautifully presented being attached to pegboards at various locations throughout the exhibition.

101 Gallery Guide for *Shaker – The Art of Craftsmanship* produced by the Barbican Art Gallery.

102 Kurtenbach, H., *The Shakers*, 1992.

103 Treays, J. (producer), *Timewatch: I Don't Want to be Remembered as a Chair*, 1990.

104 See Hill, R., 'Perfect for Intelligent Purpose', *The Times Literary Supplement*, 1998. There was also a review of the exhibition in Bergen, K., 'Original Recipe for Shake and Bake', *The Times*, 1998.

105 Chamier, S., 'Ask The Expert – Shaker Style', *The Mail on Sunday*, 1998.

106 In publicity material for the exhibition the museum stated: 'The American Museum in Bath is staging a major exhibition of Shaker furniture and artefacts from 16 May to 18 October 1998. There will be a series of workshops and related events throughout the exhibition, including a visit by Brother Arnold of Sabbathday Lake Shaker Community from 28 to 31 May ... Nearly 100 objects characterising the traditional Shaker values of simplicity, utility, order and fine craftsmanship will be displayed, some within room settings, in the New Gallery of the American Museum. Items on display include large cupboards for storage, counters for tailoring, chairs, tools, textiles, boxes and herb labels.'

107 See Beria, A., 'Brother Arnold Hadd Gives the Dallas Pratt Memorial Lecture', *The American Museum in Britain – Newsletter Number 4*, 1998.

108 The American Museum at Bath has quite a classical façade and is located in a decidedly rural environment. The gallery used for the Shaker exhibition is set to one side of the museum and is a relatively small and intimate space. In contrast the Barbican is a very urban gallery, with Brutalist surroundings. In terms of philosophy, the American Museum in Britain at Bath made a very definite decision to place a large proportion of the exhibits into faux period room settings.

109 See Armitage, A., 'Forthcoming Events – Shaker: The Art of Craftsmanship', *The American Museum in Britain – Newsletter Number 3*, 1998. Newsletters are provided to the Friends of the American Museum in Britain at Bath.

110 See Elsdon, J., *Visitor Guide – The American Museum in Britain*, 1998.

111 Elsdon, J., *Exhibition Guide – Shaker The Art of Craftsmanship*, 1998, front page.

112 Refer to Armitage, A., 'Shaker: The Art of Craftsmanship', *The American Museum in Britain – Newsletter Number 4*, 1998.

113 Elsdon, J., *Exhibition Guide – Shaker The Art of Craftsmanship*, 1998.

114 Elsdon, J., *Exhibition Guide – Shaker The Art of Craftsmanship*, 1998.

115 Companies such as The Shaker Kitchen and Furniture Workshop have created vast Internet catalogues of their work and wares.

116 The information was provided by The Smithsonian Museum in a calendar of events (Winter, 1999) for the National Museum of American Art and the Renwick Gallery.

117 All the text for the exhibition was recorded *in situ* because photography was not allowed in any part of the exhibition.

118 All the text for the exhibition was recorded *in situ* because photography was not allowed in any part of the exhibition.

119 See photograph of Jefferson Woodworking box (plate 19).

120 The video has been televised extensively in both the United States and United Kingdom. See Burns, K. & Stechler Burns, A., *The Shakers: Hands to Work, Hearts to God* (film/video), 1985.

121 See Newman, C. & Abell, S., 'The Shakers' Brief Eternity', *National Geographic*, 1989.

122 See Newman, C. & Abell, S., 'The Shakers' Brief Eternity', *National Geographic*, 1989, p. 304. In addition, the annotation for one photograph states: '"She is the most perfect Shaker I have known," Sister Frances Carr, standing, says of Sister Mildred Barker, seated. The two belong to the last working Shaker community at Sabbathday Lake, Maine. In 1774 Shakerism's founder, Mother Ann Lee, leader of a splinter group of English Protestants, fled persecution and sailed to America with eight followers. Settling at Niskayuna, New York, she travelled around New England, preaching that salvation was open to all. If the reward was great, so was the cost. Shaker belief demanded a morally perfect life patterned after Christ, including celibacy, obedience to elders and confession of sins. Says Sister Mildred: "All the Shaker does is done in the eye of eternity."' (p. 304 for a photograph on p. 305).

123 See Newman, C. & Abell, S., 'The Shakers' Brief Eternity', *National Geographic*, 1989, p. 319.

124 See Treays, J. (producer), *Timewatch: I Don't Want to be Remembered as a Chair*, 1990.

125 See Newman, C. & Abell, S., 'The Shakers' Brief Eternity', *National Geographic*, 1989, p. 321.

126 Brother Arnold Hadd has been an important source of information concerning the Shakers and

particularly those at Sabbathday Lake. He has travelled extensively and always offers a lucid and truthful account of the present day life of the Shakers.

127 Sister Francis Carr has been an incredible ambassador for the Shakers and has written about her life: see Carr, F.A., *Growing Up Shaker*, 1995. She has featured in a number of books, articles, radio and television programmes.

128 See Wolkomir, J. & Wolkomir, R., 'Living a Tradition', *The Smithsonian*, 2001, p. 104.

129 See Treays, J. (producer), *Timewatch: I Don't Want to be Remembered as a Chair*, 1990, Post-Production Script, p. 35.

130 Fox, S., 'A Life in the Day of Sister Francis Carr', *Sunday Times Magazine*, 1998.

131 Rabinovitch, D., 'Farewell Utopia – No Sex Please We're Shakers', *The Guardian Weekend*, 1993, p. 6.

132 Rabinovitch, D., 'Farewell Utopia – No Sex Please We're Shakers', *The Guardian Weekend*, 1993, p. 7.

133 Robert Hughes produced a television series on the development of art in America which also resulted in a book, in both of which the Shakers were featured. In the television programme Brother Arnold is filmed showing Hughes a Shaker chair with tilter buttons. See the programme Hughes, R., *American Visions – 2: The Promised Land*, 1996, and the book Hughes, R., *American Visions*, 1997.

134 Brother Arnold produced lectures at both venues (each were very well received).

135 Refer to Yohn, T. (ed.) & Morin, F., Catalogue/Leaflet for *The Quiet in the Land*, 1996 and the Sabbathday Lake Shaker Museum website.

136 Refer to McBreen, E. (ed.) & Morin, F., Catalogue/Leaflet for *The Quiet in the Land*, 1998.

137 For example see Temin, C., 'Art World Movers Find Harmony With Shakers', *The Boston Globe*, 1998.

138 One exhibition that typifies this approach in the United Kingdom was 'Give & Take' held at The Victoria and Albert Museum (see Corrin, L.G. & Markopoulis, L., Catalogue for *Give & Take*, 2001), in which contemporary art was placed within the galleries at the V&A, typically adjacent to artefacts/art that had acted as inspiration for the artists.

139 She has been featured in many exhibitions, the most notable of which was probably 'Sensation': see Adams, B. *et al.*, Catalogue for *Sensation – Young British Artists From The Saatchi Collection*, 1997.

140 Larson, K., 'A Month in Shaker Country', *The New York Times*, 1997, p. 30.

141 Kaplan, J.A., 'The Quiet of the Land: Everyday Life, Contemporary Art, and the Shakers: A Conversation', *Art Journal*, 1998, p. 6.

142 McQuaid, C., 'Maine's "Quiet in the Land" Plumbs Art of Shaker Life', *The Boston Globe*, 1997.

143 Camhi, L., 'Seeing and Believing', *The Village Voice*, 1997.

144 Camhi, L., 'Seeing and Believing', *The Village Voice*, 1997.

145 See Curtis, S., 'Quiet Confidants', *World Art – The Magazine of Contemporary Visual Culture*, 1997, p. 59. It continues: 'Inspired as much by the Shakers' commitment to the unity between art, labour and worship as by a desire to unsettle these mass media perceptions, Canadian curator France Morin initiated "The Quiet in the Land", the first stage of an ambitious, international project to explore contemporary connections between spirituality and art. The exhibition's point of departure is that the Shakers' spirituality provides a contrast to so-called Western spiritual art and its complicity with secular capitalism. As Western artists have been elevated to messianic status, their art is denied any chance to fulfil its potential as a contemplative spiritual talisman. The spectacle has taken over the spiritual.'

146 See Kaplan, J.A., 'The Quiet of the Land: Everyday Life, Contemporary Art, and the Shakers: A Conversation', *Art Journal*, 1998, p. 5.

147 See Berry, I., Catalogue for *Work: Shaker Design and Recent Art*, 2001.

148 See Glueck, G., 'Busy Shaker Hands Moved by the Spirit', *The New York Times*, 1999.

149 See Gouveia, G., 'Style and Grace', *New Jersey Courier News*, 1999.

150 See Ledes, A.E., 'Shaker in Skyscraper', *The Magazine Antiques*, 1999.

151 Refer to Budis, E.M. & Grant, J., Catalogue for *Shaker Gifts, Shaker Genius*, 1999.

152 For details of how to get to these collections see Murray, S., *Shaker Heritage Guidebook*, 1994.

153 See Budis, E.M. & Grant, J., Catalogue for *Shaker Gifts, Shaker Genius*, 1999.

154 See Budis, E.M. & Grant, J., Catalogue for *Shaker Gifts, Shaker Genius*, 1999.

155 See small leaflet that Seattle Art Museum provided as a free guide.
156 See Gates, M.G., SAM *Program Guide & Members News*, 2000, p. 4.
157 Refer to Kirk, J.T., *The Shaker World: Art, Life, Belief*, 1997.
158 Fairbrother was the Deputy Director of Art/Jon and Mary Shirley Curator of Modern Art. See Bibliography for work by Julie Nicoletta and Susan Buck.
159 A museum press release dated 21 September 2000 indicates that a symposium took place on 21 October 2000 and included such speakers as John Scherer, Jerry Grant, Sharon Koomler, Elizabeth Shaver, Craig Williams, Ned Pratt and Fran Kramer (who was speaking about Shaker collecting in the twentieth century).
160 The New York State Museum at Albany produced a small leaflet which was given free to those visiting the museum. The leaflet was produced in a similar graphic style to the catalogue which was produced for the exhibition. This small leaflet had similar illustrations to those found in the catalogue.
161 Scherer, J.L. (ed.), Catalogue for *A Shaker Legacy – The Shaker Collection at the New York State Museum*, 2000.
162 See small free leaflet produced for the exhibition.
163 See the exhibition virtual tour on the New York State Museum website.
164 Compare Exhibit View Four, featuring the Shaker exhibit on the Terrace Gallery of the State Museum in the 1980s, with the photograph in Exhibit View Seven of the 1930s exhibition. Also see Scherer, J.L. (ed.), Catalogue for *A Shaker Legacy – The Shaker Collection at the New York State Museum*, 2000, p. xii, which shows a photograph of a general view of the 1930–32 exhibition.
165 See the exhibition virtual tour on the New York State Museum website.
166 Fran Kramer, as previously mentioned as a participant of the symposium, has written consistently about marketplace developments. See Kramer, F., 'Shaker Antiques in the Marketplace. Good Buys, Record Prices for Shaker', *The Shaker Messenger*, 1995; 'Shaker Antiques in the Marketplace', *The Shaker Messenger*, 1995; 'A New Record For Shaker Artefacts At Auction', *Shakers World*, 1996; and 'Market Report ...', *Shakers World*, 1996.
167 Argos produced a 'Denver' Shaker-style solid pine lounge furniture and 'Michigan' solid pine Shaker-style bedroom furniture: see their 1998 catalogue, pp. 144 and 152.
168 Index – the Mayflower 'shaker' collection. 'American tradition continues, elegant simplicity and perfect craftsmanship': see their 1998 catalogue, p. 407.
169 The Marks and Spencer 1998 *Home* catalogue features the 'Vermont' furniture range, which is described as 'Solid pine furniture with a warm, honey hue that will bring a friendly feel to any kitchen or dining room. Inspired by naive, Shaker style, the clean lines give it a simplicity enabling it to sit comfortably with existing furniture' (p. 52).
170 Habitat have had a number of furniture pieces which could be described as Shaker-style, for example, a range called Colonial sold *circa* 1991 (shown on p. 79 of the 1991 *Home Furnishings* catalogue).
171 Annotations from the Warrington IKEA store state: 'At IKEA we are now able to offer our customers a complete range of furniture in a Neo-romantic rustic style that's up to date. Cottage – the ideas and influences for this range have been taken from the Gustavian era, the Puritan Shaker sect as well as the Anglo-Saxon 18th century style [sic], art and crafts which was led by, amongst others, William Morris. This is no traditional furniture series but a coordinated range in warm and friendly designs. Thanks to the clean pure lines the furniture may also be used as solitary pieces in an established home.' The furniture belonging to the Cottage range is made of solid wood (in both light and dark colours) and the rest of the products of purely natural materials, such as wool, linen and cotton. IKEA has also made Shaker-inspired goods including 'KEA' boxes and 'Hornsby' chairs.
172 Throughout the 1980s and 1990s Heal's has consistently sold Shaker-styled products, their range of cherry wood furniture being particularly Shaker in its 'feel'. In The Conran Shop a Shaker-styled range called 'Pendine' was sold, described in the catalogue as owing 'some of its beauty and simplicity to the craft of Shaker furniture. The waxed, natural maple finish, precision joints and unpretentious looks slip quietly but confidently into almost any bedroom' (2000 Conran Collection brochure, p. 66).
173 AB Woodworking produce an extensive catalogue of Shaker-derived reproductions and products.

They are based in Oswestry, United Kingdom and supply various shops, as well as running an independent business.

174 The Shaker Furniture Company has featured in the television programme Amirani, A. et al., Meet Thy Shaker, 2000.

175 This company has been responsible for a number of kitchens and styled products (some of quite dubious stylistic origin).

176 See Lacroix, C., 'Shaker Style', The Sunday Telegraph Magazine, 1996.

177 See Kramer, F., 'Sotheby's Seminar: Masterpieces in the Shaker Aesthetic', Shakers World, 1997.

178 Refer to Willis Henry Auctions, Inc., Catalogue for Americana & Estate Auction Featuring Shaker, 1997.

179 This information was contained in quite a lavish catalogue of a Shaker collection which went for sale, the majority of pieces having been acquired directly from the Shakers at Canterbury from the 1940s to 1960s. See Skinner, R.W. (Skinner Auctioneers), Catalogue for A Shaker Collection, 13 January 1996.

180 See Bibliography for articles by Van Kolken, D. in The Shaker Messenger, and Parkinson, A. in Shakers World.

181 See The Shaker Journal's website.

182 Companies like Farrow & Ball in the United Kingdom manufacture paint ranges with Shaker sympathetic colours, while comparable American companies include The Old Fashioned Milk Paint Co., Inc. and Stulb's Old Village Paints.

183 Information and storyboard given via private communication with designer from Design Studio in 1994.

184 Boots has been responsible for a number of Shaker-inspired products/packaging, some of which have been photographed for this book .

185 In Hauffe, T., Design – A Concise History, 1998, p. 24, the following is of interest: 'The round and oval wooden boxes of the Shakers were used to hold a variety of household goods and became a symbol of craftsmanship and detailed perfection. The dove-tailed sides prevented the wood from warping under wet conditions, and the nails are copper instead of iron to prevent rusting.' Also see Kammeraad, B., 'The Oval Carrier', The Shaker Messenger, 1979 and Martin, D.B., 'The Gift to be Simple (19th Century Shaker Storage Boxes)', Portfolio – The Magazine of the Fine Arts, 1983.

186 Van Kolken, D., 'Fruitlands Museums Showing Oval Boxes', The Shaker Messenger, 1987.

187 See Ketchum, W.C., Simple Beauty – The Shakers in America, 1996, p. 44: 'Oval wooden storage boxes have long been one of the most readily identifiable and desirable of Shaker collectibles. However, long-time enthusiasts were still astonished when small (6 to 8 inch) boxes in paint brought $10,000 and more at auction in the 1980s and early 1990s. While these prices may be largely attributed to clever promotion and naive, nouveau riche customers, the fact remains that the oval box stands as a leitmotif of the Shaker culture.'

188 Sharon Koomler writes about Shaker boxes in Shaker Style – Form, Function, and Furniture, 2000, pp. 111–12 and states on p. 111: 'In antique stores, auctions and estate sales, oval boxes are constantly said to have a Shaker origin. That claim tends to drive the price up! Oval boxes were produced by craftsmen in Europe and America long before the Shakers at Mount Lebanon began producing them in the 1790s. Shaker craftsmen took great pains, however, to improve and refine the common pantry box. The slender "swallowtail-shaped" overlapping finger joints and thinly planed rims of most Shaker boxes are evidence to the success of those efforts. In addition, a letter from Mary Earle Gould to Faith Andrews (dated January 25, 1968) states: "Dear Faith Andrews, For some time, there has been a question on my mind that has not been answered. It is about the Shaker boxes. As you will know, I had had some correspondence with your husband in the past, when I was beginning my research on the pantry boxes. I have that rare book of the Shakers, put out so long ago. I have always claimed that the Shaker boxes were oval and the laps were called 'fingers'. I have never wanted to call a round box a Shaker box nor any pointed lap a Shaker lap. No mention is made in that book about round boxes, or plain pointed laps being of Shaker origin."'

189 Refer to Pranian, H. & Pranian, R., Catalogue for Shaker: The Simple Form – Outstanding Works from Chicago Collections, 1992, no page numbers but taken from the section on oval boxes. The exhibition

featured Brother Delmer Wilson as the last maker of Shaker oval boxes who worked at Sabbathday Lake, Maine, until 1961. See Wertkin, G.C., *The Four Seasons of Shaker Life*, 1986 in which Delmer Wilson features throughout, with a specific reference on pp. 112–13. There is also a photograph (p. 33) of some Shaker oval boxes in a variety of colours.

190 See Ord Manroe, C., *Shaker Style: The Gift to be Simple*, 1991, p. 104. In addition, a number of illustrations of Shaker boxes are shown including a photograph of the oval-box-making workshop at Hancock.

191 Ketchum, W.C., *Simple Beauty – The Shakers in America*, 1996, p. 44 states: 'By 1834, sizes were standardised, and the 1845 revision to the Millennial Laws directed that "oval or nice boxes may be stained reddish or yellow." Examples of green and blue are also found as well as the more common varnish finish.'

192 See Koomler, S., *Shaker Style – Form, Function, and Furniture*, 2000, p. 111, in which a photograph showing a box belonging to Eldress Betsy Smith at South Union, Kentucky clearly shows a decorated upper lid which apparently was not common. Also see Klamkin, M., *Hands to Work; Shaker Folk Art and Industries*, 1972, p. 144, which features a photograph of a decorated Shaker box which is varnished and stencilled in brown.

193 See Kirk, J.T., *The Shaker World: Art, Life, Belief*, 1997, p. 154 in which a box is illustrated and described as being from New Lebanon or Watervliet, dated around 1800–20 and having a grain painted red-brown surface over a yellow base coat.

194 A carved box is illustrated in Meader, R.F.W., *Illustrated Guide to Shaker Furniture*, 1972, p. 91 with the following annotation: 'Special presentation oval box, made for Eldress Emily M. Offord of Mt Lebanon in 1869. While not a piece of furniture, the oval box was very generally associated with furniture and was an exceedingly characteristic item. It was used as a general container (but never as a cheese box). The multiple delicate "fingers", used primarily for strength but serving also as an unobjectionable element of grace and beauty, mark such boxes as of Shaker manufacture; "World's" boxes did not employ fingers of this type. The heavily carved lid, so thoroughly mid-Victorian, is exceedingly rare, and such work was generally forbidden. Obviously, in deference to her rank, the usual prohibition was set aside for Eldress Emily … (Shaker Museum, Old Chatham, NY).'

195 Examples exist in various museum collections, for example in Philadelphia Museum of Art a beautiful spool box in maple, pine, chestnut, copper tacks, silk and cotton thread is shown in the Shaker gallery.

196 See Sprigg, J. & Johnson, J., *Shaker Woodenware: A Field Guide – Volume 1*, 1991, pp. 28–29.

197 See Sprigg, J. & Johnson, J., *Shaker Woodenware: A Field Guide – Volume 1*, 1991, pp. 38–39.

198 See Andrews, E.D., *The Community Industries of the Shakers*, 1932, p. 159.

199 A reproduction Shaker box, being presented to Prince Philip as a gift, is featured in a photograph in Armitage, A., 'Trustees Chairman the Countess of Airlie presenting a Shaker-style Box to HRH Prince Philip', *The American Museum in Britain – Newsletter Number 15*, 2003/04.

200 See Becksvoort, C., *The Shaker Legacy*, 1998, p. 27 in which a John Wilson box is illustrated. In addition, Wilson is photographed alongside a tack machine on p. 28.

201 See Wilson, J., 'Shaker Oval Boxes – Reproductions Make Fine Gifts or Storage', *Fine Woodworking*, 1993, p. 54. Other articles by Wilson include 'Reflections of How Admirers Of Shaker Way Practice Sharing Today', *The Shaker Messenger*, 1985.

202 Shaker boxes have been reviewed generally in Klamkin, M., *The Collector's Book of Boxes*, 1972 and Serette, D., *Shaker Smalls*, 1983.

203 See Bowe, S.J., *Watervliet Shakerism*, Master's Thesis, 1994.

204 Taken from Scotts of Stow Autumn 1999 catalogue, p. 14.

205 The Tesco Direct mail order catalogue of 2000 featured furniture: see p. 10 of number C19.

206 The Shaker Shop has cornered the market in the United Kingdom for Shaker-styled objects and has several mail order catalogues, plus an Internet site.

207 See the television programme Weymouth, T. (ed.) & Holdsworth, J. (producer), *To DIY For*, 2001.

208 See Darley, G., 'The Power House', in Rivers, T. *et al.*, *The Name of the Room*, 1992, p. 141.

209 This has been evidenced by a significant increase in all press interest including specialist press: for

Selling Shaker

example, Van Kolken, D., 'McDonald's Helps Shaker Heritage Society Purchase Broom-Making Equipment', *The Shaker Messenger*, 1991.

210 While the trend for reproduction kitchens is very much a recent phenomenon, some were producing styled kitchens in the 1960s. For example, a letter was sent to Mrs Edward Deming Andrews from Rachel E. Rekfeldt in which she shows a 'Shaker House' with Shaker kitchen. In the letter it states: 'This is a long overdue note to thank you for the beautiful book you sent a year ago this month. "Religion in Wood" has been invaluable, a delight and inspiration. The enclosed snapshots are proof of how extensively your books have been used.' (The Edward Deming Andrews Memorial Collection, Winterthur Library, Box 28.)

211 Some research on the Internet will establish that companies in both the United States and Australia offer Shaker-inspired kitchens.

212 See MacCarthaigh, S., 'Property Supplement – Gimme that old-time ... Kitchen', *The Irish Times*, 1999.

213 See Van Der Zee, B., 'Space. Cheat Chic – Shaker Kitchens', *The Guardian*, 1997.

214 See Bergen, K., 'Original Recipe for Shake and Bake', *The Times*, 1998.

215 See Bergen, K., 'Original Recipe for Shake and Bake', *The Times*, 1998.

216 Boyer, M.F., 'As French as Apple Pie', *The World of Interiors*, 1998, features a Shaker-styled bathroom (with Shaker storage boxes); the property was located in France. Magnet (UK) also produce a 'Bathrooms and Accessories' collection including the 'Chianciano' range; the catalogue states: 'Our Chianciano bathroom suite features traditional English styling, and gives the overall impression of subtlety and elegance. We've teamed it with New England, Shaker style decor to create a beautifully warm and welcoming room' (p. 23).

217 Allnutt, A., 'Little Girl Blue', *House Beautiful*, 2000, features a children's bedroom with a number of Shaker-styled and quasi-styled products and decorations. In reality, although the room was called Shaker-inspired, there was nothing in it which bore any real Shaker influence: it was very elaborate and highly decorated in gingham checks and red borders. MFI ('Bridgeport Bedroom'), Index Extra ('The Mayflower Collection') and Schreiber ('Harvard Cherry') all produce bedroom furniture with Shaker influences.

218 Tesco uses its *Club Card Magazine* to communicate with its customers.

219 For a comparison see Gossett, A.R., 'An American Inspiration: Danish Modern and Shaker Design', *The World of Shaker*, 1977.

220 See the television programme Thomson, G. (producer) & Walton, S. (executive producer), *IKEA Mania*, 2000 and also Moss, S., 'The Gospel According to IKEA', *The Guardian*, 2000.

221 There has been a huge proliferation of interest in DIY and interior styling in the United Kingdom, as evidenced in the number of magazines available on the topic and also the rise of B&Q and other companies catering for the ever-increasing market.

222 See Dean, A., 'Weekend Makeover Winner – Movers into Shakers', *The Daily Mail*, 1998.

223 In addition to Shaker kitchens, Magnet have also developed a range of Shaker-inspired furniture that co-ordinates with the kitchens. The range is offered in both birch and a painted finish.

224 See Swengley, N., 'Shaking All The Way To The Stove', *The Sunday Telegraph*, 1996.

225 See Swengley, N., 'Shaking All The Way To The Stove', *The Sunday Telegraph*, 1996.

226 Refer to the television programme Jackson, V., *Real Rooms*, 1998.

227 Refer to the television programme Hackman, W. (ed.) & Hill, A. (producer), *Changing Rooms*, 1998.

227 See the television programme Bristow, M. (series producer) & Fisher, P. (ed.), *DIY SOS*, 2000.

229 See *Real Rooms Booklet 3*, p. 29, produced to augment the television series: see Jackson, V., *Real Rooms*, 1998.

230 Kitchens are discussed in Bergen, K., 'Original Recipe for Shake and Bake', *The Times*, 1998.

231 Bergen, K., 'Original Recipe for Shake and Bake', *The Times*, 1998 states: 'Kitchens cost around £8,000 depending on size, though a £27,000 kitchen is being constructed now for a large house in Ireland. "To some extent you can take your kitchen with you when you move," [Kate Spontana, a spokeswomen for Shaker Ltd] adds. "Some customers only want 60 per cent fitted kitchen. The remaining 40 per cent, like free standing cupboards, can be removed along with the rest of the furniture."' Both

Magnet kitchens and Plain English cupboard-makers were recommended in Van Der Zee, B., 'Space. Cheat Chic – Shaker Kitchens', *The Guardian*, 1997.

232 A number of kitchen-fitting companies were recommended in Swengley, N., 'Shaking All The Way To The Stove', *The Sunday Telegraph*, 1996. They include Alno, Andrew Macintosh, Magnet, Newcastle Furniture Company and Rhode Design. In addition, the John Lewis Partnership produces the 'Vermont' kitchen with some strong Shaker influences.

233 The Hygena 'Burlington' range, described in the 1997/98 catalogue as: 'Burlington Classic Shaker with a Modern Touch – Breathtaking is the only way to describe Burlington. Not only does it feature the latest in Shaker styling with smart square symmetrical lines but it is finished in a beautiful shade of aquamarine. That's not all – the doors and drawer fronts are crafted from PVC for superb durability and easy care. The final design flourish is provided by the maple wood knob – a perfect contrast for the doors.'

234 MFI featured in Murphy, A., 'Cooler Shaker', *Observer Life*, 1997, p. 16: 'No longer the preserve of those who can afford full-blown luxury, the sparse style has filtered down-market. MFI launched its first Shaker kitchen two years ago, which was an immediate success. David Tracey, the merchandise director, explains that MFI "follows trends rather than leading them. We recognised a movement away from ornate kitchens. Shaker style struck a chord with our customers." Tracey happily admits that MFI has appropriated the style for its own ends: "Our cabinet doors are faithful reproductions but then we bring in 'added-value features' such as wine racks, canopies and glass doors, which is what people want." All this for an average of £1,200 for a complete kitchen, none of which has been anywhere near a craftsman. For the mass-producer, Shaker style is a gift, its simplicity making it cheap and easy to manufacture. MFI is now launching Shaker bedroom and living-room furniture. "We will sell the full works – pegboards and everything," says Tracey.'

235 See Van Der Zee, B., 'Space. Cheat Chic – Shaker Kitchens', *The Guardian*, 1997.

236 For an example of a Shaker kitchen in an actual Shaker site see Stephen, C., 'A Look Into The Kitchen At South Union', *The Shaker Messenger*, 1980.

237 See the Andrew Macintosh catalogue which was recommended in Swengley, N., 'Shaking All The Way To The Stove', *The Sunday Telegraph*, 1996.

238 Alno Kitchens were recommended in Swengley, N., 'Shaking All The Way To The Stove', *The Sunday Telegraph*, 1996.

239 See Murphy, A., 'Cooler Shaker', *Observer Life*, 1997, p. 16.

240 See Williams, F., 'On the Shaker Trail', *BBC Homes and Antiques*, 2003, p. 105 and the travellers' notes.

241 Tirrell-Wysocki, D., 'Learning About Shaker Ways', *The Philadelphia Inquirer*, 1999.

242 Harper, L., 'Designers Retreat – A Time for Reflection', *Graphis*, 1996, describes how a group of designers stayed at Pleasant Hill for three days in May 1996: 'The legacy of the Shakers is the lesson that the quality of our work, beauty of our surrounds and how we live our lives can be as one.' Also for a view of Pleasant Hill see Doyle, C., 'Divine Simplicity (Travelling to Kentucky)', *Homes & Gardens*, 2001.

243 See Murphy, A., 'Cooler Shaker', *Observer Life*, 1997, p. 14. The text continues: 'In *Religion in Wood*, there is a confessional footnote that explains how Andrews had to photograph in the attic of a dwelling house because elsewhere there was wallpaper and linoleum which wasn't to his taste. Today, one of the best-known features of a Shaker interior is the way in which chairs were hung on the pegboards. This was, in fact, another Andrews invention: only small items such as mirrors or lamps were hung up. Just as Andrews never photographed rooms that were lived in, nor did he photograph living Shakers, instead publishing woodcut portraits from 100 years earlier. And all this time, according to Thomas Dennelly of the Hancock Shaker Museum (of which Andrews was the first director), he was "schmoozing the sisters in return for his 'friendship', he would be given a piece of furniture, or buy it for a couple of dollars, only then to sell it on for much more." As his books became bestsellers, he would cream off thousands of dollars more.'

244 See Ingersoll, I. & Miller-Mead, G., *The Art of Woodworking – Shaker Furniture*, 1995; Moser, T., *How to*

Build Authentic Shaker Furniture, 1995; Linley, D., Extraordinary Furniture, 1996; Sonday, R., Shaker Style Wood Projects, 1997; and Pierce, K., Making Shaker Woodenware, 1998.

245 Chris Becksvoort in Fine Woodworking details Shaker style for current makers and he has also produced a guide on handmade furniture: see Becksvoort, C.H., Understanding Handmade Furniture – A Guide, 1990.

246 Becksvoort, C., The Shaker Legacy, 1998, p. 65.

247 Woods, C.R., ''Tis the Gift to be Simple' Folding Screenbook, 1995.

248 Refer to Coulter, W. & Phillips, B., Music On The Mountain, 1996 and also the radio programme Brubeck, D., Brubeck's Cool Jazz, An 80th Birthday Celebration, 2000 in which Shaker influence is featured.

249 See Federer, K. & Federer, M., Shaker Paper – A Mixed Bag, 1996.

250 See Hulings, M.A., Shaker Days Remembered, 1989; De Wolfe, E.A., Shaking the Faith, 2002; and Thurman, S.R., O Sisters Ain't You Happy?, 2002.

251 Refer to Thorne-Thomsen, K., Shaker Children – True Stories and Crafts – 2 Biographies and 30 Activities, 1996 and Morse, F. & Newton, V., A Young Shaker's Guide to Good Manners, 1997.

252 See Mahoney, K., Wisdom From a Shaker Garden, 1998 and Donaldson, S., The Shaker Garden, 2000.

253 Mielech, R.A., 'Kentucky Theatre Presents Shaker Play', The Shaker Messenger, 1995. Also the production 'As it is in Heaven' by Arlene Hutton, performed at the Edinburgh Festival, 3–27 August 2001.

254 Refer to the television and radio programmes Goodwin, D. (ed.), Shaw, S. & Shaw, T., Home Front, 1996; Roper, D. (producer) & Grossman, L. (presenter), Simple Gifts, 1996; and Hackman, W. (ed.) & Hill, A. (producer), Changing Rooms, 1998.

255 See Downing, M., Perfect Agreement, 1998; Woodworth, D., Death of a Winter Shaker, 1997; and Woodworth, D., A Deadly Shaker Spring, 1998.

256 Taken from Delbanco, A., 'The Art of Piety (Extended Book Review of S. Stein's book The Shaker Experience in America', The New Republic), 1992, pp. 40–41.

257 See Jackson, P., 'New England ... born in old England', The Independent, 2004: 'An artist's impression in the style of a Shaker plan hangs on the wall of the marketing suite, showing names such as Vermont Hill, Pleasant Hill Road and Prospect Drive. In New England Place, the first of the five neighbourhoods, the reds, greys and blues chosen for specific village sites by the Shakers have been used in the houses and apartments.'

258 See website for The Foundation for Religious Freedom in which it states: 'Last 4 Shakers find plenty of "Friends"'; it names the four as Sister Frances Carr, Sister June Carpenter, Brother Arnold Hadd and Brother Wayne Smith.

259 Exhibition press release, 10 April 2001.

260 Callison, J., 'Museum to showcase Shaker Craftsmanship', The Cincinnati Enquirer, 4 October 2001.

261 Shaker exhibits also continue to look at the design and appropriateness of the object for the purpose it was to serve, for example the exhibition 'Inspired Choices – Creations of Shaker Life'. See 'Gallery Guide' at the Heritage Plantation of Sandwich.

262 See the television programme Amirani, A. et al., Meet Thy Shaker, 2000.

263 See the television programme Elphick, M. (ed.) & Carter, S. (producer), Changing Rooms, 2001.

PLATES

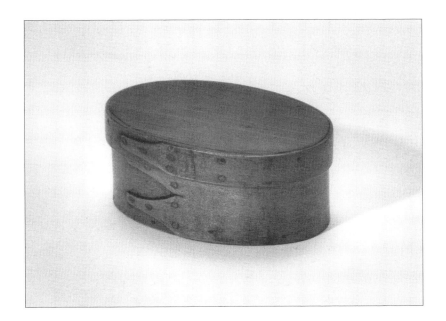

Photograph 1

An original Shaker box probably from New Lebanon, third quarter of the nineteenth century. Pine with maple. Purchased from Yellow House Antiques, USA.

Dimensions 93 x 62 x 40 mm.

Photograph by Nick Coughlin.

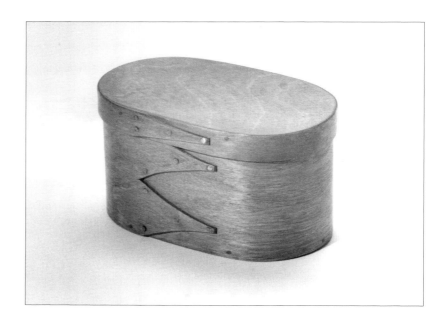

Photograph 2

Shaker-style small wooden box. Purchased from Liberty & Co., London, UK. Unknown manufacture. Plywood construction with a mid-brown stain which was used as the outer protective packaging for a Christmas cake. *Circa* early 1990s.

Dimensions 130 x 80 x 70 mm.

Photograph by Nick Coughlin.

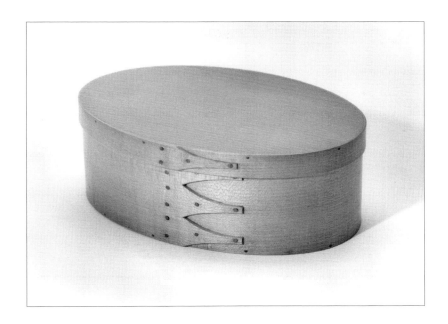

Photograph 3

A Shaker box made by Simple Gifts, Berea, Kentucky, USA. Purchased at Pleasant Hill, Kentucky, USA. The box was manufactured by Charles Harvey, *circa* 1991.

Dimensions 225 x 155 x 82 mm.

Photograph by Nick Coughlin.

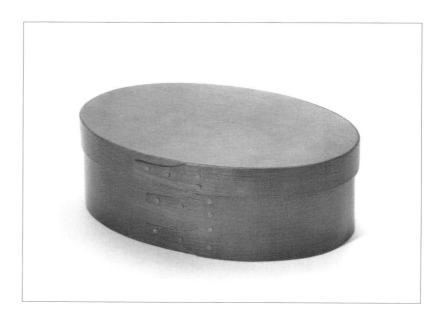

Photograph 4

Shaker-style wooden ply box. Purchased from Boots the Chemist. Far East manufacture. Part of a men's 'Monograph' gift set. *Circa* 1993.

Dimensions 195 x 135 x 70 mm.

Photograph by Nick Coughlin.

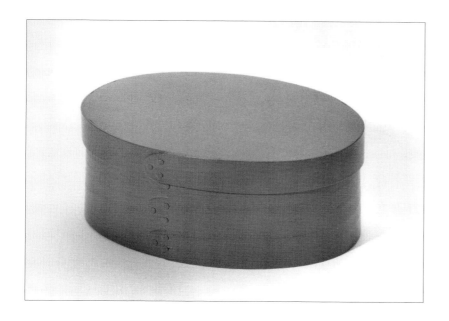

Photograph 5

Shaker-style box purchased from IKEA, Warrington, UK. Far East manufacture. Created from wooden ply with additional paint surface (yellow, red, green or blue). In production *circa* 1993.

Dimensions 175 x 125 x 75 mm.

Photograph by Nick Coughlin.

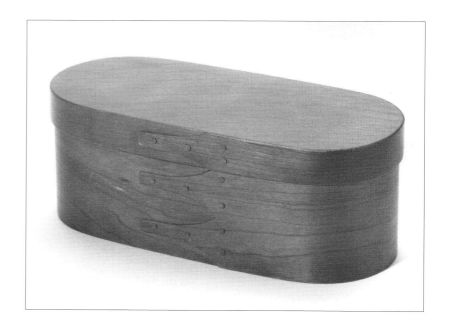

Photograph 6

Shaker-style ply box (distorted oval). Purchased from Marks and Spencer. Far East manufacture. Sold as part of a gift package for toiletries. *Circa* 1993/94.

Dimensions 225 x 98 x 88 mm.

Photograph by Nick Coughlin.

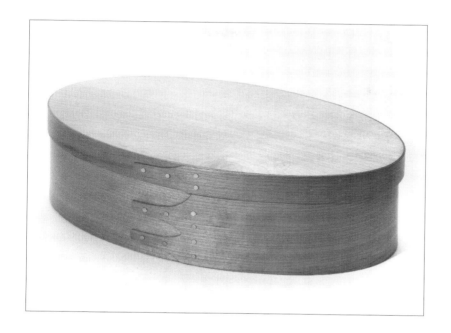

Photograph 7

Large Shaker-style ply box. Purchased from Marks and Spencer. Far East manufacture. Sold as part of a gift package for toiletries. *Circa* 1994/95.

Dimensions 270 x 165 x 78 mm.

Photograph by Nick Coughlin.

Photograph 8

Shaker box in solid cherry wood. Purchased from Hancock Shaker village. Manufactured by Canterbury Woodworks, Canterbury, New Hampshire, USA. Authentic Shaker box which internally has been adapted for card storage. *Circa* 1995.

Dimensions 187 x 130 x 100 mm.

Photograph by Nick Coughlin.

Selling Shaker

Photograph 9

Shaker-style box with unusual jointing system. Purchased from the Shaker Shop, London, UK. Made by Frye's Measure Mill, Wilton, New Hampshire. *Circa* 1995.

Dimensions 83 x 60 x 40 mm.

Photograph by Nick Coughlin.

Photograph 10

Black walnut Shaker box. Made by AB Woodworking. English manufacture. Purchased direct from the manufacturer. *Circa* 1996.

Dimensions 215 x 153 x 86 mm.

Photograph by Nick Coughlin.

Photograph 11

Shallow cherry and birdseye maple Shaker box. Made by AB Woodworking. English manufacture. Purchased direct from the manufacturer. *Circa* 1997.

Dimensions 119 x 75 x 25 mm.

Photograph by Nick Coughlin.

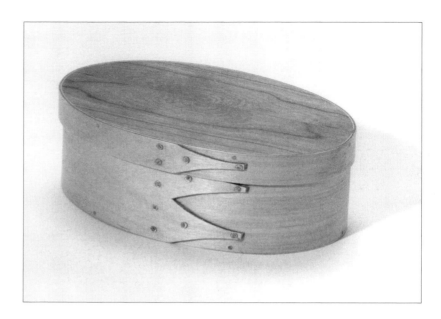

Photograph 12

A Shaker birch ply box with a cherry ply top from Wales. Purchased from The National Trust Shop, Erddig, Wales. Made by Alan and Naomi Scott. *Circa* 1997.

Dimensions 154 x 100 x 55 mm.

Photograph by Nick Coughlin.

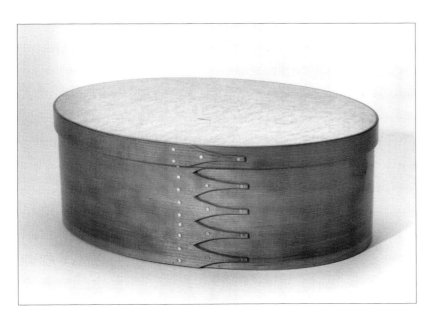

Photograph 13

A Shaker box by the maker John Wilson, USA. Purchased from the Shaker Shop, London, UK. *Circa* 1997.

Dimensions 430 x 295 x 168 mm.

Photograph by Nick Coughlin.

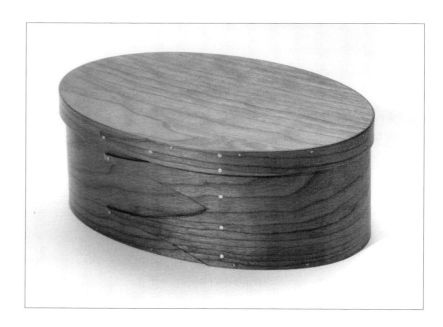

Photograph 14

A Shaker box purchased from The Art Room, UK. English manufacture. *Circa* 1998.

Dimensions 152 x 125 x 90 mm.

Photograph by Nick Coughlin.

Selling Shaker

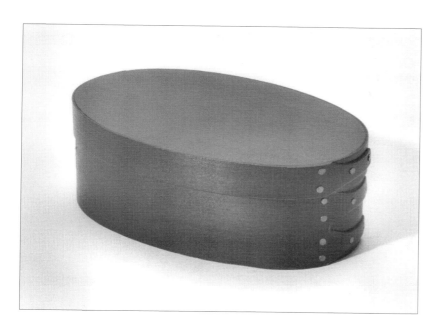

Photograph 15

Shaker-style wooden ply box. Purchased from Boots the Chemist. Far East manufacture. Sold as part of their Christmas gift range. *Circa* 1998.

Dimensions 175 x 110 x 70 mm.

Photograph by Nick Coughlin.

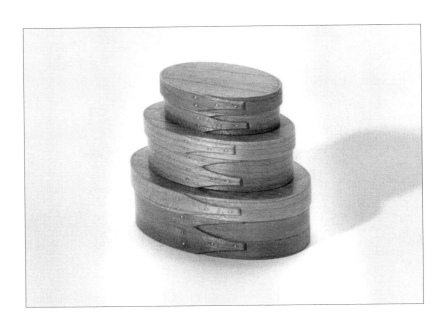

Photograph 16

A miniature set of Shaker boxes, USA. Purchased from the Shaker Shop, London, UK. Created by Paul Dixon for Orleans Carpenters. Circa 1998.

Dimensions 64 mm high.

Photograph by Nick Coughlin.

Selling Shaker

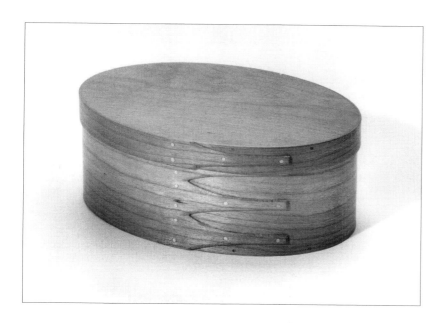

Photograph 17

Shaker box made from cherry wood with slightly elongated overlap swallowtails. Made by Wooden Dreams, Missouri, USA. Purchased direct from the manufacturer. *Circa* 1999.

Dimensions 218 x 150 x 90 mm.

Photograph by Nick Coughlin.

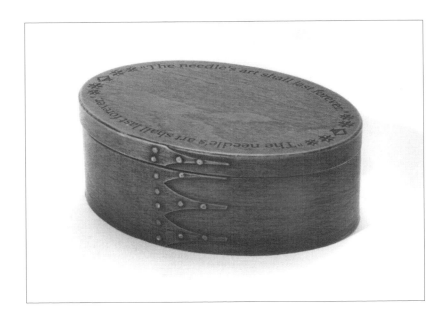

Photograph 18

A faux wood Shaker box from the UK. Purchased from Sudeley Castle, Gloucestershire, UK. *Circa* 1999.

Dimensions 148 x 105 x 55 mm.

Photograph by Nick Coughlin.

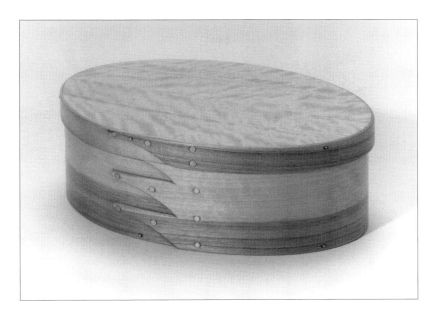

Photograph 19

A Shaker box from Jefferson Woodworking, Sumas, Washington, USA. Purchased from the Smithsonian Museum, Washington, USA. Made from western white birch by Lance and Karen Howell. *Circa* 1999.

Dimensions 240 x 160 x 90 mm.

Photograph by Nick Coughlin.

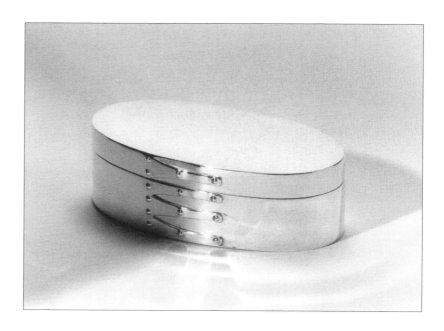

Photograph 20

A silver-plated Shaker-style box. Purchased from the Shaker Shop, London, UK. *Circa* 1999.

Dimensions 140 x 76 x 45 mm.

Photograph by Nick Coughlin.

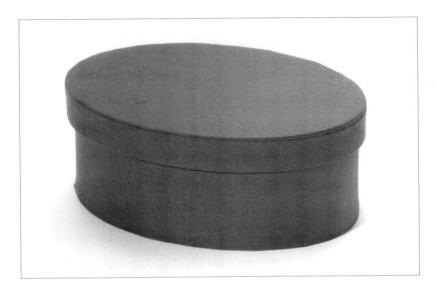

Photograph 21

Cardboard 'Shaker' box. Purchased from the Shaker Shop, London, UK.

Sold as part of the packaging for toiletries, individually or in a stack of three in a choice of either cream or blue. *Circa* 1999.

Dimensions 152 x 110 x 60 mm.

Photograph by Nick Coughlin.

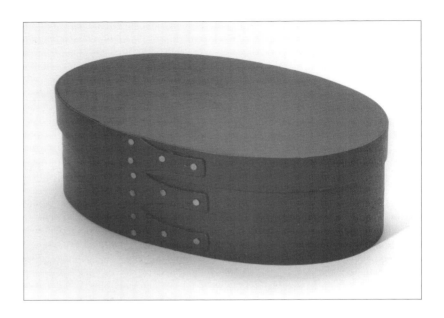

Photograph 22

Painted Shaker-style wooden box. Purchased from Lakeland Plastics, Windermere, UK. Far East manufacture. Part of a set of three and constructed in juniper plywood with a cobalt blue paint. *Circa* late 1990s.

Dimensions 197 x 137 x 70 mm.

Photograph by Nick Coughlin.

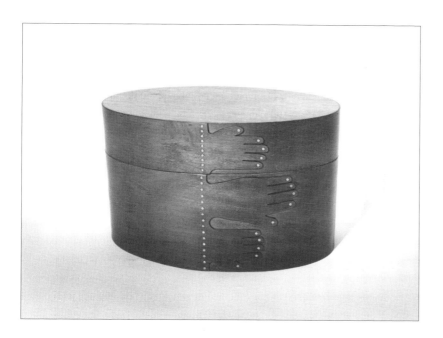

Photograph 23

Shaker-style box with a series of small hands used as the jointing system. Purchased from Frye's Measure Mill, the box is in stained fruitwood ply. *Circa* 2000.

Dimensions 300 x 215 x 190 mm.

Photograph by Nick Coughlin.

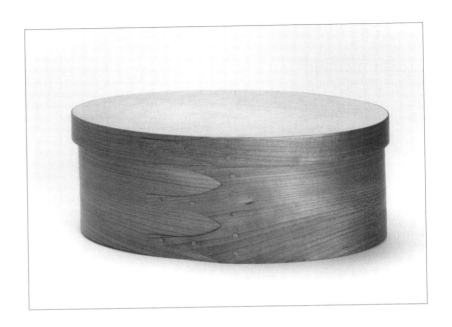

Photograph 24

Box purchased from The Conran Shop, UK. Part of a bathroom storage range. Unspecified manufacture. *Circa* 2000.

Dimensions 248 x 170 x 98 mm.

Photograph by Nick Coughlin.

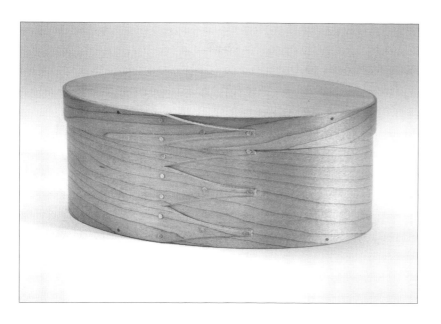

Photograph 25

Maple Shaker box. Made by AB Woodworking. English manufacture. Purchased direct from the manufacturer. Maple is used for the sides and top/bottom. *Circa* 2001.

Dimensions 215 x 153 x 86 mm.

Photograph by Nick Coughlin.

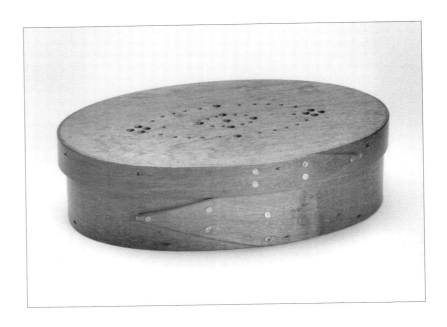

Photograph 26

A Pot Pourri Shaker Box. Made in USA and purchased in the UK from Nantucket
– New England Crafts. *Circa* 2001.

Dimensions 154 x 108 x 50 mm.

Photograph by Nick Coughlin.

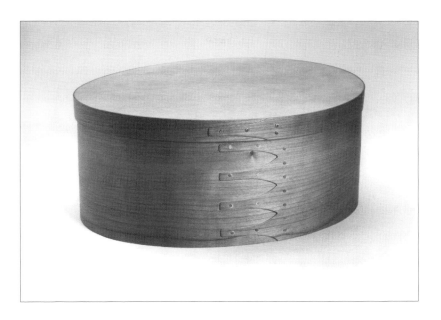

Photograph 27

Shaker-style storage box. Purchased from Tesco, UK. Far East manufacture. Sold as part of their house storage range. The box is made from very thin ply and was on sale for under £10.00. *Circa* 2001.

Dimensions 305 x 223 x 140 mm.

Photograph by Nick Coughlin.

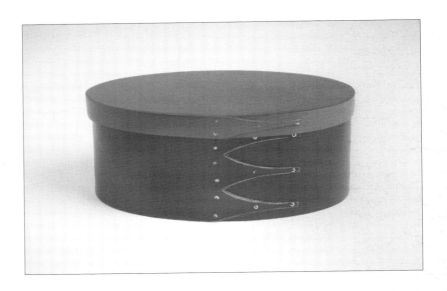

Photograph 28

A reproduction Shaker box (one of a set of three). Purchased from the Shaker Store, Ballitore, Ireland. Manufactured in the USA by Shaker Workshops. The box is made in cherry wood painted black and based on the famous set from New Lebanon (in the collection of Hancock Shaker village). *Circa 2002.*

Dimensions 240 x 165 x 98 mm.

Photograph by Nick Coughlin.

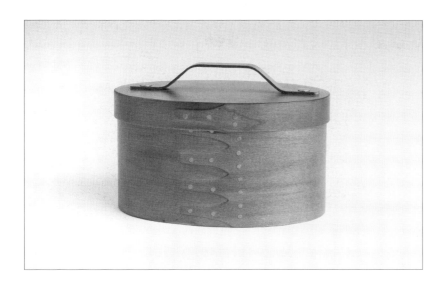

Photograph 29

A pantry box (in a Shaker style). Purchased from Past Times, UK. Far East manufacture. *Circa* 2002.

Dimensions 182 x 126 x 106 mm.

Photograph by Nick Coughlin.

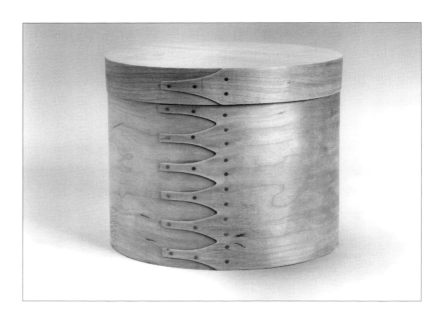

Photograph 30

Shaker-style storage box. Purchased from Next, UK. Far East manufacture. Purchased as part of a set of three round boxes in very thin plywood. *Circa* 2002.

Dimensions 250 x 250 x 210 mm.

Photograph by Nick Coughlin.

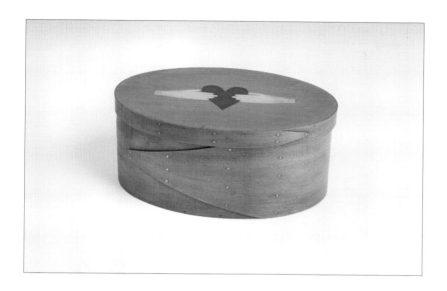

Photograph 31

Decorated Shaker-style box. Purchased from the Shaker Shop, London, UK. Manufactured in the USA. A fruitwood box with applied decoration by Toni Hardy, themed on the hand/heart motif in cream and red. *Circa* 2003.

Dimensions 292 x 210 x 138 mm.

Photograph by Nick Coughlin.

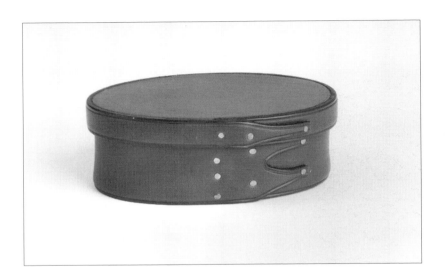

Photograph 32

Shaker-style box in leather. Purchased from the Shaker Shop, London, UK. Manufactured in Kentucky, USA. Bridle leather with copper tacks. *Circa* 2004.

Dimensions 128 x 82 x 45 mm.

Photograph by Nick Coughlin.

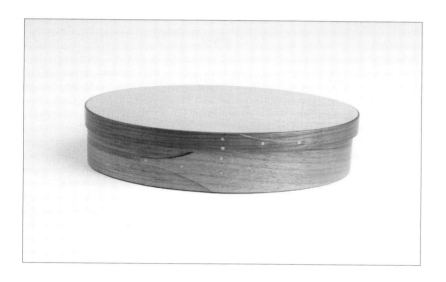

Photograph 33

A shallow Shaker button box. Purchased from the Shaker Museum and Library, Old Chatham, USA. Manufactured in Canada. A well-made box in the unusual combination of walnut and birdseye maple. It is one of the few boxes in which the fingers go in opposite directions (the lid and base). *Circa* 2004.

Dimensions 254 x 180 x 57 mm.

Photograph by Nick Coughlin.

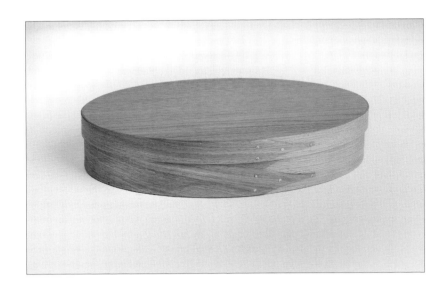

Photograph 34

A shallow (but large) Shaker button box. Made in France by B. Horton. Purchased from the manufacturer. An unusual box because it is made of oak. The maker is interested in using ecologically sound sources of wood, native to the area in which he works. *Circa* 2004.

Dimensions 375 x 270 x 75 mm.

Photograph by Nick Coughlin.

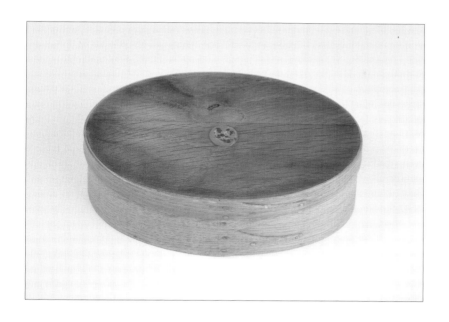

Photograph 35

An unusual Shaker-style box with metal insert. Made in France by B. Horton. Purchased from the manufacturer. *Circa* 2004.

Dimensions 150 x 96 x 55 mm.

Photograph by Nick Coughlin.

Photograph 36

Bathroom set purchased from Heal's, UK. Developed as part of a range of four pieces. Unspecified manufacture. Made of thin ply, copper tacks, stainless steel and white ceramic. *Circa* 2005.

Soap dish dimensions 112 x 112 x 43 mm.

Photograph by Stephen Bowe.

Photograph 37

A Shakeress: Sadie Neale.

This photograph was taken by William Winter and it appeared on the front cover of the catalogue for the 1940 exhibition 'Shaker Art and Craftsmanship' at Berkshire Museum. The handled box shown on the photograph was produced by George Roberts of New Lebanon, New York. Roberts was hired by Sadie Neale to make boxes but was not a Shaker himself.

William F. Winter, photographer, Private Collection.

Photograph 38

The original Shaker Shop located in Harcourt Street, London, UK.

The Shaker Shop (Shaker Ltd) has done much to promote the Shaker aesthetic to an increasingly design-conscious audience. Shaker was located in a number of premises in London including King's Road, Marylebone High Street and Bloomsbury. It also briefly had a shop in the Cotswolds at Tetbury. Shaker Ltd has been taken over by Fired Earth Interiors (part of the AGA group) and will continue to sell Shaker-inspired goods from a network of shops in the United Kingdom.

Photograph by Stephen Bowe.

Selling Shaker

Photograph 39

A Shaker: Brother Delmer Wilson.

Photograph from Sabbathday Lake showing Brother Delmer Wilson (1873–1961) in front of carriers in production. The Sisters would line these with silk and they would be sold to the outside world as sewing boxes.

Collection of the United Society of Shakers, Sabbathday Lake, Maine, USA.

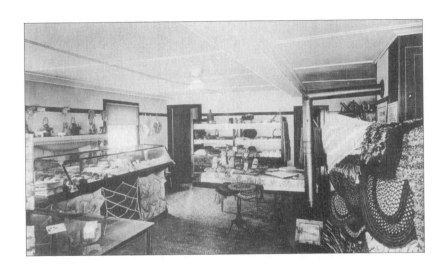

Photograph 40

An interior view of the Shaker Gift Shoppe at Hancock Shaker village, USA. This was sold as a postcard and was published in the 1930s.

C.W. Hughes & Co., Inc., Mechanicville, New York, USA.

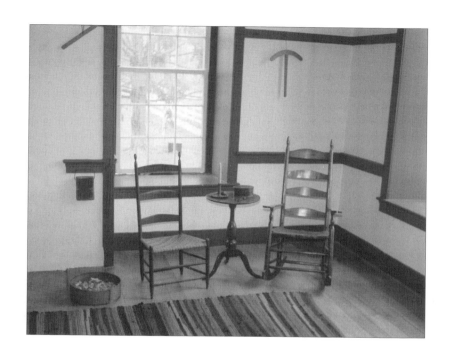

Photograph 41

An interior view taken of a room at Pleasant Hill, Kentucky, USA.

Photograph by Stephen Bowe.

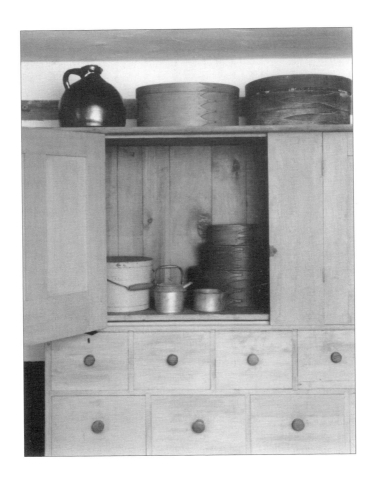

Photograph 42

An interior view taken of a room at Fruitlands Museums, USA, showing an apothecary cabinet made by Thomas Hammond of the Harvard Shakers.

Published courtesy of the Fruitlands Museums, Harvard, Massachusetts, USA.

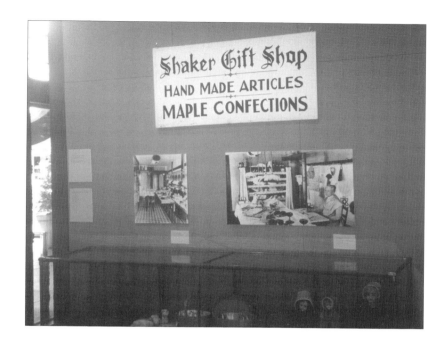

Photograph 43

An interior view of the Paine Webber Gallery, New York, USA.

Detailing part of the Shaker trades exhibition included in 'Shaker Gifts, Shaker Genius' at the Paine Webber Gallery, New York, USA in 1999. The artefacts for the exhibition came from the Shaker Museum and Library, Old Chatham, USA.

Photograph by Stephen Bowe.

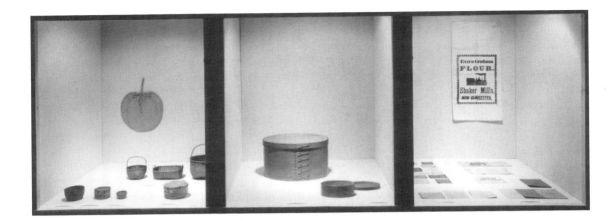

Photograph 44

An exhibition view taken from Manchester City Art Gallery, UK.

Showing an exhibition showcase containing domestic objects. 'The Shakers: The Life and Production of a Religious Community in the Pioneering Days of America' exhibition was held at City Art Gallery March/April 1975 before travelling to the V&A, London.

Courtesy of Manchester City Art Gallery, Manchester, UK.

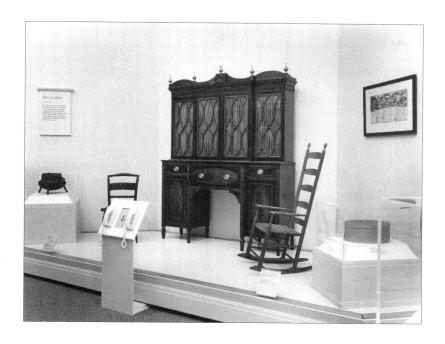

Photograph 45

View of a Shaker box and chair from the Perspective Gallery, Winterthur Museum, USA. The box has the object identification number of 1960.0119A.B. The box belonged to Mary Pomeroy Russell who donated it to the Winterthur Museum.

Courtesy of Winterthur Museum, Wilmington, Delaware, USA.

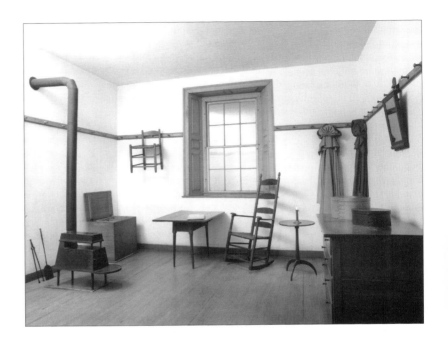

Photograph 46

The Shaker Period Room at the American Museum in Britain at Bath, UK.

The only Shaker room in the UK and used as a typical example of the Shaker aesthetic. The room was televised in the *Meet Thy Shaker* programme for Channel 5 with G. Gale talking about some of the furniture contained in the room.

Courtesy of the American Museum in Britain, Bath, UK.

Selling Shaker

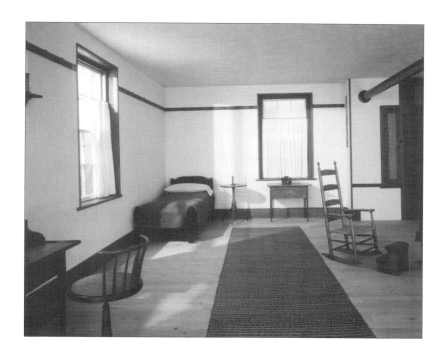

Photograph 47

The Shaker Period Room at the Metropolitan Museum, New York, USA.

This Shaker room evolved for more than a decade and was part of a major expansion and renovation of the American Wing. In 1972 woodwork was salvaged from the retiring room from the North Family Dwelling House in New Lebanon, New York before the building was demolished. The installation of the woodwork in its original configuration took place in 1980 and the room opened to the public on 11 November 1981.

Courtesy of Metropolitan Museum of Art, New York, USA. Emily C. Chadbourne Fund, 1972. (1972.187.1)

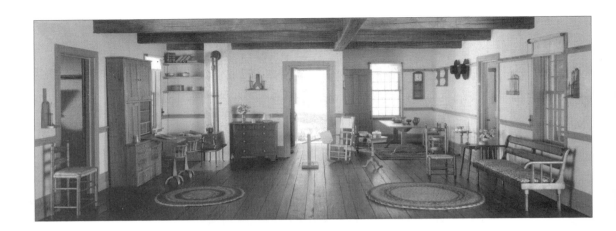

Photograph 48

The Shaker Room at the Chicago Institute of High Art, USA.

Part of the Thorne collection of miniature rooms. Typical of the Shakers production *circa* 1800 and made from mixed media in the workshops of Mrs James Ward Thorne around 1940. The room measures 22.9 x 55.2 x 62.5 cm.

Gift of Mrs James Ward Thorne, 1942.498 front. Courtesy of the Art Institute of Chicago, Chicago, USA.

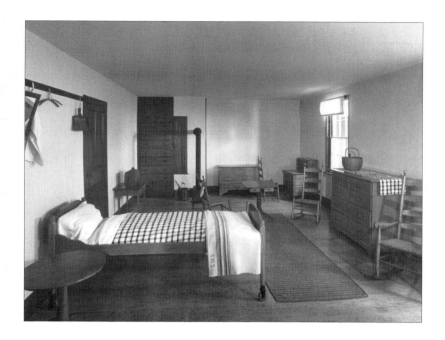

Photograph 49

The Shaker Period Room at the Philadelphia Museum of Art.

The annotation for the photograph gives the Shaker community at New Lebanon, New York as the main 'artist' and it is dated 1818–40. The accession number is 1973-3-1.

Courtesy of Philadelphia Museum of Art, Philadelphia, USA.

Photograph 50

The Shaker Period Room at Boston Museum of Fine Arts.

This room is not currently on view but is likely to be reinstated in a new American Wing. The accession number is 62.1556-1559.

Gift of Mrs F.L. Avery, reference number C22275. Courtesy, Museum of Fine Arts, Boston, USA.

Selling Shaker

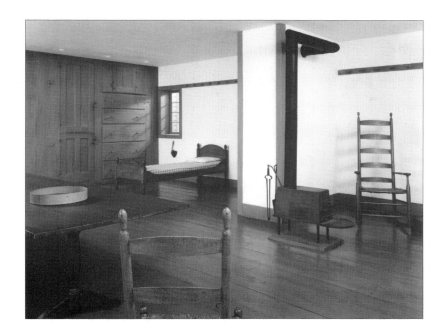

Photograph 51

The Shaker Period Room at the Henry Francis du Pont Winterthur Museum.

The period rooms at Winterthur were created in collaboration with Edward Deming Andrews and Faith Andrews in 1962. There is an opportunity to view the rooms in an extensive guided tour which takes in many of the period rooms in the main building.

Courtesy of Winterthur Museum, Wilmington, Delaware, USA.

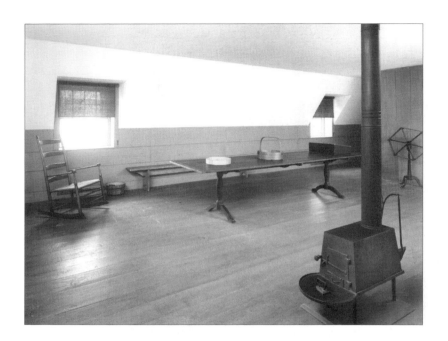

Photograph 52

The Shaker Period Room at the Henry Francis du Pont Winterthur Museum.

A further view of the period rooms at Winterthur. McKinstry, E.R. (comp.), *The Edward Deming Andrews Memorial Shaker Collection*, 1987, p. 301 states in the 'Artefacts' section: 'Although the Andrews collection is known chiefly for its printed and manuscript materials, it also contains artefacts important for the glimpse that they provide into the daily routine of Shaker lives … It is perhaps only fitting that many of these artefacts are on display in Winterthur's Shaker rooms.'

Courtesy of Winterthur Museum, Wilmington, Delaware, USA.

Photograph 53

A contemporary Shaker kitchen.

The kitchen units came from Magnet, UK. The kitchen also contains Shaker boxes from Lakeland Plastics and Shaker, London, plus an undisclosed source in the USA.

Private residence in the UK.

Photograph by Stephen Bowe.

Photograph 54

A Shaker-style bedroom.

With hanging shelf and various Shaker-styled products including textiles (Jane Churchill, UK and Laura Ashley, UK), boxes (Shaker, London), clock (Shaker Workshops, USA) and handled box (John Lewis Partnership, UK). Also includes a Shaker-style bedroom cabinet purchased from Littlewoods Index Catalogue, UK.

Private residence in the UK.

Photograph by Stephen Bowe.

Photograph 55

A Shaker-style dining room

With cabinet, table, chairs, boxes, placemats, coasters, tray and napkin rings (in maple and cherry) and also Shaker-inspired embroidery framed on the wall from a kit (Shaker Shops West, USA). Small items mainly purchased from the Shaker Shop, UK.

Private residence in the UK.

Photograph by Stephen Bowe.

Photograph 56

A Shaker-style bathroom

With built-in furniture, rug, boxes, stool and tinware, mainly purchased from the Shaker Shop, UK.

Private residence in the UK.

Photograph by Stephen Bowe.

BIBLIOGRAPHY

Whilst there are many books available on all aspects of the Shakers, only a limited number are recommended for serious reference. Clearly this includes any of the books produced by the Andrews partnership, with *Religion in Wood* ranking particularly highly in any suggested reading list. In addition, *The Shaker Experience in America* by Stephen Stein provides an excellent historical analysis of the Shakers. From the point of view of an analysis of Shaker design, two books come to mind – first, *The Shaker World: Art, Life, Belief* by John Kirk and secondly, June Sprigg's catalogue for *Shaker Design*. For general biographical information we suggest you consult Garraty and Carnes, *American National Biography* which provides excellent coverage of the majority of the principal protagonists in the promotion and selling of the Shakers. In addition, the *Historical Dictionary of the Shakers* by Duffield is useful for definitions and brief information on Shaker context. Many specialist books – far too many to be listed here – also exist and those recommended for particular reference have been indicated by an asterix. Television, video, music and radio material appear in a separate section at the end of the Bibliography. The Internet was selectively used for research and any standard search engine will register finds on the material in this study.

Abram, N., *Mostly Shaker From The New Yankee Workshop*, Little, Brown and Company, Boston, New York, USA & London, UK, 1992.

Adams, B., Jardine, L., Maloney, M., Rosenthal, N. & Shone, R., Catalogue for *Sensation – Young British Artists From The Saatchi Collection*, Thames & Hudson, London, UK, 1997.

Adams, C.C., 'Twenty-Fourth Report of the Director of the Division of Science and the State Museum', *New York State Museum Bulletin*, no. 288, New York State Museum, Albany, NY, USA, July 1931.

———, 'Twenty-Fifth Report of the Director of the Division of Science and the State Museum', *New York State Museum Bulletin*, no. 293, New York State Museum, Albany, NY, USA, June 1932.

———, 'Twenty-Sixth Report of the Director of the Division of Science and the State

Museum', *New York State Museum Bulletin*, no. 298, New York State Museum, Albany, NY, USA, April 1933.

——, 'Twenty-Seventh Report of the Director of the Division of Science and the State Museum', *New York State Museum Bulletin*, no. 301, New York State Museum, Albany, NY, USA, March 1934.

——, 'The New York State Museum's Historical Survey and Collection of the New York Shakers', *New York State Museum Bulletin – Annual Report*, no. 323, New York State Museum, Albany, NY, USA, March 1941, pp. 77–139.

——, 'One Hundred Fourth Report of the Director of the Division of Science and the State Museum', *New York State Museum Bulletin*, no. 330, New York State Museum, Albany, NY, USA, April 1942.

——, 'One Hundred Sixth Report of the Director of the Division of Science and the State Museum', *New York State Museum Bulletin*, no. 335, New York State Museum, Albany, NY, USA, January 1944.

——, 'One Hundred Seventh Report of the Director of the Division of Science and the State Museum', *New York State Museum Bulletin*, no. 337, New York State Museum, Albany, NY, USA, December 1944.

Adams, H.D., 'Whitney Museum Shows Shaker Handicrafts', *The Brooklyn Daily Eagle*, 24 November 1935, p. c13.

Adamson, J., 'A Prophetess Shaken and Stirred', *The Sunday Telegraph*, 23 July 2000, p. 14.

Alexander, E.P., 'Artistic and Historical Period Rooms', *Curator*, vol. 7, part 4, 1964, pp. 263–81.

Allen, C.M. & Andrews, E.D., *The American Shakers – A Celibate Religious Community* (pamphlet), The Shaker Press, Sabbathday Lake, ME, USA, 1974.

Allnutt, A., 'Little Girl Blue', *House Beautiful*, vol. 12, no. 10, 2000, pp. 136–38.

Anderson, J.M., 'Force and Form: The Shaker Intuition of Simplicity', *Journal of Religion*, vol. 30, October 1950, pp. 256–60.

Anderson, M.J., Landrey, G.J. & Zimmerman, P.D., *Cadwalader Study*, The Henry Francis du Pont Winterthur Museum, Wilmington, DE, USA, 1995.

Anderson, P., Catalogue for *American Folk Art from Western New York Collections*, Memorial Art Gallery of the University of Rochester, Rochester, NY, USA, 1986.

Andrews, E.D., *The New York Shakers and Their Industries. Circular 2 – Oct.*, New York State Museum, Albany, NY, USA, 1930.

——, *The Community Industries of the Shakers*, The University of the State of New York, Albany, USA, 1932.

——, Catalogue for *The Furnishings of Shaker Dwellings and Shops Exhibition from Oct.*

10–30. *Furniture, Industrial Material and Textiles of the Shakers of New England and New York. Camera Studies of the Shaker Communities of Hancock, Mass., and Mount Lebanon, N.Y.*, Berkshire Museum, Pittsfield, Mass, USA, 1932.

———, Catalogue for *Shaker Furniture*, Lenox Library Association, Lenox, MA, USA, 1934.

———, Catalogue for *Shaker Handicrafts*, Whitney Museum of American Art, New York, USA, 1935.

———, 'Antiques in Domestic Settings (Solutions and Suggestions). Summer Home of Dr and Mrs Edward Deming Andrews in Richmond, Massachusetts, USA', *The Magazine Antiques*, vol. 29, no. 1, January 1936, pp. 30–32.

———, 'Antiques in Domestic Settings (Solutions and Suggestions). Shaker Home of Dr and Mrs Edward Deming Andrews in Pittsfield, Massachusetts, USA', *The Magazine Antiques*, vol. 30, no. 4, October 1936, pp. 162–63; also in Rose, M.C. & Rose, E.M. (eds.), *A Shaker Reader*, Universe Books, New York, USA, 1977, pp. 76–79.

———, 'Communal Architecture of the Shakers', *American Magazine of Art*, vol. 30, no. 12, December 1937, pp. 710–15.

———, Catalogue for *Private Sale of Shaker Furniture From the Collection of Mrs Willard Burdette Force at 'Shaker Hollow'*, South Salem, Westchester County, NY, USA, not specified, 1937.

———, Catalogue for *Shaker Craftsmanship*, The Jones Library, Amherst, MA, USA, 1937.

———, Catalogue for *Shaker Art and Craftsmanship*, Berkshire Museum, Pittsfield, MA, USA, 1940.

———, 'Shaker Inspirational Drawings', *The Magazine Antiques*, vol. 48, no. 6, December 1945, pp. 338–41.

———, 'Kentucky Shakers', *The Magazine Antiques*, vol. 52, no. 5, November 1947, pp. 356–57.

———, 'Designed for Use – the Nature of Function in Shaker Craftsmanship', *New York History*, vol. 31, July 1950, pp. 331–41.

———, *The People Called Shakers: A Search for the Perfect Society*, Oxford University Press, New York, USA, 1953; Dover Publications Inc., New York, USA, 1963.

———, 'Shaker Influence – Traditionalists and Moderns Discover Virtues of Shaker Furniture – Honesty, Strength, Usefulness and the "Gift to be Simple"', *Look Magazine*, 23 March 1954, pp. 76–78.

———, 'Shaker Furniture', *Interior Design*, vol. 25, no. 5, May 1954, pp. 60–66.

———, 'The Shakers in a New World', *The Magazine Antiques*, vol. 72, no. 4, October 1957, pp. 340–43.

———, 'Shaker Design', *Art in America*, vol. 46, no. 1, Spring 1958, pp. 45–49.

———, Catalogue for *Shaker Inspirational Drawings – The Collection of Dr and Mrs Edward Deming Andrews*, Smith College Museum of Art, Northampton, MA, USA, 1960.

———, 'The Shakers in New England', *The New England Galaxy*, vol. 2, no. 1, Summer 1960, pp. 3–10.

———, 'The Shaker Manner of Building', *Art in America*, vol. 48, no. 3, Fall 1960, pp. 38–45.

———, *The American Shakers*, Shaker Community Inc., Hancock Shaker Village, MA, USA, 1961.

———, *The Gift to be Simple – Songs, Dances and Rituals of the American Shakers*, Dover Publications Inc., New York, USA, 1962.

———, 'Living with Antiques – A Shaker House in Canaan, New York', *The Magazine Antiques*, vol. 81, no. 4, April 1962, pp. 408–11.

——— & Andrews, F., 'Craftsmanship of an American Religious Sect', *Antiques*, vol. 14, no. 2, August 1928, pp. 132–36.

——— & Andrews, F., 'The Furniture of an American Religious Sect', *Antiques*, vol. 15, no. 4, April 1929, pp. 292–96.

——— & Andrews, F., 'An Interpretation of Shaker Furniture', *The Magazine Antiques*, vol. 23, no. 1, January 1933, pp. 6–9.

——— & Andrews, F., *Shaker Furniture: The Craftsmanship of an American Communal Sect*, Yale University Press, New Haven, CT, USA, 1937; Dover Publications Inc., New York, USA, 1964.

——— & Andrews, F., Catalogue for *Exhibition of Shaker Arts and Crafts at Worcester Art Museum*, Worcester Art Museum, USA, 1938.

——— & Andrews, F., 'Antiques in Domestic Settings – Shaker Home of Mr and Mrs E.D. Andrews in Pittsfield, Mass.', *The Magazine Antiques*, vol. 35, no. 1, January 1939, pp. 30–32.

——— & Andrews, F., *The Shaker Order of Christmas*, Oxford University Press, New York, USA, 1954.

——— & Andrews, F., 'The People Called Shakers', *The Yale University Library Gazette*, vol. 31, no. 4, 1957, pp. 154–62.

——— & Andrews, F., 'Sheeler and the Shakers', *Art in America*, vol. 53, no. 1, February 1965, pp. 90–95.

——— & Andrews, F., *Religion in Wood: A Book of Shaker Furniture*, Indiana University Press, Bloomington, IN, USA, 1966; reprinted as *Masterpieces of Shaker Furniture*, Dover Publications, Mineola, New York, USA, 1999.

———— & Andrews, F., *Some Shaker Symbols* (pamphlet dated 2 March 1966), The Edward Deming Andrews Memorial Collection, Winterthur Library, Misc. Box.

———— & Andrews, F., *The Shaker Order of Christmas* (booklet produced for an exhibition dated 24 November 1969 and 4 January 1970), Museum of American Folk Art, New York, USA, 1969.

———— & Andrews, F., *Visions of the Heavenly Sphere: A Study in Shaker Religious Art*, The University Press of Virginia, Charlottesville, USA, 1969.

———— & Andrews, F., *Work and Worship Among the Shakers*, Dover Publications Inc., New York, USA, 1974.

———— & Andrews, F., *Fruits of the Shaker Tree of Life: Memoirs of Fifty Years of Collecting and Research*, The Berkshire Traveller Press, Stockbridge, MA, USA, 1975.

———— & Parks, R.O., Catalogue for *The Work of Shaker Hands*, Smith College Museum of Art, Northampton, MA, USA, 1961.

Andrews, F., *The Hancock Story*, unpublished manuscript, The Edward Deming Andrews Memorial Collection, Winterthur Library, Wilmington, DE, USA, 1967.

Apple, N., 'Remaining Watervliet, Ohio Structures to be Destroyed', *The World of Shaker*, vol. 4, no. 4, 1974, p. 5.

————, 'Ann Lee's Toad Lane Changed to Todd Street', *The Shaker Messenger*, vol. 3, no. 3, 1981, p. 12.

* Archambeault, J. & Clark, T.D., *The Gift of Pleasant Hill – Shaker Community in Kentucky*, Pleasant Hill Press, Harrodsburg, KY, USA, 1991.

Armitage, A., 'Dallas Pratt', *America in Britain*, vol. 32, no. 2, 1994, pp. 3–10.

————, 'Forthcoming Events – Shaker: The Art of Craftsmanship', *The American Museum in Britain – Newsletter Number 3*, February 1998, p. 8.

————, 'Shaker: The Art of Craftsmanship', *The American Museum in Britain – Newsletter Number 4*, September 1998, p. 1.

————, 'From Dallas Pratt to Electra Havemeyer Webb', *The American Museum in Britain – Newsletter Number 7*, January 2000, p. 1.

————, 'Trustees Chairman the Countess of Airlie presenting a Shaker-style Box to HRH Prince Philip', *The American Museum in Britain – Newsletter Number 15*, Winter 2003/04, p. 2.

Armstrong, T., 'Foreword', in Sprigg, J., Catalogue for *Shaker Design*, Whitney Museum of American Art in association with Norton, New York, USA, 1986, p. 6.

Babbitt, S., *Philadelphia Museum of Art – Handbook to the Collections*, Philadelphia Museum of Art, Philadelphia, USA, 1995.

Baigell, M., 'American Art and National Identity: The 1920s', *Arts Magazine*, vol. 61, February 1987, pp. 48–55.

Bainbridge, W.S., 'Shaker Demographics 1840–1900: An Example of the Use of US Census Enumeration Schedules', *Journal for the Scientific Study of Religion*, vol. 21, no. 4, December 1982, pp. 352–65.

Baker, E.S., 'Kindred Spirits Exhibit in Florida Reviewed', *The Shaker Messenger*, vol. 17, no. 3, 1996, p. 12.

Baker, J., 'Remodelled Shaker Hall', *Architecture Forum*, vol. 117, December 1962, pp. 124–27.

* Barker, M.R., *The Sabbathday Lake Shakers – An Introduction to the Shaker Heritage*, The Shaker Press, Sabbathday Lake, ME, USA, 1985.

———, *Holy Land: A History of the Alfred Shakers*, The Shaker Press, Sabbathday Lake, ME, USA, 1986.

———, *Poems and Prayers*, The Shaker Press, Sabbathday Lake, ME, USA, 1987.

———, *Revelation: A Shaker Viewpoint*, The Shaker Press, Sabbathday Lake, ME, USA, 1989.

Barrett, D., *Barrett's Bottoms Chair Makers*, Barrett's Bottoms, Sanger, CA, USA, 1992.

Bates, M., 'The Shakers at Manchester City Art Gallery', *The Guardian*, 25 March 1975, p. 12.

Baur, J.I.H., 'A "Classical" Modern', *Brooklyn Museum Quarterly*, vol. 26, January 1939, pp. 23–24.

Beach, L., 'A Hot Day in the Country for Shaker', *Antiques and The Arts Weekly*, 12 August 1988, pp. 46–50.

Beale, G. & Boswell, M.R., *The Earth Shall Blossom*, The Countryman Press Inc., Woodstock, VT, USA, 1991.

Becksvoort, C.H., 'Building a Tinware Cupboard', *Fine Woodworking*, vol. 83, July/August 1990, pp. 38–42.

———, *Understanding Handmade Furniture – A Guide*, Christian Becksvoort, USA, 1990.

———, 'Elements of Shaker Style', *Fine Woodworking*, vol. 131, July/August 1998, pp. 79–83.

* ———, *The Shaker Legacy – Perspectives on an Enduring Furniture Style*, The Taunton Press, Newtown, CT, USA, 1998.

Beede, C.G., 'Art and Craftsmanship of an American Communal Sect. Pittsfield Shaker Exhibition and its Significance', *The Christian Science Monitor*, 20 August 1940, p. 12.

Bergen, K., 'Original Recipe for Shake and Bake', *The Times*, 11 February 1998, p. 7.

Beria, A., 'Brother Arnold Hadd Gives the Dallas Pratt Memorial Lecture', *The American Museum in Britain – Newsletter Number 4*, September 1998, p. 3.

The Berkshire Garden Centre, 'Visit Our Shaker Herb Industry Exhibit – Open from June 26th through July 26th', *Cuttings*, vol. 19, no. 2, 1959, p. 3.

Berridge, V., 'The Source – Catalogue of the Month', *Homes & Antiques*, May 2004, p. 25.

Berry, I., Catalogue for *Work: Shaker Design and Recent Art*, Tang Teaching Museum and Art Gallery, Skidmore College, Saratoga Springs, NY, USA, 2001.

Bial, R., *Shaker Home*, Houghton Mifflin Company, Boston, USA, 1994.

Billings, D., 'Whitney Shaker Exhibit Impressive', *The Shaker Messenger*, vol. 8, no. 4, 1986, p. 16.

Black, M.C., Catalogue for *Religion in Wood – A Study in Shaker Design*, The Museum of Early American Folk Arts, New York, USA, 1965.

———, *At The Sign of Gabriel, The Flag or Indian Chief – The Museum of Early American Folk Arts*, Memo 20 Oct., The Museum of Early American Folk Arts, New York, USA, 1966.

———, 'At The Sign of Gabriel, The Flag or Indian Chief', *Curator*, vol. 9, no. 2, 1966, pp. 134–45.

Blatchford, I., 'The Shakers and Their Achievement', *Art & Antiques*, vol. 1, May 1965, pp. 25–31.

Bliss, A.C., 'Children's Furniture', *Design Quarterly*, no. 57, 1963.

Boardman, F.W., 'A Loaf of Bread Plus Thirty Years Equals an Unusual Book About an Unusual Group of Americans' (press release), Oxford University Press, Oxford, UK, 26 August 1953.

Bone, H., 'Shaker Room at American Museum Result of Careful Study', *The Shaker Messenger*, vol. 5, no. 1, 1982, pp. 10–11.

Bookout, T.J., 'Western Shaker Furniture: Ohio & Kentucky', *The World of Shaker*, vol. 5, no. 1, 1975, p. 3.

Borchert, C.E. & Holst, N.A., *The Installation of Historic Architecture at Winterthur*, The Henry Francis du Pont Winterthur Museum, Wilmington, DE, USA, 1998.

Boris, E., *Art and Labour*, Temple University Press, Philadelphia, USA, 1986.

Boswell, M.R., 'Women's Work: The Canterbury Shaker Fancywork Industry', *Historical New Hampshire*, vol. 48, no. 2/3, Summer/Fall 1993, pp. 133–54.

Boulton, D., 'Shakers and Movers', *The Friend*, 20 March 1998, p. 11.

Bourgeault, C., 'Hands to Work, Hearts to God', *Down East*, December 1984, pp. 34–37.

Bourgeault, R., *The Stokes Collection on-site at Canterbury – Oct. 7*, Northeast Auctions, Portsmouth, NH, USA, 2000.

————, *Shaker Auction at Canterbury* – July 12, Northeast Auctions, Portsmouth, NH, USA, 2003.

Bowe, S.J., *Watervliet Shakerism*, Master's Thesis, University of Liverpool, UK, 1994.

Boyer, B.H., Weingartner, F. & Rossen, S.F. (ed.), *Miniature Rooms – The Thorne Rooms at the Art Institute of Chicago*, Abbeville Press, New York, USA and London, UK, 1983.

Boyer, M.F., 'As French as Apple Pie', *The World of Interiors*, vol. 18, no. 11, November 1998, pp. 130–37.

* Brewer, P.J., *Shaker Communities, Shaker Lives*, University Press of New England, Hanover, NH, USA, 1968.

————, 'The Demographic Features of Shaker Decline 1787–1900', *Journal of Interdisciplinary History*, vol. 15, no. 1, 1984, pp. 31–52.

Brinton, H.H., *Quaker Education in Theory and Practise*, Pendle Hill, Wallingford, PA, USA, 1958.

Bromidge, E., 'Simply Shaker', *The Lady*, 24 February–2 March 1998, pp. 42–43.

Bruhn, T.P. (ed.), Catalogue for *Simple Gifts – Hands to Work and Hearts to God*, The William Benton Museum of Art, The University of Connecticut, Storrs, USA, 1978.

Buchanan, R., 'Branzi's Dilemma: Design In Contemporary Culture', *Design Issues*, vol. 14, no. 1, 1998, pp. 3–20.

Buck, S.L., 'Bedsteads Should Be Painted Green – Shaker Paints and Varnishes', *Old Time New England*, vol. 73, Fall 1995, pp. 16–35.

————, 'Interpreting Paint and Finish Evidence on the Mount Lebanon Shaker Collection', in Rieman, T.D., Catalogue for *Shaker: the Art of Craftsmanship*, Art Services International, Alexandria, VA, USA, 1995, pp. 46–58.

Budis, E.M., Catalogue for *Making His Mark – The Work of Shaker Craftsman Orren Haskins*, The Shaker Museum and Library, Old Chatham, NY, USA, 1997.

———— & Grant, J., Catalogue for *Shaker Gifts, Shaker Genius*, The Shaker Museum and Library (in association with Paine Webber), Old Chatham, NY, USA, 1999.

Bunnell, J., *Children at Shaker Village – Rural Living in the Nineteenth Century*, United Society of Shakers, Sabbathday Lake, ME, USA, 1990.

Burks, J.M., *Documented Furniture. An Introduction to the Collections (Canterbury Shaker Village)*, Canterbury Shaker Village, NH, USA, 1989.

————, 'The Evolution of Design in Shaker Furniture', *The Magazine Antiques*, vol. 145, no. 5, May 1994, pp. 732–41.

————, 'Living with Antiques: a Folk Art Collection in Pennsylvania', *The Magazine Antiques*, vol. 146, no. 4, October 1994, pp. 506–15.

Burns, D.E., *Shaker Cities of Peace, Love, and Union – A History of the Hancock Bishopric*, University Press of New England, Hanover, NH, USA and London, UK, 1993.

Butler, J.T., 'Shaker Arts and Crafts', *Connoisseur*, vol. 177, June 1971, pp. 130–32.

* Butler, L. & Sprigg, J., *Inner Light: The Shaker Legacy*, Alfred A. Knopf, New York, USA, 1985.

Cahill, H. 'Introduction', in Christensen, E.O., *The Index of American Design*, The Macmillan Company for National Gallery of Art, Washington DC, USA, 1950, pp. ix–xvii.

——— & Barr, A.H., *Art in America in Modern Times*, Reynal and Hitchcock, New York, USA, 1943.

Callison, J., 'Museum to showcase Shaker Craftsmanship', *The Cincinnati Enquirer*, 4 October 2001, p. B3:5.

Calloway, S. & Freeman, M., 'Simply Divine', *Telegraph Weekend Magazine*, 22 October 1988, pp. 48–53.

Camhi, L., 'Seeing and Believing', *The Village Voice*, 2 September 1997, p. 89.

Campion, N.R., *Mother Ann Lee: Morning Star of the Shakers*, University Press of New England, Hanover, NH, USA and London, UK, 1990.

Candee, R.M., 'The Rediscovery of Milk Based House Paints and the Myth of "Brickdust and Buttermilk" Paints', *Old Time New England*, vol. 68, Winter 1968, pp. 79–81.

———, 'Preparing and Mixing Colours in 1812', *The Magazine Antiques*, vol. 113, no. 4, April 1978, pp. 849–53.

Cantor, J.E., *Winterthur*, Harry N. Abrams Inc., New York, USA, 1997.

Cargill, K. & Baldwin, J., 'How to decorate with panelling – Shaker style bathroom', *Homes & Gardens*, vol. 85, no. 11, May 2004, p. 137.

Carpenter, M.G. & Carpenter, C., 'The Shaker Furniture of Elder Henry Green', *The Magazine Antiques*, vol. 105, no. 5, May 1974, pp. 1119–25.

Carr, F.A., *Shaker Your Plate – of Shaker Cooks and Cooking*, United Society of Shakers, Sabbathday Lake, ME, USA, 1985.

———, 'Home Notes From Sabbathday Lake', *The Shaker Quarterly*, vol. 15, no. 3, Fall 1987, pp. 87–91.

———, *Growing Up Shaker*, The United Society of Shakers, Sabbathday Lake, ME, USA, 1995.

Casazza, E.F. & McKinnon, W.F., Catalogue for *Shaker Society Auction – June 20*, The Maine Auction Service and The United Society of Shakers, Sabbathday Lake, ME, USA, 1972.

——, Catalogue for *Shaker & Americana Auction – Aug. 20*, Auctioneers at the Auction Gallery, Limington, ME, USA, 1982.

Casey, F.C., *Catalogue of Fancy Goods – Made at Shaker Village, Alfred, York County, Maine, USA*, The United Society of Shakers, Sabbathday Lake, ME, USA, 1971 (reprinted from 1908 version).

Chamier, S., 'Ask The Expert – Shaker Style', *The Mail on Sunday*, 18 January 1998, p. 20.

Chatwin, B. & Sudjic, D., *John Pawson*, Gustavo Gili, Barcelona, Spain, 1998.

Chavis, J., 'The Artifact and the Study of History', *Curator*, vol. 2, no. 2, 1964, pp. 156–62.

Chemotti, M.R., 'Outside Sources for Shaker Buildings at Pleasant Hill', *Kentucky Review*, vol. 2, no. 2, 1981, pp. 49–74.

Christensen, E.O., *The Index of American Design*, The Macmillan Company for National Gallery of Art, Washington DC, USA, 1950.

Clark, S., 'Pure & Simple', *Home*, September 1983, pp. 78–84.

⋆ Clark, T.D. & Ham, F.G., *Pleasant Hill and its Shakers*, Pleasant Hill Press, KY, USA, 1987.

Clifford, D. & Sprigg, J., *An Early View of the Shakers: Benson John Lossing and the Harper's article of July 1857*, University Press of New England, Hanover, NH, USA, 1989.

Clifton, C.S., 'The Forgotten Shakers', *Gnosis Magazine*, Spring 1995, pp. 44–47.

Clifton-Mogg, C., 'Plain Tales', *Harpers & Queen*, October 1988, pp. 284–88.

Cliver, E.B., *The Carpentry Shop – An Historic Structure Report*, Shaker Village Inc., Canterbury, NH, USA, 1989.

Coatts, M., 'Exhibition Review – Shaker: the Art of Craftsmanship', *Crafts*, no. 153, July/August 1998, p. 59.

Cohen, G.M., 'Charles Sheeler', *American Artist*, vol. 23, no. 1, 1959, pp. 32–68.

⋆ Coleman, W., *The Shakers – Perspectives in History Series*, Discovery Enterprises Ltd, Carlisle, MA, USA, 1997.

Colihan, J., 'Shaker Retreat', *American Heritage*, vol. 46, no. 4, July/August 1995, pp. 26 and 28.

Collins, M., 'Topic for Thesis Opened World of Shaker Music', *The Shaker Messenger*, vol. 7, no. 3, 1985, pp. 10–11.

Colvin, H.M., 'The Educational System of the Shakers', in Joline, J.F. (ed.), *The Peg Board*, 1936, pp. 31–34.

Comstock, H., 'Shaker Crafts on View', in Rose, M.C. & Rose, E.M. (eds.), *A Shaker Reader*, Universe Books, New York, USA, 1977, pp. 100–03.

Cong, D., 'The Roots of Amish Popularity in Contemporary USA', *Journal of American Culture*, vol. 17, no. 3, 1994, pp. 59–66.

Consolati, D., 'The Shakers' New Converts', *American Collector*, vol. 5, no. 2, February 1974, pp. 3–.

Constable, K., 'Shaker Maker', *Elle Decoration*, vol. 1, Summer 1989, pp. 120–27.

Coomaraswamy, A.K. & Butler, L., 'Wielding the Force of Presence', *Parabola – Myth, Tradition and Search for Meaning*, vol. 21, no. 4, 1996, pp. 44–49.

Cornforth, J., 'Creating the Cult of the Shakers', *Country Life*, 21 March 1974, pp. 634–37.

Corrin, L.G. & Markopoulis, L., Catalogue for *Give & Take*, Serpentine Gallery and The Victoria and Albert Museum, London, UK, 2001.

Crosthwaite, J.F., 'The Spirit Drawings of Hannah Cohoon: Window on the Shakers and Their Folk Art', *Communal Studies*, vol. 7, 1987, pp. 1–15.

Crowninshield, F., 'Charles Sheeler's "Americana"', *American Vogue*, 15 October 1939, p. 106.

Cummings, H., 'Foreword', in Bruhn, T.P. (ed.), Catalogue for *Simple Gifts – Hands to Work and Hearts to God*, The William Benton Museum of Art, The University of Connecticut, Storrs, USA, 1978, pp. 10–12.

Curtis, S., 'Quiet Confidants', *World Art – The Magazine of Contemporary Visual Culture*, vol. 3, no. 14, 1997, pp. 58–62.

Darley, G., 'The Power House', in Rivers, T., Cruickshank, D., Darley, G. & Pawley, M., *The Name of the Room*, BBC Enterprises Ltd, London, UK, 1992, pp. 105–41.

Davenport, T., 'Righteousness', *The New Yorker*, vol. 50, August 1974, pp. 30–31.

Davies, K., 'Charles Sheeler in Doylestown and the Image of Rural Architecture', *Arts Magazine*, vol. 59, March 1985, pp. 135–39.

Day, C.L., 'Late Shaker Chairs', *The Magazine Antiques*, vol. 64, no. 5, November 1953, p. 396.

Dean, A., 'Weekend Makeover Winner – Movers into Shakers', *The Daily Mail*, 18 July 1998, pp. 52–53.

Deeley, J., 'Round Is Beautiful – This Might Well Be The Best-Designed Barn In The United States', *Connoisseur*, July 1987, pp. 94–95.

Delaney, B.S., 'The Shakers Today', *The Magazine Antiques*, vol. 98, no. 4, October 1970, pp. 618–23.

Delbanco, A., 'The Art of Piety (Extended Book Review of S. Stein's book *The Shaker Experience in America*)', *The New Republic*, 26 October 1992, pp. 37–41.

De Matteo, C., *Shaker Poems*, Brittany Books Inc., Troy, NY, USA, 1990.

De Montebello, P., *The Met and the New Millennium*, The Metropolitan Museum of Art, New York, USA, 1994.

——, 'Introduction', in Peck, A. & O'Neill, J.P. (ed.), *Period Rooms in the*

Metropolitan Museum of Art, H.N. Abrams and The Metropolitan Museum of Art, New York, USA, 1996, p. 9.

De Waal, E., *Bernard Leach (St Ives Artists)*, Tate Gallery Publishing Ltd, London, UK, 1997.

———, 'To Say The Least', *Crafts*, no. 169, March/April 2001, pp. 44–47.

De Wolfe, E.A., *Shaking the Faith*, Palgrave Press, New York, USA, 2002.

Dobson, R., *Ann Lee – The Manchester Messiah: The Story of the Birth of the Shakers*, The St. John Press, Oxford, UK, 1987.

Dodd, E.M., Catalogue for *Shaker Art*, University of Oregon Museum of Art, Eugene, OR, USA, 1966.

———, Catalogue for *Shaker Design – The Art and Furnishings of An American Communal Sect*, Craft Centre, Worcester, MA, USA, 1967.

———, 'Functionalism in Shaker Crafts', *The Magazine Antiques*, vol. 98, no. 4, October 1970, pp. 588–93; also in *The World of Shaker*, vol. 3, no. 3, 1973, pp. 1–5 and in Rose, M.C. & Rose, E.M. (eds.), *A Shaker Reader*, Universe Books, New York, USA, 1977, pp. 104–09.

——— & Miller, A.B., Catalogue for *The Gift of Inspiration – Religious Art of the Shakers*, Shaker Community Inc. (Hancock Shaker Village), Pittsfield, MA, USA, 1970.

Donaldson, S., *The Shaker Garden*, David & Charles, Newton Abbott, UK, 2000.

Dones, J., 'Pleasant Hill Friends Hear of Challenges at Village', *The Shaker Messenger*, vol. 16, no. 4, 1995, p. 7.

Dorfles, G., 'Shaker Furniture (Pieces Designed in the Early 19th Century According to the Principles of Saving and Functionality, Reproduced by Depodora, Maddalena)', *Domus*, no. 652, 1984, pp. 56–57.

Dormer, P., 'Art Lobby – Why do the Shakers Look Like Modernists', *Art Monthly*, vol. 101, November 1986, pp. 31–32.

Dorschner, C., 'Faith Andrews Shares Her Experiences', *The Shaker Messenger*, vol. 7, no. 1, 1984, p. 12.

Downing, M., *Perfect Agreement*, The Berkley Publishing Group, New York, USA, 1998.

Doyle, C., 'Divine Simplicity (Travelling to Kentucky)', *Homes & Gardens*, vol. 82, no. 10, April 2001, pp. 146–49.

Duffield, H.G., *Historical Dictionary of the Shakers*, Scarecrow Press Inc., Maryland, USA and London, UK, 2000.

Duffy, M., 'The Shakers Are Coming To Manchester', *The Manchester Evening News*, 27 February 1975, p. 4.

Dunsford, J., 'The Shakers Return To Manchester', *The Daily Telegraph*, 25 March 1975, p. 14.

Durbin, G., Morris, S. & Wilkinson, S., *A Teacher's Guide to Learning From Objects*, English Heritage, UK, 1990.

Dyer, W.A., 'The Furniture of the Shakers: A Plea for its Preservation as Part of our National Inheritance', *House Beautiful*, vol. 65, May 1929, pp. 669–73.

Eliade, M. (ed.), *The Encyclopaedia of Religion, vol. 13*, Macmillan Publishing Company, New York, USA, 1987.

Elsdon, J., 'America in London', *Christie's International Magazine*, vol. 11, no. 1, Jan/ Feb 1994, pp. 32–37.

————, *Exhibition Guide – Shaker The Art of Craftsmanship*, May 16–Oct. 18, The American Museum in Britain, Claverton Manor, Bath, UK, 1998.

————, *Visitor Guide – The American Museum in Britain*, American Museum and Jarrold Publishing, Claverton Manor, Bath, UK, 1998.

Emerich, A.D, 'A Select List of Publications', in Emerich, A.D. & Benning, A.H. (eds.), Catalogue for *Shaker: Furniture and Objects from the Faith and Edward Deming Andrews Collections*, Smithsonian Institution Press for the Renwick Gallery, Smithsonian Institution, Washington DC, USA, 1973, pp. 41–46.

———— & Benning, A.H (eds.), Catalogue for *Shaker: Furniture and Objects from the Faith and Edward Deming Andrews Collections*, Smithsonian Institution Press for the Renwick Gallery, Smithsonian Institution, Washington DC, USA, 1973.

———— & Benning, A.H. (eds.), Catalogue for *Community Industries of the Shakers – A New Look. A Catalogue of Highlights of an Exhibition at the New York State Museum 1983–84*, Shaker Heritage Society, Watervliet, NY, USA, 1983.

————, Vadnais, A.J. & Chafka, R., *Self Guided Walking Tour – Mount Lebanon*, Mount Lebanon Shaker Village, Mount Lebanon, NY, USA, 1991.

Emery Hulick, D., 'Shakers and Photography: Documentary Folk Art in the Industrial Age', in Richards, D., Emery Hulick, D. & Marini, S., Catalogue for *In Time and Eternity: Maine Shakers in the Industrial Age 1872–1918*, The United Society of Shakers, Sabbathday Lake, ME, USA, 1986, pp. 30–33.

Emlen, R.P., 'Raised, Razed and Raised Again: The Shaker Meetinghouse at Enfield, New Hampshire, 1793–1902', *Historic New Hampshire*, vol. 30, no. 3, Fall 1975, pp. 133–46.

————, 'The Early Drawings of Elder Joshua Bussell', *The Magazine Antiques*, vol. 113, no. 3, March 1978, pp. 632–37.

————, *A Report on the Court Floor Period Rooms*, Department of American Decorative Arts, Museum of Fine Arts, Boston, USA, 1978.

————, 'The Great Stone Dwelling of the Enfield, New Hampshire Shakers', *Old Time New England*, vol. 69, no. 3/4, 1979, pp. 69–85.

————, 'The Best Shaker Chairs Ever Made', *The Shaker Messenger*, vol. 3, no. 4, 1981, pp. 8–11.

★ ————, *Shaker Village Views: Illustrated Maps and Landscape Drawings by Shaker Artists of the Nineteenth Century*, University Press of New England, Hanover, NH, USA and London, UK, 1987.

Evan, F., 'American Classic, Furnishings in the Shaker Manner', *Family Circle*, June 1964, pp. 42–46.

★ Evans, F.W., *Autobiography of a Shaker*, Porcupine Press Inc., Philadelphia, USA, 1972.

Evelegh, T., *Essential Shaker Style*, Ward Lock, London, UK, 1995.

Eversmann, P.K., *Winterthur – A Portrait*, The Henry Francis du Pont Winterthur Museum, Wilmington, DE, USA, 1991.

————, *Discover The Winterthur Period Rooms*, The Henry Francis du Pont Winterthur Museum, Wilmington, DE, USA, 1998.

————, 'Small Wonders: the World of Miniatures', *Winterthur Magazine*, vol. 45, no. 1, Spring 1999, p. 14.

Fassett, K., *New World in The Old*, The American Museum in Britain, Bath, UK (no date).

Faulkner, R., *Japanese Studio Crafts – Tradition and the Avant-Garde*, Laurence King, London, UK, 1995.

Federer, K. & Federer, M., *Shaker Paper – A Mixed Bag*, K. & M. Federer, USA, 1996.

Fennimore, D.L., *Eye for Excellence – Masterworks from Winterthur*, The Henry Francis du Pont Winterthur Museum, Wilmington, DE, USA, 1994.

Ferretti, F., 'A Store Salutes American Design', *The New York Times*, 16 September 1982, pp. C1 and C8.

Fertig, F., 'Made by Shakers ... What Does it Mean?', *The Shaker Messenger*, vol. 3, no. 3, 1981, p. 19.

★ Filley, D.M. & Richmond, M.L. (ed.), *Recapturing Wisdom's Valley: The Watervliet Shaker Heritage 1775–1975*, Town of Colonie and Albany Institute of History and Art, Colonie, New York, USA, 1975.

Fillin-Yeh, S., Catalogue for *Charles Sheeler: American Interiors*, Yale University Art Gallery, New Haven, CT, USA, 1987.

Finn, P., 'Why Oprah is Worth her Weight in Gold – How the Winfrey Millions are Spent', *The Daily Express*, 14 September 1993, p. 19.

Fischer, W., 'Harmony in work and life – The functionalism of the Shakers', in Fischer, W. & Mang, K., Catalogue for *The Shakers: Life and Production of*

a Community in the Pioneering Days of America, Die Neue Sammlung Gallery, Munich, Germany, 1974, pp. 17–24.

————— & Mang, K., Catalogue for *The Shakers: Life and Production of a Community in the Pioneering Days of America*, Die Neue Sammlung Gallery, Munich, Germany, 1974 (also published as *Les Shakers – Vie communautaire et design avant Marx et le Bauhaus* and *Die Shaker – Leben und Produktion einer Commune in der Pionierzeit Amerika*).

————— & Ramseger, G. (from a translation), 'Timeless Beauty of Everyday Things – The Astonishing Products of the Shaker Commune in Exhibition in Munich, Germany', *The World of Shaker*, vol. 4, no. 2, 1974, pp. 7–8.

Fletcher Little, N., 'Preface', in Miller, A.B., Fletcher Little, N. & Sprigg, J. (eds.), Catalogue for *The Gift of Inspiration: Art of the Shakers 1830–1880*, Hirschl & Adler Galleries Inc., New York, USA, 1979, p. 6.

Flint, C.L. & Rocheleau, P., *Mount Lebanon Shaker Collection*, Mount Lebanon Shaker Village, Mount Lebanon, NY, USA, 1987.

Foster, L. 'Shakers', in Eliade, M. (ed.), *The Encyclopaedia of Religion*, vol. 13, Macmillan Publishing Company, New York, USA, 1987, pp. 200–01.

Fowke, J.S. & Longo, J.M., *The Harvard Shakers' Book of Days*, Hill Country Press, Harvard, USA, 1995.

Fox, S., 'A Life in the Day of Sister Francis Carr', *Sunday Times Magazine*, 29 March 1998, p. 82.

* Francis, R., *Ann the Word*, Fourth Estate, London, UK, 2000.

Franco, B., Catalogue for *Shaker Arts and Crafts*, The Widtman Press Inc., New York, USA, 1970.

Frankfurter, A., 'Shaker Inspirational Drawings', *Art News*, vol. 60, no. 9, January 1962, pp. 33 and 56.

Freeman, C.D., 'An American Tradition: New England and Shaker Baskets', *Fiberarts*, vol. 15, no. 1, 1988, pp. 47–48.

Frelinghuysen, A.C., 'Metropolitan Opens Shaker Room', *The Shaker Messenger*, vol. 4, no. 1, 1981, p. 9.

—————, 'Metropolitan Museum's Shaker Room Opens', *The Shaker Messenger*, vol. 4, no. 2, 1982, p. 25.

French Hewes, M.J., 'An Afternoon at Canterbury', *The Shaker Messenger*, vol. 3, no. 1, 1980, pp. 16–17.

Frost, M., 'The Prose and the Poetry of Shakerism', *Philadelphia Museum of Art Bulletin*, vol. 57, no. 273, 1962, pp. 67–82.

Fyfe, G. & Macdonald, S. (eds.), *Theorising Museums*, Blackwell Publishers, Oxford, UK, 1996.

Gable, E., 'Maintaining Boundaries', in Fyfe, G. & Macdonald, S. (eds.), *Theorising Museums*, Blackwell Publishers, Oxford, UK, 1996, pp. 177–202.

Gale, G., 'England's Exeter University Holds Shaker Symposium', *The Shaker Messenger*, vol. 11, no. 3, 1989, p. 25.

Galway, L., 'Sister Mildred Dies at Sabbathday Lake', *The Shaker Messenger*, vol. 12, no. 2, 1990, pp. 8 and 19.

Garraty, J.A. & Carnes, M.C., *American National Biography*, Oxford University Press, Oxford, UK, 1999.

Garrett, W.D., 'The American Museum in Britain', *The Magazine Antiques*, special issue (reprint March), 1993.

——, Catalogue for *Sotheby's – Important American Furniture and Folk Art*, Sotheby's, New York, USA, 1997.

Gates, M.G., *SAM Program Guide & Members News*, Seattle Art Gallery, Seattle, USA, 2000.

Gibbs, J.V. & Gibbs, R.F., 'Shaker Clock Makers', *National Association of Watch and Clock Collectors*, Supplement 7, 1972, pp. 1–32.

★ Gidley, M., Bowles, K. & Fowles, J., *Locating the Shakers: Cultural Origins and Legacies of an American Religious Movement*, University of Exeter Press, Exeter, UK, 1990.

Gill, B., 'Shaker Spirit (Architect J.B. Baker Restores Former Forge in New Lebanon, New York)', *Architectural Digest*, vol. 49, no. 3, March 1992, pp. 122–27.

Gillon, E.V., *A Cut & Assemble Shaker Village*, Schiffer Publishing Ltd, Exton, PA, USA, 1986.

Gilreath, J.W., 'The Formation of the Western Reserve Historical Society's Shaker Collection', *The Journal of Library History, Philosophy, and Comparative Librarianship*, vol. 8, 1973, pp. 133–42.

Glassie, H., 'Structure and Function, Folklore and the Artifact', *Semiotica*, vol. 5, no. 4, 1973, pp. 313–51.

Gleason, G., 'From Their Hearts and Hands: A Shaker Legacy', *Americana*, vol. 1, no. 2, May 1973, pp. 2–7.

Gluck, N., 'Shaker Items Embody Shaker Beliefs ...', *Antique Week – Eastern Edition – Weekly Antique, Auction & Collectors' Newspaper*, vol. 28, no. 48, 26 February 1996, pp. 1 and 36.

Glueck, G., 'Busy Shaker Hands Moved by the Spirit', *The New York Times* (Review Section), 19 February 1999, p. B39.

Goldman, J., 'Collecting – Know Your Shaker', *American Vogue*, vol. 168, May 1978, p. 56.

★ Gordon, B., *Shaker Textile Arts*, The University Press of New England with the

cooperation of the Museum of American Textile History and Shaker Community Inc., Hanover, NH, USA, 1980.

———, 'Victorian Fancy Goods: Another Reappraisal of Shaker Material Culture', *Winterthur Portfolio – A Journal of American Material Culture*, vol. 25, no. 2/3, 1990, pp. 111–29.

Gossett, A.R., 'An American Inspiration: Danish Modern and Shaker Design', *The World of Shaker*, vol. 7, no. 1, 1977, p. 7.

Gouveia, G., 'Style and Grace', *New Jersey Courier News*, 27 February 1999.

Graham, J., 'M. Angelou – Shaker, Why Don't You Sing', *Journal of Reading*, vol. 34, no. 5, 1991, pp. 406–10.

Graham, J.A., 'The New Lebanon Shaker Children's Order', *Winterthur Portfolio – A Journal of American Material Culture*, vol. 26, 1991, pp. 215–29.

Grant, J.V., *Shaker Register*, vol. 1, no. 1, Old Chatham, NY, USA, Spring 1995.

———, *Shaker Register*, vol. 1, no. 2, Old Chatham, NY, USA, Summer 1995.

———, *Shaker Register*, vol. 1, no. 3, Old Chatham, NY, USA, Fall 1995.

———, *Shaker Register*, vol. 1, no. 4, Old Chatham, NY, USA, Summer 1996.

* ——— & Allen, D.R., *Shaker Furniture Makers*, published for Hancock Shaker Village, Pittsfield, MA, by University Press of New England, Hanover, NH, USA, 1989.

Green, D., 'Shaker Serenity', *Industrial Design*, September/October 1986, p. 67.

Greenbaum, F., Catalogue for *Shaker: The Art of Craftsmanship*, Delaware Art Museum, Wilmington, DE, USA, 1996.

Greenhalgh, P. (ed.), *Modernism in Design*, Reaktion Books Ltd, London, UK, 1990.

Griffin, G., 'Shakertown – Many Buildings In The Town Are Damaged, But A Move Is Under Way To Preserve Them', *The Courier-Journal Magazine*, 13 August 1961, pp. 26–27.

Grigson, J., 'Like Mother Ann Made It', *The Observer Magazine*, 29 June 1975, p. 47.

Gropp, L., 'Refocus on Shaker', *Home Furnishings Daily*, 30 September 1965, pp. 6–8.

———, 'Design Tempo – No Dust in Heaven', *Home Furnishings Daily*, 4 October 1965, p. 14.

Gross, S.L., 'Hawthorne and the Shakers', *American Literature*, vol. 29, January 1958, pp. 458–63.

The Guild of Shaker Crafts Inc. (publisher), 'Restoration of Old Stone Shop Nears Completion at Pleasant Hill', *The World of Shaker*, vol. 3, no. 3, 1973, p. 5.

———, 'Edward Deming Andrews Collection', *The World of Shaker*, vol. 3, no. 4, 1973, p. 5.

Guthe, C.E., 'The Shakers', *House & Garden*, 21 April 1945, p. 13–14.

Haagen, V., 'Shakertown II: Settlement in Kentucky', *Travel*, April 1973, pp. 42–45, 74.

Hall, D., 'Born Again Shakers', *The Independent on Sunday*, 9 February 1992, p. 57.

Haller, J., 'Great New England Cooks', *Yankee Magazine*, August 1988, pp. 88–96.

Handberg, E., *Shop Drawings of Shaker Furniture & Woodenware* – vol. 1, Berkshire Traveller Press, Stockbridge, MA, USA, 1991.

———, *Shop Drawings of Shaker Furniture & Woodenware* – vol. 2, Berkshire Traveller Press, Stockbridge, MA, USA, 1991.

———, *Shop Drawings of Shaker Furniture & Woodenware* – vol. 3, Berkshire Traveller Press, Stockbridge, MA, USA, 1991.

———, *Shop Drawings of Shaker Iron & Tinware*, Berkshire Traveller Press, Stockbridge, MA, USA, 1991.

Harlow Ott, J., *Hancock Shaker Village – a Guidebook and History*, Shaker Community Inc., Hancock, MA, USA, 1976.

———, 'Ye Shall Know Them By Their Fruits', in Bruhn, T.P. (ed.), Catalogue for *Simple Gifts – Hands to Work and Hearts to God*, The William Benton Museum of Art, The University of Connecticut, Storrs, USA, 1978, pp. 17–22.

———, 'Afterword', in Miller, A.B., Fletcher Little, N. & Sprigg, J. (eds.), Catalogue for *The Gift of Inspiration: Art of the Shakers 1830–1880*, Hirschl & Adler Galleries Inc., New York, USA, 1979, p. 69.

Harper, L., 'Designers Retreat – A Time for Reflection', *Graphis*, vol. 52, no. 305, 1996, p. 18.

Harris, J., 'A Cautionary Tale of Two "Period" Rooms', *Apollo*, July 1995, pp. 56–57.

Harrison, B., 'The Background of Shaker Furniture', *New York History*, vol. 29, no. 3, July 1948, pp. 318–26.

Harrison, J., 'Shaker Chair', *Journal of Poetry*, vol. 161, no. 6, 1993, p. 333.

Harrod, T., *The Crafts in Britain in the Twentieth Century*, Yale University Press, USA, 1999.

* Hatcher, K. & Gilbert, A., *Shaker Articles and References in The Magazine Antiques*, United Society of Shakers, Sabbathday Lake, ME, USA, 2003.

Hauffe, T., *Design – A Concise History*, Lawrence King, London, UK, 1998.

Haworth, D.K., 'Shaker and Japanese Craft Explored', *The Shaker Messenger*, vol. 13, no. 2, 1991, pp. 25–26.

Hawthorne, N., 'The Shaker Bridal', *The Works of Nathanial Hawthorne*, vol. 1, Houghton Mifflin & Company, Cambridge, MA, USA, 1882, pp. 469–76.

———, 'The Canterbury Pilgrims', *The Works of Nathanial Hawthorne*, vol. 1, Houghton Mifflin & Company, Cambridge, MA, USA, 1882, pp. 518–30.

* Hayden, D., *Seven American Utopias: The Architecture of Communitarian Socialism, 1790–1975*, MIT Press, Cambridge, MA, USA, 1976.

Heald, G., 'Shaker Legacy: The Beauty of Craftsmanship', *The Kennett Paper*, 10–16 October 1996, p. B6.

Heck, S., 'Shaker Design', *Architect*, vol. 93, October 1986, pp. 52–53.

Hein, G.E., *Learning in the Museum*, Routledge, London, UK, 1998.

Hendrix, G., 'A Heritage of Horsemanship', *Midwest Living*, April 1990, pp. 55–60.

Herman, L.E., 'Foreword', in Emerich, A.D. & Benning, A.H. (eds.), Catalogue for *Shaker: Furniture and Objects from the Faith and Edward Deming Andrews Collections*, Smithsonian Institution Press for the Renwick Gallery, Smithsonian Institution, Washington DC, USA, 1973, p. 7.

Hewett, D., 'Records Fall at Annual Willis Henry Shaker Auction', *Maine Antique Digest*, October 1988, pp. E-2 and E-6.

Hiesinger, K.B. & Marcus, G.H. *Landmarks of Twentieth-Century Design*, Abbeville Press, New York, USA, 1993.

Higgins, R., 'Shaker – The Art of Craftsmanship Review', *Art & Photography* (What's On), 28 January 1998, p. 16.

Hill, R., 'Perfect for Intelligent Purpose', *The Times Literary Supplement*, 13 February 1998, p. 19.

Hines, T., 'Shaker Furniture from South Union', *The Magazine Antiques*, vol. 151, no. 5, May 1997, pp. 724–31.

Hirschl, N., 'Two Separate Worlds', in Miller, A.B., Fletcher Little, N. & Sprigg, J. (eds.), Catalogue for *The Gift of Inspiration: Art of the Shakers 1830–1880*, Hirschl & Adler Galleries Inc., New York, USA, 1979, p. 50–68.

Hoffman, A.J., 'The History of the Museum of American Folk Art – An Illustrated Timeline', *The Clarion*, vol. 14, no. 1, Winter 1989, pp. 36–63.

Hollick, F., 'Visitor Centre Opens at Enfield, NH', *The Shaker Messenger*, vol. 2, no. 1, 1979, p. 10.

Hopping, D.M.C. & Watland, G.R., 'The Architecture of the Shakers', *The Magazine Antiques*, vol. 72, no. 4, October 1957, pp. 335–39; also in Rose, M.C. & Rose, E.M. (eds.), *A Shaker Reader*, Universe Books, New York, USA, 1977, pp. 35–39.

Horsham, M., *The Art of the Shakers*, Chartwell Books Inc., Secaucus, NJ, USA, 1989.

Hosley, W.N., 'Simply Shaker', *Art & Antiques*, vol. 15, December 1993, pp. 74–81.

Hudson, D., 'The Collectors – The Shakers' Art', *Yorkshire Post*, 31 March 1975, p. 5.

Hughes, C., 'Shaker Work Seen at Renwick Gallery', *The World of Shaker*, vol. 4, no. 1, 1974, p. 7.

Hughes, G.B., 'The Furniture of the Shakers', *Country Life*, vol. 130, 21 September 1961, pp. 632–33.

Hughes, R., *American Visions*, The Harvill Press, London, UK, 1997.

Hulings, M.A., *Shaker Days Remembered*, Shaker Heritage Society, Albany, NY, USA, 1989.

Hults, B., 'Shaker Chairs', *American Art & Antiques*, vol. 1, no. 3, November/December 1978, pp. 44–51.

Humelsine, C.H., 'Fifty Years of Colonial Williamsburg', *The Magazine Antiques*, vol. 110, no. 6, 1976, pp. 1267–91.

Humez, J.M., *Gifts of Power. The Writings of Rebecca Jackson – Black Visionary, Shaker Eldress*, The University of Massachusetts Press, Amherst, MA, USA, 1981.

★ ———, *Mother's First Born Daughters – Early Shaker Writings on Women and Religion*, Indiana University Press, Bloomington, IN, USA, 1993.

Hunter, S., *The Museum of Modern Art*, Harry N. Abrams and MOMA, New York, USA, 1984.

Ingersoll, I. & Miller-Mead, G., *The Art of Woodworking – Shaker Furniture*, Time-Life Books, Alexandria, VA, USA, 1995.

Jackson, P., 'New England ... born in old England', *The Independent* (Property), 19 May 2004, pp. 8–9.

Jacob, M.J., *The Impact of Shaker Design on the Work of Charles Sheeler*, MA Thesis, University of Michigan, Ann Arbor, USA, 1976.

James, B., 'Against the Grain', *The Radio Times*, 22–28 October 1994, pp. 40–43.

Johnson, T.E., 'Shakerism for Today', *The Shaker Quarterly*, vol. 3, no. 1, 1963, pp. 3–6.

———, 'The "Millennial Laws" of 1821', *The Shaker Quarterly*, vol. 7, no. 2, 1967, pp. 35–58.

———, *Life in the Christ Spirit: Observations on Shaker Theology*, The United Society of Shakers, Sabbathday Lake, ME, USA, 1969.

———, *In the Eye of Eternity: Shaker Life and the Work of Shaker Hands*, The United Society of Shakers and The University of Southern Maine, Gorham, ME, USA, 1983.

———, Catalogue for *Ingenious & Useful – Shaker Sisters' Communal Industries, 1860–1960*, The United Society of Shakers, Sabbathday Lake, ME, USA, 1986.

——— & McKee, J., Catalogue for *Hands to Work and Hearts to God: The Shaker Tradition in Maine*, Bowdoin College Museum of Art, Brunswick, USA, 1969.

Joline, J.F. (ed.), *The Peg Board – First Shaker Number*, Darrow School, New Lebanon, NY, USA, 1936.

Selling Shaker

Jones, L. & Highton, D., *Grand Designs Indoors – A Practical and Historical Guide to Interior Design*, Channel 4 Television, London, UK, 2001.

Jones, M., 'The Shaking Quakers', *The Listener*, 2 March 1989, pp. 14–15.

Jones, R., *The American Connection* (including Liverpool's American Heritage Trail), Moreton, Wirral, 1992.

Kallan, C., 'Travelling Through Time', *USAir* (Magazine), vol. 12, May 1991, pp. 48–60.

Kammeraad, B., 'The Oval Carrier', *The Shaker Messenger*, vol. 2, no. 1, 1979, p. 22.

Kaplan, J.A., 'The Quiet of the Land: Everyday Life, Contemporary Art, and the Shakers: A Conversation', *Art Journal*, vol. 57, no. 2, Summer 1998, pp. 4–27.

* Kassay, J., *The Book of Shaker Furniture*, The University of Massachusetts Press, Amherst, MA, USA, 1980.

Kaufman, D., 'Wood Works', *Wallpaper*, no. 50, July/August 2002, pp. 123–26.

Kay, J.H., 'The Last of the Shakers', *Historic Preservation*, vol. 34, no. 2, March/April 1982, pp. 14–21.

Kedzie Wood, R., 'Henry Ford's Great Gift', *The Mentor*, vol. 17, no. 5, June 1929, pp. 3–10.

Keig, S.J., Catalogue for *The Shakers – A Lifestyle by Design*, Ryder Gallery, Chicago, USA, 1971.

———, 'The Shakers – A Lifestyle by Design', *Communication Arts*, vol. 13, no. 2, 1971, pp. 65–69.

———, 'Munich Museum to Feature Exhibit on Shakers', *The World of Shaker*, vol. 2, no. 1, 1972, p. 5.

———, *Trade with the World's People: A Shaker Album*, The Beckett Paper Company, Hamilton, OH, USA, 1976.

——— & Pearson, E.R., 'Shaker Graphics of the 19th Century', *Print*, vol. 26, no. 2, March/April 1972, pp. 40–47.

Kenyon, P. & McClafferty, M., 'Stop Press – Fired Earth's Original Shaker Collection', *House & Garden*, July 2006, p. 44.

Kennedy, G., Beale, G. & Johnson, J., *Shaker Baskets and Poplarware – A Field Guide, vol. 3*, Berkshire House Publications, Stockbridge, MA, USA, 1992.

Ketchum, W.C., *Simple Beauty – The Shakers in America*, Todtri Productions Limited, New York, USA, 1996.

Keyes, H.E., 'Exhibitions and Sales', *The Magazine Antiques*, vol. 22, no. 6, December 1932, p. 232.

———, 'Exhibitions and Sales', *The Magazine Antiques*, vol. 26, no. 4, October 1934, pp. 146–47.

————, 'A View of Shakerdom', *The Magazine Antiques*, vol. 26, no. 4, October 1934, p. 148.

————, 'Preface', in Andrews, E.D. & Andrews, F., *Shaker Furniture: The Craftsmanship of an American Communal Sect*, Dover Publications Inc., New York, USA, 1964, p. viii.

————, 'The Coming Shaker Exhibition in Manhattan', in Rose, M.C. & Rose, E.M. (eds.), *A Shaker Reader*, Universe Books, New York, USA, 1977, pp. 32–33.

Kidder, R.L. & Hostetler, J.A., 'Managing Ideologies – the Amish and Japanese Society', *Law and Society Review*, vol. 24, no. 4, 1990, pp. 895–922.

Kidder Smith, G.E., *A Pictorial History of American Architecture*, American Heritage Publishing Co. Inc., New York, USA, 1976.

Kinmonth, C., 'Exhibition Diary – Shaker: The Art of Craftsmanship', *The World of Interiors*, vol. 18, no. 1, January 1998, pp. 124–25.

Kirk, J.T., *American Furniture and the British Tradition to 1830*, Alfred A. Knopf, New York, USA, 1982.

————, 'Art Historian John Kirk Explains Intent', *The Shaker Messenger*, vol. 10, no. 3, 1988, p. 13.

————, 'An Awareness of Perfection', *Design Quarterly*, no. 154, Winter 1992, pp. 14–19.

————, *The Shaker World: Art, Life, Belief*, Harry N. Abrams Inc., New York, USA, 1997.

————, 'Contextualizing the Gift Drawing', in Morin, F., Catalogue for *Heavenly Visions: Shaker Gift Drawings and Gift Songs*, University of Minnesota Press, Minneapolis, MN, USA, 2001, pp. 101–34.

———— & Grant, J.V., 'Forty Untouched Masterpieces of Shaker Design', *The Magazine Antiques*, vol. 135, no. 5, May 1989, pp. 1226–37.

Klamkin, M., *The Collector's Book of Boxes*, David & Charles, Newton Abbott, UK, 1972.

————, *Hands to Work; Shaker Folk Art and Industries*, Dodd, Mead & Company, New York, USA, 1972.

Klyver, R.D., *The Shaker Heritage – An Annotated Pictorial Guide to the Collection of the Shaker Historical Museum*, The Shaker Historical Society, USA, 1980.

Knots, B., 'Hands to Work and Hearts to God', *Metropolitan Museum Art Bulletin*, March 1943, pp. 231–36.

Koomler, S.D., Catalogue for *Seen and Received: The Shakers' Private Art*, Hancock Shaker Village, Pittsfield, MA, USA, 2000.

————, *Shaker Style – Form, Function, and Furniture*, Courage Books, London, 2000.

————, Catalogue for *Expanding the Vision – Gift Drawings in the Eric J. Maffei Collection*, Hancock Shaker Village, Pittsfield, MA, USA, 2001.

————, Catalogue for *Shaker Chairs: Their Story*, The Art Complex Museum, Duxbury, MA, USA, 2001.

Kouwenhoven, J., *The Arts in Modern American Civilisation*, W.W. Norton, New York, USA, 1967.

Kramer, F., 'Battle Lost To Save Groveland Building', *The Shaker Messenger*, vol. 6, no. 4, 1984, p. 19.

————, 'Marker Dedicated at Groveland Shaker Site', *The Shaker Messenger*, vol. 8, no. 1, 1985, p. 8.

————, 'Shaker in the Marketplace', *The Shaker Messenger*, vol. 8, no. 4, 1986, p. 25.

————, 'Antiques Forum at Hancock Shaker Village', *The Shaker Messenger*, vol. 9, no. 3, 1987, p. 14.

————, 'Shaker in the Marketplace', *The Shaker Messenger*, vol. 9, no. 3, 1987, p. 15.

————, 'Shaker in the Marketplace', *The Shaker Messenger*, vol. 11, no. 1, 1988, pp. 8–10.

————, 'Shaker in the Marketplace – Shaker Diary Brings $6,600 at Auction', *The Shaker Messenger*, vol. 11, no. 2, 1989, p. 21.

————, 'Shaker Antiques in the Marketplace – Rare Oval Box Brings $25,300 at Auction', *The Shaker Messenger*, vol. 12, no. 1, 1989, p. 15.

————, 'Shaker Antiques in the Marketplace – Sewing Desk a Bargain at $33,000', *The Shaker Messenger*, vol. 12, no. 2, 1990, p. 20.

————, 'Mt Lebanon's Future Becoming Uncertain (Editorial)', *The Shaker Messenger*, vol. 12, no. 3, 1990, p. 7.

————, 'Darrow Collection Preserved For Now', *The Shaker Messenger*, vol. 12, no. 4, 1990, pp. 12–13.

————, 'Shaker Antiques in the Marketplace – Oprah Winfrey New Shaker Buyer', *The Shaker Messenger*, vol. 12, no. 4, 1990, pp. 18–20.

————, 'Shaker Exhibit Opens at Rochester', *The Shaker Messenger*, vol. 13, no. 1, 1991, pp. 12–13.

————, 'The Shakers of Groveland, New York', *The Magazine Antiques*, vol. 140, no. 2, August 1991, pp. 228–39.

————, Catalogue for *Simply Shaker – Groveland and the New York Communities*, Rochester Museum and Science Centre, New York, USA, 1991.

————, 'Hancock Prepares for Exhibit in Japan', *The Shaker Messenger*, vol. 14, no. 1, 1992, pp. 17 and 23.

————, 'Shaker Antiques in the Marketplace', *The Shaker Messenger*, vol. 15, no. 2, 1993, p. 18.

————, 'Shaker Antiques in the Marketplace. Good Buys, Record Prices for Shaker', *The Shaker Messenger*, vol. 16, no. 3, 1995, p. 20.

————, 'Shaker Antiques in the Marketplace', *The Shaker Messenger*, vol. 17, no. 1, 1995, p. 18.

————, 'Market Report ...', *Shakers World*, vol. 1, no. 3, 1996, p. 17.

————, 'A New Record For Shaker Artifacts At Auction', *Shakers World*, vol. 1, no. 4, 1996, p. 24.

————, 'Sotheby's Seminar: Masterpieces in the Shaker Aesthetic', *Shakers World*, vol. 2, no. 1, 1997, p. 23.

Kratz, C., 'The New York Shakers and Their Dwelling Places', *The Clarion*, Fall 1979, pp. 36–45.

Kuhn, H.B., 'Whither the Shakers', *Christianity Today*, vol. 17, November 1972, p. 45.

Lacroix, C., 'Shaker Style', *The Sunday Telegraph Magazine*, 7 April 1996, p. 31.

Lahr, J., 'Exhibition Diary – Americana', *The World of Interiors*, vol. 14, no. 1, January 1994, p. 108.

Laing, M., 'Fancy Articles Are Not Suitable For Believers', *Church Times* (Arts Section), 6 February 1998, p. 28.

Lamb, T., 'Shaker Store Opens in London', *The Shaker Messenger*, vol. 12, no. 2, 1990, p. 26.

Lambert, A., 'True Colours', *The Sunday Telegraph*, 15 October 2000, pp. 1–2.

Larason, L., *The Basket Collector's Book*, Scorpio Publications, Chalfont, PA, USA, 1978.

Large, Jr, J., 'Shaker Room is a Part of the Western Reserve Historical Society', *The World of Shaker*, vol. 2, no. 1, 1972, pp. 3–4.

————, 'What You Will Find At The Western Reserve Historical Society', *The World of Shaker* (Special Insert), 1975, pp. 1 and 4.

————, 'New Shaker Exhibit Opened at Western Reserve Historical Society', *The World of Shaker*, vol. 5, no. 3, 1975, p. 5.

Larkin, D., *The Essential Book of Shaker – Discovering the Design, Function, and Form*, Universe Publishing, New York, USA, 1995.

Larrabee, C.M., 'Harvard on National Register', *The Shaker Messenger*, vol. 12, no. 3, 1990, p. 27.

Larson, K., 'A Month in Shaker Country', *The New York Times*, 10 August 1997, pp. 30–31.

Laskovski, P.D., Catalogue for *The Shaker Chair: Strength, Sprightliness and Modest Beauty*, The Shaker Museum, Old Chatham, NY, USA, 1982.

Lassiter, W.L. (with illustrations by Vincentini, Herlich and Funk), 'Shaker – Pattern of Practical Beauty – Modern Then and Now', *House & Garden*, vol. 87, 1945, pp. 36–45.

———, 'The Shakers and their Furniture', *New York State Antiques*, vol. 44, July 1946, pp. 369–71.

* ———, *Shaker Architecture*, Bonanza Books, New York, USA, 1966.

La Trobe Bateman, R., 'Pure and Simple', *Crafts*, no. 83, November/December 1986, pp. 34–43.

Lawton, A., 'Water Colour Paintings of Shaker Furniture (Index of American Design)', *Boston Globe*, 29 August 1937, p. 14.

Ledes, A.E., 'The Canterbury Shakers', *The Magazine Antiques*, vol. 143, no. 1, January 1993, pp. 32–34.

———, 'The First American Shaker Community', *The Magazine Antiques*, vol. 147, no. 2, February 1995, pp. 252–58.

———, 'Shaker in Skyscraper', *The Magazine Antiques*, vol. 155, no. 1, January 1999, pp. 32–38.

Lee, V. & Baldwin, J., 'Divine Art', *Homes & Gardens*, vol. 71, no. 10, April 1990, pp. 114–19.

Leen, N. (photographer), 'The Shakers – A Strict and Utopian Way of Life Has Almost Vanished', *Life*, vol. 26, no. 12, 21 March 1949, pp. 141–48.

Lindsay, B., 'The Shakers' View of the Bicentennial Celebration', *The World of Shaker*, vol. 4, no. 4, 1974, pp. 1 and 8.

———, 'Shakers I Knew – My Favourite School-Teacher; Jessie Evans', *The World of Shaker*, vol. 7, no. 1, 1977, p. 3.

———, *Seasoned With Grace*, The Countryman Press, Woodstock, VT, USA, 1987.

Linley, D., *Extraordinary Furniture*, Mitchell Beazley, London, UK, 1996.

Longenecker, M.W., 'Foreword', in Sprigg, J. (ed.), Catalogue for *Kindred Spirits – The Eloquence of Function in American Shaker and Japanese Arts of Daily Life*, Mingei International, San Diego, CA, USA, 1995, pp. 15–18.

Loring Dun, R., 'Photographs of Shaker Interiors and Crafts by William Winter at Art Institute', *Times Union Newspaper*, 20 November 1938, p. D-5.

Lossing, B.J., 'The Shakers', *Harper's New Monthly Magazine*, vol. 15, July 1857, pp. 164–77.

Lowry, J.J., 'The Boston Area Study Group Visits Fruitlands', *The Shaker Messenger*, vol. 6, no. 4, 1984, p. 10.

———, 'Harvard Buys Land Around Cemetery', *The Shaker Messenger*, vol. 6, no. 4, 1984, p. 13.

Lubovitz, F.R. & Bridgwater, D.W., 'Exhibitions – The People Called Shakers, A Search For The Perfect Society', *Yale University Library Staff News*, January 1957.

Lucic, K., *Charles Sheeler and the Cult of the Machine*, Harvard University Press, Cambridge, MA, USA, 1991.

Lucie-Smith, E., *Furniture – A Concise History*, Thames and Hudson, London, UK, 1993.

MacCarthaigh, S., 'Gimme that old-time … Kitchen', *The Irish Times* (Property Supplement), 6 May 1999, p. 21.

Mac-Hir Hutton, D. (enlarged and revised by J.B. Hutton), *Old Shakertown and the Shakers*, The Harrodsburg Historical Society, Harrodsburg, KY, USA, 1987.

Mackintosh, J., 'Top Marx and Ann Lee, *Co-operative News*, 11 April 1975, p. 13.

MacLean, J.P., *A Bibliography of Shaker Literature*, F.J. Heer, Columbus, OH, 1905 and B. Franklin, New York, 1971.

Maged, E., 'An Old Look For Your New Sound', *Hi-Fidelity Magazine*, February 1955, p. 47.

Mahoney, K., *Simple Wisdom – Shaker Sayings, Poems and Songs*, Viking Studio Books, New York, USA, 1993.

———, *Wisdom From a Shaker Garden*, Penguin Group, New York, USA, 1998.

Malcolm, J., 'The Modern Spirit in Shaker Design', in Emerich, A.D. & Benning, A.H. (eds.), Catalogue for *Shaker: Furniture and Objects from the Faith and Edward Deming Andrews Collections*, Smithsonian Institution Press for the Renwick Gallery, Smithsonian Institution, Washington DC, USA, 1973, pp. 18–22.

———, 'The Modern Spirit in Shaker Design', *Early American Antiques*, vol. 2, April 1974, pp. 8–13.

Malloy, H. & Symons, L., 'Style File: Beautifully Simple – Perfectly Plain', *Homes & Antiques*, November 1994, pp. 56–58.

Mang, K., 'The Shakers – another America', in Fischer, W. & Mang, K., Catalogue for *The Shakers: Life and Production of a Community in the Pioneering Days of America*, Die Neue Sammlung Gallery, Munich, Germany, 1974, pp. 9–16.

———, *History of Modern Furniture*, Dover Publications Inc., New York, USA, 1979.

Manley, A., 'H&A Browser – Most Wanted. This Month's Object of Desire', *Homes & Antiques*, September 2006, p. 19.

Marini, S., 'In Time and Eternity', in Richards, D., Emery Hulick, D. & Marini, S., Catalogue for *In Time and Eternity: Maine Shakers in the Industrial Age 1872–1918*, The United Society of Shakers, Sabbathday Lake, ME, USA, 1986, pp. 4–6.

Martin, A.S. & Garrison, J.R. (eds.), *American Material Culture – The Shape of the Field*, The Henry Francis du Pont Winterthur Museum, Wilmington, DE, USA, 1997.

Martin, D. & Loengard, J. (photographer), 'Serene Twilight of the Shakers', *Life*, vol. 62, no. 11, 17 March 1967, pp. 58–70.

Martin, D.B., 'The Gift to be Simple (19th-Century Shaker Storage Boxes)', *Portfolio – The Magazine of the Fine Arts*, vol. 5, no. 4, 1983, pp. 64–67.

Martin, S., *The Life and Production of a Religious Community in the Pioneering Days of America (Keeper's Report)*, Manchester City Art Galleries, Manchester, UK, 1975.

Massey, D., 'Shaker Design – Americana News (Fashions in Living)', *American Vogue*, February 1968, p. 117.

Mastin, B.L., *A Walking Tour of Shakertown*, Richard S. DeCamp, Lexington, KY, USA, 1969.

Maxtone, G.Y., 'Slaves to Mastering Chaos', *The Sunday Telegraph* (Review Section), 15 October 1995, p. 8.

Mayo, E., 'Focus on Material Culture', *Journal of American Culture*, vol. 3, 1980, pp. 595–604.

Mazmanian, A.B., *The Structure of Praise*, Beacon Press, Boston, USA, 1970.

McBreen, E. (ed.) & Morin, F., Catalogue/Leaflet for *The Quiet in the Land*, The Institute of Contemporary Art, Boston, MA, USA, 1998.

McCloud, K., *Kevin McCloud's Decorating Book*, Dorling Kindersley, London, UK, 1990.

McClung, F.E., 'Artefact Study', *Winterthur Portfolio – A Journal of American Material Culture*, vol. 8, 1973, pp. 153–73.

McCool, E., 'Shaker Woven Poplarware', *The Shaker Quarterly*, vol. 2, no. 2, 1962, pp. 55–59.

McCoy, G., 'Charles Sheeler – Some Early Documents and a Reminiscence', *Archives of American Art*, vol. 5, no. 2, April 1965, pp. 1–4.

McGuire, J., *Basketry: The Shaker Tradition*, Sterling Publishing Co. Inc., New York, USA, 1988.

McIlhenny, H.P. & Madiera, L.C., 'Acknowledgments', *Philadelphia Museum of Art Bulletin*, vol. 57, no. 273, 1962.

* McKinstry, E.R. (comp.), *The Edward Deming Andrews Memorial Shaker Collection*, Garland Publishing Company, New York, USA, 1987.

———, 'The Shakers', in Martinez, K. (ed.), *American Cornucopia – Treasures of the Winterthur Library*, The Henry Francis du Pont Winterthur Museum, Wilmington, DE, USA, 1990, pp. 87–90.

———, 'Three Manuscripts Describe Shakers', *The Shaker Messenger*, vol. 15, no. 1, 1993, pp. 22–23.

McQuaid, C., 'Maine's "Quiet in the Land" Plumbs Art of Shaker Life', *The Boston Globe*, 5 August 1997, p. D7.

Meader, R.F.W., 'Reflections on Shaker Architecture', *The Shaker Quarterly*, vol. 6, no. 2, 1966, pp. 35–44.

* ——, *Illustrated Guide to Shaker Furniture*, Dover Publications Inc., New York, USA, 1972.

Meek, R. (photographer), 'A Rich Shaker Legacy', *American Home*, vol. 72, September 1969, pp. 74–81.

Melcher, M.F., 'Shaker Furniture', *Philadelphia Museum of Art Bulletin*, vol. 57, no. 273, Spring 1962, pp. 89–92.

——, *The Shaker Adventure*, The Press of Case Western Reserve University, Cleveland, USA, 1968.

Merton, T., 'Introduction', in Andrews, E.D. & Andrews, F. *Religion in Wood: A Book of Shaker Furniture*, Indiana University Press, Bloomington, IN, USA, 1966, pp. vii–xv.

Mielech, R.A., 'Kentucky Theatre Presents Shaker Play', *The Shaker Messenger*, vol. 17, no. 2, 1995, p. 15.

Milbern, G., *Shaker Clothing*, The Warren County Historical Society, Lebanon, OH, USA, 1965.

Miles, L., 'A Conversation With Eldress Bertha Lindsay', *The Shaker Messenger*, vol. 3, no. 3, 1981, pp. 8–11.

Miller, A.B., 'Celebrate the Garden – Shaker Herbs and Their Relevance Today', *Fall Antiques Show – In Celebration – The Herb Garden*, 24–27 September 1981, pp. 28–32.

——, Fletcher Little, N. & Sprigg, J. (eds.), Catalogue for *The Gift of Inspiration: Art of the Shakers 1830–1880*, Hirschl & Adler Galleries Inc., New York, USA, 1979.

—— & Fuller, P., *The Best of Shaker Cooking*, Collier Paperbacks, New York, USA, 1993.

Miller, S.M., *A Century of Shaker Ephemera – Marketing Community Industries 1830–1930*, Dr Stephen Miller, New Britain, CT, USA, 1988.

——, 'Hancock Mounts Exhibition of Ephemera', *The Shaker Messenger*, vol. 10, no. 4, 1988, pp. 10–11.

——, 'The First Shaker Icon: A Stove', *The Shaker Messenger*, vol. 17, no. 3, 1996, pp. 6 and 11.

Monaghan, K. (ed.), Catalogue for *Receiving the Faith: The Shakers of Canterbury, New Hampshire*, Whitney Museum of American Art at Champion, USA, 1993.

Money, E., 'Shakers and Jade', *The Spectator*, 17 May 1975, pp. 617–18.

Moore, R., 'Putting Their Faith in Their Furniture', *The Daily Telegraph*, 28 January 1998, p. 19.

Moriarty, K.M., *Integrating Shaker Studies Into Your Curriculum*, The World of Shaker, Holland, MI, USA, 1992.

Morin, F., Catalogue for *Heavenly Visions: Shaker Gift Drawings and Gift Songs*, University of Minnesota Press, Minneapolis, MN, USA, 2001.

Morse, F., *The Shakers and the World's People*, Dodd & Mead, New York, USA, 1980.

———, 'Brother Theodore E. Johnson Dies', *The Shaker Messenger*, vol. 8, no. 2, 1986, p. 12.

* ———, *The Story of the Shakers*, The Countryman Press, Woodstock, VT, USA, 1986.

———, 'Creating a Shaker Room', *America in Britain*, vol. 36, 1998, pp. 4–11.

——— & Newton, V., *A Young Shaker's Guide to Good Manners*, The Countryman Press, Woodstock, VT, USA, 1997.

Moser, T., *How to Build Authentic Shaker Furniture*, Sterling Publishing Company, New York, USA, 1995.

Moss, S., 'The Gospel According to IKEA', *The Guardian* (G2), 26 June 2000, pp. 2–3.

Muller, C.R., 'It Looks Shaker', *Ohio Antiques Review*, vol. 29, no. 3, July 1982, pp. 8–10.

———, 'Stickley, not Shaker', *The Shaker Messenger*, vol. 4, no. 4, 1982, p. 17.

———, 'Authors Find Unusual Chair They Missed For Their Book', *The Shaker Messenger*, vol. 12, no. 4, 1990, p. 24.

———, 'Editorial – "It's a Damn Shame"', *The Shaker Messenger*, vol. 13, no. 4, 1991, p. 18.

* ——— & Rieman, T.D., *The Shaker Chair*, The Canal Press, Winchester, OH, USA, 1984.

Murphy, A., 'Cooler Shaker', *Observer Life*, 18 May 1997, pp. 12–21.

Murphy, A.K., 'An Expression of Faith', in Monaghan, K. (ed.), Catalogue for *Receiving the Faith: The Shakers of Canterbury, New Hampshire*, Whitney Museum of American Art at Champion, USA, 1993, pp. 4–6.

Murray, J.E., 'Stature among Members of a Nineteenth-Century American Commune', *Annals of Human Biology*, vol. 220, no. 2, 1993, pp. 121–29.

———, 'Determinants of Membership Levels and Duration in a Shaker Commune, 1780–1880', *Journal of the Scientific Study of Religion*, vol. 34, part 1, 1995, pp. 35–48.

* Murray, S., *Shaker Heritage Guidebook*, Golden Hill Press Inc., Spencertown, NY, USA, 1994.

Muse, V., *The Smithsonian Guide to Historic America – Northern New England*, Stewart, Tabori & Chang, New York, USA, 1989.

Myerson, J., *Gordon Russell – Designer of Furniture*, The Design Council, London, UK, 1992.

Naeve, M.M., *Identifying American Furniture*, W.W. Norton & Company, New York, USA and London, UK, 1998.

Nalley, R.V., 'The Simple Shaker Style', *USAir* (Magazine), vol. 5, no. 6, June 1983, pp. 42–60.

Neal, J., 'Regional Characteristics of Western Shaker Furniture', *The Magazine Antiques*, vol. 98, no. 4, October 1970, pp. 611–17.

———, 'In Remembrance of Mrs Irene Zieget', *The World of Shaker*, vol. 7, no. 1, 1977, p. 1.

———, *The Kentucky Shakers*, The University Press of Kentucky, Lexington, KY, USA, 1982.

———, 'The American Shakers', *Communities*, vol. 68, 1985, pp. 14–19.

Nelson, G.G., 'Lassiter Sale Puts Shaker On Its Way', *The Shaker Messenger*, vol. 4, no. 2, 1982, pp. 24–25.

———, 'Sixty Years of Shaker Study by the Andrews', *The Shaker Messenger*, vol. 5, no. 2, 1983, p. 23.

———, 'Duxbury Show Offers Look at Quality Pieces of Shaker', *The Shaker Messenger*, vol. 5, no. 4, 1983, p. 17.

———, Moriarty, K.M. & Wisbey, H.A., *The Twentieth Anniversary Shaker Seminar – Harvard and Shirley, Mass.*, Berkshire Community College, Pittsfield, MA, USA, 1994.

———, Moriarty, K.M., Wisbey, H.A. & Gale, G., *Berkshire Shaker Seminar. From Manchester, England to Waterliet, New York*, Berkshire Community College, Pittsfield, MA, USA, 1995.

Newman, C. & Abell, S., 'The Shakers' Brief Eternity', *National Geographic*, vol. 176, no. 3, September 1989, pp. 302–25.

Nickels, E., 'The Shaker Furniture of Pleasant Hill, Kentucky', *The Magazine Antiques*, vol. 137, no. 5, May 1990, pp. 1178–89.

* Nicoletta, J. & Morgan, B., *The Architecture of the Shakers*, The Countryman Press, Woodstock, VT, USA, 1995.

Nitschke, G., *From Shinto To Ando*, Academy Editions, Ernst & John, London, UK, 1993.

* Nordhoff, C., *The Communistic Societies of the United States*, Dover Publications Inc., New York, USA, 1966.

Noyes, L.M., *Catalogue of Fancy Goods*, Shaker Press, Sabbathday Lake, ME, USA, 1992 (reprinted from 1910 version).

O'Connor, F.V. (ed.), *Art for the Millions – Essays from the 1930s by Artists and Administrators of the WPA Federal Art Project*, New York Graphic Society Ltd, Greenwich, CT, USA, 1973.

O'Connor, L.B., 'Shaker House – The Simple Beauty and Functionalism of Shaker Design in a Home for the Present', *The Shaker Spirit*, July/August 1989, pp. 25–28.

Olmert, M., 'Winterthur's Forgotten Treasures', *Historic Preservation*, January/February 1989, pp. 64–68.

Ord Manroe, C., *Shaker Style: The Gift to be Simple*, Crescent Books, New York, USA, 1991.

O'Rourke, F., 'Ballitore Rich in Quaker History', *The Nationalist*, 8 October 1999, p. 10.

Overy, P., 'The Shakers: Form and Function', *The Times*, 1 April 1975, p. 6.

Paige, J.S., *The Shaker Kitchen*, Clarkson Potter Publishers, New York, USA, 1994.

Parker, G. & Winkleman, B., *The Times Atlas of World History*, Times Books, London, UK, 1995.

Parker, R.A., 'The Classical Vision of Charles Sheeler', *Studio International*, vol. 84, May 1926, pp. 68–72.

Parkinson, A. & Parkinson, K.C., 'Utilitarian Objects, Crafted with Excellence and Artistry, Contrast Shaker and Japanese Cultures', *Shakers World*, vol. 1, no. 1, 1996, pp. 14 and 19.

———, 'Rare Shaker Drawings Discovered', *Shakers World*, vol. 1, no. 3, 1996, pp. 23 and 27.

———, 'Auction News – Enfield Shaker Village', *Shakers World*, vol. 2, no. 1, 1997, p. 12.

———, 'The Milton Sherman Collection: Exhibit and Sale', *Shakers World*, vol. 2, no. 1, 1997, p. 21.

Parrish, T., *Restoring Shakertown*, The University Press of Kentucky, Lexington, KY, USA, 2005.

Paterwic, S., 'The Last of the Shakers', *The Shaker Quarterly*, vol. 20, no. 2, 1992, pp. 67–79.

* Patterson, D.W., *Gift Drawing and Gift Song – a Study of Two Forms of Shaker Inspiration*, The United Society of Shakers, Sabbathday Lake, ME, USA, 1983.

————, 'Gift Drawing and Gift Song – a Study of Two Forms of Shaker Inspiration', *New York Folklore*, vol. 13, no. 3/4, 1987, pp. 115–17.

Pawson, J., *Minimum*, Phaidon Press Ltd, London, UK, 1996.

Pearson, E.R. & Kealy, H.L.P., 'Unusual Forms in Shaker Furniture', *The Magazine Antiques*, vol. 98, no. 4, October 1970, pp. 606–10.

* ———— & Neal, J., *The Shaker Image* (Second and Annotated Edition), Hancock Shaker Village, Shaker Community Inc., Pittsfield, MA, USA, 1994.

Peck, A. & O'Neill, J.P. (ed.), *Period Rooms in the Metropolitan Museum of Art*, H.N. Abrams and The Metropolitan Museum of Art, New York, USA, 1996.

Peder Zane, J., 'Dr Fad's Advice on Buying Art: Keep it Simple. He's the Complete Shaker Connoisseur', *The New York Times*, 7 January 1996, p. 6.

Peladeau, M.B., 'Shaker Material in the Historic American Buildings Survey', *The Shaker Quarterly*, vol. 9, no. 4, 1969, pp. 107–32.

————, 'Early Shaker Chairs', *Historic Preservation*, vol. 22, no. 4, 1970, pp. 30–37.

————, 'The Shaker Meetinghouses of Moses Johnson', *The Magazine Antiques*, vol. 98, no. 4, October 1970, pp. 594–99; also in Rose, M.C. & Rose, E.M. (eds.), *A Shaker Reader*, Universe Books, New York, USA, 1977, pp. 44–49.

————, 'Review of the book *Illustrated Guide to Shaker Furniture*', *The Shaker Quarterly*, vol. 12, no. 2, 1972, p. 69.

Pevsner, N., *Pioneers of Modern Design from William Morris to Walter Gropius*, Penguin Books, London, UK, 1984.

Phillips, H.S., 'Shakers in the West', *Philadelphia Museum of Art Bulletin*, vol. 57, no. 273, 1962, pp. 83–88.

————, *Shaker Architecture – Warren County Ohio*, Hazel Spencer Phillips, Oxford, OH, USA, 1971.

Pico, C. (auctioneer), Auction Catalogue for *Important Shaker and Folk Art – The Collection of George and Roberta Sieber*, Litchfield Auction Gallery, Litchfield, CT, USA, 1988.

Pierce, K., *Making Shaker Woodenware*, Sterling Publishing Co., Inc., New York, USA, 1998.

Pike, K.J., 'Shaker Manuscripts and How They Came to be Preserved', *Manuscripts*, vol. 29, no. 4, Fall 1977, pp. 226–36.

Pile, J.F., Davis, S., Heinemann, S., Reynolds, P. & Meyer, S.E., *Dictionary of 20th-Century Design*, A Roundtable Press Book for Facts On File Inc., New York, USA and Oxford, UK, 1990.

Pointon, M., 'Quakerism and Visual Culture 1650–1800', *Art History*, vol. 20, no. 3, 1997, pp. 397–431.

Poppeliers, J.C., 'Shaker Architecture and the Watervliet Shaker South Family', *New York History*, vol. 47, no. 1, January 1966, pp. 51–60.

———— (ed.) & Stephens, D., 'Shaker Built – A Catalogue of Shaker Architectural Records From The Historic American Buildings Survey', *Historic American Buildings Survey*, National Park Service, US Department of the Interior, 1974, pp. 1–87.

Pranian, H. & Pranian, R., Catalogue for *Shaker: The Simple Form – Outstanding Works from Chicago Collections*, Harvey Antiques, Evanston, IL, USA, 1992.

Pratt, R., 'Shaker House', *Ladies Home Journal*, vol. 67, 1950, pp. 68–69.

Procter-Smith, M., *Women in Shaker Community and Worship – A Feminist Analysis of the Uses of Religious Symbolism*, The Edwin Mellen Press, New York, USA, 1985.

* Promey, S.M., *Spiritual Spectacles, Vision and Image in Mid-Nineteenth-Century Shakerism*, Indiana University Press, Bloomington, IN, USA, 1993.

Prown, J.D., 'Mind in Matter – An Introduction to Material Culture Theory and Method', *Winterthur Portfolio – A Journal of American Material Culture*, vol. 17, no. 1, 1982, pp. 1–16.

Pulliam, D., 'Narcissa Thorne's Miniature Career', *Piecework*, vol. 6, part 3, May/June 1998, pp. 16–21.

Purcell, L.E., *The Shakers*, Crescent Books, New York, USA, 1991.

Quimby, I.M.G. (ed.), *Material Culture and the Study of American Life*, W.W. Norton & Company Inc., New York, USA, 1978.

———— & Swank, S.T., *Perspectives on American Folk Art*, W.W. Norton & Company Inc., New York, USA, 1980.

Rabinovitch, D., 'Farewell Utopia – No Sex Please We're Shakers', *The Guardian Weekend*, 1 May 1993, pp. 6–9.

Rack, H., 'Establishments, Evangelicals & Enthusiasm in 18th-Century Manchester, England, Part 2', *The Shaker Quarterly*, vol. 17, no. 3, 1989, pp. 75–96.

Ratcliff, C., 'Amazing Grace – The Artful Simplicity of America's Shakers', *Travel & Leisure*, September 1986, pp. 127–38.

Ratkai, G., 'Shaker Furniture: Perfect Unto Its Purpose', *McCall's*, vol. 99, April 1972, pp. 106–07.

Ray, M.L., 'A Reappraisal of Shaker Furniture and Society', *Winterthur Portfolio – A Journal of American Material Culture*, vol. 8, 1973, pp. 105–32.

———— & Stimpson, M., Catalogue for *True Gospel Simplicity: Shaker Furniture in New Hampshire*, The New Hampshire Historical Society, Concord, NH, USA, 1974.

Raycraft, D. & Raycraft, C., *Shaker – a Collector's Source Book II*, Wallace-Homestead Book Company, Des Moines, IA, USA, 1985.

Reif, R., 'Antiques: Furnishings of the Shakers', *The New York Times*, 6 January 1972, p. 26.

Reser, J. (photographer), 'Display Windows at Saks Fifth Avenue', *The Shaker Messenger*, vol. 13, no. 4, 1991, p. 23.

Rhodus, J., 'Ohio Shaker Chairs', *The Shaker Messenger*, vol. 5, no. 2, 1983, p. 12.

Richards, D., 'Travelling Exhibitions Organised by Sabbathday Lake Shaker Museum', *The Shaker Messenger*, vol. 9, no. 1, 1986, pp. 8–9.

———, 'The 1816 Spin House: A Restoration Project', *The Shaker Quarterly*, vol. 16, no. 3, 1988, pp. 93–96.

———, Emery Hulick, D. & Marini, S., Catalogue for *In Time and Eternity: Maine Shakers in the Industrial Age 1872–1918*, The United Society of Shakers, Sabbathday Lake, ME, USA, 1986.

* Richmond, M.L., *Shaker Literature – A Bibliography, vol. 1 – By The Shakers*, Shaker Community Inc., Hancock, MA, USA and University Press of New England, Hanover, NH, USA, 1977.

* ———, *Shaker Literature – A Bibliography, vol. 2 – About The Shakers*, Shaker Community Inc., Hancock, MA, USA and University Press of New England, Hanover, NH, USA, 1977.

Rieman, T.D. (with an essay by S.L. Buck), Catalogue for *Shaker: The Art of Craftsmanship*, Art Services International, Alexandria, VA, USA, 1995.

* ——— & Burks, J., *Complete Book of Shaker Furniture*, Abrams, New York, USA, 1993.

Ries, S., 'The Shaker Round Barn', *Interior Design*, vol. 58, May 1987, pp. 282–83.

Rivers, T., Cruickshank, D., Darley, G. & Pawley, M., *The Name of the Room*, BBC Enterprises Ltd, London, UK, 1992.

* Rocheleau, P., Sprigg, J. & Larkin, D., *Shaker Built – The Form and Function of Shaker Architecture*, Thames and Hudson, London, UK, 1994.

Rogers, M.R., *American Rooms in Miniature by Mrs James Ward Thorne*, The Art Institute of Chicago, Chicago, USA, 1941.

Romanelli, M., 'There is No Dirt in Heaven', *Domus*, no. 675, September 1986, pp. 4–7.

Rose, M.C. & Rose, E.M. (eds.), *A Shaker Reader*, Universe Books, New York, USA, 1977.

Rosenberg, W.S., 'Shaker Buildings Preserved', *The Clarion*, vol. 13, Spring 1988, p. 20.

Selling Shaker

Roueche, B., 'A Reporter at Large – A Small Family of Seven', *The New Yorker*, vol. 23, August 1947, pp. 46–57.

Rourke, C., Catalogue for *Index of American Design Exhibition*, Fogg Museum of Art, Harvard University, MA, USA, 1937.

———, *Charles Sheeler – Artist in the American Tradition*, Harcourt, Brace and Company, New York, USA, 1938.

———, *The Roots of American Culture*, Greenwood Press, CT, USA, 1942.

Rovetti, P.F., 'The Director's Note', in Bruhn, T.P. (ed.), Catalogue for *Simple Gifts – Hands to Work and Hearts to God*, The William Benton Museum of Art, The University of Connecticut, Storrs, USA, 1978, p. 9.

Rubin, C.E., 'American Museum in Britain', *The World of Shaker*, vol. 3, no. 4, 1973, p. 7.

———, 'Shaker Makes The Big Time', *The World of Shaker*, vol. 4, no. 5, 1973, p. 1.

Rule, V., 'New World Seen by Old Eyes (Obituary – Dallas Pratt)', *The Guardian*, 31 May 1994, p. 19.

Ryan, J.F., 'The Story of Shaker Poplarware', *Shakers World*, vol. 1, no. 2, 1996, pp. 20–23.

Scherer, J.L., 'Introduction' in Kramer, F., Catalogue for *Simply Shaker – Groveland and the New York Communities*, Rochester Museum and Science Centre, New York, USA, 1991, p. 9.

——— (ed.), Catalogue for *A Shaker Legacy – The Shaker Collection at the New York State Museum* (New York State Museum Circular 63 – 2000), The University of the State of New York, The State Education Department, Albany, NY, USA, 2000.

* Schiffer, H., *Shaker Architecture*, Schiffer Publishing Ltd, Exton, PA, USA, 1979.

Schlereth, T.J., 'Material Culture Studies in America: Notes toward a Historical Perspective', *Material History Bulletin*, no. 8, 1979, pp. 89–98.

Schorsch, D., *The Photographs of William F. Winter, Jr, 1899–1939*, D.A. Schorsch, New York, USA, 1989.

Sears, C.E., *Gleanings from Old Shaker Journals*, Houghton Mifflin Company, Boston and New York, USA, 1916.

———, *The Romance of Fiddlers Green*, Houghton Mifflin & Company, Boston, MA, USA, 1922.

Sekers, D. & Rose, M., *Styal – An Illustrated Souvenir*, The National Trust, London, UK, 1993.

Sellin, D., 'Shaker Inspirational Drawings', *Philadelphia Museum of Art Bulletin*, vol. 57, no. 273, 1962, pp. 93–99.

Sembach, K.-J., Leuthauser, G. & Gossel, P., *Twentieth-Century Furniture Design*, Benedikt Taschen Verlag GmbH, Köln, Germany, 1991.

Serette, D., *Shaker Smalls*, The Cardigan Press, Sebasco, ME, USA, 1983.

Shafernich, S.M., 'On-Site Museums, Open-Air Museums, Museum Villages and Living History Museums: Reconstructions and Period Rooms in the United States and the United Kingdom', *Museum Management and Curatorship*, vol. 12, March 1993, pp. 43–61.

Shallcross Wohlauer, G. & Rogers, M., *A Guide to the Collection of the Museum of Fine Arts, Boston*, Museum of Fine Arts, Boston, MA, USA, 1999.

Shanor, R., 'Berkshire Shaker Village to be Museum Town', *The New York Times*, 18 June 1961, Section 10, p. 4.

Shaver, E. & Pratt, N., *The Watervliet Shakers and Their 1848 Shaker Meeting House*, The Shaker Heritage Society, Albany, NY, USA, 1994.

Shaw, R., *America's Traditional Crafts*, Hugh Lauter Levin Associates Inc., New York, USA, 1993.

Shea, J.G., *Making Authentic Shaker Furniture With Measured Drawings Of Museum Classics*, Dover Publications Inc., New York, USA, 1971 and 1992.

Sheridan, B., 'Quaker Village Provides Ideal Business Backdrop', *The Nationalist*, 27 November 1998, p. 34.

Sitwell, E., *English Eccentrics*, Penguin Books, London, UK, 1971.

Skinner, R.W. (Skinner Auctioneers), Auction Catalogue for *Americana Auction* (number 666), Robert W. Skinner Inc., Bolton, MA, USA, 14 March 1980.

———, Catalogue for *A Shaker Collection*, Robert W. Skinner Inc., Bolton, MA, USA, 13 January 1996.

———, Catalogue for *A Shaker Auction (featuring the collections of Richard Klank and Gus & June Nelson)*, Sale 2240, Robert W. Skinner Inc., Boston, MA, USA, 31 October 2003.

Skolnick, S.M. (photographer), *Simple Gifts – The Shaker Song*, Hyperion, New York, USA, 1992.

Skramstad, Jr, H.K., 'Interpreting Material Culture: A View from the Other Side of the Glass', in Quimby, I.M.G. (ed.), *Material Culture and the Study of American Life*, W.W. Norton & Company Inc., New York, USA, 1978, pp. 175–200.

Smith, C.S., 'Museum, Artefacts and Meanings', in Vergo, P. (ed.), *The New Museology*, Reaktion Books Ltd, London, UK, 1989, pp. 6–21.

Sonday, R., *Shaker Style Wood Projects*, Sterling Publishing Company Inc., New York, USA, 1997.

Sorensen, C., 'Theme Parks and Time Machines', in Vergo, P. (ed.), *The New Museology*, Reaktion Books Ltd, London, UK, 1989, pp. 60–73.

Sparrow, M.L., 'Research Reveals Pleasant Hill Shaker Sacred Outdoor Meeting Site', *Shakers World*, vol. 2, no. 1, 1997, pp. 8–11.

Spencer, P., *Religion in Styal – The Religious Influences Upon the Greg Family and Their Effects on the Development of Styal*, Quarry Bank Mill Trust Ltd, Styal, UK, 1983.

Spraker, E.C., 'Simple Art of the Simple Life', *Evening Journal* (Wilmington, Delaware), 20 November 1969, p. 35.

Sprigg, J., 'The Shaker Way', *The New York Times Magazine*, 2 November 1975, pp. 68–71.

———, 'The Gift To Be Simple', in Bruhn, T.P. (ed.), Catalogue for *Simple Gifts – Hands to Work and Hearts to God*, The William Benton Museum of Art, The University of Connecticut, Storrs, USA, 1978, pp. 23–27.

———, 'Introduction', in Miller, A.B., Fletcher Little, N. & Sprigg, J. (eds.), Catalogue for *The Gift of Inspiration: Art of the Shakers 1830–1880*, Hirschl & Adler Galleries Inc., New York, USA, 1979, p. 6.

———, 'Marked Shaker Furniture', *The Magazine Antiques*, vol. 115, no. 5, May 1979, pp. 1048–58.

———, 'Out of this World: The Shakers as a Nineteenth-Century Tourist Attraction', *American Heritage*, vol. 31, no. 3, April/May 1980, pp. 65–68.

———, 'Hancock Shaker Village: The City of Peace', *The Magazine Antiques*, vol. 120, no. 4, October 1981, pp. 884–95.

———, 'By Shaker Hands – an Exhibit of Shaker Pieces', *The Shaker Messenger*, vol. 6, no. 1, 1983, p. 17.

——— (Guest Curator), Catalogue for *Shaker – Masterworks of Utilitarian Design Created Between 1800 and 1875 by the Craftsmen and Craftswomen of America's Foremost Communal Religious Sect*, The Katonah Gallery, Katonah, NY, USA, 1983.

———, 'Shaker Perfection', *Art & Antiques*, June 1985, pp. 58–63.

———, 'The Development of Shaker Design', *The Magazine Antiques*, vol. 129, no. 4, April 1986, pp. 812–23.

———, 'June Sprigg Explains Beginnings of Exhibit', *The Shaker Messenger*, vol. 8, no. 4, 1986, p. 17.

———, Catalogue for *Shaker Design*, Whitney Museum of American Art in association with Norton, New York, USA, 1986.

———, Catalogue for *Shaker Original Paints & Patinas*, Muhlenberg College Centre for the Arts, Allentown, PA, USA, 1987.

———, 'Shaker Colour and Light', *Art & Antiques*, April 1988, pp. 90–94.

———, 'The Karl Mendel Shaker Collection', *Maine Antique Digest*, November 1988, p. 28.

* ———, *By Shaker Hands*, University Press of New England, Hanover, NH, USA and London, UK, 1990.

———, *Simple Gifts – 25 Authentic Shaker Craft Projects*, Blandford, London, UK, 1991.

———, 'Shaker in France and Germany', *The Shaker Messenger*, vol. 16, no. 1, 1994, p. 8.

———, 'The Fifteenth Rock: On Shaker Design' (Prologue), in Sprigg, J. (ed.), Catalogue for *Kindred Spirits – The Eloquence of Function in American Shaker and Japanese Arts of Daily Life*, Mingei International, San Diego, CA, USA, 1995, pp. 9–14.

——— (ed.), Catalogue for *Kindred Spirits – The Eloquence of Function in American Shaker and Japanese Arts of Daily Life*, Mingei International, San Diego, CA, USA, 1995.

———, *Simple Gifts – A Memoir of a Shaker Village*, Alfred A. Knopf, New York, USA, 1998.

——— & Johnson, J., *Shaker Woodenware: A Field Guide – Volume 1*, Berkshire House, Great Barrington, MA, USA, 1991.

——— & Johnson, J., *Shaker Woodenware: A Field Guide – Volume 2*, Berkshire House, Stockbridge, MA, USA, 1992.

* ——— & Larkin, D., *Shaker – Life, Work and Art*, Cassell Publishers Limited, London, UK, 1987.

Sprigg Tooley, J., *A Shaker Sister's Drawings*, The Monacelli Press, New York, USA, 1997.

Starbuck, D.R., 'Those Ingenious Shakers', *Archaeology Magazine*, vol. 43, no. 4, July/August 1990, pp. 40–47.

———, 'Canterbury Shaker Village – Archeology and Landscape', *The New Hampshire Archeologist*, vol. 31, no. 1, 1990, pp. 1–163.

——— & Swank, S.T., *A Shaker Family Album*, University Press of New England, Hanover, NH, USA, 1998.

Stead, T., 'A Great Exhibition – Now Buy The Goods', *Chic*, April 1998, p. 51.

Steadman, K.R., 'Shaker Style Addition Wins Award', *The Shaker Messenger*, vol. 15, no. 3, 1993, pp. 8–9.

Stechler Burns, A. & Burns, K., *The Shakers: Hands to Work, Hearts to God*, Aperture Books, New York, USA, 1987.

Stein, S.J., 'A Candid Statement of Our Principles – Early Shaker Theology in the West', *Proceedings of the American Philosophical Society*, vol. 13, no. 4, 1989, pp. 503–19.

———, *The Shaker Experience in America: A History of the United Society of Believers*, Yale University Press, New Haven, USA and London, UK, 1992.

———, *Inspiration, Revelation and Scripture – The Story of the Shaker Bible*, 1996 (Offprint

booklet 958, from the *Proceedings of the American Antiquarian Society*, vol. 105, no. 2, 1995, pp. 347–76).

Stell, L., 'Faith Andrews: A Celebration', *The Shaker Messenger*, vol. 10, no. 1, Fall 1987, pp. 7 and 26.

Stephen, C., 'A Look Into The Kitchen At South Union', *The Shaker Messenger*, vol. 2, no. 3, 1980, pp. 6–8.

Stern, R.A.M., Averitt, J. & Carlin, E., 'Shakertown Visitor Centre', *Journal of Architecture and Urbanism*, no. 129, 1981, p. 20.

Stewart, P.L., 'Charles Sheeler, William Carlos Williams and Precisionism: a Redefinition', *Arts Magazine*, vol. 58, November 1983, pp. 100–14.

Stier, M. & Fuller, R.N., *Shaker Sites in Harvard – A Guide for the Harvard Shaker Bicentennial 1791–1991*, Harvard Shaker 200 Committee, Fruitlands Museum and Harvard Public Library, Harvard, MA, USA, 1991.

Storey, W.R., 'Native Art From Old Shaker Colonies – A Distinct Style of American Furniture Which Has Interest For Our Times', *The New York Times Magazine*, 23 October 1932, pp. 14 and 18.

———, 'American Antiques Recorded in Pictures', *The New York Times Magazine*, 20 September 1936, Section 7, p. 10.

Struthers, J., *Wood*, Ebury Press, London, UK, 1991.

Styles, J., *Titus Salt and Saltaire – Industry and Virtue*, Salt Estates Ltd, Saltaire, West Yorkshire, UK, 1994.

Sudjic, D., 'Introduction', in Chatwin, B. & Sudjic, D., *John Pawson*, Gustavo Gili, Barcelona, Spain, 1998, pp. 11–15.

Sutherland, C.A., Catalogue for *Receiving the Faith: The Shakers of Canterbury, New Hampshire*, The Museum of Our National Heritage, Lexington, MA, USA, 1992.

Sutherland, C.S., 'Shaker Chair Demonstrates Idealism, Progress', *The Shaker Messenger*, vol. 8, no. 2, 1986, pp. 8–10.

* Swank, S.T., *Shaker Life, Art, and Architecture – Hands to Work, Hearts to God*, Abbeville Press, London, UK, 1999.

——— & Hack, S.N., 'All We Do Is Build: Community Building at Canterbury Shaker Village, 1792–1939', *Historical New Hampshire*, vol. 48, no. 2/3, Summer/Fall 1993, pp. 99–131.

Swengley, N., 'Shaking All The Way To The Stove', *The Sunday Telegraph* (Review Section), 13 October 1996, p. 28.

Talmey, A., 'Whitney Museum of American Art and the One-Women Power Behind It – Juliana Force', *Vogue*, 1 February 1940, pp. 94–133.

Tamulevich, S., 'Dr Fad's Dilemma', *Art & Antiques*, vol. 9, January 1992, p. 22.

Tarbell, B., 'Canterbury Shaker Village – A Legacy Lives On', Art & Antiques, vol. 15, December 1993, p. 78.

Taylor, J.C., 'Introduction', in Emerich, A.D. & Benning, A.H. (eds.), Catalogue for Shaker: Furniture and Objects from the Faith and Edward Deming Andrews Collections, Smithsonian Institution Press for the Renwick Gallery, Smithsonian Institution, Washington DC, USA, 1973, pp. 9–11.

Taylor, M., 'Two Paths to Perfection', The Shaker Messenger, vol. 7, no. 2, 1985, pp. 11–13.

Tecimer, D., 'Shaker Aesthetic', The World of Shaker, vol. 4, no. 2, 1974, p. 5.

Temin, C., 'Art World Movers Find Harmony With Shakers', The Boston Globe, 12 June 1998, pp. D1 and D12.

Thomas, J.C., 'Micajah Burnett and the Buildings at Pleasant Hill', The Magazine Antiques, vol. 98, no. 4, October 1970, pp. 600–05.

Thomas, S.W. & Thomas, J.C., The Simple Spirit – a Pictorial Study of the Shaker Community at Pleasant Hill, Kentucky, Pleasant Hill Press, Harrodsburg, KY, USA, 1973.

Thompson, D., 'Eleanor Roosevelt: The Shakers and the Meaning of Craftsmanship', The Shaker Messenger, vol. 13, no. 3, 1991, p. 13.

———, 'Eleanor Roosevelt and The Shakers', The Shaker Messenger, vol. 14, no. 2, 1992, p. 7.

Thorne-Thomsen, K., Shaker Children – True Stories and Crafts – 2 Biographies and 30 Activities, Chicago Review Press, Chicago, USA, 1996.

Thrasher, W., 'Commentary', in Sprigg, J. (ed.), Catalogue for Kindred Spirits – The Eloquence of Function in American Shaker and Japanese Arts of Daily Life, Mingei International, San Diego, CA, USA, 1995, pp. 19–27.

Thurman, S.R., 'O Sisters Ain't You Happy?' Gender, Family, and Community among the Harvard and Shirley Shakers, 1781–1918, Syracuse University Press, Syracuse, NY, USA, 2002.

Tirrell-Wysocki, D., 'Learning About Shaker Ways', The Philadelphia Inquirer, 17 January 1999, p. 19.

Trinder, B., Ironbridge – A Pictorial Souvenir, Ironbridge Gorge Museum Trust, Telford, UK, 1993.

Troyen, C., 'The Open Window and Empty Chair', The American Art Journal, vol. 18, no. 2, 1986, pp. 24–41.

——— & Hirshler, E.E., Charles Sheeler: Paintings and Drawings, Little, Brown and Company Inc., Boston, USA, 1987.

Turner, A. & Minor, W., Shaker Hearts, Harper Collins, New York, USA, 1997.

Unspecified, 'Disgraced Shaker Elder Ernest Pick', The Sun, 11 April 1909, p. 6.

———, 'By Their Works Ye Shall Know Them', *Vanity Fair*, February 1928, p. 62.

———, 'Shaker Craft on Exhibition Here', *The New York Herald Tribune*, 12 November 1935, p. 16.

———, 'Austere Beauty', *The Magazine Antiques*, vol. 43, no. 4, April 1943, pp. 188–89.

———, 'Shaker Collection Given To Yale', *The Berkshire Eagle*, 1 September 1956, p. 10.

———, 'Yale To Receive Collection Of Shaker Artefacts – Authority on Communal Religious Sect Also Named Faculty Member', *New Haven Register*, 2 September 1956, p. 6.

———, Catalogue for *Shaker Inspirational Drawings*, The Abby Aldrich Rockefeller Folk Art Collection, Williamsburg, USA, 1962.

———, 'Obituaries – Edward D. Andrews Dies; Noted Expert on Shakers', *The Berkshire Eagle*, 8 June 1964, p. 15.

———, 'Shaker Crafts Revived', *Interior Design*, January 1967, pp. 137–39.

———, 'The American Country Look – Shaker', *Better Homes and Gardens*, August 1972, pp. 50–55.

———, 'Shaker Pieces to Buy', *Colonial Homes*, 1979, p. 159.

———, Auction Catalogue for *Important Shaker Furniture and Related Decorative Arts: The William L. Lassiter Collection – York Avenue Galleries – November 13*, Sotheby Parke Bernet Inc., New York, USA, 1981.

———, 'The Shaker Surge', *Colonial Homes*, March/April 1982, pp. 118–23.

———, 'The Golden Lamb', *Colonial Homes*, March/April 1985, pp. 128–39.

———, 'Style Insider', *The Guardian Weekend*, 17 January 1998, p. 33.

———, 'Latest Looks – Shaker Springtime', *Homes & Ideas Magazine*, March 1998, p. 30.

———, 'Endangered Species – The Last Seven Shakers In The World', *The Economist*, 13 February 1999, p. 31.

——— and Librizzi, J. (photographer), 'Moving Day at Hancock', *The Berkshire Eagle*, 21 March 1962, p. 21.

Upton, C.W., 'The Shaker Utopia', *The World of Shaker*, vol. 2, no. 1, 1972, pp. 1–2; also in Rose, M.C. & Rose, E.M. (eds.), *A Shaker Reader*, Universe Books, New York, USA, 1977, pp. 10–15.

——— & Upton, H., 'Living with Antiques – Shaker Adventure', *The Magazine Antiques*, vol. 90, no. 1, July 1966, pp. 84–89.

Vadnais, A.J., 'Foreword', in Flint, C.L. & Rocheleau, P., *Mount Lebanon Shaker Collection*, Mount Lebanon Shaker Village, Mount Lebanon, NY, USA, 1987, p. ix.

Vaizey, M., 'Basic Beauty', *The Sunday Times*, 30 March 1975, p. 37.

Valentine, L., 'The Shakers: Background and Philosophy', in Valentine, L., Catalogue for *The Shakers: Pure of Spirit, Pure of Mind*, The Art Complex Museum, Duxbury, MA, USA, 1983.

———, Catalogue for *The Shakers: Pure of Spirit, Pure of Mind*, The Art Complex Museum, Duxbury, MA, USA, 1983.

Van Der Zee, B., 'Space. Cheat Chic – Shaker Kitchens', *The Guardian*, 26 September 1997, p. 23.

Van Dusen, G. (photographer), 'The New Shaker Exhibit in the Reception Centre at Fruitlands Museums', *The Shaker Messenger*, vol. 4, no. 4, 1982, p. 13.

Van Kolken, D., 'A Comprehensive Show...', *The Shaker Messenger*, vol. 1, no. 3, 1979, p. 16.

———, 'Shaker exhibition, seminar scheduled in New York City', *The Shaker Messenger*, vol. 1, no. 4, 1979, p. 10.

———, 'New York Seminar and Exhibitions ... A Joy to Hear, See and Absorb', *The Shaker Messenger*, vol. 2, no. 1, 1979, p. 18.

———, 'In Memoriam – Gus Schwerdtfeger', *The Shaker Messenger*, vol. 3, no. 2, 1981, p. 23.

———, 'Mrs Reagan Orders Oval Boxes for Senate Wives', *The Shaker Messenger*, vol. 4, no. 1, 1981, p. 16.

———, 'New Shaker Exhibition', *The Shaker Messenger*, vol. 4, no. 4, 1982, p. 13.

———, 'Shaker Museum Founder John Williams Sr Dies', *The Shaker Messenger*, vol. 4, no. 4, 1982, p. 13.

———, 'New York Museum Opens Second Major Shaker Exhibit', *The Shaker Messenger*, vol. 5, no. 4, 1983, p. 9.

———, 'Exhibition at Fruitlands Museums', *The Shaker Messenger*, vol. 5, no. 4, 1983, p. 24.

———, 'Hancock Shaker Village 25 – Founded in 1790 – 25th Anniversary as a Museum', *The Shaker Messenger*, vol. 7, no. 3, 1985, pp. 6–9.

* ———, *Introducing the Shakers – an Explanation & Directory*, Gabriel's Horn Publishing Co., Bowling Green, OH, USA, 1985.

———, 'Shaker Museum Opens 37th Exhibition Year', *The Shaker Messenger*, vol. 8, no. 2, 1986, p. 13.

———, 'Canterbury Revives Poplar Industry', *The Shaker Messenger*, vol. 8, no. 4, 1986, pp. 10–12.

———, 'Fruitlands Museums Showing Oval Boxes', *The Shaker Messenger*, vol. 9, no. 3, 1987, p. 16.

————, 'Mt Lebanon Collection in New Book', *The Shaker Messenger*, vol. 10, no. 1, 1987, p. 14.

————, 'Shaker Items at Muhlenberg', *The Shaker Messenger*, vol. 10, no. 1, 1987, p. 21.

————, 'Hancock Observes 200th Anniversary', *The Shaker Messenger*, vol. 12, no. 2, 1990, p. 13.

————, 'Shaker Historian Faith E. Andrews Dies', *The Shaker Messenger*, vol. 12, no. 4, 1990, p. 12.

————, 'Bertha Lindsay, Last of the Shaker Eldresses, Dies', *The Shaker Messenger*, vol. 13, no. 1, 1991, p. 9.

————, 'Fruitlands Museums Mark Harvard's 200 Years with Exhibitions And Symposium', *The Shaker Messenger*, vol. 13, no. 2, 1991, p. 12.

————, 'McDonald's Helps Shaker Heritage Society Purchase Broom-Making Equipment', *The Shaker Messenger*, vol. 13, no. 2, 1991, p. 26.

————, 'Attendance at Shaker Seminars Proof That Interest is Growing', *The Shaker Messenger*, vol. 13, no. 3, 1991, p. 17.

————, 'Canterbury on Exhibit in Lexington, Mass', *The Shaker Messenger*, vol. 14, no. 3, 1992, p. 34.

————, '200 Years for Sabbathday Lake', *The Shaker Messenger*, vol. 15, no. 4, March 1994, p. 13.

————, 'Mt Lebanon Looks at Future Roles', *The Shaker Messenger*, vol. 16, no. 1, 1994, p. 20.

————, 'Mt Lebanon Collection on Exhibit', *The Shaker Messenger*, vol. 16, no. 3, 1995, p. 6.

————, 'Research Shows Shakers Used Bright Colours', *The Shaker Messenger*, vol. 17, no. 3, 1996, p. 13.

————, 'Shaker Exhibition Closes in Nebraska; Opens in Columbus', *The Shaker Messenger*, vol. 17, no. 3, 1996, p. 19.

Vergo, P. (ed.), *The New Museology*, Reaktion Books Ltd, London, UK, 1989.

Volmar, M., *Under the Mulberry Tree* (Fruitlands Museums newsletter), Spring/Summer 1996.

Votolato, G., *American Design in the Twentieth Century*, University of Manchester Press, Manchester, UK and New York, USA, 1998.

Wagan, R.M., *An Illustrated Catalogue and Price-List of the Shakers' Chairs*, The United Society of Shakers, Sabbathday Lake, ME, USA, reprinted 1992.

Walker, J., 'Shaker Design – 150 Year Old Modern', *Home Furnishing Ideas*, Spring/Summer 1972, pp. 80–87.

Walker, J.A., *Design History and The History of Design*, Pluto Press, London, UK, 1989.

Walsh, D., 'The Canterbury Story – Establishment of the Community', *The Shaker Messenger*, vol. 2, no. 1, 1979, pp. 3–6.

————, 'The Canterbury Story – The Years of Growth and Prosperity', *The Shaker Messenger*, vol. 2, no. 2, 1980, pp. 14–21.

————, 'The Canterbury Story – The Start of the Decline', *The Shaker Messenger*, vol. 2, no. 3, 1980, pp. 22–24.

————, 'Canterbury: New Challenges', *The Shaker Messenger*, vol. 3, no. 1, 1980, pp. 20–22.

Wanamaker, J. (advertiser), 'Wanamaker's Gallery of American Design', *The New York Herald Tribune*, 16 November 1937, p. 20.

————, 'Shaker Simplicity', *The New York Times*, 19 January 1939, p. 20.

Ward, D., 'Call for Church to Honour Shaker Leader', *The Guardian*, 19 September 2000, p. 13.

Ward, G.W.R. (ed.), *Handbook for Winterthur Interpreters, A Multidisciplinary Analysis of the Winterthur Collection*, The Henry Francis du Pont Winterthur Museum, Wilmington, DE, USA, 1987.

Ward, H., 'They Make Shaker Furniture in Yorkshire Too', *Design*, no. 398, 1982, p. 7.

Warren, J., 'All Shook Up', *The Daily Express*, 3 March 2001, pp. 60–61.

Watkins, D., 'Julia Neal Showed Early Interest in Kentucky Shakers', *The Shaker Messenger*, vol. 11, no. 4, 1989, pp. 8–9.

Watt, J., 'Exhibition Review – The Art of Craftsmanship', *Perspectives in Architecture*, February 1998, p. 30.

Weir, G., 'Shaker Seminar, Lebanon, Ohio', *National Antiques Review*, vol. 6, no. 11, May 1973, pp. 16–18.

Weis, V., 'With Hands to Work and Hearts to God', *The Shaker Quarterly*, vol. 9, no. 2, 1969, pp. 35–46.

Wellman, R. & Cahill, H., 'American Design – From The Heritage of Our Styles Designers are Drawing Inspiration to Mould National Taste', *House & Garden*, July 1938, pp. 15–23.

Wertkin, G.C., 'Introduction', in Unspecified, Auction Catalogue for *Important Shaker Furniture and Related Decorative Arts: The William L. Lassiter Collection – York Avenue Galleries – November 13*, Sotheby Parke Bernet Inc., New York, USA, 1981.

————, 'The Museum at Twenty', *Fall Antiques Show – In Celebration – The Herb Garden*, 24–27 September 1981, pp. 16–21.

★ ————, *The Four Seasons of Shaker Life*, Simon & Schuster, New York, USA, 1986.

————, 'Given by Inspiration – Shaker Drawings and Manuscripts in the American Society for Psychical Research', *Folk Art*, vol. 20, Spring 1995, pp. 56–62.

———— & Balmer, R., Catalogue for *Millennial Dreams*, Museum of American Folk Art, New York, USA, 2000.

Westerkamp, M.J., 'Book Review – *The Shaker Experience in America* – Stephen J. Stein', *Winterthur Portfolio – A Journal of American Material Culture*, vol. 29, no. 1, 1994, pp. 91–94.

Wetherbee, M. & Taylor, N., *Shaker Baskets*, The Martha Wetherbee Basket Shop, Sanbornton, NH, USA, 1988.

Wheeler, D.H., 'Shaker Influences Architectural Design', *The Shaker Messenger*, vol. 13, no. 3, 1991, p. 10.

White, A. & Taylor, L.S., *Shakerism Its Meaning and Message*, AMS, New York, USA, 1971.

Whitson, R.E., Catalogue for *The Shakers: An Exhibition Concerning Their Furniture, Artifacts and Religion with Emphasis on Enfield, Connecticut*, The Women's Auxiliary of the United Cerebral Palsy Association of Greater Hartford, USA, 1975.

Whitworth, J.M., *God's Blueprints: A Sociological Study of Three Utopian Sects*, Routledge & Kegan Paul, Boston, MA, USA, 1975.

Wiencek, H., *The Smithsonian Guide to Historic America – South New England*, Stewart, Tabori & Chang, New York, USA, 1989.

Williams, F., 'On the Shaker Trail', *BBC Homes & Antiques*, September 2003, pp. 102–05.

Williams, J.S., *The Shaker Religious Concept*, The Shaker Museum Foundation, Old Chatham, NY, USA, 1959.

Williams, R.E., *Perfectionism: The Shaker Way of Life*, Master's Thesis, New Brunswick Theological Seminary, USA, 1977.

Williams, R.L., 'The Shakers, Now Only 12, Observe their 200th Year', *The Smithsonian*, vol. 5, no. 6, September 1974, pp. 40–49.

Williams, R.M., 'Shaker of the West – One Man's Collection', *Americana*, vol. 7, March 1979, pp. 50–55.

Willis Henry Auctions, Inc., Catalogue for *Shaker Auction*, Oct. 8, Pittsfield, MA, USA, 1982.

————, Catalogue for *Shaker Auction*, June 12, Kingston, MA, USA, 1983.

————, Catalogue for *Shaker Auction*, June 30, Duxbury, MA, USA, 1984.

————, Catalogue for *Shaker Auction*, Aug., Mount Lebanon Shaker Village, Mount Lebanon, NY, USA, 1988.

————, Catalogue for *Shaker Auction (The Karl Mendel Shaker Collection)*, Sept. 25, Albany, USA, 1988.

———, Catalogue for *Shaker Auction*, Aug. 6, Pittsfield, MA, USA, 1989.

———, Catalogue for *Americana & Estate Auction featuring Shaker*, Oct. 13, Pittsfield, MA, USA, 1997.

———, Catalogue for *Shaker Auction*, June 8, Pittsfield, MA, USA, 2002.

———, Catalogue for *Shaker Auction*, June 28, Old Chatham, NY, USA, 2003.

Wilson, J., 'Reflections of How Admirers Of Shaker Way Practice Sharing Today', *The Shaker Messenger*, vol. 7, no. 3, 1985, p. 15.

———, 'Shaker Oval Boxes – Reproductions Make Fine Gifts or Storage', *Fine Woodworking*, vol. 102, September/October 1993, pp. 54–57.

Winchester, A., 'Shakertown at Pleasant Hill', *Historic Preservation*, vol. 29, no. 4, October–December 1977, pp. 13–20.

Winter, W.F., Catalogue for *Exhibit of Applied Photography*, Lenox Library Association, Lenox, MA, USA, 1934.

———, 'Shaker Portfolio', *US Camera*, vol. 1, no. 3, 1939, pp. 22–25.

Wisbey, H.A., *The Sodus Shaker Community*, Wayne County Historical Society, Lyons, NY, USA, 1982.

———, 'Shaker Scholar Lists Favourite Structures', *The Shaker Messenger*, vol. 6, no. 4, 1984, pp. 8–9.

Wolfe, R., 'Hannah Cohoon', in Lipman, J. & Armstrong, T. (eds.), *American Folk Painters of Three Centuries*, Hudson Hills Press, New York, USA, 1980, pp. 58–65.

Wolkomir, J. & Wolkomir, R., 'Living a Tradition', *The Smithsonian*, vol. 32, no. 1, April 2001, pp. 98–108.

Wood, D., *Handmade Style: Shaker*, Chronicle Books, San Francisco, USA, 1999.

———, *Shaker: Creating The Style*, MQ Publications Ltd, London, UK, 1999.

Woodham, J., *Twentieth-Century Design*, Oxford University Press, UK, 1997.

Woods, C.R., '*'Tis the Gift to be Simple' Folding Screenbook*, Harper Collins, New York, USA, 1995.

Woodworth, D., *Death of a Winter Shaker*, Avon Books, New York, USA, 1997.

———, *A Deadly Shaker Spring*, Avon Books, New York, USA, 1998.

Writers' Program of New Hampshire, *Hands that Built New Hampshire*, Stephen Daye Press, Brattleboro, VT, USA, 1940.

Yates, S., *An Encyclopaedia of Chairs*, Shooting Star Press Inc., New York, USA, 1988.

Yohn, T. (ed.) & Morin, F., Catalogue/Leaflet for *The Quiet in the Land*, Sabbathday Lake, ME, USA, 1996.

Ypma, H., *American Country*, Thames and Hudson, London, UK, 1997.

———, 'Shaker Shaped', *The World of Interiors*, vol. 18, no. 7, July 1998, pp. 54–63.

Zieget, I., *Julius Zieget – A Sketch*, Ardmore, PA, USA, 1960.

———, 'Our Shaker Adventure', unpublished manuscript, archives of the Philadelphia Museum of Art, USA, 1967.

———, 'Our Shaker Adventure, *The World of Shaker*, vol. 4, no. 5, 1973, p. 2.

Zimmerman, P.D., *Seeing Things Differently*, The Henry Francis du Pont Winterthur Museum, Wilmington, DE, USA, 1992.

Television, Video, Music and Radio Material

Adams, J., 'Shaker Loops' in *Minimalist*, London Chamber Orchestra, Virgin Classics Ltd, 2000.

Amirani, A., Browne, K., Solomon, C. & Valmas, Z., *Meet Thy Shaker*, Uden Associates production for Channel 5, UK, 19 March 2000.

Anderson, A. (director), Silver, E. (series producer) & McCloud, K. (presenter), *Grand Designs*, TalkBack production for Channel 4, UK, 29 March 2001.

Barker, M.R. (with other Shakers from Sabbathday Lake), *Early Shaker Spirituals*, Rounder Records Corp., Cambridge, MA, USA, 1996 (featuring sleeve notes by Daniel W. Patterson).

Breeding, M., Lindgreen, J. & Thomas, J., *The Architectural Heritage of the Shakers at Pleasant Hill* (video), A Pleasant Hill Production, Pleasant Hill, KY, USA (no date).

Bristow, M. (series producer) & Fisher, P. (ed.), *DIY SOS*, BBC 1, British Broadcasting Corporation, London, UK, 1 November 2000.

Brubeck, D., *Brubeck's Cool Jazz, An 80th Birthday Celebration*, BBC Radio 2, British Broadcasting Corporation, London, UK, 25 December 2000.

Burns, K. & Stechler Burns, A., *The Shakers: Hands to Work, Hearts to God* (film/video), Direct Cinema Limited, Santa Monica, USA, 1985.

Copland, A., *Appalachian Spring*, Boston Symphony Orchestra, RCA Classics (Bertelsmann Music Group, Germany), 1994.

Coulter, W. & Phillips, B., *Tree of Life*, Gourd Music, Felton, CA, USA, 1993.

———, *Music On The Mountain*, Gourd Music, Felton, CA, USA, 1996.

Davenport Films, *The Shakers* (film/video), Davenport Films, Delaphane, VA, USA, 1974.

Elphick, M. (ed.) & Carter, S. (producer), *Changing Rooms* (featuring a 'Shakey

Wakey' bedroom by Anna Ryder Richardson), BBC 1, Bazal Productions for British Broadcasting Corporation, London, UK, 18 September 2001.

Folger, R., *Gentle Words*, American Productions, USA, 1993.

Goodwin, D. (ed.), Shaw, S. & Shaw, T., *Home Front* (featuring Shaker style), BBC 2, British Broadcasting Corporation, London, UK, April/May 1996.

Goulden, J. (presenter), *The Great Antiques Hunt* (featuring Fruitlands Museums, Harvard, MA), BBC 1, British Broadcasting Corporation, London, UK, 4 May 1997.

Hackman, W. (ed.) & Hill, A. (producer), *Changing Rooms* (featuring a New England-inspired room by Graham Wynne), BBC 1, Bazal Productions for British Broadcasting Corporation, London, UK, 30 July 1998.

Hall, H., Thompson, D. & Phelps, L., *Let Zion Move: Music of the Shakers*, Rounder Records Corp., Cambridge, MA, USA, 1999.

Hancox, A. (producer) & Jackson, B. (presenter), *Simple Gifts*, BBC Radio 4, British Broadcasting Corporation, London, UK, 27 October 1994.

Hughes, R., *American Visions – 2: The Promised Land*, BBC 2, British Broadcasting Corporation, London, UK, 10 November 1996.

Jackson, V., *Real Rooms* (Chris and Frankie's Kitchen at Crowthorne, Berkshire), BBC Publications and Video 1/NBH.I.041.S/71; also featured in *Real Rooms Booklet 3*, British Broadcasting Corporation, London, UK, 1998.

Kurtenbach, H., *The Shakers* (film/video), Films for the Humanities Inc., Princeton, NJ, USA, 1992.

Marshall, P., Kaye, P. & Longenecker, M.W., *Kindred Spirits – The Eloquence of Function in American Shaker and Japanese Arts of Daily Life* (film/video), Crown Point Media, San Diego, CA, USA, 1996.

Misrahi, K. (producer & director), *Making It*, BBC 2, British Broadcasting Corporation, London, UK, 1 April 2000.

Robson, K. (producer) & Nightingale, M. (presenter), *Wish You Were Here* (with a report by R. Owen on New England and Canterbury), Thames Television and Pearson TV, London, UK, 5 March 2001.

Roper, D. (producer) & Grossman, L. (presenter), *Simple Gifts*, BBC Radio 2, British Broadcasting Corporation, London, UK, 4 and 11 September 1996.

Tharp, L., *The Shaker Chair – For What It's Worth*, BBC Radio 4, British Broadcasting Corporation, London, UK, 23 April 2002.

Thompson, D. (producer & director), *Aaron Copland: American Composer*, BBC 2, British Broadcasting Corporation, London, UK and WNET, New York, 29 October 2000.

Thomson, G. (producer) & Walton, S. (executive producer), *IKEA Mania* (part of a series of four), Meridian Television Productions for Channel 5, Southampton, UK, 25 October 2000.

Treays, J. (producer), *Timewatch: I Don't Want to be Remembered as a Chair*, BBC 2, British Broadcasting Corporation, London, UK, 17 October 1990; also available as Post-Production Script, Spool Number 69443.

Vila, B. & Ferrone, M., *Bob Vila's Guide to Historic Homes* (film/video featuring Hancock Shaker village), BVTV Inc. in association with A&E Network, Home Video Group, New York, USA, 1996.

Weymouth, T. (ed.) & Holdsworth, J. (producer), *To DIY For*, Yorkshire Television for Channel 4, London, UK, 10 September 2001.

INDEX